The Continuum Encyclopedia of Native Art

THE CONTINUUM

Encyclopedia

of Native Art

Worldview, Symbolism, and Culture in Africa, Oceania, and Native North America

Hope B. Werness

Line drawings by Joanne H. Benedict, Tiffany Ramsay-Lozano and
Hope B. Werness. Maps by Scott Thomas.

Continuum
New York • London

The Continuum International Publishing Group Inc
370 Lexington Avenue, New York, NY 10017

The Continuum International Publishing Group Ltd
Wellington House, 125 Strand, London WC2R 0BB

Printed in the United States of America
Book design: Stefan Killen Design
Cover art: Paddy Dhathangu (b. 1915), David Daymirringu (1927–1999), George Malibirr (1934–1998), Jimmy Wululu (b. 1936), and other Ramingining artists, *The Aboriginal Memorial*, 1987–88. Wood, ochres installation of 200 hollow coffin logs. Height from 40.0 to 327.0 cm. Purchased with the assistance of funds from gallery admission charges and commissioned 1988. Collection: National Gallery of Australia, Canberra. Used with permission.

Library of Congress Cataloging-in-Publication Data

Werness, Hope B.
 The Continuum encyclopedia of native art: worldview, symbolism, and culture in Africa, Oceania, and North America / Hope B. Werness ; line drawings by Joanne H. Benedict, Tiffany Ramsay-Lozano, and Hope B. Werness ; maps by Scott Thomas.
 p. cm.
 Includes bibliographical references and index.
 ISBN 0-8264-1156-8
 1. Indian art—North America—Encyclopedias. 2. Art, African—Encyclopedias. 3. Art, Oceania— Encyclopedias. 4. Symbolism in art Art, North America—Encyclopedias. 5. Symbolism in art Art, Africa—Encyclopedias. 6. Symbolism in art Art, Oceania—Encyclopedias. 7. Indians of North America—Social life and customs—Encyclopedias. 8 Africa—Social life and customs—Encyclopedias. 9. Oceania—Social life and customs—Encyclopedias. I. Title.

E98.A7 W49 2000
704.03—dc21

00-021842

Dedication

Even as short a time ago as fifteen years, this would have been a very different book. It is possible that it could not even have been written because there was very little work on the meaning and significance of images in indigenous cultures. The study of what used to be called "primitive" art, now called native, indigenous or Non-Western, is a fairly recent one. The earliest work was devoted to taxonomy and identification of styles. Once the valuable work of systematizing was done, scholars have increasingly been addressing broader questions. This book, thus, is most respectfully dedicated to the generations of scholars—explorers, archaeologists, ethnographers, anthropologists and art historians—who labored in the field and in their towers, ivory or otherwise. I have drawn most on the works of the present generation who so ably consolidate what came before and thoughtfully synthesize it with their own perspectives. It is especially dedicated to Herbert M. "Skip" Cole.

Additionally, this book is dedicated to the countless indigenous artists, both the ancestors and the living. Their art celebrates, embodies and serves their own cultures and vastly enriches our own.

I am also very thankful to California State University, Stanislaus for the sabbatical that made the research possible and to my colleagues and friends Donna Pierce and C. Roxanne Robbin who provided invaluable editorial suggestions.

Introduction

This book deals with art of the native peoples of Africa, North America and Oceania, especially with its symbols and meanings. The encyclopedia format results in separate "nuggets" of information, expressed as concisely and clearly as possible. And while brevity may be the soul of wit, there are some generalities or "givens" of which the reader should be aware. First of all, art must be understood against the backdrop of the culture that created it. Museums display, and we are used to seeing, native art in static, antiseptic conditions remote from the way the objects functioned in their own societies. "At home" the objects are/were, more often than not, just one part of complex, dynamic events.

Second, it is necessary to shed a number of Western preconceptions about the nature of art. It is often said that since many native cultures have no word in their language that corresponds to the Western word, "art," they therefore have no concept of art, no aesthetic. On the contrary, although the ideals of beauty are different from those of the West, indigenous artists often judge objects by clearly understood and applied criteria. The aesthetic of the Yoruba of Nigeria, for instance, involves complex and interlocking criteria that apply not only to art, but to human behavior as well.

Another Western set of ideas that must be jettisoned is the preoccupation with illusionism from the Renaissance on, the idea of "Art for Art's Sake," and the hierarchy that places painting at the apex. These are irrelevant in appreciating native art. While African art can be extraordinarily realistic (see, for instance, Baule portrait masks or the famed Ife brass heads), mimesis is generally less important than the degree to which the art embodies concepts like power, spiritual presence and life force. Furthermore, all of the above Western concepts are part of an "art culture" that is increasingly remote from people's lives. Art in Africa, Native America and in the Pacific continues to be part of the fabric of life. To draw just one parallel, in the modern United States marital difficulties are solved by divorce or psychological counseling. In the Democratic Republic of Congo, a Woyo wife, displeased with her husband's behavior, may serve a meal in a vessel topped with a pot lid on which a pertinent proverb is depicted. Meals are communal affairs, so the non-verbal criticism is witnessed by all and the husband must respond not only to his wife, but the extended family as well. Art provides a pointed but indirect and gentle way to reestablish harmony within the family.

The modern ideal of progress and the cult of individualism are also irrele-

vant. In indigenous societies, artists are frequently valued individuals (they may be shamans or kings) but instead of constantly striving to create new, revolutionary art, they create objects that reaffirm their cultures' worldview. Until recently, native art was regarded largely as anonymous. Increasingly, scholars are revealing the names and styles of artists as we become more sensitive to individual differences.

Additionally, the distinction between form and content does not exist for the native artist; the two are inseparable. There is nothing that corresponds to Nietzche's dichotomy between Apollo and Dionysus, reason and the senses. Actually, there are many dichotomies in native art, but ultimately, they are conceived of as part of an inseparable whole. For instance, the upward curving ridgepole of the Abelam men's houses of New Guinea is thought of as the visible path of the sun. At noon the sun stands directly over the triangular façade of the house and then follows an invisible mirror of the house as it descends to spend the night in the underworld. Furthermore, the paintings on the façade, together with the rituals and objects that occupy the interior of the house contribute important elements of meaning. As a total, unified form and content, the house is located at the center, the meeting point and intersection of a number of dichotomies—visible/invisible, male/female, night/day, life/death and human/spirit.

Westerners, while valuing constant, restless change, also value enduring objects and materials: art is supposed to last. There are some indigenous societies that valued materials that Westerners would agree are intrinsically valuable, for instance, the splendid Akan goldwork. But these criteria make it hard to understand the value placed on other materials or the enormous time and effort put into objects that are used once and discarded or, at least, not maintained. In Hawaii, for instance, the most valued material was bird feathers. In Nigeria, the Igbo may devote months or even years to building mud Mbari houses to honor the Earth Mother Ala. After the house is completed and dedicated, its purpose accomplished, it is allowed to revert to nature.

Finally, the purposes of art differ. In the technologically advanced West, the visual arts have been relegated to the sidelines. The art culture that includes serious contemporary artists, critics, museums and art galleries at all levels (from the New York mainstream to the local arts commission) has come to be largely non-essential to the rest of society. The "public" has insufficient education to appreciate the work of contemporary artists or is simply indifferent to it. At best,

the visual arts receive funding to create art to supplement (decorate) public projects. At worst, the lack of understanding alienates artists and people in the society from one another. This marginalizing of art is one of the failures of the late 20th century. Although Non-Western artists have been victimized by a voracious and manipulative art market in search of exotic objects, there is still a great deal of art in indigenous cultures that serves the needs of those cultures. Where artists still work within their societies, art fulfills life-enhancing functions. Traditionally, native art was intrinsically related to the entire human experience of life, marking the stages of life through ritual. Art was linked with social control; it was part of judicial activities that enforced morality and protected society from those with evil intentions. Art unified people with one another and with the spiritual realm of ancestors. It provided ways of coming to terms with some of the most troubling aspects of life such as sexuality, the role and place of individuals within society and finally, it provided ways of facing death. The value and efficacy of art was understood and accepted by all members of society. Of course, there are and were failures in indigenous societies as well: cultural practices such as cannibalism and other forms of human sacrifice, the fear and abuse of women are only two instances. Still, there are many lessons to be learned from looking closely at the art of indigenous peoples: lessons about life, the world and, above all, about different sorts of beauty.

Several examples are given above to show how fundamentally native art differs from that of Western culture. The examples are chosen with care, as they have been throughout the book, from the most recent fieldwork. By this means, I have attempted to avoid the pitfalls of over- and misinterpretation. There is, however, an underlying approach that is used, based on the belief that there are certain universals that appear over and over in human culture. While the approach is not, strictly speaking, Jungian, it does attend to the concept of archetypes as they are expressed in visual forms. For instance, the concept of the center mentioned above—the belief that the culture and the individual are at the center of existence physically and spiritually—is "pictured" in architectural plans, buildings and a host of geometric designs of which the cross is the most prominent. The literature often backs up the interpretation, as for instance, the importance of the center in Kongo art where it functions as a cosmogram.

One of the most dramatic differences between Western art of recent years and native art is the degree to which, in the latter, ethical and moral issues are

inseparable from aesthetics. The West links truth and beauty, but in Africa goodness and beauty are inextricably tied together. The ideal beauty of Mende women, embodied in the masks of the Sande society, is composed of physical attributes (*nyande*) and goodness (*kpeke*). The ideal is a combination of physical and ethical concepts. Unless a woman is goodhearted, kind, generous and competent, unless she has a fine character, her beauty is empty. Real beauty contributes to the entire community, since it is good to see, fulfills its social purpose and is generous and loving.

Finally, in assembling the material included in the encyclopedia, beyond being aware of preconceptions, I have tried to be accurate concerning details. For instance, I have attempted always to give the names by which indigenous peoples prefer to be called as well as accurately recording the names of groups, persons and places. The numerous variations in orthography made this a difficult task. I used, where possible, the indigenous names for objects, as well as providing the English equivalent. I have tried to avoid indiscriminate use of the "ethnographic present," that is, use of the present tense which implies that the people described are still active.

To assist the reader in using this volume, cross references are indicated in capital letters. At the end is an index composed of general categories. This was done to avoid long lists of cross references that would be disruptive to the text. The index also provides the reader with a thematic way of approaching the text. The general headings of the index are:

Animals
Art, Artifacts and Techniques
Artists
Deity Archetypes
Geographical Subdivisions and Native Cultures
The Human Body
Natural Phenomena and Materials
Miscellaneous

Large scale maps are included to provide an overview of the main geographical entries. Smaller maps will help the reader locate places and societies in the rich art-producing areas of New Guinea, the American Southwest and Nigeria. I have attempted to include all the places referred to in encyclopedia entries on one or more of these maps.

Index of Maps

A'a. Figure of a god from Rurutu, in the Austral Islands. Variously said to represent Tangaroa in the act of creating the other gods and people, or A'a, national god of the island of Rurutu, ancestor of the island's people, deified at death. The back of the figure is hollowed out and once held twenty-four small carvings. The figures carved on the front of the image represent past generations, while the five knob-like protrusions on the spine are future generations in keeping with the Polynesian idea that the future lies behind, as it is not yet visible. The figure thus presents complex ideas about life such as past and present, death and rebirth, people and gods in a graphic way. See INDEX: Deity Archetypes.

Abelam. The Abelam live in hamlets centered on spirit houses to the north of the Middle Sepik River. Sometimes Abelam art is identified as Maprik, after the range of mountains and one of the central villages of the area. One of the most remarkable features of Abelam society was the KORAMBO spirit house, which combined male and female imagery, so energetic in form and in amounts so prolific as to guarantee prosperity for the community. Although the hamlets are grouped into settlement associations or villages, there is no central political structure uniting the 40,000 Abelam. Sago and yams are the basis of their diet. Men cultivate the yams, considered to be images of the ancestors and the village community, in an atmosphere of intense competition and stringent taboos. Women hand-raise pigs which is

believed to strengthen the pigs' fourfold links with the underworld (from which they originate), the primary forest, with the gardens and with the human beings who feed them. Pigs serve as mediators; they are exchanged, sacrificed and even serve as "soul carriers." Christian Kaufmann describes the Abelam treatment of the figure as exhibiting "a sort of playful disintegration" which links human beings with both yam tubers and the original tree trunks from which the first humans were carved. Basketry masks and plant material attachments are used in creating powerful squatting ancestor figures called NGGWALNDU-PUTI ("human grandfather, empty having given everything"). Basketry masks called BABA are worn on top of the head. Abelam pottery is both utilitarian and ceremonial. Carved cassowary bones, decorated with faces, figures, insects, plants and geometric patterns, are fashioned into spatulas for cultivating yams and for eating betel. During one segment of initiation rituals, bone spatulas and daggers are driven into the ground as a symbol of the entire male line of descent. Women make colored string bags, images of which are included on the men's house facades. There are some linguistic similarities between Abelam and the IATMUL and SAWOS, as well as shared beliefs and worldviews. See also WOSERA. See INDEX: Pigs in Animals; Yam in Natural Phenomena and Materials.

Aboriginal Australia. The vast landmass of Australia was uninhabited until approximately 40,000 years ago. Because

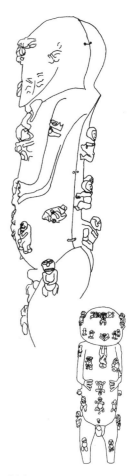

A'A

Above: In the past the British Museum label read "Tangaroa Upao Vahu" (Tangaroa-up-in-the-sky), but the figure is now identified as A'a, the national god of Rurutu, Austral Islands. Collected in 1821 by missionaries.

of the scarcity of resources, the aborigines of Australia continued to be largely nomadic, hunter/gatherers until well into the 20th century. Art is produced throughout the continent by aboriginal peoples who speak over 200 separate languages, but who nonetheless share common cosmology and religious beliefs. Rich and diverse styles and art forms exist in all of the principal geographic areas of southeast Australia and Tasmania, central Australia, the Kimberleys, Arnhem Land and Cape York Peninsula. The central and universal concept is the DREAMING (or Dreamtime). Important shared mythological cycles include Rainbow Snake, the WAWALAG SISTERS and the DJANGGAWUL creation myths. Regardless of medium, aboriginal art falls into two representational systems, figurative representations and geometric patterns. Artists are persons of importance in aboriginal societies as they are the repositories of the oral and visual traditions of their people. Artists inherit the right to reproduce patterns, which are set and unchanging, although new designs are possible as well as individual, creative interpretations of the time-honored designs. Art forms include rock art (see X-RAY STYLE, WANDJINA, MIMI SPIRITS), figurative sculpture, sand sculpture, BODY ART, mortuary art (see PUKAMANI), more recently BARK PAINTING and many others such as weapons, bags and baskets, wooden dishes, as well as personal adornments made of shell, seeds and reeds. After 1970, due to the encouragement of art teacher Geoffrey Bardon, aboriginal artists began painting on canvas resulting in the development of a lucrative and extensive market (see WALBIRI). See Colorplate 1 and map, OCEANIA.

Adena Complex. Named after the Adena Mound north of Chillicothe, Ohio, this prehistoric complex developed

ADENA COMPLEX

Right: Some thirty-five tablets like the so-called Berlin tablet are known. The Berlin tablet depicts a bird identified as a raptor or vulture. One writer feels that the entire bird seems compressed as if it were struggling to break out of an egg. The dotted circles may be joint marks. Although the purpose of these tablets is unknown, it is speculated that they may have served as stamps for body decoration or textiles. Alternatively, it is suggested that the grooves may have channeled the blood in ceremonial bloodletting. Berlin and Wilmington Tablets, both sandstone. 400 BCE–1 CE.

in the Ohio River Valley sometime between 1100 and 700 BCE and waned between 100 and 400 CE, but lasted in some places as late as 700 CE. Its influences were felt as far away as the northeastern seaboard. The HOPEWELL Interaction Sphere followed Adena. Over 200 Adena sites, characterized by large earthworks, are known in Ohio, West Virginia, Pennsylvania, Kentucky and Indiana. The purpose of the early geometric forms such as circles, squares and pentagons and of the later effigy mounds was sacred and ceremonial rather than defensive. The Adena people also built burial mounds varying from simple clay-lined basins to large log tombs for up to three individuals. Grave goods included pottery, shell gorgets, carved stone tablets, tubular pipes and copper jewelry. Many Adena objects are finely decorated with curvilinear designs. Repeated imagery includes representations of animals (felines), snakes and birds. See INDEX: Animals.

Adinkra. One of two royal ASANTE textiles (see also KENTE). *Adinkra*, made of cotton, is stamped with bark-dye designs that form a SIGN SYSTEM. The

cloth takes its name from a royal prisoner of war, King Adinkra who is said to have worn a cloth stamped with designs symbolizing his sorrow at his loss of freedom and over the deaths of his soldiers. Historical evidence shows that *adinkra* was used among the Asante before King

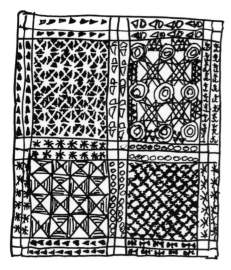

Adinkra's 1818 defeat, but the oral tradition linking it with victory enhances the cloth's value. Made by men, the cloth formerly functioned primarily as funeral cloth but is now in general use. The term *nkra* means "message," and the individual symbols form a system conveying meaning that often relates to the soul and to proverbs, both of which provided spiritual insight of supernatural origin. Some of the designs may have been introduced through the North African trade route. The designs have NAMES, such as the pattern of three concentric circles called *adinkrahene*, "king of *adinkra*." This design, considered the most important of all, is associated with the prisoner-king and indicates authority, grandeur, firmness, magnanimity and prudence. Early *adinkra* were red, russet or black and the dyes were applied with carved calabash stamps. Those dark hues of mourning are now supplemented with many others, including green, blue, purple and yellow.

Adinkra is worn as fine dress on Sundays or for festivals.

Admiralty Islands. These islands make up the province of Manus of the state of Papua New Guinea. The art of the area is largely unstudied because few objects are found in European collections. The German colonization of the area was met with greater violence than elsewhere and the area was subject to social upheaval following World War II. Utilitarian objects from the Admiralties are finely made, decorated with motifs drawn from the plant and animal realms, at times stylized into nearly abstract geometric forms. One of the most important animals represented is the crocodile, which can be indicated just by its open, gaping jaws. Impressive paired figures (male and female, memorials or spirit containers) were found at the entrance to men's houses and residential houses. Little evidence exists to help interpret these figures, but Mino Badner, analyzing what little there is, suggests that the figures likely occupied a sliding scale of referents which extended from the recently dead to ancient, mythological ancestors. Similar figures appeared on the finials that topped house ladders, on horizontal slit drums and on the supports of ceremonial seats and beds. Three different regions have been identified: Manus, Matankol and Ussiai.

ADINKRA

Left: Detail of a cloth worn by King Prempe I (reigned 1888–1896) when the British exiled him in 1896.

ADMIRALTY ISLANDS

Below: Wooden bowl for large ceremonial feast, Matankol.

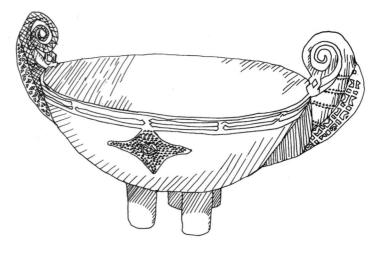

Basketry, pottery and objects for personal adornment show the mastery of form for which the art of the area is known. See INDEX: Crocodile in Animals. See map: NEW GUINEA, IRIAN JAYA, ADMIRALTY ISLANDS, NEW IRELAND, NEW BRITAIN.

Adze. The most widely used tool in Africa and Oceania. Polynesian adzes are works of art. The blades are hafted and inset into elaborately carved handles.

Aesthetic Judgment. Because many indigenous people have no word parallel to the Western word "Art," it has been assumed mistakenly that they had no interest in judging the merit of the objects they made. Actually, as recent fieldwork by Philip Dark and Robert Farris Thompson among others has shown, indigenous people often have very finely tuned aesthetic criteria that are applied by artists and other members of society. The Western criterion of originality sometimes plays a part, but more often skill (see the KILENGE), utility, adherence to tradition and moral strength (YORUBA) are evaluated and brought to bear in determining whether objects have beauty and aesthetic merit. See INDEX: Aesthetics in Art, Artifacts and Techniques.

Africa. Africa, the second largest continent in the world and the original home of humankind, today is home to over 1000 ethnic groups. There are four major language families: Niger-Congo (Bantu), Nilo-Saharan, Afroasiatic (Hausa, Arabic) and Khoisan. The oldest tools in the world, discovered with early hominid remains by Louis Leakey, come from the Olduvai Gorge in eastern Africa. These tools, smoothed and rounded "cores," are said to be between 1.6 and 1.7 million years old. The earliest art—ROCK ART—appears around 6000 to 4000 BCE, possibly as early as 8000 BCE in the

Sahara and Kalahari deserts (see SAN and TASSILI N-AJJER). Ancient kingdoms emerged by 1000 CE and existed side by side with village-based societies of enormous diversity. Traditional religions, and by 800 CE Islam and Christianity from the 15th century, were and continue to be part of the pattern of daily life in Sub-Saharan Africa. Although sculpture—especially masks and sculptures of the human figure—is the preeminent art form in Africa, prodigious amounts of art are produced in other media and techniques including textiles, metalwork, basketry, beadwork, clay and mixed media in items for personal adornment. Architecture, from the megalithic masonry walls of GREAT ZIMBABWE to the mud granaries, houses and shrines of the DOGON, is also a vital and highly significant art. Surveys of African art subdivide the material into large geographical areas or by modern states. A shortcoming of this is that political boundaries fluctuate, and also indigenous peoples often live in several states. Some recent volumes on African art have included Egyptian and Ethiopian art, both of which are excluded here. Geographic areas (and the states within them) included here are the Western SUDAN (Mali, Niger and Burkina Faso), WESTERN AFRICA and the GUINEA COAST (Guinea, Sierra Leone, Liberia, Ivory Coast, Ghana, BENIN, Nigeria and CAMEROON), CENTRAL AFRICA (Gabon, CONGO, Central African Republic, Democratic Republic of Congo and Angola), EASTERN and SOUTHERN AFRICA (Tanzania, Kenya, Zimbabwe and the Kalahari Desert). Numerous variant spellings of African cultures exist. Biebuyck, Kelliher and McRae's *African Ethnonyms* has been used to identify preferred forms and some of the most common variants are included.

Afro-Portuguese Ivories. One of the first

ADZE

Above: This adze from Mangaia, in the Cook Islands, is said to represent TANE mata ariki (Tane of the royal face). The blade is lashed to the wooden handle with coconut fiber sennit.

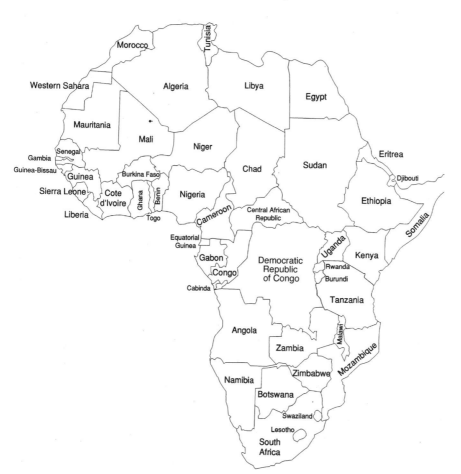

AFRICA

trade commodities brought back to Europe was ivory. The Portuguese recognized the refined craftsmanship of African artists from Benin and Sierra Leone and commissioned ivories, of which over 200 are extant. These have been discussed extensively in Ezio Bassani and William Fagg's *Africa and the Renaissance*. Trumpets, spoons, lidded vessels and saltcellars combine African and Renaissance styles, resulting in a unique and virtuoso art form, spanning the late 15th through the 17th century.

Agiba. Skull racks kept in the men's houses in the Papuan Gulf. See KEREWA.

Agoli Agbo. FON ruler whose brother GBEHANZIN was sent into exile in 1894 by the French. Colonial authorities installed Agoli Agbo as nominal ruler.

Until the end of his reign in 1900, Agoli Agbo collected, preserved and revitalized the royal arts. The Abomey palace museum is a tribute to this ruler whose name means "Attention Abomey the kingdom stumbled but did not fall." His signs include a foot, or a shoe, and a self-biting serpent.

'Ahu 'ula. The Hawaiian words *'ahu 'ula* mean "red shoulder garment." Approximately 160 feather capes and cloaks survive in museums and private collections (capes are shorter, ending around the knees, whereas cloaks reached the ankle). The people themselves regarded these as the most precious of all objects. The abstract geometrical designs and solid colors have been shown by Tom Cummins to be highly significant symbols of royalty and kinship. Red was the color associated with

AFRO-
PORTUGUESE
IVORIES

Above: Sapi-Portuguese saltcellar from Sierra Leone, depicting a woman and child in an unusual pose. c. 1490–1530.

'AHU 'ULA

Right: Hawaii. Red and yellow feathers on a netted backing. 7' 6" wide.

AKAN

Above: Two Akan memorial heads (mma) one realistic and the other more abstract. It has been suggested that the more realistic ones are older or that they were made for individuals of higher status than the more schematic ones. The downward gaze is said to show sorrow, while an up-tilted head "shows ecstasy and trust in God." 17th–19th century.

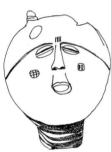

royalty and the red feathers from the Iwi bird were originally used exclusively for royal cloaks. Red was also associated with the rainbow, another royal symbol. As the power of the high chiefs grew, yellow feathers from the Mamo bird were added. The yellow feathers were valued because of their rarity and the labor-intensive manner in which they were gathered. The yellow feathers indicated the chief's power to command commoners to labor on his behalf, further inflating the cloaks' value as symbols of conspicuous consumption and power. The contrasting red and yellow, with the addition of black, created bold crescent and half-crescent shapes. The latter, symmetrically placed either side of the central closing, become complete crescents when the cloak is fastened. The crescent shape is linked to the rainbow and to mythology. All of these play a part in the ambiguous attitude toward royal brother/sister marriages (incest was not prohibited because of the divine and noble status of those involved, but nonetheless was referred to as "bent" like the crescent shape and the rainbow). After Kamehameha II dissolved the state religion in 1819, cloaks were made almost entirely of yellow feathers, indicating that the cloaks, although extraordinarily valuable prestige objects, were no longer royal. See also MAHIOLE.

Airport Art. Generally associated with sloppily crafted, degenerate art objects produced for tourists to pick up quickly at the airport as souvenirs. Nearly universally denounced by those who appreciate tra-

ditional indigenous cultures as the worst result of Western commercialism and secularization. The demand for mementos, however, is an important financial factor. At worst, undiscriminating tourists purchase mass-produced "ethno-kitsch" souvenirs. Airport art is generally regarded as being lower quality than MARKET ART (see WALBIRI), which, at best, involves the use of new materials without prostituting traditions. In the latter instance, art production economically enriches the community while continuing to fulfill the positive function of mediation and of making sense of and controlling the world.

Akan. The Akan are a large group of related peoples who speak similar languages and have similar cultural patterns in central and southern Ghana and the eastern Ivory Coast. Akan political organization is characterized by centralized power embodied in a divine king. One of the most striking features of Akan culture is the extensive impact of oral traditions, especially proverbs, on symbols of power and many other art objects. The Akan were exposed to Islam through trade associations and their cosmology is a unique combination of Islamic and indigenous traditions. Early terracotta heads commemorating the royal dead are widespread. They apparently served as memorials placed in a sacred grove near the cemetery and were used in the concluding feast of the funeral where food was brought to the grave. Called *mma*, "infants," the sculptures are idealized likenesses that include identifying details such as scarification, coiffure and amulets. These vary in style from quite realistic to the later flattened, more abstract heads from the ASANTE area. The famed AKUABA figures used by Akan women for fertility and protection may be a proletarian form, carved in wood, which evolved from the royal terracottas.

Another important funerary art form is the so-called "family pots," on which are found symbols that facilitate the dead person's transition from life to afterlife. Most display a "ladder of death," indicating the universality of death—"it is not only one man who climbs the ladder of death." LADDERS, of course, are symbols of ascension/transition. Animals such as snakes, lizards, frogs and crocodiles are associated with the underworld of death and have associated proverbs. A python, a powerful symbol of life and regeneration, encircles the vessel's neck, illustrating the proverb "the rainbow of death encircles every man's life." The most powerful Akan State was that of the ASANTE. Other Akan peoples and regions are the Fante, Anyi and Adanse, among others. See LINGUIST STAFF and for additional references to the above named animals, see INDEX: Animals.

Akan Gold. Gold was the source of Akan wealth and a symbol of power. Linked to the life-giving sun, gold was said to represent the sun's very essence and to embody *kra*, life force or soul. The single most important ASANTE object, the original GOLDEN STOOL, was said to be solid gold. Akan rulers reinforced and dramatized their power with golden objects. Gold was cast into solid objects and applied as gold-leaf to wooden objects such as finals for umbrellas, the famous linguist or speaker's staffs, sword handles and ornaments. One of the most frequently reproduced objects, a gold head associated with Kofi Kakari, is often said to represent the king himself. In reality, it was part of his treasury taken as war booty during the British sack of Kumasi. Gold portrait heads like this one are a very elegant and valuable instance of trophy heads. After victories, portrait heads of slain enemies were commissioned as ornaments for state swords, which as historical artifacts, symbolized Asante power and

military might. For a stool purported to have belonged to Kofi Kakari (reigned 1867–1874), see the illustration accompanying the entry on the Golden Stool. Finally, exquisite gold disks called *akrafokonmu*, "soul washers" were worn by the royal family and certain high court officials. The mandala-like patterns on

disks suggest the CENTER and the sun, source of life force and *kra*, the spiritual essence received at birth. A special court title was that of "soul" bearer, granted to particularly handsome individuals born on the king's birthday and believed to share the king's soul and vitality. These officials served as doubles and protec-

AKAN GOLD

Left: Gold sword ornament from the treasury of Kofi Kakari, the ruling Asantehene when the British conquered the Asante in 1874. Said to represent Worasa, chief of the state of Banda, defeated c. 1765. Before 1874.

Below: This akrafokonmu ("soul washer's" disk) once belonged to Prepeh I. The concentric patterns symbolize the radiant energy of the sun and kra, its gift of spiritual essence to individuals. The circles are repeated in the plan of the Asante State radiating outward from Kumasi. 19th century.

AKAN
GOLDWEIGHTS

Left to right: Geometric gold weights can convey proverbs, such as the large 17th-century weight from a king's treasury with a key design: "Death has the key to open the miser's chest."

Many geometric weights are called "puzzle-weights" with imaginative forms that reflect the brass caster's ingenuity.

Figurative weights depict an endlessly inventive spectrum of human strengths and foibles. The mounted horseman, in the finest Asante 19th-century style, probably depicts a warrior from the northern savanna.

The man playing fontomfrom drums may represent the proverb, "Firampon says he won't have anything to do with the drums: yet when they beat the talking drums they say 'Condolences, Firampon.'"

tors—they tasted the king's food, carried state swords and conducted purification ceremonies to renew and energize the king's soul. The patterns of soul-washers, like most other Asante art, often have proverbial symbolism. For instance, one pattern of concentric circles, called "the back of the tortoise," is combined with four openwork dumbbells called "eye of the yam." Together these symbolize fertility, abundance and luck. Cowry shells symbolize wealth and joy. Another with four elements radiating outward from the center illustrated the proverb, "the chief is like a crossroads, all paths lead to him." The disks were traditionally buried with the ruler, his "souls" accompanying him to the grave. The sun symbolism provided light in the darkness of death.

Akan Goldweights. Between 1400 and 1900, Akan goldweights were used to weigh gold dust by the Akan and Akan-related peoples of southern Ghana and the adjacent Ivory Coast. The Akan mined gold in the forest and traded it across the Sahara desert into North Africa. There were two series of weights, one equivalent to an Islamic ounce, used in Trans-Saharan trade, and the other, the *mithqal*, about one-sixth of an Islamic ounce. After opening trade with the Portuguese in the 1470s, new weights based on the Portuguese ounce were

made. Eventually, there were four sets of weights for external trade, which over the centuries became merged into a table of about sixty units measured by over 1900 weights. The figurative weights, for the most part, served as MNEMONIC DEVICES representing proverbs. Thus, they display a veritable circus of human affairs ranging from humorous to moralizing. Over one hundred identifiable species of animals are represented, most associated with proverbs. Only the owl and the cat are never seen, as the owl is considered an ill omen and the word for cat, *okra*, also means "soul." Spiders are infrequently found, but their rarity is because of the difficulty of casting these delicate creatures. It is said that weights were sent from one person to another as a way of conveying messages. Since all gold originally belonged to the rulers, the weights functioned as display and status objects for those of highest rank. By the 19th century they came into use in the general population. For additional references to the above named animals, see INDEX: Animals.

Akrafokonmu ("soul washers"). See AKAN GOLD.

Akuaba (pl. *akuama*). AKAN sculptures called *akuaba* ("Akua's child") are named after Akuua, a woman who, unable to

have children, commissioned a wooden image. She soon became pregnant and was safely delivered of a daughter. Thus, Akan women who have difficulty conceiving visit local shrines with the senior woman in the family to purchase a sculpture. The figure is placed on the home altar for a time, and subsequently cared for by the woman as if it were a living baby. Women carry these figures on their backs as they go about their daily affairs. After a successful delivery the figure would be returned to the shrine as an offering, but if the baby were to die, it was kept as a memorial. Blier suggests that the stylization and simplicity of *akuaba* figures convey the incompleteness of the fetus. It is also said that the figures represent an ideal of feminine beauty that the prospective mother looks upon to guarantee a beautiful child. Despite their small size, the iconic character of the *akuaba's* visage is rather formidable, conveying the powerful protection offered to mother and unborn child. Most *akuaba* are female in gender recalling the myth of Akua's child—a daughter—as well as the importance of women in Akan society. Innovations in contemporary Akan sculpture include the fantastic coffins made by Kane Kwei (a Ga carpenter) and large-scale sculpture in wood, stone, cement and bronze by Vincent Kofi. Kofi, who merged Akan style with European influences, played an important role in the development of contemporary Ghanaian art.

Ala. The principal deity of the IGBO, Ala (Ani) is linked with the Earth or Land. She is the basis of life as both spirit (*mmuo*) and substance. Undoubtedly part of her centrality stems from the importance of agriculture, but her cult is also the guardian of law and morality. Ala herself is depicted prominently in the MBARI houses of the southwestern region. Ala/Ani is the implicit recipient

of honors and sacrifices also during ceremonies such as "The Fame of Maidens" (*Ude Agbogho*) festivals in the northcentral region. The Igbo, following a broad African tradition, link white with daylight, spirituality, purity, morality, social values and beautiful female spirits. By contrast, black or dark-colored things are associated with night, mystery, death, DANGER and bad/ugly masked spirits, often male. In Owerri, Ala is considered to be dark and her consort, Amadioha, God of Thunder and Lightning is fair-skinned. However, Ala is depicted as light in color in *mbari* houses to honor her and through praise to mitigate her potential dangerousness.

Aleut. An Arctic people who live in the Aleutian Islands. The people call themselves Unangan. The name Aleut was given to them by the Russian explorers and fur traders in the 18th century with whom contact was disastrous. Captain James COOK arrived in 1778, searching for a northwest passage. John Webber, the artist on Cook's expedition depicted a "Man of Oonalashka" wearing a hunting visor topped with a small seated human figure. The open topped visor later

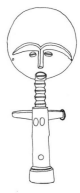

AKUABA

Above: Akan mothers shape their babies' heads with warm compresses in emulation of the ideal of beauty. Disk-shaped heads are common in sculpture among the Asante, while rectangles and cone shapes are found in the south, in Fante and Brong akuaba. Akuaba are generally very dark, or black in color, which links them to ancestors and the spiritual realm. Ancestors are believed to facilitate conception, serving as intermediaries between the unborn and the living. 19th–20th century.

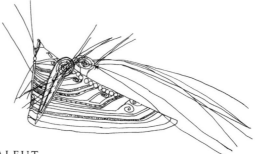

ALEUT

Above: The characteristic triangular shape of the classic Aleut hat did not appear until the early 19th century. The most dazzling of all, painted with intricate designs and parallel lines and ornamented with sea lion bristles, feathers and beads, were symbols of rank. The wood (preferably drifted California oak) was planed as thin as possible, bent into shape over steaming water and sewn together with sinew. The hats were worn to prevent glare while hunting at sea in kayaks. The meaning of the designs has been lost, but the hats' beauty may have been regarded as pleasing to the animals that were hunted.

evolved into closed hunting hats with a triangular profile. Other Aleut art forms included ivory figurines used as amulets on hats and as fasteners on kayaks, masks, basketry and model kayaks.

Algonquian. A linguistic group composed of the INNU (formerly Naskapi), Cree, Northern Ojibwa and other nomadic hunters of the Subarctic. In historic times, some Algonquian peoples, including the Sauk (see ROACH), Fox, Miami, Illinois, Kickapoo, OJIBWA (or Chippewa), Ottowa, Potawatomi, Menomini and Shawnee apparently entered the northeastern United States fairly late, driving the LAKOTA westward. Other Algonquians, the Arapaho (see GHOST DANCE), Cheyenne and the Blackfeet, lived west of the Mississippi and their art reflects Plains forms. Northeastern Algonquian art forms include various sorts of bags ornamented with quillwork and later beadwork as well as birch-bark containers. The double-curve motif appears to be quite old; other favored motifs include floral, geometric and figurative designs among which the so-called Underwater Panther is the most famous. This supernatural feline lives in lakes and the flashes from its eyes are said to be fatal to human beings. The Virginia Algonquian were among the first Native Americans to interact with Europeans. Chief Powhatan's confederacy banded together to halt their advance, interrupted by a brief period of peace following the marriage of Powhatan's daughter Pocahontas to John Rolfe.

Alter Ego. So-called *alter ego* representations show a large animal holding, sometimes protectively, sometimes in the act of swallowing, a human figure. The impulse behind these figures is SHAMANISM and their imagery involves the collapsing of two of the themes in the shaman's initiation. While undergoing initiation, the shaman receives her/his helping spirit and often is dismembered and devoured by the initiatory forces. The shaman's relationship with the helping spirit(s) offers support and protection. Furthermore, it is generally believed that in the trance state, the shaman takes the form of the spirit in order to travel through the spirit world in search of lost souls of the sick and the dead. While those *alter ego* depictions that show the animal devouring the human are sometimes interpreted as hunter/prey

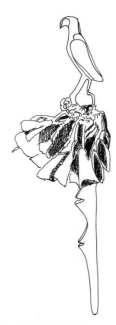

ALGONQUIAN

Above: Ojibwa deer toe rattle representing a hawk, probably the owner's guardian spirit. The spirits of bird and deer are evoked to cure or assure well-being. The carving's soft-edged planes and elegant stylization are typical of Woodlands art.

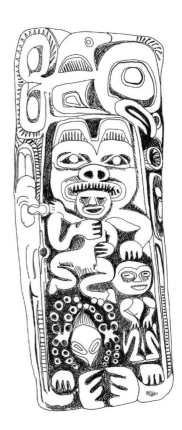

ALTER EGO

Above: Tlingit ivory shaman's amulet found in the grave house of the Gunnah-ho clan on the Towtuck River between Yakutat and Dry Bay. This charm offers the shaman the protection and assistance of several spirit helpers. The central BEAR holds two human figures, one of which is about to be devoured. The devil fish spirit below has octopus suckers around its beaked head. Above is the spirit of a whale and on the sides two abstract sandhill cranes appear. 4 3/4" high.

images, it is possible to see them also as a dramatic way of showing the shift into the trance state—the moment when human and animal become one. Joan Halifax writes of the famous Shang bronze *alter ego* sculpture: " the neophyte here affirms the covenant between the beast of the wilderness and himself by his delicate embrace of the representative of the feminine and absorbing aspect of nature." The shaman must be willing to give up his/her ego, allow it to be devoured by the forces of nature, in order to achieve spiritual wholeness. It could be argued that this is true of artists as well. See also POSTURES.

Altered States of Consciousness (ASC). Recent neuropsychological research identifies three stages in the development of mental imagery during trance states. In the first stage, people experience ENTOPTIC PHENOMENA, including zigzags, chevrons, dots, flecks, grids, vortexes and U-shapes, all of which shimmer, move and seem to increase in size. Entoptic phenomena derive from the structure of the human nervous system; thus all humans undergoing trance states, irrespective of age, gender or cultural background experience them. In the second stage people try to make sense of the phenomena by linking them to familiar shapes—here cultural models come into play. The third stage involves a radical transformation of mental imagery and the trancer becomes part of the experience. Trancers all over the world experience feelings of descent (into rotating tunnels, caves or holes in the ground), although the particulars are determined by local environment. The worldwide similarity of rock art imagery and its demonstrable correspondence to entoptic phenomena has led scholars to link it with the controlled trance states of the SHAMAN. Studying mythology, ritual and cosmology can reveal the specific symbolism of some

entoptic phenomena. See INDEX: Pattern in Art, Artifact and Techniques.

Amadioha. IGBO God of Thunder and and consort of ALA.

Amasumpa Motif. Patterns of raised studs decorate ZULU pottery made by women whose bodies were scarified in similar patterns. The design may originally have been reserved for the royal family serving as an insignia. As such, it symbolized the ruling house and its patronage and may have been associated with its wealth and power. In its vernacular form, the colloquial name of the pattern, *amasumpa* means "warts." It came to symbolize wealth in the form of animals. The motif appears on headrests and pottery, both of which are connected with individuals, their status and their family lineage.

Amma. The Supreme Deity of the DOGON, Amma existed first in the form of an egg with four collarbones (linked both with the FOUR/SIX DIRECTIONS and the four elements). An act of self-fertilization, accompanied by speaking seven creative words, resulted in the creation of human beings. One seed divided into a double placenta with a male set on one side and a female set on the other. One of the male twins became impatient and tore away part of the placenta, which became the earth. He mated with the earth, committing incest and defiling the earth. Amma attempted to set things straight by making NOMMO, the other male twin, ruler of the universe. Altogether, he created four pairs of Nommo spirits who were the ancestors of the Dogon. Amma transformed YURUGU, the defiling twin into the pale fox, enemy of light, water, fertility and civilization. Yurugu is condemned to wander eternally, searching for his female twin. Yurugu symbolizes individual liberty in contrast to commitment to the group on which society depends for sur-

AMULET

Above: The wooden CROW amulet came from a MEDICINE BUNDLE.

Above right: Northwest Coast shaman's amulets often depict the shaman's helpers and the magical acts in which he engaged to cure sufferers. The intricate ivory TLINGIT charm shows a sea-lion-shaped spirit canoe with bird and octopus traits, carrying seven helping spirits.

ANASAZI

Above: Black-on-white cylindrical vessel with a handle and bulbous base characteristic of Anasazi ceramics. Such hand-built pots were unglazed and porous, with dynamic, boldly geometric designs. From Chaco Canyon.

vival. Yurugu does make one important contribution, however: Dogon diviners "read" his tracks on their sand grids to predict the future. See INDEX: Egg in Natural Phenomena and Materials.

Amulet. Amulets or charms generally take the form of small objects which are worn for protection from evil forces and to gain good fortune in a variety of enterprises such as war, hunting, weaving and love. The effect of ESKIMO ivory amulets, which worked only for their first owner, was increased by food offerings or by the singing of secret songs. These amulets, carved in myriad animal, human and abstract forms, were purchased from the shaman and were sewn on clothing or placed on boats and in homes. PLAINS PEOPLES' amulets, derived from or modeled upon objects in the natural world, often combine protection with emulation. Cheyenne warriors, for instance, wore dragonfly hair ornaments hoping to mimic the insect's speed and agility when they went into battle. For other amulets see INDEX: Art, Artifacts and Techniques.

Anasazi. The Anasazi (from a Navajo word said to mean "the old ones" or "enemy ancestors") were an agricultural people who lived in the river drainages in the Four Corners area (the intersection of Arizona, New Mexico, Colorado and Utah). The name by which these people called themselves is not known; archeologists refer to the early stages as Basketmaker and the later phases are called Pueblo. The culture developed slowly and steadily, beginning possibly as early as 3000 BCE. Generally the tradition is dated between 700 and 1350 CE. The most dramatic aspect of the Anasazi tradition is the so-called Chaco Phenomenon (900–1150) centered in Chaco Canyon, New Mexico. This efflorescence followed a rapid population increase and expansion covering some 25,000 square miles. Extensive road and water systems linked the larger cities to outlying villages inhabited by farmers. The roads are remarkable for their straightness. They do not follow the contours of the land, but rather stairs and ramps—some mere toeholds, others cut out of bedrock or made of great masonry blocks—circumvented obstacles. The largest roads were nearly thirty feet wide and some ran for a distance of fifty miles. The entire network is currently thought to encompass some 250 miles—though

they had no wheeled vehicles or beasts of burden. Scholars are divided on whether the road systems served commerce or religion. The centers of population, of which PUEBLO BONITO is the most famous, consisted of multistory buildings inhabited by an elite culture. Luxury items abounded, including turquoise, macaw feathers and copper bells traded from far away (see CASAS GRANDES). Chaco Canyon may have assumed the dominant role in turquoise processing in the 10th century. This stone, still sacred among Southwestern peoples, came from near Santa Fe, 100 miles away. More than 60,000 turquoise fragments have been found in processing workshops in Chaco Canyon. After the peak years between 1100 and 1130, the system apparently collapsed due to extended droughts. In some places, Anasazi communities continued to flourish at places like MESA VERDE, Aztec and Salmon. See also ARCHEOASTRONOMY.

Anatsui, El (born 1944). Anatsui is an internationally known African artist born in Ghana. Although he is Ewe, he now lives in Igbo territory at Nsukka. He was trained in art, achieving a bachelor's degree in sculpture and a postgraduate diploma in art education from the College of Art at the University of Science and Technology at Kumasi, one of the most distinguished African art schools. He has worked in ceramics, manganese tailings—both deeply symbolic materials for him—and in wood. His work reflects his diverse heritage and is informed by his knowledge of modernism and postmodernism.

Androgyny. The androgyne is half-male, half-female. O'Flaherty and ELIADE suggest that androgyny is not universal or archetypal, but instead is associated with early "high cultures" and those areas influenced by them. There are two types of androgyne images: horizontal (breasts above and penis below) and vertical (divided down the middle and having male genitalia on one side and female on the other). They may also be divided into two conceptual groupings: first, those resulting from the fusing of separate male and female bodies; and second (and more frequently) a single fused form that subsequently split into a male and a female. O'Flaherty and Eliade compare Jungian and Freudian concepts of the relationship between androgyny and primordial chaos—negative and connected with death for Freud, positive and unifying for Jung. In most indigenous objects, although the idea of return to primordial chaos before male and female genders were separated may be a factor, it also seems likely that the presence of both genders symbolizes the creative potential of union. This seems to be pertinent especially in the case of androgynous ancestor figures that embody the life force of all ancestors. For instance, the powerful androgynous NALIK sculptures of central New Ireland, placed in the men's houses at the end of cult rituals, are said to represent the vital complementary contributions of females (children and yams) and males (ritual energy). Unfortunately, ethnographical reports do not always provide enough information to determine which type is represented in the many instances of androgyny in the art of indigenous peoples. Generally, the horizontal type of representation (breasts above, penis below) is found more frequently than the vertical type. Androgyny is recurrent in Polynesia, where deities are represented with both male and female attributes. African androgyny, as Herbert Cole has suggested in *Icons: Ideals and Power in the Art of Africa*, may suggest a childlike, primordial, precultural state of being. BAMANA N'tomo masks, used in boys' circumcision rituals, represent the androgyny of the boys before the feminine

ANATSUI, EL

Above: Entitled Tapper, this sculpture utilizes an old vessel used in making palm oil and wood purchased from the shrines of village priests. The cloth hat perched on the vessel's remaining handle emphasizes the figurative quality of the upright mortar. Hanging over its shoulder, the figure has a raffia palm fiber belt of the sort used by palm wine tappers to help them climb trees. The figure carries firewood gathered along the way. Gathering the materials for such works keeps Anatsui in touch with village people. These materials convey ideas of regeneration and survival. 1995.

foreskin is removed. DOGON ancestral figures are often androgynous, reflecting their connection with primordial conditions. See SANGO and INDEX: Animals.

ANDROGYNY:

Right: This Nalik figure from central New Ireland is a "horizontal" type androgyne.

ANIMALS

Above: Made from a weathered whale vertebra, this Eskimo carving shows how the image is "brought out" by the artist. The carver reveals the powerful polar bear as if seen from both outside and inside, thereby magically suggesting both physical and spiritual animal. Also, by sleight of hand, the artist pays homage to the whale, as the interior view is a SIMULTANEOUS IMAGE made up of two leaping killer whale profiles. 20th century.

Animals. Whether they are hunter/gatherers or agriculturalists, all indigenous peoples have close ties with animals. Animals were, of course, the first subjects represented by human beings during the Paleolithic period. A common explanation for the large number of animals on the walls of caves is "hunting magic" or "sympathetic magic"—creating images gives the creator control over the animal; killing the image guarantees success in the hunt. It is also likely that the animals were perceived as being powerful and divine. They were clearly more effective at surviving than humans. They fed themselves with efficiency, they mated and reproduced easily and their young were capable of independence much sooner than human infants. The presence of what appear to be altars with the bones of large predators, such as bears, indicates that as early as the Paleolithic, groups of people allied themselves with specific animals that they regarded as their protectors and clan totems. TOTEMISM and the idea of an animal progenitor are widespread in indigenous cultures. Naturally, the species of animal varies from environment to environment, but the awe and respect with which people regard animals is universal. In Africa, animals are among the most frequent symbols of power. Paula Ben-Amos points out, with regard to Benin, that the parallels between human and animal are linked to the distinction between civilized terrain and the wilderness ("Humans and Animals in Benin Art"). In both areas, there is a clearly established hierarchy—the king dominates both, as do lions, leopards and crocodiles. More docile animals like cattle, mudfish and fowl are denizens of the civilized area only and are subject to the power of both human beings and "wild" animals. Furthermore, the behavior of wilderness creatures is capricious and unpredictable, making them expressive symbols of the dangerous side of power. Herbert Cole suggests that animal symbolism in village-based societies is less emblematic and has a greater concern with spirituality and the cycles of nature. For cross-references and a listing of animal species covered, please see INDEX: Animals.

Animism. In general terms, the belief, in

most indigenous cultures, that everything is imbued with life, from organic life (plants and living creatures) to inanimate objects (rivers, stones, art objects). An enormous range of subsidiary beliefs exists, connected with and reflecting the worldviews of specific cultures. Human interactions with the spirits that surround them are mediated through art and ritual. Animism is also the term used for a theory about early cultures set forth by the early English anthropologist, E.B. Tylor. Tylor used the term animism to describe the earliest form of religion, which was characterized by the belief in a plurality of spirits and ghosts.

Aningaaq. The male principle in nature and also the INUA (spirit) of the MOON among the ESKIMO. It was widely believed that Aningaaq was responsible for the fertility of women of whom he was particularly fond—indeed, it was believed he could impregnate women by simply shining on them. According to myth, the Moon was once a man who, hidden by darkness, had intercourse with his sister. In order to identify her lover, the sister marked his face with soot, which became the dark spots on the moon. The spottedness also extends to the Moon's favorite game, the white whale with a black spot and his sled dogs, white with a black head or spots on their sides. When she discovered his identity she fled to the sky where, becoming the Sun, she is pursued eternally by her brother. The Sun played little part in Eskimo religion, while the Moon was a great hunter of aquatic creatures (seals among some groups, walrus in others). Because of his connection with the creatures of the sea—indeed, he was believed to be responsible for their fertility—Aningaaq was regarded as the link between the sea and the sky. The Moon was generally friendly to man and provided advice on how to avoid the wrath of SEDNA, whose domain was the sea.

Shamans visiting the Moon had to take care not to be singed by the Sun as well as avoiding the Entrail Robber (Erlaveersisoq in Greenland and Ululiarnaaq in eastern Canada). This monstrous supernatural was a female CLOWN of ridiculous appearance who, if people even smiled at her, would rip out their innards and put them on her wooden dish. Unlike the shaman, ordinary people could not travel to the Moon, but they could visit him when he came to earth as a human.

Anishnabe. The currently used collective name for the Ottawa, OJIBWA and Potawatomi (all Algonquian speakers) refugees who banded together in the central Great Lakes region after being driven out of their own territories. See SHAMAN, for an Anishnabe shaman's drum.

Antelope. See INDEX: Animals.

Anus. The human anus is depicted in the art of some indigenous cultures. It also serves as a receptacle in figurative sculpture, as for example, in BEMBE protective ancestor figures. The priest captures an ancestral spirit (*nkuyu*) and seals it up in the sculpture's anus with a plug of resin and medicinal materials. See MASSIM, KOMINIMUNG SHIELDS, MISSISSIPPIAN CULTS, YULUNGGUL.

Aotearoa. Indigenous name for the islands of New Zealand, see MAORI.

Apache. The Apache are relatively recent arrivals in the Southwest. They probably entered the area from the north in a single, unified group of Athapaskan speakers in the 14th century and became diversified with the passage of time. There are seven recognized divisions among these people: Chiricahua, Jicarilla, Kiowa-Apache, Lipan, Mescalero,

APACHE

Below: Dancers impersonated gaan, Mountain Spirits, in night dances associated with girls' puberty rituals. The masks consisted of buckskin hoods (more recently cloth) that fit tightly over the dancers' faces, crowned with turkey feathers and a spiky, painted superstructure made of split yucca or sotol stalks. The uprights are referred to as "horns." c. 1935.

Big Blue Mountain Spirit,
The home made of blue
 clouds,
The cross made of the
 blue mirage,
There, you have begun
 to live,
There, is the life of
 goodness,
I am grateful for that made
 of goodness there.

— *Mescalero Apache song.*

NAVAJO, and Western Apache. Apache religion involved a combination of shamanism and priesthoods, its primary focus being long-life and healing ceremonies—masking and sand painting rituals show close association with Pueblo and Navajo practices. Generally speaking, the Apache were more war-oriented than their neighbors, and their practices are often contrasted with those of PLAINS PEOPLES. For instance, COUNTING COUP and acquiring scalps both were of minimal importance in comparison to killing the enemy outright. Fear of contamination and the importance of horses to the Apache are evident in funeral rituals. After the corpse was properly prepared and clothed, the deceased was placed on his favorite horse with as many possessions as possible and taken far away by a small contingent of mourners. After burial the horse was killed at graveside to continue the deceased's journey. The burial party returned by a different route, washed and purified themselves and discarded all clothing. Puberty rituals for Chiricahua and Mescalero girls were organized by close relatives and lasted for four days.

During the ceremony the girl was addressed as a culture heroine and songs were sung to safeguard her health and grant a long life. *Gaan* (or *gan*) Mountain Spirits (the equivalent of Hopi and Pueblo KACHINAS), impersonated by masked dancers, performed in the evening. The *gaan* were culture/tutelary spirits sent by the Supreme Being to teach people the proper way to live, as well as practical things, like hunting and planting. According to myth, the *gaan*, disappointed by the slack ways of the Apache, returned to their mountain caves, returning only to remind people of their teachings on ceremonial occasions. *Gaan* masks have painted images representing snakes, hummingbirds, dotted crosses, sun symbols, crescents (moons), water and lightning, all associated with fertility. The hummingbird is the creature that serves as an intermediary between the Apache and the supernaturals, also serving as guide to the upper worlds. The *gaan* impersonators are sometimes inaccurately referred to as Crown or Devil Dancers. Apache women were particularly accomplished basket makers.

Archeoastronomy. Scholars in this relatively recent sub-field of archaeology study the considerable astronomical knowledge held by ancient and indigenous cultures. Particularly interesting are the ways in which archaeological sites are aligned to and/or mark certain phenomena. One example of such astronomical expertise is the alterations made in three sandstone slabs at Fajada Butte in Chaco Canyon. The slabs had fallen from the cliffs and stood in such as way that they threw patterns of light on the bluff wall. The Chacoans, noticing the seasonal movement of light, pecked a large and a small spiral on the wall behind the slabs positioned so that the light cut across the spirals on the summer solstice and bracketed the large spiral on the winter solstice. See INDEX: Pattern in Art, Artifacts and Techniques; Solstices in Natural Phenomena and Materials.

Archetype. The term originated with the Greeks and appears in Hellenistic esoteric writing to describe a cosmogonic principle. In the twentieth century both Mircea ELIADE and C.G. Jung revived the word. According to Beverly Moon, Eliade used it to name the sacred paradigms expressed in myth and acted out in ritual, while Jung applied it to the dynamic structures of the unconscious that determine individual patterns of behavior and experience. The use of the term in this book generally follows Eliade's broader application. Eliade said that, for him, the terms exemplary model, paradigm and archetype were synonomous. Revealed to humankind through supernatural/divine agency at the beginning of time, the archetypes formed part of a sacred reality. Archetypes and the sacred are apprehensible to human beings through their senses and the sacred is a highly desirable state (Eliade called this state hierophany) in contrast to the profane, even mundane quality of daily existence. For Eliade religion involves not escape from the world, but rather its transformation into a replica of the atemporal, eternal and sacred archetypal world that existed at the beginning. In the modern world, Eliade suggested, the archetypes survive as guiding themes that provide a framework for individuals to move beyond mere self-interest and to achieve some degree of self-knowledge in relation to a greater whole. In both Eliade's and Jung's views, the concept of archetypes was possible only if one believes in an external, sacred reality which exists outside of humankind. See INDEX: Deity Archetypes.

Architectural Models. Miniature replicas of houses and temples are found in many indigenous cultures. Among the most beautiful are the feathered temples from Hawaii and the intricate Fijian temple models knotted and woven from sennit.

Architecture. See INDEX: Architecture in Art, Artifacts and Techniques.

Arctic. The Arctic region of North America encompasses the coasts of

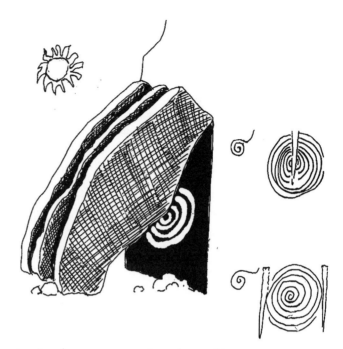

ARCHAEOAS-TRONOMY

Above: Fallen stone slabs and petroglyph on cliff wall, Fajada Butte, Chaco Canyon. A wedge of light bisects the spiral petroglyph on the summer solstice and two wedges bracket it at the winter solstice.

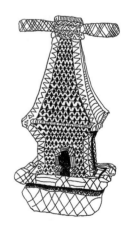

ARCHITECTURAL MODELS

Above: Temple model from Fiji. Sennit and shell.

Alaska, Canada and Greenland and is closely related to the Arctic coasts of Siberia. Waves of immigrants passed through from Manchuria, Mongolia and Siberia as early as c. 12,000 BCE. The two main groups who settled the area, the ESKIMOS (in Canada, INUIT) and the ALEUTS, were established there between 6000 and 4000 years ago. The extremes of weather and lack of natural resources (or perhaps, more properly, access to them) led to limited material culture which was balanced by an active spiritual life. Since no cultivation of plants is possible, the people are completely dependent on hunting and fishing for sustenance. As a result, the mythology and art revolves around the extremely close ties these people have to the animals on which they

rely. Mythologies incorporate three ages or stages: an early time in which there was no separation between humans and animals, a single language was spoken by all and individuals could assume any form they desired. The second age is that of the CULTURE HERO who separated humankind from the animal world, but provided all material and spiritual knowledge. The hero occupied an intermediary position as he was able to enter and interact with the supernatural realm; but people can no longer understand the language of the animals or enter the spirit realm except in death. The hero constantly battles with monstrous adversaries and, affected by wanderlust, he travels unceasingly. In the present, third epoch, the hero has departed although humans

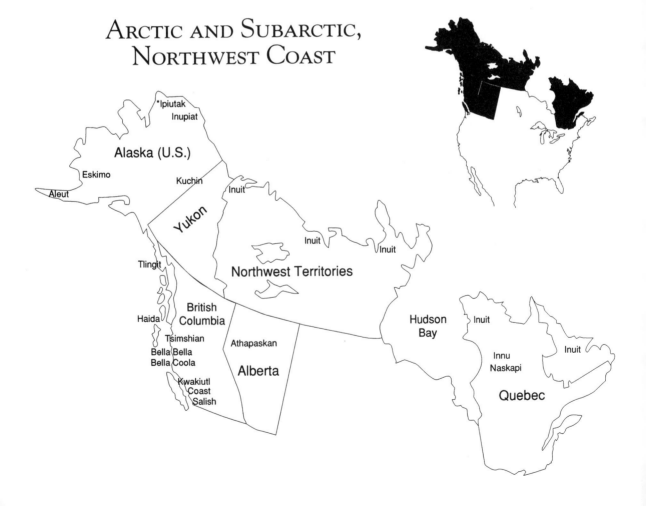

ARCTIC AND SUBARCTIC, NORTHWEST COAST

still retain their special position in the world. Only the shaman is able to cross the boundaries into the spirit realm.

Areogun. See YORUBA ARTISTS.

Argillite. A type of fine-grained slate, ranging in color from gray to black, favored after European/American contact for sculpture on the Northwest Coast. The HAIDA controlled the source of the most desirable argillite, noted for its density and color, which came from Slatechuck Creek near Skidegate. Haida argillite pipes were originally made for ceremonial purposes, but by the 1830s, when the sea otter trade ceased, the Haida's main source of wealth disappeared and art works became increasingly important sources of income. Argillite carvings were especially in demand for sale by the Hudson's Bay Company. There was a dip in the market from World War I until the 1950s, and it has never recovered its former energy. Most souvenirs today are simulated argillite made in Asia.

Arioi. A special class of performers (see also CLOWNS) in the Society Islands who not only entertained, but, because they enjoyed immunity, also served as agents for social criticism. They could, for instance, like Medieval court jesters, even ridicule the chiefs.

Arnhem Land. One of the richest art producing areas of Aboriginal Australia. See also BARK PAINTING, MIMI SPIRITS and X-RAY STYLE.

Artists. Until recently, studies of indigenous art treated it as anonymous and generally made no attempt to differentiate between individual artists' hands. To give early collectors and scholars credit, the enormous diversity and profoundly "foreign" appearance of indigenous art must have been bewildering. No wonder that they saw their primary tasks as preserving, classifying and identifying objects. At worst, their superior attitude towards the "curiosities" and the "savage" people who produced them, resulted in their ignoring the artist's role in society and overlooking individual styles. Recent scholarship is correcting this and the names of some of the artists and their styles are being identified. See INDEX: Artists.

Asante (or Ashante). This extensive kingdom rose to power in the early 1680s in the Gold Coast area of Ghana. The founder of the kingdom, Osei Tutu consolidated his power by conquering local chiefs and established a capital at Kumasi. Asante power extended for several hundred miles in each direction and continues to be a political force today. The Asante are AKAN speakers. Asante architecture consisted of walls of woven canes, packed with moistened earth and decorated with geometric or figurative relief before plastering. The Asante liken the process of building to the TRICK-STER spider Ananse weaving his web. The Asante likely thought of the kingdom as an earthly image of the cosmos, a wheel with Kumasi at the center of a circle (see COSMIC MODEL and CENTER). Geometric patterns are also found on a smaller scale in the decorations of buildings. The curvilinear patterns, which are sometimes said to reflect Islamic script, convey multi-layered meanings that are often proverbial. A crocodile biting a mudfish, for instance, illustrates the proverb, "whatever the mudfish acquires ultimately will go to the crocodile." The proverb suggests that the natural pecking order is repeated in human culture with the powerful benefiting from and exploiting the weak. Trees played an important symbolic role in the Asante kingdom. The king's courtyards contained "symbolic trees" called *nyame dua*, "god's tree," in the form of small staff-like tripods sup-

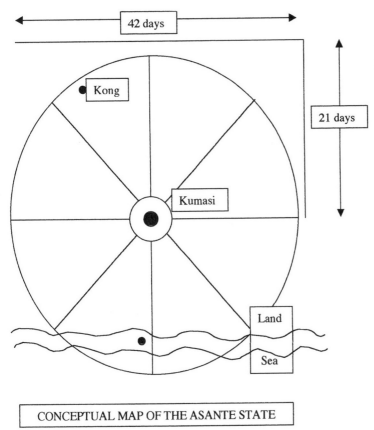

42 days

21 days

Kong

Kumasi

Land

Sea

CONCEPTUAL MAP OF THE ASANTE STATE

ASANTE

Above: The Asante state was conceived of as a disk or wheel with Kumasi, the capital at the center. The king's palace was at the center of Kumasi and adjacent to it was a royal temple. Wide avenues spread out from the center. The diameter of the wheel took forty-two days to traverse, a span that resonated with the forty-two day Asante month.

porting offering bowls. T. E. Bowdich's early 19th-century travelog shows actual trees growing in the compound as well. In fact, the name of the city, Kumasi, means "under a tree" and the ruler was often referred to as the "shade tree" of the nation. The Asante placed a great deal of importance on gold that was said to represent the essence of the sun and to embody life force or soul (*kra*). The central Asante object, the GOLDEN STOOL, as well as the king's and chiefs' regalia and gold memorial heads (see AKAN GOLD) all show the central role of gold in Asante culture as well as the exquisite craftsmanship of gold workers. In addition to gold, fabrics also embodied royal power (see Colorplate 2, KENTE and ADINKRA). Copper alloy vessels called KUDUO are yet another royal prerogative and were used to store treasures. See also AKUABA and PROVERBS.

Asantehene. Supreme ruler of the ASANTE. The founding Asantehene was Osei Tutu (reigned 1697–1731). KOFI KAKARI (reigned 1867–1874) was defeated by the British during the Asante war of 1874. Prempe I (reigned 1888–1896), together with many of his senior chiefs, was exiled. After years as a Crown Colony, the British allowed the Asantehene to return in 1924 and Prempe II restored the confederacy in 1933. In the early 1990s, the Asantehene continued to be the most powerful ruler, supported by fourteen recognized paramount chiefs. The Asantehene's power is intimately linked with the GOLDEN STOOL. See also AKAN, AKAN GOLD and AKAN GOLDWEIGHTS.

Asmat. The Asmat live in the swampy delta and jungles on the south coast of New Guinea, in Irian Jaya. The people believe the world has always existed and will never end, although the lives of human beings are marked by cyclical change. Transitions within the cycle are critical periods, particularly that following death when the spirits of the dead remain in the world of the living for awhile before moving on to the realm of the dead (*safan*). Asmat ritual life and associated art has been interpreted as an ongoing effort to appease the spirits of the dead until they depart. Four distinct style regions have been identified, two in the coastal area, two in the eastern interior. HEAD HUNTING and war were, until after World War II, the primary male activities. Loss of individuals to head hunting raids caused not only an imbalance of power, but also prevented proper funeral rituals resulting in wandering angry spirits capable of damaging the living. BIS POLES were erected to serve as vessels for the spirits of the dead and the spirit canoes (*uramon/uramun* see CANOES) used in initiation rituals served a similar function. The Asmat erect men's ceremonial houses

ASMAT: "The Asmat trip was equal to most of my wildest dreams…. The Asmat is filled with a kind of tragedy. For many of the villages have reached that point where they are beginning to doubt the worth of their own culture and crave things western. There is everywhere a depressing respect for the white man's shirt and pants, no matter how tattered and dirty, even though these doubtful symbols of another world seem to hide a proud form and replace a far finer, if less concealing form of dress. Yet much more ominous is the economic and spiritual future of the Asmat. The West thinks in terms of bringing advance and opportunity to such a place. In actuality we bring a cultural bankruptcy which will last for many years and, what is more, poverty. Poverty after all is a relative thing. The Asmat is a land of great winding rivers, tropical forests and mud. Literally nothing else. The people have for centuries lived on little besides the pulp of the sago palm and fish. There are no minerals; and not a single cash crop will grow successfully. Nonetheless, the Asmat like every other corner of the world is being sucked into a world economy and a world culture which insists on economic plenty in the western sense as a primary ideal." —*Michael Rockefeller, June, 1961.*

called YEU. Other important Asmat art forms include: the tubular drum, figurative clan posts for men's houses, crocodile poles, war shields, two types of masks, engraved bamboo LIME containers and wooden ceremonial plates. Since 1970 various programs have led to the production of art, often in nontraditional forms, for Western consumption. Michael Rockefeller collected outstanding examples of Asmat art while doing fieldwork in New Guinea. After his tragic early death in New Guinea, the objects formed the core of the Pacific component of the Nelson A. Rockefeller Collection now in the Metropolitan Museum of Art, New York.

Asmat War Shields. Shields represent a specific named ancestor, but may have images and symbols referring to as many as three additional close relatives. The designs are arranged in registers that appear to suggest a sequence or ladder-like form, but according to Gerbrands, in *Wow-Ipits*, the ancestors represented may not necessarily be of different generations. The designs appear to be abstract, but they are all named and all refer to specific objects, animals and birds. Despite the restricted vocabulary (Gerbrands numbers the designs between fifty and sixty

ideograms—see SIGN SYSTEMS), the Asmat combine the designs resulting in endlessly creative variations on the theme of HEAD HUNTING. The connection between the designs and head hunting is based on the metaphorical parallel between man and the sago tree on which the Asmat depend for sustenance. Man and tree are, in fact, interchangeable, as are their parts—the tree's fruits are equivalent to the human head. Therefore, fruit eaters (the cockatoo, hornbill and flying fox particularly) correspond to head hunters. These creatures can be represented by abbreviated signs, for instance, the flying fox (a large fruit-eating bat) is represented by outspread wings. The "C"

ASMAT WAR SHIELDS:

Above right: A shield named Babu, the father of the carver, consisting of five "V" shapes called ama wow, which probably means "carving representing a pair of arms." "Arms" refers to the wings of the flying fox, called tar. Carved by Viti, Monu village.

Right: This shield is topped with a female figure representing the artist's mother. The paired "V" shapes representing tar are joined by circles that represent navels. The "C" shapes on the outsides represent bi pane nose ornaments. Carved by Mben, Tjemor village. Both collected by Michael Rockefeller, 1961.

ASTROLABE BAY

Above: Shield (gubir) from Madang Province, Papua New Guinea. This shield is carved with sun or star shapes.

human figure and equally large male and female ancestor figures which served as house posts, literally and symbolically supporting the roof of the men's houses. Objects collected in the late 19th and early 20th century include *gubir*, circular painted shields (the only circular shields in Melanesia) carried in net bags and powerful masks.

Athapaskan Peoples (also Athapascan, Athabaskan or Athabascan). An Arctic and Subarctic language group (with numerous subgroups speaking eleven different languages). These people were among the first arrivals, crossing the land bridge into North America as early as 8000 BCE. Around 500 CE the group split into three subdivisions called the Alaskan, Plains and Southwestern branches. Today, the Alaskan Athapaskan call themselves Dene, "the people." Subgroups of Alaskan Athapaskan include the Eyak, Ingalik, Koyukon, KUCHIN, Tanaina and Ahtena as well as others. Athapaskan women excelled in beadwork and made a wide variety of beaded objects including several types of bags (*babiche*, mossbags, firebags and sled bags), dog blankets, wall pockets and other objects for interior decoration and BABY BELTS. Adult apparel included beaded mittens, moccasins, tunics, jackets, cape collars, shirts, caps and other headgear. Designs show regional variation, but the most prized museum artifacts, the energetic floral designs found in the Great Slave Lake-Mackenzie River region, developed after European contact. The Southwestern Athapaskans, the NAVAJO and the APACHE, entered the Southwest over a long period of time, possibly as early as 1200 CE up through the early 16th century.

shape, which appears so often, is the *bi pane*, a nose ornament twisted through the septum that symbolically transforms human beings into boars. Hunting boars is as fraught with danger as head hunting and boar tusks are comparable to human skulls. The *bi pane* is actually made not of boar tusks, but of shell and is said also to represent the moon. Made from the plank roots of mangrove trees, the shields were generally carved and painted on the occasion of a shield festival. The Asmat believe that no one dies of natural causes (illness is caused by magic), so the shields, like BIS POLES and other objects, serve the purposes of revenge and righting the imbalance caused by loss. The shields were sometimes placed, fence-like, at the entrances to YEU houses to keep intruders and evil spirits away.

Astrolabe Bay. Artists of this area of northeastern New Guinea produced life-sized freestanding sculptures (*telum*) of the

A-tshol. BAGA family medicine shrines protected by sculptured bird heads with long beaks.

Atua. MAORI word meaning "god(s)"; in Hawaiian, *akua*.

Austral Islands. Located in central Polynesia along with the nearby Mangareva and Tuamoto Islands. Social organization, while not highly stratified, was based on inherited rank. Woodcarvings from the Austral Islands are some of the most astonishing objects in the world. A'A, the national god and founding ancestor, is one of the most frequently reproduced Oceanic objects. Other objects include drums, ornamental canoe paddles, staffs, fly-whisk handles, adzes, ladles and bowls. The finesse of detail and elegance of form is remarkable. Fly-whisks (see JANUS FIGURES) formerly identified as Tahitian are now believed to be from the Austral Islands. Three types of Janus fly-whisks are found in museum collections today. The "classic" type consists of two back-to-back figures atop a wooden spindle the base of which was wrapped in braided cordage. The whisk, made of flexible coconut fiber was attached to the tip of the handle. The confusion may have resulted when these whisks were collected in Tahiti having been imported for use by high-ranking chiefs. See map: OCEANIA.

Australia. See ABORIGINAL AUSTRALIA.

Awa. The DOGON society of masks in Africa's Western Sudan. With over eighty different mask types, Awa oversees one of the most complex masking traditions in the world.

Azande. See ZANDE.

AUSTRAL ISLANDS

Above: This object has been variously identified as a canoe prow ornament and a ridge carving from a bone house. Terence Barrow and others note the strong resemblance between this carving and the famous Maori so-called "Kaitaia carving." Collected on Captain Cook's first voyage, 1768–71. Rurutu,

B

Baba. ABELAM basketry masks from New Guinea's Middle Sepik River are characterized by large eye shapes. The masks are worn on top of the head above a leafy costume, which completely conceals the wearer to below the knees. The mask is linked with the pig as intermediary between the worlds. Pigs, connected with the forest and to their underworld origins, owe humans a debt for their hand-raising and feeding. *Baba* masks help human souls find the way to the land of the spirits.

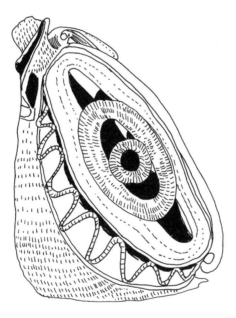

Babalawo. Literally "father of secrets," priest of the cult of IFA, Yoruba god of divination.

Babiche. One of several types of beadwork bags made by the Athapaskan peoples. These game bags are made of thongs of raw or slightly tanned hide. Some of the finest examples come from the Great Slave Lake-Mackenzie River region. The thongs were netted to form wide mouthed bags with an ornamented strip at the top—designs were floral or geometric—and many had tassels both on the body and base of the bag.

Baby Belts. Athapaskan women carried infants in mossbags, and once the child was older used baby straps or belts, which passed under the child's buttocks and across the mother's shoulders. Three to five feet long and five inches or so across, the belts had tasseled ends and elaborate beadwork, quillwork or embroidery. Baby belts are still popular today.

Baby Carriers. Mothers took their babies wherever they went, thus most indigenous women invented ingenious ways of transporting them so they would be comfortable and safe. Often, in addition to pure practicality, baby carriers were profoundly significant. This includes what might be called anatomical symbolism, providing a second womb for the infant, see STRING BAGS. Plains beaded CRADLE BOARD designs illustrate their makers' wishes for the child, such as repeated animal motifs symbolizing wealth. Geometric designs are rarely simply decorative, but represent culturally significant patterns that protect the infant and set its new life within the larger social context. And the sheer beauty and care lavished on them shows not only love, but also the importance of children both personally and culturally. Another type of infant carrier was the MOSSBAG.

Back Bone. See SPINAL COLUMN.

Baga. Baga oral tradition tells of the people migrating into their present home in Guinea on the northwestern area of the Guinea Coast as early as the 14th century. A combination of outside factors including forced conversion to Islam in the 1950s, involvement of young people in nationalistic movements and the "demystification" program of the late 1950s that compelled revealing of religious secrets and destruction of ritual regalia, led to the collapse of traditional Baga society. Formerly, Baga masks associated with the initiation of boys and girls included a tall python mask called *a-Mantsho-na-Tshol* painted with red, white and black triangles. The vertical profile of the mask and its geometric designs are similar to other Western Sudan masks. Furthermore, the important mythological role of serpents among the DOGON and others was another parallel. The mask, referred to as "author of earthquakes, master of river sources," was worn by the male responsible for overseeing the boys' circumcision and protected against disruptive forces. At other times the mask appeared in order to end droughts and at funerals. *A-Mantsho-na-Tshol* appeared in groups and their gender varied. With regard to cosmology, the mask has been interpreted as reconciling the spirits of water and the forest. The Baga made two other famous masks, the composite BANDA mask and the yoke headdress NIMBA mask. Another distinctive Baga artform was the *a-tshol*, a word that translates "medicine." *A-tshol* family shrines, controlled by the oldest member of the family, held collections of potent medicinal materials. The upper parts of the shrines usually took the form of bird-like heads with extraordinarily long beaks that stood guard over cylindrical containers. The shrines were regarded as embodying the spiritual existence and well-being of the lineage. *A-tshol* heads could also be worn as masks during initiation rituals.

Bai. Large gable-fronted houses of Micronesia, such as those in Yap, Kiribati and Belau, were built and decorated to convey fertility and the wealth and prosperity of the community. The most elaborate, of which only three remain today, were on Belau where they continue to be used as chief's clubhouses, for meetings of men's and women's groups and for ceremonial purposes. It is possible that extensively decorated *bai* only developed after European contact. Nineteenth-century documentary images show high gables with two faces at the peak; horizontal circular motifs run along the base of the gable, with birds and more faces beneath. It has been suggested that the human heads and faces originally related to HEAD HUNTING and to dedication ceremonies in earlier times which used the head of an enemy warrior. Currently, the decorations are connected with wealth: circles signify valuables (stone money disks); the birds are Delarok (money bird) or roosters, a male symbol; and finally, the faces depict heads ransomed for money. Mangidab the spider, which brought natural childbirth to Belau, is usually found on the underside of the mat holders inside the *bai*. Over the door, oriented to face the rising sun, DILUKAI, the HERALDIC WOMAN, is suspended, said to be a

BAGA

Above: A-Mantsho-na-Tshol mask in the form of a stylized python. At rest these tall slender masks appear static. When danced, accompanied by gunshots and cacophony, the mask shook and twirled high over the heads of the crowd. Its sinuous upright form simulated the python's attack position, actively and energetically warding off potential danger.

BAI

Below: Men's house, Belau, Caroline Islands.

BAINING

Right: Uramot and KAIRAK motifs found on masks for day and night ceremonies: (left to right) chicken tracks, tears, cross section of leaves and snake or caterpillar tracks. Redrawn after Corbin.

reminder to women to be moderate in sexual activities. Modern *bai* continue the financial symbolism, but are also decorated with "storyboard" gables which evolved from paintings of myths and historical events on interior house beams. The *bai's* four corner posts are the sitting places of the four male title-holders of the village who are elected by the women and can be removed by them as well. The buildings are also connected to the four metaphors (identified by Parmentier) the people use to unify their world: 1) "paths," linear spatial linkages between people and natural features of the landscape; 2) "sides," dualistic oppositions that divide space and people into paired opposites; 3) "corner posts," a combination of the first two in relation to four coordinated supporting elements; and 4) "larger/smaller," the basis of social ranking. These four aesthetic and metaphorical principles, of which the *bai* is a visual expression, unite Belau society. The *bai*, thus, is a visual expression of Belau society.

Baining. The name refers to people living in the Baining Mountains of the Gazelle Peninsula on New Britain. Stylistically and liguistically, the area is subdivided into the Uramot who live in the interior mountainous jungle, the northwestern or Chachet Baining, the centrally located KAIRAK BAINING and southeast areas which are quite distinct from one another. The most impressive masks, huge bark cloth structures, are found in all areas.

BAKOR

Above: This stone monolith is known as Ebiabu, the name of the society responsible for carrying out death sentences. It was found in situ at Etingnta, one of the main Bakor villages. The figure wears a stocking cap used in the area today by men of high status throughout eastern Nigeria, so it is likely that it represents a chief. Raised keloid marks circle his eyes and appear on the cheeks and neck. The overall phallic shape of the monolith is a powerful symbol of human (and plant, because of its connection with the yam cult) fertility. Dating is uncertain. Associated sites yield radiocarbon dates as early as 200 CE, although some sources date them as late as the 16th century.

Bakbakwalanooksiwae. The most important of several supernatural gift givers in KWAKIUTL mythology. See HAMATSA.

Bakor. Properly speaking, Bakor is a subdialect of the Ejagham language group in southeastern Nigeria. The term is used to refer to a group of over 300 columnar basalt monoliths found almost exclusively in five villages in the middle of the CROSS RIVER region. Originally, the monoliths were set in clusters or individually beside a large tree in the center of the village. When communities moved from one location to another, the stones were moved as well. They seem to represent dead ancestors, especially dead legendary figures of great fame, ugliness or beauty. Most of them feature concentric circles located at the navel. The monoliths are incorporated into the New Yam Festivals, demonstrating the link between vegetable and human fertility. Their location adjacent to trees is also significant—as lineage ancestors, the figures symbolize human continuity as enduring "family trees." See INDEX: Navel in Human Body; Trees in Natural Phenomena and Materials.

Bamana (formerly Bambara). The Bamana Mande-speakers are the largest ethnic group in Mali. The 18th-century Bamana kingdom reached its apex during the rule of N'golo Diarra (1760–87) who held sway over the Peul people and the cities of DJENNE and Timbuktu. In decline by the 19th century, the Bamana fell under French control from 1892 until 1960. The Bamana largely resisted conversion to Islam, unlike many of their Voltaic-speak-

ing neighbors. Bamana art forms include BOKOLANFINI mud cloth, ironwork and a rich variety of carved figures and masks, most of them associated with various associations. The most famous Bamana masks are the CHI WARA headdress masks. The N'tomo (or Ndomo) society is concerned with boys' circumcision and initiation rituals. N'tomo is the first of six initiatory stages which progressively reveal knowledge about humankind, the universe, and presumably, oneself. In the fifth and final year of the N'tomo rank, the boys are circumcised, removing their female aspect (the foreskin). Members wear wooden face masks topped with two to eight horns during harvest initiation festivals and during the dry season, when begging for rice. Komo society masks are horizontal helmet masks carved by the blacksmith, who is the leader of the society of the same name. The Komo society acts to protect the community against sorcerers and evil spirits—individuals undergo years of training as they move through the several levels, eventually becoming elders. The society stresses self-sufficiency, law and order. Women and uninitiated males may not see Komo masks as their power is dangerous. As with other indigenous peoples, the dark powers are embodied in incomplete, composite, incrusted and ugly forms that look and act in contrast to the finish, clarity and beauty of other Bamana carvings. Another group, the Kore society is reserved for adult males. Kore society masks are also composites, but the individual elements are more identifiable, including human faces and animals such as antelope and hyena. Kore masqueraders appear in public performing essentially social roles, commenting on proper and improper behavior. Trees and tree altars play important parts in both the N'tomo and Kore societies. N'tomo members make blood offerings on stones placed at the base of tree altars—the combination representing inorganic and organic counterparts of

immortality, continuity and strength. Kore society initiatory groves are cleared, carefully pruned and swept. At the foot of the sacred tree within the prepared space rest two stones, one white and one red. The clearing within the forest represents the knowledge and order provided by initiatory societies in the midst of the larger mystery of forest/life. Composite BOLI figures are placed on altars in men's association sanctuaries. Originally secret, but now avidly sought by Western collectors, *boli* figures begin as carved wooden human and animal forms which gradually loose their identity as they are covered with layer upon layer of sacrificial materials. The myriad materials symbolize the universe and the figures themselves become powerful spiritual receptacles whose energies protect and benefit the society. Finally, the Jo and Gwan societies have impressive art including brass staffs and wood sculpture. Both men and women can join the Jo society (found only in the south of the Bamana area; Jo is also the generic term for all initiation associations), although their initiations differ. Gwan is a branch of the Jo society in southern Mali. Monumental figurative sculptures of mothers and children are associated with this cult connected with childbirth, ideals of physical beauty and character and fertility (see NURTURING FEMALE). The Marka and Bozo live in the northern region of Bamana territory and, although they speak different languages, their art is often related to that of the Bamana. See BEMBA. See INDEX: Trees in Natural Phenomena and Materials.

Bamgboye. See EPA and YORUBA ARTISTS.

Bamileke. See CAMEROON, CAMEROON MASQUERADES and ELEPHANT.

Bamum. Originating as early as the 17th

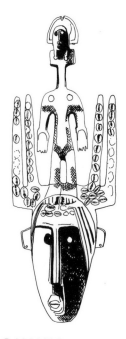

BAMANA

Above: N'tomo society masks are often covered with cowry shells and red seeds. The masks, embodiments of divine creativity, are said to be the ancient tutelary spirits responsible for boys' education. They also represent man in his primordial, androgynous (pre-circumcised) state. This example, in the Segu style, has a female figure standing between the horns.

century, the CAMEROON grasslands kingdom of Bamum reached a high point during the reign of Njoya (c. 1870–1933). Njoya became king while in his teens following the death of his father Nsa'ngu in battle. Njoya became *fon* (king) after his first son was born sometime between 1892

BAMUM

Right: The throne of King Nsa'ngu was called mandu, "richness of beads." Njoya gave this throne to the German emperor Wilhelm II in 1908, grateful for help in retrieving the head of his father, Nsa'ngu, which had been kept by the enemy N'so. Before 1905.

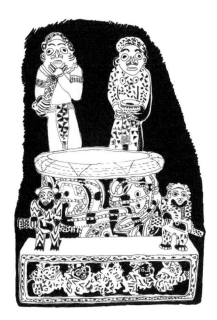

and 1896. Intellectually gifted, Njoya was a brilliant diplomatist and great patron of the arts. He developed his own syncretistic religious doctrine and invented a writing system to document Bamum history, religion and medicinal knowledge. He built many splendid palaces and established a school to teach his invented script, drawing, history and other subjects. He ruled until 1931 when he was exiled by the French. He died in confinement at Yaounde. Njoya's extensive palace at Foumban had approximately seventy-two rooms and twenty-six courtyards and housed 2000 to 3000 people, among whom were his 1200 wives and 350 children. The palace was entered through three doors called the "mouth of the king" (see DOORS AND THRESHOLDS). Beyond, the palace was divided into three zones, the center associated with the king, the left with non-royal administrators and the

right with the princes. The maze-like plan featured public rooms at the front and increasingly private regions at the back. The architectural precincts symbolized the division of public and private, secular and sacred and the various subdivisions of the power structure. The throne room, royal cemetery and the rooms of the *mbansie* regulatory society were at the heart of the complex. One of the most symbolically potent of all objects in the heart of the palace was the beaded throne of Nsa'ngu. The back of the throne is supported by the court TWINS whose real-life equivalents guarded the king's burial ground and supervised enthronements. The male twin holds a drinking horn, his other hand raised to his face in a gesture of respect. The female twin holds a calabash bowl, likely containing an offering of kola nuts, water or some other food. The twins' headdresses are patterned with frogs, symbolizing fertility. It is suggested that her bowl is a symbolic womb and his horn a phallus. The throne symbolizes the procreative power of the king as a potent and good father to his people. Spiders appear on the ends of the footrest, symbols of wisdom and diligence. Either side of the seated ruler's feet stand two warriors holding rifles and court officials occupy the box-like space below his feet. The cylinder beneath the seat is encircled by knotted double-headed snakes said to be a reference to the great military ruler king Mbuembue (c. 1820–1840) who wore a serpent belt symbolizing military might. Cowries and beads, symbols of wealth, cover the entire surface, making the throne intrinsically valuable. Njoya's palace burnt down in 1913 and was replaced over the following decade with a European-style royal residence. In addition to thrones and stools, royal regalia include horsetail fly-whisks, drinking horns for palm wine, jewelry, pipes and *ndop* cloth (see SIGN SYSTEMS).

Banda. Enormous BAGA composite mask

that resembles a crocodile and combines an elongated human face with antelope horns and attributes drawn from serpents and birds. *Banda* masks appear at male initiation ceremonies. The aggregate nature of the mask represents the combined powers of the different spheres inhabited by each creature, a new whole—a forest spirit—that facilitates the transformation from child to man.

Bangwa. The Bangwa are one of the autonomous kingdoms in the CAMEROON grasslands. Their culture is very similar to that of the Bamileke and was still largely intact in the 1960s, with the chiefs continuing to be the major art patrons. Art includes royal paraphernalia called "king-things," masks for royal dance societies, so-called "terror" masks associated with judicial control and ancestor figures. Among the most important objects are the large portrait figures. Both professional artists and amateurs carve.

Bansonyi. Former name for stylized python mask, *a-Mantsho-na-Tshol*, see BAGA.

Bark Cloth. Textiles made from tree bark are found all over the world and serve a variety of purposes from bedding, wall hangings, clothing, to sacred, ceremonial burial cloths. Generally in western Polynesia, bark cloth is made by a pasting technique with stenciled and painted designs. In eastern Polynesia, the technique was felting with stamped designs. Bark cloth is also stretched over frameworks to make masks, sculptural forms of various sorts and shields. Polynesian *tapa* cloth is a rich art form found throughout Oceania. In fact, one of the most sacred images in the Hawaiian *heiau* is a bark cloth roll. On Fiji, bark cloth called *masi* was an important chiefly gift. Chiefs often wrapped their bodies in hundreds of feet of bark cloth, which was dramatically

unwound and laid at the feet of the recipient. For bark cloth as a material for masks and sculpture see EASTER ISLAND, ELEMA and KAIRAK BAINING. For additional entries on and illustrations of bark cloth, see INDEX: Textiles in Art, Artifacts and Techniques.

Bark Painting. The aborigines of the north coast of Australia, particularly Arnhem Land, continue painting traditions begun in much earlier ROCK ART (see also MIMI SPIRITS and X-RAY IMAGES). Although the aborigines may have painted on the insides of bark huts prior to the arrival of Europeans, painting on sheets cut from the stringybark (eucalyptus) tree is a recent practice begun largely after colonization. Now the art form most often associated with Australia, bark painting plays a significant part in the current cultural and economic system. The figurative and abstract designs which usually depict mythological subjects can only be painted by those who have the right, established by clan relationships. Especially well-known centers of bark painting are Oenpelli (Gunwinjgu), Milingimbi, Yirrkala (Yolngu), Groote Eylandt, Melville and Bathurst Islands (Tiwi) and Port Keats.

Barotse. See ROTSE.

Basketry. Basket making is nearly universally a women's art form. In North America, the people believe that baskets have been around as long as people and, indeed, it is one of the most ancient arts. In North America, the earliest date between 9000 and 8000 BCE. Many techniques—wicker, plaiting, twining and coiling—are found all over the world. Baskets vary in size from a matter of inches to several feet and they fulfilled as many purposes. Materials used in basketmaking are too numerous to mention, but women ingeniously used whatever was available.

BANGWA

Above: Statue of a mother of twins. The woman's open mouth suggests sound, either speech or the obligatory song that mothers of twins must learn. The songs are sung during funerals and other ceremonies. The figure's powerful dynamism dramatizes the vitality of mothers, especially those of twins. 19th century.

BASKETRY

Top right: The Apache made large shallow trays used originally for winnowing or parching seeds and for girls' puberty rituals. These and the large storage jars are sought-after tourist items. The irregular spacing of the outer border and the central star are common Apache motifs.
c. 1915.

Center right: Pima basket with a tasita or swastika design at the center. The swastika appears frequently in North American designs where it symbolizes a host of complex and interlocking properties including water and the moving sun.
19th century.

Bottom right: The Navajo ceremonial or wedding tray–made by the Paiutes– shows the dau or spirit break. When the basket is used ceremonially, the "pathway" must face eastward. 1890–1910.

Designs often have names and carry significance, although in many cases the meanings have been forgotten. Basketry techniques are also used to make mats, sandals, hats, baby carriers and other objects. Basketwork techniques and designs influenced other art forms such as weaving and pottery and, in fact, basketry is sometimes given credit for the invention of fired pot-

tery. According to the theory, baskets were made watertight with clay liners. People noticed, when these baskets were used for heating water or cooking, after the basketry had burned off, that the fire-hardened clay was stronger and longer lasting. In North America, the most accomplished basketmakers were found in California and in the Southwest. Southwestern basket traditions are of considerable antiquity and, in fact, the ancestors of the Pueblo people are called the Basketmakers. The basketry tradition was handed down over many generations and continues to be vital today. The Pima and Papago of southern Arizona use different materials and techniques and the so-called "devil's claw" (*Martynia proboscidea* or *martino*, a desert plant) produced characteristic geometric designs. Favorite Pima patterns around the turn of the century were "juice falling from saguaro fruit," "coyote tracks," "turtle," "deer in woods," and *tasita* or the swastika motif. Papago women today make intricately figurative baskets with black and white horsehair. Apache women are among the most famed Southwestern basketmakers. Two utilitarian forms are made, shallow trays or bowls and large storage jars. The trays play a major role in girls' puberty rituals where the finest ones were heaped with ceremonial foods symbolizing the bounty and blessings that flow from White Painted or Changing Woman. Navajo women made baskets prior to the 20th century, but ceased producing them when they began to concentrate on weaving rugs. Today, the famous "Navajo wedding baskets" are made by and purchased from the San Juan Paiutes for use in Navajo rituals. Most Southwestern baskets incorporate the *dau*, or spirit break, an outlet where the spirit can enter to inspect the basket or escape should the basket be destroyed. An alternate interpretation is suggested with regard to Zuni pottery, where incomplete patterns are said to symbolize the potter's own incomplete life. See

INDEX: Basketry in Art, Artifacts and Techniques; Names in Miscellaneous.

Bat. Unlike their negative association with vampires and witches in Western cultures, bats in indigenous cultures are generally regarded positively. In the COOK ISLANDS bat-like images appear on carved adze handles, apparently symbols of successive generations of ancestors. The wings of the flying fox, a large fruit-eating bat, adorn ASMAT WAR SHIELDS, offering protection to the warrior. One of a number of symbols of head hunting, the flying fox is thereby linked to the souls and life force of individuals. The LIMINAL qualities of bats—they are mammals that fly, hunting in the dusky half-light of twilight—make them ideal embodiments of duality. KAIRAK BAINING night dance masks include bat motifs. The night dance masks are associated with darkness, males, wilderness, hunting and chaos. They form a complementary duality with day dance masks linked to light, women, community, gardening and fertility. The rituals as a whole revitalize life. The supernatural powers of the ruler of IFE are symbolized by the bat/snake-bird motif—potentially harmful or beneficial. The bat appears in Native American art of the Southwest, such as in the wall paintings inside the KIVA, where it is one of several images symbolizing the interconnectedness of life, water and fertility. Finally, speaking of the Ojibwa SHAKING TENT, a native informant likened the voices of spirits to bats' shrill cries.

Batcham. See CAMEROON and CAMEROON MASQUERADES.

Baule. The Baule are AKAN speakers who live in central Ivory Coast. Susan Vogel has written that Baule art has remained at the core of the Western canon of African art because of its relative naturalism, exquisite workmanship and calm dignity

(*Baule, African Art, Western Eyes*). Baule art is also characterized by subtle but overt asymmetry. Stemming from a spirit of intense competition, Baule art is vivid, idiosyncratic and artists strive to surprise the spectator through inexhaustible invention. Because of this individuality and flamboyance, Baule art includes many one-of-a-kind objects. Living in a territory split between the Ivory Coast and Burkina Faso, the various sub-groups called the Baule have never been politically unified. Despite the lack of cohesion in origins or ethnicity, there is a cohesive art style throughout the area. There is no evidence to support the oft-repeated origin myth about Queen Abla Poku fleeing the Asante kingdom and settling in the Baule area. Vogel's field research uncovered an alternate origin story concerning the Mamla who believe their ancestors either emerged from the earth or descended from heaven on a chain; the Mamla were likely the "root Baule" culture in the 18th century and possibly earlier. The present-day Baule attribute their religion, ritual, aesthetic principles and art styles to the Mamla. The Baule world is a dualistic one, composed of the dichotomy of WILDERNESS and community, men's art and women's art. Ancestors play a major role in daily life, exerting beneficent or malevolent powers. Not all dead become ancestors, but non-figurative offertory shrines, stools or chairs, memorialize those that do. The Baule do not carve figurative representations of ancestors, despite the fact that many books on African art identify Baule figures as ancestor figures. Instead, carved figures are properly called *amuin*, a conflation of several concepts, including power, a supernatural spirit—malevolent or beneficent—its cult, objects representing it and wearers of masks. *Amuin* are the most powerful spirits in Baule life; they require blood offerings and they can kill human beings. Mask types include portrait masks. Called *ndoma*, meaning "double" or

BAULE

Above: The Baule guard their art, and the most important art is rarely seen. Trance diviners own standing monkey figures, kept in their private shrine rooms. These figures are the receptacles for wilderness spirits called mbra (also the name of the possession cult) that enter the diviner during trances. Monkey figures vary in power and some are not to be seen by women, even if the woman is a diviner. Male clients consulting the diviner in the same room with the sculptures neither look closely at them nor talk about them. Owning such objects enhances the diviner's reputation. Mbra figures may be encrusted with blood and sacrificial offerings and sometimes incorporate actual animal skulls. Before 1930.

"namesake," these masks are regarded as true doubles of the person portrayed. The mask can only appear in public accompanied by the person depicted, or by a close same-sex relative. Masks representing natural phenomena—sun, moon and rainbow—preface the arrival of other masks in performances. Four pairs of masks are associated with the GOLI performance, which is gradually replacing other Baule dances. Baule men also make composite animal helmet masks called BO NUN AMUIN which are held in great awe. The Baule make gold-covered wood sculpture (*sika blawa*) for display, including inventive linguist staffs, fly-whisk handles, and others. Finally, a special class of Baule figurative sculptures is the SPIRIT SPOUSES. See also LINGUIST STAFF and NAMES.

Beadwork. North American Natives obtained large glass beads from Russian traders by the late 18th century. Beads were used to decorate clothing, bags and pouches, but were also used as currency, for example, *wampum*. Smaller European seed beads first appeared in the early 19th century and the majority of collected items date between 1890 and 1930. Beadworking skills were often learned at mission schools and, in the Arctic and Subarctic, from the Hudson's Bay Company wives and daughters who moved periodically and were thus responsible for the exchange of designs and techniques. Typically beads were strung on a single strand of sinew and fastened to the backing with tiny stitches between every second or third bead. Although most beadwork was done on caribou, deer or moose hide, velvet, broadcloth and British wool fabric were often used. Designs vary regionally with indigenous basketwork being the source for Tahltan designs while European traditions influenced the Cree and Great Slave Lake-Mackenzie River region. Innovation did occur and occasionally designs were introduced from pictures in European and American magazines. In Africa, beadwork is one of the most valued status art forms. In some cultures, only the king or high chief owned beads, as was true of the Oba of Benin or Zulu rulers. Beadwork, supplemented by cowry shells, is the most important medium for crowns among the Yoruba and the Fon. Beads also encrusted the royal thrones of various Cameroons rulers, such as the *tour de force* throne of Bamum King Nsa'ngu. Finally, royal Kuba masks are heavily beaded. In some village-based or nomadic African groups such as the Maasai, beads constitute an important form of wealth. See INDEX: Beadwork in Art, Artifacts and Techniques.

BEARS

Above: The legend of Bear Mother explains the origin of the bear clan: Skoaga, a Haida woman married or was carried off by the Lord of the Bears. She gave birth to a child that was half-bear, half-human which made for very painful nursing. This argillite figure was made by the Haida artist Tsagay (Skaowskeay). Collected at Skidegate, Queen Charlotte Islands. c. 1883.

Bears. Bears are like human beings because they stand upright, but they are infinitely more powerful physically. Throughout North America, wherever bears are found, they play an important part in the mythology and ritual lives of the people. Arctic and Subarctic hunters may regard the bear as a supernatural being which is a Lord of the Animals, a special protector of the bear or spirits which take the form of the bear to offer themselves as prey. In the last instance, the bear is treated respectfully and its remains given proper burial so that it will offer itself again. Among the Eskimo, the bear was a favored helping

spirit of the SHAMAN and often appears in the form of ivory amulets. Myths tell of marriage between bears and human women, of the bear's descent from the sky god and ancestral bears. Remnants of an older North American bear cult, possibly related to the widespread practices of northern Eurasia, Russia and the Japanese island of Hokkaido, are found across the Arctic Circle, among Algonquian speakers and possibly in some Mississippian cultures. It is possible that these remnants may be part of a hunting culture archetypal complex transmitted by diffusion. The notion that the bear is a dark and dangerous force continued among the Navajo, who perform the Mountainway Chant to combat "bear sickness," arthritis and mental illness. On the other hand, petroglyphs representing bear tracks are found all over the Southwest and are said, as they do among the Pueblo people, to symbolize the curing power of the bear. See INDEX: Bear in Animals.

Beauty. While many indigenous people have no word for art, many have terms linked with the complex associations that surround beauty. Beauty is almost never merely a material attribute, but instead involves a host of interdependent spiritual, cosmic and physical ideals. In NAVAJO AESTHETICS, for instance, the word *hozho* describes the dynamic condition of being in balance with oneself, others and the surrounding world which is described as "walking in beauty" (see CHANT-WAYS). The ZUNI word *tso'ya* has a similar meaning, but also embraces a number of dramatic visual characteristics including multicolored diversity. Cultures that so clearly define beauty in this fashion usually conceive of it as a primordial state later corrupted by an equally dynamic dualism—the purpose of ritual in such societies is to restore the original beauty, harmony and balance. Beauty is often dramatized by its opposite, that which is dangerous, dark

and ugly. Among the Zuni this dark side is often more powerful than that which is beautiful. Finally, beauty is almost never static in indigenous cultures. Yoruba GELEDE masks are an excellent example of this. The faces of these wonderfully varied masks are almost always calm, aloof and very cool in contrast to the explosion of forms, colors, humans and creatures that characterize the superstructures of Gelede masks. Finally, the costume beneath is layered with many hotly colored floating pieces of cloth. As the dancers move, keeping rhythm with drums, *oriki* praise songs and the buzz of the crowd, the masks shine with power. Sylvia Boone writes that the Mende (see SANDE) of Sierra Leone use several words as qualifiers to describe beauty. Beauty itself is *nyande*. But, beauty is not just physical, as the Mende say "...no one can be beautiful if she doesn't have a fine character." *Nyande gbama* is wasted or empty beauty, referring to physical beauty marred by arrogance and lack of competence. Goodness, *kpekpe*, is linked with good-heartedness, kindness and generosity. Real beauty, then, contributes to the entire community, as it is good to look at, fulfills its social purpose through industry and dedication and is generous and loving. The BAULE value individuality and vividness, and considerable latitude is encouraged among artists. The word *klanman*—meaning "beautiful, agreeable, of good quality"—applies to aesthetically pleasing environments (a sculpted clay hearth or a well-swept yard, even though the patterns created are transient), as well as to works of art.

Belau. See BAI.

Bella Bella. See KWAKIUTL.

Bella Coola. By the late 18th century, these Salishan speakers had moved into permanent villages along the creeks and rivers of the Bella Coola valley. Around

BEAUTY

Akat means both beautiful and good among the ASMAT.

The Yoruba word ewa, "well done" or "well made," describes things pleasant to behold that elicit admiration, honor and respect. It refers to physical beauty and good character.

The Zuni word tso'ya refers to those things which are dynamic, multicolored, musically chromatic, varied, new, exciting, clear and beautiful.

The Eskimo term takminaktuk, meaning "it is good to look at" or beautiful, refers to people and art objects.

the time of contact (1793), they resettled around the mouth of the Bella Coola River. In addition to the POTLATCH, the Bella Coola had two secret societies, the Sisaok and Kusiut. Membership in the former was confined to the children and relatives of certain chiefs, and was concerned with their initiation. The Kusiut society

BELLA COOLA

Right: Frontlet representing Raven. Small faces are carved into the hands flanking Raven's beak and the head of a cod appears beneath. The style is called "Bella Coola Bluebird" because of the characteristic blue paint. High-ranking people wear frontlets, inset with mirrors and glittering shell mosaic, on the forehead.

maintained secrecy through fear and intimidation. The primary ritual occurred at the September full moon when a supernatural canoe left the land of the salmon people and traveled up the Bella Coola River. The being in the canoe, the leader of the Kusiut society, was the earthly representative of the female spirit guarding the sources of power. The masks made to honor this visitor were usually burned at the conclusion of the dance and were unique in earning praise for their carvers' innovations. Bella Coola art is compared to that of the KWAKIUTL, but the distinctive hemispherical, "bulbous" facial form is said to be unique. See also TWINS.

Bella Coola Cosmology. The Bella Coola believe the world consists of four layered worlds (see LAYERED UNIVERSE) one above the other. There are two upper worlds above the flat circular island of the human world. A supernatural being that lived in the upper layers kept tension on ropes that held the island in place and prevented it from capsizing. The sky was conceived of as an inverted dome, the bottom edges of which rested on the human world. The uppermost world was a large house called *nusmata*, the place of myths, legends and stories. Below was an underworld, the realm of ghosts. Franz BOAS reported a second underworld, bringing the number of layers to five, but this cannot be confirmed. A timeless, pre-existing Supreme Being created four supernatural carpenters who, in turn, created all land features, flora, fauna and human beings. Pregnancy was believed to occur when the Supreme Being asked the four carpenters to carve a new child.

Bemba. The Supreme Deity of the BAMANA, Bemba existed originally as a whirlwind (pure thought) in a void after which he became a quaternity consisting of the four elements.

Bembe (also Bemba, Babembe). Some 50,000 Bembe live in the Republic of the Congo. Closely related to the LEGA, they are said to be descended from the LUBA, having left the Congo in the 18th century. The Bembe venerate powerful ancestors who make their wishes known through dreams or divination and can benefit or injure the living. Figures containing ancestral spirits (*nganga*) typically have identifying scarification patterns and emblems of rank rather than physically resembling the ancestor. These figures serve to protect descendants and are sometimes used in healing rituals. Large Bembe *nkondi* power figures, possibly influenced by Sundi power figures, performed judicial and punitive

roles. Bembe 'alunga association masks ('alunga is also the name of an ancient nature spirit) fulfilled similar functions, acting as agents of social control. The masks perform privately among the initiated for success in the hunt and village health and in public the masks enforce the

will of the association. The mask represents the nature spirit, which manifests itself with the combined attributes of owls and civit cats, both night creatures with superhuman powers. In *The Four Moments of the Sun: Kongo Art in Two Worlds*, Robert Farris Thompson suggests that 'alunga masks' diamond-shaped eyes surrounded by squared-off ovals resemble the cross-in-circle Kongo DIKENGA sign. Furthermore, he points out the apparent relationship between the mask's name—'alunga—and the Ki-Kongo word *kalunga* meaning, "ocean, completion, God." The horizontal line across the eyes' centers can thus be interpreted as representing the dividing line between the realms of the living and the dead. When not in use, the masks are kept in a sacred cave. When worn, this mask would have been surmounted by a huge crest of feathers.

Bena Luluwa. See LULUWA.

Benin. Since the 10th century, the modern city of Benin (now called Benin City) has been the capital of a centralized kingdom in southern Nigeria (not to be confused with the geographically and politically distinct country called the Republic of Benin established in 1990). According to oral traditions, between 900 and 1150-1300 the Ogiso, Rulers of the Sky, held sway in Benin. Late in the 13th century, the present system of government was instituted following a period of upheaval. Aranmiyan (Oranmiyan in Yoruba), son of ODUDUWA founder of IFE, was invited to rule Benin. Although linked mythologically and dynastically to Ife, the people of Benin are Edo speakers and differ not just linguistically, but also culturally from Ife and from the Yoruba to whom they are stylistically compared. The ruler of Benin, or OBA, held the monopoly on black pepper, ivory and slaves and thus controlled trading with the outside world—the Portuguese arrived in 1486, followed by the French and Dutch. Great wealth was accumulated. Having reached its greatest expansion in the 16th century, and progressively weakened by ineffective Obas and the collapse of the slave and ivory trade, the Benin Empire was conquered by the British. A young British vice consul, acting without clear orders attempted to visit Benin during Igue, the New Yam festival renewing the Oba's powers. The palace chiefs ambushed the party and once news of this reached London, a punitive expedition was sent. Oba Ovoramwen (his name translates "the morning sun that spreads everywhere") initially surrendered, but later escaped. Recaptured, he went into exile in 1897. After his death in 1914, his oldest son Eweka II was permitted to return to Benin. He rebuilt the palace, established schools to reinstitute arts and crafts and partially reinstated traditional court structure—all under the watchful eye

BEMBE

Left: 'Alunga association mask with owl and cat attributes: the large eyes evoke the visual acuity of night creatures and the small mouth contrasts with the loud noises that issue forth from the mask as it performs.

of the British colonial administration. Most of the art of Benin is connected with royalty. In fact, there is a long link between art, royalty and history in Benin—art is a means of enshrining the past metaphorically and literally. The materials used are the most enduring; metal in particular is valued for its permanence and for its inherent power associated with Ogun, god of metals. The BENIN PALACE COMPLEX, although rebuilt after the Oba's return in 1914, is probably less impressive than the one burned by the British. In earlier times, the palace walls were covered with brass plaques and impressive sculpture surmounted its roof. BENIN ANCESTOR SHRINES were laden with art including brass heads, great curving carved tusks, musical instruments such as rattle staffs, bells and a host of smaller figure groups. The Oba's resplendent regalia featured crowns; ivory, coral and beaded jewelry; maskettes and ceremonial weapons. Attendants carried fly-whisks, fans and various noisemakers such as clappers and sistrums. The Queen Mothers, who had their own brass heads and regalia, lived in separate palace compounds, outside the walls of the city. The artists responsible for creating these many objects were valued members of society and lived in their own quarters. The metal workers' quarter today continues to be a lively place with glowing forges and the drama of brass pours.

BENIN ANCESTOR SHRINES

Top: Brass bell with a central face and an open, latticework structure.

Bottom: The court dwarf is said to be one of the most priceless of all Benin objects. Little is known about the function of dwarves, but it has been suggested that they served as court jesters and acrobats. Alternatively, the dwarf could be seen as a liminal creature, its physique and stature contrasting with and dramatizing the ideal represented by the Oba.

Opposite: Two views of a brass head of an Oba, iron-inlaid pupils. The realism and the finesse of the craftsmanship on the high coral bead collar and lattice work crown with agate bead rosettes are typical of late-16th–early-17th-century brass castings. The three scarification marks over the eyes are called ikharo, "tribal mark of eye" (four marks identify women, see IVORY).

Animal imagery played a major role in symbolizing the power of the Oba. Although some of Benin's treasures have been returned to Africa, sadly, many of the several thousand brass castings are scattered across the world in various museums—the largest concentration rests in the British Museum, having been seized by the so-called punitive expedition in 1897. The people of Benin are sometimes called the Bini. See also AFRO-PORTUGUESE IVORIES, FELINES.

Benin Ancestor Shrines. The semi-circular shrines dedicated to the past Obas of Benin are regarded as national shrines (see Colorplate 3). The oldest son of the Oba is responsible for erecting his father's shrine on his death and cannot fully accede to power until the shrine and certain rituals are completed. The living Oba is caretaker of all the shrines representing the royal line reaching back to Aranmiyan, the divine ruler who came to Benin from IFE in the 13th century. The objects found on the shrines are complex, interlocking symbols that make manifest the Oba's power and his continued spiritual presence. The objects include: "thunderstones," musical instruments, carved elephant ivory tusks supported by brass heads, individual human and animal figures and figure groupings. Not only does each of the objects carry significance, each is ornamented with further symbols. The "thunderstones," actually prehistoric celts said to have fallen from the sky, serve as reminders of the sudden destructive power of Ogiwu, god of death. Two sorts of musical instruments are found on the shrines, both of which serve to call the spirits and mark the beginning of rituals. Carved wooden rattlestaffs (earlier, these were made of both ivory and brass), when not in use, stand together like a miniature forest, leaning against the corrugated wall behind the shrine. The tops of many staffs are carved with human figures said to represent gener-

alized forbears; some have power symbols such as clenched fists indicating the Oba's ability to seize or release. The staffs are tapped on the ground to summon the spirits, making a rippling noise something like pebbles rolled about by water. Various sizes of box-shaped bells with strap handles are placed on the altars, usually with one large one at the front. The bells are rung to announce the beginning of ritual, to neutralize hostile forces and to signal continued spiritual presence. Bells are one of the most numerous brass art objects throughout all of southern Nigeria. Originally all bells were made at the Oba's command, and although this is no longer true, brass bells are associated with the Oba and royal power. This royal connection doubtless explains why bells served as markers of military rank and protected the warrior, producing a "power field" around him. Bells are decorated with geometric patterns, human faces, animals. Exactly when brass heads originated is not known. Some sources report that the practice of making wood memorial heads originated with the earliest (Ogiso) dynasty of Benin. Brass casting is generally said to have been introduced from Ife by Oba Oguola in the mid/late–14th century, although the purpose and significance of the Benin heads seem not have fulfilled the same aims as those of Ife. It is even reported that it originated with the taking of trophy heads in war and/or with human sacrifice. Whatever their origin, the heads are regarded in the West as among the most spectacular productions of this culture. The people of Benin regard the head as the source of an individual's power—it directs the body and "leads one through life." Although no comprehensive chronology has yet been developed for Benin objects, the heads are grouped into a sequence from the most naturalistic, least complexly adorned 15th-century pieces (in *The Art of Benin*, Ben-Amos suggests that these are trophy heads) to the stylized, elaborately

crowned images of the 19th century. The increasing elaboration is said to reflect the power and prosperity of Benin; likewise the practice of further aggrandizing them by setting carved ivory tusks in them occurred late as well. It is also suggested that the ivory tusks functioned like an *axis mundi*, symbolically linking the Oba with the realm of the spirits. Finally, freestanding figures once occupied shrines. These form a diverse body of objects that have been interpreted in various ways, said to be messengers, court attendants, warriors or priests. All of these diverse objects work together to create a composite image of power couched in history, in the spirit realm and in the present, funneled through the living Oba by virtue of his care and responsibility for the shrine. The Queen Mothers had their own shrines and terracotta and wood heads adorned the ancestral shrines of brasscasters and chiefs respectively. At the time of the punitive expedition the altars (sources disagree on the number extant, between thirteen and seventeen) were stripped of their furnishings—when Eweka II returned in 1914 he began the process of reestablishing the altars. Today individual altars commemorate Obas Adolo, Ovonramwen and Eweka II and a communal shrine is dedicated to all previous Obas. See IVORY.

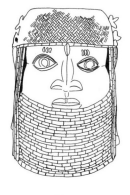

Benin Palace Complex. The city of Benin consisted of two sections. The inner city contained the Oba's palace compound, and palaces of the Ogiso dynasty, palace and town chiefs as well as the artists' quarters. Residences of additional title-holders, the *uzama*, or kingmakers and the war commander occupied the outer city. The Crown Prince and Queen Mother lived just outside the outer walls to the north of the city. Judging from 17th-century accounts, the Oba's palace was enormous and dramatically enhanced with gables sporting brass birds. These birds have been identified variously as ibis, vultures, fish

BENIN PALACE COMPLEX

Below: Brass plaque from the Oba's palace. The Oba is mounted sidesaddle supported by attendants and shielded from the sun. The size variation of the Oba and his retainers suggests their relative importance—were the Oba to stand up he would barely fit within the plaque's confines. The plaque is a triumph of the brasscasters' art with its high relief, nearly freestanding, figures. 16th–17th century.

eagles, white-tailed thrush, pin-tailed why-dah, marabou storks or, and most likely, black-casque and ground hornbills. The hornbill resembles the local "bird of destiny" linked with the Oba's responsibility for human destiny. The marabou stork, a carrion-eating waterbird, is another candidate because of its impressive size and dangerous associations. The palace façade also featured great brass pythons zigzagging, headfirst, down the trapezoidal turrets. The pythons are referred to locally as *omwasomwa*, meaning, "all people are not equal," indicating social differences amongst those inhabiting the palace compound. The snakes visually link earth and sky and, like many other symbols associated with the Oba, are liminal creatures as they swim in water, slither across the earth and climb trees. The python, hanging head-downward above the entrance to the palace signified the danger of entering the precinct. They are vigilant guards prepared to drop upon the unwelcome much as pythons in the wilderness fall on their victims from tree limbs, smother and swallow them alive. Pythons were similarly positioned above the royal tomb. Suzanne Preston Blier notes that two species are depicted—the smaller royal python and the aggressive rock python that may grow to thirty feet in length. Together they may represent the king's dual nature—simultaneously dangerous and promoter of well-being. The beneficent python is also linked with both lightning and the over-arching, wealth-bearing rainbow, while the *ikpin ama* or the "rain python" is said to swallow unwary humans. The birds and snakes would also have served as lightning rods, and frequent lightning strikes served to further enhance the dangerous majesty of these creatures, the palace and the Oba. As impressive as the birds and snakes are, however, far more dramatic were the brass plaques—Phillip Dark recorded 895 of them, other estimates run as high as 1000—that originally hung on the palace walls. All of Benin life is pictured on these plaques from the Oba and his courtiers, to warriors, to Portuguese soldiers and traders. Attention to detail, degree of relief and sheer diversity make them triumphs of brasscasting. Blier suggests that although the plaques were taken down sometime before the punitive expedition of 1897, they served as an archive consulted with regard to rituals and regalia. See INDEX: Animals.

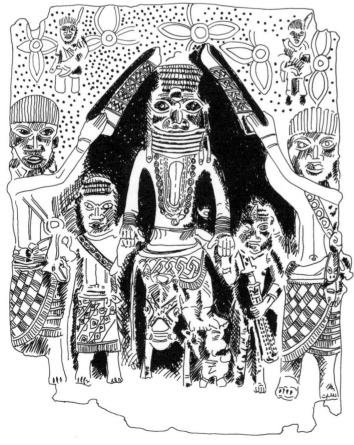

Betel/Betel Nut. A mild stimulant used throughout New Guinea, Southeast Asia and other areas of the Pacific. The drug, which is chewed, is composed of a variety of palm nut (*Areca catechu* originally domesticated on the Malay Peninsula), the fruit or leaf of the parasitic betel-pepper (*Piper betle*) and slaked lime from sea shell or coral. It is consumed ritually and social-

ly and can be addictive. Chewing is accompanied by spitting blood-red saliva. In the United States, betel nut is well-known from the character of Bloody Mary in the Broadway musical and film *South Pacific*. A number of finely made art objects are associated with the drug, such as spatulas, mortars and lime containers.

Bieri (also *byeri*). Reliquary figures, see FANG.

Bifwebe. The SONGYE and LUBA word for masks, see the singular form, KIFWEBE.

Big Man/Men. Term designating those of highest social status in Melanesia.

Bilum. Netted bags with symbolic implications from New Guinea, see STRING BAGS. Similar bags called *wut* are made by the WOSERA.

Birds. The generalized Western idea of the bird as a symbol of the unfettered human soul and messenger of the gods is also found in indigenous cultures. However, other explanations for the numerous bird images exist. Birds are often the shaman's spirit helpers, their swift and graceful flight serving as a powerful metaphor for his/her ecstatic flight. Actually, the shaman can fly (see MAGICAL FLIGHT) perfectly well without the assistance of birds. Birds play a major role in two different types of

creation myth—the EARTH DIVER and the world egg. Additionally, there are numerous myths in which birds speak to human beings, issuing warnings, carrying messages or conveying knowledge. The bird as TRICKSTER is found in the Raven stories prevalent in the Arctic, Subarctic and Northwest Coast. In Melanesia, the most important aspect of birds is not their ability to fly, but rather their large beaks. The curved shape of cassowary and hornbill beaks underlies much of the art of New Guinea, where it is related to head hunting. Because of their mating and nesting behavior, both birds are linked to male initiation rites. Owls, as creatures of the night, are linked with death, magic and dreams. As such, for many North American natives, the owl was especially closely tied to the shaman. The Kiowa, for instance, believed that the shaman became an owl after death. The Ojibwa called the bridge over which the dead passed, the "Owl Bridge." Owl feathers were buried with the dead to facilitate their journey. The eagle was the most frequently represented bird in North America (Thunderbird may possibly be regarded as the Eagle's supernatural counterpart), although one also finds condors, falcons, flickers and a flock of others. The eagles' high nesting places, the heights to which they can fly and their sharp vision and dignity single them out. It is said that Ben Franklin preferred the turkey as the national bird—Native Americans would not have agreed. The California Chumash, for instance, explain the phases of the moon as shadows of Eagles' wings. The Hopi took fledgling eagles from their nests, hand-raised them and released them to carry good reports to the Spirit world. For a listing of the many references to birds, see INDEX: Birds in Animals; Egg in Natural Phenomena and Materials.

Birth. First of the RITES OF PASSAGE, birth is both mysterious and magical and,

BIRDS

Left: Birds are frequently the shaman's spirit helpers. After an original drawing by ESKIMO artist Jessie Oonark. 1971. The drawing is captioned: "When the moon rocket went to the moon and some of the young kids were trying to tell the old people about this, they were getting really frustrated because the old people were saying, 'Oh, that's nothing, my uncle went to the moon lots of times.'"

Above: Birds are also ancestors, as among the SENUFO who kept large sculptures of birds in sacred groves. The bird is variously identified as a hornbill, vulture, crow, eagle or buzzard, but the old people just say bird. It is sometimes called kasigele, "the first ancestor," founder of the human race and sacred forest. The conjunction of curving beak and swelling belly is said to represent harmony between the male and female elements—and, given the bird's ancestral status, procreation.

in fact, it serves as a model for other life passages establishing a pattern of withdrawal, seclusion and return. Because birth is a period of great vulnerability for both mother and child and due to the sheer power of the event, in many places pregnant women are sequestered before delivery. In some societies, the shaman and occasionally the father-to-be are present, but generally speaking, birth in indigenous societies is the province of women. The mother and child stay in isolation for varying lengths of time and, upon reentering society, introduce the infant to the larger community. Birth is often the metaphor for creation in mythology. For instance, Papa, the Earth Mother of Polynesia, gives birth to humankind. Other myths establish models for both the first, physical birth and a second, spiritual birth (see INITIATIONS) as for instance, in the Australian Aboriginal myth of the WAWALAG SISTERS. Although there are several versions of the myth, the central role played by birth is constant. The sisters, one of whom has just given birth, while the other is menstruating, camp near the sacred water hole of YULUNGGUL, the Great Python, and without realizing it, defile the sacred place. The snake retaliates by swallowing them, but later regurgitates them—a second birth—after which he shares his secret knowledge. The act of regurgitation is not only a metaphor for birth, it also serves to fertilize all of nature. The second birth experienced by the sisters (together with the notion that human intercession and intervention is a necessary activating and fertilizing force) shows how closely birth is related to initiation. In most cases, initiation rituals mimic physiological birth but, at crucial times (puberty or the calling of a shaman) they enact a second spiritual birth, integrating the individual into society for the next phase of life. Rita Gross writes that second birth initiation rituals often focus on the differences between the first birth (physical, profane and the

province of women) and the second birth (spiritual, sacred and orchestrated by men) emphasizing that the second is the *real* birth. Although the societies in which this mode occurs tend to show hostility toward women to the point of seeming dysfunctional, Gross suggests that the underlying motivation is not scorn but awe. See also female and birth imagery connected with Melanesian men's houses: Abelam KORAMBO, Sepik River TAMBARAN and Asmat YEU. Finally, FUNERAL rituals are often filled with birth imagery. The dead are buried in the fetal position; ancestors are depicted in the HOCKER position which, while it ostensibly represents squatting figures, is also similar to the fetal pose. See also HEI TIKI, INVERSION.

Bis Pole (also *mbis, bisj*). Tall sculptural poles, cut from entire tree trunks, were erected by the ASMAT to assuage the anger of the dead, especially those killed in HEAD HUNTING raids. Actually, the trees are inverted, the flaring protrusions at the top being carved from the roots of the tree (see INVERSION). When the elders determine that *bis* poles must be made, the men "hunted" the trees, ritually killed them and brought them back to the village where they were treated as ancestral objects. Indeed, the Asmat traced their ancestry to trees carved into the forms of the first men and women by the culture hero FUMERIPITS. Once the *bis* poles were complete, the poles were set up in front of the men's house where they were ceremonially dedicated. Afterwards, the poles were removed to the sago plantations where they served as spirit protection for the village's major food source. The upper parts of the poles are carved with stacked ancestor figures in poses based on the praying mantis (*wenet*), a symbol of head hunting. Although the mantis is not a fruit eater like other creatures linked with head hunting, its limbs are articulated much like those of humans. More importantly, it eats

other insects (like human cannibals, see CANNIBALISM). A pointed form resembling a bird's head tilted back, its beak pointing toward the heavens tops the poles. Similar bird-like forms in other Asmat art are identified as an erect penis, linked with male virility and warfare. The

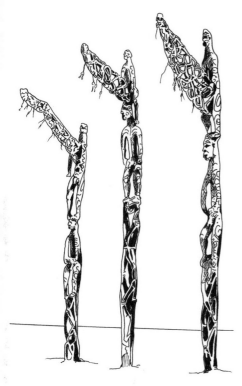

openwork flaring protrusions characteristic of *bis* poles, also called penises (*tjemen*), are decorated with curvilinear patterns, small seated human figures, and beak-shaped forms. The latter are analogous to head hunting, as the birds eat fruit and crack nuts with their beaks. The base of the pole takes the form of a non-functional canoe or openwork shapes representing the roots of the sacred banyan tree. The poles act as soul containers which, through their vital combination of elements, guarantee the soul's safe journey to *safan*, the world of the ancestors. The journey might be conceived of vertically—up the *axis mundi*/WORLD TREE/ancestor ladder and down into the underworld—or horizontally, across the sea on the spirit canoe. This is consistent

with the ambiguity about the location of *safan*, which is said to be in the mountains as well as in the sky. See INDEX: Animals.

Biwat. The Biwat and Mundugamor live on the Yuat River, which marks the uppermost boundary of the Lower Sepik style. Margaret MEAD's field studies stressed the belligerence and overt aggression of the people. The best-known art objects from the area are flute stoppers representing birds and human figures with disproportionately large and elongated heads. Sculptures of male figures, masks, war shields, ceramic pot stands and paintings are also found.

Black Dance. A cult which emerged in the mid-18th century in the eastern Great Lakes region. Apparently concerned with hunting and war, it was similar to, but of shorter duration than the Ojibwa MIDEWIWIN religious society.

Black Elk (1863–1950). Oglala Sioux (LAKOTA) spiritual leader well-known among his own people and brought to national attention through the 1932 book *Black Elk Speaks* by Nebraska poet laureate John G. Neihardt. Black Elk witnessed the major historic events concerning his people beginning with the Battle of the Little Bighorn, the murder of Crazy Horse, Sitting Bull's sojourn in Canada and the massacre at Wounded Knee. He joined Buffalo Bill's Wild West Show, met Queen

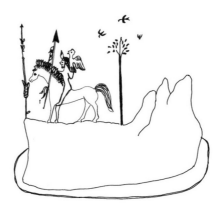

BLACK ELK

Left: Black Elk at the center of the earth (Harney Peak, Nebraska) redrawn after a painting by Standing Bear.

Victoria and traveled Europe, returning to South Dakota in 1889. More important than his participation in these momentous and tragic events, were his spiritual visions beginning at age nine. Told poetically by Neihardt and accompanied by illustrations by Standing Bear, Black Elk's visions profoundly, yet simply, record powerful actual and spiritual experiences expressed in the universal imagery of SHAMANISM.

Blackfeet (known as Blackfoot in Canada). The Blackfeet PLAINS PEOPLE are Algonquian speakers. Karl BODMER recorded their costume and other aspects of material culture. See also EFFIGY FIGURES and TIPI.

Blacksmith. Smiths are often especially respected in indigenous cultures because of their apparently magical ability to transform raw materials into useful tools and weapons and, sometimes, sculptural objects of power and beauty. In cultures touched by SHAMANISM, the blacksmith often plays a role in the shaman's initiation, part of which may consist of having his bones or skull "forged." Particularly powerful shamans sometimes claim to have extra ribs contributed by the blacksmith that grants them special powers. In some cultures, the blacksmith is also the shaman, as is true among the DOGON of Mali. The "office" is hereditary and accorded great respect.

Bladder Feast. This ESKIMO feast was celebrated annually in midwinter. Believing that the seat of the animal's soul was its bladder, the Eskimo preserved that organ. The central event of the feast was the returning to the sea of the bladders of all the seals caught during the previous year. This was done in the hope that the souls of the seals would find new bodies and, having been gratefully and respectfully treated, allow themselves to be caught again the following year. Masked dancers

flattered the spirits of animals, food plants and birds to further honor and entice them. Skins of small birds and animals caught by boys were displayed in the festival house and gifts were given to human and seal souls.

Blessingway. One of some two dozen Navajo CHANTWAYS, Blessingway is regarded as the backbone of their religion and is said to have historical precedence over the others. Some Blessingway chants can be performed in only two nights, thus it is the shortest and least expensive to perform. Not primarily a healing ritual, its purpose is to combat ugly things and to restore *hozho*, or as the Navajo put it "for good hope." It is often performed during periods of transition for protection and to invoke positive blessings. Girls' puberty rites, *kinaalda*, are just one instance of Blessingway rites. The ceremony recounts the activities of CHANGING WOMAN after the Emergence.

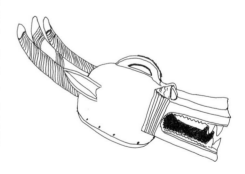

Bo nun amuin (also *bonu amuin*). The name of this BAULE mask means "gods in the bush." These helmet masks represent composite animal heads with open jaws and prominent teeth. Kept in a forest sanctuary outside the village, the masks had nothing "civilized" about them and were entirely products of the wilderness. As such, they were among the most feared of Baule masks and women were not permitted to see them. They made manifest the

BO NUN AMUIN

Right: The Baule do not associate these masks with particular animals, but see them as embodiments of the bush and maleness. Late 19th century.

duality of wilderness/civilization, male/female. They appeared to protect the village against threats and to discipline women who were thought to be disrespectful or defiant. Additionally, life-threatening illness and deaths were attributed to them.

Boas, Frans (1858–1942). Boas, who some believe to be the dominant influence on American anthropology in the first half of the 20th century, served as a curator at the American Museum of Natural History before assuming a teaching position at Columbia University in 1896. His analysis of Northwest Coast art was incorporated into his landmark study of "primitive" art published in 1927. He made many research trips to the Northwest, focussing especially on the KWAKIUTL. His insistence on approaching the material without ethnocentric bias, his belief that mythology and oral traditions were keys to understanding culture and his systematic analysis of art—especially his refusal to reduce the complexity of the artistic process—have had lasting influence on scholarship. His students included some of the most important anthropologists and ethnographers of the next generation including Alfred Kroeber and Margaret MEAD.

Boat Burial. In the Pacific the practice of boat burial and boat imagery associated with funeral ritual seems to appear where DONGSON and LAPITA influences are strongest. The strong role of SHAMANISM in the Dongson culture appears where boat burial is found throughout the rest of the world, so it would seem to be the impetus. The Northwest Coast Chinook painted their dead with ochre and water and wrapped them in several folds of mats or blankets and placed the bundles in canoes raised up on posts—a mummified state resulted. The Coast Salish placed their dead in canoes that had been "killed" by drilling holes in the bottom, with a second

canoe inverted over the top to cover the body. These were placed on four posts or put in the branches of a tree. Also see TOLAI.

Bobo. Some 100,000 Bobo live in Burkina Faso. They are primarily farmers whose lives are regulated by a council of elders and a ceremonial cycle tied to the agricultural season. The indescribable creator god Wuro, never depicted in art, ordered the universe in the form of dichotomous pairs: human/spirit, hot/cold, domesticated/wild, culture/nature, man/woman, and village/wilderness, farmer/blacksmith. Christopher Roy writes that the balance between these oppositions is precarious and easily polluted by the simple acts of man. Although Wuro withdrew from his creation, he left three sons, Dwo (conceived of as a materialization of Wuro), Soxo (vital force/wilderness) and Kwere (lightning and thunder) to intercede in human affairs. Dwo is incarnated in a costume of leaves, fiber and cloth made by the blacksmiths. These leaf "masks" never dance, although fiber ones may. The blacksmiths also make a variety of carved wooden masks, many of them in animal form. The smiths, as well as farmers, don the masks for harvest rituals, male initiations and funerals. In the area around Bobo-Dioulasso wooden masks spin wildly, seeming almost out of control. Generally, masks fall into three categories, *molo* and *nwenke* (sacred masks), *nyaga* (escort masks) and *bole* (entertainment masks). Some Bobo masks have human features as well as human crested hairstyles and scarification patterns. Studies on African art before 1970 identify masks by the BWA as Bobo-Fing. The Bwa identified themselves as Bobo and only later corrected the situation, telling ethnologists and anthropologists that they were different from the Bobo and should be called Bwa.

Bocio. FON *bocio* figures, the principal

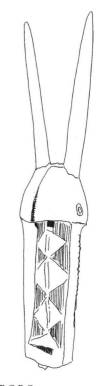

BOBO

Above: Bobo molo masks are used by blacksmiths in initiation ceremonies.

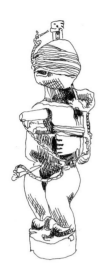

BOCIO

*Above: The hands of
this bocio cover the
abdomen in a gesture
found frequently in these
protective figures. Four
pegs are inserted in the
lower abdomen, chest,
neck and top of the head.
The figure is bound about
the eyes and around the
upper arms. The binding
magically blinds and
constrains enemies or
dangers. The pegs'
locations may relate to
the part of the body they
occupy; the one in
the chest may still the
frightened heart.*

non-royal art form, are small sculptures that serve to protect individuals. The word derives from *bo*, "objects of power" and *cio*, "cadaver." Made in secret, *bocio* consist of a core wooden human figure to which magical materials such as animal skulls, bird bills, shells, cord, beads and wooden pegs are added. Acting as surrogates, the figures absorb and neutralize danger and death. The commissioner whispers secretly into the figure's body cavities and inserts a plug to seal up the words and activate its power. The term is also applied to larger cylindrical wooden figures made by the blacksmith from whole tree trunks. These are set in the ground at the entrances to villages or houses, offering communal protection.

Bodmer, Karl (1809–1893). A Swiss artist, Bodmer accompanied Prince Maximilian of Wied on his exploration of the Missouri River in 1833 and 1834, painstakingly recording Blackfeet and MANDAN material culture in realistic paintings and drawings. Although the Prince's expedition was among the earliest to explore the area, the Mandan already had European trade goods—such as overcoats and hats—which Bodmer assiduously edited out. He did, however, show Mandan warriors wearing Navajo and Pueblo trade goods, which Plains peoples prized. Despite such "inaccuracies," Bodmer's images contributed to what became the stereotypical "Indian."

Body Art. The human body is painted, scarred, tattooed (the Maori body art is called *moko*), dyed, painted and otherwise decorated universally in indigenous cultures. While beautification and enhancement of the body's natural form and grace may be an aim, body art frequently has profound meaning and ritual significance. Designs are often controlled and can be used only by those "entitled" to them, such as the lineage patterns the Aboriginal Australians apply to their bodies in paint or by affixing bird down. These patterns

are inherited and provide personal identity as well as linking individuals to the land itself (see DREAMING). See INDEX: Body Art in Human Body.

Bokolanfini. Painted mud cloth made by the BAMANA and worn by hunters who are protected from the dangerous spirits of the forest by its geometric patterns. Aside from hunters, the cloth is associated primarily with the most important events in women's lives. It is given to girls following excision, used to swaddle first-born babies and women are married and buried in it. Bamana girls are excised to mark their transition to marriageable women. Performed by post-menopausal women, excision was believed to form the girls' characters as well as cleansing and purify-

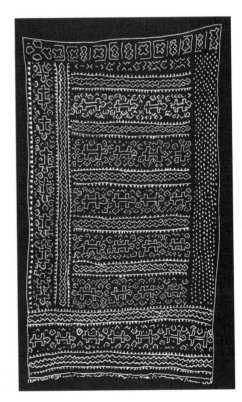

BOKOLANFINI

*Above: Although the overall impression of this
highly valued Bamana cloth is one of symmetrical,
repeated patterns, it is a dynamic symmetry where
large blocks balance and offset one another.*

ing them. As great blood-loss occurred, the girls needed the protection afforded by the *bokolanfini* cloth. The cloth is painted with black pigment made from iron-rich mud and fermented crushed leaves. The dark pigment is applied to strip-woven cotton cloth, sewn together to make larger pieces, forming a dark background through which the light uncolored cloth shines. The intricate designs have been said to suggest script or symbolic notations that may act as mnemonic devices.

Boli Figures. See BAMANA.

Bone Receptacles. Also called bone boxes and/or baskets, burial chests and reliquaries. The practice of secondary burial is widespread. The body is initially buried or exposed and allowed to decompose. That process complete, the bones and especially the skull are carefully cleaned, often painted or dusted with red ochre and sometimes overmodeled or decorated in elaborate ways. The bones are stored in containers of various sorts. In Africa bone receptacles often take the form of the human figure, see FANG *bieri*, Kongo NIOMBO and KOTA. The style and visual impact of these figures involves complex symbolism, designed, in part, to warn off those who might accidentally come in contact with the powerful ancestral remains. Maori *waka tupapaku*, made to contain the bones of high-ranking individuals, are carved

with protective creatures and often take the form of miniature canoes. See INDEX: Containers in Art, Artifacts and Techniques.

Bonito Cult. In the SOLOMON ISLANDS bonito and men share an abundance of red blood and the actions of both are controlled by supernatural spirits. Male initiations revolve around bonito fishing expeditions. After catching "his" fish, the boy hugs it to his chest and is taken out to sea—like a fish—lying on his back with the fish in his arms. Ritually transformed (reborn) under the protection of the bonito, the boys return to the village where they mount a large platform called the *gea* which may take an animal form. There, the villagers view the boys as the final act in their initiation. Emerging from the *gea* is seen as issuing forth from the body of a gigantic bird or fish—the boy/bonito thereby becomes man/predator. As predator, the initiate is associated with other predators in the role of guardian and protector of the bonito.

Box and Border. For an illustration of this Lakota design, see BUFFALO.

Bozo. See BAMANA.

Breast. See INDEX: The Human Body.

Breath. Breath is associated both with life

BONITO CULT

Left: Bonito-shaped container for human skull, Santa Ana, SOLOMON ISLANDS. Collected 1890–93.

"A fully developed school [of bonito] is a frenzy of predation: thousands of thrashing and leaping bonito and dozens of diving swooping birds feeding on the bait; large groups of sharks closing in from the outside snapping at anything. The sea rolls with fish, parts of fish, and blood, true fishing birds plummet in for catches and dart out to contend with intimidations from the other species bent on robbing them. And there is the noise, a cacophonic blend of bird shrieks against the roar of a churning sea."

—*Davenport 1981.*

BUFFALO

Right: Yankton LAKOTA robe. Painted with native and commercial paint, the designs derive from pre-contact rock art. Each motif of the so-called "box and border" design is believed to represent a different part of the animal. These robes were made and worn by women. 1870.

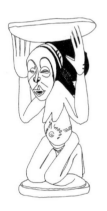

BULI SCHOOL

Above: Stool attributed to Ngongo ya Chintu, possibly the sole producer of objects associated with the Buli School. Stools were symbols of power and mnemonic devices. They may be thought of as a kitenta, "spirit capital," a conduit linking spiritual and material, past and present, ancestors and the living. The powerfully expressive female figure might be said to embody the full weight of the king's responsibility.

in general and with the human soul. The so-called "heart line" connecting the mouth and heart in ZUNI X-RAY style paintings is said to symbolize the source, or breath of the animal's life. "S" shaped petroglyph designs from the HOPI area of northern Arizona are also said to symbolize breath. The breath of certain powerful people is regarded as dangerous to others and precautions are taken to protect lesser persons (see VEIL, YORUBA). Among the Navajo, wind, breath and life are closely associated and words (organized speech) are of great importance. Words are the "outer form" of thought, and through language human beings can be whole and have a measure of control over their surroundings.

Buffalo. These great creatures once roamed the North American Plains by the hundreds of thousands. The Athapaskan and Plains peoples hunted them from prehistoric times, initially by strategically setting fires and running the herds over cliffs. Later, after the arrival of the horse, the buffalo hunt became more efficient. The systematic slaughter of buffalo for their hides by white hunters and by the U.S. Army drove the buffalo to the brink of extinction. Native people used all parts of the buffalo, not just the hides and the honored animal clothed, fed and provided shelter (see TIPI). The image of the buffalo is common in Plains art. One of the most fascinating aspects of its representation is its reduction to abstract geometric forms in the so-called "box and border" patterns painted on actual buffalo hides. See INDEX: Animals.

Bugle. Composite DAN masks representing male forest spirits.

Buli School. The so-called Buli School is named for a village in southeastern Democratic Republic of Congo. About twenty objects are attributed to the area that is also associated with the Kunda clan, source of LUBA/Hemba kings and progenitors. Mistakenly called "mendicant figures," the figures are called *mboko* by the Luba. They represent women of high status in attitudes of respect, with characteristic scarification patterns and elaborate coiffures. They are found on neckrests, stools and bowls and especially on paraphernalia associated with LUBA DIVINATION. The bold style associated with the Buli School is contrasted with the miniaturistic perfection of the so-called "Master of the Cascade Hairdo." Vogel has suggested that one of the hallmarks that sets the Buli School apart is its expressive naturalism and purposive violation of African aesthetic principles of restraint ("The Buli Master, and Other Hands"). She draws attention particularly to the hands, which she describes as "just a little too big and too yearningly carved…. the hands are not 'cool.'" Scholars believe that Buli School objects can be attributed to a single master, Ngongo ya Chintu who lived in the nearby village of Kateba. Based on local oral tradition, Neyt dates his work to about 1830, but Vogel feels that the quality of age, pessimism and mortality they convey indicates a later date reflecting the post-Colonial era.

Bullroarers. Thin wooden instruments pierced at one end and threaded with cordage or leather thongs. Swung around rapidly, the bullroarer vibrates, producing a sound generally regarded as the voice of spirits, ancestors or ghosts. Bullroarers are found in many cultures and can be plain or decorated. SCHUSTER illustrates a number of examples from all over the world with notched edges (*Materials for the Study of Social Symbolism in Ancient & Tribal Art*). He links these to Paleolithic vulva symbols, suggesting that the peripheral notches are reductions of the vulva, the multiplication of which represents a chain of female ancestors. See INDEX: Musical Instruments in Art, Artifacts and Techniques.

Bushmen. See SAN.

Bushoong. The royal dynasty of the KUBA Empire. See also KUBA ROYAL PORTRAITS.

Butterfly. The HAIDA identify both butterflies and dragonflies with human souls. The shaman is said to be able to see lost souls and, to restore the individual to health, traps the soul in a double-ended SOUL CATCHER, keeping it in with red cedar plugs until it can be returned to its owner. Butterflies are frequently depicted in petroglyphs in the Southwest as well as on *kachinas*, pottery, jewelry and Navajo pictorial rugs. In some cases, the design is immediately recognizable, and in other cases it is reduced to connected triangles. The HOPI, who have a butterfly clan, call stacked triangles the "cloud ladder," but conceive of it as a butterfly symbol of fertility and life. At CASAS GRANDES, the strong Mexican influence is evident as the butterfly motif is said to symbolize the souls of dead warriors as it does in art from Teotihuacan onward. The NAVAJO say that the butterfly was the first to use body "paint," the bright colors of its wings.

Since butterflies and their colors are short-lived and impermanent, they are regarded as being dangerous and by association, body paint is also dangerous and must be used with caution and only applied ceremonially. For the ZUNI, multicolored butterflies are symbols of life and beauty that

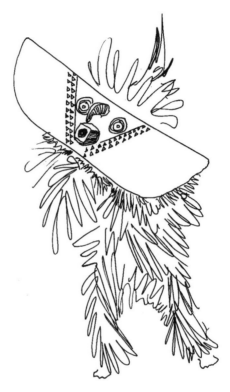

contrast with the dangerous, unfinished lumpy MUDHEAD clowns. But the mudheads have the potential to become beautiful and fruitful, since the knobs on their heads are packed with butterfly wings and seeds. Among the BWA people of Burkina Faso, butterfly swarms signal the beginning of the rainy season. Horizontal masks representing butterflies are carved with low relief geometric patterns and painted in dramatically contrasting colors. These masks are linked with DO, the generative force of nature. See INDEX: Animals.

Button Blankets. Red button blankets, which only came into use after contact, are now the most popular apparel at feasts. Initially, crest designs were sewn onto

BUTTERFLY

Left: BWA butterfly masks appear during spring renewal rituals and after the harvest. The boldly painted geometric patterns convey additional significance based on the interpreter's level of knowledge. The triangular patterns, for instance, can represent the hooves of the koba antelope, the male number three or the iron BULLROARERS that represent DO.

BUTTON BLANKETS

Right: This KWAKIUTL button blanket or cloak uses several sizes of pearl buttons and small broken coppers as well as applique to depict a sun design. New Vancouver.

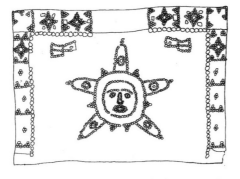

Hudson's Bay Company blankets. By the middle of the 19th century, blue duffel blankets with red applique and abalone shell decorations became popular. Fur traders supplied pearl buttons, which were sewn onto the edges of FORMLINES. The blankets, now covered with buttons filling entire zones, have become symbols of social and artistic rebirth.

Bwa. Christopher Roy has shown that Bwa, Nuna and Nunuma (or Gurunsi) art originates from a single style center in the Burkina Faso village of Ouri where the Konate family worked. Originally Mande speakers, the Konate family eventually learned the Voltaic language of their area patrons and their influence was widespread. Masks thus demonstrate a mingling of ethnic and stylistic heritages and, because of the rich cross-fertilization, it is difficult to sort out the often subtle differences between ethnic groups—LOBI, KURUMBA, BOBO, Nunuma and Tussian—in the area. Used in initiation, purification, funerary and agricultural rituals, Bwa masks are characterized by bold dark/light contrast and repeated geometric motifs (particularly ✘ and ✚ shapes, checkerboards, crescents, zigzags, triangles and concentric circles). The Bwa call these

patterns scars and they have the same meaning as those applied to the human body as part of initiation. The geometrical motifs are meaningful and are understood in increasingly complex ways depending on the age and knowledge of the interpreter. Beyond male/female, dark/light dualism, the black and white checkerboards are said to represent the separation of innocence and knowledge—the black squares being the old, soiled hides on which elders sit, and the white ones the clean hides of initiates. Tall plank-shaped masks, said to represent nature spirits, perform energetically at funeral ceremonies. Horizontal masks representing hawks and butterflies and non-wooden body coverings of leaves and feathers are associated with DO, the god of renewal. The last sort may reflect earlier traditions in the area, before the arrival of the wooden masking traditions. In some areas, tension exists between the two traditions, resulting sometimes in outright conflict, while in other regions, the two work in concert. Bwa artists carve free-standing sculptures and make divination instruments, both fairly numerous, but unseen. Because of their power, they are kept hidden in homes, on family altars, or in diviners' shrines. Flutes are also made in graduated sizes that take the form of abstract, truncated human figures.

Bwami Association. See LEGA.

BWA

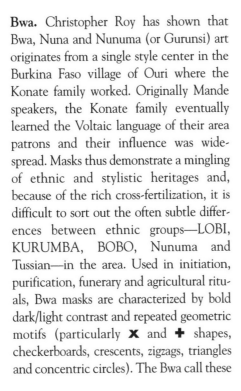

Above: The geometric patterns are understood in different ways as people gain access to their secret, esoteric meanings. The protruding hook is said to represent the beak of the hornbill, a bird associated with sorcery and divination. Black triangles, for instance, can symbolize the hooves of the koba antelope, the male number three or the iron BULLROARERS that represent DO. The checkerboard signifies the dualities of dark and light, male and female, while the crescent is associated with the moon. In studies on African art before 1970 masks like this one were often misidentified as Bobo-Fing.

Cahokia. The largest city of the Mississippian Period, as well as the largest city on the continent north of Mexico, Cahokia is located in the alluvial plains of the Mississippi River opposite St. Louis. At its height between 1050 and c. 1250 CE, it was home to some 10 to 15,000 people. The site covers some 1650 acres, enclosed by four elongated mounds with ridged tops. The flat iron-shaped enclosure measures 3 1/4 by 2 1/4 miles. The entire complex contains some 120 mounds. The largest is Monks Mound, estimated at 100 feet high and covering over thirteen acres (710 x 1080 feet). Built over three centuries and in fourteen building phases, it is the largest mound north of Mexico. The larger mounds appear to have functioned as temple platforms and some of the smaller ones contained burials. It is possible, based on historical Natchez use of platform mounds, that the large mounds housed ancestor cult shrines for the rulers. It is not surprising to learn that the layout incorporated solar and astronomical alignments, given the close association of the ruler and the sun, evident in MISSISSIPPIAN CULT symbolism.

California. The indigenous population of California numbered some 310,000 people, reduced by 1900 to 20,000. Prior to contact California was home to some 500 groups who adapted to the very different environments within the state. In the northwest, the Hupa, Yurok, Shasta, Tolowa and Wiyot lived along bodies of water and depended primarily on fishing for sustenance. Northeastern peoples included the Modoc and Atsugewi who hunted small game. Three-fifths of all California natives lived in the great Central Valley, a rich environment for hunting and gathering. Central Valley Natives included the Miwok, Maidu, Yokut, Costanoan, Esselen and POMO. By contrast, resources in the Great Basin area were comparatively sparse, making life for the Mono, Northern Paiute and WASHOE difficult. Southern California groups included the CHUMASH, Gabrielino, Diegueno and Cahuilla. Finally the Yuma and Mojave were the only true agriculturalists, living on the rich floodplain of the Colorado River. The last two were more aggressive than other

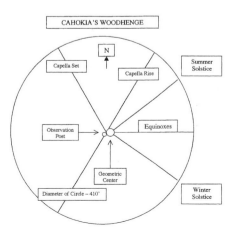

Left: Plan of the site and its "Woodhenge" located 880 yards due west of Monks Mound. Warren Wittry reconstructed parts of the Woodhenge, using telephone poles, and demonstrated that the location of its posts corresponded to sunrise at the autumn equinox and the winter and summer solstices.

1 mile

CAHOKIA'S WOODHENGE

N

Capella Set

Capella Rise

Summer Solstice

Observation Post

Equinoxes

Geometric Center

Diameter of Circle – 410'

Winter Solstice

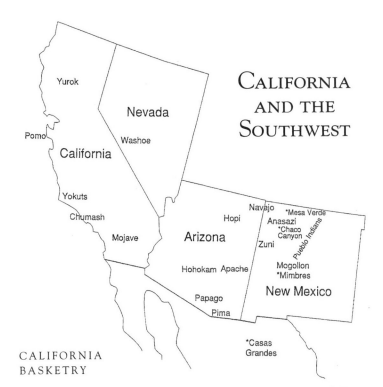

CALIFORNIA AND THE SOUTHWEST

CALIFORNIA BASKETRY

Below left: These two baskets made by Mary Benson show variations on a design called "turtle" or "turtle neck" by the Eastern and Southeastern Pomo and "turtle back" by the Northern Pomo. Native American informants say the designs symbolize the turtles floating on the waves of Clear Lake at Creation.

Below right: Yokuts designs: The hourglass shape is identified as a butterfly, the four joined rectangles is a fly and the six joined rectangles is called "water skate" (a type of insect).

Native Californians. Several different forms of architecture are found reflecting availability of materials. The Chumash lived in dome-shaped grass-thatched structures with a willow framework. Other building materials included reed (woven into mats for wall coverings), cedar and redwood bark and wood. The Costanoans and Miwok built large sweat lodges and separate huts for the isolation of menstruating women. Art forms included painting, basketry, pottery, musical instruments, apparel and personal adornment and the SHAMAN's ritual paraphernalia. Shell currency was made from clam or dentalium shell, pierced and strung on fiber or leather thongs. Religious beliefs and ritual varied from group to group, but most California natives revered a creator god, variously called "Above Person," "Great Traveler,"

or "Immortal One" and sometimes personified as thunder or as an animal. Like other North American indigenous people, California natives saw the world as inhabited by unseen forces and energies in constant motion. Both men and women SHAMANs existed and continued to be active after conversion to Catholicism. Various cults operated including the Hupa White Deer Cult, the World Renewal Cult among the northwestern groups and the datura (jimsonweed) cult. The most elaborate was the Pomo KUKSU CULT. Throughout the state, native people formed the slave work force for the Mexican land grant ranchos and the California Missions until 1834 when the Mexican government secularized the system. American settlers continued the pattern of exploitation. Large numbers died due to disease, adverse living conditions and periodic uprisings. Today California Native Americans have revived or still practice indigenous art forms such as basketry and many artists, like Harry Fonseca (Maidu) and Frank LaPena (Wintu) work within mainstream styles while paying homage to their heritage.

California Basketry. Basketry is often said to be the most important California indigenous art form. Women made functional baskets for carrying babies and other burdens, for storage, sifting, winnowing and cooking. These baskets were decorated with geometric designs of great refinement. Scholars who study these named designs identify between fifty-five and eighty-five. The names refer to objects and phenomena found in the environment as well as in mythology and cosmology. Some designs were associated with specific groups, for example, the zigzag design called *ci.yoci.yo*, "waves on the lake" by the Eastern Pomo. Non-functional GIFT BASKETS, decorated with shell, beads and feathers, show the skills of basketmakers to the highest degree. Nearly all California groups

excelled in basketry, especially the Maidu, Yurok, Karok, Yokuts, POMO and WASHOE. See also NAMES.

Cameroon. A number (one estimate is ninety) of independent centralized kingdoms exist in the grasslands of the Republic of Cameroon. Despite their autonomy and diverse origins, the kingdoms share cultural and artistic traits, especially the emphasis on art associated with the *fon*, or ruler. Two of the most powerful kingdoms are the BAMUM at Foumban and the Bamileke at Bandjoun. The Bamileke circle includes the Bandjoun, Bangwa and others. In the northwestern highlands live the Kom, Bali, N'so, Oku, Aghem, Bafut, Mankon and Babanki-Tungo. Similar centralized authority is found among the MANGBETU of northeastern Democratic Republic of Congo. In contrast, village-based systems and economies typically occupy the OGOWE RIVER area. The art of the Cameroon area is characterized by use of symbols. Animals (especially leopards, elephants and snakes) are symbols of royal power and frogs and lizards symbolize fertility. The earth spider (*heteroscodra crassipes*) is a particularly prevalent symbol, appearing on thrones, in headdresses and graphically as an ✖, ✚, a rosette or a six- or eight-pointed star. The spider symbolizes diligence and wisdom. Because it lives underground, it is a link between the ancestors and the living. A form of divination is practiced where palm-leaf chips marked with signs are placed where the spider will move them. The diviner interprets the configurations for insight into social and individual problems. The BAMUM king Njoya invented a script that was taught at the palace and a SIGN SYSTEM establishes the meaning of motifs on *ndop* cloth. Other major Cameroon art forms include the carved figurative posts lining palace facades, dynamic and very diverse masks and sculptures (often life-size) of the human figure. For additional information on the above named animals see INDEX: Animals.

Cameroon Masquerades. Cameroon masks are among the most memorable and dynamic in Africa. The masks belong to lineages, princes and the men's non-secret regulatory associations. The latter originally served the king as warriors, but over time were transformed into merit-based prestige societies. Acting as a counterbalance to the king, the associations play administrative, judicial and police roles. Masks are made in two materials—wooden masks representing animals and the human face and beaded masks representing elephants. Wooden masks are variations on a theme—rounded forms that seem to expand outward, bulging eyes, bulbous noses and full

mouths. The bold assurance with which they are carved gives them a vital quality that is sometimes engaging, sometimes frightening. As many as thirty of these masks might perform at any given time. Members of the Kuosi society wore eye-catching beaded elephant masks during funerals and public ceremonies. The elephant is one of the principal royal symbols and the wealth of beads adorning these masks increased the prestige of society members. Color symbolism is also involved, with the white color of bones symbolizing the ancestors and red, associated with blood, signifies life, women and kingship in contrast to black, the color of night and the relationship between the living and the dead. For an illustration of a Cameroon Bamileke mask, see ELEPHANT.

Campbell, Joseph (1904–1987). Prominent American scholar who synthesized material from various disciplines, including Art History, Anthropology, Comparative Literature (mythology and folklore) and Comparative Religion. A respected scholar as well as popularizer, Campbell drew on the Jungian concept of archetypes augmented and enriched by concepts from other fields, such as the animal behaviorialist theory of Innate Releasing Mechanisms (IRMs). One prevalent IRM is the human face, especially the eyes, the sight of which elicits positive responses in infants at a very early age. This psychological mechanism may help explain the repetitious eye forms that appear in indigenous art all over the world, for instance, the large-eyed WANDJINA spirits that appear in the Kimberley region of Australia. Campbell's publications are extensive and his theories and ideas were widely disseminated through public television series.

Cannibalism. Eating human flesh was practiced in several Melanesian groups and was one of the most profoundly disturbing social practices as far as missionaries were concerned. Closely connected with HEAD HUNTING, cannibalism is one means of increasing one's physical and spiritual power by ritually ingesting the bodies of slain enemies (particularly their brains). In Aboriginal Australia, Mimi spirits include the greatly feared Namandi, a cannibal/rapist (see X-RAY IMAGES). Spirits that devour human beings are found in several places on the Northwest Coast of North America, although actual cannibalism may not have been practiced. The myths regarding them often involve ritual ingestion followed by rebirth and may be connected with initiations or funeral ceremonies. TSONOQUA, the Kwakiutl cannibal woman, is sometimes depicted as a series of vessels aligned to represent her head, breasts, navel and knees. Participants symbolically eat those parts of her body. The Tsimshian, Haida and Kwakiutl apparently did bite high-ranking people in some ceremonies, but most recent sources suggest that eating human flesh was pretense only. The Haida created elaborate artificial human and dog carcasses to fool the spectators, which caused fear and created drama. The Eastern and Middle Sioux adopted Midewiwin rituals from their Ojibwa neighbors. Initiates received a dish and spoon and were obligated to keep them and ordinarily to eat all that was served to them. The bowl was often carved with images of voracious animals in which the spirit of Eyah, the glutton god resided. Early European correspondence concerning Africa reported cannibalism that later turned out to be exaggerated, as was the case with the Mangbetu. Some Igbo *ikenga* figures are adorned with trophy heads, a symbol of accomplishment linked with the earlier practice of head hunting and cannibalism. This long-abandoned cannibalism is also recalled in one of the intentionally ugly creatures found on Igbo *mbari* houses, Okpangu the half-monkey, half-human cannibal rapist.

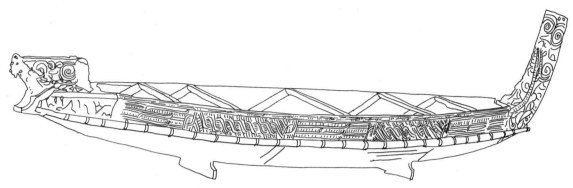

Canoes. The canoe was the primary method of transportation in Oceania. Often physically beautiful in both stream-lined shape and decoration, canoes were of great symbolic importance. One of the most important aspects is the canoe's function is that of the SOUL BOAT which conveys the spirits of the dead on their last journey. It has been suggested the soul boat's inverted moon-shaped crescent entered the Pacific with the DONGSON culture, having originated in Southeast Asia. In New Zealand, canoes, like the Maori meeting house (WHARE WHAKAIRO), are COSMIC MODELS. The upper, vertical elements of the carved prows are said to represent Rangi, Sky Father, while the horizontal figures on the baseboards represent Papa, Earth Mother. Between, Tane can be found pushing them apart surrounded by spirals representing the coming of the light. Since the Maori traced their descent to the captains who piloted the colonizing canoes, the parts of the canoe are said to be parts of their bodies. The Maori also used canoes for burial of the dead and bone boxes were often shaped like canoes. Elsewhere in Oceania, canoes also play an important symbolic role in initiation rituals. ASMAT initiations involved a canoe journey for the initiate and the head of an enemy taken in a head hunting raid. The initiate acted out progressive aging and death, and was symbolically reborn following immersion in the river. A non-functional canoe, the *uramon*, was also used in initiation and funeral ceremonies. Carved from a single tree, the bottomless *uramon* had a turtle in the center, surrounded by figures probably representing slain enemies. In initiations, the boys straddled the canoe, above the turtle, and the blood from their circumcision and scarification flowed over the carvings. As with the actual river journey described above, the symbolism involved self-sacrifice and ritual death and rebirth. So-called "revenge" canoes were ornamented with prows depicting long beaked birds and praying mantises (both associated with head hunting) and crocodiles as well as human and abstract forms. Other objects, usually connected with funeral rituals, often have boat-like properties or are referred to as canoes (see Maori WAKA TUPAPAKU, Asmat BIS POLES and Malekulan SLIT GONGS). Model canoes are found in several Pacific cultures, most notably in the Caroline Islands and the Marquesas. Additionally, there are art objects associated with canoes, including navigation devices (see MARSHALL ISLANDS), prow and stern ornaments (see CAROLINE ISLANDS and HUMBOLDT BAY), splash shields (see MASSIM), finials, paddles and bailers. The connection between canoes and funeral ritual is likely attributable to Dongson influence. A further Dongson trait is the link between boat-like bowls and human skulls (e.g., ADMIRALTY ISLANDS). On the Northwest Coast of North America, Haida canoes, made of red cedar, were among the most finely crafted and impressive. None

CANOES

Above: MAORI *canoe model.*

CASAS GRANDES

Above: Human effigy polychrome pots from Casas Grandes, Chihuahua. 1160–1260.

CAROLINE ISLANDS

Above: The position of the canoe prow ornament was a sign of the captain's intentions—war if upright, peace if lowered. In the upright position, the abstract bird designs likely served to protect the canoe's occupants, making it capable of darting across the water as swallows do.

of the large war canoes, which carried fifty to sixty warriors, have survived, but replicas exist today. The canoe prows were carved and painted with images of clan CRESTS.

Cargo Cults. Intense religious movements originating in New Guinea after European contact (particularly after World War I) which appear irregularly throughout Melanesia. Usually of short duration, cargo cults often centered on a messianic leader who demanded that his followers abandon traditional belief systems. In the hope of enticing the ancestors to return, cultists collected extensive consumer goods and placed them in ships and airplanes. Such cults, focused on Western materialism and consumerism, resulted in the destruction of traditional societies.

Caribou. One of the most important animals in the Arctic and Subarctic regions, the caribou is treated with great respect by hunters. The KUCHIN believe that every human being has a bit of caribou heart and the caribou have a morsel of human heart—an immediate way of expressing their feelings of shared knowledge and emotion. See INDEX: Animals.

Caroline Islands. Nearly 1000 small Micronesian islands make up the Carolines including Belau (formerly Palau) and Yap in the western Carolines, CHUUK (formerly Truk) in the central Carolines and Pohnpei and Kosrae in the eastern Carolines. The islands are known for architecture, for instance the archeological site of NAN MADOL, and loom-woven textiles. Of the many BAI (houses) which existed on Belau, only three remain today. Decorated with relief carvings and paintings, the houses pictured important mythological and historical events, symbolized wealth and provided a metaphor for understanding the world. Canoe prow and stern ornaments from Chuuk appear to be flat

abstract shapes with bold light-dark contrast. The symmetrical designs actually represent birds (sea swallows) with beaks which touch in the center and flared tails stretching out behind. Although large-scale sculpture was apparently not common in the Carolines, outstanding examples include the HERALDIC WOMAN gable figure DILUKAI and a goddess called Kawe de Hine Aligi, associated with human sacrifice. Finally, dramatic black and white masks (said to be the only ones from Micronesia) were worn during mock battle dances in Chuuk, Satawan and the Mortlocks. See map: OCEANIA.

Casas Grandes (also Paquime). Located in Chihuahua, Mexico, this multistoried, colonnaded city was possibly a political center and definitely a center of trade starting around 1130 CE. The large central marketplace may have witnessed exchanges of raw materials and prestige objects between the Mesoamerican cultures further south and the Southwest. Turkeys and macaws were bred for their feathers and the city is believed to be the source of those used by the Anasazi. Artists continued to produce marketable goods, but the city itself fell into disrepair and the political system apparently failed resulting in Casas Grandes' abandonment in the early 15th century. Traces of its influence lingered in the Mogollon tradition, but the people themselves apparently left no descendants.

Cassowary. Large beaked species of bird which plays an important role in much of the art of Melanesia. It is linked with HEAD HUNTING because it eats the fruit of trees just as head hunters consume the brains of enemies. Generally, the large beak that pervades Melanesian designs (see ASMAT WAR SHIELDS, BIS POLES) has been interpreted as phallic. However, the bird's symbolism is not confined to masculinity as the male cassowary not only

builds the nest, but he also incubates the eggs and feeds and protects the hatchlings. This assumption of female roles makes the cassowary an ideal symbol of the initiatory responsibilities of men. The boys are separated from their biological mothers and the senior males take over their nurturing and education, transforming them into adult males. Only fully initiated males may wear cassowary plumes said to be symbols of the ANDROGYNOUS primal mother. The cassowary, thus, is a complex symbol in which normal gender distinctions are blurred. See also HUMBOLDT BAY and INDEX: Animals.

Catharsis Theory. The theory that the purpose of ritual is to create a cathartic state taken as genuine religious experience. Catharsis is reached through group ritual combinations of dance, music and art display (*communitas*) coupled with revelation of the spirit world transmitted by multiple aesthetic messages emitted by human enactors. The purpose of the ritual is to reintegrate society on a cyclical basis.

Catlin, George (1796–1872). Artist-explorer George Catlin described his self-appointed task: to rescue "from oblivion the looks and customs of the vanishing races of native men in America." The first professional painter to visit the West, Catlin devoted his life to studying and recording the lives of the Plains peoples.

Catlinite. A reddish colored stone favored for effigy pipes and pipestems by the Plains peoples. Quarried near present-day Pipestone, Minnesota, the stone is called catlinite in honor of artist-explorer George CATLIN.

Cattle. See INDEX: Animals.

Cenderawasih Bay. See GEELVINK BAY.

Center. The concept of the center is near-ly universal in indigenous cultures. A number of related images are involved such as the circle or spiral, a vertical *axis mundi* (WORLD TREE, pole, architectural feature) which penetrates and connects the bands of the LAYERED UNIVERSE. The horizontal plane of the earth is often conceived of as divided by lines stretching out to the FOUR/SIX DIRECTIONS or the solstices, the intersection of which marks the center. The homeland of the people is often regarded as existing at the center of the universe with subsidiary centers such as the buildings housing persons of power (e.g., see ASANTE and BAMUM). The center is conceived as having both physical and spiritual location and power. The World Tree is a symbol of the center among the Plains peoples in the SUN DANCE LODGE with its central tree/pole and twenty-eight rafters corresponding to the lunar month. As well as centering the World Tree, the Sun Dance Lodge is, for the duration of the ritual, a COSMIC DIAGRAM. There are many instances of buildings that both locate and serve as symbols of the center, such as the Maori WHARE WHAKAIRO, NORTHWEST COAST ARCHITECTURE, the Navajo HOGAN and the Pueblo KIVA and SIPAPU. In some cases rituals invoke the power of the center to effect healing, as in Navajo SAND PAINTINGS. When the healer completes the mandala-like centered designs, the patient sits in the center, thus restoring balance and harmony. Among the Zuni the concept of the center involves time as well as space. Their name for the winter solstice translates "the center," i.e. the center of the ritual calendar. Additionally, the center is located in mythical time. Thus for the Zuni, the center is a multivalent, multivocal condensed symbol that may represent many centers simultaneously, e.g., the temporal centers just mentioned, the navel or heart of a person, as well as persons observing rituals involving the six directions and the place

of emergence. See also ASANTE, CIR-CLE, IFE, KONGO COSMOLOGY, PAWNEE, TOGU NA and WATER SKATE.

Central Africa. Central Africa includes the modern states of Gabon, Republic of Congo, Central African Republic, Democratic Republic of Congo (formerly Zaire) and Angola. This area is one of great diversity and even a short list of ethnic groups would run to considerable length. Modern national boundaries often cut across ethnic groups. Although many of the people living in the area are Bantu speakers, there are many regions that are best called "fragmentation zones" where languages and people intermingle in complex ways with their neighbors. Efforts to systematize—largely by style, social and

CENTRAL AFRICA

religious function—the artworks of Democratic Republic of Congo (Zaire) go back to the late 1930s. One of the richest areas is the Zaire River basin, a vast savanna criss-crossed by the many tributaries of the Zaire River. This area was inhabited between 3000 and approximately 1000 BCE by proto-Bantu peoples who migrated into the area. Between the 10th and 14th centuries CE the peoples of the area were small-scale agriculturalists with no centralized authority. Elders of male societies organized by age and rank served as leaders and the societies oversaw boys' puberty initiations. Leaders of the 16th- and 17th-century states that developed out of this system tended to emerge from the male societies. Such states or kingdoms include, in the southeast, the LUBA and the Lunda. The KONGO were located in western Democratic Republic of Congo, and in the central area, the KUBA/Dengse and CHOKWE. These state societies, which were more limited than the powerful kingdoms of the western Sudan, existed side by side with village-based societies including—in the central area—the YAKA, Suku, PENDE and Salampasu; and in the eastern region the LULUWA, Hemba and SONGYE. Religious cults in the area involve deified ancestors, cult heroes and nature spirits. Throughout Central Africa, water and trees are particularly important—rainfall or drought is attributed to a powerful rainbow snake deity. Pygmy people lived in the area, and although they mostly have disappeared or have been absorbed, they continue to exist in people's memories. Other Central African groups of major importance are the KOTA who live mostly in Gabon, the FANG who live in a territory that stretches from south of the Cameroon to the Ogowe River basin, including Equatorial Guinea. The Kwele, Lumbo, Ashira and Punu live in the OGOWE RIVER BASIN.

Ceremonial Cycle. Many indigenous peo-

ple organize their activities into a series of activities known generally as a ceremonial cycle. Among agriculturalists, such cycles often mirror the seasons and their primary purpose is to promote fertility. Some of the most elaborate rituals of this type are conducted in the American Southwest among the Pueblo peoples, especially the HOPI and ZUNI. Among these people, corn and beans are the primary crops and corn especially is represented in their art and corn meal is used ceremonially. In Oceania, the growing of yams entails equally complex ceremonial activities among the ABELAM of Papua New Guinea. People who depend more on hunting and gathering for sustenance often have closer ties to SHAMANISM and its complex rituals that promote health and are more individually directed. Although the NAVAJO now practice agriculture and have a largely 20th-century economy, they formerly were primarily herders and hunters. The complex ceremonial activity centering on SAND PAINTINGS focuses on restoring personal balance within a world beset by complex, often inimical forces.

Chaco Phenomenon. The efflorescence of ANASAZI tradition, the Chaco Phenomenon occurred between 900 and 1150 CE in Chaco Canyon, New Mexico. See also PUEBLO BONITO, the most important city.

Chamorro. Indigenous peoples of the MARIANAS ISLANDS in Micronesia.

Changing Woman. Navajo Earth Mother-type deity, Changing Woman renews herself with the seasons and clothes herself anew every spring. On the sacred mountain, First Man and First Woman discovered Changing Woman in her cradle board of rainbows and sunrays, the curved rainbow arching over her head. Alternatively, they are said to have created her by combining all the sacred objects. Impregnated

by the sun, she gave birth to the HERO TWINS. Changing Woman created corn and the Earth-Surface People—the Navajo—from flakes of her skin. She learned weaving from SPIDER WOMAN. Changing Woman's puberty ritual, attended by all the gods, became the model for the *kinaalda* (one of the Blessingway rites), still performed for Navajo girls today.

Chantways. Originally, some two dozen NAVAJO chants were performed to heal as well as to restore HOZHO or ideal harmony. The Navajo shaman—*hataalii*, meaning "singer"—serves an apprenticeship during which s/he learns to recite flawlessly the lengthy and complex songs and to reproduce the SAND PAINTING designs associated with some chants. (More men than women become chanters.) By the 1970s only about eight chants were regularly performed. In cases of illness, the shaman must first diagnose the problem by entering a trance state, crystal gazing or hand trembling. Once the nature of the illness is understood, the appropriate chant is ordered. For instance, Mountainway is performed in cases of "bear sickness," arthritis and mental illness or "porcupine sickness" which may manifest itself as constipation and internal pain. There are three groups of chants, or ways of performing chants, called Holyway, Lifeway and Evilway. The now largely obsolete Evilway chants concerned war and pollution by outside elements. One Evilway chant, Enemyway lasts three nights and is concerned primarily with counteracting imbalance stemming from contact with non-Navajos and to exorcise both native and foreign ghosts. The fundamental Lifeway chant, called Flintway, is performed to treat accidental injuries. The largest number of chants is connected with Holyway and aims to promote goodness and harmony. One Holyway chant, called Nightway or Yeibichai, lasts nine nights and involves intricate sand paintings and

CHANTWAYS

In Beauty (happily)
 I walk
With Beauty before
 me I walk
With Beauty behind
 me I walk
With Beauty above
 me I walk
With Beauty all around
 me I walk
It is finished in Beauty.

—*Navajo Nightway
prayer, repeated four times.*

performances by god impersonators. Talking God keeps careful watch to make sure that no error occurs. BLESSINGWAY, which consists of some five kinds of rites, is regarded as the backbone of Navajo religion and is said to have historical precedence over the others. Chants are held within the client's *hogan*. The client sits on the northwest side, the shaman on the southwest side; women relatives occupy the north and males the south. All movement during the ceremony is clockwise, i.e. following the sun's path. Prayer sticks rest by the eastern door, where offerings are made. Song, visual imagery, color, DIRECTIONAL SYMBOLISM, ritual actions and paraphernalia as well as various medicines all work together to create a totality that banishes ugly and evil elements. The focus of the ritual is to recount creation myths and thereby restore the beauty and harmony that existed at the beginning of time. Finally, NAVAJO CEREMONIALISM has been contrasted with PUEBLO ritual in that it focuses on human health instead of communal concerns with rain and fertility. Pueblo ritual follows a cyclical calendar and is conducted by organized priesthoods or ritual societies, while Navajo rituals take place as needed to cure individuals and are practiced by specialists who are not part of any larger organization.

Checkerboard. See INDEX: Pattern in Art, Artifacts and Techniques.

Chi Wara (also Tyiwara, Ci wara). The Chi wara is the best-known of the BAMANA associations because of the elegant antelope headdresses that originally appeared in the fields at the beginning of the agricultural season. Bamana mythology tells of a mythical creature, half-antelope, half-human, that introduced agriculture. Chi wara masks are actually headdresses attached to basketry caps worn atop the head. Adding about three feet to the dancer's height, the headdresses appear in male/female pairs. Beyond the obvious link with human gender and the male and female principles of nature, the masks are also said to represent the sun and moon. Concealed by a raffia cascade, men mimic the movements of the antelope and with great athletic prowess pretend to plow the soil with their horns. Regional styles have produced variations on the antelope theme, some of which are quite abstract.

Chibinda Ilunga. See Chokwe.

Chief Joseph. Famous Nez-Perce leader, see PLATEAU.

Chilkat. Chilkat blankets—more accurately, ceremonial robes worn draped over the shoulders—made of goat's wool and cedar bark are a unique late development among the northern TLINGIT. Sometime around the mid 19th century, weaving patterns derived from basketry (both women's

CHI WARA

Below left: Chi Wara headdresses employ endlessly imaginative variations on a theme. Vertical openwork and powerful use of negative space are characteristic of Chi Wara headdresses from the eastern Bamana region. Brass tacks, cowry shells, tassels and quills ornament the male and female with baby.

Far right: Headdresses from the southern region are more abstract, such as this one which combines antelope and anteater elements with a zigzag representing the sun's path. The horizontal orientation is typical of Bamako/ Beledougou area headdresses.

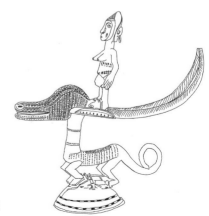

art forms) changed. The development is said to have resulted from the fact that at that time women began weaving blankets based on pattern boards painted by men. The designs on the boards reflect male carving motifs and depict clan CRESTS. Colors include yellow, yellow-green, white and black. Designs are bordered by braids, which outline the FORMLINES and provide texture. Additional details and design refinements were added by the use of drawstrings. The Chilkat style declined after 1900, although there has been a revival mainly among the Tsimshian who may have been the first to make them.

Chippewa. See OJIBWA.

Chokwe. Since the 17th century, the Chokwe have intermarried with the Lunda and at least three times conquered the Lunda kingdom, leading eventually to its collapse. In the past 200 years, the Chokwe migrated outward and now are dispersed across the Democratic Republic of Congo, Angola and Zambia. Chokwe history tells of powerful chieftains, especially the culture hero and hunter Chibinda Ilunga who is depicted in many Chokwe sculptures wearing a distinctive curved bark cloth headdress. Female figures depict chief's wives and reflect the important roles of women in this culture. The Chokwe have a rich masking tradition. One type, called *cikungu*, a personification of the collective power of the ancestors, appeared during times of tension and change within society. The oldest masks, made of resin, were later copied in wood. Among the most beautiful are the serene *mwana po* masks representing female ancestors, guardians of procreation and fertility. The young men who dance the masks wear a costume consisting of a skintight knitted body suit with false breasts, and move with short, mincing steps. Chokwe thrones are virtuoso performances, modeled on 17th-century and

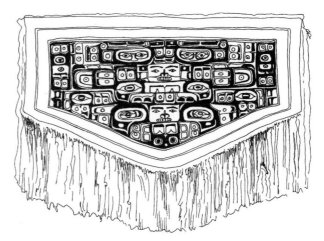

later European furniture styles but are carved with scenes symbolizing chiefly authority as well as lively genre subjects. Another aspect of Chokwe art is the small divination (*ngombo*) figures representing diverse objects, animals and human figures. Diviners keep the figures in baskets, which are shaken and figures' arrangement studied to determine the causes of misfor-

CHILKAT

Above: This TLINGIT Chilkat style blanket has many CRESTS and parts of crests woven into its design.

CHOKWE

Left: Figure of Chibinda Ilunga. According to Chokwe myth, this culture hero married a female Lunda chieftain who gave him the symbolic lukano bracelet, enabling him to seize power. His large hands and feet and well-defined musculature all emphasize his physical prowess, while his expression is composed and haughty as befits the dignity of a king. The distinctive royal headdress is peopled with small figures said to be tutelary figures and vigilantes searching for game or lawbreakers. Before 1850.

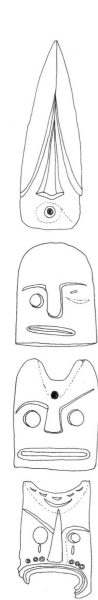

CHUGACH

Masks from Prince William Sound. Late 19th century.

tune, illness, sterility or larger community problems like epidemics. Although these figures are not considered by the Chokwe to be art, their elegant simplicity and liveliness is very appealing.

Chugach. An Eskimo people living on Prince William Sound. These people made hunting hats out of reeds and wood, the latter painted with designs that sometimes resembled Tlingit motifs. Little is known about Chugach masks, which take both human and animal shapes. The painted masks, powerfully simplified in form compared to other Eskimo masks, were likely used in shamanistic and ceremonial performances. The masks with the pointed heads may represent evil people transformed into spirits called Kalaq who live in the woods and caves. The shaman recognizes them by their pointed heads and can enlist them as spirit helpers. Social control may have been involved in a Chenega secret society reported by Birket-Smith to involve six men called "winds" who, wearing masks made by the shaman, went about the village, unexpectedly entering houses. Other Chugach art forms included intricately patterned twined basketry and beadwork.

Chumash. The large and diverse Chumash population of Southern California resided in greatest numbers along the Santa Barbara Channel. Major art forms included basketry and CHUMASH ROCK PAINTING. Chumash society consisted of an elite, including the SHAMAN, responsible for maintaining the spiritual balance of the community through ritual, including astronomical observation. The two most important Chumash deities were HUTASH, mother earth, and the Sun. Hutash's powers complemented—mirrored—those of the Sun. A religious cult, called 'antap, was found throughout Chumash territory and appears to have overridden political divisions. The cosmos was seen as containing vast competing

supernatural forces in a state of constant flux. Human beings could, through ritual, maintain balance and avoid catastrophe. The principal ritual took the form of a gambling game called *peon* played by two celestial teams, captained by the Sun and Sky Coyote. Sky Coyote's team included Morning Star, while Evening Star and Slo'w (Golden Eagle) played on the Sun's team. On the eve of the winter solstice, it was determined which team had won the majority of the games. If Sky Coyote's team won, the following year promised to be rainy and food abundant. If the Sun's team won human lives were the price. Slo'w, the Golden Eagle, was associated with death and the afterlife, the place where all the bones of the dead went. Dreams, ingestion of datura and the shaman's kit including quartz crystals, amulets and charms all play parts in Chumash ritual. Several Franciscan missions were built in the area and conversion of the Chumash has been described as outright annihilation of their beliefs, or as a "progressive compromise" in which old beliefs were fused with new ones. Whatever the spiritual situation actually was, physically, non-native contact was disastrous as diseases decimated the population and people became a source of free labor for the mission system. See also FOUR/SIX DIRECTIONS and HALLUCINOGENS.

Chumash Rock Art. Caves and cliff faces are painted with elaborate geometrical and figurative patterns all over California, especially in the Chumash area (see Colorplate 4). Campbell Grant identified forty repetitive patterns, the bulk of which are abstract geometric, and about one-quarter are figurative. Some of the geometric patterns are said possibly to represent comets or stars. Paintings often densely cover rocks, cave interiors and cliff shelters, indicating that they may have been added to over time. Executed by shamans, the paintings are said to depict their spiri-

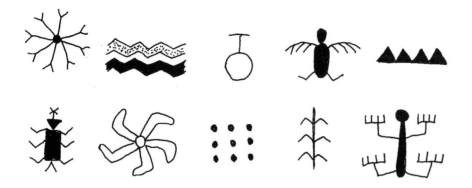

CHUMASH
ROCK ART

*Left: Some of the repetitive
designs found at more than
one Chumash site.*

tual experiences in dreams, trances or under the influence of datura which the Chumash reverently call "Grandmother." Colors are extraordinarily brilliant and, because all are earth pigments, in protected locations they have stood up to the passage of time fairly well. The sources of red were iron oxide and hematite, yellow was limonite, white was made from diatomaceous earth, black was hydrous oxide of manganese, while blue and green were probably derived from serpentine. See also ENTOPTIC PHENOMENA, HALLUCINOGENS and MILKY WAY.

CHUUK

*Above: Wooden face
mask, Mortlock, Caroline
Islands. Lime and soot,
approx. 18″ high.*

Chunkey (also *chunkee*). A game played by the Mississippian cultures, known from its historical equivalent, played among the Muskogean-speakers. Towns had smooth playing fields along which stones were rolled. The players threw poles after the stone, attempting to hit the stone, come as close to the stone when it came to rest, while preventing their opponents from accomplishing either of those aims. Based on a Cherokee myth, the game seems to have been connected with divination. The way in which the stone came to rest and the location of the poles were "read," following some set of now forgotten guidelines. George Catlin recorded the Mandan playing *chunkey* in 1832.

Chuuk (formerly Truk). Located in the Caroline Islands. Powerful black and white masks, apparently the only ones from Micronesia, were worn during mock battle dances in Chuuk, Satawan and the Mortlocks. The masks were hung in the men's houses when not in use.

Cicatrization. A type of African body art consisting of raised welts achieved by rubbing foreign materials into wounds. Cicatrization is common from southeast Nigeria to Democratic Republic of Congo. The Tabwa sometimes covered the bodies of women, in preparation for marriage, with designs related to their worldview. In Central Africa, cicatrization seems to have been associated with rank, see the LUBA/Hemba (see BULI SCHOOL). The LULUWA, who were displaced by the Luba, carve some of the most intricate cicatrization patterns, which may be associated with language and proverbs. See INDEX: Scarification in Human Body.

Circle. The Plains peoples of North America considered the circle to be the ideal form reflecting the eternal continuity of life. The seemingly limitless expanses of

CHUNKEY

*Left: Shell gorget showing a
chunkey player from Perry
County, Missouri. The
player holds a discoidal
stone in one hand and
game sticks in the other.
1250–1450.*

CIRCLE

"I was standing on the highest hill in the center of the world. There was no sun, but so clear was the light that what was far was near. The circle of the world was a great hoop with the two roads crossing where I stood, the black one and the red. And all around the hoop more peoples than I could count were sitting together in a sacred manner. The smokes of all the people's little fires stood tall and straight and still around the circle, and by the murmur of the voices of the peoples, they were happy."

—*Vision of Eagle Voice, a LAKOTA holy man.*

Above: Plan of Te Papa o Sokoau. Redrawn after Peter Bellwood.

their environment rimmed by the distant horizon may have contributed to this symbolism, and the form of the circle recurs over and over again in their art and ceremony. They built circular earth lodges and conical TIPIS. Warriors carried circular SHIELDS and magic hoops figured in religious ceremonies. Even their language refers constantly to circles—"the sacred hoop of the tribe," the larger "circle of council fires" and the still larger circle of humanity. They saw themselves as surrounded by the greatest circle of all, *wakan*, the unknowable spiritual realm that was outside human perception and control. In African kingdoms the cosmos or the land itself was frequently conceived of as circular, with the capital, especially the king's quarters, located at the center (see ASANTE and KONGO COSMOLOGY). For additional references to the circle, see INDEX: Pattern in Art, Artifacts and Techniques.

City of Refuge. Place where Polynesian wrongdoers could flee to safety. Once inside the precinct, they were free from punishment, but unable to leave. Wrongs ranged from murder to accidental offenses against TAPU. One of the most elaborate is Te Papa-o-Sokoau in Omoko, Tongareva in the Cook Islands, which takes the form of a human figure. The site is named for the unfaithful Sokoau, a daughter of Tangaroa, killed by her husband. The restored HEIAU (sacred precinct) at Po'uhonua o Honaunau National Park at Kona, Hawaii also includes a City of Refuge.

Cleft Head. An indentation on the top of the head is often a sign of the SHAMAN. The cleft may be the survival of the notion of the shaman's spirit physically leaving his body though the top of his/her head to enter the spirit realm in pursuit of lost souls. Alternatively, the cleft may be an indication of, indeed the mechanism mak-

ing possible, the shaman's openness to the supernatural forces around him/her. In Western art, the cleft survives in surprising ways; to mention just two, the horned Moses (e.g., Michaelangelo's masterpiece for the Tomb of Julius II) and representations of Satan and other demonic figures.

Cliff Palace. Anasazi cliff dwelling, see MESA VERDE.

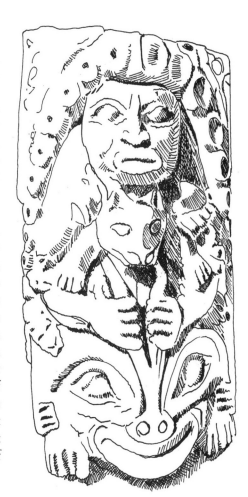

CLEFT HEAD

Above: This four and one-half inch Tlingit bone charm depicts the shamen and some of his spirit helpers—Mountain Goat, Octopus and Land Otter. The shamen grasps a V-shaped cleft in the head of the lowest creature, which he appears to be riding. 19th-century.

Clothing. See COSTUME and INDEX: Textiles in Art, Artifacts and Techniques.

Clouds. The Pueblo people of Southwestern North America believe that when a person dies, his/her spirit or BREATH returns to the place of Emergence and becomes a cloud. Clouds, thus, are not only the source of rain and therefore of all life, they are also regarded as the spirits of all the good and/or valuable ancestral dead—others may end up as stink bugs. A surprising variety of shapes symbolize clouds in Southwestern art. Found in petroglyphs, on pottery and *kiva* walls, and, most elaborately, on *kachina* masks, *tabletas* and dolls, clouds are represented as stepped pyramids, stacked half circles, circles with internal arcs and even by triangles. Often zigzag forked lightning extends upward and comb-like parallel lines representing rain fall from the bottom edge. The MARIND-ANIM of New Guinea live in an environment peopled with the spirits of creatures and natural forces that they call *dema*. They make large, intricate headdresses that embody the *dema*, such as that of the Cloud-Dema, a double fan-shaped construction made of perishable materials such as palm leaves, feathers and seeds.

Clowns. Clowns are LIMINAL BEINGS with deliberately unresolved, contradictory and conflicting characteristics and behavior. Don Handelman suggests (based on the early English derivation of the word—lump, clot and clod) that clowns are incomplete, out of context and undergoing transformation. Throughout the world, they appear on various ceremonial occasions to entertain and thereby defuse tensions, to criticize through satire, or, by reversing norms, they communicate physical, moral and spiritual ideals. As figures linked to inchoate origins, clowns appear frequently in seasonal transitional rituals where their incompleteness parallels the transformation of nature. Their very costume dramatically conveys their liminality, such as, for instance, the striped, horned attire of the Hopi sacred clowns or the lumpy earthiness of Zuni MUDHEADS. The Polynesian ARIOI of the Society Islands are truly liminal—itinerate, existing outside other social classes, these performers are allowed to ridicule even the highest chiefs. The theatrical productions of clowns are like reversed microcosms that are staged to revalorize and reinforce

CLOUDS

Left: Hopi kachinas frequently have cloud headdresses; this one has sleepy rain cloud eyes with eyelash rain. 19th century.

Below: The stepped pyramid or "stairway to heaven" symbolizes rain clouds and the path to the sky world. At Gila Cliff Dwellings National Monument in New Mexico, a frieze of birds sits atop the clouds.

CLOWNS

Right: Hopi sacred clown, from a watercolor by Fred Kabotie. 20th century.

COAST SALISH

Below: Maplewood spindle whorl showing a male figure bracketed by an otter on the left and a bird on the right. Two bird heads fill the space between the figure's arms and head. The figure is in the position usually associated with the HERALDIC WOMAN. Collected from Cowichan Halkomelem on Vancouver Island. 1884.

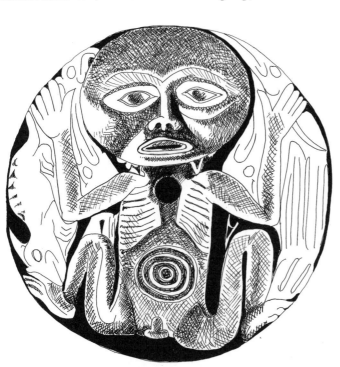

cultural values or, alternatively, to raise questions and doubts, thereby promoting change.

Coast Salish. The most heterogeneous Northwest Coast group, Coast Salish terri-tory extends down both sides of the Georgia Straits as far south as the Strait of Juan de Fuca and Puget Sound. Today there are forty-nine Coast Salish nations in British Columbia. Some of the most famous Coast Salish objects are the unique carved wooden spindle whorls that were made in the central area. The spindles themselves had shafts of up to four feet in length and the eight inch whorls (decorat-ed side toward the spinner) held the spun thread. The designs were carved by men and may be both protective and purifying because of the importance of the spindle in transforming wool into wealth. Furst inter-prets the spindle as an *axis mundi* and the central hole in the whorl is a "hole in the sky." North Coast Salish art also includes a powerful mask called Tal (a Kwakiutl word) that depicts a legendary giantess, a kidnapper and eater of children, who could only be deterred by causing her to dance. Coast Salish weavings have been com-pared to those of the Navajo. They are also renowned for the intricate baskets woven by women.

Coitus. Images of coitus appear frequently in indigenous art. The sexual act is often depicted in rock art inside caves, where renewal and fertility rituals were conduct-ed. Coital imagery occurs in conjunction with phallic imagery and depictions of vul-vae. In most of Africa, where the earth is regarded as feminine, farming is likened in ritual to coitus. Human sexuality and pro-creation are comparable to cosmic fertility, communicated by visual metaphors and euphemistic substitutions. For instance, the checkerboard scarification patterns carved on the abdomens of Dogon female figures represent cultivated fields. In girls' initiation rituals among the Bemba the penis is represented by the farmer's hoe. Temne men sing of their betrothed: "I've secured my own plot of ground; when I get there, I'll sow the seed." See Dogon TOGU NA.

Color. Unlike in Western art, where local color is generally prevalent, in the art of indigenous peoples, color is laden with significance and symbolism. Or, as Christian Kaufmann puts it, coloring substances are life forces. The Abelam of New Guinea, for instance, use pigments to stimulate the growth of yams. The two activities (gardening, growing plants) and using pigment (coloring, painting) are simply different forms of creation. While there are different associations linked with black and white, red universally is linked with blood, the sun and with life. Additionally, cultures use a color vocabulary that remains largely unchanged over long periods of time. Red, black and white are the colors used most frequently in Melanesia. Black is produced from charcoal, sump oil, soot and vegetable saps. Red, made from human blood, iron-rich earths and plant juices, is linked with blood and life. White, the color of death and of the human brain, fresh skulls, sperm and sago, is made from limewater mixed with vegetable binders. Yellow, from earths, clays and vegetable juices, is also used as are blue and green, likewise obtained from plant sources. Color symbolism plays an important part in BAINING night dances as outlined by Anne D'Alleva. Red is understood as being male and involves a number of related associations such as fire, blood and the blood-red saliva from BETEL. The men pierce their tongues and spray blood on the masks to activate them before performing. Black, by contrast, is the female color, linked with ashes, soot, and the earth. The white barkcloth of Baining masks is the color of spirits, clouds and foam on the beach, itself associated with afterbirth and primordial slime. In North America, the colors associated with the FOUR/SIX DIRECTIONS vary but the concept itself is widespread. For additional references to color symbolism, see INDEX: Art, Artifacts and Techniques.

Composites. Some of the most powerful masks and objects made by indigenous people are combinations of features from several different creatures. Additionally, the original appearance of objects changes with the build up of offertory materials making them ever more powerful. Generally the drama gained by combining different creatures and materials results in intentionally ugly and frightening aggregates. These powerful images often play major roles in the central rituals in the culture, particularly funerals. The spiritual power is frequently connected with the mysterious regions outside the known, human community—the land of the dead, the watery depths and the WILDERNESS. Some offer protection by producing terror as is the case with ASMAT WAR SHIELDS. Others form part of a complex duality that sets the ugly, raw and unfinished against the beautiful and complete like the ZUNI Shalako, which combine bird, buffalo and ogre characteristics. These formidable images, together with the MUDHEADS (Koyemshi), lumpy incomplete clowns, interact in ceremonies with less powerful and more beautiful masqueraders such as the five member Council of the Gods. The entire assemblage forms another sort of composite—one that corresponds to the complexity of life itself. Composite images serve as visual symbols that encode complex ideas that are understood differently by individuals in the society. Some are so powerful that those least likely to understand them—women and children—are forbidden to see them at all. Among those who may see them, the youngest initiates' grasp of their significance is exceeded by the wisdom which elders bring to bear. The Western idea that "seeing is believing" takes on new meaning in this context—seeing is believing, is knowing in an ever-expanding way. An African instance of this is the Baule mask called BO NUN AMUIN, which means "gods in the bush." These helmet masks

COITUS

Above: Petroglyphs in the so-called Cave of Life, in Petrified Forest National Park, Arizona, depict a coital couple at the bottom of the scene. KOKOPEL-LI, a shaman, and a large star in the form of a double outlined cross also appear. The entire group of petroglyphs, including what may be an instance of ritual coition, is likely connected with renewal and fertility rituals.

represent composite animal heads with open jaws and prominent teeth. Kept in a forest sanctuary outside the village, the masks had nothing "civilized" about them and were entirely products of the wilderness. As such, they were among the most feared of Baule masks and women were not permitted to see them. They made manifest the duality of wilderness/civilization, male/female. For additional composite images, see INDEX: Composite Beings in Animals.

Compulsive Magic. Term used by Ruth Bunzel specifically to describe magical attempts by Southwestern peoples to compel animals to give themselves over to the hunter (see ZUNI). In some ways, the words are preferable to "hunting magic" referring to Paleolithic cave paintings where certain forms were interpreted as arrows or spears. The idea that animals could be better killed after conducting a ritual in which they were symbolically (pictorially) "killed" seems simplistic. And, in any case, other scholars have suggested that the objects interpreted as weapons may actually have been plant forms. Given the enormous awe and respect indigenous peoples had for animals the word compel seems to better express the emotional complexities involved in the predator/prey relationships. Further evidence for this is found in the INNU practice of wearing special clothing and using decorated weapons to please the animals.

Concentric Patterns. Concentric circles have a multitude of meanings. The circle with a central dot, Schuster's "nucleated circle," according to him, may relate to joint marks (*Patterns That Connect*). It strongly resembles an eye. Zuni concentric circles symbolize the journey in search of the CENTER. The image that occupies the center of concentric patterns is often highly significant in its own right, and the arrangement serves to further dramatize it.

The circular boss at the center of ASANTE *akrafokonmu*, "soul washer's" disks, symbolizes the sun and by association, the life force or spiritual essence of individuals. In the Kongo *bidimbu* SIGN SYSTEM, concentric circles respresent the movement of the sun and the cycle of human life (humans are miniature suns), as well as growth and change. See also ENTOPTIC PHENOMENA and INDEX: Pattern in Art, Artifacts and Techniques.

Continuous Line Drawings. In many cultures, people draw uninterrupted complex patterns in sand or create string figures. Usually the drawings are done ritually accompanied by chanting or drumming. The unbroken path is a labyrinthine spatial and temporal symbol for a narrative or a recreation of a journey. Among the most interesting are the sand drawings made in MALEKULA. The complex, symmetrical patterns are called *nahal*, "the path" and creating them is connected with the journey of ghosts to the realm of the dead. Called Wies, the land lies northward and is reached by crossing a lagoon and entering a distorted landscape. There the traveler meets Temes Savsaq, a female guardian ghost who sits in front of a rock (or beside a cave) with the *nahal* sand drawing before her. As the ghost approaches, she erases the drawing and challenges the spirit to reproduce it correctly. Those who are able to do so pass on safely, but those who cannot are devoured by Temes Savsaq.

Cook, Captain James (1728–1779). Made three voyages into the Pacific. Although he did not accomplish what he set out to do (find the Northern Passage among other things), Cook's voyages resulted in the first contact with many Pacific peoples and the collection of more than 2000 "Artificial Curiosities," to use the 18th-century terms. Art objects were collected as one aspect of natural history and, ironically, were the easiest to obtain as the indigenous peoples showered their visitors with gifts. Cook's adventurous life ended on Hawaii. He was initially received by the people as Lono, god of peace and agriculture, because his ship's masts resembled representations of the god. However, Cook, several of his men and several natives were killed after an unfortunate misunderstanding. In Europe, Cook's charisma was such that objects collected on his voyages attained a kind of supernatural force. As a result, private and public collections contain many more objects purportedly obtained by Cook than the some 2000 actually collected.

Cook Islands. Named after Captain Cook, who never actually set foot on any of the fifteen Polynesian islands that compose this island group, with a total land mass of about 93 square miles. Spread over approximately 1,000 miles, the group is located between Samoa and the Society Islands. Rarotonga, the main island was not discovered until 1820. The islands' culture apparently derives from the Society Islands from which they were settled in the 9th century. Extraordinary woodcarvings ornament canoe prows, staffs, slit gongs, drums, weapons, adze handles and images of gods and ancestors. The ceremonial adzes apparently symbolized one of Tane's aspects, namely his patronage of woodcarving and carpentry. Both open-work and solid carvings are characterized by precise, rather miniaturized repeated motifs. The individual design units often take the

form of stylized human figures or human body parts (the spine), as well as other creatures such as bats. An alternative explanation is that the large bat-like ears are associated with the ancestral figure Taranganui whose name translates "great ears." Equally refined designs are woven into pandanus strip mats and painted on bark cloth. Cook Islanders are also known for song and dance. See map: OCEANIA.

Coolness. See INDEX: Temperature in Natural Phenomena and Materials.

Coppers. Made from copper traded into the Northwest Coastal region from the interior and from European sheet metal, coppers had a standardized form—said by some to be anthropomorphic—with a curved upper edge atop two rectangles separated by a raised T-shaped ridge. Coppers were the ultimate symbol of the wealth displayed at POTLATCHES, naming ceremonies and funerals. The surface was engraved with designs which were not clan CRESTS as the coppers were a form of currency and thus changed hands. Each copper had a name and its value was established by the worth of property distributed at the last potlatch in which it changed hands—one was said to be worth 12,000 blankets. The copper color was linked with the red of salmon flesh, menstrual blood, fire and the sun—all, like the coppers themselves, associated with bountiful generosity. Due to the increasingly inflated value of coppers, in practice they rarely

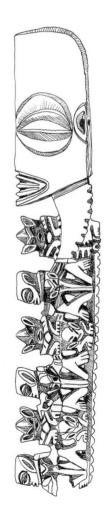

COOK ISLANDS

Right: Staff God from Rorotonga. These staffs were carried upright on a horizontal ladder by several bearers in religious ceremonies. The alternating profile human and bat-like frontal figures represent successive ancestral generations. The phallus-shaped lower end (missing here), was wrapped in three layers of sennit cordage for protection. The whole represents the procreative power of the god. Late 18th–early 19th century.

COPPERS

*Above: Painted by famed
Kwakiutl artist Willie
Seaweed, Chief Mungo
Martin's "KILLER
WHALE" copper, is one
of the few which retains
its history. Originally pur-
chased by Martin in 1942
for $2,010, it was subse-
quently ceremonially
broken, first, at the
HAMATSA initiation
of the chief's son David
and, second, to shame a
rival chief. It was used
in other important public
ceremonies until David's
death in 1960 when it was
taken out of circulation
and given to the British
Columbia Provincial
Museum.*

changed hands. Only the Nootka and the
Coast Salish did not use coppers. See
INDEX: Names in Miscellaneous.

Coral. The regalia of the OBA of BENIN
were encrusted with coral beads, on which
the Oba held the monopoly. The beads are
said to commemorate the first beads stolen
from the palace of the god of the waters,
Olokun. Coral was one of many symbols of
the Oba's liminality. Like a coral reef, the
Oba existed between two realms. Coral's
blood-red color is a reminder of the poten-
tially lethal powers of the ruler and his
blood ties with his people. The coral beads
were traditionally strung on elephant-tail
hair, which adds to their symbolic potency,
as the elephant is another symbol of phys-
ical force and royalty. Additionally, coral
was believed to make the king's words
come to fruition.

Corn. The Hopi say, "Corn *is* life." Corn or
maize is the most important crop in many
areas of North America, particularly in the
Southwest. Among the Hopi, corn is
regarded as the mother of people and at
birth, infants are given two perfect ears of
white corn to act as its "mothers." At
death, ears of blue corn are buried as suste-

nance for the journey. Corn meal is the all-
purpose sanctifying substance; it is sprin-
kled on dancers, on altars and used to form
spiritual paths for the *kachinas* and the
dead. Corn motifs, often markedly phallic
in form, adorn pottery, KACHINA
DOLLS—especially Shalako Mana, Corn
Maiden—prayer sticks and the great *table-
tas* of headdresses (see HEMIS). The
Navajo use cornmeal and corn pollen in
forming SAND PAINTINGS, and corn is
one of the four sacred plants. See INDEX:
Corn in Natural Phenomena and
Materials.

Corn Maiden. See Hopi KACHINA
DOLLS.

Cosmic Models. Buildings and architec-
tural precincts are often designed and built
as models of the cosmos. The Maori
WHARE WHAKAIRO, for instance, can
be seen as Rangi (Sky Father) enclosing his
children. The houses are dark inside like
Po, the primordial darkness. The house is
also anthropomorphic, its ridgepole/spine
is that of the founding ancestor, its
rafters/ribs and supporting posts bear depic-
tions of the succeeding generations of
ancestors. In Tahiti, the god house is the

COSMIC MODELS

*Above: Façade of a KWAKIUTL house at Alert
Bay, British Columbia showing Thunderbird and
Whale, the deities of above and below, sky and sea.*

*Left: Diagram of a HAIDA house, showing the
layered universe. After Nabokov and Easton.*

body of Ta'aroa (Tangaroa). The indigenous people of the Northwest Coast of North America do not built separate ceremonial structures, instead, the principal chief's house serves both residential and religious purposes. Since the chief is the living embodiment of the ancestors and the owner of the territory, it is fitting that his house is the center of society. Beyond its temporal associations, the house is also a cosmic structure. The HAIDA house is situated at the center of the universe, which is conceived of as having three layers—sky, earth and underworld. These layers are both vertical and horizontal, as the Haida consider that the souls of the unborn emerge from the sea (the underworld), live out their transitory lives in the middle earth zone, and finally are buried in grave boxes near the forest (sky world). The two major deities of the zones are Whale, chief of the underworld/sea, and Thunderbird, chief of the forest/sky. The vertical axis is the shaman's WORLD TREE, extended up through the smoke hole and regarded as the vertical link between the three realms. The Haida house, thus, is a cosmic model embodying the delicate and dynamic balance of above and below, secular and sacred.

Cosmology. Indigenous peoples often have long-rooted and complex concepts about the origin and form of the universe. Cosmology is imbedded in myth and expressed in architecture (see COSMIC MODELS) as well as in ritual. Many elements found in cosmological concepts are nearly universal and have an archetypal character, ennumerated in the discussion of SHAMANISM. For specific cosmologies, see INDEX: Cosmology in Miscellaneous.

Costume. Costume and clothing are indicators of rank in indigenous societies. Chiefs and kings wore fabrics, patterns and jewelry, which were often restricted for their use. For instance, the Oba of Benin's state costume was made almost entirely of netted CORAL beads. The Oba owned all the coral beads in his kingdom and gave them to retainers as a sign of his favor. On the Northwest Coast, apparel was hierarchically arranged in ways paralleling the social structure. Only chiefs wore the conical carved hats. Frontlets (e.g., BELLA COOLA), often more striking, were ranked lower and were worn by the chiefs and members of their families. Others wore basketry hats woven in shapes similar to the chief's carved wooden ones (see CHARLES EDENSHAW). In rituals, costumes consisting of cloth, fiber or other covering conceal the bodies of masqueraders. Some costumes involve considerable physical prowess, as they may be voluminous, cumbersome and weighty. A striking instance of this is the Igbo IJELE, which Cole and Aniakor call a "progressive aggrandizement" of earlier cloth headdresses and the openwork crests of maiden spirit masks. *Ijele* masks, at over fifteen feet tall and six feet wide, are expensive to commission, requiring the labor of four skilled tailors and experts in applique for six weeks, working ten-hour days, seven days a week. They used to be seen rarely, but with greater affluence are more common. The mask consists of a wooden five-foot diameter disk that rests on the dancer's head. Over 1000 individual items are attached to the disk and to the palm rib armature. The mask's kaleidoscopic appearance represents the great spirit, the energy and prosperity of the community and its continuity with the ancestors. See INDEX: Textiles in Art, Artifacts and Techniques.

Cotokinugwuh. Hopi star god, see CROSS.

Counting Coup. From the French, *coup,* "to strike." Plains warriors achieved prestige by performing brave deeds. Public narration was called "counting *coup*." The

COUNTING COUP

Above: Yanktonai Sioux coup stick carved with a head on its end. Traces of red face paint can be seen on the face and the dotted line of the arrow on the chest is outlined in red. Hitting an enemy with such a stick doubled the insult, as the carved head was a reminder that one's head was vulnerable. The arrow line is reminiscent of the "heart line" or "entrance trail" on X-RAY IMAGES connected with the life force or breath. Fort Peck, Montana. c. 1860-80.

COYOTE

Above: It is often said that the names attached to basketry patterns have no significance, no link with the thing named. Having said that, it is interesting to see that one of the most repeated designs in Southwestern basketry is called "coyote tracks." The design consists of a grid of squares or rectangles with their corners touching. It was particularly popular in Apache baskets.

Below: Coyote appears in Navajo SAND PAINTING with zigzags showing the trail of embers he left behind when he stole fire from the Sun and brought it to first people's kiva.

reputation for savagery resulted from the struggle for survival in their confrontation with the U.S. Army. In fact, the primary goals of Plains warriors were maintaining personal honor and their own continued existence, not complete annihilation of the enemy. *Coups* were ranked by the bravery involved. Warriors gained prestige from shooting enemies, running them down on horseback, stealing enemy horses and, most important of all, succeeding in touching an enemy and retreating to safety without retaliation.

Coyote. The wily TRICKSTER Coyote is revered and feared by North American peoples. Coyote often is credited with giving people important information and objects, necessary for survival, but his volatile and unreliable nature can cause discord and chaos. Among the Chumash, Sky Coyote played a game with the Sun that determined the coming year's weather—if Sky Coyote's team won, human beings were assured of rain and abundance. The Crow of the Great Plains say Coyote was the first to ornament horses. The NAVAJO link Coyote with dark and dangerous things, but they also credit him with stealing fire from the Sun and giving it to the first people. His dual nature may be linked with the mixed blessings inherent

in the power of the sexual impulse. On the one hand, sexuality assures fecundity, but uncontrolled it can be destructive. The same mixture of admiration, humor and fear can be seen in conjunction with the African Yoruba god, SANGO. See INDEX: Deity Archetypes.

Cradle Boards. North American native women lavished attention on elaborately beaded cradles. These multipurpose objects could be carried on the mother's back or hung from a horse's saddle, tipi poles or tree limbs. They were used until the child began to walk. The designs varied from people to people. Because of high infant mortality, designs frequently symbolize vitality, luck and supernatural protective power. Figurative designs may have indicated the maker's desires for the child—such as repeated animal figures as symbols of hoped-for wealth. Non-representational designs included the intricate florals of the Subarctic (see Kuchin DOG BLANKETS). On the Great Plains, female relatives of Kiowa babies made decorated cradles with floral and geometric designs. Kiowa and Cheyenne cradles were attached to slats of wood with triangular ends and brass carpet tack ornamentation. The wooden pieces extended above the top of the cradle, providing protection for the baby's head if the cradle were to fall. Geometric designs are reminiscent of those that appear in early rock art.

Crescent. Kaeppler suggests that symmetry is related to art, while asymmetry is related to ritual (*Oceanic Art*). In Hawaii, symmetry is regarded as being aesthetically pleasing to people and the gods. The crescent is ubiquitous and it clearly functions metaphorically. Indigenous words for the shape vary from descriptive (V-shaped segment) to comparative (moon, fish scales, shoots of the flax plant). One word for crescent, *hoaka*, means among other things "arch, crest, spirit, protection and various

sorts of light (flame, lightning flash, shining, glittering, glory)". The crescent is the primary design woven into 'AHU 'ULA, feather capes and cloaks, and forms the basic shape of MAHIOLE, the feathered helmets. It also appears on drums, bowls and the buttocks of human beings, but rarely on bark cloth. There may be an association with the royal rainbow, or it may be that the rainbow is powerful because of its crescent shape. The aim of the chief was to resemble a series of crescents from the inverted curve of his feather helmet to those surrounding his body on his cloak. Thus, the chief took on a multitude of associations linked with the crescent from genealogy to spiritual fire. Outside Hawaii, the crescent shape is most frequently associated with the moon, as for instance in APACHE *gaan* masks and in the moon-shaped soul boat associated with the Dongson Culture (see CANOES). For additional references to the crescent, see INDEX: Pattern in Art, Artifacts and Techniques.

Crests. Crests are symbolic emblems found in the art of the Northwest Coast of North America. They are visual images that combine metaphorically to refer to mythology, cosmology and genealogical family relationships. They are said to be visual embodiments of communal memory. About 1900 John R. Swanton worked out a list of nearly seventy HAIDA crests with knowledgeable artists such as Charles EDENSHAW. The crests, which represent animals, birds, sea creatures, human and mythic beings, appear on most objects, especially TOTEM POLES. They indicate not only lineages, but refer to myths in which the crest animals played important parts. The two principal Haida crests are Raven and Eagle; surprisingly the Raven lineage does not use the Raven as a crest. Of the seventy, only about a third are used frequently such as Killer Whale, which appears with different attributes, connect-

ed with lineage myths such as the Raven-Finned Killer Whale (used by the Raven lineage). The latter relates to a story about how Raven, having been swallowed by Killer Whale, pecked himself out through the end of its dorsal fin. Color also plays a part in the scheme. For example, Raven crests representing Killer Whale have black dorsal fins, while those of the Eagle lineage always have a diagonal white stripe. The Raven lineage owns all land mammal crests except for Beaver. The Eagle lineage owns many bird and fish crests, but shares some (e.g., the Dogfish and Skate) with the Ravens. Some crests represent creatures that do not live in the Haida's Queen Charlotte Islands, such as Grizzly Bear, and were imported from other groups. Beaver and Frog, for instance, came from the Tsimshian. See INDEX: Animals.

Crocodile. Sacred crocodiles are carved from whole tree trunks in villages bordering Lake Yimas in the central Sepik region of New Guinea. Measuring over twenty feet long, the hollow carvings were kept hidden in men's and cult houses. They appeared in pairs in public displays, carried by several dancers by means of rods inserted through the crocodile's body. Low relief carvings ornament the cone-shaped trunks, with openwork three-dimensional carvings following the spine. The wealth of imagery includes human faces, hornbill and parrot beaks, bird bodies, and ambiguous heads with prominent serrated foreheads and chins. The amalgamation preserves the memory of mythical ancestors. The Iatmul believed they lived on the back of a giant crocodile from which they were descended. The crocodile ancestor made the land and created the course of the Sepik River. Arnhem Land mythology places Ying-arpiya, the great crocodile, in the river of the Milky Way; the largest stars mark the spines on his back and the curve of his tail. In Africa the crocodile is associ-

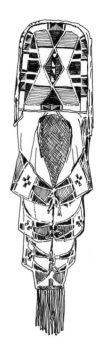

CRADLE BOARDS

Top: This cradle board shows two unique CROW features—a foot panel and three pairs of straps. 1890.

Bottom: This PAWNEE cradle board probably, following the Pawnee tradition, was cut from the center of a living tree in order to preserve the "heart of life." The design symbolizes Oprikata, Morningstar, the male progenitor whose power is evoked to protect the child.

CROCODILE

Right: Carved from an entire tree trunk, Korewori, Lake Yimas, Middle Sepik.

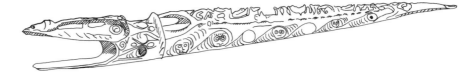

CROSS

Right: Fragment of a ceramic beaker from CAHOKIA. This cross-decorated container was found close to the winter-solstice posthole. The central cross design has been interpreted as representing the earth, surrounded by the radiating rays of the sun and its circular pathway.

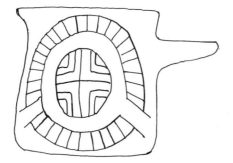

ated with power and proverbs among Akan speakers. For instance, a crocodile biting a mudfish illustrates the Asante proverb, "whatever the mudfish acquires ultimately will go to the crocodile." The proverb suggests that the natural pecking order repeats in human culture with the powerful benefiting from and exploiting the weak. Additionally, the crocodile is one of the five primordial animals in Senufo myth and makes a dramatic appearance in hybrid masks representing wilderness spirits such as the Baga BANDA mask and the Senufo *kponyugo* (see SENUFO MASKS). For additional references, see INDEX: Crocodile in Animals.

Cross. Although in Western culture, the primary association of the cross is with Christianity, it has been a universal archetypal symbol from the most ancient times. Some cultures attach specific significance to the cross, but generally speaking it is a symbol of the CENTER and of the FOUR/SIX DIRECTIONS. In indigenous cultures, the most prevalent form is that of the equal-armed cross oriented in two ways: ✚ or ✖ . Some specific associations are its use in the form of a cross-in-circle motif by the Mississippian Cults as a solar symbol. In Southwestern petroglyphs, the

cross appears to be a star symbol, as for instance in representations of the Hopi star god, Cotokinungwuh. Some sources suggest that there may be Mesoamerican influence in both cases. Cross shapes appear frequently in Africa, many of them as part of SIGN SYSTEMS. One of the most potently symbolic is the DIKENGA, the so-called Kongo cosmogram (also see NIOMBO). An ✖ shape within a square, the cosmogram represents several overlapping concepts, including the shape of the cosmos (two mountains standing base to base), the four moments of the sun (rising, ascending, fading and returning at dawn) and the cycle of human life. According to Carl SCHUSTER, the cross may serve as a symbol of the first being, or of the first man and woman crossed in mating (*Materials for the Study of Social Symbolism in Ancient & Tribal Art*). The point of intersection is located at the navel of the figure. Schuster believes that other metaphors, such as the four quarters or four seasons, are simply the collective parts constituting the Primordial One. The cross shape, thus, represents the first being macrocosmically, and each individual is a microcosmic replica of the whole. Design divisions and architectural arrangements involving quartering are reflections of the macrocosmic first being. See also COITUS, SWASTIKA and INDEX: Deity Archetypes; Pattern in Art, Artifacts and Techniques.

Cross River. This region of southeastern Nigeria is an environment rich in masking traditions. Although there are a variety of mask types, the rather uncannily naturalistic skin-covered helmet masks are the most famous. The majority of these masks were

made of pre-soaked antelope skin stretched over a wooden form, but there are some documented cases of human skin. The masks were used primarily by the EKPE association (leopard cult) for purposes ranging from entertainment to social control. Early literature reported that the masks were trophies worn by warriors in

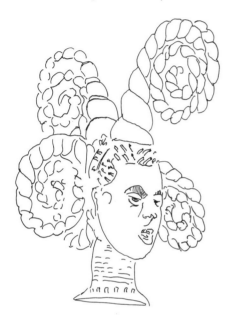

victory celebrations. Lack of reliable information, especially regarding provenance, makes identification difficult; initially, they were said to be Ekoi (now called the Ejagham), but presently Ejagham and Efik seem to be preferred. Many of the masks are marked with *nsibidi*, a secret script developed by the Ejagham (see SIGN SYSTEMS). See also BAKOR.

Crossroads. The space demarcated by the intersection of two roads or paths takes on symbolic significance associated with the CENTER. Unlike some symbols of the center, the crossroads is a dynamic symbol that implies movement, potentiality and transformation. Thus deities and rulers often are linked with the crossroads, as is the case with the Yoruba god of the crossroads, ESU. Kongo NIOMBO figures stand with their arms outstretched in what is

called the "crossroads pose." Since *niombo* are funerary figures that contain bones, the symbolism serves to locate the spirit or soul in a way that resonates with KONGO COSMOLOGY. The Kongo believe that human souls are like miniature suns that, like the sun, circle into and out of life/death, light/darkness. Finally, one Akan proverb has it that "the chief is like a crossroads, all paths lead to him."

Crow. The Crow live in the area between the Missouri and Yellowstone Rivers. Like other Plains peoples, they were originally nomads, following the buffalo herds and other game animals. They are known as the finest horsemen of the area, famed for their finely trained horses. Crow women made TIPIS, clothing and still today are expert beadworkers. Historically, most Crow beadwork was used to adorn horses, which the people say they were taught to do by Coyote. The Crow celebrated the renewal SUN DANCE which they called Thirst Lodge. As with other Plains peoples, the center poles of Crow dance lodges symbolized the WORLD TREE, connecting the realms of existence. The Crow placed their symbols of heaven and earth in the branches of the tree, a buffalo head facing east and an eagle. For additional Crow objects see AMULET, CRADLE BOARD, MEDICINE BUNDLE and SHIELDS.

Crown. Crowns are probably the most important among the SYMBOLS OF OFFICE, as they protect the royal head. In the West, the association between crowns and authority is summed up in the saying "crowned heads." Elaborate crowns (in contrast to headdresses) in indigenous society tend to be confined to complex, stratified societies such as in Africa, BENIN, FON, YORUBA, YORUBA ARTISTS and QUEEN MOTHER. The materials used in these cultures are glass and coral beads. The Igbo transfer the

CROSS RIVER

Left: Skin-covered mask identified as Ejagham. The soft, delicate layer of tissue reveals structural details on the wooden core beneath, like skin over skull, creating an uncanny quality. Thompson suggests that the skin acts as a magical agent invoking ancestral spirits and blurring the distinction between the living and the ancestors. The spirals are said to represent the hairstyle worn by girls during initiation ceremonies prior to marriage.

royal significance of crowns metaphorically to the Earth Mother Ala, calling the MBARI houses built in her honor "her crown." Finally, see TIKI for a Marquesas turtleshell crown (*paekaha*). Chiefs and kings elsewhere wear headgear that cannot properly be called crowns, but which are

CROWN

Right: YORUBA *beaded crown with sixteen birds and a veil that protects both the king and his subjects. The king, especially his head and breath—container and carrier of his life force—is so powerful that others may be damaged. The faces on crowns are said to be those of various gods as well as evoking destiny* (ori) *as the province of the king.*

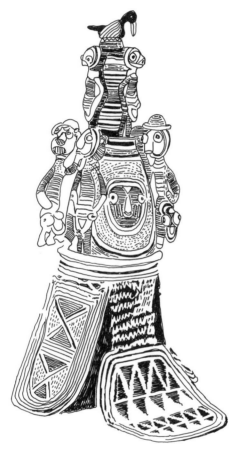

laden with symbolic meaning, see Hawaiian MAHIOLE and Northwest Coast headgear such as BELLA COOLA frontlets and Haida hats such as that painted by CHARLES EDENSHAW.

Cult. Cohesive group of people that observes a formal set of rites devoted to veneration or propitiation of specific individuals, spirits or forces. Cult practices usually are characterized by complex symbolism and elaborate costume designed to embody cultic concepts and to better carry out rituals. Victor Turner differentiates

between two different types: earth and fertility cults and ancestor and political cults. Earth and fertility cults were socially inclusive and focused on unification rather than sectarian divisiveness; access to the spirits and participation was available to all members of society. Ancestral cults, on the other hand, emphasized ultimate authority, which was held by one individual or a small group. Such cults were politically manipulative and access was generally hereditary.

Culture Hero. Often closely associated with creator god(s), the culture hero, although he may actually in some cases create things such as animals, is concerned primarily with human survival. The hero first rids the world of threats to human beings such as monsters. After that, acting as a teacher, the culture hero orders human life by establishing gender roles; differentiating between animals and humans; teaching hunting, animal husbandry and agriculture for which he supplies the weapons and tools as well as teaching the various crafts. Speech, ritual and law are also taught. The hero is usually of divine birth and frequently is connected with the appearance of death in human culture. Having accomplished his goals, the hero departs and remains distant from human affairs. Sometimes the hero is killed, and in other instances he is transformed into heavenly bodies, natural features or objects. Although the culture hero is generally male, there are instances of females in the role, such as the Eskimo SEDNA. There are numerous cases of TWIN culture heroes. Occasionally, animals, especially TRICKSTERS, fill the culture hero role. See INDEX: Deity Archetypes.

Currency. In Oceania currency consisted of a variety of natural objects and raw materials as well as man-made objects. Pigs—both living animals and their tusks—were symbols of wealth and items

of exchange in Melanesia. In Hawaii, feathers were valuable in their own right, but became more valuable when made into items of apparel such as the colorful 'ahu 'ula cloaks and capes. Hawaiian feathers, in principle, belonged only to the high chief. Some objects, usually made from rare or hard to obtain materials, have no other use except as currency. An example of this is the Massim wealth presentation scepters called GOBAELA. Carved from wood and turtle shell, these were carried by marriageable girls in dances and formed an important part of dowries. In Africa currency often took the form of forged metal objects. Shells, beads, ivory, cattle and slaves as well as many other things constituted forms of wealth. In many African kingdoms, the king reserved the right to own and distribute certain commodities, for example, in Benin the Oba controlled ivory and coral. At one time, wearing beads was the exclusive prerogative of the Zulu king who granted the right to others. See INDEX: Beadwork in Art, Artifacts and Techniques.

Curtis, Edward Sheriff (1858–1952). Born in Wisconsin, Curtis grew up in Seattle, Washington where he began photographing Native Americans in 1892. In 1899 he served as official photographer on an expedition to Alaska and somewhere along the way conceived the idea of producing a comprehensive written and photographic record of indigenous peoples west of the Mississippi and Missouri Rivers. Although Curtis was sensitive to the people's plight, he contributed to the romanticizing and pessimism surrounding them, and in fact, titled his first series "The Vanishing Indian." For over thirty years, he worked seventeen hours a day, supporting his family, traveling—both on lecture tours to raise money and to study and photograph Native Americans—and working on what became the forty volumes of text and photographs of the monumental *The North American Indian*. Reproductions of his photographs today are collectors' items and his vision undoubtedly still affects the way the Native North Americans are seen.

Cushing, Frank (1857–1900). Cushing was a talented naturalist, with no training in ethnology, who worked for the newly founded Bureau of American Ethnology. In 1879, at age twenty-two, Cushing traveled to New Mexico Territory where he lived for the next four and one-half years among the ZUNI. He was adopted by them and became a Bow Priest and a member of the Macaw clan. He eventually became second chief. He later excavated the Woodlands KEY MARCO site in Florida.

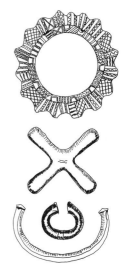

CURRENCY

Various metal objects that served as currency in Africa.

Top—Bateke brass collar.

Center—currency cross from Katanga, Democratic Republic of Congo.

Bottom— brass manillas introduced by the Portuguese, probably West Africa.

D

Dahomey. See FON.

Dan (also Dan-We). The Dan are a Mande-speaking people who migrated into the area of Liberia and the Ivory Coast from Mali beginning in the 16th century. They are known for their masks which, in pre-colonial times, belonged to the chiefs who used them primarily to keep peace between warring factions. Now the masks are owned by families and are used for social control, entertainment and rites of passage, particularly boys' circumcision rites. Each mask comes into being after a spirit reveals itself to an individual in a dream or a vision. The individual then makes the costume and commissions a sculptor to carve an image of the spirit. Despite the fact that Dan masks are separate entities, making it difficult to categorize them as a whole, eleven major types have been identified. Although there are myriad sub-types, all masks are believed to contain *du*, a spiritual force that is experienced by human beings and allows itself to be carved in wood. Masks speak in unintelligible sounds, the meaning of which is interpreted by knowledgeable individuals who accompany the masks. The most common, called *deangle* (or *dea*), meaning "smiling mask," represents a female forest spirit. The ideal form of *deangle* masks may have been created by a sculptor active in the western area in the 1930s and 1940s named Tame ("wanderer"). These shining oval, realistic masks are embodiments of female beauty, grace and restraint. The composure of the masks contrasts with the bulky costume that conceals the male dancer. Within the context of boys' initiations, the *deangle* mask provides a surrogate female presence to instruct the initiates. The unique combination of male and female embodies the importance of balance within individuals and the community. Another type, called *bugle* ("gun"), offers a further dramatic contrast. Representing male forest spirits linked with warriors, the composite masks are lumpy, anti-ideal accretions of animal fur, teeth, horns, shotgun shells and feathers. The masquerader dances aggressively, reflecting the mask's earlier function as a social control mask charged with judgment, enforcement and punishment. Other masks are *gunyege* ("house spirit"), *zakpai*, a fire extinguishing mask and *gle wa* ("large mask") one of the most impressive of Dan masks. The Dan also make miniature masks, sometimes called passport masks and display ladles for high status women. The honorific title WUNKIRLE is conferred on a woman when she and her husband are successful farmers and she is identified as the most generous woman in the community. The *wunkirle* distributes rice with her ladle dur-

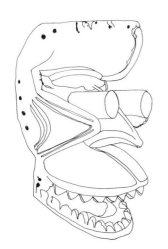

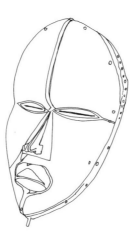

ing festivals. The ladle's handle terminates in the head of a beautiful woman and its rounded bowl symbolizes the *wunkirle's* pregnant belly and, more generally, links human with agricultural fertility.

Dance Paddles. Carved wooden paddles or wands were swung in circular motions further dramatizing dance movements. Although the symbolism of the designs on paddles is lost, undoubtedly their significance added to the dance. See KAIDIBA (MASSIM) and RAPA (EASTER ISLAND).

Danger. Dangerous things are depicted as antitheses of beautiful things in many indigenous cultures (see BEAUTY). Deliberate distortion, asymmetry, protrusions, added-on parts and aggregations of unpleasantly textured materials of dubious origin result in powerfully ugly masks and other objects. Often unusually large scale and dark coloration contribute additional force. Both places and people can be dangerous. Danger pervades those mysterious and unknown regions where human beings feel most vulnerable, such as night, the WILDERNESS, caves and the watery deeps of rivers, lakes and the sea. In the social realm, danger attends all life transitions and, in fact, relates closely to the anxiety resulting from change. Things that by their nature are changeable or are prone to change (weather, the moon, women and dreams) seem dangerous by association. Furthermore, danger is attached to persons whose behavior lacks control or which is antagonistic to others—witches, the insane and those who are driven by sexuality. And, above all, danger is linked with power. Indigenous people recognize that great power has the potential to enormously benefit others, but it can also be profoundly destructive. This sort of dangerous power is associated with rulers and with women. In most cases, the images linked with this sort of danger are quite beautiful

as their purpose is to honor the powerful and thereby incur their pleasure for the benefit of all. A striking example of this can be seen in the Igbo MBARI houses that honor the goddess Ala. In building the houses, people incorporated all that was beautiful and dangerous in life in what Cole has called a "spiritual art gallery" (in Cole and Aniakor, *Igbo Art: Community and Cosmos*). The dangerous things are creatures from the wilderness, leopards, forbidden masks and the rapacious cannibal rapist Okpangu. The beautiful things are unified happy families, objects of material wealth and symbols of the natural universe like the sun, moon, stars and rainbows. Most beautiful is Ala herself, the deity of increase, prosperity and large families. Because of her enormous power she is conceived of as being dark, but in the *mbari* house her image is painted white and flashing mirrors ornament her headdress, capturing brightness and light. To honor her and thereby encourage her beneficence, she is depicted as beautiful, light and brilliant. The underlying duality is dramatized in two masks that appear in IGBO MASQUERADES, the white maiden masks that are beautiful, calm and remote in contrast to the ugly, composite *mgbedike* masks. The latter, often twice life-sized, bristle with jutting horns and other unpalatable materials. The hostile forces of the one balance the beauty of the other—both are necessary and gain definition by their opposition. In some cases, like BOCIO figures and Kongo NKISI, the ugliness has a protective function, averting danger through fear. Innumerable other instances link power, danger and ugliness in deliberate contrast to beauty, see INDEX: Danger in Miscellaneous.

Darkness. Darkness and the night are nearly universally associated with death and form part of the duality of male/female, sun/moon, right/left, life/death, white/black, light/darkness. In

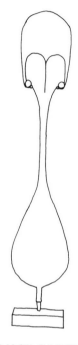

DANCE PADDLES

Above: Wooden dance paddle called RAPA from Easter Island. 18th–19th century.

some cultures darkness is banished by culture heros like Raven who steals the sun and gives it to humankind or the Polynesian Tane who pushes his parents apart allowing light to enter the world. Yet the dark side of the duality is not always negative; rather it is seen as a complementary and dynamic aspect of the cycle of life, as it is in Kongo cosmology. For some, though, darkness is associated with the dangers of the wilderness and the unknown. Darkness is also linked to invisibility. Susan Vogel notes that the Baule live close to the equator and thus experience twelve hours of darkness practically year round (*Baule, African Art, Western Eyes*). Yet, the Baule do not fear the night, instead they associate it with relief from the work and the heat of the day, with coolness, rest and privacy. Many of their most powerful objects are kept hidden from sight and even when in plain view, powerful art objects are not stared at. Thus, the Baule de-emphasize the materiality of art objects, which Vogel suggests is consistent with an attitude toward art and life which incorporates invisibility and ambiguity. Invisible objects are safe, private and become more powerful because of their secrecy. See INDEX: Darkness in Natural Phenomena and Materials.

Dat So La Lee (c. 1850–1925). Pseudonym meaning "wide hips," the invented name of famed WASHOE basket maker Louisa Keyser.

Datura. Common name Jimsonweed, see HALLUCINOGENS.

Dau. Deliberate interruption in the otherwise perfect patterns woven into California baskets, see POMO. Although the purpose of the *dau* is uncertain, it has been interpreted as a SPIRIT BREAK.

Deangle (or *dea*). The most characteristic DAN mask type; *deangle* masks represent female forest spirits.

DARKNESS

"…obscurity and ambiguity do not have the negative connotations [for the BAULE] they have had in… European culture…. Night and darkness provide a way of knowing and experiencing in which understanding is actually deepened by ambiguity and fed by imagination and memory."

—*Susan Vogel*

Death. Of all life transitions, death is the greatest crisis in most societies. Generally speaking, indigenous cultures consider life and death to be different modes of being which somewhat lessens the anxiety connected with it. At the same time, death is seen as a rupture in the perfect order of the cosmos and its presence is a universal preoccupation in mythology. In fact, there seems to be a widespread compulsion to explain how death came to be. Three of the principle explanations for the presence of death, according to T.P. van Baaren, are: death is often seen to be the normal destiny of man as part of a divine plan (a divine economy, to prevent overpopulation); it occurs because some divine or mythic being gave rise to it; or it is the result of some human shortcoming, misdeed, misjudgment or wrong choice (the latter frequently stems from curiosity and disobedience). Although there are myriad variations in the details of beliefs about death, indigenous societies universally believe that there is a place where the spirits or souls of the dead go. And, nearly universally, the living must assist the dead in making the final transition, otherwise the spirits may wander forever, or may remain to haunt and disrupt human society. The death "industry" involves preparation, purification and disposal of the corpse; sacrifice; making and building various props (memorials, effigies, architectural structures) to be used in ceremonies; and, finally, the rites themselves which include feasting, recitation, song and dance to send the dead on their way. The still living experience complex emotions with regard to death, the predominant ones being rejection, guilt (for continuing to live) and grief. In all cases, the rituals serve not only to honor, dispatch and liberate the dead, but also to protect and revivify the living. The honored dead continue to interact with their descendants in the form of ancestors. It goes without saying that funeral ceremonies are more elaborate for

individuals of great importance, such as chiefs and shamans. This is true not just because of their status, but because their deaths represent the greatest disjunction for society. For some of the most elaborate funereal rituals see New Ireland MALANGGAN. For deities associated with death, see INDEX: Deity Archetypes.

Deble. This word is used in the literature to identify SENUFO elongated figures, which range from fairly naturalistic to quite abstract, often called rhythm pounders because those carrying them swing them laterally and pound the ground with them. *Deble* is a corruption of the Tyebara name for a bush spirit.

Deer. See INDEX: Animals.

Deity Archetypes. This vast subject can only be touched on here. Sources for further study are Stith Thompson's *Motif-Index of Folk-Literature*, Nancy E. Auer Falk's entry on "Feminine Sacrality" and M. H. Kaliman's on "Masculine Sacrality" in *The Encyclopedia of Religion*. Creator gods vary in gender and may be anthropomorphic or animal in form. In many cultures a plethora of creators generates various aspects of nature, human beings and even contributes to the quality and shape of human life by providing the models for artifacts and rituals. In cultures where there is considerable complexity, the supreme god frequently remains remote from his creation while lesser deities continue to interact with human beings. Deities often overlap categories, e.g., CULTURE HEROES can also be TWINS who fill CREATOR roles as well as bringing "culture" into human affairs. For those deities referred to in this volume, a simplified categorization appears in the INDEX: Deity Archetypes.

Dema. See MARIND-ANIM.

Diaspora. The breaking up or scattering of a people. In the three areas of the world examined in this volume, Africa was most affected by diaspora. Many Native Americans were removed from their original homelands and forced to travel long distances, experiencing extraordinary physical and mental suffering (see TRAIL OF TEARS and the NAVAJO Long Walk). However, although their treatment was tragically demeaning, the establishment of reservations enabled societies to remain physically intact. The African diaspora—the Atlantic slave trade—involved the displacement of hundreds of thousands of West African peoples. The YORUBA, KONGO and FON, in particular, despite long histories of urban civilization, were ripped from their homelands, subjected to horrendous journeys and harsh working conditions in Cuba, Brazil, the Caribbean and the United States. Robert Farris Thompson has pointed out that the Yoruba had been diasporic prior to the Atlantic slave trade, through trade and travel. As he puts it, "…no matter where they went or what happened to them they knew who they were and how to maintain their self-sufficiency" (*Face of the Gods*). They carried with them religion and the art forms intimately associated with it, but because of their enslavement, concealment and invention were necessary. Thompson refers to the resulting "creative adjustments" as offering a "sense of rootedness" that continues to appeal to migrants today. See EGUNGUN, SANTERIA and VODUN.

Didjeridu. Australian Aboriginal dronepipe made of wood naturally hollowed out by termites, fitted with a wax or hardened gum mouthpiece. Three to five feet in length, the *didjeridu* originated in Arnhem Land and spread from there to the Kimberleys. Capable of delivering a wide variety of sound effects, the instrument symbolizes Rainbow Snake, whose voice is heard at INITIATIONS and fertility rites.

Dikenga. The KONGO cosmogram depicted as a cross within a circle. The *dikenga* represents the Kongo concept of the soul as a miniature sun, mirroring the circular path of the sun, rising above the horizon, mounting up into the sky, where it shines like a star, setting to traverse the land of the dead beneath the horizon and rising once again. The *dikenga* is a symbol of the CENTER, the meeting of the FOUR/SIX DIRECTIONS and the crossroads. Robert Farris Thompson suggests that the concepts underlying the symbol—especially the cycling of souls—are incorporated into the art of numerous other African cultures (*The Four Moments of the Sun: Kongo Art in Two Worlds*). For instance, the facial features of KOTA reliquaries are distributed inside a cross contained within an oval. See also BEMBE and TEKE. Furthermore, the *dikenga* appears in the art of the Africans dislocated by the diaspora to Cuba and the southern United States.

Dilukai. HERALDIC WOMAN found over the doors of BAI houses in Belau. The figure faced the rising sun and was surrounded by planks called *bagei* carved with

erect phalluses pointed at her. *Bagei* is also the name of Dilukai's brother as well as a noun meaning "married." The entire complex augments other symbolism on the *bai* linked with wealth and fertility.

Dinka. See EASTERN AFRICA.

Directional Symbolism. Robert Hertz seems to have been the first to note the widespread use of left and right symbolism in world religions. He suggested that such symbolism is rooted in the general human experience of facility associated with the right hand and clumsiness and lack of control with the left. The duality is said to have given rise to a number of analogous pairs in which the positive half (the first item in the following list) is linked with the right side: male/female, light/dark, order/disorder, sun/moon. For instance, the MAORI say the right side of the body is male (*tama tane*), strong, lucky as well as being connected with vitality, health and virility. On the other hand, the left side is female (*tama wahine*), weak, listless, unlucky and is linked with misfortune and death. The arrangement of images in the Hawaiian HEIAU reflects directional symbolism: the female images are placed on the left and the male images on the right. The interior space of the Navajo HOGAN is said to be male on the south and female on the north; the entrance always faces east. In Africa, the right hand is connected with power and identity. For instance, Igbo IKENGA sculptures embody the force of

the right arm and hand, symbolizing the purposeful activity of individuals. *Ikenga* shrines also connect individuals to their ancestors as do Kongo NIOMBO figures, which contain the bones of ancestors. *Niombo* stand in what is called "the cross-roads pose," arms stretched out to the sides at right angles to the body. The right hand is raised, palm up, invoking God, the sky and the law as well as blocking the negative powers of witches. The palm down left hand indicates the horizon, the threshold between life and death. Thus, such figures are located at the center and act as intermediaries between the living and the dead. See also CENTER, FOUR/SIX-DIRECTIONS.

Divination. Various methods of foretelling the future exist in indigenous cultures, some of which involve numerical systems, while others entail the reading of random and accidental signs. In Micronesia divining knots are folded from coconut leaves. Divination in the Baule culture of Ivory Coast is carried out by trance diviners, males and females who have experienced the calling and initiation of a shaman, and have learned to control their spiritual possession and trance states. These individuals dance in public divination performances and make pronouncements on individual and community-wide matters.

DIRECTIONAL SYMBOLISM

Below: The chests of TABWA figures from Zaire are divided in half by a vertical line. The right side was associated with maleness, birth and vitality and the left with femaleness, death and dependency. The vertical axis connects the head (intelligence) with the abdomen (sexuality). The division expressed the Tabwa worldview based on a dualistic struggle between good/evil, light/darkness and fertility/sterility. Furthermore, the isosceles triangle called balamwezi, meaning "the rising of the new moon," frequently found on figures and other Tabwa objects refers metaphorically to cyclical renewal, hope, courage and positive action. The points of the triangle signify the balancing of opposites, with the moon at the apex. The triangle also symbolizes the dual and ambivalent dangers of power—the chief's ability to benefit or harm society.

Baule trance diviners' kits include hats, mallets, display weapons and iron gongs. Diviners also own sculptures of human figures that are among the most beautiful and finely crafted of all Baule objects. Ironically, they are rarely seen, because of their power. Baule diviners also practice a non-trance method of divination using mice. A field mouse is kept in a cylindrical vessel. As it feeds, the mouse displaces batons attached to the side of the tortoise-shell tray within the vessel. The diviner then reads the patterns of displacement. Yoruba Ifa divination involves throwing palm nuts, cowry shells or casting chains, the fall of which is read according to a complex body of oral literature. While the throws involve chance, the patterns are read numerically, referring to *odu*, an ordered system of oral literature. Bamana and Dogon diviners lay out grids in the sand to divine the future. Bamana diviners use mathematical sets to foretell coming events (see NUMBER SYMBOLISM). Dogon sand grids are set out in the evening with food bait that attracts animals. The diviner interprets the marks, believed to be made by Yurugu, the pale fox, left in the sand during the night. In all cases, the aim of the diviner is to allay the confusion of daily life by revealing its underlying order. See INDEX: Divination in Miscellaneous.

Djanggawul Cycle. One of the most important creation myths of aboriginal

DIVINATION

Left: Baule mouse divination vessel. Made of wood and terracotta, with a metal lid, this vessel has become an icon for Baule art. Collected in the early 1930s, it may have been made in the 19th century.

DJANGGAWUL CYCLE

Below: Carved painted figure of Djanggawul Brother by Madaman, depicting Djanggawul as he came ashore on Arnhem Land, his face dotted with sea foam and the sacred dilly bag hanging around his neck.

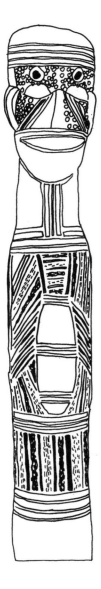

Australia, the cycle is associated with the KUNAPIPI CULT. The myth tells how two sisters and a brother came to the ancestral homeland in northcentral Australia and there gave shape to the land. The first humans were born from their union and the sisters, in particular, are responsible for replenishing the earth. Originally, the two sisters controlled the sacred totems, but eventually they were stolen by their male offspring who thereby gained control over women—the sisters note, however, that it is only women who have the power of giving birth. The woven mat (*ngainmara*), symbolizing the sisters' uteruses, is coupled with male poles (*rangga*) underlining the necessary and basic complementarity of male and female. The Djanggawul are the ancestors of the Dua, one of two moieties occupying the area; the other moiety progenitor, Laindjung is depicted as the barramundi fish.

Djenne. The word Djenne, from the name of the ancient city in the inland delta of the Niger River, is used to identify small bronzes and impressive terracottas found throughout the area and dating between the 12th and the 16th centuries. Many of the bronzes and small fragments of terracotta figures have come to light as a result of looting, but systematic excavations in Djenne itself over the last twenty years have led to the discovery of a number of intact large-scale figures. The style of these figures varies from area to area, with those from Djenne itself being the most sophisticated. Their highly modeled bodies are decked with elaborate jewelry and clothing and the skin is marked with impressed stamps, drawn lines and sometimes a wealth of bumpy protrusions suggesting some disfiguring disease. Their purpose is speculative, but contemporary Arabic sources condemned animistic cults in the area, so it is likely that they served as cult images. Serpent imagery is common, and the figures' poses and wide-open eyes often

suggest awe and adoration. They may have also commemorated the dead or depicted myths. Mounted riders appear, examples of the "rider-of-power" theme, which are similar to Dogon sculptures. Many of the bronzes are actually (mis)identified as Dogon—it is suggested that a single family of metalworkers, of unknown ethnicity, produced these sculptures for both the people of Djenne and the Dogon. The Djenne people appear to have left the area, forced out by the Moroccan invasion of 1591. As more excavation is carried out in this area, the relationship between Djenne and the Dogon may be better understood. It is clear even now, however, that Djenne artistic traditions had great impact on the Dogon, and may even be said to be continued by the Dogon. See SUDAN for the present-day mosque at Djenne.

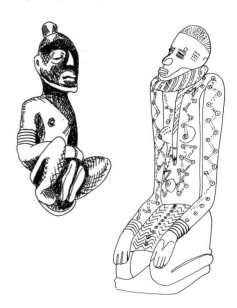

DJENNE

Above left: The closed eyes and reclining pose of the small bronze pendant figure suggest a shamanic trance.

Above right: The kneeling pose and the snake coiled around the terracotta figure's neck may indicate a ritual practice. The stamped decorations pick out scarification patterns on temples and breast, body painting and a zigzag textile patterned skirt.

Dluwalakhu. With the HAMATSA, one of two Kwakiutl masking societies. Dluwalakhu is the supernatural gift-giver associated with the social side of human life—with the hierarchical status system, clan crests and the POTLATCH. The other side of a duality, the Hamatsa society is concerned with the supernatural realm and the forest.

D'mba. The most famous Baga mask, see NIMBA.

Do . An ancient cult found among the BWA and Nunuma of Burkina Faso. Do was the son of the creator god, a wild bush spirit represented in the form of costumes made up of vines and leaves. Do masqueraders appeared in spring renewal rituals called *loponu*, held before the coming of the spring rains. The masqueraders entered the villages with the rising sun, danced and made sacrifices, finally disappearing in the direction of the setting sun. The costumes were then cut up and burnt. In some areas, the Do tradition came into conflict with the newer wooden masking tradition, while in others, the two coexisted peacefully. Also see BUTTERFLY and Dwo in BOBO.

Dog Blankets. Athapaskan dog blankets, generally made in sets of two, four or six, were embroidered on velvet with multicolored fringes and ribbons. They were used for special occasions. Usually people stopped a few miles before their destination and put on their finery so as to arrive in a flurry of color and excitement. Designs were symmetrical, either side of a broad strip, usually red in color, which lay across the saddled dog's body. Bells were sewn on this transverse strip. Round collars of leather were often attached and had a standing iron hoop decorated with ribbons, pompoms, animal tails and feather dusters. These were not just decorative, as the movement and brilliant color helped the driver keep his direction in low visibility.

Dogon. The Dogon of Mali are a Voltaic-speaking group that, according to oral history, settled in their present homeland between the 14th and 15th centuries. Dogon mythology tells of a snake that led the people to the Bandiagara Cliffs at the southern end of the plateau where they conquered and drove out existing peoples, the TELLEM and Niongom. Dogon lands are arid, but annual rains provide enough water for subsistence farming. The delicate balance of life, depending as it does on rainfall, led to art and religion dominated by prayers for rain and for the health of the crops. The Dogon have been focus of intense ethnographic, anthropological and art historical interest because of the extraordinary richness of their cosmology and art. Researchers from various European and American backgrounds contribute a wealth of information about Dogon culture which is sometimes conflicting. Recent discoveries at DJENNE and elsewhere in the Inland Niger Delta show styl-

DOG BLANKETS

Below: This KUCHIN blanket from the Mackenzie River must have glittered against the white snow with its ornamentation of colorful seed and metal beads on velvet with worsted wool braid edging. Two rows of sleigh bells are attached in the center. Late 19th century.

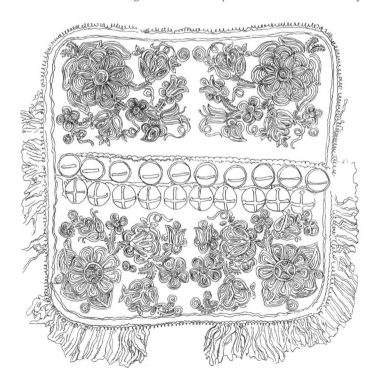

DOGON

*Above: This standing
female figure is attributed
to the Master of Ogol
after the village where this
piece was collected.
Characteristic of this
artist's work is the complex
interlocking of horizontal
and vertical forms and
planes, especially the
stacked bands of chin,
lips and nose.
Collected, 1935.*

istic continuity between the ancient cultures of that area and the Dogon. The principal Dogon art objects are figurative sculptures representing lineage ancestors, some seven dozen types of masks mostly for funeral rituals, iron figures and staffs, stools, neckrests, various containers and jewelry. Dogon architecture includes granaries embellished with carved doors and shutters, TOGU NA men's meeting houses supported with carved and painted posts and finally, houses and shrines with facades divided into eight rows of ten niches representing the eight ancestors and their descendants. The niches are said to be the homes of the ancestors, who occupy them by birth order from the top left.

Dogon Cosmology. According to Dogon myth, Amma created the universe and everything in it. According to one version, Amma's original form was an egg with four collarbones. By an act of self-fertilization, he created two sets of TWINS and human beings. Another version indicates that Amma first created NOMMO, a water spirit, who soon multiplied, becoming four pairs of twins. Great importance is placed on these eight original ancestors, especially Lebe, and on clan "immortal" ancestors and lineage ancestors to whom shrines are

dedicated in family residences. Rituals enshrine ancestors and the ancestors are "revived" in annual celebrations following the harvest. Funeral rituals are observed for individuals and the great Sigi festival that occurs every sixty years commemorates the first death, that of Lebe, and re-creates the "great mask" made to contain Lebe's spiritual force. One of the original eight ancestors, Lebe is the embodiment of the fertile forces of nature, agriculture and the renewal of the earth and vegetation. According to Dogon myth, after Lebe was buried, the people dug up his bones to take them along when they moved. Instead of bones, they found a living snake, evidence of Lebe's regenerative powers. To their new homes, they carried earth from the grave and erected altars, also called Lebe, into which some of the regenerative earth was incorporated. Once they had fulfilled the role of CULTURE HEROS, sending to earth in an ark everything humans needed, the Nommo continued to act as water spirits and overseers of the universe. The *hogons*, Dogon religious and political leaders, are the priests of Lebe. The landscape itself is sacred and is dotted with altars, shrines, mounds and sacred pools, stones and caves. The Dogon have changed in response to late-20th-century pressures, but they still seem to be one of the most integrated cultures on earth. Art continues to be produced and plays a major role in the lives of these people. Images of paired figures identified as the Primordial Couple are among the most famous Dogon images. Kate Ezra

DOGON

*Left: Residence of a lineage head, the ginna has a
facade characterized by a grid of niches. The
ancestor altar is sometimes stored over the door,
protected by a wooden shutter. A granary stands
to the left and a ladder leans against the wall on
the right. Such ladders served a functional pur-
pose, but also likely symbolized the family tree and
ancestral lineage. After a photo by Eliot Elisofon,
Ogol du Haut, 1970.*

suggests, in *Art of the Dogon*, that such paired figures would be more accurately called "ideal couples," indicating the balance between male and female roles. See also YURUGU, the pale fox and INDEX: Deity Archetypes; Egg In Natural Phenomena and Materials.

Dogon Masquerades. With about eighty different types of masks, the Dogon may very well be the most prolific mask makers in the world. Most of them are made by the blacksmith, the exception being the famous *kanaga* masks made by initiates of the Awa, the men's masking society, for their own use. *Kanaga* masks are the most numerous of Dogon masks. They are in the majority among as many as 300 masks that may appear during the *dama* funeral ritual. Death causes a disruption, allowing chaos to descend on society. The earlier phases of *dama* rituals act out the chaotic conditions with mock battles and noisy, disorderly dances. Gradually, the Awa society restores order and transforms the spirits of the dead from dangerous and destructive forces into honored, supernatural ancestors well disposed toward the living. The rituals also serve to enhance the prestige of the deceased and his family. The variety of masks that participate might possibly be

DOGON MASQUERADES

Above, left to right: Kanaga masks are characterized by architectonic faces topped by a double-barred cross, the arms of which end in short vertical elements. Griaule was told that the superstructure represented a bird with white wings and a black face, but he later came to realize that this interpretation represented the understanding of non-initiates. Along these same lines, the mask is also said to be the mythological crocodile. The deeper understanding of initiates makes it possible for them to see the mask as a diagram of the cosmos, the top bar representing the sky and the lower one the earth; or alternatively, the arms and legs of Amma. The architectonic quality of both the face mask and the superstructure is comparable to Dogon house façades.

Satimbe masks recall the ancestral female who originally discovered masks. The female figure atop satimbe masks may depict yasigine, the "elder sisters" of the masks, women who are born during the Sigi festival. Such women, who provide food and drink during festivals, are the only female members of the Awa society. Their conduct transcends gender roles.

Rabbits and antelope are among the many creatures represented in Dogon masks. They appear during the first three days of dama (the funeral ritual) and, as denizens of the bush, express their dangerous, chaotic and supernatural control over human affairs. This rabbit mask consists of a classic Dogon face mask topped by a very long-eared rabbit face. The entire surface is covered with painstakingly applied dots, which creates the impact of unified, vibrating planes. Collected in 1931.

The sirige mask is a smaller version of the Great Mask that appears only during the Sigi festival, said to embody the nyama, the life force of Lebe, the first ancestor to die, reincarnated as a snake. Unlike the Great Mask, the 15- to 20-foot sirige masks are actually worn to perform strenuous, athletic dances. Their openwork structure resembles a multistoried house and many generations of people. Painted black, white and red, the checkerboard patterns are also likened to those of strip-woven funeral shrouds. While other dama masks represent individual beings, the sirige mask represents the collective life force of nature and the ancestors.

thought of as representing the inchoate forces of the universe, as they sort themselves out and take solid, material form. *Sim* masks have the same cross-shaped superstructure as *kanaga* masks, but they are made of thin, flexible wands of palm wood. Their anthropomorphic bodies seem unfinished, ungainly and extremely fragile. The many animals represented recall clan ancestors who took animal forms as well as recreating a sort of primordial paradise teeming with birds, rabbits, antelope, monkeys and many other creatures. *Satimbe* masks are topped by seated, kneeling or crouching female figures and are said to represent the female ancestor who obtained masks from the original inhabitants of the area. The men usurped the masks without understanding their power resulting in the coming of death to the formerly immortal people. Ever since, the Awa society, consisting largely of men, is responsible for instilling knowledge of the nature and powers of the masks as well as performing to assuage the anger of the dead and to bring order out of chaos. The most important mask of all, the Great Mask (*imina na*, "Mother of Masks") is not worn, but instead is carried, appearing only once every sixty years at the SIGI FESTIVAL. Measuring up to twenty feet or more, the mask is said to represent the living snake that was found when people dug up the bones of the first ancestor to die. The mask is regarded as containing *nyama*, or life force and it symbolizes the continually regenerating powers of nature.

Dogs. See INDEX: Animals.

Dolls. In some indigenous cultures, girls are given dolls to play with. Since researchers often regard these as insignificant, they do not often make it into scholarly literature unless cultural meaning is attached to them. Among the MOSSI people of Burkina Faso, little girls play with dolls that are well represented in Western

collections because of their collectability and elegant forms. These are reported to be playthings, however, older Mossi women use dolls to promote fertility in the same way that the Akan people use AKUABA figures. Among the Asante, once conception has occurred, these "dolls" serve as embodiments of ideal beauty that protect the pregnant woman and her child and guarantee the safe birth of a beautiful child. Hopi KACHINA DOLLS are deeply significant teaching aids for Hopi girls who learn the names and attributes of the spirits from handling them. Equally significant are the Yoruba IBEJI twin figures, carved to protect the twins and their families. Although these are not normally categorized as dolls, recently plastic dolls have been replacing Ibeji sculptures. The ZULU also make beaded dolls that are often called "fertility" dolls.

Dongson (also Dong-Son). A distinctive curvilinear style named after a metal-using culture based in northern Vietnam. Douglas Newton notes that the dates of the style are "somewhat elastic," i.e. 500

DOLLS

Below: Mossi doll from Ziniare, Burkina Faso. Mid 20th century.

DONGSON STYLE

Right: Ceremonial bronze axe blades cased in a single piece with the handles. Roti Island, southwest of Timor.

BCE to 100 CE (or, at its most expanded range, 1000 BCE to 500 CE). Bronzes of some antiquity have been found in OCEANIA. Newton points out the fallacies involved in Heine-Gelderen's identification of the Dongson as the pivot of a diffusionary system originating in Shang and Chou China and distributed throughout Indonesia and MELANESIA. However, whatever the mechanisms for their dispersion, Dongson designs clearly influenced curvilinear patterns in certain areas of Melanesia and Polynesia. Also, an important Dongson motif, the "ship of the dead" or SOUL BOAT, was influential as well. See Asmat BIS POLES, CANOES, MASSIM, SOLOMON ISLANDS and TURTLE.

Doors and Thresholds. The symbolic dividing line between secular/exterior space and sacred/interior space is often dramatically delineated in indigenous architecture. The doors of homes and palaces are oriented symbolically. For instance, the Navajo HOGAN faces east to greet the first rays of the rising sun. In Africa, the rising and setting sun flooded through the doors of the KONGO royal palace of Mbanza Kongo, located high above the city on an east-west axis. In this culture, the horizon was regarded as the threshold, the meeting place of two mountains. The upper mountain was the land of the living and inverted beneath it was the land of the dead. Human souls, like miniature suns, moved back and forth across the threshold, alternating between life and death. Doors and thresholds also protected those who lived within. In New Caledonia, KANAK chief's house doors were ornamented with posts recalling recent male ancestors and a threshold with a face representing the "all-seeing one." Shield-like doors protected the fronts of Haida houses and the collective power of totems adorned housefronts, houseposts and totem poles all along the Northwest

Coast. While Northwest Coast houses model the cosmos, men's meeting houses in the Pacific frequently are thought of in terms of female anatomy. Throughout Polynesia doors are topped with female figures with widespread legs (see HERALDIC WOMAN). Passing beneath the legs of the figure not only marked entry into the sacred space, it also symbolized re-entering the womb, as the house itself was conceived of as the body of an ancestor. In other cases, the threshold is sometimes the separator between life and death. SKY DOORS, circular openings in Solomon Islands funeral monuments are thresholds through which souls pass. See also IBEJI, LIMINAL STATES and LONGHOUSE. For illustrations of three doors see NAVEL, SWAHILI COAST and YORUBA ARTISTS.

Dragonfly. The dragonfly appears frequently on objects from the Great Plains such as shields, clothing and personal adornment. The speed and darting movements of this insect were admired and warriors wished to emulate them in battle and ceremony.

Dreaming (also Dreamtime). Aboriginal Australians believe that before a person can be conceived, the child's father or a specialist dreamer (*banman*) must dream its spirit. This helps in understanding the complex and universal concept of the Dreaming. The world itself and all things in it were created in the dreams of the primordial spirits. These ancestral spirits in the form of animals, inanimate objects (stones) as well as those having human qualities and shape-shifters, journeyed across the face of the land (or dreamt of the journey), interacting much as humans do. Their actions created and transformed the land, leaving behind traces of their forms and spiritual force, which remained even after they withdrew. Although they withdrew, the ancestors are still present, as

the entire land is conceived of as an eternal, living entity, replete with their spiritual essence. People maintain/restore balance by reenacting ancestral journeys (WALK-ABOUT), through rituals that utilize the patterns the ancestors left on the land and by observing the rules laid down in the Dreaming and handed down through oral traditions. Among the most important ancestors was RAINBOW SNAKE.

Dreams. Dreams are powerful agents in indigenous societies. Unlike in the West where little heed is paid to dreams, they carry great significance. They are regarded as a separate, but no less real state of being. In New Guinea, the Kwoma word for soul is *may*, meaning "shadow," "reflection in a mirror or water," or "image in a photograph." The *may*, which resides in the head, is responsible for consciousness and rational thought. It leaves the body during sleep and sits beside the body or wanders the neighborhood, re-entering when the individual awakens. Awakening people too quickly is believed to cause disorientation as the *may* has not been able to return. Furthermore, the Kwoma believe that dreams arise from the soul's journeys. The images in dreams are the YENA spirits, the totems connected with life and well-being. After death, the *may* becomes a ghost. The images on Kairak Baining masks are said to originate in old men's dreams. The entire worldview of Australian Aboriginal peoples is wrapped up with the concept of the Dreaming, or Dreamtime, but the dreams of living people are important too. The Walbiri, for instance, believe that the designs in both men's and women's art are revealed to them in dreams. And several Australian people believe that the conception of children occurs as a result of dreams. Among North American peoples, dreams—or as they were more often called, "visions"—were tools for contacting and interacting with the forces of nature, espe-

cially the individual's guardian spirit. Dreams were generally kept secret as it was believed that telling them lessened their power. Since the guardian spirit was indwelling, self-directed designs on clothing were intended to please and honor the spirits. Hugh Brody reported that the Athapaskans of northeast British Columbia spoke of their ancestors' ability to dream of the hunt, including dreaming maps. Good men dreamed of heaven and the maps to get there. These maps began where all the animal trails came together and showed misleading trails to avoid as well as the true path. Brody's informants had lost the ability to dream in this way, they told him, due to too much drinking, too little respect and people weren't good enough. The Mojave of California and the Great Basin learned the myth and ritual of their people through communal, lucid dreams. In Africa, ancestors and spirits communicate with the living in dreams. Finally, both the form and content of art work is frequently said to occur in dreams which artists then render. Ruth Bunzel was told that women who shaped Pueblo pottery dreamed their designs. Mabel McKay, the famed Pomo basket maker, was said to have dreamed her designs. See INDEX: Dreams in Miscellaneous.

Drift. A concept in the field of Anthropology used to explain style change. Fieldwork has shown that artists rarely copy their own or the work of others and yet the style of art changes gradually over the passage of time. The prerequisites of drift include the differences of one piece from others in one or more ways, and that the direction of change is unaffected by considerations of practicality (i.e. changes do not occur in ways that make objects more effective when used). Richard Anderson speculates that drift occurs because people prefer works of art that differ slightly from earlier, traditional models. The preference may be explained by the

openness within the culture to individual taste; by the desire among the elite for unique, high-quality art objects that are not debased by copies by commoners; or by the value even the most traditional societies place on inventiveness and adaptability as a human trait. On the other hand, change that is too rapid or exaggerated may undermine the social structure, may disrupt the response to works of art based on its reassuring and unchanging forms, or may result in ridicule.

Drinks. Fermented and hallucinogenic liquids are found in both social and ritual contexts all over the world. The mildly intoxicating narcotic drink KAVA (*ava*, and in Hawaii '*awa*) was ritually consumed in the Pacific. In FIJI, *yaqona* (the Fijian name for *kava*) infused from a pepper plant (*Piper methysticum*), was ritually consumed as part of RITES OF PASSAGE ceremonies. Special vessels for this beverage sometimes took anthropomorphic form. In North America, the roots of the powerful HALLUCINOGEN datura were made into infusions by Chumash shamans and carefully dispensed to initiates. The shamans also ingested datura to aid them in achieving trance states. In Africa the MANGBETU drink hallucinogenic *naando* from elegant anthropomorphic pots. Palm wine is consumed in Africa and drinking horns are among the regalia of BAMUM royalty. For other references to palm wine see ANATSUI and YORUBA PANTHEON. The ZULU people offer beer to their ancestors and drink it out of special vessels.

Drum. The repetitious rhythm of drumming is one of the most powerful aspects of ritual—people enter alternate, often ecstatic, states as they respond to the sound. Recent studies have shown that physiological changes take place. Drums come in all shapes and sizes and are made of myriad materials. Arctic SHAMANs' drums often

have cosmic diagrams on them, picturing the HELPING SPIRITS and the WORLD TREE by which the shaman enters other realms. Plains, Great Lakes and Woodlands shamans' drums often follow the same practice (see SHAMAN, Anishnabe drum). The first ASMAT drum was made by FUMERIPITS. The culture hero/creator god played it to bring to life the lifeless wooden human figures that he carved as well. The Asmat believe themselves to be descended from trees, and that their very lives sparked into being to the beat of a wooden drum, a story that has interesting implications for drumming in the rituals of living peoples. As in the mythological past, present people may conceive of their drumming as bringing the images of the ancestors momentarily alive as long as the sound of the drums animates them. See also HULA and INDEX: Musical Instruments in Art, Artifacts and Techniques.

Duk-Duk. A TOLAI secret society and male mask type linked to the powers of the chief in NEW BRITAIN. Also see TOLAI for the female *tubuan* mask.

Dzonokwa. See TSONOQUA.

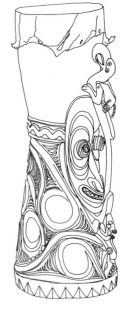

DRUM

Above: IATMUL hand drum, East Sepik Province. Cassowary birds are carved at both ends of the drum's handle. Collected in 1909.

E

Below: Two male figures lie just below the crest of a ridge near Fort Mojave, Arizona. They were made by scraping away surface stones. Known since the late 19th century.

Eagle. The eagle is the king of the birds in North America, associated with bravery, visual acuity and strength. Its majestic appearance, the mysterious inaccessibility of nesting sites and the seemingly impossible heights to which it flies all add to its power. The bird appears in mythology, as a clan totem, as well as on innumerable art works including pipes, clothing, shields and beadwork. Its feathers are the most valued of all (see FEATHERWORK and WAR BONNETS). Among the CHU-MASH, Slo'w the Golden Eagle was one of the players in the annual cosmic game that pitted the Sun against Sky Coyote. The outcome of the game affected human fortunes, since it determined the weather for the next year. Additionally, the eagle was associated with death and the afterlife, the place where all the bones of the dead went. Eagle and Raven are the two major HAIDA CRESTS and the great Northwest Coast deity Thunderbird can be thought of as Eagle's supernatural counterpart. The Hopi capture young eagles or hawks and hand-raise them, releasing the mature birds to carry messages to the Spirit realm regarding the exemplary behavior of their human hosts (see FEATHER-WORK). Although the eagle is not quite so important in Oceania and Africa it does appear. The white-tailed eagle, for example, revived the Asmat culture hero FUMERIPITS by pressing smoldering wood against his body. And at GREAT ZIMBABWE monumental sculptures depicted eagles, believed to be intermediaries between the gods, ancestors and the living. Furthermore, the eagles symbolized royal power. For other entries, see INDEX: Animals.

Earth Diver. A common mythic theme in Native North American creation myths. The earth diver, usually an animal, dives to the bottom of the primordial waters and brings back the sand or dirt to create solid land. Several failures by other creatures may take place before the earth diver succeeds. And success is hard won, as the creature is exhausted and nearly dies in the effort. The sand or dirt has magical properties and is able to float and increase. Sometimes it is supported on verticals (pillars, upright snakes or trees). See INDEX: Animals.

Earth Mother. See INDEX: Deity Archetypes.

Earth Works. Large-scale movement of earth to create geometrical and effigy-shaped mounds was characteristic of North American Woodlands societies, e.g., CAHOKIA, GREAT SERPENT MOUND and POVERTY POINT. In the Southwest, human figures were scraped into the earth near Ft. Mojave, Arizona. A 19th-century account tells of a dance which the Mojave said represented their creation myth: "Where the big medicine man representing the Judge (the Creator) was to stand was marked thus, and near this on the ground was traced a hieroglyph...which bore some slight resemblance to the figures of a man, woman, and a child or of three grown persons tied together."

Easter Island. One of the world's most isolated cultures, Easter Island was probably settled from the Marquesas in 400 CE with a second wave arriving in 1400 from central Polynesia. The people of the island call the island, their language and themselves Rapanui. Tattoos, pigmented with a natural blue powder in patterns found also on petroglyphs, covered the entire body. Although sculpture made from bark cloth exists, stone and wood sculpture (arranged in ten categories) is more characteristic. In fact, the monumental stone figures (MOAI) and the small wood ones (MOAI KAVAKAVA) are among the most memo-

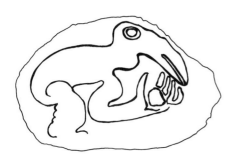

rable sculptural objects in the world. The people of Easter Island also developed what may be a writing system (found only on twenty carvings called *kohau rongoron-*

go, the antiquity of which has been questioned) which is as yet undeciphered. The tablets are thought to be objectified representations of chants "read" by specialists while reciting genealogies and during important ceremonies. See map: OCEANIA and DANCE PADDLES.

Eastern Africa. By 8000 BCE people who depended upon herding cattle and hunting and gathering settled East Africa. Rapid change occurred after the beginning of first century CE with the arrival of the so-called "eastern stream" of Bantu agriculturalists and later with the introduction of the Indian Ocean trade. Today, the areas of Tanzania and Kenya are inhabited primarily by cattle herders such as the MAASAI whose cattle herds, gifts from God, are directly connected with their idea of wealth and status. Art forms among the pastoralists are mostly portable, including elaborate costume, jewelry and hairstyles as well as beautifully made utilitarian objects such as the wooden containers made by Turkana women. These objects form a display that clearly expresses differences of age, gender and status. Gender divisions exist with women making beadwork, decorated gourds and certain jewelry items, while men sculpt the hairstyles and carve their own headrests and staffs. Headrests are distinctive prestige items in eastern Africa, serving to protect the elaborate male hairstyles preferred among the pastoralists—women wear their hair simply or shave their heads focusing attention

EASTERN AND SOUTHERN AFRICA

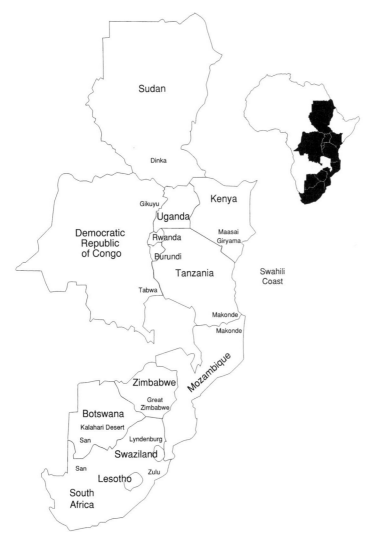

clear in the art of the SWAHILI COAST and may also play a role in the grave and memorial posts of the Mahafalay and GIRYAMA. The Nyamwezi of Tanzania carved high-backed stools, "seats of power" for 19th-century chiefs and a powerful figurative sculptural tradition is evident among the Nyamwezi, Kamba, Sakalava and Zaramo, as well as among various peoples in Malawi, e.g., the Yao. The MAKONDE who live in Tanzania and Mozambique are among the most prolific carvers of masks and figures in eastern Africa.

Edan. Yoruba paired male and female brass figurines, connected by a chain worn around the neck of OGBONI society members.

Edenshaw, Albert Edward (1812–1894). Legendary Haida artist and founder of the Edenshaw line of artists that includes his nephew Charles Edenshaw whom, according to tradition, he chose as his successor. MacDonald writes that Albert Edward Edenshaw laid "the groundwork for his successors to nurture the fundamentals of Haida culture and assure its survival." Edenshaw achieved the status of chief in 1832 and lived in several locations, including Kung where he built House That Can Hold a Great Crowd of People with its famous house-front pole, which launched his career in woodcarving.

Edenshaw, Charles (Daa-x-ligang, c. 1839–1920). Successor to his uncle Albert Edward Edenshaw, Charles Edenshaw achieved fame in his own right. He became a chief in 1885, just at the time the POTLATCH was outlawed by the Canadian government. He is known for wood and argillite models and miniatures made for non-Haida, although he did carve for Haida patrons as well. His silver and ivory work was also important, as was the role he played as an informant for anthropologists and eth-

on jewelry, their symbols of status. In addition to serving as headrests, they are also used as stools. Although they somewhat resemble ancient Egyptian headrests, most Africanists prefer the word "parallel" to "prototype" to describe the relationship. Shapes vary from horizontal to crescent and some have a single columnar support, while others have legs. The type of headrest is a visual indication of the owner's age and status. Among the Somali people, headrests as well as monetary gifts form part of wedding ritual. Islamic influence is

nologists. The artistic line continues today as Edenshaw was the great-great-uncle of contemporary Haida artist BILL REID.

Edo. The name of a mid-15th-century supporter of the Benin warrior king Ewuare. The king named the centrally planned city of Ob-Edo after him, as without his efforts, Ewuare could not have taken the throne. Edo is also the name of the widespread culture and language of the area, which appears to derive from this heroic individual's name.

Effigy Figures. The literature on North American Plains art refers to a large class of objects as effigies. Most are carved in wood, but certain rocks and shells also fulfilled the same function. Plains peoples believed that supernatural powers could be transmitted through them to benefit or harm human beings. Effigies appear on war clubs, dance sticks, military society emblems and PIPES. They are also common features of various sorts of medicine ritual apparatus, such as small sculptures used in hunting medicine and the flutes used in courting and love medicine. Bowls and spoons for various ritual purposes also commonly have effigy handles or the entire object may take the form of an animal. SIOUX horse dance sticks vary from heads to quite detailed effigies with attached manes and tails and brass-tack eyes. These sticks were carried in ceremonies such as victory dances and to honor horses killed in battle. Although Sioux horse effigies are the best known, examples from the Blackfeet, Crow and Hidatsa are also known.

Egg. As in Western art, eggs symbolize fertility and immortality. Creatures like turtles and frogs, which lay dramatically large numbers of eggs, are often regarded as especially potent in this regard. Additional specifics apply, such as the ostrich eggs atop Moslem minarets in the SUDAN, which symbolize not only fertility, but purity. Kings sometimes appropriate egg symbolism, as for instance the Fon ruler, King Gbehanzin. The egg was one of his divination signs and personal icons and was linked with his very name, made up of the first three words of a phrase that translates, "The earth holds the egg that the universe desires." Finally, World Egg creation myths connect life, fertility, purity and immortality presciently with a globular-shaped earth. See INDEX: Egg in Natural Phenomena and Materials.

EDENSHAW, CHARLES

Left: Edenshaw painted the designs on this finely woven clan hat made by his wife Isabella. Such woven hats mimic the shape of the carved wooden hats that were at the top of the hierarchy of Haida objects. Late 19th-century.

EFFIGY FIGURES

Below: Teton SIOUX horse effigy dance stick. This elaborate stick is over three feet long and has traces of paint as well as attached mane, tail and tack. Described as a wounded horse, the three-dimensional, sculptural quality of this effigy is unique. Collected at Standing Rock Reservation, 1885–1910.

EGG

The YORUBA chant tells of the chaos that results when people do not perform proper sacrifices to the gods. On a deeper level, it seems to speak of the world as a shattered egg, irretrievably destroying the primordial World Egg.

The world is broken
 into pieces;
The world is split
 wide open;
The world is broken
 without anybody
 to mend it;
The world is split open
 without anybody
 to sew it.

—*Ifa verse*

Egungun. The YORUBA Egungun (the word means "masquerade") society honors the spirits of ancestors in the culture's most prevalent masked festival (see Colorplate 5). In addition to the annual festival, the masqueraders may appear at times of crisis within a family or town, such as death, disease or disruptions caused by witches. The energies of the ancestors are called upon to restore balance within the group. The cult apparently originated in Old Oyo and served the king by performing social control activities. After the 19th-century collapse of Old Oyo, it spread throughout Yorubaland where it is performed using various styles and forms of masks. While some Egungun costumes have wooden headdresses and masks representing humans and animals, those most closely connected with Yoruba ancestors consist of cloth ensembles. The cloth momentarily encloses the immaterial spirits for the peri-od of the performance and its inhuman formlessness contrasts dramatically with the firm, tangible bodies of the living. Some ensembles consist of tubular sacks, while others are composed of strip-woven fabrics sewn together, imported foreign cloth, stitched patchwork and layered lappets. These great mounds of cloth enable the dancer to create kaleidoscopic dances and some are designed so that the dancer can shift part of the costume and transform himself literally before the spectators' eyes. The costumes are the joint effort of a lineage group and their amplitude not only symbolizes and honors the ancestors, it serves also as status markers for the living. Egungun is a composite performance that includes praise poems (see ORIKI), music, especially drumming—two types of drums are used, the *bata* and the *dundun*—and dancing. Egungun performances are found among other groups, such as the FON of Dahomey as well as in the Americas, introduced by Yoruba displaced during the diaspora.

Ejagham. See CROSS RIVER.

Ekoi. A derogatory name used by the Efik, now largely abandoned in the literature, having been replaced by Ejagham (see CROSS RIVER).

Ekpe. Ekpe and EKPO are two secret men's groups in Nigeria and into the Cameroon. Although there is some crossover between the two, Ekpe is the more extensive. The word *ekpe* is Efik/Ibibio for LEOPARD and, in fact, Ekpe is often called the leopard cult. Other communities use their own word for leopard to identify their version of Ekpe. Ekpe's arena is primarily social control. The most famous Ekpe masks are the skin-covered realistic headdress/helmet masks from the CROSS RIVER region. Ekpe ceremonials include accession rituals, warrior performances, puberty rituals and enactment of relations

EKPE

Above: House emblem of the Ekpe association, Ejagham. Animal skulls form the "four quarter" motif also painted on society drums. The encrusted, aged accumulation strongly appeals to 20th-century Western aesthetic standards, no doubt increased by the hint of profound concealed meaning.

between the sexes and funerals. In addition to masks, another characteristic Ekpe society object is the so-called house emblem. These objects hang on the central post of the lodge house or on a wall in its inner sanctum. They consist of an accumulation of animal bones, carved wooden objects, medicinal leaves, rope and other elements attached to a woven cane mat with a raffia fringe. The animal bones are from association feasts. Often a drum is included as a symbol of Ekpe's legislative authority, as drums punctuate announcements made by the society crier. The "four quarter" motif likely is related to the concept of Ekpe as the center of the community (see CENTER, FOUR/SIX DIRECTIONS). Doubtless, there is additional esoteric symbolism involved. The assemblage, which may seem random and meaningless to non-members, carries significance for the initiated and serves as an emblem of membership. See also Igbo *ukara* cloth painted with the esoteric "language" of *nsibidi* (SIGN SYSTEMS — EJAGHAM/IGBO NSIBIDI).

Ekpo. Ekpo is a Nigerian age-grade society charged with maintaining proper relationships with ancestors. Society members play major political, legislative, judicial and religious roles in their communities. See IBIBIO.

Elema. The easternmost inhabitants of the Papuan Gulf, the Elema are well-known for their large bark cloth masks for two important rituals, the ten- to twenty-year *hevehe* cycle, and the less important *kovave* ceremony. The *hevehe* cycle, begun with the building of the enormous *eravo* (ceremonial house), is concerned with giant sea spirits living in the waters of Orokolo Bay. The ten- to twenty-year cycle culminated when the *hevehe*, or daughter-of-the-sea-spirits masks, issued forth from the *eravo* in a pre-dawn ceremony. *Kovave* spirit masks represent mythical spirits who lived in the

trees in the forest. During the cycle, the spirits were invited into the village, fed and induced to initiate the boys. During the initiation, the boys were led into the bush and the masks clapped on their heads. For the following month, the boys appeared in public wearing the masks, performing in comico-serious ways and receiv-

ing offerings of pigs from the villagers. At the end of the month, the boys returned to the bush, burned the masks and reappeared in society as adults. A third mask type, the *eharo*, was connected with the creation of a new door for the *eravo*. These masks, unlike the others, were not surrounded by secrecy. The Elema also make unique carved dwarf coconuts called *marupai*. The intricately carved, lime-filled patterns take on different aspects depending of the angle of view. From the top, they look like the designs on *gope* ancestor boards; from the side, they resemble animals; frontally, they appear to be stylized human faces. Carried in tightly woven mesh bags, they function as magical amulets, promoting wealth and

Below: Hohao, the most important of the three types of ancestor boards made by the Elema of the Gulf of Papua, are painted with stylized human body parts.

good hunting and protect against illness and bad magic.

Elema Ancestor Boards. The Elema carve ancestor boards with designs similar to their masks and shields. There are three types of relief-sculpted, painted boards called *hohao, kwoi* and *gope. Hohao,* the most important type, shows the oversized face of a particular clan ancestor. Kept in ceremonial houses, the boards were regarded as intermediaries between the spirit world of the creator beings, *kaiamunu,* and the material world. The designs on the *hohao* apparently represent the creator beings as shadows of heaven and spiritual leaders of the clan lineages.

Elephant. Among the South African SAN people, the elephant was one of several large mammals associated with rain and fertility. Generally though, the African elephant is one of the most frequent symbols of royalty as in CAMEROON, BENIN and KUBA art. At Benin, the elephant was a general symbol of physical power, leadership, longevity and wisdom. More specifically, the elephant represented the town chiefs, since their leader came from the village of the royal elephant hunters. The elephant's tusks were a royal monopoly and whenever a hunter killed an elephant he was obligated to give one of the tusks to the Oba before he could sell the other. Consequently, IVORY was used for some of the most important objects associated with the king's regalia, such as maskettes and plaques worn around the Oba's waist or at the hip; bracelets; trumpets and divination instruments. Most impressive of all were the whole tusks carved with ritual, historical and mythological scenes that rested on brass heads on BENIN ANCESTOR SHRINES. One last thread linking the Oba and elephants— the Oba's CORAL beads were strung on elephant tail hair which only added to its power. See INDEX: Elephant in Animals.

Eliade, Mircea (1907–1986). One of the great scholarly and creative minds of the 20th century. Born in Romania and educated in Hungary, Eliade was a prolific writer in the field of religious studies. His scholarly writing was creative, fluid and poetic which enhanced the profound con-

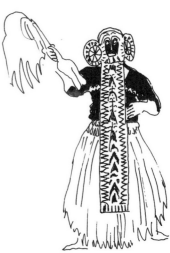

Above: Overview and detail of the upper part of Bamileke beaded elephant masks, worn by members of the royal Kuosi regulatory society in the Cameroon. The masquerader in the detail wears ndop cloth (see SIGN SYSTEMS), but leopardskin—another indicator of elite status—is also worn.

tent of his subject matter. After the Nazi invasion of Romania, he spent the war years as a diplomat and cultural counselor, finally moving in 1945 to Paris where he devoted the following decade developing what he later called a total hermeneutics. His approach involved the systematic synthesis of information from the history of religions, philosophy, mythology, folklore, ethnology, Orientalism and other disciplines. The fruit of his synthesis can be seen particularly in *Patterns of Comparative Religion* (1958). In 1957 he joined the faculty of the University of Chicago where he lived the remainder of his life. His years in Chicago saw the translation into English of his earlier works (especially important was his monumental work, *Shamanism: Archaic Techniques of Ecstasy*, 1964) and he embarked on an "historical" study of the history of religions. The last major project was the editorship of the *Encyclopedia of Religion* to which the most important scholars from the entire world contributed. Although Eliade never claimed to know the answers to the mysteries of life, he came closer than practically anyone else. See also ARCHETYPES.

Elitism and Art. In stratified indigenous cultures, art objects are often the single most important elements used to establish and validate social rank. The Northwest Coast Tlingit, as Jonaitis has shown, established not only hierarchical ranks among people, but also in their rating of various categories of art objects. The conical hat, for instance, was more important than beaded caps with frontlets (see EDENSHAW and BELLA COOLA). Clearly, the ranking was not based purely on appearance in this case, as the frontlets are among the most highly crafted and beautiful objects found on the Northwest Coast. Jonaitis suggests that monumentality (actual size and bulk), display (proliferation and visual complexity) and spatial separation (see NORTHWEST COAST

ARCHITECTURE) as well as formal design principles (heraldic arrangement, relative size, doubling of details, frontality and location—top and center being the most important) all help convey ranking. She further suggests that the Tlingit shaman also was concerned with hierar-

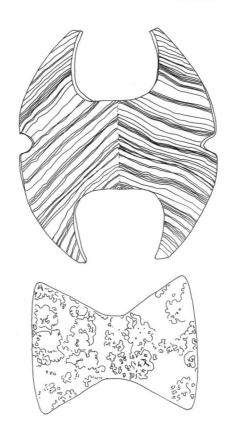

chy—s/he must impress both the client and the spirits if the work is to be successful. The shaman's "kit" including costume, regalia, charms, amulets and various other equipment has the same sort of hierarchical order and formal design as found in chiefly art (see also POTLATCH). David Penney, in discussing the Mississippian cultures of North America, suggests that art works functioned as "primitive valuables," which circulated among people via extensive trade networks. Trade partnerships were mutually beneficial, since primitive valuables could serve as a form of insurance against shortfalls. Art objects—sumptuary implements—and trade, he

ELITISM AND ART

Mississippian notched ovate and butterfly-shaped bannerstones (atatl weights). Functional bannerstones were fitted in the center of the atatl between the handle and the hook used to launch the spear. They apparently increased the atatl's flexibility and thereby lengthened the thrower's range. Bannerstones found in elite male burials are made of aesthetically pleasing materials in elegant shapes and often show no sign of use. They likely functioned as sumptuary implements.

Top: banded slate, 2000–1000 BCE.

Bottom: porphyry, 1500–500 BCE.

EPA

Right: Warrior mask by Bamgboye, famed carver of Ekiti. Carved from a single block of aberinberin wood, Epa masks measure four to five feet high and weigh between fifty and eighty pounds. The warrior's horse and his broad-brimmed hat are symbols of authority as well as evidence of influence from the Muslim Hausa kings. Many Yoruba rulers converted to Islam while continuing to practice their own religious rituals. The cage-like arrangement of attendants surrounding the central figure suggests the complex interrelationship between power and responsibility. 20th century.

believes, also played a major role in the internal ordering of societies, since elite possession established and dramatized status. Finally, the Mississippian funerary cult, by burying sumptuary implements with the dead, removed them from the social context. This "consumed" them and created a demand for more art objects, which served to reaffirm the status of living descendants (who also gained credit for burying the deceased with valuables). Chiefly and royal regalia developed extensively in Africa, especially in the historical states/kingdoms such as the following: AKAN, BENIN, FON, IFE, IGBO-UKWU, KONGO and KUBA. Metalwork, especially gold, ivory, beadwork, woodcarvings and textiles all reiterated the power and glory of the rulers. The same sort of elite art forms are found in highly stratified Oceanic cultures, such as the MAORI and in the HAWAIIAN ISLANDS, but the raw materials available were generally more limited so feathers, jade and whale ivory played a greater part. Hawaiian royal regalia are striking instances of the way that pattern and color convey power and status.

Entoptic Phenomena. Entoptic phenomena are the visual displays that occur in the first stage of altered states of consciousness (ASC). Peter Furst labels such visual displays "phosphenes," noting that they are a common product of hallucinogens, but can be produced by meditation, fasting, sensory deprivation or so simple an act as pressing gently on the eyeballs with the lids closed. He remarks that, while the initial hallucinatory experience is extremely rapid and transient, phosphenes can repeat as after-images for several months making it possible to "render" them. The geometric forms—parallel lines, zigzags, chevrons, dots, crosses, concentric circles, grids, ladders, checkerboards, lattices and spirals—seem to shimmer, move and grow before the trancers' eyes. These geometric patterns occur as a result of the structure of the human nervous system and are thus universal and unaffected by cultural conditioning. Similar geometric forms appear in ROCK ART all over the world and have been linked to trance states, especially the controlled trances of the shaman. See PATTERN.

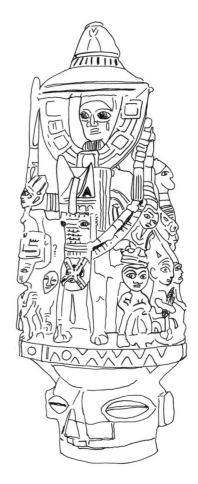

Epa (also *elefon*). The YORUBA Epa cult is centered in northeast Nigeria, in Ekiti and Igbomina, where young men dance in annual ceremonies honoring the "pillars" of society. Wearing masks with elaborately carved superstructures representing those honored, the youths must leap to the top of a large earth mound. If they are successful, it is taken as a good omen for the following year; a kind of "danced divination" according to Henry Drewal. The ritual stresses the transformation of young men into

strong adults capable of performing difficult tasks at the same time it reaffirms and celebrates cultural and community values. The masks, which appear in a prescribed order in different communities, embody different gods and social types (Oloko, the owner of the farm; hunter-warrior-chiefs; Eyelase, powerful mother; Iyabeji, mother of twins; Olosanyin, an herbalist priest and Oragun, king). When not in use, *epa* masks are kept in shrines and sacrifices are made to them.

Eskimo. The harsh but beautiful Alaskan tundra, along the coasts and the Yukon and Kuskokwim rivers, is the home of the Eskimo. The name, Eskimo has long been said to stem from an Algonquian word meaning "raw meat eaters." Lately, the theory is that it comes from the same source, but from words meaning "speaking the language of a foreign land." In Alaska, the term Eskimo has been used since the 1830s to refer to all Arctic peoples, while in Canada and Greenland, the name Inuit ("people") is preferred. Alaskan indigenous people themselves favor the name Yup'ik ("real people") which is gradually replacing the word Eskimo used in the literature. The term Eskimo is used here, although, where available, identification of peoples based on geographical locations is given. The earliest art from the area dates from the Paleo-Archaic tradition (the Thule, Okvik, Old Bering Sea, IPIUTAK and Dorset cultures) beginning as early as 800 BCE. As was true of the Northwest Coast, European contact was less invasive than in the rest of the world and the introduction of new tools, materials and increased trade created what has been called a mini-renaissance in art. Much of the art is linked with SHAMANISM and the guardian spirit complex as well as with hunting. Although the colorful, highly complex masks with moveable parts (see INUA and TUNGHAK), are perhaps the most memorable Eskimo art

form, the people also decorated their kayaks, tools, weapons, food containers, clothing and carved intricate charms and smoking pipes. The Yukon and Kuskokwim River Eskimos made impressive mortuary art, especially memorial grave figures. Mythological creatures were carved and painted on functional objects

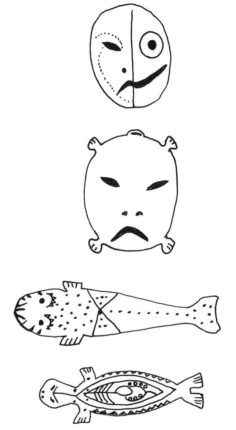

ESKIMO

Left: Ivory beads, earrings, amulets and fasteners were carved in the form of human faces and figures, and an endless variety of animals, such as the mythical fish and X-Ray view of a seal seen here. The face with the downward-turned mouth also depicts a seal, while the split face is a TUNGHAK. Eskimo carvers respond to the material as it tries to be itself. All from Cape Vancouver. 19th century.

associated with hunting for the protection of the hunter and to guarantee success. Kayaks, for instance, were decorated with images of the *palraiyuk*, a monster believed to live in and near bodies of water. Thunderbirds, bears, whales, various other sea mammals and caribou as well as human beings occur, animals outnumbering humans showing the bonds of reciprocity, gratitude and respect that underpin society. Two more recent art forms are produced by the Eskimo for collectors and tourists—small argillite and soapstone carvings, mostly of animals and scrimshaw.

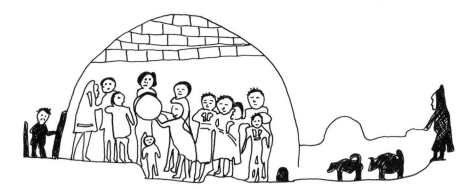

ESKIMO
DWELLINGS:

*Above right: X-Ray view
of a song festival in an
igloo, redrawn after a
sketch by Alorneq, a
Netsilik.*

"An Eskimo doesn't
mold his [snow] igloo
from the outside looking
in, but from the inside
looking out. Working
from the center, he
builds a series of con-
centric circles, tapering
upward conically. When
the keystone at the apex
has been set in place,
Eskimo and structure are
one. Only then does he
cut the small hole at the
base through which he
crawls-in effect, doffing
his igloo....Visually and
acoustically the igloo is
'open,' a labyrinth alive
with the movements of
crowded people. No flat
static walls arrest the ear
or eye, but voices and
laughter come from sev-
eral directions and the
eye can glance through
here, past there, catch-
ing glimpses of the
activities of nearly
everyone."

—*Edmund Carpenter.*

Contemporary paintings by Alaskan
natives incorporate mythological crea-
tures. See also BLADDER FEAST and
CHUGACH.

Eskimo Dwellings. During the winter in
the far north, the ESKIMO make dome
shaped domiciles out of compacted snow.
In the summer they live in sealskin tents
which are also dome shaped. Where timber
is available along the Yukon and
Kuskokwim Rivers and on the coast of
western Alaska the people built permanent
rectangular semi-subterranean residential
and ceremonial architecture of logs and
sod. People wore no clothing within oil-
lamp-lit houses, as interior temperatures
were quite warm from accumulated body
heat. Fires were needed only on the coldest
winter nights. The ceremonial houses were
large enough to accommodate the entire
population for the dancing, singing and
story telling that occupied people during
the long Arctic nights.

Eskimo Masks. Surviving masks came
mostly from Alaska, having been collected
between 1877 and 1900. They are made
from spruce or cottonwood driftwood. As a
whole, the masks represented the totality
of Eskimo cosmology—the graceful con-
centric rings attached to the circumference
of masks symbolize the layers of the uni-
verse—as well as good and bad spirits and
aspects of human life. Religious masks
divided into two broad categories: first,
those representing guardian animals and

inanimate spirits as well as the
SHAMAN's helping spirits, and second,
those representing the shaman's journey.
The shaman him/herself occasionally
made masks, but more usually an expert
was hired to interpret his/her vision. Masks
were worn by both the shaman and lay per-
sons for increase ceremonies such as the
BLADDER FEAST, at times of crisis (such
as bad weather, famine, widespread illness)
in order to discover causes and less fre-

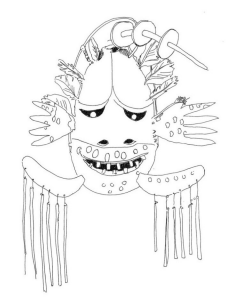

ESKIMO MASKS

*Above: The mask represents Walaunuk, which
means "bubbles, as they rise up through the
water." Although the Eskimo were boundlessly
sensitive to natural forces, here the bubbles were
also interesting as indications of the location of
game, such as seals, surfacing to breathe.
–From the Kuskokwim River. Before 1900.*

quently in curing ceremonies. When the shaman died, his/her masks were hung over the grave on a stick or tripod. The range of spirits represented, shapes, colors, materials and size is extraordinarily diverse. Some masks had moveable parts that revealed different aspects depending on their position. Added-on materials are characteristic, such as carved human and animal figurines, body parts (eyes, heads, hands, flippers and wings), bones and concentric hoops. See INUA, LAYERED UNIVERSE and TUNGHAK.

Esu (also Esu Elegba, Eshu). Esu is the YORUBA trickster, the youngest and most clever of all the *orisa*. Mediator and god of the crossroads, he represents the capricious forces at work in the universe and is often blamed for the small misfortunes of daily life. His nature is shifting and ambiguous, like chance itself. He is usually depicted as a male figure with a great curving phallic-shaped hairstyle on the dance hooks worn over the shoulders of Esu priests. The hook also resembles a knife—the word *abe*, "knife" can also refer to the penis —it represents the dangers of aggression and uncontrolled sexuality. The hair often has medicinal gourds attached along the ridge. Sometimes a second face is carved looking backward; a Janus face representing Esu's role as mediator and his connection with fate as it works itself out in the stream of time. Thus, IFA priests invoke Esu at the beginning of divination rituals—he guards the ritual way and is the conduit between the diviner and the spiritual realm. Small dance statuettes depicting devotees are associated with the Esu cult as well as paired male and female figures enmeshed in mounds of cowry shells. The paired images are worn inverted by the priest during ceremonies and when not in use hang inverted within Esu shrines. Altar figures with square or circular bases, holding calabashes and more recently gin bottles adorn Esu altars. Esu's images are often

darkened with indigo, associated with wealth and power, but his images are ornamented with white cowries linked with royalty and purity. An oft-repeated myth concerning Esu tells of him painting one side of his face white and the other black, enabling him to present the two sides of

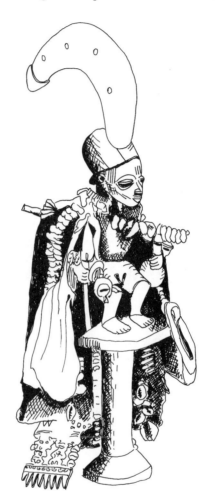

his nature by simply turning his head. Conical earthen mounds with schematic facial features dedicated to Esu are found in market-places, at crossroads and at the entrances to domestic compounds. See INVERSION and VODUN.

Eye. Bulging, shining and glaring eyes protect sacred places in nearly all indigenous cultures. For instance, in Africa the large, protruding metal eyes add to the protection afforded by Kota reliquary figures that

ESU

Left: Dance hook representing Esu. Esu's inherently contradictory nature is evident in the indigo color rubbed on his images, which contrasts with the strands of white cowries. Tall and short, disruptive and protective, he is associated with the east, but as the god of the crossroads he is also linked with the center. These contradictions are fused by Esu's dynamism.

He is like a chameleon, like one who can appear as a newborn child. He is as attractive as a crown.

—*Yoruba praise song, Owoade P.C. 1981.*

stand over ancestors' bones. The eyes flash in the darkness of the hut, warning away those who have no right to enter. In New Guinea, the enormous eyes of Abelam *baba* basketry masks help the masqueraders guide the dead on their last journey. And in North America, False Face society

EYE

Right: Wandjina creator spirit, rock painting from the Kimberleys.

masks embody the powerful spirits that interact with human beings in curing ceremonies. The staring eyes of many False Face society masks dramatize their spiritual nature. For other instances of apotropaic eyes see GOD'S EYES, HEI TIKI, KEREWA, KOKORRA MOTIF, METALS, TAMBARAN and U'U. In the Pacific, oval and circular eye shapes often appear as multivalent motifs on shields, housefronts and other objects. The Mimika of Irian Jaya carve and paint a repetitious oval design said to be a navel on canoes, paddles, bowls, sago pounders and shield-shaped planks. The design refers also to eyes, mouths and joint marks. Similar multivalence takes the form of overlapping layers of symbolism and verbal puns in the case of *nggwalndu* images on the exteriors of Abelam *korambo* houses. These clan ancestor paintings have concentric eye patterns that expand to fill nearly the

entire face and are likened to other bright things such as stars and fireflies. The radiant energy conveyed by the target-like concentric circles recalls the discussion of Innate Releasing Mechanisms (IRMS). The idea that human beings have an instinctive response to the human face, particularly to its most basic characteristics, i.e. the exterior oval of the head and two eyes, may explain why the eye is such a recurrent image. As children grow, they come to understand the world around them through their ever-expanding senses, of which the facility of sight is one of the most important. In Africa, for instance, the Dogon use visual images painted on cave walls to educate the boys as they undergo circumcision and initiation. Secret societies that govern the stages of individual lives communicate to men, as they move upward within these societies, increasingly complex interpretations attached to images (see discussion of the *kanaga* mask in DOGON MASQUERADES). Women, on the other hand, are often strictly forbidden from seeing sacred objects. See INDEX: Eye in Human Body.

False Face Society (also Society of Faces). An IROQUOIS medicine society, said to be their favorite, whose members wear powerfully expressive masks in curing ceremonies. Linked with the older thread of Iroquois religion associated with hunting and SHAMANISM, society rituals cleanse the community of disease in the spring and fall. The powerful False Face society masks usually depict humanlike spirits with long hair, distorted features and staring eyes, but they may also represent animals and other beings. Membership in the Society of Faces is open to anyone who has been cured by the society, has dreamt of joining or received a dream interpretation to that effect. The most important of the Faces is Gagohsa, or Rim Dweller, known among the Seneca as "Great Defender," and to the Onondaga as "Great Humpback." This powerful mask depicts a powerfully inimical spirit who, once tamed, became a defender of humankind. Whirlwinds and other disasters are attributed to him. Others include the Red Face, or "Laughing Mask," black and white ones representing one "cleft in half," those representing specific illnesses such as smallpox and venereal disease and, finally, a mask with huge lips that functions as the Doorkeeper who guards the doors of the longhouse during ceremonies. Current day Huron performers handle hot coals, imitate hunchbacks and carry sticks, actions described by 17th-century observers.

Fang. The Fang have lived in Gabon and in adjacent areas of Cameroon and equatorial Guinea since the 17th century. Some eighty clans exist, with no centralized authority, organized around lineage elders. Men's houses played a major role in initiations and as meeting places and residences for unmarried men. Blacksmiths and sculptors worked there as well. Reliquary figures called *bieri* were particularly important because of the emphasis placed on genealogy. Male members of the *bieri* ancestral cult rubbed the figures with palm oil and consulted them regarding important life

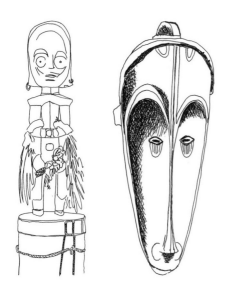

FANG

Above left: Fang bieri, reliquary figures, stood guard over bark boxes in the forest sanctuaries devoted to the ancestors. This figure has large metal disks for eyes, with nails for pupils that add to the uncanny energy of the figure.

Above right: Fang ngil masks were among the first to be "discovered" by Parisian artists, where they were appreciated for their abstract elegance, conveying no trace of the terror the masks evoked in their own environment. Northern Fang, 19th century.

FALSE FACE SOCIETY

Above: IROQUOIS False Face society mask of Gagohsa, "Face," the Grandfather of all Grandfathers, also known as Rim-Dweller. The great spirit who lives at the edge of the world is the patron of the curing faces. According to Iroquois myth, in a contest to see which was the most powerful, the Creator summoned a mountain. Gagohsa, hearing the mountain rushing up behind him, turned around and the impact broke his nose and distorted his mouth. c. 1920.

decisions. Conceived of as embodiments of ancestral benevolence, *bieri* exude a quality of contained vitality. Their style is remarkably consistent, being characterized by large heads that are nearly half forehead and projecting mouths. The abnormally large head has been likened to the proportions of a newborn, indicating the *bieri's* place in the circle of existence—ancestors, the unborn, the newly born and the living. The upright cylinder of the body is repeated in the rounded arms and legs, which adjoin the body at right angles, creating the impact of symmetrical but taut rhythmic balance. The legs are powerfully flexed and the fists meet, knuckle to knuckle, protecting the chest. The earliest figures had cavities in the abdomen or chest into which bones and a skull could be inserted. A post extending from the buttocks facilitated attachment to the reliquary basket. Eventually, carved heads replaced full figures. The reliquary cult was suppressed during the colonial period and many Fang reliquaries and heads were seized and distributed throughout foreign collections. Fang masks were used by the men's secret societies, the best-known associated with the Ngil (gorilla) society charged with peacekeeping, adjudicating between clans and villages and controlling witchcraft. The large, elongated masks with heart-shaped faces rubbed with white kaolin were likely also connected with death. The inclusive term Yaunde-Fang refers to the combined northern and southern culturally and linguistically unified people living in Central Africa; the German term Pangwe conveys the same meaning.

Featherwork. Bird feathers adorn human beings all over the world. Not only do they add drama and color to costume, feathers symbolize the attributes of the birds themselves and, because they are often difficult to obtain, are symbols of wealth and status. Hawaiian capes and cloaks (*'ahu 'ula*) and helmets, (*mahiole*) are worn only by the

highest ranking chiefs and the colors of the feathers and their patterns embody complex meanings, all conveying the power and divinity of the chief. In North America, particularly on the Great Plains, wearing feathers was restricted to the most accomplished warriors and the great feather headdresses were a complex system

where the type, position and manner of attachment all indicated matters of importance. Eagle feathers were the most prized since the eagle was regarded as the king of the birds. Wearing its feathers granted warriors swiftness and courage. The right to wear feathers was accomplished in battle and the feathers themselves told the story. The headdress maker listened to the warrior's deeds and then named the feather as he placed it. Upright eagle feathers worn in the hair signified striking (see COUNTING COUP) an unwounded enemy, while a horizontal feather signified hitting a wounded adversary. A split feather referred to wounds received, while a tuft of hair

glued to the tip of the feather symbolized taking a scalp. Having accumulated a large number of feathers, a warrior was entitled to own a war bonnet. About thirty feathers were required to encircle the head and more cascaded down the back. Those on the back were given by others to symbolize the combined valor of all the warriors in the group. Although the war bonnet is the stereotypical headdress, very few earned the right to wear it. Eagle feathers also surrounded shields where they symbolized the rays of the sun radiating outward from the circular sun disk of the shield. The Hopi take hatchling eagles (or hawks) from aeries high up the cliffs. They hand-raise them, naming them as if they were human, and finally release them during NIMAN to carry messages of Hopi rectitude to the spirits. Hopi prayer feathers, prayer sticks, *kachina* masks and dolls are ornamented with feathers, which they believe carry prayers to the spirits. In Africa, the wooden carved heads that occupied the ancestral shrines of Benin chiefs were characterized by a single, vertical vulturine fish eagle feather that projected upward to one side. Single feathers are also found on figures carved on the Oba's ivory tusks. Such feathers were worn as emblems of longevity, status and achievement. See INDEX: Featherwork in Art, Artifacts and Techniques.

Felines. In Arnhem Land (Aboriginal Australia) Milnguya, the Milky Way is spoken of as a great river in the sky or alternatively, the twinkling campfires of Walik the crow and Bari pari the cat who flew to the sky. In North America, felines are found in archeological contexts within the ADENA culture and are linked with fertility cult imagery in the MISSISSIPPIAN CULTS. One supernatural feline, the Underwater Panther that lived in streams and had lethally flashing eyes, was frequently represented by the ALGONQUIAN. The leopard is one of many symbols of the power of the OBA of BENIN. The tradition is said to have begun with a treed leopard that dripped blood on the sleeping Oba Ewuare beneath. When Ewuare awoke he killed the leopard and began the yearly sacrifice of leopards to promote royal power. Leopards live in the

forest—they are designated King of the Bush—and although those depicted by Benin artists are spotted, not black leopards, they are still regarded as dark and dangerous. Their aggressive but elegant beauty, speed and effectiveness as hunters all make them striking symbols of the Oba. The famous pair of brass leopards is said to have stood either side of the Oba when he sat in state. These leopards have circular "spots," others are marked with concentric circles and crosses in circles—the latter said to be the work of a brasscaster known as the "Master of the Circled Cross."

Fetish. From Portuguese, meaning literally, "to make in order to make." The word has generally fallen into disuse because of its negative connotations and is replaced by the designation "power figure" or the indigenous names of such objects. Stones, shells and trees owe their power to the nat-

FELINES

Left: This is one of a pair of ivory leopards from Benin. Carved from five elephant tusks, also a royal symbol, the leopards have copper spots and glass eyes. Real leopards lived in the palace compound and were paraded on state occasions. 19th century.

Right: The Chief of Nadrau, upper Sigatoka River wearing over 180 yards of bark cloth. After Theodor Kleinschmidt. 1877.

Far right: Shell breastplates are said to be a distinctively Fijian art form by some and attributed to Tongan craftsmen by others, ornaments decorated with stylized birds and celestial symbols were the property of those of high rank. Pearl shell and whale ivory. c. 1820.

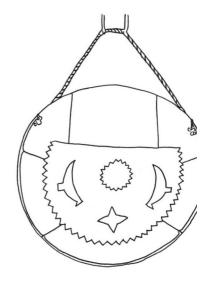

FINGER MASKS

Below: Although animal faces and geometric forms were also represented on Eskimo finger masks, the two depicted here are both human faces. Painted red, gray, blue and white, both approximately 4 1/2" high. Yukon/Lower Yukon or northwest Bering Sea.

ural forces that inhabit them as a result of animism. The most famous African sculpture, formerly identified as a fetish, is the NKISI *nkondi* power figure. Often in the shape of animals or human beings, these figures obtain power through ritual processes and are regarded as receptacles, or conduits, for the supernatural power channeled through them. The Kongo *nkisi* is characterized by a calm, relatively realistic face that contrasts with a rather rudimentary body and an aggressive stance. The term is still used to refer to the ZUNI FETISHES, small animal figures carved for apotropaic purposes.

Fiji. Placed by some scholars in Melanesia, Fiji is also considered to be part of Polynesia based on cultural similarities. Consisting of many islands, the largest being Viti Levu and Vanua Levu, Fiji became independent from Great Britain in 1970. Fijian art objects include sculptures of the human figure, huge war CANOES, weapons and bowls for the sacred *yaqona* (see KAVA) drink. Now consumed socially, the drink was originally ritually consumed on a daily basis. Fijian bark cloth (*masi*) was a status symbol as were the elegant shell and ivory breastplates. Bark cloth was made by women but worn primarily by men. One of the most prized of gifts, male chiefs often wrapped their bodies in hundreds of feet of *masi*. Turning in circles to unwind the cloth, the presenting chief, once unwrapped, laid the piles of cloth dramatically at the recipient's feet. See map: OCEANIA.

Finger Masks. ESKIMO women used these miniatures in pairs, one on each hand. The tiny masks sometimes copied face masks and were worn on the same occasions. Usually trimmed with feathers or caribou hair, they had two holes for the woman's fingers. The JANUS faces are carved on one side with upturned mouths representing males, while the other side, representing women, have downturned

mouths. They represent the complementarity of the sexes. They seem to have been a local fashion in the region between the Yukon and Nushagak Rivers.

Finials. The protruding top of the ridgepole or central supporting post of men's, spirit and chief's houses is often decorated with a carved wooden or modeled clay finial. Symbolically, this location is important because human structures end there and indigenous peoples may have felt there was a certain vulnerability to it. The finials atop KANAK chief's houses are called the "face" of the chief and are taken during the *jado* ritual which marks the death of the chief. Paired IATMUL finials top TAMBARAN houses where they symbolize the aggressive force of the village. Undoubtedly they also had a protective function like the carved treefern finials of HUMBOLDT BAY men's houses. Finials are also found on god staffs (MAORI), canoes (MASSIM) and top house ladders (ADMIRALTY ISLANDS).

Fire. Myths involving the theft of fire from the sun or the gods are widespread; the brave thief is sometimes a human culture hero, sometimes an animal or a god. The firebringer of the Natchez was a spider, while Maui, Coyote and Raven all brought fire to their cultures. According to the Dogon, one of the ancestors stole fire from the sun. Caught in the act, he slid down the rainbow and struck the earth with such force that his arms and legs were broken, thus explaining how human beings came to have joints. In many cultures the firepit is located at the center of dwellings and ceremonial structures. Finally, fire is associated with specific deities, whose nature has the abivalent qualities of fire, being both warming and potentially dangerous. See INDEX: Deity Archetypes; Fire and Sun in Natural Phenomena and Materials.

Firebags. Pouches for carrying fire-making implements with a carrying strap or cord are found among many indigenous North Americans. In some cases the bags were used for ammunition. At the turn of the century, firebags were male status items among the Athapaskans, Ojibwa and Woodlands peoples. The rectangular bags were generally heavily beaded and often had tassels hanging from the lower edge. Pipes were carried in long rectangular hide pouches.

Flute Stopper. The figures topping BIWAT flute stoppers for ceremonial flutes are multivalent images of great power. On one hand, they are said to be embodiments of crocodile spirits living in the Yuat River. Important musical instruments used at fes-

FIREBAGS

Above: Tahltan firebag of moose hide ornamented with red cloth, braid and beads. Teit, who collected the bag, found no meaning for the designs, but compared them to bags from the Interior Salish and Chilcotin. This type of bag was used originally to carry ammunition. Collected in 1912.

FLUTE STOPPER

Left: The wealth of ceremonial attire, turtle shell ear ornaments, cassowary feathers and the boar's tusk inserted through the septum, all contribute to this figure's remarkable sense of presence. Especially powerful are its cowry shell eyes with their intense gaze. Biwat, Yuat River, East Sepik. Collected before 1914.

tivals and initiations, flutes were also regarded as images of the founding ancestors with superhuman qualities. The figures were decked out in conus shell disks and feathers and, along with the flutes and stoppers, were passed from generation to generation, specifically from father to daughter and on to her son. According to Margaret MEAD, girls, upon marriage, had the right to a flute as a dowry given by their fathers. The bride pretended to run away from home to the house of her husband (actually, to the house of her mother-in-law). The newly married man (as the son of his mother) in turn gave a flute to his wife's father. The exchange constituted a pledge, cementing the new lineage relationships established by the marriage. Since only social equals married, the pledge also guaranteed equal rights and signified new understandings regarding land ownership. The flutes and their stoppers embodied pride and the identity of the ancestral chain and of the cult community as a whole. See INDEX: Musical Instruments in Art, Artifacts and Techniques.

Flutes. Great skill is lavished on carving

flutes all over the world. Perhaps more than any other musical instrument in Oceania, the flute is connected with the ancestors. Among the BIWAT, the flute is regarded as an image of the ancestors and believed to have supernatural qualities. In North America, flutes were used for courting. Lakota flutes (*siyotanka*) often had images of woodpeckers or elk carved on them. According to a legend, a hollow tree branch pierced with woodpecker holes inspired the first flute. When the wind blew through the holes a beautiful whistling was heard. Such flutes are often called "elk whistles," in homage to the animal's distinctive (and reputedly highly successful) mating call. See INDEX: Musical Instruments in Art, Artifacts and Techniques.

Fly River Region. This region includes the Gogodala, Kiwai and Boazi.

Fon (1). The kingdom of Dahomey, located in what is now the Republic of Benin, rose to prominence in the early 17th-century. According to myth, the kingdom was founded by Agasu, the offspring of a Tado princess and a leopard that she met when fetching water from the forest. The name Fon, from the *fon* trees that grew profusely throughout the area, came into use during the reign of Guezo (1818–1858). Strong influence from and conflict with both the AKAN and the YORUBA mark the early history. By the 18th century, Dahomey had become wealthy and powerful, supplying slaves from the neighboring Akan and Yoruba for the European market. Fon royal regalia show the impact of Yoruba contact, especially the elaborate beaded CROWNS. The Fon also incorporated deities from the Yoruba pantheon into their own religion, particularly Hevioso (Sango) and Legba (Esu/Elegba) and they believe in destiny or fate, called *fa* which can be determined by geomancy and palm nut divination. The importance attached

FON

Below: Plan of the Dahomey palace and surrounding city of Abomey. The city is oriented to receive the first rays of the life-giving sun and takes the form of a cross within a square. It is likely that the Fon thought of their city as a microcosmic mirror of the cosmos. The cross and square design (and a cross within a circle) appears on royal regalia, signifying the centrality and divine nature of kingship.

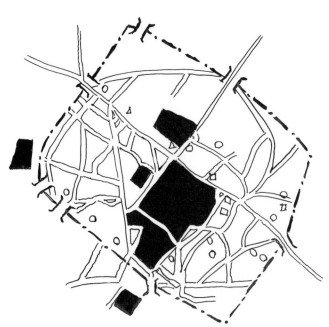

FON FABRICS

Left: Royal costume (kansawu), possibly belonging to Gbehanzin. The bull's head on the cap may symbolize the sun, while the fish just above the cuffs is likely the king's personal symbol, the shark. 19th century.

Far left: Applique dedicated to King Gbehanzin showing the shark, his most common symbol. The hands holding an egg related to one of the king's divination signs, Aklan Winlin, which includes the phrase "Gbe hen azi bo aji jele," which translates: "The earth holds the egg that the universe desires." The first three words of the phrase, combined and slightly altered, are the king's name. 1950s or 1960s.

to stools shows Akan contact and Fon leatherwork shows HAUSA influence. Beyond these connections, though, Fon art is unique and distinctive in its own right. One of the most striking elements is the symbolic imagery associated with the rulers known from oral traditions. Based on proverbial descriptions of the ruler's prowess, sculptural images (see GBE-HANZIN, GLELE and GU [Guezo]) and brightly colored applique cloth personify the ruler's power (see FON FABRICS). The plan of the royal palace also reflects history as each new ruler built a new entrance and residences. The palace compound covered more than 108 acres at its fullest extent, with the dwelling of Huegbadja, founder of the dynasty at its center. Agaja, who ruled from 1708–1740, is credited with the form of the current palace as well as the layout of the city. A twenty-foot wall and a dry moat surrounded the city. Filled with water during the rainy season the moat encircled and protected the Fon, just as the watery realm of Ayidohwedo, the rain-bringing rainbow python, surrounded the world. As is true of

the BENIN PALACE COMPLEX, artisans occupy quarters adjacent to the royal compounds, indicating their importance because of their ability to dramatize and make visible the king's power. In contrast to the pomp and glory of royal arts, BOCIO figures and objects associated with the VODUN cult are small, composite but very powerful objects.

Fon (2). In the CAMEROONS, the word *fon* (plural *a-fon*) is the word for ruler.

Fon Fabrics. Fon royal regalia included a royal scepter, embroidered and appliqued war tunics, jewelry, appliqued wrappers, umbrellas and banners. Beginning with GLELE (1858–1889) rulers wore silver nose masks shaped like a feline nose. Not only did this link the ruler with powerful kings among the creatures of the forest, it also conserved the ruler's breath as did the veiled beaded crowns borrowed from the YORUBA. The war tunics are among the finest African textiles. Predominantly red in color (traditionally the Fon royal color), the necks of the tunics were encircled with

rings, the number of which indicated the wearer's rank. Nested triangles radiating out from the neck are said to recall the claws of the royal leopard progenitor. The other major fabric art form is the applique banners that surround the king on important state occasions. The first appliques are said to have been espionage maps introduced by King Agaja. During the reign of King Agonglo, the Yemadje family of male royal tailors took up the formerly female art and expanded it to ornament umbrellas, hammocks and cushions. The cloths incorporate the individual symbols of the rulers and references to royal history and power. It is likely that some of the symbols are not fully grasped except by the most prominent individuals, while others may be readily understood. See SIGN SYSTEMS, FON FABRICS.

Forest. See WILDERNESS.

Formlines. A term invented by Bill Holm to describe the distinctive style of NORTHWEST COAST art, founded on the simple principle that creatures could be represented by delineating their parts (*Northwest Coast Indian Art*). The formline system is based on a set of explicit, formal rules that were followed with few exceptions. Stylized body parts were represented with broad contours, which always joined to create an uninterrupted grid over the design area. Due to stylization, certain uniform shapes resulted, including ovoids and U-shapes which, along with other formlines, joined in a limited number of ways and flowed smoothly into one another. The formline technique seems to have originated with woodcarving where the contour and major internal shapes of CREST animals and other creatures remain raised, the intervening spaces being incised. Primary formlines are nearly always painted black, while secondary, interior formlines are red. The formlines generally have an overall curvilinearity, although on larger forms, the shapes are rectilinear with rounded corners—this gives the impression of strong, blocky shapes with gracefully curved corners. Smaller forms and internal shapes are generally ovoid. The formal grammar of formlines extends to all other art forms such as non-relief paintings on wood and skin, blankets and basketry.

Four/Six Directions. The cardinal points, usually defined as north, south, east and west, play a major role in cosmology and are often linked with the LAYERED UNIVERSE. The directions are often represented by the equal-armed CROSS and

FOUR/SIX
DIRECTIONS

	Zuni		Hopi	Navajo				Yoruba	
	color	animal	color	color	bird	stone	deity	color	deity
North	yellow	mountain lion	yellow	black	blackbird	jet	Monster Slayer	red	Ogun/war
South	red	red badger	red	blue	bluebird	turquoise	Black God	white	Obatala/ creativity
East	white	white wolf	white	white	pigeon	white shell		green/ yellow	Esu/ trickster
West	blue-green	blue bear	blue	yellow	yellow warbler	abalone	Talking God	black	Sango/ lightning
Above	multi-colored	speckled eagle/knife wing	black						
Below	black	black mole	all colors						
Center					grasshopper	various	Talking God		

have particular colors linked with them. The Zuni concept of beauty is linked with the combination of all the colors and with the rainbow. The Hopi link directions, colors, space and time in an elaborate system of correspondences. The directions are defined in relation to the points on the horizon where the sun rises and sets on the solstices. The combination is expressed in the six directions altars with their strategically placed and colored ritual objects. Prayers and offerings radiate outward from the altar and blessings spiral in, so the entire thing could be considered to be a dynamic center of exchange between material and spiritual. Among the California CHUMASH, the directions were linked with the forces of nature and human ritual mirrored the sacred compass. The sun was associated with the east and the communal ceremonial structure; the earth was symbolized in the west by a group of people gathered to watch the rituals; and the MILKY WAY, moving from north to south, formed the path used by ritual participants. The intersection of these axes located the CENTER, the balance point where sacred time and space and profane time and space coexisted. Through the center passed a vertical axis connecting the upper sky realm, the human world and the underworld. The center was also linked with various physical locations (Mt. Pinos and Huasna, east of Arroyo Grande).

Friendly Isles. See TONGA.

Fruits and Vegetables. See INDEX: Natural Phenomena and Materials.

Fulani. The pastoral Fulani are the largest nomadic group in Africa. These people prefer to call themselves the Fulbe; in English literature regarding them, they are generally known as Fulani, their HAUSA name (they are called the Peul by the Wolof and French writers). The Muslim Fulani conquered the Hausa Empire and established themselves as a ruling class, eventually becoming the most powerful political unit in the Sudan, the Sokoto Caliphate. Fulani regalia were made by Hausa craftsmen. Present day Fulani nomadic males decorate their bodies for the annual Geerewol festival. Their efforts

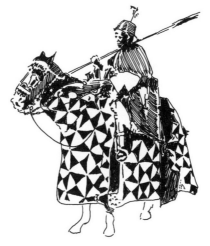

FULANI

Left: cavalryman and horse both wearing quilted armor.

to beautify themselves are judged by the women. One of the most prolific Fulani art forms is women's gourds, essential for milking. Professional weavers in the Niger area of Mali produce elaborately patterned strip-woven wool blankets called *kaasa*. Other textiles were highly valued, but are now being replaced by commercially woven fabrics.

Fumeripits. Before the Asmat CULTURE HERO Fumeripits created human beings, he died and was brought back to life. After he drowned, his body was washed out to sea, eventually coming to rest against a sandbar. War, the white-tailed eagle revived him by pressing smoldering wood against his body. After being revived, Fumeripits built the first *yeu* and carved human figures of wood, which he placed in the ceremonial house. He was disappointed that the humans had no life, so he made a drum and as he played, the figures came alive and danced. Fumeripits was the first builder, carver, drummer and the first head hunter. See also BIS POLE.

G

Gaan. Apache mountain spirits, culture/tutelary spirits sent by the Supreme Being to teach practical matters as well as how to live. See APACHE

Gagohsa. See FALSE FACE SOCIETY.

Games. Several California Native Americans, the CHUMASH and the Yokuts among them, conceive of the world as a vast cosmic game. Two supernatural teams battled and the outcome determined human prosperity or failure for the coming year. Among the Woodlands peoples, CHUNKEY seems to have been connected with divination as well as entertainment.

GAUGUIN, PAUL

Right: Wood block print of Christ on the cross surrounded by motifs inspired by Oceanic art. c. 1900.

Gauguin, Paul (1848–1903). French 19th-century painter who exhibited with the Impressionists but is categorized as a Post-Impressionist or Symbolist. One of the first Western artists to seek inspiration in primitivism, Gauguin wished to find a purer way of life, first in the Brittany region of France and later in Tahiti. Describing himself as a savage, a wolf in the woods, he felt that Western society had become decadent, its art remote from broader human experience. He worked in ceramics, carved wood, drew, painted and wrote books. *Noa-Noa* (meaning "fragrance"), his account of his life on Tahiti and retold Polynesian myths (culled from a book borrowed from a French official at Papeete) was written to record and explain his complex Polynesian subjects. A set of wood block prints, although apparently intended as illustrations, was never published with the text. Gauguin's style, which he called Synthetism, drew on diverse Non-Western influences and sources including the art and mythology of Japan, Indonesia, Peru and Oceania (particularly that of the Marquesas). His greatest masterpieces, such as *Where Do We Come From?…* synthesize Western and Non-Western art styles and deal with the human condition

in a profound and universal manner. He died in the Marquesas, poverty stricken and alone. The recent discourse on body imagery and colonialism has pointed out Gauguin's colonialist sexism without, as Richard Brettell notes, taking into account the artist's sardonic irony and awareness of the futility of searching for paradise on earth.

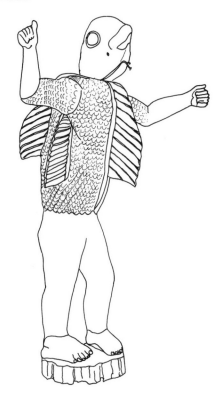

Gbehanzin (also Behanzin). This FON king ruled between 1889 and 1894, rising to power on the death of his father King GLELE. Gbehanzin was in power when the French conquered the Fon. Known as the "shark that made the ocean waters tremble," he was exiled on Martinique. The French set up his brother Agoli Agbo as nominal ruler who, until the end of his reign in 1900, collected, preserved and revitalized the royal arts. The Abomey palace museum is a tribute to this ruler whose name means "Attention Abomey the kingdom stumbled but did not fall." Agoli Agbo's signs include a foot, or a shoe, and a self-biting serpent.

Gbini. Mende PORO society masks, regarded as the "husbands" of Sande society *soweisia* masks.

Geelvink Bay. The large bay on the north side of Irian Jaya (east of the Vogelkop Peninsula) is now called Teluk Cenderawasih or Bird of Paradise Bay— the older name is used here because most of the literature uses it. The distinctive KORWAR style dominates the area. Although the art of the area is among the best-known from New Guinea, systematic field studies are lacking; furthermore strong Western and Indonesian influences have obscured early art forms. A single god is worshipped, Manseren Naggi, Lord of Heaven (or Lord Heaven), presiding over a world divided into two parts: the spiritual world of the winds and the material world of the body. After Manseren Naggi, the four wind gods are the most important. The east wind is more powerful than his brothers, and the sun, while less significant, is his ally in the war against evil spirits. The moon is connected with *korei*, life arising from death, a polarity which is reflected also in Geelvink Bay social organization: two rival clans, individual/community, the recently, remembered dead/nameless dead. The Geelvink Bay shaman, called *mon*, had a significant role in the battle against evil spirits. Elders are valued in this culture which, together with ancestor veneration, provides a sense of permanence and stability. The initiation house has a central pole representing the ancestors (a symbol of the CENTER) and the house itself is regarded as a microcosm reflecting the universe. The best-known sculpture from the area is the ancestor figures called *korwar*. Other art forms from the area are household utensils, neckrests, musical instruments, beaded dance aprons, low relief and painted boards and intricately ornamented canoes and paddles.

Gelede. The Gelede society is particularly

GEELVINK BAY

Above: Finely carved headrests generally have two outward facing KORWAR heads, which likely protected the owner and guided him through the dream world. Collected in 1954.

GBEHANZIN

Left: Life-sized sculpture of a shark-man dedicated to King Gbehanzin carved by a royal son, Sosa Adede. The size and powerful stance convey the power of the king and inspired warriors to battle with the same ferocity and implacability. This and a life-sized lion representing Glele were believed to have once walked and talked like humans. 19th century.

prevalent in southwestern Yorubaland, possibly originating at Ketu in the late 18th or early 19th century. The senior members are mature women and the male members of the society pay homage to "our mothers" who are believed to have powers comparable to those of the gods, ancestors and kings. Such enormous power is potentially capricious and Gelede ceremonies seek to channel it for the benefit of society. Ambivalent feelings toward older women past the age of childbearing may result in profound suspicion (fear) of women who are regarded as witches. Indeed, menopause is the only life transition that goes largely unmarked by ritual. Yet women often experience feelings of great creative energy and this upwelling force is celebrated in Gelede in tandem with the endangering and destructive side. Furthermore, a host of other deities—some hot and some cool—are connected with Gelede, especially Yemoja, OLOKUN and Ogun. The center of all Gelede masks,

GELEDE

Above: This old mask from Anago, Ago Shasha area, seems at first to be simple compared to the modern masks with their elaborate superstructures. Yet the simplicity is deceptive. The three crown-like elements projecting up from the face at first suggest an elegant hairstyle. A second look reveals them as feathers, referring to the idea that women have the ability to transform themselves into birds at night and roost in the trees. Alternatively, they may represent knife blades. Finally, the rounded tips suggest the nipples of pendulous breasts. This host of conflicting and overlapping associations is typical of Gelede. Above all, Gelede masks have a terrible beauty, in keeping with the Yoruba belief that such beauty has power against the forces of death and destruction.

My mother kills quietly without a cry
To prick our memory suddenly....
Great mother with whom we dare not cohabit
Great mother whose body we dare not see
Mother of secret beauties
Mother who empties the cup
Who speaks out with the voice of a man,
Large, very large mother on the top of the iroko tree,
Mother who climbs high and looks down on the earth
Mother who kills her husband yet pities him.

—*Yoruba praise song.*

which are otherwise uniformly energetic, diverse and colorful, is a calm, idealized female face. Stylistically, the faces recall the visages of Benin Obas and QUEEN MOTHERs. Their quiet, inward gaze contrasts with explosive superstructures that represent all aspects of Yoruba society. The masks are worn on the crown of the head with a cloth veil suspended from the bottom edge that partially conceals the dancer. The costume is completed by a tailored bodice, a colorful waistpiece made of headties loaned by prominent women or an embroidered/appliqued wrapper, leggings and ankle rattles. The entire ensemble conveys the amplitude, power, beauty and stature of mature women. Gelede masks perform in pairs, staging skits that comment, along with the imagery atop the masks, on the positive and negative aspects of behavior. The masquerades praise and propitiate, and through entertainment and enlightenment, shape society in positive ways. The multiplicity of associations and the praise poems addressed to the "mother," suggest that it is not particular mothers that the Yoruba have in mind, but the female creative principle itself.

Gender Roles. Gender roles are not markedly different among indigenous peoples than they are in the West, although the sphere of women is more narrowly circumscribed in many of the cultures described. Women are the mothers and nurturers, they plant gardens and care for domesticated animals. Men hunt and perform the most important rituals within societies. In many cultures, particularly those of the Pacific (more specifically in New Guinea) men regard women with a mixture of fear and respect. A great deal of male activity is devoted to creating images and conducting ceremonies to neutralize or co-opt women's creative power. Male activities (see, for example, the yam cult of the Abelam and Wosera) have been described as dysfunctional and obsessively

masculine/phallic. However, it is possible to see male ceremonies as resulting from a sort of dynamic tension and an attempt to balance the powerful opposing forces of male and female creativity/procreativity. Since the males cannot physically bear children and regard pregnancy and birth as mysterious, highly sacred events, they create art and ritual to establish their own part in the human life cycle. Much of the symbolism involved in initiation aims at establishing the men's ability to nurture and educate the boys. This probably should not be understood as usurping the female role, but rather as contributing to the continuity of gender roles in society. Myth underscores gender roles as well. A repeated motif explains how the men came to own and control the cult objects that formerly belonged to the women. The women's loss occurs because of theft, justified because of their abuse or misuse of their great power. The Australian DJANGGAWUL CYCLE and the stories regarding DOGON masks are two instances of the motif. The Djanggawul sisters, having lost the sacred totems, said that it was not important as they still had their wombs. The consequences of the Dogon myth were dire. The men used the masks they had stolen without understanding their powers and as a result, brought death to humankind. (See also YAFAR.) Another aspect of gender roles results in a division of labor stemming from the sorts of tools and materials that are used. Jehanne Teilhet has pointed out that in the Pacific, tool use is a symbolic marker of manhood. And generally, in indigenous societies, women traditionally were prevented from using tools connected with "hard" materials. Thus, women weave, mold clay and make baskets while men forge, carve and build. Each of these enterprises has a rich mythological basis and symbolism. To give just one example, Navajo mythology attributes the origin of the cosmos to Spider Woman, who wove it on an enormous loom, using clouds, sunbeams, lightning bolts and rainbows. She, in turn, taught Navajo women how to weave. The division of labor is, however, not inflexible and does change in response to economic necessity. In Africa, where women typically make pottery and men are blacksmiths, HAUSA women made pottery until the mid-19th century when their culture was converted to Islam. Because the women's mobility was limited by the Muslim sequestering of women, the men took over and eventually expanded the production of pottery for regional markets. See also NAMES.

Genitalia. See INDEX: The Human Body.

Ghost Dance. The earliest occurrence of the Ghost Dance dates to 1869 when a Northern Paiute prophet named Wodziwob dreamt the dance. He taught that people should join hands in a circle, alternating male and female, and shuffle to the left singing special songs. The dance was to be performed at night at least five successive nights, and repeated some twenty times during the year. The dance, delivering visions to exhausted participants, would restore the people's lost resources and return the dead to life. The Ghost Dance spread rapidly after 1889 when a Northern Paiute holy man named Wovoka (Jack Wilson) claimed to have had a vision that the white man would disappear when the earth turned over, taking them with it. Native American dead and the buffalo would return to life, once again adopting the old ways. In addition, Wovoka claimed to have been taught a dance and its associated regalia by the spirits. The complex eventually spread westward into California, as far north as Tillamook, Oregon and swept throughout the entire Plains region. The messianic Wovoka preached that it was unnecessary to fight with the white men, as they would soon disappear. The United States govern-

GENDER ROLES

"…it is possible to surmise that women, with their innate powers to give birth to human life in the real world, were already too powerful and to balance that power men took as their prerogative the right to create supernatural life in the forms of anthropomorphic and zoomorphic images."

—*Jehanne Teilhet*

GHOST DANCE

Above: Arapaho Ghost Dance painted deerskin dress. The symbols reflect a combination of native tradition such as the celestial bodies and creatures associated with the sky and Christian elements. The red, white and blue coloration was said to invoke the American flag. The LAKOTA believed that Ghost Dance garments made them impervious to white soldiers' bullets.

ment, fearing that the Ghost Dance would instead cause hostility prohibited its performance. The movement ended on December 29, 1890 with the killing of 260 LAKOTA men, women and children at Wounded Knee where they had gone to perform the Ghost Dance.

GIFT BASKETS

Right: Beaded basket by Mabel McKay (Pomo/Patwin), one of the most renowned basketmakers in the country. She was also a medicine woman whose dreams inspired her basketmaking. Pomo hanging baskets can be interpreted as replicas of the cosmic basket used by the culture hero when he stole the sun and hung it up in the sky to light the world. The pendants are said to represent stars and the fish in the cosmic ocean in which the earth floated.

Gift Baskets. These baskets, ornamented with shells, beads and feathers, embody the highest achievements of CALIFORNIA women basketmakers. Although gift baskets vary in size, most are small, some even miniature in scale. Symbols of wealth in their own right, the baskets were made for very important individuals and played roles in RITES OF PASSAGE, such as coming-of-age ceremonies, weddings and births.

Gikiyu (formerly Kikuyu). The Gikuyu live in central Kenya. Among the most distinctive art objects are wooden SHIELDS made for boys' initiation dances, which relate to the militarism expected of adult males. The five-foot-high leaf-shaped shields are carved on both sides with non-figurative designs in low relief. A hole pierced the center of the shield, enabling the user to insert his arm as well as holding it by the edges. The designs are agreed upon in advance and vary by region and initiation group. The front of the shield, ornamented with contrasting colored zigzags, has a bowl-like protrusion, while the back was carved with eye and eyelid-like shapes. The shields were apparently reused, scraped down and recarved for younger boys within the same family.

GIKUYU

Above: Both sides of a boy's initiation dance shield. Early 20th century.

Giryama (or Giriama). The Giryama, a subgroup of the Mijikenda peoples, live in East Africa along the southern Kenya coast. The Giryama erected carved wooden posts called *vigango* (sing. *kigango*) as memorials to deceased males. Apparently only the wealthiest families follow the practice, and then only when the deceased appears in a dream to a family member, indicating his unhappiness at not having a body. The word *vigango* means "binding" or "splicing," indicating the ability of the powerful and wealthy deceased to enjoy continued contact with their families, perhaps serving as intermediaries between the material and spiritual realms. Although these posts are sometimes called grave markers, their purpose is not to mark the location of the body, but rather to serve as

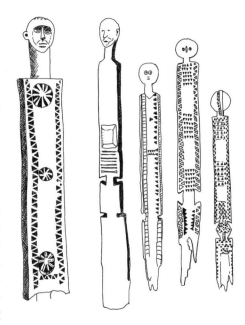

GIRYAMA

Above: The heads of kigango posts range from flat two-dimensional circles with rudimentary facial features to three-dimensional, carefully detailed heads. Generally the bodies are reduced to two-dimensional planks carved with geometric patterns—sometimes said to show Islamic influence—such as circles, rectangles and zigzag triangles which may represent ribs as well as symbolizing genealogy and the family tree.

a residence for the spirit of the deceased—thus they are often located within the men's conversation hut in the family compound. Once the particular ancestor commemorated begins to be forgotten, the sculpture loses its force. The Giryama also carve small phallic knobs called *koma* commemorating less wealthy individuals. These are also more portable, while *vigango* can be moved once at most.

Gitskan. See TSIMSHIAN.

Glele. The FON ruler between 1858 and 1889, Glele was one of the most powerful and famed. Son of a usurper, he was regarded with ambivalence which continued despite his financial and military success. Glele commissioned art objects to symbolize and substantiate his power. He sought to rival the glory of other royal courts, and, taking Versailles as a model, is said to have covered the portals to his new palace with mirrors. Some twenty buildings were added

to the palace as a result of his building programs. His personal symbols are the lion, hornbill and crocodile, all kings of their own realms. The lion is particularly prevalent, representing his "strong" name, Kini Kini Kini, "lion of lions." The lion continues to be part of the family crest among his relatives and descendants. Sculptures of lions (from life-sized wooden ones to smaller silver ones), a grandiose throne, palace doors and the large iron figure of a warrior (see GU) all bear witness to Glele's patronage. He was the last great king, and the Fon kingdom fell only five years after his death. See DOORS AND THRESHOLDS.

Gobaela (or *gabaela*). Wealth presentation scepters made in wood and turtle shell by the MASSIM people of the Triobriand Islands. *Gobaela* were carried by marriageable girls in dances and formed an important part of dowries. The same form is used on lime spatulas. The form refers to the origin of the people of the Louisiade Archipelago. With the blade pointing downward, it has been likened to a male anthropomorphic being or female reproductive organs. Inverted, it can be seen as an erect phallus. Finally, it is said to be the single-masted mythical canoe that brought the people to their present home.

God Sticks. MAORI god sticks (*taumata atua*), head-shaped finials, approximately twelve to fourteen inches tall, wrapped with cord, served as receptacles for deities to enter when invited to come and receive sacrifices. Ceremonies invoking the god involved the use of attractive sacred materials (red feathers, sennit cord and red ocher), ritual address and twisting or KNOTTING the cord to magically constrain the god. See also COOK ISLANDS.

God's Eyes. The yarn-wrapped objects called God's Eyes now widespread in the Southwest are thought to have come from

GOBAELA

Above: Massim lime spatula in the form of a gobaela made by Kaerihe, Sudest Island. This is unique as it is carved out of whalebone. 19th or 20th century.

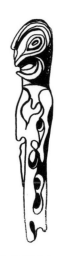

GOD STICKS

Above: Throughout the Pacific sticks are carved to serve as receptacles for the gods, to entice their presence in rituals. Maori god sticks are called taumata atua. This wooden one takes the form of a god called Hukerenui, guardian of the bones of the dead. 1500–1800.

GLELE

Above: The lion served as King Glele's personal icon and was the most important symbol associated with the king. In addition to being related to the king's divination name, a proverb also connects Glele with the lion: "The lion's teeth are fully grown and he is the terror of all." The technique is repousse, a technically simpler relief method compared to the lost wax brass and copper sculpture associated with the Yoruba, Asante and Benin. However, the silver and fine workmanship result in a resplendent object worthy of a king.

the Huichol of Mexico. Diamond shapes do appear in the Southwest and elsewhere in North America independently of Mexican influence in ROCK ART, basketry and other art forms. The motif seems to symbolize the eyes of watching spirits; they are likely protective in function.

GOD'S EYES

Right: Mojave hair ornaments from the Colorado River Indian Reservation. c. 1980.

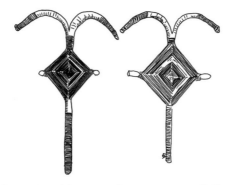

Gold. Gold was used most extensively by the Akan speakers of West Africa, where it symbolized the sun and the power of the ruling families. It was a royal monopoly among the ASANTE resulting in a wealth of gold ornaments associated with royal regalia (see AKAN GOLD and GOLDEN STOOL). To maintain control, gold was

GOLDEN STOOL

Right: This spectacular late-19th-century royal stool, said to have belonged to KOFI KAKARI, is clad in silver. The stool was probably taken as booty in 1874 during the Anglo-Asante war. The curved seat supports are said to suggest rainbows connecting the earthly and heavenly realms. Moreover, the rainbow conveys the ruler's power in proverbial form: "The rainbow surrounds everyone," i.e., the king controls and unites his people. The elements of the stool convey anthropomorphic symbolism: the support symbolizes the neck, the seat is the face, the protrusions at the ends are ears and the holes carved in the seat top are the mouth. When displayed in public, the stools are placed on their sides, thus presenting the "face" to the assembly. Stools were said to communicate with the living chiefs though the holes.

"Things happen in the stool house. Wonderful things, about which many do not know. One day I heard a great noise in the open hall. It was like a storm or an earthquake: po-po-po. I tried to run away, but I was afraid to pass. I waited and called the praise-names of the stools.

Father, gently oo. Father gently oo....

I took a calabash, filled it with water, and poured libation. I asked for peace, prosperity, and health. And as I did this, the place became quiet."

—Akuropon palace attendant, 1977.

weighed using GOLD WEIGHTS carefully calibrated to keep track of the valuable gold dust. Finally, in the same way that the moon is often regarded as the antithesis of the sun, silver is seen as the antithesis of gold. Thus silver is associated with night, darkness and the feminine and gold with the sun, day, light and masculinity—this symbolism is most evident among the AKAN for whom gold was the ultimate symbol of life force, energy and of their rulers. See also KUDUO, SUDAN and SUN.

Golden Stool. The name of the ASANTE Golden Stool is *kika dwa kofi,* "the Golden Stool born on Friday." According to legend, Asante founder Osei Tutu was seated under a tree on a Friday in 1701. Thunder rolled and lightning flashed and the solid gold stool floated down from the sky realm of Nyame and came to rest on the king's lap. The king's chief priest interpreted the stool as representing *sunsun,* the soul or spirit of the Asante nation. The gold was the stuff, the very essence of the sun, identified with life force and eternity (the life-giving sun never "dies" like the moon). The stool is so sacred and powerful that it must never touch the earth and is never sat upon—the king only rests against it in the course of enstoolment and other state ceremonies. The present Golden Stool is probably a faithful reproduction of the original, buried to protect it from colonial

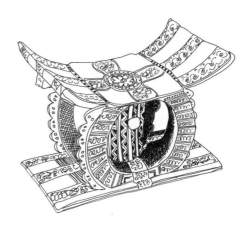

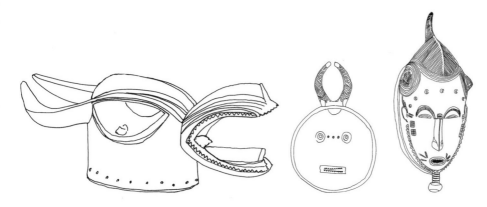

officials. Dug up in 1921 by construction workers, who desecrated it, the present stool incorporates remnants of the original stool. The Golden Stool has its own regalia, including bells and fetters representing spirit voices and victory. The central supporting element may symbolize the king's family tree that, like a WORLD TREE, connects the earthly and heavenly realms. In the same way that the Golden Stool embodied the soul of the nation, royal stools embody the souls of rulers and account for their well-being. While they are less sacred than the Golden Stool, they were and are of extraordinary importance. The most common form is a flat rectangular base and a curved seat supported by five posts—these symbolize both the king and four subsidiary chiefs or the sun and the FOUR/SIX DIRECTIONS. These lesser stools are also covered with precious metal and are ornamented with symbolic forms and patterns. Royal stools are "blackened stools," referring to the patina from offerings and ritual smoking performed during funerary rites. Power was transferred to the new ruler who lowered himself, lightly touching the stool three times. Non-royal stools are called "whitened stools," referring to their bleached color from the practice of scrubbing them with sand and lime juice to lighten the wood. These stools, belonging to court officials and Asante commoners, were not clad in metal nor were they adorned with elaborate symbolic references.

Goli. A day-long BAULE performance that gradually seems to be replacing all other dances. *Goli* can be performed for important occasions, such as the funerals of important men, or for entertainment. *Goli* originated among the Wan, a small Mande-speaking group related to the GURO; the Baule began performing their versions between 1900 and 1910. Part of its appeal lies in the four pairs of masks that appear in prescribed order. First to appear are the disk-faced *kple kple*; followed by *goli glen*, a pair of animal helmet masks; third, *kpan pre*, a pair of horned face masks and finally *kpan*, two human-faced masks with crested hairstyles. Each member of the pair is nearly identical to its mate, as they are said to represent the male and female manifestations of a single individual. Even though the gender of *kple kple* masks is communicated by color—usually male masks are red and female masks are black—the *kple kple* and the *goli glen* are conceived of as male in contrast to the second two (female) pairs. To complicate matters further, each mask has a male and female aspect. The arrangement implies a complex hierarchy, with the senior female being the last and most powerful of the eight. *Kpan pre* masks have backward curving ram horns and dance in a fluid manner. The final pair, the senior female masks, carries fly-whisks, symbols of their elder status, and wears the royal leopard skins on their backs. Arriving at dusk, the *kpan* enter the street surrounded by a huge, bil-

GOLI

All goli masks are worn with a netted shirt and pants, a raffia cape that hangs from the mask and an animal skin that covers the back.

Left: The goli glen, senior male masks, are said to combine antelope and crocodile features. Their dance is the most difficult to dance, not only because of the masks' bulk and weight but also because the dancer must move with a rapid, rather wild, but not uncontrolled gait.

Center: There has been little change in the abstract, circular kple kple masks from their early-20th-century beginning.

Right: First published in 1927, this senior female mask, kpan, is one of the oldest known.

lowing, "chamber" of cloth that is suddenly dropped to reveal the masks. Following their graceful, rhythmic dance, they depart suddenly. Vogel suggests that the hierarchy of *goli* appears about the same time as and may parallel the imposition of colonial rule, providing the Baule with their own structure (*Baule, African Art, Western Eyes*). Above all, though, *goli* could be adapted to express the dualistic Baule worldview.

Great Basin. The Northern Paiute, Northern Shoshone and Bannock, Eastern Shoshone, Western Shoshone, Ute, Southern Paiute and Owens Valley Paiute occupy the Great Basin region between California and the Plains, north of the Southwest. The WASHOE are sometimes included in this area, but here are found in the section on CALIFORNIA. The 19th-century millenarian GHOST DANCE had its source among the Northern Paiute, with the prophet Wovoka. Basketry, dating as early as 9000 BCE, was an important art form. ROCK ART spanning several thousand years is found throughout the area in several styles and motifs, including abstract, painted, scratched and representational. Finally, Great Basin archeological artifacts also include split twig figurines depicting game animals, incised and painted stones and pottery that vary from crude examples to the sophisticated Fremont clay figurines. Later Great Basin peoples continued to make basketry but their material culture as evident in ceremonies, associated costume and other art forms and

techniques is similar to that of the Plains peoples (e.g., the Grass Dance, SUN DANCE and Winter Count paintings). Current-day Chemehuevi, Shoshone and Ute women make outstanding baskets.

Great Serpent Mound. Located at Locust Grove, Ohio, this great effigy mound may have been erected by the ADENA Culture, the HOPEWELL Interaction Sphere or, based on a recent radio carbon date of 1070 CE, MISSISSIPPIAN. Because of the common connection of snakes with water—the sinuous switchbacks parallel a nearby creek—it is generally suggested that the imagery is associated with fertility. Although it contains no burials, it may also be associated with death and rebirth. Not only are its jaws wide open, surrounding an oval, egg-like shape, but its tail concludes in a spiral, both symbols of immortality. Recently, an archaeologist, noting two astronomical events that occurred around the time the mound was built—a supernova in the Crab nebula in 1054 and the passage of Halley's comet in 1066—has suggested that it may represent a comet. See INDEX: Animals.

GREAT SERPENT MOUND

Right: The sinuous body of the snake measures 1254 feet long.

GREAT BASIN

Right: Anthropomorphic figures from the White River drainage in the so-called Barrier Canyon Style. These figures, which may number in the dozens, appear in rows within arched sandstone alcoves and rock shelters. Frequently ghostly in appearance, the figures are painted in dark red and have abstract heads topped with headgear that may have horns, antennae or crowns of white dots. Between 500 BCE and 500 CE.

Great Zimbabwe. The word Zimbabwe is translated to mean "houses of stone" or "royal court." The city was the capital of the Shona Empire, which lasted from 1250 to 1450 CE and engaged in trade with Indian Ocean trading stations and local trade. The archaeological site occupies over sixty acres and at its apex, was home to over 18,000 people. The nobility had its own quarters, and the royal family and the king, who was probably regarded as being divine, and at the very least in contact with the spirits of his ancestors, lived in ritual seclusion. The walls of the buildings consist of unmortared stones stacked in patterned arrangements, often to great heights. The walled enclosure of the upper valley measured 830 feet in circumference, with twenty-four-foot-high walls, between four and seventeen feet thick. A conical tower of solid masonry was thirty-five feet high and fifty-seven feet around. A chevron-patterned frieze topped the outer wall. It is speculated that the purpose of the walls was not defensive, but rather to make a statement about Shona wealth and power. They may also have been used as pens for cattle, suggesting an early instance of the importance of cattle as wealth symbols in southern Africa. Stone sculpture in the form of soapstone bowls and eight great monumental birds adorned the complex, placed in locations infused with great symbolic significance. One of the birds was associated with the king's sanctuary at the back of the western enclosure. Six were apparently mounted on the low stone terraces of the eastern enclosure, a ritual center. The eighth bird was placed in the sanctuary of the lower ruin, where the king's pregnant wives lived. The Shona believed that birds, especially eagles, are messengers and intermediaries between the living and the ancestors. Royal ancestors, the most powerful of all, provided health, fertility and prosperity. Each sculpture, a unique combination of human and avian features, may have represented a specific leader.

Furthermore, it is suggested that the poses of the birds are gender related—some are depicted as standing, while others are seated. As the one from the royal wives' quarters is of the seated type it may have represented the king's first wife. More powerful yet, was the king's ritual sister, the senior ruling female possibly memorialized in the six seated birds on the terraces of the ritual center.

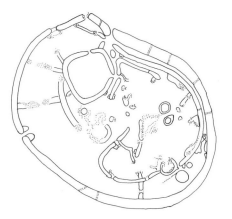

GREAT ZIMBABWE

Top: The eight large steatite birds from the walled city appear all to have been carved by the same artist. The seated ones are said to represent female royal ancestors. This one, from the sanctuary associated with the enclosure for the king's pregnant wives, looks rather pregnant itself.

Above and left: Plans of the Hill Ruin and the Elliptical Building.

Gu (1). Gu is the FON god of war and is associated with the power of iron and blacksmiths. One of the most famous Fon images personifies King Guezo and, by association, his son King GLELE who commissioned the sculpture. The figure is described as a warrior and as Gu and originally was located in the palace military shrine where it was surrounded by a ring of oversized iron swords and machetes driven into the ground. The figure not only memorializes Guezo, it also functioned as a BOCIO, an empowerment image. Prior to battle, sacrifices were made before it. It was

carried into battle where it was said to warn the Fon of danger, yelling "watch out." The French found it on the coast, where it may have been taken by Glele's successor GBEHANZIN to protect the Fon from the approaching armies.

Gu (2). Mask type representing beautiful females, see GURO.

Guinea Coast. The coastal region is usually divided into western and eastern areas. The eastern region, which saw the rise of powerful kingdoms between the 10th and 18th centuries, stretches from the AKAN area of Ghana to the Niger River delta in Nigeria. The earliest arose at Ile-Ife, which later was regarded as the founder of later dynasties in the area, the source of traditions and the center of the cosmos (see IFE). Others include BENIN and the ancient YORUBA kingdoms of Owo, OLD OYO and NUPE. The modern Yoruba are the inheritors of art traditions from these ancient cities. The western Guinea Coastal art includes *pomdo* and NOMOLI (see WESTERN AFRICA

AND THE GUINEA COAST), ancient stone sculpture from Sierra Leone, and more recently the diverse and powerful arts of the MENDE, BAGA, GURO, DAN and BAULE.

Guro. Speaking a Mande dialect close to that of the DAN, the agricultural Guro live west of the BAULE on the Ivory Coast. They immigrated into the area in the 16th century and remained relatively unaffected by outside factors until colonialization in 1912. Three cultural regions exist among the Guro: the northern area where wood carving is highly developed, the western Guro, who are known as weavers and the densely forested south, where ivory and wood carving are the only art forms. Guro social life consists of clans, headed by the oldest male member; a council of male elders governed village matters. In the northern area, masks, the best-known art form, are owned by families who stage masquerades to mark marriages and funerals. *Gu*, the realistic female masks, represent forest spirits and embody ideal female beauty. *Gu* masks are said to

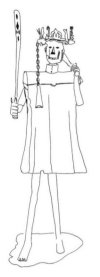

GU

Above: This life-sized figure is said to be the war god Gu, a warrior and a personification of King Guezo. It was commissioned by King Glele from Akati Akpele Kendo, a prisoner of war taken in Glele's first battle. The figure wears a hat bristling with miniature iron weapons and tools, objects found also on shrines dedicated to Gu. c. 1858.

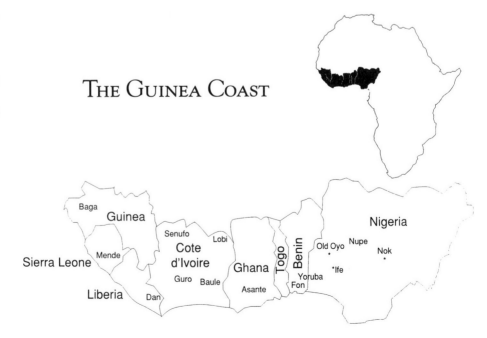

THE GUINEA COAST

embody each individual carver's idea of beauty. The hairstyles of *gu* masks reflect the most recent fashions as do the modern dance steps of the masquerader. The performer wears a blue and white cotton mantle over a knitted costume. The male spouse of *gu* manifests itself as *zamble*, a polychrome antelope mask with a crocodile snout and leopard eyes. The mask formerly had an anti-sorcery function. A third mask, called *zauli*, the wild aggressive brother of *zamble*, is an animal with exaggerated features. *Zauli*, seen as the more powerful antithesis of *zamble*, jokes with the women and behaves in a capricious and wild manner. Recently, Guro "entertainment" masqueraders, wearing masks they own themselves, perform dances that show off the latest fads and fashions. The Guro are also known for their heddle pulleys (*kono*). The Guro rate the work of wood carvers more highly even that that of blacksmiths and weavers. The names of several prominent Guro carvers are known: the Master of Buatle (active c. 1900–1925), the Master of Yasua (active c. 1915–1935), Tra bi Tra (born c. 1935) and another younger sculptor with the same name (born c. 1950). Master Boti, the most important sculptor active in the 1990s, produced work for Guro clients, while the masks of Beli bi Ta (known as Descar) are exported world wide.

Gwan. See discussion of Bamana NURTURING FEMALE.

Gwaytihl, Charles (c. 1820–1912). HAIDA 19th-century carver whose style was originally identified by Bill Holm ("Will the Real Charles Edanshaw Please Stand Up?"). Robin K. Wright has recently reattributed much of the work first attributed to this artist to Simeon STILTHDA. The styles of both artists are marked by naturalism and they appear to have worked closely and perhaps even collaborated.

GURO

Above: Masks representing zamble, *the male antelope, and* gu, *the beautiful female, are known for their refined, polished surfaces. Stylistically, they are related to both the Senufo and Baule.*

H

HAIDA

Above: Carved wooden figure of a SHAMAN attributed to Simeon Stilthda. The shaman's hair is bound in a knot behind his head. He wears a CHILKAT style blanket apron fringed with deer hoof rattles on its lower edge. His pierced nose once held a bone ornament. The shaman is undergoing transformation, taking on the shape of his helping bird spirit, its wings appearing on his back and its head protruding from his chest. Collected 1869.

Haida. For about 5000 years, the Haida have lived on what they call Haida Gwaii, an archipelago known as the Queen Charlotte Islands off the coast of British Columbia. Since contact in 1774, their social organization consists of two groups called Raven (twenty-two lineages) and Eagle (twenty-three). Lineage property included fishing and hunting rights; myths, songs and music; NAMES, including personal names and named objects such as houses, canoes, feast dishes and spoons; face painting and tattoo designs; and clan CRESTS. The Haida traded finely crafted objects in exchange for raw materials with their neighbors to increase status. They quickly adapted to new trade opportunities after European/American contact. Most numerous are small ARGILLITE carvings which continue to be an important tourist-trade item. Most art objects were made for the chiefs and the symbols of rank, especially clothing, were borrowed from the TSIMSHIAN and Nishga. An inventory of Haida chiefly art includes clothing (CHILKAT blankets traded from the TLINGIT, capes, button blankets, tunics, dance aprons and leggings, headdresses, frontlets and hats), rattles, COPPERS and, finally, feast objects (dishes, bowls, trays, ladles and spoons). The shaman had his own regalia. Important Haida villages include Skedans, Skidegate, Kiusta—home of the EDENSHAW lineage—and Masset. European contact in the 1860s was disastrous resulting in the death of ninety-five percent of the population. Monumental sculpture was abandoned after the 1880s and carvers miniaturized their production, carving model totem

poles and houses for the tourist market. Many Haida traditions were lost. Beginning in the 1950s a Renaissance in Haida art and culture occurred resulting from artists' interaction with universities and anthropologists and art historians. One of the key figures was Bill REID, the grand nephew of Charles EDENSHAW. Reid served a four-year apprenticeship as part of a team working on a University of British Columbia grant to recreate a Haida village on campus. Reid studied historical Haida art in books and museum collections and, having learned carving techniques and subject matter, reinfused the old traditions with new life. His art achieved international recognition. See also KONANKADA, PIPES.

Haida Cosmology. According to the Haida, the universe is a large house (the World Box or World House) each side of which corresponds to the four cardinal directions. Raven stole the sun from a box in the house of Sky Chief and brought it to the World Box inhabited by human beings. The sun entered the World Box every morning and passed out of sight over the roof at night. The stars were said to be sunlight leaking through holes in the World Box. Human houses were regarded as small replicas of the World Box with a central axis, a post thought of as the WORLD TREE, which connected the house to the other layers of the universe. The SMOKE from the hearth rose upward conveying prayers and in important chief's houses a series of box-shaped pits extended symbolically down into the underworld. Photos of over 400 Haida houses taken in the last

half of the 19th century survive in museum archives, but not a single Haida house from that time remains intact. Thirty house models in Chicago's Field Museum were commissioned for the Columbian World Exposition in 1893. House fronts were painted with CRESTS owned by the householders and three-dimensional sculpture was added in the form of masks over the shield-like door or carved symmetrical posts. The house interiors had carved poles and posts, screens that separated the public from the private parts of the house, and carved rafters and smoke hole surrounds.

Hair. The styling of hair is an important aspect of BODY ART and costume. Plaiting, weaving, cornrowing, parting, packing or tying are used to arrange hair in indigenous cultures. The head may be shaved cleanly or in decorative patterns. Various embellishments are added such as shells, beads, buttons, pins and ties made from fabric, leather and fur. Pomade, grease, oil, mud and colored pastes provide additional opportunities for styling. Finally, hair can be bleached or dyed. Neatness and cleanliness are generally preferred, unkempt hair being regarded as a sign of mental illness. Men's styles tend to be functional in comparison to women's more elaborate coiffures. Beyond enhancing appearance, hairstyles convey the specifics of the wearer's position in society, including age, marital, social and economic status. In Polynesia, where the head was the source of MANA, hair was adorned with feathers, shells and tapa, and additional power was gained from wearing elaborate headdresses made of enemy human hair. Human hair was also used in wigs, necklaces, fans and belts. In North America, men generally wore their hair long, tied back with cloth or hide ties, braided or wrapped with buckskin. Women's styles, in some groups, indicated marital status, such as the large horn-shaped buns of unmarried Hopi girls.

Called "squash blossom" or "butterfly," the style was achieved by parting the hair down the center of the head and wrapping it around a large wooden U-shaped hair pin in figure-eight patterns. Then, once the hair was tied, the form was removed and the hair was fanned out making the whorl shape. African styles often show great virtuosity, especially those of high status women who can afford professional services and have no need to worry about destroying the effect by carrying burdens on their heads. Some styles were confined to particular individuals, such as the QUEEN MOTHERS of Benin who still wear the traditional, characteristic style. In the 19th and well into the 20th century, Northern and Southern IGBO women added clay, carbon and oil to the hair, making it possible to sculpt the hair into intricate patterns. The hardened mud kept the coiffure in place, but could only be removed by shaving the head or cutting the hair. AKAN women of Ghana formerly wore carved combs in their elaborate hairdos. The combs gradually increased in size, offering more scope to carvers and are now luxury items too large to be worn. Hung in homes, the combs are given as gifts by male family members to mark special events such as puberty, weddings and births. The combs are carved with symbols, some of which reflect Western and Christian influence, like hearts and crosses. Others signify proverbs such as the backwards-facing sankofa bird, meaning "go back and fetch it," i.e., "learn from/correct past mistakes." Changes in hairstyles are also linked to RITES OF PASSAGE, such as shaving the head during INITIATIONS, and shaving or, alternatively, leaving the hair uncut as a sign of grief.

Hako. Also called the Peace Pipe or Calumet ceremony, Hako was the name of the ritual among the PAWNEE dedicated to blessing the children. Alice Cunningham Fletcher thoroughly docu-

HAIR

Top: Young married woman wearing a wig replicating an Igbo coiffure styled with mud, Eastern Nigeria. 1939.

Bottom: Akan carved comb topped with sankofa bird, Ghana. 12" high. Probably 20th century.

HAKO

Above: Kawas, the female brown-feathered pipe stem for the PAWNEE pipe ritual.

Kawas flying, o'er us flying, we her nestlings
cry for joy as now we see her come;

Kawas flying! Glad our hearts as now we
see her come.

'Tis Kawas brings to us good gifts!
'Tis Kawas brings to us good gifts!

Kawas brings gifts to us; we, like her
nestlings, cry.

—*Third song from the fifteenth ritual.*

———

I now know that the voice of man can
reach the sky;

I now know that the mighty one has
heard as I prayed;

I now know that the gifts I asked have all
granted been;

I now know that the word of old we truly
have heard;

I now know that Tirawa harkens unto
man's prayer;

I know that only good has come, my
children, to you.

—*Sixth song from the fifteenth ritual.*

mented the ritual, working with Tahirussawichi, a Pawnee priest-informant over a period of four years. The ceremony could take as many as five days and its purpose was to provide long life, health, prosperity and happiness for the children as well as to promote bonds of friendship and peace between the people. It was celebrated in all seasons except winter, since, as the priest said, "…we are praying for the gift of life, of strength, of plenty, and of peace, so we must pray when life is stirring everywhere." The most important ceremonial articles for the *hako* were two pipe stems painted with symbolic colors and prepared

with feathers and the parts of four sacred birds. These four birds—the eagle, owl, duck and the woodpecker—symbolized day, night, pathless air/water and trees respectively. The woodpecker was also acquainted with storms and could protect humans from their force and destruction. The more important pipe stem was painted blue to symbolize the sky, the abode of Tirawa, with a red groove, the path of communication along which the spirits of the birds traveled, and the path followed by human breath. This stem represented the mother, the north, the night and the moon. Its properties were kindness and helpfulness. Red and white cloth streamers representing the sun and the moon and a sheaf of feathers from Kawas, the brown eagle, were attached. Also associated with this stem was an ear of corn symbolizing Mother Corn. The other, less important, stem was painted green, symbolizing the earth and ornamented with seven white eagle tail feathers. It represented the male, the father, the warrior and defender. Both stems were treated with great care and respect, but the male stem was never brought near the children and was kept outside where it could cause no discord but could protect and defend. The two were sacred symbols, preserved, kept in good repair and passed on from generation to generation. Rattles, drums and whistles accompanied the many prayers, songs and dances of the ritual. The entire ceremony consisted of twenty rituals, each embodying a simple idea and complete in itself, but with an overall repetition of themes of invocation, thanks and blessing.

Hallucinogens. The ingestion of various substances in order to achieve ALTERED STATES OF CONSCIOUSNESS (ASC) is found throughout North America. In California, the shaman and the ruling elite took the poisonous psychotropic *Datura inoxia* (known in the early 20th century as *Datura metaloides* in the West, or *Datura*

stramonium/Jimsonweed in the East). The popular name Jimsonweed is nicknamed for Jamestown, Virginia because 17th-century English soldiers became intoxicated with it while on duty, supposedly accidentally. Shamans or specialized priests use datura root to make an infusion that is carefully dispensed to initiates. The substance caused unconsciousness, from which the individual awoke to a trance-like state of long duration. Guided by adepts, datura-takers experienced ASC during which they acquired spirit helpers and received instruction in myth and ritual. The peyote cult, possibly entering North America from Mexico, is found all over the Southwest and plays a major role in the NATIVE AMERICAN CHURCH.

Hamatsa. A KWAKIUTL secret society and a ritual complex (including dance) which apparently originated among the Haisla, the northern Kwakiutl. The TSIMSHIAN and HAIDA of Skidegate recently borrowed and perform the ritual. The age-grade society consists of three grades of four years each; to be a fully initiated Hamatsa member, thus, takes twelve years. Less important societies exist within Kwakiutl culture and novices generally go through several ranks in them before moving on to the Hamatsa society. The four-day performance incorporates an extensive cast of mythological characters, the most memorable being CANNIBAL bird-monsters searching for human prey. Impressive staging, powerfully expressive masks and a great many other props created horrific effects. The overall supernatural impression, augmented by spirit possession, served to recall primordial chaos. The chief cannibal spirit Bakbakwalanooksiwae was invisible, but weird whistling noises—the wind blowing through the millions of mouths in his body—provided evidence of his presence. The other spirits were inhabitants of Bakbakwalanooksiwae's sky home. These included:

The Hamatsa: the cannibal aspect of Bakbakwalanooksiwae in human form;

Noonsistalahl: fire thrower;

Komunokas and Kinkalatlala: the Hamatsa's two attendants who danced with him, respectively the rich woman and a female

HAMATSA

Left: A multiple Hamatsa mask by Charlie James of Alert Bay. From Fort Rupert, painted wood and cedar bark. c. 1914.

slave (these characters were actually danced by women, who themselves each had four attendants);

Kwakwakwalanooksiwae: the cannibal raven;

Hokhokw: long beaked bird monster;

Galokwudzuwis: the crooked beak bird monster;

Nanes Bakbakwalanooksiwae: cannibal grizzly bear;

Hamshamtsus: a less violent cannibal; and

Noohlmahl: the fool dancer.

The performance began with the initiate appearing in a frenzy calling out *haap, happ* ("eat, eat") and rushing about pretending to bite the spectators. The initiate ran into the woods, was brought back, jumped down from the roof into the room from

which he disappeared from time to time into a closet behind the *mawihl* (screen). The absences were punctuated by dances by the various characters listed above. A great cannibal-tethering pole, the *hamspek*, was erected at the back of the house—fastened loosely so that it appeared to sway with supernatural movement when the initiate was tied to it. After four days and nights, the initiate finally calmed and wearing his new costume, he danced and received his new Hamatsa name. Final purification rituals followed. On the last

HAND

Below: Paired hand designs decorate this Oglala (LAKOTA) Sioux war shirt.

night, a great feast occurred, the legend was recounted and payment was made for any damage done by the initiate during his frenzy. In keeping with Kwakiutl duality, there is a second masking society surrounding Dluwalakhu, the supernatural gift-giver associated with the social and human side of life. Working together, the two societies act to mitigate anti-social behavior and promote social concord and prosperity. See INDEX: Animals.

Hand. Positive and negative hand prints appear in body painting, on clothing and on walls all over the world. Essentially a social symbol, the hand protects as well as indicates presence. Fingers may be associated with relatives, as SCHUSTER shows

that finger-amputation as part of funeral rites is common (*Materials for the Study of Social Symbolism in Ancient & Tribal Art*). The imprint of the hand is believed to contain the essence of the individual that may linger wherever it is impressed. Thousands of hand and foot prints (and animal tracks) appear in Southwestern rock art where they were regarded as signatures or as a means of taking into oneself the blessings and power of the sacred place. Ewuare, the mid-15th-century warrior Oba of BENIN is said to have introduced altars to the hand (*ikegobo* or *ikengobo*). Originally linked with success in war, the altars came to be linked with various other achievements such as art, medicine, agriculture, trade and politics, all fields in which individual accomplishment is valued. The powers associated with the hand continue be important in later Nigerian sculpture, namely Igbo IKENGA and URHOBO *ivri*. *Ikenga* sculptures embody the positive side of individual power. They contain a multitude of interlocking properties—the individual's life force/fate (*chi*), his ancestors, his right arm or hand (*aka ikenga*) and his power (*ike*). Among the Urhobo, the hand is a symbol of power and humanity because it is able to transform thought into action, immaterial into the material. But *ivri* sculptures seem to deal, to a greater degree than *ikenga*, with the negative potential of power. See DIRECTIONAL SYMBOLISM and, for other entries referring to hands, see INDEX: Hand in Human Body.

Handsome Lake. In the 18th century, the charismatic mystic and reformed alcoholic, Handsome Lake began a new form of Iroquois religion called Longhouse Religion. See IROQUOIS RELIGION.

Hataalii. Navajo word meaning "singer," the name of the medicine man/woman who performs the healing CHANTWAYS and creates SAND PAINTINGS. See also HOSTEEN KLAH.

Hausa. The Hausa people, one of the largest groups in Africa (numbering some 15 million), have lived in the central Sudan for over 500 years. Their autonomous city-states were political,

commercial and artistic centers—Kano emerged in the 19th century as the most powerful. Also in the 19th century, the nomadic Muslim FULANI conquered the Hausa and established themselves as a ruling class of what became the largest political entity of the Sudan, the Sokoto Caliphate. Fulani nobility became important patrons, commissioning Hausa artists to create their court regalia. In 1903, the British imposed colonial rule in the area. In addition to Fulani regalia, other notable Hausa art forms are leatherwork (horse trappings), embroidery and distinctive mud architecture. The art is said to be decorative and the recurrent elaborate, curvilinear designs that appear in all media are said to carry no significance, despite the fact that they are named. Some embroidery designs replicate Islamic patterns brought back from Mecca by pilgrims. Indigenous patterns date back at least to the 17th century. Some are used universally, while others are found only in certain locations. Names include references to knives, drums, animals, trees, birds, buildings, games and hairstyles. Embroidery both enhances the value of the garment and the wearer's prestige. Counter to the

normal gender division of labor in Africa, during the 19th century Hausa men took over the pottery and indigo dye industry. This role reversal came about, in part, because intense 19th-century conversions to Islam, following the Fulani conquest, led to observation of the Muslim practice of female seclusion. Women were no longer permitted to participate in these economically important pursuits.

Hawaiian Islands (Owhyhee). One of the most important island groups in Polynesia. The area was settled between 500 and 700 CE from central eastern Polynesia. Isolated after c. 1300 CE, a largely homogeneous culture developed with regional art styles. Among those most disastrously affected by colonization, the islands' centralized accessible location and rich natural resources made them attractive to Europeans, Americans and Asians, especially the Japanese. Adrienne Kaeppler has identified two concepts as being central to Hawaiian aesthetics, skillfulness or cleverness (*no'eau*) and layered or veiled meaning (*kaona*) (*Oceanic Art*). The first of the two resulted in objects attaining value and social significance with age. The hierarchical social system, based on descent from the gods, was emphasized by art. Kaeppler characterizes the art of Hawaii as a system of "aesthetic inequality" which served to separate those of high rank from common-

HAUSA:

Above left: The decorative curvilinear relief patterns, characteristic of the traditional style, decorate the facade of the workroom of Alhaji Sanni, an embroiderer, scholar and builder of Kano.

Above right: The artist Musa Yola stands in the doorway of one of his earliest murals (1972), on the exterior of an herbalist's house in Zaria City. Despite the Islamic prohibition of representational imagery, Musa Yola's art is in demand. The plant motifs undoubtedly illustrate the herbalists' inventory, while other images are symbols of wealth and prosperity.

ers. The separation became more marked after the 12th-century arrival of Pa'ao, a Tahitian priest who instituted human sacrifice and greater social stratification. In 1819 Kamehameha II overthrew the rigid state religious system. Although a more flexible society resulted, much of the art associated with the old system was destroyed. Diverse art forms characterized by great energy were practiced on the islands, including architecture (HEIAU), sculpture (see KUKAILIMOKU), textiles (TAPA/called *kapa* in Hawaii), musical instruments, weapons and a rich panoply of objects for personal adornment, especially featherwork ('AHU 'ULA, feather capes and cloaks and MAHIOLE, feather helmets). The art of TATTOO was less important in Hawaii than in the rest of Oceania. Another contrast with other Pacific cultures can be seen in pre-contact patterns, which were asymmetrical, with an emphasis on the potent crescent shape. This pattern not only established status, it also protected its wearer. Other protective tattoos consisted of a row of dots around the ankle said to function as a charm against sharks. All of these diverse art forms served a major role in the complex social hierarchy. Artists were grouped with priests, holding the high rank of *kahuna*, because they alone made objects with the sacred materials, such as feathers, which became repositories for supernatural power and its temporal embodiments in the highest-born chiefs. See map: OCEANIA.

Head. In many indigenous cultures the head is the most important part of the human body, the source of spiritual power and the location of the spirit or life force of the individual. In Polynesia, the top of the head was sacred, the source of MANA, and because of its power, it was protected by TAPU. Brass heads sit on BENIN ANCESTOR SHRINES in Africa. These heads embody the continuing power and spiritual presence of deceased rulers.

Because of this widespread importance of the head, disembodied heads fulfill a number of roles, functioning as memorial heads, trophy heads and as protective devices. Memorials sometimes take the form of preserved heads such as the striking Maori chiefs' heads on which the tattoos are still visible. Other peoples disinter the heads of important ancestors and over-model them with clay and other materials, restoring the semblance of life. This practice is found in Melanesia among the Iatmul, on the Solomon Islands and in Malekula (see RAMBARAMP). Others create heads in clay, wood and metal to memorialize ancestors. In Africa, clay heads such as those made by the AKAN peoples and the famous Lyndenburg heads from South Africa (for illustration, see SOUTHERN AFRICA), seem to embody ideal physical characteristics. Trophy skulls and heads of captured enemies are not only indications of military success, they likely were believed to augment the power of those who captured them. This is evident in the large numbers of skulls obtained from head hunting in men's houses in New Guinea. Trophy heads, made of clay and wood, are found on Igbo IKENGA, on KALABARI ANCESTOR SHRINES and in the funerary remains associated with MISSISSIPPIAN CULTS. The Akan made golden trophy heads for great warriors to hang on their swords. Finally, the detached head or face appears all over the world as a protective and warding device, see JANUS FACES/FIGURES, SHIELDS and YAKA. Head coverings and headdresses enjoy similar protective and symbolic significance because of their close contact with the powerful head. For instance, MAHIOLE, Hawaiian feather helmets, are topped by a crescent shaped ridge, the crescent being a powerful royal protective symbol. The spiked projections that arch up over the heads of Hawaiian images of gods (see KUKAILIMOKU) resemble the notches of the spinal column.

The repetition of this motif, which is a symbol of ancestral descent, offers the protection of the ancestors, which in Hawaii includes the divine progenitors. One final indication of the importance of the head is the widespread occurrence of disproportionately large heads in indigenous art. Some of these are linked with infantilism, such as FANG *bieri* figures that protect ancestor bones. The large, rounded heads of these figures are also smooth and the distribution of facial features resembles those of infants: the *bieri* occupies its own place in the circle of existence—ancestors, the unborn, the newly born and the living. Similar infantile proportions are found in Maori HEI TIKI from New Zealand and KOTA reliquary figures. In other cases, abnormally large heads dramatize the spiritual power of the individual or the spirits they represent. For instance, in KUBA ROYAL PORTRAITS, the king's head occupies nearly one-third of the height of the body. Such portraits are believed to contain power that can be drawn upon and which is passed on to the living ruler. NGGWALNDU paintings cover the facades of Abelam men's houses in New Guinea. These large heads occupy the entire exterior surface of the houses and represent ancestors. Their enormous eyes and concentric ovals and zigzag patterns suggest the ancestors' power and energy as well as their continued ability to protect and interact with the living community. See INDEX: Head in Human Body.

Head Hunting. Head hunting is found in Oceania where the head is regarded as the seat of the soul and the individual's life force. In MELANESIA, the practice of preserving the heads of enemies taken in raids was characteristic of the ASMAT of New Guinea. Now outlawed, head hunting continued in the coastal areas until the early 1960s and until more recently in remoter areas. The act of taking an enemy head was a central part of initiation rituals.

The young warrior had to kill an enemy and take his head (and his name) before he could become an adult. Having succeeded in taking an enemy head, the initiate meditated several days, sitting with the skull between his legs, against his genitals. After the period of meditation, the initiate was taken on a canoe ride towards the land of the ancestors. The initiate mimed rapid aging, symbolically died and was reborn by being immersed in the river. On the return journey the initiate acted out the return of strength and life. When a head or skull was lost or destroyed, a wooden head called *kus* was made to replace it. In Asmat villages where INITIATIONS are still performed, the *kus* have replaced enemies' heads altogether. Asmat art is laden with symbols of head hunting. The inseparable link between humans and trees resulted in analogies between parts of the tree and human bodies. Fruit is analogous to the human head, and thus fruit-eating animals and birds are symbols of head hunting. See ASMAT WAR SHIELDS. Many New Guinea peoples preserved trophy heads within the men's houses on SKULL RACKS such as the *agiba* made by the KEREWA.

Headrests. High-ranking individuals often own carved headrests used while sleeping and in some cases, for seating. The headrests raise the head and thus protect the elaborate hair styles that such individuals sometimes wear. In other cases, the importance of the head as the container of life force may explain their importance. For additional references to, and illustrations of, headrests see CROWN, EASTERN AFRICA, GEELVINK BAY, HAIR, YENA and ZULU.

Heat. See INDEX: Temperature in Natural Phenomena and Materials.

Hei tiki. Small carved nephrite (also referred to as green stone and jade)

HEI TIKI

Above: Green stone amulet worn on the breast of Maori nobles, New Zealand. 18th century.

HEIAU

Above: Reconstruction of the most elaborate type of Hawaiian heiau, called luakini, dedicated primarily to Ku, god of war. After Rockwood.

HEMIS

Above: Lines of Hopi dancers wear Hemis masks during the public summer solstice niman ceremonies when the kachina spirits return to their homeland. The tableta in this mask is made up of stair-step designs which represent clouds, while in other cases, the clouds are semi-circular in shape. 19th century.

amulets, *hei tiki* were treasured ancestral heirlooms, worn by male and female MAORI nobility. Remaining with their owners during the primary funeral rituals, the pendants were removed at the time of secondary burial and passed on to the next generation. The smooth, highly polished sculptures characteristically depict rounded embryonic, hybrid bird-human forms, head tilted to one side, with large circular eyes inset with iridescent shell. Legs are splayed to the sides similar to the HERALDIC WOMAN motif and hands and feet bear only three digits. Some examples appear to have an erect penis, which terminates at or in one side of the mouth. This unique combination of infantile and genital imagery may reflect the amulets' connection with the Maori myth which attributes the creation of humankind to the *atua* Tiki, but in any case, when Tane is credited with creating humans, he was said to have used his *tiki* (penis) to do so. Given their link with ancestors and the similarity to the ubiquitous MANAIA images, *hei tiki* took on *mana* with the passage of time, becoming imbued with powerful magical forces connected with continuity and fertility. In modern times, mass-produced plastic *hei tiki* good-luck charms are a mainstay of the souvenir tourist trade.

Heiau. Religious centers in the Hawaiian Islands took several forms. The simplest were single upright stones. Open-air centers for public worship consisted of raised unwalled platforms that varied in size and complexity depending on the chief's status. This type had, at the least, an altar and images. Second, more elaborate walled precincts, sited and designed by the *kahuna*-architect, consisted of several terraces, an altar, images, refuse pits, burial grounds, buildings for drums and other sacred objects and a *kapa* cloth-covered oracle tower (*anu'u*) unique to Hawaii. Usually built on high places, their walls parallel or at right angles to the shoreline, these *heiau*

were modeled first in sand by the *kahuna*. The images were arranged in a crescent with the most important one in the center. Smaller than the others, this most important image often consisted of a non-figurative roll of bark cloth decorated with sacred feathers. Male images were placed on the right outside the *heiau* enclosure, while female figures were on the left. According to tradition, this exclusive type of *heiau*, open only to the highest-ranking chiefs and *kahunas*, was introduced by Pa'ao, a Tahitian *kahuna* who arrived sometime in the 12th century. Outside the walls was the Hale o Papa (house of Papa), where the highest-ranking female chiefs observed worship of the most powerful female deities. The largest state temples (*luakini*), where human sacrifices took place in wartime, were dedicated to Ku (see KUKAILIMOKU), while smaller precincts honored various gods, particularly Lono, god of agriculture. *Heiau* fell into disuse after 1819 when the state religion was abolished, although large ones still exist at Pi'ilanihale in Hana, Maui and Honauau in Kona, Hawaii (now Po'uhonua o Honaunau National Park).

Hemba. Hemba was originally a directional indicator meaning east of the Luba territory in eastern Democratic Republic of Congo, but today the people of the area call themselves Hemba. The most important art from the area is linked with the BULI SCHOOL named after the village identifed with some twenty objects in a distinctive, energetic style. The most important Hemba ritual object is a large power figure with a single torso, four arms, four legs and two Janus faces. The image is said to reflect a myth about a child born deformed. Hidden away from women and children, the figure can only be touched by the head of the family lineage, who inherits it on his investiture. See also LUBA.

Hemis (also called *niman*). Meaning "far

away," Hemis is one of the most common and important Hopi KACHINAS. It is one of several *kachinas*, like the Shalako, borrowed from other Pueblos, in this case from the Zuni. The mask, like other Hopi masks, is believed to be imbued with spiritual force and is carefully preserved, repainted annually and "fed." The Hemis *kachina* mask generally consists of a cylindrical lower element made of wood or leather, topped and flanked by flat, plank-shaped extensions called *tabletas*. The cylinder is divided in half, light green on one side and pink on the other. Horizontal rectangular eye slits allow the dancer to see. Variations on a theme, the mask and *tableta* are painted with designs representing raindrops, a rainbow, cloud shapes, phallic corn and sometimes butterfly, frog and lightning symbols. White down, twigs and eagle and parrot feathers are attached to the mask, and move as the dancers do. Hemis *kachina* masks are worn during the NIMAN ceremonies marking the departure of the spirits from human society. Beginning at dawn, thirty or more dancers, carrying rattles and sprigs of spruce, move in unison in a line so close together that no daylight can be seen between their bodies. The day-long dance recreates the Hopi creation myth, re-enacting the beginning and ending of the three previous worlds, while seeking to guarantee the continued vitality of this world. Properly honored and blessed, they depart at dusk, disappearing into the Kachina House, silhouetted against the setting sun. See INDEX: Color in Art, Artifacts and Techniques and Rain in Natural Phenomena and Materials.

Heraldic Woman. This motif was named by Douglas Fraser who found instances of it dating over a 3000 year span and in locations ranging from West Africa to the Middle East, the Americas and from China down through Southeast Asia into the Pacific. The Heraldic Woman, located in the center of a composition in which she is flanked by symmetrically arranged elements, is "displayed." The figure holds its knees apart, exposing the genital area, especially the vulva. The motif may have been diffused along trade routes having originated in the Ancient Near East. Although it is not a truly universal motif (there are some cultures where it is absent), its central importance as a symbol of fertility, renewal and rebirth makes it one of the most potent images in indigenous cultures. See COAST SALISH, DILUKAI, SUSPENSION HOOKS, TAMBARAN and WHARE WHAK-AIRO.

HERALDIC WOMAN

Below: Dilukai, female bai gable figure from Belau. Collected 1908–10.

HERO TWINS

Right: The Hero Twins, Monster Slayer and Born-for-Water, appear in most Navajo chantways. The masks are made of young antelope skin for male patients and braided yucca leaves for females, worn over spruce garments. Monster Slayer's black mask is darkened with charred weeds and tallow. It has square eyes and a round mouth over which olivella shells are tied. The four zigzag lines on the right are said to represent the twins' shoulder straps. Born-for-Water's mask is red and also has olivella shells sewn over eyes and mouth. The solid black shape represents "his real looks." The hourglass shapes—all closed except two, one on the back at the upper right and the second on the lower left front—represent hair bundles or queues.

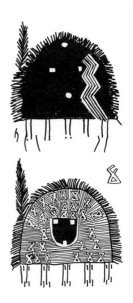

Hero Twins. The Navajo Earth Mother, CHANGING WOMAN gave birth to twin sons, Monster Slayer and Born-for-Water. Fathered by the sun, the twins killed the monsters that inhabited the world, making it safe for human beings. The twins represent war power. The monsters' remains litter the Navajo landscape in the form of unusual rock outcrops or landforms.

Heyerdahl, Thor (b. 1914). Controversial archaeologist/explorer who proposed American continental origins for the Polynesians. He excavated the stone monoliths on Easter Island, but is best-known for his 1947 journey on the Kon-Tiki, a raft on which he traveled 4000 miles from Callao Peru, eventually crash-landing on a reef at Raroia in the Tuamotu Archipelago. Although he was much maligned for his origin theory, Heyerdahl aroused worldwide interest in Polynesia.

Hina/Hine. Hina is one of the most important Polynesian supernaturals. Spoken of in some cases as a goddess and guardian of the land (the Maori call her Hine-hau-one, Earth-formed), in other myths, she is the first woman. Hina is closely associated with the moon and was invoked in fertility ceremonies. There are many myths explaining her connection with the moon. In Tahiti, Hina-the-canoe-pilot sailed with her brother on a voyage of discovery. She visited the moon and decided to stay there and set her canoe adrift. Thus, she became Hina-the-watchwoman, guardian of travelers. When the moon is full she can be seen beating *tapa* (the cloth forms the shadows on the moon's surface); she is the patroness of earthly female art forms, especially *tapa*. Her destructive aspect is seen in the Maori goddess of death, Hine-nui-te-po. In Hawaii, she is the female counterpart of Ku. See INDEX: Deity Archetypes

Hine-nui-te-po. MAORI goddess of death.

Carved figures on WAKA TUPAPAKU (bone boxes) are said to be the embodiment of this deity who brought death to mankind (see MAUI). Alternatively, they may represent ancestors (*whakapapa*, genealogical connections, are related to the exposed spinal column). Kaeppler compares the spinal columns of these bone chests, as well as their form, to the famous sculpture of the creator god A'A from Rurutu in the AUSTRAL ISLANDS (*Oceanic Art*). See INDEX: Deity Archetypes.

Hocker Position. The squatting position, with elbows resting on knees is said to be quite natural among people who commonly sit on the ground. The position is associated with genealogical PATTERNS. It is also similar to the fetal position in which the dead are buried in many cultures. The ASMAT call hockers *kave* and assign them the NAMES of deceased persons. *Kave* are stacked vertically on shields and spears. Split vertically, *kave* are called *wenet*, after the praying mantis, which it resembles. Humans are said to be interchangeable with the mantis. See INDEX: Animals.

Hogan. The Navajo word *hogan* means "home place." Ideally, the *hogan* is circular in plan, like the rim of the horizon. It is the CENTER of Navajo life where, at best, harmony and beauty prevail. Navajo CHANTWAYS, such as the Blessingway, are staged within the house to restore balance. According to one Blessingway story, Talking God created the first *hogan*. The God greeted the Primordial Couple when they completed their emergence with his gift, the "male" forked-pole type. The *hogan* was supported with four posts located at the cardinal points made of the four sacred minerals, white shell, turquoise, abalone and obsidian. The conical exterior form was modeled after a promontory on New Mexico's Gobernador Knob Mountain, which the Navajo call "heart of

the Earth." Talking God also gave the Navajo a second house type, the "female" *hogan* inspired by the form of Huerfano Mountain that the Navajo call "lungs of the Earth." This was said to be the home of Changing Woman, wife of the sun. In actuality, the traditional dome-shaped house form did not evolve into its present form until after the people settled in the Southwest. A variation made with leaning logs appeared by the 1870s. The "female" *hogan*, still in use today, became common after the 1880s. It is six-sided with a corbeled log roof. Traditionally, *hogans* are single-room dwellings with a central fireplace, a smoke hole directly above and an eastern-facing doorway. The house is alive and must be treated with care, periodically purified and fed. There are hundreds of house blessing songs to ensure that the house will provide its occupants with beauty, harmony and protection. While the house as a whole has feminine associations, inside it was divided into a male (south) half and a female half (north). A number of prohibitions were observed to maintain harmony. Sites were selected carefully—for instance, in places where lightning had never struck, away from box canyons or ridges to avoid bad dreams sent by the wind people, and distant from rivers so as not to incite the jealousy of water spirits. And very importantly, given the Navajo fear of death and dead bodies, well away from prehistoric ruins where Anasazi ghosts still wandered. It was particularly important that death not take place within the house, as then the space was forever unharmonious. The smoke hole was blocked up, the corpse removed through a hole knocked in the north wall, and the inhabitants departed. The *hogan* is an expression of the Navajo worldview and the pursuit of personal harmony, in contrast to the communal way of their Pueblo neighbors; for an expanded comparison, see SOUTHWESTERN ARCHITECTURE.

Hogon. *Hogon* is the title of DOGON priests and political leaders. The first *hogon*

HOGAN

Left: View up into the roof of a stacked-log hogan. The origin of this corbeled hexagonal form is unclear, but the interlaced logs resemble the "whirling log" sand painting design.

was said to have come from heaven, alighting on the earth when its surface was still hot. His iron shoes protected his feet. Among contemporary Dogon, the *hogon* is the patriarch of the oldest family within the village.

Hohao. See ELEMA ANCESTOR BOARD.

Hohokam. With the Mogollon and the ANASAZI, one of the three major prehistoric traditions of the SOUTHWEST.

Hopewell. Sometime between 200 BCE and 400 to 500 CE, the ADENA Culture gave way to Hopewell, centered in the Scioto River Valley of southern Ohio, which elaborated Adena traits to new levels. The complex was on the wane by 400, although construction of mounds continued after 700. Because much of the archeology in this area was done in the 19th century, evidence was destroyed which might have led to a better understanding of the chronology. The term Hopewell "Interaction Sphere" is preferred to the word "culture" as Hopewell was not a culture or political entity, but rather a widespread set of beliefs, symbols and practices including mound building and elaborate burials. The sphere is seen as a cross-cul-

HOPEWELL

Above: Sheet mica from the Appalachians was cut into graceful shapes for elite burials. Ohio Hopewell, c. 200 BCE–400 CE.

HORNBILL

Above: Brass ideophone representing a hornbill identified with the Benin royal "bird of prophecy." The beak of the instrument was tapped during certain ceremonies as a symbol of strength. 17th–18th century.

HOPI

Right: The ceremonial calendar is divided into two periods, both of which are concerned with rain and germination. From the winter solstice on December 21st through July, the kachinas live among the Hopi and participate in six major ceremonies. Their departure is marked by NIMAN. The rest of the year, the kachinas live in their home in the San Francisco Mountains. While they are away, although various dances occur, only one major ceremony, powamu ("purification"), the children's blessing and initiation, takes place.

tural "ideal" which superceded culture and language. Like Adena earth works, Hopewell mounds functioned as sacred enclosures rather than for defense or burial. The amount of material found in burial mounds is truly astonishing. For instance, a single burial in the Turner group in Hamilton County, Ohio contained 12,000 unperforated pearls, 35,000 pearl beads, 20,000 shell beads, copper and iron beads and nuggets of copper, meteoric iron and silver. The original sources of animal parts and inorganic burial goods shows that a vast trading network existed: copper from Michigan, shark teeth and barracuda jaws from the Gulf of Mexico, grizzly bear teeth from Yellowstone, quartz crystal and mica from the Appalachians are just a few. Beyond sheer quantity, the objects are also of the highest quality in both craftsmanship and design. Sculptural objects include clay effigy heads and figurines, stone platform pipes, rectangular tablets, wafer-thin mica carvings and embossed copper. Despite the overall cohesiveness of Hopewell, there are differences between

HOPI RITUAL CALENDAR

different geographical areas and over time, these result in considerable complexity. The collapse of Hopewell is unexplained, but it is speculated that the trade network broke down, or that subtle climatic change decreased food production.

Hopi. The word Hopi is an abbreviation for *hopituh shinumu,* "The Peaceful People." The Hopi, inheritors of the ANASAZI tradition, today live in twelve villages atop three mesas in Arizona. Relative isolation, a cohesive worldview, complex ceremonial calendar and a powerful sense of community identity govern Hopi life and contribute to their cultural health and survival. Walpi, "place of the notch," the mother village of First Mesa was established by 1700 CE and restored in 1975. Men cut the pine and juniper framework for the houses in the sacred San Francisco Mountains. The women frame the interior structures like fireplaces and vents with sunflower stalks and apply the plaster, making scallop-shell textures, with their bare hands. At Walpi, there are five *kivas* where men meet, male clans gather and where the boys are initiated. The form of the village as a whole is related to the complex but egalitarian social organization of the Hopi; people belong simultaneously to religious *kivas,* housegroups, lineages and clans. According to myth, after several abortive earlier worlds, the Hopi emerged from the SIPAPU, the world navel or vagina. Spider Woman saved people from destructive floods by hiding them in reeds and floating them to dry land. In the present, the third world, Masau'u, the earth spirit, the giver and taker of life, is the caretaker. The ceremonial cycle marks the solstices and the appearance and disappearance of the over 300 KACHINAS who live among the Hopi for part of the year. NIMAN, celebrated after the summer solstice bids the *kachinas* farewell, while the winter solstice and the return of the *kachinas* is marked by SOYALA.

Hornbill. The hornbill's large beak is a basic design element in much of Melanesian art. On one level, the hornbill is associated with HEAD HUNTING and the transfer of power. On another level, the bird unites (like the cassowary) both male and female characteristics important in initiation rituals. The hornbill nests in hollow trees. The mother bird does not leave the nest and is totally dependent on the male for feed and protection as she loses all her feathers and cannot fly. The male's large beak entering the hole is an unmistakable image of copulation, but it can also be seen as an instrument of nurture. The breeding habits of the bird are analogous to male INITIATIONS as the hornbills mate in secret and then miraculously remerge. This male-female conjunction is found in the STRING BAGS of central New Guinea. Early in their lives babies were carried in string bags (external wombs) made by their mothers. At the time of their initiation, the boys were removed from their mothers and sequestered in the men's house, which was spoken of as a large surrogate womb/bag. Within its confines, senior males, wearing hornbill-feather-decorated string bags they made themselves, undertook the boys' spiritual education. Like the hornbill, the men nurture and transform the boys. Hornbills are also commonly represented on the mouthpieces used singly or inserted into MALANGGAN masks from New Ireland. Since the masks are used in ceremonies that send the dead on their way to the land of the dead, the birds may function as soul carriers. Hornbills also appear in Africa. The great brass birds that once adorned the palace roof in BENIN are said to be hornbills (ground hornbills and black-casque hornbills). The birds, paired with enormous pythons, acted as lightning rods and the resulting frequent lightning strikes linked them with Ogiwu, the sky god of lightning, death and swift justice. Furthermore, hornbills were associated with the local "bird of prophecy," whose call and danger signal *oya o oya* sounds like the hornbills' clamorous non-stop *oum oum*. Additionally, the hornbill's extraordinarily hard beak was a symbol of strength. All of these associations are connected with the ambiguous liminal character of the Oba, his protection, his responsibility for the destiny of his people and his capricious lightning-like power. Hornbills also appear frequently in FON royal art (Kingdom of Dahomey, presently Togo and Benin) where their large beaks symbolize the bearing of burdens. See INDEX: Hornbill in Animals.

Horses. The horse is generally a symbol of power, social status and nobility as well as being linked with war, physical prowess and bravery. The North American horse returned with the Spanish, having become extinct in prehistoric times. Plains peoples quickly recognized their virtue and stole or purchased trained horses or caught and tamed wild horses. Horses only reached the area in large numbers after the 1680 Pueblo Revolt when horses escaped or were set free. Although the buffalo was perhaps more important to these people, horses changed many things in their cultures. With horses to pull *travois*, tipis became larger, but the more far-reaching impact was on war and the buffalo hunt. Horse images appear in the form of effigy figures, on pipes, mirrors and carved wooden models of weapons. Elaborate beaded trappings were made for these prized animals and they were painted with protective totemic devices before the warriors rode out. The CROW were the most famed horsemen on the Great Plains. The intricate geometric patterns of Crow beadwork reflect the pride taken in their equines. In fact, the Crow say that their creator god, Old Man Coyote, was the first to ornament horses. The importance of horses in Africa is evident in the dramatic and oft-repeated "rider-of-power" theme

HORSES

Above: The Crow Indians adorned their horses with elaborate and colorful beadwork in which triangles, hourglass shapes and other geometric patterns predominate. Collars were hung around the horses' necks for parades and ceremonies. 1890.

My horse has a hoof like
 striped agate;
His fetlock is like a fine
 eagle-plume;
His legs are like quick
 lightning.
My horse's body is like an
 eagle-plumed arrow;
My horse has a tail like a
 trailing black cloud.
His mane is made of
 short rainbows.
My horse's ears are made
 of round corn.
My horse's eyes are made
 of big stars.
My horse's head is made
 of mixed waters
(From the holy springs—he
 never knows thirst).
My horse's teeth are made
 of white shell.
The long rainbow is in his
 mouth for a bridle,
And with it I guide him.

—*Navajo song.*

that symbolizes the power and authority of African rulers. The theme is found in highly stratified royal kingdoms such as the HAUSA of northern Nigeria, as well as in village societies like the DOGON of the western Sudan. Hausa rulers rode elaborately decked-out horses from their palaces to the mosque in the Sallah festival that marks the end of Ramadan. By the 17th century Hausa craftsmen had begun to copy and elaborate on Arabic horse trappings. The padded leather and cloth coverings originally served to protect the horse in battle, but now function as a sheer display of wealth and artistry. Beyond power imagery, equestrian sculptures, according to Herbert Cole, frequently were conceived as metaphors for spirits (*Icons: Ideals and Power in the Art of Africa*). This explains their relative lack of realism; mounts may resemble crocodiles, dogs or unidentifiable quadrupeds. For additional discussions of horses see INDEX: Horse in Animals.

Hozho. A Navajo concept and life ideal often, but somewhat inadequately, translated as "harmony." According to mythology, First Man and First Woman embodied *hozho* and they created CHANGING WOMAN who in turn was responsible for creating the material world. Thus the primordial state of beauty and harmony continue in the present world. *Hozho* is dynamic, and although threatened by ugliness and evil, it can be reestablished through ritual and through living beautifully. *Hozho* is a creative process as well as an ideal. The opposite of *hozho* is *hocho* (or *hochxoo*), all that is evil, disorderly and ugly. See NAVAJO CEREMONIALISM.

Hula. In its modern form, *hula* is a remnant of dances performed by men during temple ceremonies. Although deeply serious within the religious context, missionaries found it to be lascivious and outlawed it. *Hula* was not reinstated until 1888 when King

HULA

Above: The performance combines movement, poetry and the sound of drums called pahu. The largest drums had names and could be played only by chiefs. Wood, shark skin, fiber. Collected on Cook's third voyage, 1778.

Kalakaua promoted a revival of the dance for his official coronation ceremonies. A powerful symbol of national pride, the dance is now performed largely by females, and is one of the main tourist attractions. Originally, the powerful males, "talking chiefs," who performed the *hula* uttered words of power on behalf of the sacred chief. The primary character in the *hula* myth is Pele, the goddess of the volcano. Her favorite little sister, Hi'iaka-in-the-bosom-of-Pele, was charged with escorting Pele's lover to her. As her journey progressed, the younger sister chanted continuously, and her words of power made her a conduit between Pele and her lover. When the lover died, Hi'iaka chanted him back to life, linking the *hula* to rebirth and healing. The actual *hula* deity is called Laka. At its most exalted, the dance was called the *hula pahu* after the name of the large drums associated with Lono, god of peace and agriculture. The *pahu* drum was the largest of several graduated in size (the smaller ones are called *puniu*) and it could only be played by chiefs. The continuous wave-like designs carved on the base of *pahu* drums may be stylized human figures with upraised, connected arms like those found on drums from the AUSTRAL ISLANDS. The patterns are reminiscent of those connected with genealogy and the ancestors. In any case, the crescent shapes recall those on Hawaiian feather garments— 'AHU 'ULA and MAHIOLE—and other objects associated with the power and divine status of chiefs.

Humboldt Bay (now Jos Sudarso Bay). Formerly considered to be homogeneous with LAKE SENTANI, recent work has shown that this area of the north coast of NEW GUINEA is stylistically distinct. Among the most important art objects from the area are canoe prow figureheads which are imbued with dynamic force. Stylized animals including birds (cormorant, hornbill) and fish (shark, sawfish

and dolphin) are combined and intertwined in elegant designs. Little information is available to help interpret these objects beyond remarks on their protective and magical functions (supernatural powers ensuring success in fishing). Men's houses were tall pyramidal structures called *mau* which were apparently moved from the coast of Papua New Guinea, acquired in exchange for beads. These structures disappeared by 1925 due to Western influence. The buildings had carved treefern finials that protected the house and its inhabitants. The interiors had coral hearths (one for each clan); weapons, hunting trophies, drums and bamboo flutes hung from the walls. The center space was left open for dancing and ritual blowing of the sacred flutes, which hung on the central post when not in use. The flutes are connected with the cassowary. According to myth, a snorting, buzzing cassowary so frightened a woman that she ran away. Men learned to mimic the sounds by blowing on bamboo flutes and thereafter neither killed nor hunted the cassowary, which they called the "mother" of the secret ritual. The flutes were blown when a chief died, at the slaughter of pigs, during INITIATIONS as well as to call for food (provided by the women). Other art objects include earthenware pots (made by women, but painted by men), circular headdresses and suspension hooks. Most objects dealt with the struggle for life or were used in rituals. See also bark cloth painting (MARO) and INDEX: Animals.

Hunting Magic. The term hunting magic was used originally in reference to Paleolithic cave paintings showing what were interpreted as animals wounded by spears or arrows. Aside from the so-called "Well Scene" at Lascaux, which apparently depicts a disemboweled bison, later scholars have questioned whether the objects identified as weapons might not represent plant forms. At any rate, the idea

that prehistoric peoples symbolically "killed" animals by painting their images on walls, thereby hoping to render the actual hunt successful, seems simplistic. Additionally, aside from some instances of "killed" animals in Southwestern pictographs, hunting magic seems to be largely absent in more recent cave painting and rock art. Ruth Bunzel's terms COMPULSIVE MAGIC may be preferable. Compulsive magic involves the use of magic and magical implements to compel animals to give themselves up to the hunter. This seems to be more in keeping with the intricate bonds of awe and respect that bound hunters and their prey.

Hutash (Chup or Shup in secular contexts). The CHUMASH and other California natives worshipped the earth as Hutash, a feminine being, source of all sustenance. Highly sacred, Hutash possessed will, reason, emotions and power. Her three aspects were wind, rain and fire—white, blue or black and red respectively, depicted in the rainbow, a sign of plenty and good luck. Hutash was depicted as a large encompassing disk or circle in Luiseno and Diegueno sand paintings and in Chumash rock paintings. The Chumash apparently believed the earth and heavens were equal and complementary forces, mirroring one another. See INDEX: Rainbow in Natural Phenomena and Materials.

Hybrids. See INDEX: Composite Beings in Animals.

HUMBOLDT BAY

Below: Figurehead from a canoe prow, Sko area. The composite creatures including birds, fish and reptiles magically guaranteed a good catch. Collected 1961.

I

Iatmul. The Iatmul and the SAWOS live in the fairly homogeneous Central Sepik region. The Iatmul live in the flood plain and are primarily dependent on the river. Due to the annual flooding, they build their houses on piles, sometimes bringing their canoes right into the houses during severe floods. The closely related Sawos

IATMUL

Right: Big-abwan double mask of the ancestor Moem. The individualized paintings identify the wearer with the ancestor and thereby provide access to the spirit realm. From Kararau. Collected in 1963.

live in the forested area north of the river and depend on agriculture for sustenance. Both believe that humanity originated at a place close to Gaikorobi. The Iatmul and Sawos live in larger communities (up to

1500 people) than other Sepik groups. The most impressive buildings were the lavishly decorated men's houses formerly subdivided into three categories organized around age and social rank (see TAMBARAN). The buildings symbolized the ancestors' protective mantle, which settled on the river in the form of a floating grass island. The house was the gateway to the world beneath the waters where prehuman ancestors lived. Central among these was the crocodile (sometimes said to be two-headed) who created the dry land from his saliva as he beat the waters and on whose body the Iatmul believed they lived. (Earthquakes were caused by the movement of the crocodile.) According to another myth, the crocodile created the Sepik River by swishing his tail. Images carved on *malu* boards allude to the mythological discovery of the path to the land of the dead and the permanent separation of the upper and lower spheres. Other Iatmul art objects include many musical instruments (slit gongs, hourglass drums, bull-roarers and flutes), multiform mask costumes, overmodeled skulls, SUSPENSION HOOKS, orator's stools (TEKET) and *Big-abwan* (or *awan*) masks. *Big-abwan* masks consist of one or two carved or woven faces fastened to a tall, woven cone with arm-holes. Representing ancestral spirits, the masks are worn by boys in honor of their uncles' founding clan ancestor. The ancestor is represented by a hard, wooden male internal core, covered with the soft, maternal *yimba* (fine clay mixed with tree resin). The other mask type (MAI) is also linked to four sets of ancestors representing the four original paired brothers and sisters.

The third type (*baba taqwa*) is a basketry helmet mask, which entertains the women and young children and keeps them away from the initiation preparations. For more information on the animals named above see INDEX: Crocodile in Animals.

Ibeji. The YORUBA apparently have the highest rate of twin births in the world. As the Yoruba have a special regard for children and treat them as a blessing and form of wealth, twins are doubly valued. Because of low birth weight, twins are especially vulnerable and infant mortality is high. Twins are sacred and like all powerful beings, potentially dangerous or beneficial. The Ibeji cult commemorates dead twins. The Yoruba believe that when twins are born, a single soul is split between them. When a twin dies, the parents commission a sculpture which is fed, clothed and cared for as if it were alive. This continued demonstration of love comforts the dead twin so that it will not call the remaining twin (its soul's other half) to it. Ibeji figurines exist by the thousands if not hundreds of thousands. There are several distinct regional styles and the names of

many of the artists are known. SANGO is the *orisa* charged with protecting the twins and they often wear beaded vests patterned with Sango's double axe or thunderbolts. These special garments, as well as their link with Sango, connect twins with royalty. At least once a year, mothers of twins dance in the marketplace, opposite the palace. They hold the statues tightly in the palms of their hands or tucked carefully into their wrappers. The dancers' movements suggest care, concern and reverence. Recently, photographs and plastic dolls are being substituted for the carved figurines.

Ibibio. The Ibibio live west of the Cross River, to the west of the IGBO and consist of six subgroups including the Annang (western Ibibio), often said to be the most talented and prolific artists of the area. Others include the eastern or Ibibio proper, the Enyong (north), Eket and Oron (south), Andoni-Ibeno (delta) and the Riverain or Efik. The ancestor cult and secret societies govern daily life. The age-grade Ekpo society presides over the ancestor cult. Once a year and at funerals of society members, Ekpo performers imper-

IBEJI

Below left: Two single twins. One wears a beaded Sango vest and is from the Oshogbo region. The other was carved by Lawore of Anko Quarter, Eruwa, probably in 1960. Ibeji statuettes are particularly powerful instances of YORUBA AESTHETIC criteria, especially jijora (relative likeness) and odo (ephebism).

Below: Pair of twins, probably from Igbomina, Ijomu.

You are the ones who
 open doors on earth.
You are the ones who
 open doors in heaven.
When you awaken, you
 provide money;
You provide children; you
 provide long life;
You, who are dual spirits.

—*Yoruba praise song, Owoade P.C. 1981.*

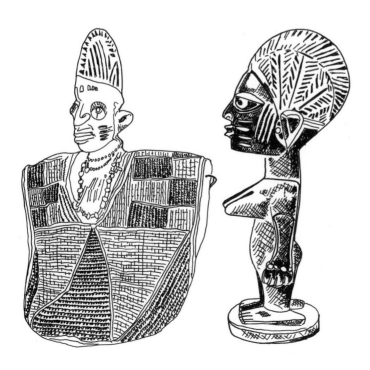

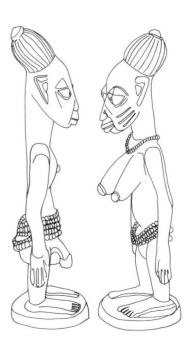

sonate ancestors' spirits who have temporarily rejoined human society. The society uses two types of masks, one of which, *Idiok ekpo*, an ugly mask, evokes wandering evil spirits. These contrast with *mfon ekpo*, beautiful masks representing spirits who have safely reached the land of the spirits.

IBIBIO

Right: Idiok, a mask representing ugly evil spirits of wandering ghosts, is worn over a black raffia costume. Dancers carry weapons and behave in an aggressive and capricious manner.

Ekpo should not be confused with EKPE, the leopard cult concerned with ethical considerations that the Ibibio adopted briefly. Other secret societies within Ibibio culture include *ekon* (social control), *idiong* (diviners) and *ikong* (war). There is cross over between these societies, *idiong* diviners, for instance, are often members of Ekpo and they worship Ala, the Earth Mother. Ekpo has, in recent years, become increasingly secularized. Ekpo society rituals vary from place to place, but generally at the beginning of the Ekpo season, new members are initiated into the society's secrets. After their induction in a lodge in the sacred grove, the initates perform in public. They are led into the marketplace by a masker called *akwa ekpo* ("leader of ghosts") who evokes each ancestor and directs the performance. Masqueraders believe they are possessed by ancestral spirits and behave in a frenzied manner. Sculptures include large figures kept in the sacred groves and male ancestor figures (called *ekpu* in Oron). Female sculptures depict MAMY WATA and *mbobo*, plump

figures of young women who were secluded and fattened prior to marriage. Funerary shrines for both men (*ngwomo*) and women (*nduongo*) included mural paintings, textiles and commemorative sculpture in concrete.

Ifa. Ifa is the YORUBA name of both the god and the cult associated with DIVINATION. Orunmila, the deity of wisdom, is said to have founded Ifa. Orunmila was present at creation and thus knows the secrets of the powers of good and evil and the means of coping with them. His wisdom guarantees that moral order will prevail over disorder and suffering. When Orunmila left his earthly dwelling he gave the sacred palm nuts to his children so they could continue to communicate with him. As a personified deity, Ifa is seen as the companion and antithesis of ESU. Esu's virtues are concealed and although he exposes evil, his nature is shifting and ambiguous. Ifa's virtues are apparent and his cult provides reassurance. Divination and kingship are interwoven; kings sometimes function as state diviners and the diviner's elaborate regalia parallel that of kings. The diviner sits, if possible, facing east. He places the divination tray so that light from a door streams across it and no shadow falls upon it. The board seems to have inherent meaning as a whole, as the top is called the head and is always occupied by the face of Esu, and the foot is always placed closest to the diviner. Furthermore, the process of divining is linked with the common Yoruba idea that life is a journey—the right side of the board is called "the Straight Path," and the left side is named "the Direct Path." Divination begins when the *babalawo* strikes the tray with an ivory tapper to invoke the presence of Orunmila. He then dusts the tray with powdered wood or flour and casts the sixteen palm nuts, marking the results on the powdered tray. Today, a chain has replaced palm nuts for day-to-

day divination, the palm nuts being reserved for more important questions. The marks are "read" based on *odu*, an oral tradition made up of 256 sets, some 600 separate sayings or poems. The diviner begins to recite the verses associated with the patterns in the dust until the client

selects a verse applicable to her/his situation. The diviner then applies the wisdom of the *odu*, suggesting a solution to the client's difficulty. Divination lessens anxiety and helps people to see that their problems are not only solvable, but are shared by others who came before and those who will follow. When not in use, the *babalawo* stores his implements in a lidded bowl (*opon igede*). The lid is carved with low relief faces and the interior is divided into four quarters around a central compartment. The four compartments are linked to the FOUR/SIX DIRECTIONS. Other equipment consists of the tapper (*iroke*), a miniature elephant's tusk carved with a figure of kneeling woman, the pose symbolizing respect, greeting, devotion and suppli-

cation. The palm nuts are stored in an open or lidded cup called *agere* after Oronmila's wife, who once saved him from enemies by hiding him inside her stomach. The most striking diviner's tools are the carved circular, oval, semicircular or rectangular trays called *opon*, "to flatter," with raised low relief carvings that evoke a cosmos of competing, autonomous energies— the "ground" on which the divination takes place.

Ife. The town in southwestern Nigeria, believed by the YORUBA to be center of their culture and the place where the world was created. The spiritual home of modern Yoruba, it was, from the 11th to the 15th centuries, the capital of a prosperous and extensive kingdom headed by an hereditary ruler known as the ONI of Ife. Around 1400 Ife began to decline perhaps due to its eclipse by Old Oyo, located at the terminus of the Trans-Saharan caravan route. Although the artists of Ife worked in terracotta (several hundred fragments exist) and stone, the most remarkable productions are the naturalistic bronze (technically speaking, zinc-brass) images depicting the rulers. Approximately thirty brass sculptures including heads, figures and one unique pure copper mask have survived. All of the work reflects enormous technical sophistication, the metal in some cases being paper-thin. The geniuses who fashioned the sculptures captured the subtle contours of the human face, e.g., the flare of the nostrils; and the delicate skin of the eyelids suggests the moist globe of the eye itself. At the same time, the details of costume and jewelry in the clothed figures show careful attention to detail. The heads are generally interpreted as idealized portraits used in ancestor worship and/or secondary burial rituals. Holes that follow the hairline, and in some cases, the contour of jaw, upper lip and chin, are thought to have served for attachment of beards or costume. They

IFA

Top: Ifa divination board (called the Ulm Opon Ifa) collected in the Ayizo town of Allada, under Yoruba control from the 17th century. The large face at the top is that of Esu in his role as messenger and guardian of the ritual way. The tray is unique in combining the rectangular and round forms of most Ifa trays. The arrangement of persons, creatures and other objects reflects what Henry Drewal calls a "discontinuous aggregate" in which things are interchangeable, discrete and of equal value. The composition thus visually conveys the myriad, shifting forces that affect human life. Some of the design elements are the sixteen palm nuts (or cowries, or leaves of the sacred akoko tree) below the circular basin and the tusks to the right of the circle that refer to the iroke, the ivory tappers used to summon the spirits. Collected before 1650.

Bottom: Circular Ifa tray from Osogbo with arched eyebrows characteristic of that area. The frogs and snakes refer to Esu's role as messenger. Esu himself appears as a traveler, with a walking stick and a bag over his shoulder.

IFE

Above: This life-sized head was one of several found in 1938 in the Wunmonije Compound, which was at the time within the palace compound. This and other heads, a life-sized mask and figures are triumphs of the bronze casters' art. They remain in Africa, unlike many others of the continent's treasures.

IGBO

Right: Ukara cloth is a striking stitched-and-dyed indigo and white fabric, laden with symbolism. It is the cloth of Ekpe, the most powerful men's secret society, used as a wrapper by members as well as a screen inside the lodge to separate the highest-ranking members from others. Many motifs represent dangerous, powerful animals, the potency of which is doubtless analogous to elder society members. The signs, called nsibidi, may serve as passwords. However, the full depth of symbolism is unknown because of the secrecy that surrounds it.

embody modern-day YORUBA AESTHETICS such as *tutu* (detachment or coolness), relative mimesis and others.

Brief history of archaeology in Ife:

1938–39 Discovery of seventeen copper alloy heads, Wunmonije compound

1953 First systematic excavations by Bernard Fagg, William Fagg, John Goodwin in the sacred groves

1957 Discovery of full-length figure of an Oni, other works at Ita Yemoo

1957–58/62–63 Excavations by Frank Willett resulting in unearthing two shrines and terracotta figures

1963–64 Igbo Obameri mound excavated by Oliver Myers, terracotta heads

1969 Odo Ogbe Street and Lafogido excavated by Ekpo Eyo

1971–72 Obolara's Land and Woye Asiri excavated by Peter Garlake

Igbo. The Igbo are thought to have originated beginning around 3000 BCE in the confluence of the Niger-Benue rivers, some one hundred miles north of their current homeland. About 1200–1000 BCE they

began to practice agriculture, the original population was augmented by migrations and trade with other areas began. Five major regions—differentiated by language dialect and culture—developed early and have been maintained into the 20th century: northcentral, northeast, southeast, south and west. Sometime in the 9th-10th century the culture of the northcentral area consolidated, probably among the Nri people, at IGBO-UKWU. Igbo society is characterized by authority vested in elders and family heads; emphasis on community (*mmaduka,* "group is strength"); the development of professionals in ritual and the arts; and a combination of secret societies and public cults. Among the latter, an important one is the MBARI complex of the southwestern region, honoring powerful local deities, especially Ala, the Earth Goddess. Initially, European contact was limited because of the inland location of Igboland, but major changes occurred after 1900. The decades before and after Nigerian independence in 1960, were times of strong Igbo influence and adaptation during which the people's "receptivity to change" and inventiveness was evident. Today, traditional values and art continue but are affected by increasing commercialization and Westernization. Igbo art work, bewildering in its variety, can be classed as follows: personal shrines (IKENGA), cult architecture and community shrines (*obu* men's meeting houses, MBARI and display sculpture), IGBO MASQUERADES (e.g., maiden-spirit masks, *agboho mmuo, mgbedike* masks and IJELE), title and chiefs' regalia and finally the MAMY WATA cult. The northcentral Igbo carve life-sized display figures called *ugonachonma* ("the eagle seeks out beauty") that embody ideals of female beauty. These are more life-like than the stiffer, more conventionalized shrine figures from the same area. These figures have elaborate hairstyles, elegant body painting and other adornments. Their attributes include an umbrella and a

mirror, according to Herbert Cole in *Icons: Ideals and Power in the Art of Africa*, symbols of vanity and wealth. Physically, they resemble the ideal beauty of maidens seen also in spirit masks. See also YAM for an illustration of an Igbo yam shrine.

Igbo Masquerades. Literally thousands of masks appear in various ceremonies throughout Igboland. The multiplicity of masks is a reflection of Igbo individuality and complex thought patterns, where concepts and images interlock and proliferate. The masks belong to village dancing societies or men's age-grade groups and fall into hierarchical types associated with different grades within the men's groups. A broad dichotomy exists throughout Igboland between beautiful and dangerous masks, the former largely associated with women, lightness, beauty and community and the latter with men, distorted exaggeration (ugliness), darkness and the mysterious forces of nature. The best-known and most widely distributed beautiful masks are those of the northcentral region that represent "maiden-spirits," which are used for social regulation, during agricultural cycles and at funerals of prominent individuals. The maiden masks embody the Igbo ideal of female beauty, which like beauty elsewhere in Africa, is a combination of physical and moral qualities. A beautiful woman is lightly complected, tall and long-necked, with a narrow waist and full, pointed breasts. She should have fine facial features, a straight long nose and small mouth and her face painting and tattoos should add to the attraction of her features. She should have a graceful, dignified carriage and smooth, glistening skin that glows with health. Purity, generosity and good character only make her more beautiful. These characteristics are visually manifested in the refined maiden masks worn over brilliantly colored, tight-fitting costumes. Older masks often have a skull-like appearance in keeping with the con-

cept that spirits are "ghosts." Diametrically contrasting with the calm beauty of the maiden masks is the *mgbedike* type (the name translates "time of the brave"), also from the northcentral area. This type almost always sprouts horns. *Mgbedike*

masks are varied and numerous and are worn over voluminous, noisy composite costumes. The NAMES of these masks often refer to fierce animals and they behave aggressively as they dance. They evoke the ideals of middle-grade men whose strength, bravery and virility protect the community. The heads and superstructures of these masks are often very large, twice life-sized and projecting features, gaping fanged mouths and spiraling horns add to their puissance. Cole and Aniakor identify two broad categories, "night spirits" and "bad spirits" (*ajo mmuo*), manifestations of the "incarnate dead." The bad spirit masks, closely allied to powerful medicines, the spirit world and the wisdom and heroism of deceased elders, were the most powerful of all.

Igbo-Ukwu. An archaeological site in the northern Igbo area where, in 1939, a group of unique objects were found. Not much more was known of this ancient Igbo tradition until Thurston Shaw conducted further archaeological work in the 1960s, at which time it was established that the culture spanned the 10th and 11th centuries.

IGBO MASQUERADES

Above left: Maiden mask, agbogho mmuo, with a white face and an elegant crested coiffure. Worn on top of the male dancer's head, the beautiful maidens are literally larger than life.

Above right: Mgbedike means "time of the brave," and refers to male masks embodying dangerous spirits. The four great spiraling rams' horns and gaping mouth add to the power of the mask.

The over 1000 Igbo-Ukwu objects that have come to light consist mainly of terracotta vessels and metalwork that were apparently placed in shrines, buried with ancient rulers and cast into a "disposal pit." One shrine or treasury included many bronze bowls, shells, pendants, pot stands, staffs and over 63,000 glass and stone beads. The metalwork is of incredible sophistication. The style, with its all-over, refined, miniaturized geometric and animal designs and its unique combination of realism and imagination, is quite distinctive. Scholars now feel that Igbo-Ukwu was likely part of an extensive cultural phenomenon, later in date than the NOK culture, but earlier than IFE. It is suggested that the society involved was the Nri people. Cole and Aniakor point out parallels between Igbo-Ukwu objects, Nri myth and ritual and the modern Igbo.

Ijele. *Ijele* "masks" from the northern IGBO region, Onitsha to the Anambra Valley, are among the most astonishing in the world (see Colorplate 6). Cole and Aniakor have called them a "progressive aggrandizement" of earlier cloth headdresses and the openwork crests of maiden spirit masks. *Ijele* masks, at over fifteen feet and six feet wide, are very expensive to commission, requiring the labor of four skilled tailors and experts in applique for six weeks, working ten hour days, seven days a week. They used to be seen rarely, but with greater affluence are more common. The mask consists of a wooden five-foot diameter disk that rests on the dancer's head. Over 1,000 individual items are attached to the disk and to the palm rib armature. Liana vines are bent into two arches resembling rainbows. Mirrors, human and animal figures, streamers, flowers and a long python create a complex, kaleidoscopic tableau that represents the great spirit, the energy and prosperity of the community and its continuity with the ancestors. The overall architectural shape of the mask is like that of circular buildings with conical thatch roofs. The entire assemblage weighs over two hundred pounds and moves with assurance and surprising speed, accompanied with music and attended by lesser masks and acrobats. The twelve- to fifteen-minute performance is as much a *tour de force* as the mask itself.

Ijo. The Ijo live in the Niger delta and make their living primarily by fishing. Two style clusters exist, the eastern region and the central/western region. Art forms associated with the eastern area are softer and less aggressive than the other region's geometric and abstract masks. The best-documented art is that of the eastern Ijo KALABARI group which has a distinctive tradition of its own.

Ikenga. IGBO sculptures called *ikenga* are used in male cults concerned with personal power and failure or accomplishment. Success rests on moral probity and physical strength, with the prosperous yam farmer who accumulates wealth, titles and a large family setting the standard. *Ikenga* sculptures occur in seemingly endless elaborations, from the simplest (3- or 4-inch heads with horns) to the most complex (life-size standing male figures with elaborate headdresses incorporating horns). The *ikenga* contains a multitude of interlocking properties—the individual's life force/fate (*chi*), his ancestors, his right arm or hand (*aka ikenga*) and his power (*ike*). Young men generally acquire *ikenga* in early maturity, around the time of marriage and establishment of family. Initially an *ikenga* is activated by prayer and sacrifice in the presence of the individual's lineage head after which it is treated as a living entity, an altar that will remain with the owner/guardian throughout life. Upon the owner's death, *ikenga* may be buried or split in two, but often they are kept in the family shrine as heirlooms and memorials. *Ikenga* are said to crystallize male power. The horns, frequently those of

IGBO-UKWU

Above: This leaded bronze "roped waterpot" is a tour de force of the metal casters' art, being made entirely out of metal. Certain ritual vessels apparently had such potent contents that they could not be allowed to come in contact with the earth, for fear of corruption and defilement. Pot stands and methods of suspension solved the difficulty in ancient times and are still in evidence among the modern Igbo. 9th–10th century.

a ram, a creature that fights rarely, symbolize aggression tempered by restraint and perseverance. The figures carry knives, severed trophy heads and occasionally staffs and elephant tusk trumpets. The knife signifies decisive action and bravery. The trophy heads, linked originally with head hunting and perhaps CANNIBALISM, symbolize accomplishment and success. Genitalia are often depicted realistically, since one measure of success is fathering a large family. Related *ikenga* altars or the concept, at least, are found also at BENIN and among the Igala, Ishan, Isoko, URHOBO and IJO. See INDEX: Ram in Animals.

"Indian Time." Native North Americans think whites are slaves to time. Flexible "Indian Time" might be defined as "some unspecified time following a specified time." A question of priorities, Native North Americans do not allow anything to interfere with that which is considered to be important. "Indian Time" involves a refusal to live in a strictly material, temporal universe, an interpenetration of sacred time and profane time. As Ralph Coe puts it, Indian Time "…is governed by a larger, allover spectrum in which fragments become a whole, like a circle of life" (*Lost and Found Traditions*).

INDIAN TIME

Above: Beaded watch by Joyce Growing Thunder Fogarty. Fogarty, descendant of Joshua Wets-His-Arrow, the great Assiniboin leader, and One Bull, nephew of Sioux warrior Sitting Bull, made this faceless, handless watch for anthropologist Ralph Coe when he moved to Santa Fe and "became a real westerner." 1985.

Initiations. Mircea ELIADE delineates three categories of initiations: first, those marking RITES OF PASSAGE from childhood or adolescence to adulthood; second, the rites involved in entering a secret society; and third, those occurring in connection with mystical vocation, e.g., SHAMANISM. In many traditional societies, the first and second categories are collapsed, since puberty rites simultaneously involve initiation into the group's secret men's society. The initiation sequence typically begins with the separation and isolation of the individual from the rest of society. With shamanistic initiations this often takes the form of a retreat into the forest or some other remote region, while with puberty rites the boys are separated from their mothers. During their isolation, the initiates undergo various trials and tests often involving symbolic death. Education in various forms is an important aspect of this phase. The shaman is taught the skills of healing by the divine or demonic spirits who test and teach him. Boy initiates learn the mythology and the complex details of social, spiritual and interpersonal relationships within the group. Often, the boys are instructed regarding the society's practices and expectations as far as sexuality is concerned. The shaman may experience and show symptoms of mental and physical illness during the period of seclusion. The boys are often circumcised, subincised and cicatrized or scarified (see BODY ART) during this period. The pain they undergo serves to dramatize the seriousness of the ritual as well as testing their courage. Other common elements play a part as well, including ANDROGYNY and transvestitism, both of which emphasize male roles by reversal. Male initiations usually involve symbolic parallels with the boy's first physical birth. The men's houses in which the rituals take place (see Abelam KORAMBO, Asmat YEU and Iatmul TAMBARAN, for instance) are wombs within which the elders teach and nurture

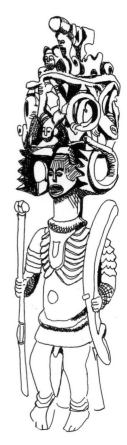

IKENGA

Above: Complex Igbo ikenga from the Aguleri/Umuleri area. Although the name of the carver is not known, other virtuoso work by him exists. The characteristic horns are elaborated into a kind of symbolic headdress. Given the complexity and size of this sculpture, it must have belonged to a high-ranking man.

INNU

Right: The designs on this summer coat were believed to be pleasing not only to people, but to the animals they hunted. Caribou hide, sinew and fish-egg paint. 19th century.

INSECTS

They are so wise,
They always remember
 where their home is.
They travel great
 distances,
But always find their
 way back.
We make offerings to
 ants for their wisdom,
So that we will have the
 ability
To keep the prayers in
 our memory.

—*Zuni man.*

the boys, thereby making possible their second birth. The blood of circumcision and scarification is like the blood that accompanied their biological birth or like menstrual blood. Having survived a kind of surrogate death, the second birth is thought of as a spiritual birth, as well as the beginning of—the being born to—the next stage of their lives. Above all, the dramatic events sever the boys from earlier modes of being and thinking and, at the end of the ceremonies, they emerge from their seclusion as transformed, fully initiated members of society. Initiations thus serve not only to establish the individual's place within society, they reestablish societal lineages and links with ancestors and progenitors and, above all, reiterate the balance and continuity of society. Women also undergo initiation, but it has rarely received the attention devoted to male initiation. Generally, rituals mark the physical changes in girls' bodies. The first menstruation is often attended by separation from the community for varying lengths of time. During their segregation, girls are taught customs and learn the secrets of fertility and sexuality. See also GENDER ROLES.

Innate Releasing Mechanisms. See IRMS.

Innu (formerly Naskapi, Montagnais-Naskapi—Naskapi is an old Innu word meaning "people beyond the horizon"). The Labrador Innu (not to be confused with their northern neighbors, the INUIT) made caribou skin summer coats that were painted with detailed designs consisting of parallel lines, triangles and curvilinear scrolls and spirals. Made by women, the coats' form has recently been shown to reflect European 18th- and 19th-century fashions, but the painstaking paintings and patterns stem from local beliefs. Speck, a 1930s ethnographer, reported the Innu belief that animals preferred to be killed by hunters wearing decorated clothing (the designs were also satisfying to the hunter's

inner "soul-spirit" see also MASTER/MISTRESS OF ANIMALS). In modern times, when North American peoples no longer depend on game for survival, the tradition of dressing well continues as it adds to self-confidence and prestige in the eyes of oneself and others. Dorothy Burnham, who

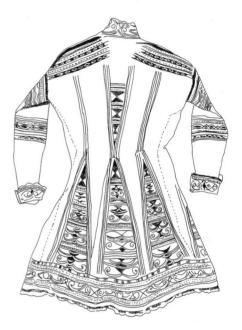

established the link to European fashions, notes the symbolic power of the patterns: the non-functional triangular gusset was the center of the coat's power and symbolized the mountain where the lord of the caribou lived and from which the caribou came to deliver themselves to the hunters. An important Innu ceremony was the shamanistic SHAKING TENT.

Insects. Insects play a surprisingly large role, given their size, in indigenous art and mythology. Indigenous peoples as acute observers of the life around them witnessed insects' appearance, behavior and life cycle and incorporated them into their symbolism. The ASMAT of New Guinea, for instance, noting that the female praying mantis bites off the head of the male following mating, transformed them into symbols of head hunting and, by a complex

series of associations, linked them to ancestral lineages. Spiders are found frequently—usually in conjunction with their webs. In at least one case, the spider is a solar symbol and the creature is credited with bringing FIRE to human beings. The Navajo say Spider Woman wove the cosmos and taught weaving to the women, while the Hopi credit her with saving humanity from a flood that destroyed the world. In the Southwest, a wide range of insects is depicted in rock art, including ants, stink bugs, butterflies and the water skate. The Zuni believe that insects are wise and powerful. For other insects see INDEX: Insects in Animals.

Intermontaine. See PLATEAU.

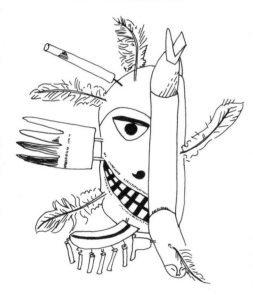

Inua. In the INUPIAT language, the word for the beneficent spirits or souls of all living things (*yua* in Yup'ik). More specifically, *inua* refers to the human counterpart of a being or object, i.e., the human aspect of a mask representing a spirit, animal or inanimate object. The concept also likely reflects the interchangeability of humans and animals. The Yup'ik believe that *inua* are in constant circulation; in a process of continuous reincarnation. Like the INNU, these ESKIMO people showed respect and gratitude toward the animals they depend-

ed upon for food—thanking them for providing sustenance. Certain rules and taboos governed relations with the spirit world; breaking them caused illness and misfortune. The SHAMAN was called upon to restore the balance through ritual. This could be done in a shamanic seance or in a masked performance. Eskimo masks depict animals and their *inua*. Beyond human/animal interchangeability, the masks are very likely linked to the myth of Raven's first sight of man who had just emerged from a pea pod. The astonished Raven pushed his beak to the top of his head, as if removing a mask, and changed into a man. *Inua* masks can be thought of as depicting primordial combinations of man/animal and their ability to shift from one form to another just as Raven became a man. Thus, Eskimo masks can be said to restore the original mythic situation. Wearing such masks evoked primordial time and enabled the dancer, like the shape-shifting shaman, to become at will either or both the animal spirit and its *inua*. The masks, as well as those depicting dangerous spirits called TUNGHAK, were used in increase (especially hunting), curing and funeral rituals. Although the style and appearance of Eskimo masks varied, there are some shared characteristics. The exterior shapes of the masks are extraordinarily diverse, an impression augmented by the presence of added-on materials. These added-on materials (shell, bones and feathers) and carved elements are pegged into the sides of the mask and create an effect of energetic, sometimes bewildering, outward expansion. The core of the mask may be fairly flat, but the overall impact is quite three-dimensional as the projecting add-ons break the vertical plane. While symmetrical balance is usually present, asymmetrical volumes do occur, especially in *tunghak* masks. The masks also use color in a way that adds to their expressiveness. Finally, although not as complex as Northwest Coast TRANS-

INUA

Left: This Alaskan Eskimo mask represents a seal on the right and its inua in the form of smiling half face. The added-on elements include a harpoon shaft, a flipper with dangles and white feathers. The lack of symmetry is more typical of tunghak masks, but here the flat oval of the face is more than balanced by the volume of the seal's body. Before 1910. Redrawn after Nelson, 1899.

INUIT

And I think over again
My small adventures
When with a shore wind
I drifted out
In my kayak
And thought I was in
danger.

My fears,
Those small ones
That I thought so big,
For all the vital things
I had to get and to reach.

And yet, there is only
One great thing,
The only thing:
To live to see in huts
and on journeys
The great day that dawns,
And the little light that
fills the world.

—*Little Song/Traditional*

INVERSION

*Right: Three views of an
early Eskimo ivory figurine
from Thule, approximately
2″ high. Worn to engage
the protection of ancestors
or by pregnant women to
encourage safe delivery.
After 900 CE – 1700 CE.*

FORMATION MASKS, Eskimo masks do have hinged elements that open and shut to reveal different aspects. Style areas include Pacific Eskimo (strongly simplified masks within square or triangular frames), Nushagak River and Good News Bay (painted eye bands, chevrons, massive, ferocious masks with eyes with pupils), Kuskokwim River (many of the most prized masks come from this area, known especially for added-on features), Yukon River (flat nose ridges separating the eyes, smiling heart-shaped faces, small pear-shaped masks) and St. Michael region (converging traditions). See also CHUGACH.

Inuit. Meaning "the people" in the Inuktitut language, the word is used in Canada and Greenland to refer to ARCTIC peoples (ESKIMO is used in Alaska). The first European to make contact with the Inuit people was Sir Martin Frobisher in 1576.

Inupiat (or Inupiak). INUIT/ESKIMO who live in some three dozen villages and towns in northern Alaska and northwestern Canada. According to the accepted, but oversimplified, model, Inupiat nations from their 19th-century beginnings divided into two groups, one of which lived along the coast and depended on the sea for sustenance and the other lived inland and depended on the caribou.

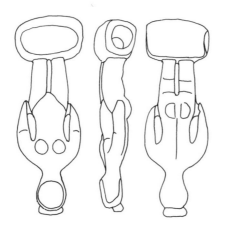

Inversion. Inverted figures rarely occur just to produce symmetry and balance in design. Usually, symbolic significance is attached to inversion. For instance, in Asmat BIS POLES, where the mangrove tree is inverted, the uppermost part carved from the tree's roots symbolizes a penis. Inverted trees also play a part in mythology, as for instance, the MAORI creation myth in which TANE (god of forests) pushes his parents apart, his hands rooted in PAPA, mother earth, his legs straining to raise RANGI his father. After he succeeds, he props up the sky with trees. The Asmat believe that human beings were carved from trees by the culture hero FUMERIPITS and brought to life when he played a drum. The original ancestors were trees and the *bis* poles, dedicated to recent dead, assuage their anger at having died and safely return them to the vital, procreative realm of the ancestors. Planting the family tree, the tree of life, upside down may symbolize the notion that death is simply an inversion of life. ESKIMO ivory female figurines were pierced between the feet for suspension and clearly made to hang upside down. These figures, said to be honored and protective ancestors, seem also to involve the idea that death is simply life inverted. The Eskimo, in fact, believe an individual may have multiple souls, including one called *nappan*, a vital force that kept individuals on their feet. Clearly, loss of this soul would result in inversion. Another possibility, suggested by Henry B. Collins, is that pregnant women wore the tiny inverted figurines to promote safe delivery. See also ESU.

Ipiutak. Early ARCTIC culture, named for the large archeological site (discovered 1939) consisting of several hundred households near Point Hope, Alaska. Rich burial goods accompanied the burials of shamans and chieftains, including replicas of tools, amulets, interlocking chains and masks. The latter, as well as ivory loon heads, are

similar to shamanic equipment from Siberia. The double contoured, curvilinear patterns have also been compared to the Scytho-Siberian animal style. The highly refined carving techniques and patterns are found throughout the Old Bering Sea (or Norton Tradition) culture and endured within the Arctic region for some 1500 years.

Irian Jaya. Formerly the western half of the island of NEW GUINEA, now called Irian Jaya, or West Papua; since 1962, a province of the republic of Indonesia. The major art-producing cultures of the area are the MARIND-ANIM, the ASMAT, MIMIKA, GEELVINK BAY, HUM-BOLDT BAY and LAKE SENTANI. See map: NEW GUINEA, IRIAN JAYA, ADMIRALTY ISLANDS, NEW IRE-LAND, NEW BRITAIN.

IRMS. Innate Releasing Mechanisms. The concept comes from animal behavior-ism, particularly the work of Tinbergen and Lorenz. Simply put, species have hard-wired into them (in the genetic code) sur-vival behaviors that are triggered by visual signs. For example, the human infant responds very early to another human face—and, importantly to the basic ele-ments of the face, the exterior oval of the

head and two eyes—by smiling. The smile guarantees parental care and affection, thus contributing to well-being and sur-vival. Joseph CAMPBELL merged IRM signs with his discussion of Jung's concept of ARCHETYPE.

Iroquois. The Woodlands Iroquois con-sisted of five nations, the Mohawk, Oneida, Onondaga, Cayuga and Seneca, at the time of European contact. In the early 18th century, these were joined by the Tuscarora to form the Six Nations of the Iroquois or Iroquois Confederacy. Iroquois territory covered the area east of Lakes Erie and Ontario, and parts of New York State and Pennsylvania. Believed to be the language of the soul, dreams played a role in every aspect of Iroquois life. Guardian spirits, often in animal or bird form, revealed themselves to individuals in dreams. Dreams were investigated to reveal sources of illness and spiritual imbalance, consulted about hunting, mili-tary and political plans. Dreams could fore-tell the future. Dreams of ill portent were acted out in order to control their force—for instance, a warrior who dreamt of cap-ture or injury might ask his fellow warriors to bind and wound him, fulfilling and thus dissipating the danger of the dream vision. See also IROQUOIS RELIGION, LONG-HOUSE, WAMPUM.

Iroquois Religion. A pair of TWINS cre-ated the three-tiered world (positive sky realm, negative underworld and that of human experience, an amalgam of the oth-ers). The Master of Life, Tsenta, culture hero/creator of flora and fauna, gave man customs associated with the sky world. The other, Taweskare, the evil twin associated with the underworld, affected all life with his negative, cold influence. Iroquois spiri-tual life aimed to increase life-sustaining forces, while eliminating or at least lessen-ing death-dealing forces. The eight-day Midwinter festival begins with rituals

drawn from earlier hunting/SHAMANIS-TIC rituals (expulsion of the old year, confession, dream fulfillment and curing ceremonies), followed by the "four sacred rituals." The latter, reflecting the later agricultural nature of Iroquois society, are primarily increase ceremonies that invoke blessing, fruitfulness and offer thanksgiving.

IROQUOIS
RELIGION

Above: Husk Face society mask made from braided cornhusks.

Additionally, there are eight "medicine societies" that aim to counteract negative forces. The famed FALSE FACE society is said to be the favorite of the Iroquois. The Husk Face society is dedicated to agricultural spirits. These spirits are active in curing rituals, but more importantly, they burst into the Longhouse during the Midwinter festival and announce that they are going to the other side of the world to till the crops. The masks worn by Husk Face society members are made by women of woven or braided cornhusks. Husk Face masks, regarded as the female counterparts

of the male False Face masks, represent vegetation spirits. Both men and women wear Husk Face masks to assist members of the False Face society to purify homes, drive out illness, evil spirits and bad luck. At the end of the 18th century, Handsome Lake, a charismatic mystic and reformed alcoholic began a new form of Iroquois religion called Longhouse Religion. The new doctrine, which attempted to revive Iroquois traditions at a time when they were being threatened by acculturation, involved living in harmony with the spiritual forces and cycles that sustain human life. Today, approximately one-quarter of the Iroquois still practice this religion.

Islam. Islam was probably introduced into the western Sudan in the 8th and 9th centuries, arriving with merchants and scholars. Islamic Arab and Persian merchants colonized the coastal regions of East Africa in the 8th century. The impact of Islam on African art is extensive and has not yet been thoroughly analyzed except for mosques and domestic architecture. Generally, Islam is associated with urbanization and the introduction of new techniques. At the same time, local traditions were encouraged and the new Islamic residents adapted to the unique conditions, limitations and benefits of the region and the environment. The prohibition of figurative images and the resulting proliferation of decorative patterns in areas affected by widespread conversion to Islam is deserving of further study. Masking and figurative traditions continued after the arrival of Islam. This occurred because Islam acknowledges the existence of witchcraft and when Muslim methods of controlling it failed, traditional methods were invoked. See DJENNE, HAUSA, SUDAN, SWAHILI COAST.

Ivory. Ivory was regarded as embodying the attributes of the ELEPHANT such as physical power, leadership, wisdom and

longevity. The hardness of ivory guarantees that the historic and symbolic messages carved into it will be available to later generations. Finally, the white color, reminiscent of chalk, signifies purity and furthermore, in Nigeria, it is associated with the sea, province of OLOKUN. Unlike other ritual objects where the accretion of offerings increased their power, ivory objects were washed and bleached with lemon juice to keep them as white and pure as possible. After the beginning of European trade when ivory became a valuable commodity, whole carved tusks were added to BENIN ANCESTOR SHRINES, arching up out of the tops of brass heads. These and other ivory objects were overt signs of the OBA's wealth and power. The regalia include maskettes and armlets and the Oba sounded an ivory sistrum. Ivory animals are among the most spectacular objects from Benin (for an illustration, see FELINES). Trumpets, divination tappers and various sorts of containers were also fashioned out of ivory. See also AFRO-PORTUGUESE IVORIES.

Ivri (also *ivwri*, *iphri*). URHOBO sculptures from the western Niger delta are referred to as altars or shrines to the hand. The underlying concept parallels Igbo IKENGA sculptures.

J

Jado. New Caledonian funeral ritual. See KANAK.

James, Charlie (c. 1870–1938). KWAKIUTL artist who worked primarily in Alert Bay. See HAMATSA.

Janus Faces/Figures. Some MARQUESAS ISLANDS food pounders, used to mash breadfruit and taro were ornamented with Janus heads. Marquesan U'U war clubs are carved with heads facing in both directions. Functional objects, the clubs were used not only in battle but were prestige objects, which their owners carried with them. The warriors leaned on the club's crutch-shaped top in public. In both cases it is likely that the heads served an apotropaic function. Objects associated with the preparation of food are more than functional utensils as they are surrounded by the rules of TAPU, while the two-faced clubs were double protection in war or in daily life. In Africa, phallic-shaped Yoruba ESU dance hooks, worn over the shoulder by priests, often have faces looking in both directions. The faces symbolize Esu's dual nature and his connection with fate, both past and present. See also AUSTRAL ISLANDS, FINGER MASKS, NOMMO, PIGS, SENUFO MASKS and WIND CHARMS.

Jebba. Jebba is a NUPE village upstream from TADA. Three copper alloy figures from Tada were kept in Jebba, until one was stolen in 1969, after which the remaining two were housed in the Lagos Museum. The so-called Jebba figure, which represents an archer, is more stylized than

JANUS FACES/FIGURES

Below: This figure is duplicated on the other side of this classic type fly-whisk from the AUSTRAL ISLANDS.

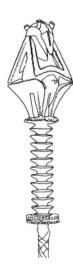

JEBBA

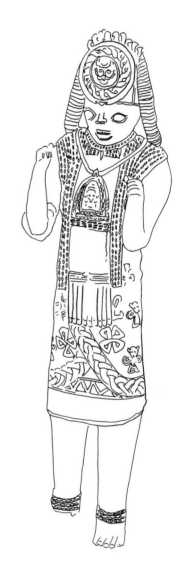

Above: The rich costume of the unique so-called Jebba figure includes an Ife motif on the sides identified as a bat or snake-winged bird. The motif is said to be a symbol of the ruler's supernatural power. As a liminal creature, a flying mammal, abroad at twilight, the bat is an excellent symbol of the king's supernatural and unbounded powers. Early 14th century.

the famous seated figure from Tada. Various sources are suggested for this figure including IGBO-UKWU, Old Oyo and Owo. The remaining male figure wears an elaborate costume, all elements of which can be found in the arts of IFE, Owo and BENIN. The costume consists of an elaborately embroidered or appliqued tunic, bells, cowry shells, a ram's head pectoral and a necklace of leopard's teeth. He wears two disks on his head, the front-facing one adorned with a horned human head with snakes coming out of the nostrils, topped with a row of birds. The significance of this complex costume is unknown.

Jimsonweed. Common name for datura, see HALLUCINOGENS.

Joint Marks. Patterns that draw attention to the joints of the human figure are called joint marks. Carl SCHUSTER believed that such marks functioned as symbols of ancestral descent and located numerous examples, distributed throughout the world (*Patterns That Connect*). For instance, the HAIDA depict joint marks as raised ovoids, often carved in the form of small faces. The Haida believe that the soul leaks out of the body's joints or orifices prior to death. In the Pacific, joint marks are found frequently in those cultures influenced by DONGSON cultural patterns (e.g., MASSIM). See also CONCENTRIC PATTERNS, MIMIKA, NORTHWEST COAST STYLE and SAWOS.

Jos Sudarso Bay. Contemporary name for HUMBOLDT BAY, New Guinea.

Journey of Life. See PATH OF LIFE.

Jump Dance. The Jump Dance is part of the World Renewal Cult found in northwestern California, centered among the Yurok, Karok and Hupa, but found elsewhere as well. The people believed the

world became unbalanced due to the weight of human error and misconduct. The ten-day Jump Dance autumn ceremony "fixed" the world, while the Deerskin Dance reaffirmed the interdependence and vitality of all life. Jump Dancers wear flicker headbands, dance aprons, beaded necklaces and carry distinctive Jump Dance baskets. The baskets' cylindrical shape is unique among California baskets and may be inspired by the elkhorn purses traditionally used to hold shell currency, as well as to signify good luck and being in a state of balance with *woge*, Spirit Beings.

JUMP DANCE
BASKET

Above: Ceremonial cylindrical basket made by an unknown Yurok artist. The primary motif on this basket is called a "crab claw." c. 1920.

K

Kachina. Composed of the words *ka* (respect) and *china* (spirit), the word *kachina* most commonly refers to the cottonwood root dolls. The word also describes masks (as well as their wearers) and the supernatural forces they embody. Numbering over 300, the *kachinas* are not gods, but rather spiritual intermediaries—sometimes referred to as spiritual essences—messengers from the gods associated with rain and fertility. Frank Waters has said that they are the uniquely Hopi embodiment of life force. Beyond this generality, their essence is said to be cloud-like, insubstantial and shifting—including the spirits of pure human souls, of the dead, of the ancestors, of minerals, plants, birds and animals, or of STARS yet to be born. Some of the principal *kachinas*, like Shalako Mana (Corn Maiden) and HEMIS, are found universally throughout Hopi communities and among their neighbors, such as the Zuni. Others are unique to particular pueblos and clans. Between mid-July and the winter solstice, when they are not part of human society, the *kachinas*, typical of their ambiguous nature, seem to live simultaneously atop the San Francisco Mountains and in the underworld. In December they join human society at the beginning of the nine day ceremony of SOYALA, coming down from the high mountain peaks in torch-lit processions. In July they depart through the SIPAPU, the entrance to the underworld, marked by the ceremony called NIMAN (Home). The Hopi ceremonial cycle is one of the most powerful instances of the mirroring of natural cycles. Participating in and marking the cycle of nature, brings human beings into balance with the universe and provides a sense of continuity.

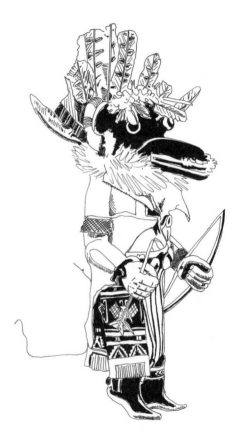

Kachina Dolls. The least significant of the three applications of the word *kachina*, these dolls are made by the fathers or maternal uncles of Hopi girls and given to them by the masked *kachinas* at the conclusion of festivals. Unlike the masks, the dolls are not imbued with spiritual power. Nor are they playthings; instead, their purpose is didactic. They are used to teach Hopi girls the complex combinations of colors, forms and symbols traditionally used to depict the *kachinas*—the boys

receive this information when they undergo initiation. Although most *kachinas* are benevolent, some are monstrous. Dolls representing both types, hung on the walls or up in the rafters of Hopi homes, undoubtedly serve to enforce lessons that go beyond physical appearance to include the "do's and don'ts" of Hopi life. The oldest dolls were rudimentary in form, having simple, blocky or cylindrical bodies with no separation between arms and legs. Painted designs were kept to a minimum. As time passed, the dolls became more elaborate and, once they interested collectors, more realistic. Contemporary Hopi artists make *kachina* figures in bronze, complete with elaborate costumes and in energetic dancing poses.

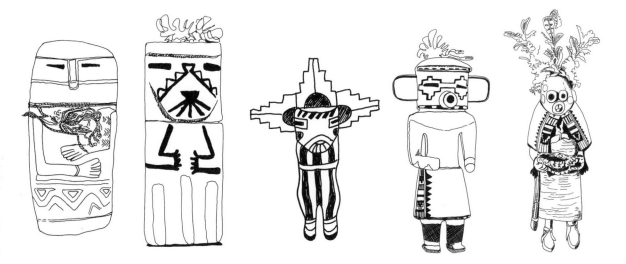

KACHINA DOLLS

Left to right: Kachinas are classified according to chronological divisions: pre-1870, 1870–1910, 1910–1945 and post-1945 or modern. In keeping with Hopi non-hierarchical order, no one kachina is more important than any other, but some are extraordinarily striking and appear more often than others.

The long-snouted Black Nataska is one of several ogres that appear early in the kachina season. The masked dancers visit the children's homes and demand food. They return later and if the offerings are insufficient, threaten to eat or kidnap the children. Later in the day, the fathers engage the ogres in a dance and leap on them, driving them from the village. This frightening event is said to teach the children the importance of self-reliance and cooperation as well as respect for the sometimes capricious kachinas. Post-1945.

The age of the kachina cult is unknown, but small images have been discovered in archeological contexts and are regarded as being predecessors of the cottonwood figures of historic times. Painted stone proto-kachina from northern New Mexico. 13th century.

Two versions of Shalako Mana, Corn Maiden. The earlier, slat-like pre-1870 doll has only a slight groove separating neck and body and details of costume and anatomy are painted. The rudimentary anatomy and attached arms of the later Shalako Mana are characteristic of older dolls, probably between 1870 and 1910.

Kachinas represent various creatures and natural forces, such as Nuvak, the Snow Kachina. Although the arms of this figure are separated from the body, its simple boldness is characteristic of the period between 1910 and 1945.

Masau'u, spirit of the fertile crop-bearing surface of the earth and god of the underworld, is one of the oldest Hopi deities. One indication of his importance is that he is the only kachina who appears outside of the kachina season. His skull-like mask with protruding goggle eyes and toothy mouth is a reminder that he is guardian of the dead. The ambiguous but dynamic balance embodied in the spirit is evident in the contrast between his rather frightening, inhuman appearance and the food basket and his female costume. The realism and attention to detail are instances of modern kachina carving. By William Quotskuyva. 1939.

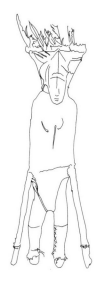

KAFIGELEJO

Above: The finely carved wooden figure within the encrusted cloth wrappings is visible, but blurred, adding to the image's sense of power. It is possible that an ancestor figure was reused to make this kafigelejo; its function then changed.

KAIDIBA

Below: Two stylized frigate birds sit back to back with elongated bird forms spiraling up from their beaks. These MAS- SIM dance paddles were painted red or black and contrasting white lime was rubbed into the lines.

Kafigelejo (or *kafigueledio*). These SENU- FO composite figures made of wood, cloth, feathers and sacrificial materials are not documented prior to 1950. The figures are believed to have magical abilities—indeed *kafigelejo* means "tell the truth"—including revealing lies and unmasking sorcerers. It is possible that they were also used to invoke spells directed against individuals.

Kaggin Inua. Master of the Singing House, a vengeful ESKIMO spirit embodied as a black, hairless bandy-legged man, knees bent outward and forward. This frighten- ing spirit has no bones in the back of his head and touching him was believed to result in death.

Kahuna. Polynesian word for priest and, in the Hawaiian Islands at least, artist.

Kaidiba. DANCE PADDLES from the MASSIM area of New Guinea take the form of two stylized canoe prow orna- ments. Like Massim shields, *kaidiba* repeat the same basic shapes with a subtle inven- tiveness. Either side of a bar for the dancer to hold, the two arch-shaped paddles have rounded ends and squared off bases. Although the overall design is symmetri- cal, subtle intentional variations become apparent on a closer look. The intricate designs consist of spirals, Greek keys and relief circles (like peas in a pod) as well as stylized, but recognizable frigate bird heads. The low relief designs contrast with lacy openwork sections. Individually, the shapes are rather skull-like. Taken as a whole and viewed horizontally, the two halves may make up part of a SIMULTA-

NEOUS IMAGE. The *kaidibas*, twirled back and forth to the rhythm of drumbeats, appeared in various ceremonies including harvests, canoe launchings and prepara- tion for war. The same designs appear on canoe prows and GOBAELA, the shell currency presentation scepters made to hold shell money in the form of discs cut from the red Spondylus shell.

Kairak Baining. In the central Baining area of New Britain, Kairak masks associat- ed with the night snake dance are the best- known Baining objects. Over 200 pre- World War I masks are distributed among museum collections. Three types are said to exist: 1) the *lingan*, a decorated cone- shaped headdress, 2) *kavat*, a small helmet mask and 3) *vungvung* (also *vunbun* or *vun- vun*) a large composite helmet mask. Similar masks are made and used today. The first to dance in modern night dances is the *lingan* (in three variants consisting of fish, bats, frogs' and spiders' legs and plant forms) said to be the younger son of the *kavat* mask. The wide variety of designs is believed to refer to images seen in old men's dreams. Dozens of *kavat* masks are mixtures of humans, animals, birds, rep- tiles, phenomena and human beliefs, actions and objects. These vary from *surra- ga* ("wise old man") to a mask that repre- sents the seed that falls from the tree. The composite type mask, *vungvung*, also con- sidered to be the child of *kavat* masks, is made up of an extended vertical and hori- zontal tail and a bark cloth covered trum- pet issuing from its mouth. Repeat patterns called *memdas* cover these masks as well as the day dance masks. Not mere fill, these hieroglyphic motifs represent chicken tracks, tears beneath the eyes, leaf cross sections and the prints made by snakes and caterpillars. George Corbin has interpreted the myriad forms of Baining art as express- ing a dualistic division between daytime dances which focus on female-oriented activities, fertility, gardening and commu-

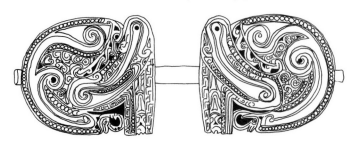

nal activities which contrast with the night dances which feature male activities, hunting and the bush with its chaotic energy. Baining art, thus, visually expresses

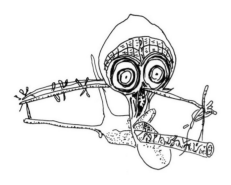

(and presumably thereby revitalizes) their concept of the world. See COLOR and INDEX: Animals.

Kalabari. One of the six IJO subgroups, the Kalabari developed a distinctive tradition in the 15th century when they became middlemen in the Atlantic trade. They believe in, and make sculpture linked with, a triad of spirits made up of ancestors, culture heroes and water spirits. Ritual activity tends to focus on unifying the three, since they believe that their power can be increased by collective action. Art forms consist of masks, KALABARI ANCESTOR SCREENS, figurative sculpture and various textiles. Positive and beneficial spirits inhabit the watery realm. Although their behavior can be capricious, generally they are less dangerous than the malevolent spirits associated with the WILDERNESS among other African peoples. Ritual cycles honor the water spirits that are associated with particular bodies of water and the human ancestors who originally linked the spirit to the human community. The Ekine association, named after the hero-goddess who was abducted by the water spirits from whom she learned the secrets of dancing, is found in every Kalabari community. Although (as among the DOGON) masks were introduced by a woman their use was taken over by men;

women's roles are honored, but men maintain control. The water spirit festival begins when men paddle a canoe to "the beach of the water people" where they make an offering and invite the spirits to come to the village. Individual masks appear during the various stages of the festival, which concludes when all the masks dance together in a ceremony called *owo aro sun*, "filling the canoe of the water people." After the concluding dance, the masks seem to disappear into the water.

Kalabari Ancestor Screens. Social stratification developed as trade in slaves, ivory, palm oil and pepper enriched individuals. Trade was controlled by rival houses of slave origin, which became increasingly powerful. By the 18th century, one line became predominant and Amachree I declared himself king. Ancestor shrines, *duen fobara* "foreheads of the deceased," were kept in the trading group's meeting house headquarters. Made by the families that provided pilots for European vessels, the screens reflect knowledge of the importance non-Africans attached to icons and royal images. The screens with their central frontal figures, iconic stares and frames uniquely combine Western and African

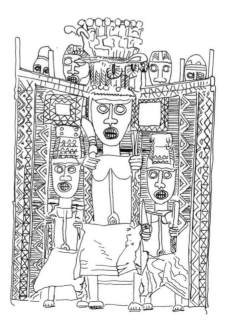

KAIRAK BAINING

Left: Vungvung, a night dance composite helmet mask, represents a leaf used in cooking food.

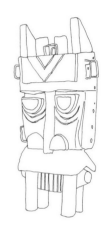

KALABARI

Above: Otobo, a hippopotamus mask, Degema region, Nigeria. Many of the Kalabari water spirit masks were worn horizontally, as if floating on the watery realm of the spirits. 19th century.

KALABARI ANCESTOR SCREENS

Left: This screen represents Alagba, identified by his feathered headdress. The flanking figures wear water spirit masks. All three figures are draped with imported satin fabrics. The square shapes attached to the background probably represent mirrors, prestige trade objects used to embellish headdresses. 19th century.

traditions. Compared to the plasticity of most African art, the figures are quite flat, probably showing the desire to mimic the two-dimensionality of European religious images. The symbols of power, however, are African. Each screen depicts a specific ancestor, generally wearing a masquerade outfit, holding a knife and sometimes trophy heads indicating power and accomplishment.

Kamanggabi. Name given by Anthony Forge to the striking stylized hook figures made by the YIMAR; a corruption of a phrase meaning "the figures from Amangabbi" after the main village in the area.

Kamik. Skin boots made by INUIT women from seal and caribou hide, the boots can be the black, undecorated waterproof type made for hunters, or a more decorative type covered with haired seal skin. The latter make use of inlaid skins of contrasting color for dramatic effect. Flowers are preferred for women's boots, while men's are decorated with animals and birds. The Inuit of western Canada decorate *kamik* tops with fabric, yarn and finely tanned hides with cutout designs. The

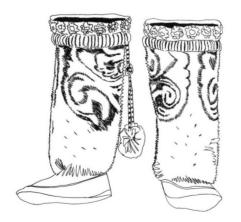

boots are regarded as symbolizing the Inuit lifestyle and people who move away take their boots along, carefully preserving them in their freezers.

Kanaga. One of the most famous mask types of the Dogon of Mali. The only mask made by non-specialists, the flat, double-armed cross-shaped *kanaga* mask is worn by initiates in the Awa masking society. See DOGON MASQUERADES.

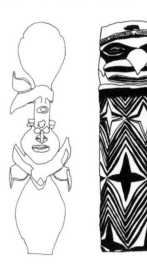

Kanak. In the central region of NEW CALEDONIA, Kanak chiefs were the living representations of the ancestors and of political power. Although descended from the ancestors, the chief's immediate origin was complex, as he was simultaneously the son of the sun, born from a yam in the forest or from a stone. Despite this magical origin (and growth—chiefs were believed to grow up with supernatural speed) the chief was also the progeny of, link and balance point between his paternal and maternal clans. Round chiefs' houses, built on mounds associated with the origins of the paternal founding clan, were ornamented with carved roof finials (the "face" of the chief). The finial was placed at the center of the round roof, above the top of the central housepost, rising out of a basketlike woven construction just under the roof. The house was also ornamented by exterior doorposts (recent male ancestors) and thresholds adorned with a face representing the "all-seeing one." The central interior support post was made from hardwood cut in primary forest (the origin site

of the oldest clan), whereas the finials and doorposts are carved in corpsewood (houp wood). The images, the types of wood and the locations of objects all served to link the living and the dead. The house itself was an image of the authority of the chief in whom intersect the clan lineages back to and including the founding ancestors, the specialized clans (master of the ground, master of the yam gardens, etc.), local history and the members of the living community. At the death of the chief, the finial was taken as part of the violent and frightening *jado* ritual. This ritual represented the seizing and destruction of the paternal symbols of power and authority by the maternal clan. The chief's material being—his flesh, blood, breath—originated with his uterine clan on which fell the responsibility for carrying out the extended *jado* ritual (enacted three times over a period of two years or so) until the body was completely decomposed. Only then could the chief's remains be cleaned and finally deposited. Presumably, the theft and destruction of the paternal images paralleled the decomposition of the physical chief's body. The ritual thus served to reestablish the balance between the male and female sides of the lineage, as well as between the dead and the living. See also the Kanak chiefly symbol, the *gi okono*, often called an axe, although it appears to have functioned as a SCEPTER.

Kanak Masks. Among the most distinctive masks from Melanesia, these played a part in chiefs' final funeral rituals. The masks had two functions: first, political (the mask was "on loan" to the chief from the clan of the local people), and second, representative (it stood for those absent, the dead chiefs). The masks have nearly identical features consisting of protruding, unpierced eyes (the wearer looked through the mouth), prominent nose and open mouth with two rows of teeth. A ball-shaped wig made of mourners' hair topped

the entire ensemble. The typical black patina of the masks is in keeping with color use in other Kanak objects—black was used for faces and the upper body, red for accessories and ornaments. Red is the color of everyday objects and daily life, while black keeps spirits away. The black coloring of the mask is also related to the roads that lead to the land of the dead. The mask was worn over a pigeon feather cape that terminated at the knees.

Kapa. Term for beaten bark cloth in Hawaii. See TAPA.

Kapkap. Pidgin English term referring to filigree turtle-shell disks attached to white seashell disks worn in many parts of Oceania. The finest are made in the SOLOMON ISLANDS, but they are also found in the ADMIRALTY ISLANDS and NEW IRELAND. The designs are closely related to the UHIKANA headband ornaments from the MARQUESAS ISLANDS. The disks, divided into quarters or more rarely into sixths, require a high degree of competence. The designs, which often incorporate skeletal figures, are likely apotropaic devices meant to engage the ancestors. Reserved for persons of highest rank or great warriors, *kapkaps* were emblems of personal and family identity.

KANAK MASKS

Above: These large masks involve the visual conflation of the birdlike original forest spirit, the clan creator father, the deceased chief, the being from the other world who guided the deceased and a theatrical being which amused or frightened.

KAPKAP

Left: This six-fold design from the SOLOMON ISLANDS incorporates ancestor figures alternating, head-up and head-down, around the disk. The use of negative space is especially powerful.

KEREWA

Above: Skull rack, agiba. This agiba is painted black and red against a white ground. The skeletal pattern on the trunk of the body seems appropriate, not only because of the object's function, but also because of the visual connection between the chevron-shaped ribs and genealogy patterns. It may be that the central black circle is a NAVEL, or a SKY DOOR, a threshold between the realms of the living and the ancestors.

KENTE

Right: Men wear kente over the left shoulder and upper arm, the left being the dangerous arm. Women usually wear smaller cloths as skirts or bodices. This detail is from a cloth of the type called sika futura, "Gold Dust Aweaneasa." The pattern is called "skill is exhausted." 19th–20th century.

Kava (or *'awa* in the HAWAIIAN ISLANDS). *Piper methysticum*, a member of the pepper family is indigenous to the Pacific region. At European contact, *kava* drinking was an integral part of religious, political and economic life throughout the Pacific; today *kava* is still consumed in Melanesia, western Polynesia (TONGA and SAMOA) and on Pohnpei Island in Micronesia. *Kava* is also being marketed in Europe and the United States. The drug is a non-addictive mild narcotic, a soporific, with diuretic and muscle relaxant effects. The taste has been described as "earthy" with a mildly peppery quality. At its mildest, *kava* promotes relaxation and sociability—conveying imbibers to the realm of ancestors and gods—while at its strongest it causes sleep.

Kente. Kente is a type of AKAN royal cloth. The word *kente* (from *kenten*, "basket") is actually of Fante origin, but it is used most often to identify ASANTE cloth. Royal weaving, performed by men, dates back to the 17th century and centers at Bonwire, a village about twelve miles from Kumasi. Traditionally woven of silk, the cloth was first made in cotton and currently is mostly rayon. The brilliant colors make it one of the best-known African textiles, one that since the 1960s has assumed a broadly African identity. *Kente* patterns are endless in variation and indi-

vidually named—more than 300 have been documented and originally kings owned "copyrights" to various patterns. Some NAMES derive from visual qualities of the patterns, while others refer to proverbs, themes, or the occasion on which the cloth was first woven. See Colorplate 2.

Kerewa. The most prolific art producers of the PAPUAN GULF area. SKULL RACKS (*agiba*) and shelves within Kerewa men's houses held as many as 700 skulls taken in HEAD HUNTING. Most clans owned a pair of *agiba*, one male, and one female. These were kept on small platforms within special compartments, fastened to the pole supporting the roof. *Agiba*, with their human images, zigzag and chevron patterns linked with genealogy, were ritually repainted by an elder known as the "father of the *agiba*," which reinfused them with power. Offerings, in the form of such ritual acts and enemy skulls, to the ancestors promoted the vitality of the living community and maintained positive connections between the living and the dead. The flat sculptures make powerful use of positive and negative space, further dramatized by the contrasting colors of low-relief carvings. The large concentric eye patterns and "smiling" mouths contribute to what seems to Western eyes to be a lively, even approachable, quality strangely at odds with the sculptures' function. Miniature *agiba* were attached to war canoes for protection.

Ketohs. Navajo bow guards, see SILVER.

Key Marco. Frank CUSHING excavated the Florida mounds that yielded over 100 objects known as the Key Marco finds in 1895. Carefully wrapped in bark matting, the carvings (most of them depicting animals) were preserved by the dampness, but unfortunately, the drying process irreparably damaged some of them. Some of the

animals represented took the form of masks (deer, alligator and wolf, many of them with moving parts). Highly animated human masks also numbered among the finds. The many small figurines—felines, tortoises, opossum and a spectacular pelican—of unknown purpose, are often said to be among the most sensitive prehistoric art works produced by North American Natives. The subtle handling of volumes, use of paint and extraordinary realism of these carvings is unique. The carvings, which may have some connection to MISSISSIPPIAN CULTS, have been attributed to the historical Calusa who lived in southwestern Florida. See INDEX: Animals.

Keyser, Louisa. See DAT SO LA LEE.

Kifwebe. *Kifwebe* (pl. *bifwebe*) is the word for mask in the LUBA and SONGYE languages. Luba *bifwebe* are less angular and abstract. The masks formerly served as agents of social control, exorcising malevolent forces and enforcing allegiance to the rulers. They are understood on different levels, depending on the rank and age of the individual. Most Songye know that white masks with striations and a black band running up the nose represent females, whereas those representing males are multicolored, the striations are bolder and they have larger crests. Outsiders and non-initiates cannot, however, grasp the more complex significance of the masks, which are said to allude to cosmology, referring to planets, certain animals and mythical culture heroes. The animal evoked is the striped bongo antelope, or according to some sources, a now-extinct zebra. The crest—masks with higher and more prominent crests are worn by elders—is said to evoke the zebra or a mountain. The striations recall the antelope's stripes, but for those in the know, they may refer to Songye creation myth that tells of humans emerging from a cavern. The grooves refer to the underworld of emergence and, true to the layered meanings, may also be identified with the path or roadway of the dead who await rebirth. The nose is said to be both a vertical axis and a symbol for the WORLD TREE. The largest mask, a black and red striped one called *kya ndoshi*, is the most powerful and feared. This mask also symbolizes the world tree.

Kilenge. The 3,500 Kilenge, especially known for their woodcarving, live in western New Britain. Craftsmen oversee architecture (including cult figures, carved house posts and painted plank walls), make canoes, slit gongs, drums, spoons, mortars and food containers, combs, and above all, *nausang* masks. Artists achieve status through distinguished craftsmanship—the highest acclaim results in the right to be called *namos tame*, "the father, Great Man, maker of well-made objects that please"—in mask making, canoe building and tattoo design. Possibly the form and more certainly, the content, of Kilenge art was borrowed and assimilated from the Tami Islands. With highly individualized facial features (face paintings),

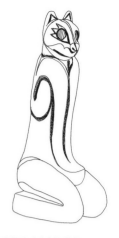

KEY MARCO

Above: This wood carving appears to be a kneeling human being wearing a FELINE mask, possibly that of a puma. It has a quality of monumentality even though it is only about six inches tall. The forked eye motif is also common on Mississippian cult objects. Excavated 1895 in Collier County, Florida.

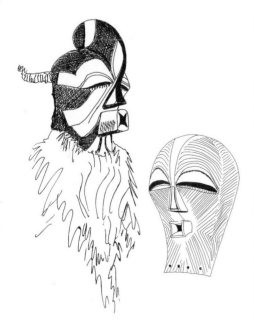

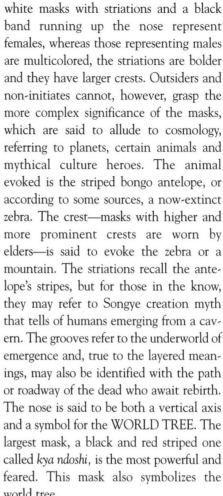

KIFWEBE

Left: The parts of bifwebe masks have names such as "the opening of a furnace" for the nostrils, "the swellings of sorcerers" for the eyes or "the snout of a crocodile" for the chin. These names and the masks' eclectic implications are learned by initiates and form the basis for esoteric knowledge that increases as individuals advance in status and age.

nausang masks have names and are the productions of master artists. The masks follow the same pattern of oval face with slit eyes and protruding tongue. The marks around the mouth, which are more varied, denote family ownership. The marks on the face are said to represent a man who cries when his child dies. On his journey to Endeiwa, the land of the dead, the deceased pauses at a big stone called Virigaii where tears come into his eyes as he thinks of those he left behind. The masks may personify Moro, a hybrid half-snake, half-human culture and his TRICK-STER brother Aisipel. Thus, the masks express a fundamental dualism as well as being associated with the founding clans who are said to be the sons of Moro. The right to carve such a mask is inherited, although a carver can make a mask for which he owns no "rights" at the chief's orders. The bold red, black and white masks were formerly powerful agents of social control used at the circumcision of the Big Man's eldest son. Although today artists carve *nausang* masks for Western collectors, in theory women and uninitiat-ed boys are still forbidden sight of them. The Kilenge also make two other mask types. The *bukumo*, said by the Kilenge to have originated in the bush, is a huge fan-like headdress of feathers (eagle, hornbill and cockatoo). *Nataptavo* masks are the most numerous and exist in three main forms, the most common being the conical type constructed on frames covered with coconut bast which is painted with designs like those found on *nausang* masks. See INDEX: Animals.

Killer Whale. No Northwest Coast Natives actively hunted Killer Whale, the largest member of the dolphin family. Killer Whale appears repeatedly in Northwest Coast art and plays an impor-tant role in mythology. He appears often in CREST designs, but is linked specifically only with the Gitksan TSIMSHIAN.

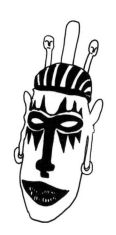

KILENGE

Above: The nausang mask was carved and painted in 1967 by the master artist (namos tame) Talamia.

Kinaalda. Navajo girls' puberty rights, *kinaalda* is one of the Blessingway rituals performed to promote positive blessings. The ceremony includes ritual dressing, hair combing and tying, molding (symbolically pressing the girl's body into a woman's shape), running races and corn grinding. The ritual, in part, affirms women's con-nection with the power and fertility of CHANGING WOMAN, the Navajo Earth Mother.

Kissi. The Kissi of northern Sierra Leone dig up ancient stone figures made by the Sapi called *pomta* (sing. *pomdo*). The mod-ern people of the area believe that the fig-ures are portraits of ancestors who have returned from the land of the dead (*tye pom*). They are referred to generically as *pom'wana* ("divining" *pomdo*) or *pom'kandya* ("dressed" *pomdo*); there are nude *pomta*, but they are of less interest to the Kissi. Each *pomdo* is named for the ancestor it portrays. The figures are kept in isolated huts or in the house of the guardian, usually the son or grandson of the ancestor. The identity of the specific ancestor is revealed in several ways, some-times even before the figure is unearthed. The identification may occur in a dream, in response to divination or in celebrations that follow the unearthing of a *pomdo*. The ancestral spirits do not reside in the stone figures continually, but are invoked through ritual. Sometimes *pomta* act judi-cially, determining guilt or innocence and for sealing oaths.

Kiva. *Kivas* are circular subterranean rooms in ANASAZI and PUEBLO archi-tecture. Described as ritual theaters, *kivas* are nearly perfect circles varying between twenty and sixty feet in diameter. The smaller ones likely served individual clans or families, while the larger ones were for communal ceremonies. At PUEBLO BONITO, the largest Anasazi city, there are over three dozen *kivas*. *Kiva* plans differ

from area to area, but all have altars, a fire pit, fire screen and a SIPAPU, the center, symbol of the mythological place of emergence. Thus each *kiva* is a sacred place where rituals take place that recreate and reenergize individuals and the cosmos. Many *kivas* had paintings on interior walls depicting supernatural beings, myths and agriculture-related scenes.

Klah, Hosteen (1867–1937). A Navajo healer, *hataalii*, and artist of great charisma and talent. His name translates "Left Handed" and he was possibly a hermaphrodite. Whatever his sexual characteristics, he embodied the condition the Navajo call *nodle* ("man/woman"), transcending GENDER ROLES and restrictions. He did not attend mission school, but instead apprenticed to several *hataalii*. By age ten, the extraordinary ease with which he learned the long chants and visual patterns of some of the most complex chantways had already been noted. He learned weaving from his female relatives and designed his own looms for larger weavings. In 1919 he made the controversial move of incorporating sand painting designs into weaving. Traditionally sand paintings and the substances of which they were made were destroyed because of their sacredness and power. Hosteen Klah adapted the designs and not only did he survive this dangerous act, he flourished. The unique combination of male sand paintings and female weaving created a new dynamic art that established *hohzo*, beauty and harmony, in his own life and in the lives of his family and his people.

Knots. The underlying principal of knots and knotting is, as Mircea ELIADE has shown, binding. The purpose may vary from control to protection. Polynesian knots are ritually tied (see GOD STICKS) to invoke and then restrain the god for whom the stick is a container. The *kahunas* of Hawaii chanted prayers while braiding

sacred cords call *'aha*. The incantations were entangled with the cords, which became visible prayers—doubly powerful offerings. The fishnet-knotted backing of Hawaiian 'AHU 'ULA (feather capes and cloaks) likely had the same significance. Weaving and plaiting are associated with knots. Polynesian mats are undervalued,

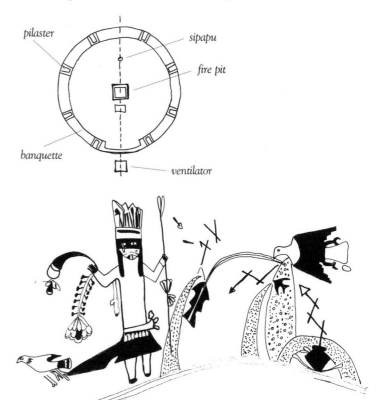

KIVA

Top: Plan of a Chacoan-type kiva. Stone and log pilasters resting on the seating banquette supported the roof.

Bottom: Kiva mural painting from Kuaua, Coronado State Park, Bernalillo, New Mexico. This section of the long, frieze-like painting depicts a costumed dancer evoking Kupishtava, the deity associated with rain and lightning. The figure holds a staff in his right hand and a prayer stick and feather offering in the other. To the left is a bird with moisture coming from its beak. On the right more moisture droplets connect the staff and a fish with zigzag lightning lines and a rainbow passing through its body and out its mouth. The rainbow arches toward an eagle in flight with more moisture or possibly seeds flowing downward from its beak. These descend over a bat-like creature (one source identifies it as a swallow). Sitting just above the baseline—which may also represent a rainbow—is a pot from which zigzag lightning forks upward. The moisture, lightning and seeds create paths linking all the creatures in the mural emphasizing the interconnectedness of all life. After 1300.

since they are generally treated as utilitarian objects, whereas they were heirlooms laden with MANA. In TONGA, for instance, the first intercourse of a chief's daughter was conducted in public to prove virginity, the virgin's blood being caught on a mat. In Africa, knots often seem to stem from ISLAMIC aniconic designs originating in the Near East. Although the way the designs were transferred is unclear, knots, interlaces and guilloche patterns appear on many objects from Benin and other Nigerian cultures and in KUBA royal art. The famous IGBO-UKWU "roped waterpot" utilizes knots to suspend the ritual object above the potentially defiling dirt of the earth. The knots served a protective function beyond the practical one. The binding implications of knots are clear in the Kongo NKISI *nkondi* figure where the power of the figure is evoked by driving metal nails or knives partway into the figure. When used in judicial contexts, to seal contracts, bind oaths or finalize treaties, the figures and their bristling metal are bound in raffia, symbolizing the binding agreement. Should any of the parties break their vows, the *nkisi nkondi* figure was believed to hunt down and punish the offender. For other examples of binding, see BOCIO. Often African knot patterns seem to be linked with snakes, as is apparent in the intertwined double-headed snakes on the BAMUM beaded throne. And knots appear in conjunction with snakes on the powerful ritual heads of OSUN, the Benin god associated with health and healing. In this context, the knots are said to refer to the permanence and force of the spirit world. Knots are recurrent in African SIGN SYSTEMS as well. Also see SCEPTER.

Kofi Kakari. Ruler at the time of the British colonization of the ASANTE kingdom. Many gold objects have survived from his rule, see AKAN GOLD and GOLDEN STOOL.

Kokopelli (also Kikopilau, Kokopele, Kokopeltiyo, Kokopelmana). Kokopelli is the Hopi name for the Humpbacked Flute Player of the American Southwest associated with fertility and rain. The Hopi KACHINA Kokopelli originally had a hump, a long snout, an erect phallus, but no flute. As a flute player, he is depicted in ROCK ART, on pottery, murals and can even be found in 20th-century Navajo pictorial rugs, modern silver and logo designs for radio stations. In fact, Kokopelli has become a sort of "in" symbol of the new age. Flute player imagery occurs at least as early as 300 BCE in HOHOKAM images from Arizona. It is suggested that the image may have traveled north from Meso- or South America with—indeed, inspired by—traders carrying packs (humps) on their backs. When Kokopelli plays his flute, it is said that the snow melts and the earth warms. He is often depicted with snakes in rock art as well as with other water symbols like water gourds, lizards, clouds and spirals. Other imagery commonly found in conjunction with him includes birth scenes, COITUS, various animals, birds and insects, as well as hunting scenes. Because of the way his head often sprouts a horn-like extension or is topped by a bird, he is linked with the SHAMAN.

Kokorra Motif. SOLOMON ISLANDS anthropomorphic motif with many variants, from the northern Bougainville style area. The motif usually consists of a frontal squatting human figure, its upper legs and arms tight against the body, the lower extremities splayed outward. The hands are raised to shoulder height in what has been called a gesture of adoration. The body is surmounted by a huge head. The head, characteristically ovoid with large eyes, wide nose and elongated earlobes, may be used by itself. Despite the dominance of the motif, it is not known whether it was regarded as or represented a

KOKOPELLI

Above: Kokopelli from a petroglyph from La Cieneguilla, New Mexico and from a Hohokam bowl.

KOKORRA MOTIF

Above: Three squatting figures in low relief, painted in red and black, are silhouetted against the lighter reddish background of this paddle from Buka or northern Bougainville in the SOLOMON ISLANDS.

divine spirit. The *kokorra* may be linked with ceremonies in which initiates receive new names from the spirits of deceased clan members. The pattern of the motif is a variation on those associated with genealogy and descent (see HOCKER POSITION, PATTERN).

Kolowisi. The Zuni plumed or horned serpent is represented in Southwestern rock art, and on Zuni pottery from which it was adapted by Julian MARTINEZ. See INDEX: Snake in Animals; Names in Miscellaneous.

Komo Society. See BAMANA.

Kominimung Shields. The isolated Kominimung live in two villages on the Goam River, a tributary of the Ramu River, to the south of the Lower Sepik River. They were, in the 1980s, said to be the most intact culture among the middle Ramu groups. Older shields, divided roughly in half horizontally, had undecorated woven matting on the lower half, while the upper part was carved and painted. These old shields are ritually repainted. Dirk Smidt's work shows that more recent shields continue the division, but the lower part is now left plain, since the skill involved in making the matting has been lost. The central design on the upper part is a large face, known as Bwongogo, a mythical ancestor. Other named designs include *ompago* (the ANUS of a chicken, a possible euphemism for sexual organs), *tukwama* (shell ornaments), *kwangena* (chevrons) and *owo* (a circular design signifying fire). Some designs were linked to particular clans, for example, *etsjambega*, the crocodile head. The latter can be carved only for those who hold copyright to them. Colors also symbolize clan membership. When used in fighting, the shields physically and magically protect the warrior, but also visually communicate his clan and social status. Making the shields

entails spiritual preparation as well as the application of design and manual skills. Less sacred than figures or masks, shields are made in public with males and children present (the wife of the carver keeps her distance, but glances up from her own work indicating her interest). Aesthetic evaluation of the process and results included: preparation of the plank (smooth, regular and not too thick), quality of the design (symmetry, relationship to overall shape of shield, relative size of motifs, the design should not be copied but must follow the artist's own thinking), color (contrast, separation and neatness), ability of the artist to concentrate, speed of progress and finally, the whole must come "from inside, straight from the heart."

Konankada (or Gonankadet or Gonaqadet among north coast mainland Native people, Komokwa among the Kwakiutl). The HAIDA Chief of the Undersea World is frequently represented in art, but rarely identified by name. This supernatural being is found in prehistoric representations from Washington State to Alaska. The Haida represent Konankada as a being with a small body and an over-large broad head with split in it (see CLEFT HEAD). The eyes are frequently made up of smaller profile heads. Oversized hands, narrow

KOMINIMUNG SHIELDS

Above: The major motif in the center of this shield by the master carver Mangal is the face of a mythical ancestor. The fish-like shape repeated four times has been identified as the Victoria leaf.

KONANKADA

Below: Bentwood HAIDA storage chest with the image of Konankada, Chief of the Undersea World. 1898.

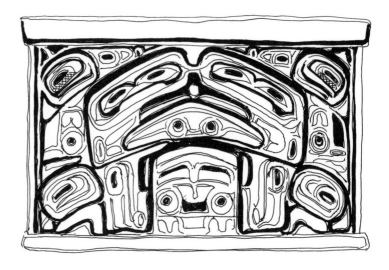

arms bent at the elbows may be depicted or alternatively the claws of a bird. The figure is used on food and other sorts of storage boxes to protect whatever is kept in the box. Konankada is the Master of Souls and his realm is the land of the dead. Haida myth tells of the Master Gambler whose house is midway between human habitation and Konankada's realm of souls. If people stop to gamble and lose, more people will die, but the salmon will increase. Human souls are regarded as being capable of being recycled and interchangeable with those of other creatures depending on their interactions with supernatural beings.

Kongo (also Bakongo). The Kongo was the most powerful state in the western area of the Central Africa's Zaire River basin. It was founded by Nimi a Lukeni, a legendary hunter, sometime around 1400 and endured until the 18th century. The divine king ruled a centralized kingdom consisting of a network of provincial nobles and village chiefs. The main Kongo peoples include the Kakongo, Vili, Yombe, Nkanu, Woyo and Boma. At its greatest expansion the Kongo Empire embraced as much as 115,000 square miles and controlled a lucrative and complex trading system. The capital, located on the highest hilltop at Mbanza Kongo (now in Angola), featured royal residences built on a rectangular plan with poles supporting woven raffia palm roofs and walls. Although the royal buildings were larger and more solid than those of people of lesser status, they too could be quickly disassembled and moved. The palace complex was embellished by carved support poles and wall paintings and elaborately woven matting. The walls of the buildings were nearly obscured by plants, vines and screen-like fences that separated the residences according to the status of the individual. High-ranking individuals were buried within their homes and the screen fences and trees then served to differentiate the tomb from the surrounding

land. Furthermore, given the nearly universal link between trees and genealogy, it is possible that these funereal groves were thought to facilitate the transformation of the dead into honored ancestors. Eventually the trees grew up and the buildings reverted to forest. The Kongo kings, in fact, were symbolically linked with the forest, especially with the leopard. The association of physical and sacred violence and power is similar to that attached to the OBA of Benin. Carved ivory and figurative iron staffs served as symbols of divine authority that augmented the impressive regalia of Kongo kings. The stone *mintadi* tomb figures may have been introduced in the 19th century, as their naturalism reflects European representational art. Two sculptural traditions also exist, the well-known NKISI power figures and the NIOMBO ancestor reliquaries.

Kongo Cosmology. The Kongo visualized the cosmos as two mountains, joined at their bases and separated by the sea. The ocean formed both a barrier and a passage between the mountains, one of which was the land of the dead and the other that of the living. The sun circled the mountains daily and four moments held particular significance—rising, ascending, fading and returning at dawn. Human life followed a comparable circle, sunset signified death, while birth and rebirth were equivalent to sunrise. Indeed, the sun circle and the soul circle were conceived of as one. Death was merely a transition and the soul was a moving miniature of the sun. The capital city of Mbanza Kongo was crowned by the royal house, placing the king at the top of the world mountain. One of the king's many titles was Matombola, the "one who summons spirits from the land of the dead." The king was, like the sun at its zenith, at the vital, living CENTER of the cosmos. Atop his mountain, the king witnessed the first rays of the rising and last gleams of the setting sun, mirroring the

KONGO

Above: Stone guardian figures were placed on royal burials. This ntadi (pl. mintadi) wears a hat with four leopard claws or fangs that curve inward from its four corners. These may suggest that the ancestor has completed the four corners of his existence, the four moments of the Kongo sun/soul or the four aspects of royal power. The latter consist of the earthly ruler, the ruler as judge, the ruler's son as future king and the female lineage heads (or women in general). The figure's pose, one of several conventional Kongo gestures/poses, suggests sorrow. The hardness of the material suggests the enduring nature of power and rulership.
19th century.

spiritual cycling of souls from light to dark-ness. The symbol for the cosmos was the cross-in-circle design, called the DIKEN-GA; see also Kongo *bidimbu* in SIGN SYS-TEMS.

Korambo (or *korumbo*). ABELAM spirit houses. In 1963, Anthony Forge who lived among the Abelam for two years counted over 100 ceremonial houses within a five-mile radius of his base village. *Korambo* are storage places for sacred objects and are adorned with paintings and sculpture. Sometimes called TAMBARAN houses, they can measure up to 100 feet and their triangular sixty-foot high façades dominate the surrounding village. Unlike Sepik River *tambaran* houses, Abelam *korambo* are not residential men's houses, but rather are built for the spirits and used for INITI-ATIONS, harvest ceremonies and as clan club houses. Although the *korambo* interi-or is filled with carvings and three-dimen-sional offerings, the façade paintings create their effect two-dimensionally with intri-cate pattern and brilliant color. Under the direction of a master artist, the façade is painted with registers filled with NGG-WALNDU, large and small male faces and figures representing clan ancestors. The heads are often surrounded and connected by energetically executed zigzag patterns, symbolically reduced bodies that symbolize genealogy. The concentric patterns around the eyes of the largest heads have a hyp-notic quality and the somewhat disembod-ied character of the floating heads recalls Campbell's discussion of IRMs. Also included are images of women's STRING BAGS. These humble utilitarian objects are, as symbols of women's fertility (wombs) likely microcosmic representa-tions of the house itself. The protruding end of the ridgepole is said to be the penis of the house and is erected by two men who have bled their penises. The visible house is the body of *nggwalndu puti*, the principal ancestor and is conceived of as

KORAMBO

Left: Abelam spirit house at Kinbangwa village. The façade projects outward forming a sort of porch where the highest-ranking men sit daily.

facing its own invisible mirror image. The orientation of the entire structure corre-sponds to the course of the sun—after ris-ing in the east, the sun follows the ridge-pole until it stands directly overhead at noon and, following the invisible ridgepole of its mirror image, it descends into the west. The sun spends the night under-ground in the land of the dead. The *koram-bo*, thus, is located at the CENTER, where the visible and the invisible, living and dead, human and spirits intersect. Finally, despite the predominantly male imagery, the house itself is also spoken of as being female. Indeed, the single large face at the top represents a greatly feared female flying witch called *ku tagwa* associated with the feminine power of the house itself. The houses are entered through a small side entrance likened to reentering the womb, a symbolic second BIRTH. See INDEX: Sun in Natural Phenomena and Materials.

Kore Society. See BAMANA.

Korwar (or *korvar*). These carved wooden ancestor figures from the GEELVINK BAY area of New Guinea are characterized by disproportionately large heads and rather rudimentarily carved bodies (standing or

KORWAR

Below: The upper part of these ancestor figures sometimes conceals a skull. From Saukoren, Doreh Bay. Wood and beads.

squatting). Many hold a shield-like form in front of the body, which is often carved with curvilinear openwork patterns. It has been suggested that the shield derives from the snake (singly or paired) which in Geelvink Bay mythology symbolizes death and night as well as the power of *korei*—rejuvenation and regeneration. Van Baaren distinguishes between five categories of ancestor figures (*korwars*), some of which have cult status, while other less important ones are grave figures, protective or symbolic representations of the ancestors. The more important images are regarded as sacred and dangerous. Among these, some incorporate the skull of a high-ranking ancestor into the sculpture. Lesser figures appear on objects of daily use, thus providing a blessing and maintaining contact between the living and the dead. Scattered information exists regarding the production and use of *korwars*. They seem to have been made by the shamans who ritually located the wood from which they were carved. Once completed, the spirit was enticed to occupy the figure. The figures were not the ancestors, but served as representations of them, and acted as a channel of communication between the living and the dead, answering simple yes/no questions. They may also have been used in funeral ceremonies and placed on graves. The land of the dead is at the bottom of the sea or under the earth. The shadows of the dead (*nin*) remain on earth until a *korwar* has been made after which they can enter the abode of the dead. *Korwar* were kept wrapped up and out of sight except when consulted as oracles—they could, however, be "decommissioned" (their spiritual force dispersed) and sold to tourists and collectors. See INDEX: Snake in Animals.

Kota (formerly Bakota). The Kota of Gabon and the adjacent areas of the Congo are subdivided into two groups, the northern (including the Mahongwe,

Shake, Shamay and Ndambomo) and the southern Kota (the Wumba and the Ndassa). The Kota make masks, but are best-known for the striking metal-clad reliquary figures called *mbulu ngulu*. Linked with the founding ancestor of the family lineage, the figures stand guard over baskets filled with ancestral bones. There are

numerous sub-styles within the area, including that of the Mahongwe people who make leaf-shaped figures covered with woven wire. The unifying characteristics are abstraction (Kota reliquaries are among the most abstract of all African figurative sculpture) and the shining brass and copper surfaces. The reflective properties of the metal are likened to the white surfaces of OGOWE RIVER BASIN masks and other objects from Gabon. The metallic flash is said to warn off and deflect unwanted visitors from entering the sanctuary where the reliquaries were kept. Many Kota reliquaries lack mouths, possibly suggesting the silence and discretion necessary for worship. Most Kota reliquary figures, like FANG *bieri* figures, have large staring

KOTA

Right: Kota reliquary figure covered with sheets and strips of copper and brass. The shining metal surfaces simultaneously ward off evil and symbolize the rejuvenating light of the sun.

eyes that add to the powerful protection offered by the figures. However, the contents of the baskets were more important than the reliquary figures. Presumably the ensemble became more powerful as the bones of descendants were added to the baskets along with medicines, tortoise and rodent bones, as well as metal objects such as keys and hooks. Robert Farris Thompson suggests that Kota reliquaries demonstrate symbolic design elements present in KONGO art (*The Four Moments of the Sun: Kongo Art in Two Worlds*). For instance, the open diamond shape beneath the faces of the Kota figures resembles the arms akimbo pose of Kongo figures. Furthermore, the faces of Kota reliquaries frequently take the form of a cross within an oval, a variation on the Kongo *dikenga* sign, symbol of the crossroads and the eternal cycle of life.

Kowhaiwhai. Beginning in the 1870s figurative painting called *kowhaiwhai* became an increasingly popular form of decoration in Maori WHARE WHAKAIRO. Apparently in response to the political and religious changes following the Land Wars, the Maori were forced to define themselves in European historical terms (i.e., fixed linear time as opposed to pre-contact fluid time). Painting, formerly regarded as a lesser art form because of its impermanence, was used along with new European content, to make an innovative statement of group identity. The basic anthropomorphism of the houses remained unchanged, but representational paintings of modern historical events, persons and realistic plant motifs were added. The Maori *whare whakairo* thus was a dynamic form capable of maintaining its basic significance while responding to the demands imposed by social, religious and political change. This absorption of the very modern, secular elements that threatened the Maori way of life is powerful evidence that the houses are literally living symbols that unify soci-ety. The houses give the Maori "a place to stand" in modern times.

Kpelie and Kponyugu Masks. See SENU-FO MASKS.

Ku (Tu among other Polynesian peoples). Ku was one of the four main deities of the Hawaiian Islands, the others being Kane, Kanaloa and Lono (see also Maui). Together with his female counterpart Hina, Ku represented the male and female reproductive principles. Ku (the word means "upright") was linked with the right hand, east and sunrise, Hina (meaning "prostrate") with the left hand, west and sunset. Unified, Ku and Hina are symbols of the fertile meeting of cosmic axes, symbols of the CENTER. Ku was also seen as the complementary opposite of Lono. Ku is linked with competition and aggression, while Lono, by contrast, is associated with continuity (genealogy) and peaceful pursuits. Together they are concerned with agriculture, plants, rain, pigs, peace and war, forests, canoes, houses and crafts. See INDEX: Deity Archetypes.

KUBA

Left: Raffia pile cloth of the Kuba-Bushoong, Democratic Republic of Congo. 20th century.

Kuba (also Bakuba). The Kuba kingdom lies to the east of the KONGO area where the forest and savanna meet in the central Kasai region of Democratic Republic of

Congo. Beginning in the 16th century, the royal dynasty of the Bushoong (also Bushong or Kuba-Busoong) emerged as the most powerful entity among a group of related peoples. The height of the Kuba Empire occurred between 1870 and 1890. The empire controlled the following groups, the Ngeende, Kete, Lele, Binji, Dengest, Mbuun and Wongo. These groups exercised autonomous control over daily affairs, but paid tribute to the Bushoong king. Woot, the legendary founder of the Bushoong dynasty was regarded as the culture hero, and in some cases, as the first man—all descendants are said to be the progeny of Woot and his sister Mweel. Depictions of some of the estimated 124 rulers following Woot are among the most powerful examples of Kuba art (see KUBA ROYAL POR-TRAITS). The well-being of the people depended on the king who inhabited a splendid palace and wore elaborate regalia on state occasions. The kings themselves were said to be artists. The costume, which weighs about 150 pounds, consists of layers of fabric encrusted with embroidery, cowry shells, beads and feathers. The regalia, along with cut-pile embroidered raffia cloth with intricate geometric patterns, were supposedly introduced by King Shyaam (Shyaam aMbul a Ngoong came to power c. 1625) and were the main form

of clothing and the primary monetary unit until the 19th century. Shyaam may have introduced the patterns, but according to myth, mats themselves were of divine origin. The creator god Mbwoom laid out the cardinal directions as a flat mat placed in the sky. The Kuba capital was laid out similarly, with the eastern royal palace being the first to be illuminated by the rising sun's rays. The importance of pattern in Kuba art is evident in the fact that the Kuba word *bwiin* means "art," "pattern" and "design." Furthermore, the word for taste, *pim*, is linked with originality. Jan Vansina writes that the history of Kuba design is a history of invention. He suggests also that Kuba art, even given their great achievements in sculpture (see KUBA ROYAL PORTRAITS), generally is more concerned with pattern than with three-dimensionality. See SIGN SYSTEMS-KUBA PATTERN and INDEX: Names in Miscellaneous.

Kuba Masks. Before ascending to power, Kuba kings underwent initiation, after which they became the tutelary leaders of initiation rituals throughout the kingdom. Three colorful masks—Mwaash aMbooy (also Moshambwooy, Mashamboy or Mukenga), Ngady mwaash aMbooy (Ngaady a mwaash), and Mbwoom—appear at royal initiations, funerals and

KUBA MASKS:

Above: Ngady mwaash aMbooy, meaning, "pawn woman of Mwaash," represents the sister-wife or mother of Woot, the king's female consort or women in general. The curved lines below the eyes are said to represent tears signifying the hardship of women's lives. The dark-light triangles are also found on raffia cloth associated with the ancestral costume, further linking this mask to dynastic succession.

Right: Mwaash aMbooy, a mixed-media construction of leather, leopard skin, beads, shells, feathers, raffia and textiles, is the most important royal mask. It seems to represent the king, or more generally, royal power and the continuity of the lineage, as the mask simultaneously personifies Woot (the first human and culture hero), the ruler as an elephant, as well as powerful water or forest spirits. The animal attributes of the mask are said to demonstrate the close connection between the ruler and the forces of nature.

Far right: Mbwoom, the third mask, is said to commemorate a prince experiencing great grief and suffering after killing his predecessor's son. Two other suggestions are made, first, that it depicts a commoner; second, it is suggested that the somewhat distorted facial features and projecting forehead, made of beaten copper, may reflect Kuba memories of former Pygmy inhabitants. In any case, Mbwoom was apparently not a royal mask originally, but became one after the King Miko admired it. In performance, the mask balances royal power by defying authority and competing for the affections of the royal consort.

during performances of dynastic myths. Together, these masks form a composite representation of the political and power structures of Kuba-Bushoong society. The masks—called "friends of the king"—were kept in the palace and, once the king had danced a mask, it could be lent to talented performers. The meaning of each mask brings into play complex and overlapping associations, creating a sense of their link with history and the supernatural. Some masks were buried with the king. Color symbolism played a part: red suggested both suffering and increase, white signified mourning and purity and blue stood for rank and the contributions of individuals. The three hues, taken together, represent the divine ancestry and powerful forces associated with hereditary rulers balanced by the importance of being responsive to the forces of nature and human society.

Kuba Royal Portraits. Carved wooden images (*ndop*) of Kuba rulers were introduced in the 18th century by King Misha mi-Shyaang a-Mbul who oversaw the carving of his own image. The sculptures depict the king seated cross-legged, with rich glowing surfaces and an overlarge head. Each king holds attributes of power, accompanied by some personal symbol associated with his rule. These symbols, called *ibol*, were established by the king himself at the time of his investiture and took the form of a proverb. The *ibol* of the late-18th-century blacksmith king Mbopelyeeng a-Ntskey was an anvil. Drums were associated with three kings, including the powerful Misha mi-Shyaang a-Mbul, while other symbols included a slave, a fly-whisk and basket of knowledge. Jan Vansina writes that Kuba sculpture represented states of being, rather than action. Kuba insistence on symmetry and static order acts as a powerful force that repels metaphysical disorder and discord. The kings' facial expressions are aloof and benign, conveying the impression of gentle spiritual composure and idealized power. The sculptures were placed next to the dying king and were infused with the ruler's life force. The power was passed on to the next king who slept next to the figure before his own investiture. The figures

KUBA ROYAL
PORTRAITS

Above: One of the most famous Kuba kings was Shyaam the Great (Shyaam aMbul a Ngoong) who ruled in the late 18th century. Shyaam's personal symbol was the game of capture, lele (called mankala in the West), a proverbial and oblique reference to his masterful and cunning strategy in gaining the throne. Shyaam supposedly discovered the game during his travels. His heroic status is further indicated by the inclusion of the "Woot" pattern on the top of the royal cap and the three rows of cowries in his belt.

"When they look at this statue they will be able to remember me, and think that I watch over them, consoling them when they are sad, giving them inspiration and courage anew."

—*Words of a Kuba king.*

KUDUO

Above: This elaborate kuduo is a royal object kept near the "blackened stools." The lid shows a royal scene that centers on an asantehene smoking a long pipe while being entertained by musicians. Since the ruler is unshod, it is suggested that this scene "reverses" the normal, such as during the Odwira new year (and new yam) festival where reality is momentarily turned upside down–chiefs, for instance, can be abused by their subjects without fear of reprisal. Odwira is a transitional period of renewal and rejuvenation, during which time is momentarily suspended as the new cycle begins.

are kept in the women's area of the palace where they watch over childbirth.

Kuchin (also Gwitchin, Gwich'in referring to the Alaskan branch and Kutchin). The name used to refer to the people who live in the Yukon Territory of western Canada and eastern Alaska is a misnomer stemming from an early explorer named Murray. He thought the word meant "the People," whereas it actually referred to a place name connected with another group of people. Today these people call themselves *dijiezuh,* meaning "people." Athapaskan speakers, the Kuchin maintain an extremely close relationship with the caribou, their primary food source. The people believe that every human being has a bit of caribou heart and conversely, the caribou have a bit of human heart resulting in shared knowledge and feelings. Although Kuchin religion and cosmology was unsystematic, their idea of spiral time was fundamental to their worldview. Originally, humans were part of nature and only became separate after the culture hero Ataachookaii ("he paddled the wrong way") was isolated after he accidentally killed his brother. Time moves in a spiral and events and relationships repeat, but differently. Although the Kuchin speak of the precontact period as being "before we knew how to tell the time," spiral time continues to exist alongside Western linear time. Bead and quillwork, caribou hide clothing and, following the introduction of European materials, beautifully embroidered velvet dog team trappings were notable art forms. For more on time see INDEX: Natural Phenomena and Materials.

KUKAILIMOKU

Right: Nearly six feet tall, this aggressive temple image has a disproportionately large head, a gaping, grimacing "mouth of disrespect," elongated, non-human eyes and flared nostrils. The clenched fists and flexed knees as well as the suggestion of muscular tautness give the impression of barely contained power. Probably Kona, Hawaii. Late 18th–early 19th century.

Kuduo. Copper alloy vessels made by the ASANTE said to have been inspired by a variety of metalwork such as 14th- and 15th-century Arabic basins from Mameluk Egypt, other Islamic pieces and European trade wares. Although the silhouette preserves the Arabic container type known as *tisht* and the dense patterns reflect Islamic decorative traditions, the vessels them-

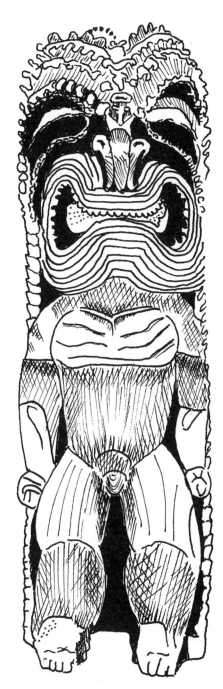

selves are a unique Asante creation. One function *kuduo* served related to rituals connected with a man's masculine line of descent. Another related to rituals related to a man's soul (*kra*). *Kuduo* also served as funeral containers for gold dust and other valuables, and sometimes held sacred objects or sacrificial foods. The sculptured lids are the most distinctively Asante aspect of *Kuduo*, representing proverbs and other symbols.

Kukailimoku (Ku, "snatcher of the land"). One of the aspects of the Hawaiian deity Ku, god of war. Large carved images of this god stood in temples (HEIAU/*luakini*). See INDEX: Deity Archetypes.

Kuksu Cult. A northern California religious cult which focused on restoring the world to its primordial mythic condition as well as curing and initiation rituals. The word Kuksu comes from the name of the POMO creator-culture hero who is impersonated during the ceremonies. Centered in earth-covered structures, this cult may have originated among the Patwin or Valley MAIDU, spreading throughout northern California and the Central Valley. It was found among the Pomo, Miwok, Kato, Yuki, Wailaki and Wappo. It is characterized by a male secret society.

Kunapipi Cult (or Gunabibi). Religious cult or constellation of concepts originating in the Roper River area which spread across northcentral and northwestern Australia. In addition to the concept of the DREAMING, the Kunapipi cult is marked by shared myths (see DJANGGAWUL CYCLE and WAWALAG SISTERS), as well as rituals and art forms. Features of the Kunapipi cult coexisted alongside, as well as being absorbed and/or adapted by, the groups already present.

Kuosi Society. See CAMEROON MASQUERADES and ELEPHANT.

Kurumba. The Kurumba live in Burkina Faso (formerly Upper Volta). They call themselves *nyonyosi*, meaning "early settlers," an indication that they predate the 15th-century MOSSI invasions. The most characteristic masks are elegant antelope masks owned by individual families.

Kuskokwim River. With the Yukon River, one of the most important areas of Eskimo mask making. See INUA.

Kwakiutl (Kwakwala, Kwakwaka'waku). More ethnographic work has been done on the Kwakiutl than on any other Northwest Coast group, beginning with the work of Franz BOAS between 1886 and 1931. Kwakiutl territory once extended from the Heiltsuk Kwakiutl (often called the Bella Bella) on the 59th latitude to more powerful Southern Kwakiutl who live as far south as Cape Mudge. The Kwakiutl had a more aggressive reputation than other Northwest Coast peoples. Their environment is especially rich in resources, leading to the amassing of great wealth by certain chiefs. Kwakiutl woodcarving is distinctive for its added protuberances rather than the normal restriction to the natural shape of the material. Their art is said to be freer in its use of color and less restrictive approach to the use of FORMLINES. Three noted modern carvers were Charlie James, Ellen Neel and Mungo Martin. The Kwakiutl perform two major ceremonials—one in the winter and the other in the summer, although these should not be thought of as opposed. The winter HAMATSA ceremony, called the Cedar Bark Dance by the Kwakiutl themselves involves the dramatic reenactment of their ancestors' adventures or demonstrations of the power they acquired from supernatural beings. The most prestigious dancer is the Cannibal Dancer. This wild spirit represents the antisocial and chaotic forces inimical to human society who is progressively tamed and finally honored for his return to the

KURUMBA

Above: Kurumba antelope masks generally measure four feet tall. The elegant curve of the animal's ears and horns are echoed in the long neck and the painted geometric designs.

Above: Crooked Beak mask by Willie Seaweed. One of several Hamatsa bird monster masks, Galokwud-zuwis, or Crooked Beak provided artists an opportunity for individuality because of its elaborately curved, but short beak.

human condition. During the summer, the less important Weasel Dance, imported from the Bella Bella and Oowekeen was performed. Other masks involved in the Weasel Dance were those of the chief of the undersea world and woodman masks. See also TSONOQUA.

Kwele. See OGOWE RIVER BASIN.

Kwoma. The Kwoma (and their neighbors the Nukuma) live in the Washkuk Hills region of the Sepik River, New Guinea. Kwoma ceremonial houses (*korob*) are located in the centers of the villages. They have no walls, although the profile of the roof is peaked at both ends like IATMUL *tambaran* houses. The interior posts and the eight slit gongs associated with each house are ranked in order of importance and location. All houses have a front nor-

mally oriented north or northeast, the direction from which the monsoon rains come. The interior posts and beams are carved with mythological figures and two of the three crossbeams are decorated with replicas of YENA and *mija* figures. Kwoma women are strictly forbidden to enter the *korob* or even to see sacred objects. Indeed, Ross Bowden's 1983 study of the Kwoma is prefaced with a request not to show the photographs in the book to Kwoma women. Additionally, striking wooden sculptures adorned the slanted roof spires. Temporary yam shrines were decorated with three types of sculptures: *yena* (heads/masks on rods), *mindjama* (relief panels) and *noukwi* (or *nogwi*, female figures). Pottery is a much more important art form among the Kwoma than is generally true in the rest of New Guinea. The names of male potters are known for several generations. Potters had to have not only a grasp of the technical processes involved, but also had to be able to visualize between forty and eighty traditional motifs. Clay is used to make human *yena* heads (these may take the form of pigs as well) which have protruding noses said to be penises and the bulging eye sockets are the testicles. Clay pots (sometimes called poison pots) were filled with magical substances and liquid, then sealed and placed on the fire. The steam eventually exploded the plug and dispersed the magic into the air. Painted MBI (or *bi*) boards depict mirror images of the human form joined at the waist.

Left: Ceremonial ceramic head-shaped pot. Among the Kwoma, pottery was a more important medium than in other areas of the Sepik and the potters were men instead of women as was the usual custom among most other New Guinea peoples.

L

Labret. Personal adornment attached to the lips. Among the peoples of the Northwest Coast, high-ranking women wore labrets. The size of the labret was a reflection of rank and the number of children a woman had. The lower lip was pierced in childhood for the insertion of the labret.

Labyrinth. See CONTINUOUS LINE DRAWINGS and MAZES.

Ladder. Functional ladders exist, of course, but the ladder is often a symbol of transformation. In areas where men's houses are built on piles, anthropomorphic ladders are used to gain access to the sacred place, the presence of the ancestors. Placed on graves, full-sized and miniature ladders assist souls in their heavenly ascent. SCHUSTER and Carpenter link the ladder to genealogy and its visible symbols in Y-posts, shaved sticks and family trees (*Patterns That Connect*). According to them, ascent symbolizes retracing one's ancestry back to the founding ancestor. Notched steps also appear on totem poles in the NORTHWEST COAST. In the American Southwest, functional ladders gave access to the ceremonial KIVA in Pueblo architecture, although the act of climbing may have had symbolic meaning, bringing individuals into the sacred space of the *kiva* at the heart of which was the SIPAPU, the place of emergence. Additionally, among the Hopi, the motif of stacked triangles is called a cloud ladder, a design conflated with butterfly motifs. In Africa, funerary and geneological symbolism predominates. For instance, Akan funerary "family pots" are ornamented with the so-called ladder of death which not only facilitated the transition from life to death, it also illustrates the proverb, "It is not only one man who climbs the ladder of death." The saying underscores the universality of death. See also INDEX: Ladders in Art, Artifacts and Techniques.

Lake Sentani. Located on the north coast of NEW GUINEA, Lake Sentani was considered to be homogeneous with HUMBOLDT BAY. Recent studies have focused on the differences between the two areas.

LABRET

Above: Mask of an old Nishga woman with wrinkles and stringy hair. The very large labret, inlaid with abalone, is an indication of high status. Collected in British Columbia, probably 1825-50.

LADDER

Above: Each rung of this house ladder from Singrin on the SEPIK RIVER is the hollowed out body of an ancestor, while the entire ladder appears to take the form of a crocodile. Collected between 1910 and 1912.

Although the lake seems rather isolated, evidence of outside contact dates as far back as the period of the DONGSON culture. And, in fact, it is the only area of Melanesia where Bronze Age objects have been found. Canoes of two distinctive types, one for women, the other for men, were made. Houses were built on pilings in the water. Chiefs' houses (*ondoforo*) were supported with elaborately carved V-shaped poles that have been compared to similar posts in ASMAT men's houses. On Lake Sentani poles, human figures were carved at the junction between the pole and the wing-like lateral extensions. Sculptures of human figures also sometimes were placed in front of the *ondoforo* house. The human figure is characterized by what has been called an air of equanimity and repose. The flowing rounded volumes of mother and child images are memorable. Lake Sentani artists also make drums, suspension hooks, dance staffs, food bowls and lime containers. See also bark cloth painting (MARO).

Lake Yimas. In the Middle Sepik region of New Guinea, see INDEX: Crocodile in Animals.

Lakota. The Lakota, or Western Sioux, have three languages: first, *ikce*, the common, dialectical language; second, *tob-tob*, the formal language; and third, *hanbloglagia*, the sacred language known by only a few. They have seven sacred ceremonies given to them by Woope (the Law) when she moved among them in the form of White Buffalo Woman. All of the ceremonies deal with times of crisis such as RITES OF PASSAGE and aim at lessening human anxiety. The following discussion comes from the words of Charlotte Black Elk, the great granddaughter of BLACK ELK. The Keeping of the Spirit allows the spirits of the dead to become reconciled with death—the Keeper of the Spirit enables the dead individual to finish

LAKE SENTANI

Above: Mother and Child Figure, from gangway post. Ifar, Lake Sentani. Collected 1926.

those things left undone and conducts a final releasing ceremony which enables the spirit to depart for the Spirit World. The second ceremony is the VISION QUEST, which involves fasting, prayer and the setting of personal limits while reiterating law. Third is Making of Peace during which the creation story is repeated and the relationship with mother earth is reaffirmed. Over Her Alone, They Sing, the fourth ceremony, is a young women's puberty ritual. Fifth is *Inipi*, the purification ceremony often called Sweat Lodge, which symbolizes rebirth and regeneration. The sixth ritual, the SUN DANCE, involves four days of dancing with no food or water—the physical suffering that results enables the participants to take on the pain of the universe and make it whole again. The last ritual is She Tosses the Ball, which utilizes a ball filled with bison hair representing the matter and spirit of the universe. The women must do their best to catch the ball, an act signifying choice and personal responsibility. For the Lakota TRICKSTER, Inktomi see INDEX: Insects (spider) in Animals.

Lapita Culture. Likely the foundation culture of Melanesia and Polynesia. Lapita settlements first appeared in the Bismarck Archipelago beginning c. 1800 BCE, eventually spreading throughout New Guinea, New Britain, New Hebrides, New Caledonia and the Solomons as well as Samoa, Tonga and Fiji. Douglas Newton dates Lapita influence from 2000 to 500 BCE and identifies three Lapita design types, which he traces in the art of Melanesia. The culture was first identified at and named after a site in New Caledonia. Sites are found on the coast or on small offshore islands and are remarkably similar despite their far-flung extent. Originating somewhere in southeast Asia (a relationship to the later DONGSON material is suggested), the Lapita culture shared cultural characteristics such as the

outrigger canoe and expert navigation, earth ovens, stone adzes, tattooing, a societal structure based on descent and seniority and economies based on fishing, gardening and domestic animals. Characteristic Lapita pottery is marked with intricate geometric and figurative stamped dentate designs. Designs are simpler in the eastern Lapita areas, in comparison to more complex, curvilinear patterns in the west. The complex curvilinear design motifs of the latter are said to provide the foundation for those found in TAPA cloth and other art forms such as TATTOO.

Layered Universe. Many cultures conceive of the universe as being composed of multiple layers of varying number and complexity. Most basically, the layered universe consists of an underworld (usually negative in connotation, the dark land of the dead), the intermediate plane (the world of humankind, of "real" time and space) and the heavens (usually positive, the light-filled realm of the gods). More complex cosmologies add layers, usually in odd numbers. The MAORI, for instance, conceive of ten or eleven layers, including the underworld/primordial darkness (po), this world of light (Papa, Earth Mother), and the heavens above. The lowest heaven is separated from the earth by a solid transparent barrier like ice or crystal. The sun and moon move along the underside of the barrier, while above were layers in which spirits, winds, rains and light moved. Above was the realm of the gods, occupied principally by Rangi, Sky Father. In North America, most Natives conceived of the universe as having three major layers, which may be further subdivided. Navajo mythology numbers between two and fourteen hemispherical layers, which become larger as they ascend. The congested, dark lowest layers were filled with constant, chaotic motion and ugliness, making the inhabitants dizzy. The

uppermost layers, lit by the sun and moon, by contrast, were filled with harmony and beauty (see HOZHO). Fóur pillars supported and separated the layers. Called Those-Who-Stand-Under-the-Sky, the pillars were regarded as deities and consisted of precious stones: whiteshell to the east, turquoise to the south, abalone to the west and redstone to the north. The space between the hemispheres was filled with stars. The reed of emergence also linked the layers and by climbing it, first creatures (cicada was first of all) and later people were able to emerge into this world. The circular Navajo HOGAN incorporates the four sacred stones into its construction, making it a COSMIC MODEL. Instances of the layered universe in Africa are found among the Songye and the Kongo. The surface of the Songye KIFWEBE mask is cut with deep grooves said to refer to the underworld of emergence and the paths of

LAPITA POTTERY

Above: Intricately stamped designs are characteristic of the Lapita Culture. This shard shows a face mask design surrounded by geometric patterns from Nenumbo village, Main Reef Islands, Santa Cruz. c. 1100 BCE

LAYERED UNIVERSE

Left: A Kuskokwin River area shaman dreamed this Eskimo mask called Tomalik, Windmaker. The two tubes represent the winds of winter and summer, while the danglers at the bottom represent air bubbles rising from submerged seals. The concentric rings are said to symbolize the levels of the universe. Early 20th century.

the dead who await rebirth. Kongo NIOM-BO reliquary figures take what has been called "the cross-roads pose," the vertical trunk is intesected horizontally by the outstretched arms, right hand up and left hand down. The figures serve as mediaries between the spirit realm above and the land of the dead below. See INDEX: Layered Universe in Miscellaneous.

Lebe. One of the eight original Dogon ancestors, Lebe died and was buried. According to myth, the people dug up his bones to move them to their new homeland. Instead of dry bones, they found a living snake, evidence of Lebe's regenerative powers. Lebe, thus, embodies the fertile forces of nature, agriculture and the cyclical renewal of the earth and vegetation. See DOGON COSMOLOGY.

Ledger Drawings. A late-19th-century flowering of the PLAINS PEOPLES' narrative tradition, the name stems from the fact that most are in ledger books given to them while in captivity. During this period, the people were under constant pressure from the United States military and the only possessions they were able to save were portable. The prevalent subject matter of these records was war, but nostalgia for better times led to images of childhood, courtship and ceremonies. Two of the best-known ledger books of this type were by the Dog Soldier and Little Fingernail. The Fort Marion books produced by Native North American prisoners between 1875 and 1878 show a rare and short-lived concern with evoking emotion and a conscious pursuit of artistic expression for its own sake.

Left. See DIRECTIONAL SYMBOLISM.

Lega (formerly Warega). The Bantu-speaking Lega were established in eastern Democratic Republic of Congo by the 15th or 16th century. As with the neigh-

boring Mbole, Lega social organization rests on local clans and age-grade associations, the most important of which is Bwami. Five male and three female grades initiate individuals, as well as serving as the focus and repository of power and knowledge within Lega society. Bwami is also the major patron of the arts. While Bwami is not, strictly speaking, secret—it is known who is being initiated and when—the meaning of objects is secret and is progressively revealed as individuals move upward in rank. Lega art, thus, is hierarchical and can only be understood as part of a complex social and ritual context. When not in use, objects are stored in bags or baskets. Bwami objects serve as insignia, prestige items, iconic devices and symbols of continuity. Generally, the objects assist in maintaining the social hierarchy and aid people in their goal of moral perfection within the context of the Bwami association. Lega masks have the heart-shaped form and whiteness associated with OGOWE RIVER BASIN masks. Worn on the top or back of the head, at the temple, on the face or fastened to some other part of the body, the masks are said to represent an ancestral skull or embody a social concept. Over 2,000 Lega figures, most of them between four and eight inches high, have been documented in world collections. In diverse materials (stone, ivory, clay, hide and elephant sole) the figures are simple but energetic and are often ornamented with the circle and dot motifs also found on masks. Names and aphorisms are associated with the figures, such as "Bringer-of-Joy-and-Prosperity" or "Smart-Person." These sayings communicate personal attributes of initiates. The Lega also make stools and prestige items including unique caps covered with buttons.

Lei. A word well-known to modern visitors to Hawaii who are greeted at the plane or boat with a flower necklace. Necklaces in private and museum collections are

LEGA

Most Lega objects are called iginga, "objects that sustain the teachings and precepts of Bwami." The Lega are said to judge art based on its effectiveness. Removed from the context that establishes their meaning, Lega objects are deprived of their significance.

Top: Lega mask.
Bottom: Lega statuette.

made from twisted human hair and other fibers strung with feathers, bone and ivory from whales and other creatures, as well as coral, calcite, seeds and shells. The whale-tooth *lei* seems to have been the most valued as early visitors, identifying them as amulets or idols, felt they had supernatural power.

Leopard. Like the elephant, the leopard is a nearly ubiquitous African symbol of royal power. However, the leopard's power is tinged with darkness and danger in contrast to the rather more benign elephant. Leopards are more solitary by nature than other felines and are known to be excellent and sometimes capricious hunters. They are said to be the only cats that kill for the sake of the hunt, and not just to satisfy their hunger. The leopard, thus, is a symbol of the liminality and potential dangers of power. The link between the leopard and royalty is especially dramatic among the FON who believe that the royal lineage descends from the founder Agasu, the offspring of a Tado princess and a leopard she encountered in the forest. Leopard symbolism is also found in conjunction with the OBA of BENIN and the rulers of the CAMEROON grasslands and the KONGO. See INDEX: Felines in Animals.

Lightning. See INDEX: Natural Phenomena and Materials.

Lime. In Oceania, lime from burned or crushed seashells is used ritually. The ASMAT kept lime in decorated tubes. The powdery lime issued forth in great clouds when the tubes were swung back and forth. A hot, magical substance, lime was a kind of repellant used during HEAD HUNTING raids, to greet arriving Europeans and to chase the dead away. Lime was also consumed socially, mixed with betel/betel nuts and chewed. Many beautiful utensils are connected with lime use. MASSIM lime

spatulas, moistened with saliva, were used to remove lime from narrow-necked containers. The gourd containers were pyrographically decorated with multiple images of yams, symbols of male virility, wealth and power. The maze designs found on Massim war shields also appear on lime containers where they symbolize vulvae and the patterns on women's skirts. The containers themselves may be thought of as female, since the spatulas have phallic serpent designs and connotations.

Liminal States/Beings. From the Latin *limin*, meaning "threshold." Introduced into anthropological literature by Victor Turner to describe the periods during RITES OF PASSAGE when human beings are suspended between one stage of their life and the next. Turner also extended the concept to include liminal beings who are "betwixt and between" such as TRICKSTERS, clowns, the SHAMAN and jesters (see ARIOI). The term liminal can also be used to describe the ambiguous character of powerful rulers, such as the OBA of BENIN. Many of the symbols associated with this ruler relate to the concept of the king as a liminal being, whose combined human and divine nature enabled him to mediate between the spiritual and material realms. Some of the creatures that symbolize the Oba's liminality, such as mudfish and snakes, are associated with OLOKUN, god of the sea. Mudfish are able to survive long periods out of water and are reputed to "walk" on land. Indeed, Benin artists treat the mudfishes' barbels almost like legs and, in fact, in some representations of the Oba, substitute the fish for the ruler's legs. Both mudfishes' estivation and the moulting of snakes can be understood as symbols of rejuvenation or of rebirth. Frogs and grasshoppers, both noisy nocturnal creatures, undergo striking physical changes as they mature. Tadpoles grow legs and grasshoppers sprout wings. Both are also

LEI

Above: This necklace, identified more specifically as lei niho palaoa, "whale-tooth material," would have been worn only by those of chiefly rank.

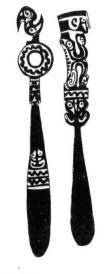

LIME

Above: MASSIM lime spatulas carved with varied figurative and abstract motifs.

associated with environmental changes that may be beneficial or dangerous. The metamorphosis they undergo and the capricious conditions linked with them both transcend normal boundaries, making them striking symbols of the Oba's dangerous power. See also DOORS AND THRESHOLDS and RITES OF PASSAGE.

Linguist Staff. Figurative gold-leaf finials adorned the tops of the staffs belonging to AKAN court linguists. These finials, believed to be a 19th-century development, proverbially depict the linguists' high status and the ruler's power. For instance, the image of a bird is linked to the proverb "Woodpeckers hope the silk cotton tree will die," i.e. ordinary people, like woodpeckers, can only hope that the mighty will fall. The BAULE also make gold-covered linguist staffs that serve as a sign of authority for chief's spokesmen. Philip Ravenhill states that Baule and Asante staffs derive from staffs distributed by European traders and government officials as a sign of recognition or delegated authority. Staffs are found in other indigenous societies that symbolize power and the right to speak in public, e.g., see PROVERBS, TALKING STICK and the above-named animals in the INDEX: Animals.

Lion. See INDEX: Animals.

Lipiko (pl. *mapiko*). MAKONDE helmet masks which, until the 1990s, came to the village from the bush to initiate boys and girls. The masks are typically realistic, an effect intensified by the addition of human hair and scarification patterns in wax.

Lizard. Lizards symbolize both death and fertility in many indigenous cultures. Among the MAORI, the lizard (also reptiles and monsters, see MANAIA) is a symbol of death. The Maori believe that a lizard gnawing away at internal organs causes illness. Additionally, other people can send illnesses, and if the sending individual is not dealt with, the sick person dies. In the Hawaiian Islands, the word for lizard is *mo'o* (cf. *mo'o ku auhau*, "genealogy") and the creature is a symbolic metaphor for genealogy stemming from the pattern of the creature's well-defined backbone. Among the KANAK of New Caledonia, lizard, born of the moon, was one of the zoomorphic beings responsible for the first creation of the world. See also TAMI ISLANDS. In the Americas, the lizard appears frequently in rock art, particularly in conjunction with KOKOPELLI as part of the water and fertility complex so important in the arid Southwest. In Africa, the lizard is one of several creatures the AKAN associate with the underworld and death, while in the CAMEROONS, the lizard is associated with fertility. The SENUFO include the chameleon as one of the five primordial animals. The chameleon is important in divination and as a symbol of transformation, because of the creature's ability to change color for protection. See INDEX: Lizard in Animals.

Lobi. The Lobi people live in Burkina Faso, Ivory Coast and Ghana. They differ markedly from their Burkina Faso neighbors as they do not make masks. Their principal art forms include seats, apotropaic pendants and other jewelry. The main focus, however, is on carved wooden figures for ancestor shrines called *thildu* (or *thila*). A variety of spirits, including ancestors, are evoked in these shrines, erected under the direction of a diviner. One type of sculpture, called *bateba duntundora*, represents spiritual beings sent by the creator to assist and protect human beings. These large figures seem to embody formidable strength showing their power to avert misfortune. Copulating figures and women bearing children evoke procreation and fertility. Finally, a type known as *bateba*

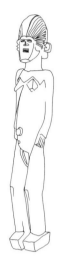

LOBI:

Top: Standing female figure from an ancestor shrine, bearing traces of sacrificial blood and feathers. The formal power of this figure contrasts with the animation of other Lobi statuary.

Bottom: Lobi male figure with upraised arms.

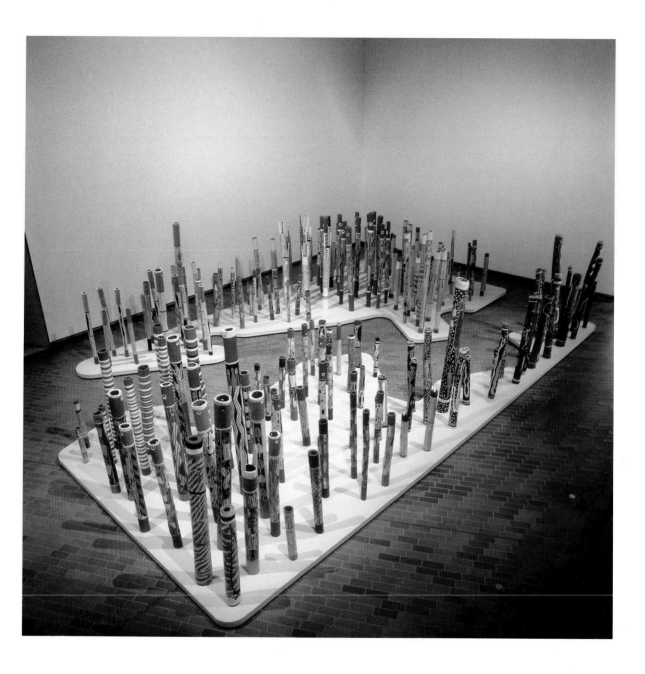

1: ABORIGINAL AUSTRALIA

Paddy Dhathangu (b.1915), David Daymirringu (1927-1999), George Malibirr (1934-1998), Jimmy Wululu (b.1936), and other Ramingining artists. The Aboriginal Memorial. 1987-88. Wood, ochres installation of 200 hollow log coffins. Height from 40.0 x to 327.0 cm. Purchased with the assistance of funds from gallery admission charges and commissioned 1988. Collection: National Gallery of Australia, Canberra. A detail of this work appears on the front cover of the book. Used with permission.

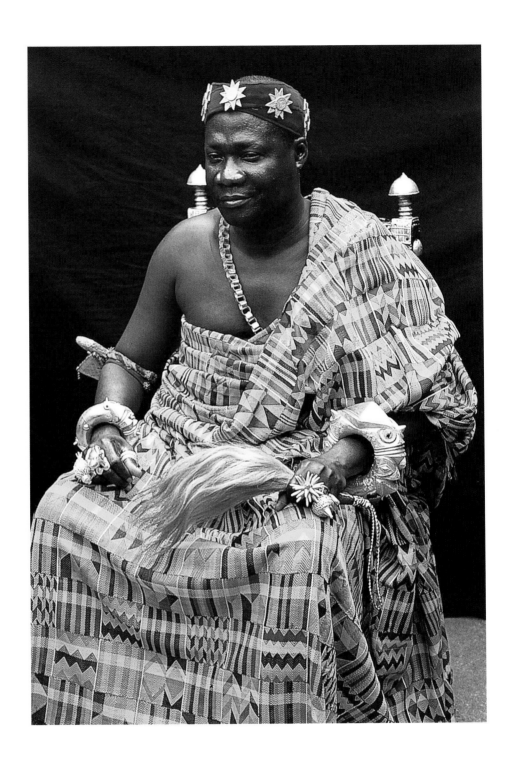

2 : ASANTE

Ejisuhene Nana Diko Pim III, wearing gold regalia and a rare kente cloth called Oyokoman Adweneasea, Ejisu, Ghana, 1976. Photograph by Doran H. Ross. Used with permission.

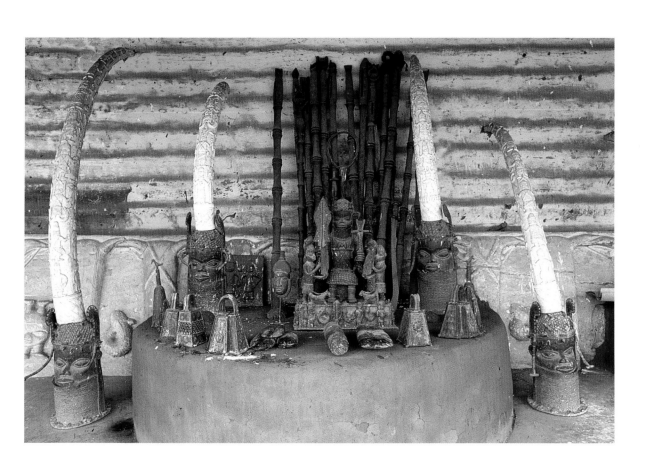

3 : BENIN ANCESTOR SHRINES

Ancestral altar dedicated to Oba Ovoramwen, Benin City, Nigeria. Photograph by Eliot Elisofon, 1970. Slide no. I BNN 2.4.3. (7590).
Eliot Elisofon Photographic Archives, National Museum of African Art, Smithsonian Institution, Washington, D.C. Used with permission.

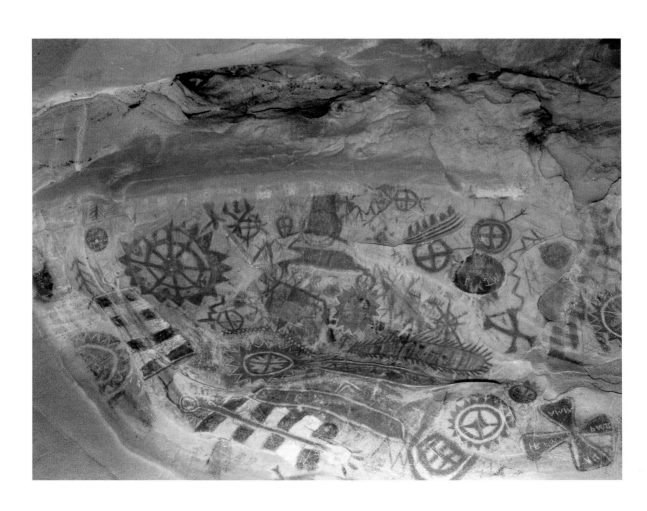

4: CHUMASH ROCK ART

The Chumash paintings in Painted Cave on San Marcos Pass, near Santa Barbara, may depict phosphenes, the brilliant, shining images that appear during altered states of consciousness. Photograph by Mark R. Arnold, Ph.D. Used with permission.

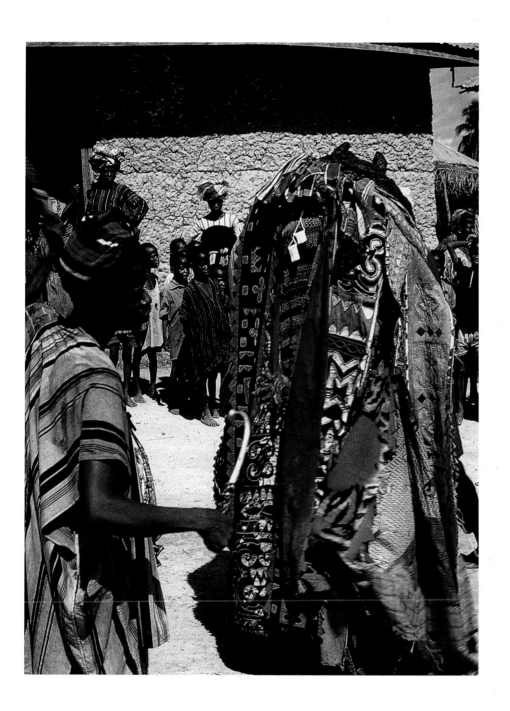

5 : EGUNGUN

Egungun dancer, Ipapo, Oyo country, Nigeria, summer, 1965. Photograph by Robert Farris Thompson.
Used with permission.

6: IJELE

One of three Ijele masks that danced at the second burial ceremony of a prominent Achalla man, 1983.
Photograph by Elizabeth Evanoff Etchepare. Used with permission.

Leis hang around the saints' necks and kappa cloth adorns the altar of the Church of St. Benedict near Kona, Hawaii, 1875. Although the other decorations stem from the European illusionistic tradition, the tropical trees painted on the supporting columns are an instance of the universal symbolism of the WORLD TREE. Photograph by Joanne Benedict. Used by permission.

8: TAMBARAN

The Men's House at Kuvenmas Village, Blackwater River, middle Sepik River region, Kapriman people. Photograph by Christina Dodwell/Hutchinson Picture Library, London. Used with permission.

yadawora, or "unhappy" *bateba*, has facial expressions indicating shock, suffering and misery. This sort of figure was supposed to

St. Lawrence River

Hudson River

Lake Ontario

Lake Erie

experience the negative emotions, thus relieving the living of such unpleasantness. Gesture and pose convey meaning, such as figures with bowed heads and hands clasped behind the back depicting mourning or figures with an outstretched arm that blocks evil spirts from entering the home. The style variation in Lobi figures, from formal and aloof figures to expressive, even playful, figures probably reflects their intended purpose. Also, the fact that all adult Lobi males consider themselves to be potential artists results in large numbers of individualistic carvings.

Long Walk. See NAVAJO.

Longhouse. From prehistoric times, the longhouse was the primary architectural structure among the IROQUOIS. The original form of the house was mythical: at first, only a sky world existed where "elder brothers" lived in long, bark-covered houses oriented on an east-west axis. The largest longhouse to be excavated, located near Syracuse, New York, was probably occupied between 1380–1400 and measured 334 x 23 feet. The outer wall was made up of three-inch diameter poles set about a foot deep. Two inner rows of eight-to ten-inch poles ringed an inner corridor

that separated the central aisle from the lateral sleeping areas and supported the roof. Two horizontal poles ran the length of the building, but the profile of the roof was an arch resulting from the slender poles bent and lashed to the rafters. The structure was sheathed with elm. Between 150 and 200 families resided in the largest longhouses, each with its own private living space. Not only was the form of the house prescribed by myth, the shelter of each Nation, it also was a potent symbol of the Iroquois League of Five Nations (after the early 18th century, the Six Nations), or Confederacy. The eastern end was guarded by the Mohawks, the "keepers of the eastern door," while the Seneca were the "keepers of the western door." The Onondagas lived at the center and were "keepers of the FIRE" and it was in their territory that the League met for councils. This imaginary but potent longhouse is a COSMIC MODEL.

Longhouse Religion. See IROQUOIS RELIGION.

Lono (in Polynesia, Rongo). God of agriculture on Hawaii, as well as peace and prosperity. Lono is the complementary opposite of KU, god of war, destruction and the forces of aggression and competition.

LONGHOUSE

Left: The IROQUOIS longhouse was the unifying symbol of the Iroquois League. The people thought of their territory as a gigantic longhouse that stretched 240 miles from near Albany, New York to Buffalo on the shores of Lake Erie.

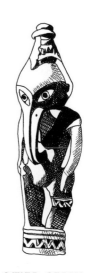

LOWER SEPIK

Above: This small figure, supposedly buried with a chief, probably was an amulet. The powerful stance, slanted eyes and prominent brow ridge as well as the long beak are characteristic of the area.

Lower Sepik. The Sepik Delta and Lower Sepik region, less coherent than other Sepik cultural areas, includes the art of the Schouten Islands, just off the coast, that of the Keram and Porapora River areas, as well as the Mundugumor and BIWAT people of the Yuat River. Impressive sculptures from Angoram Village depicting human figures wearing what appear to be long-beaked masks supported mortars, bowls and possibly other objects. The beak, mistakenly referred to as trunk-like, is probably that of a bird and it is found also on amulets, suspension hooks and masks representing ancestors and mythological spirits.

LUBA

Right: The fine craftsmanship and highly polished surface of this female figure (kabwelulu) is characteristic of Luba/Hemba art. This figure at one time sat atop a calabash that contained secret objects associated with diviners and with the Bugabo association charged with social control, hunting and healing.

Luba (formerly Baluba). The mythical origins of the Luba Empire date back to 1585 after which a military federation was founded that extended from the Zaire River eastward to Lake Tanganyika. The Empire ended after being defeated by the CHOKWE in 1885. And, in fact the early history and art style of the Luba is bound up with that of the Lunda and Chokwe. The twin culture heroes Mbidi Kiluwe and Kalala Ilunga were said to be from the Kunda clan, associated with the royal lineage and Luba progenitors. The lands of the Kunda clan are linked with some of the most famous objects from Central Africa, those attributed to the so-called BULI

SCHOOL. These and other objects from the eastern regions of the Luba area are identified as Luba/Hemba—Hemba was originally a directional indicator meaning east of the Luba territory, but today the people of the area call themselves Hemba. Most Luba objects are associated with power and prestige, including stools, headrests, bowstands, staffs and cups that were distributed by kings and chiefs at their enstoolment. Images of females played a major role in Luba art, indicating the importance of historical figures (the mothers, sisters and daughters of early rulers) and of women in Luba society in general. Mary Nooter Roberts writes that each deceased king was incarnated as a female spiritual medium, called *mwadi*, who resided in the former ruler's village to continue his rule. The spiritual powers of male rulers, thus, resided in women who guaranteed and perpetuated their power. The Bugabo association was a widespread society concerned with hunting, healing and judicial matters. The main objects associated with the society were power figures called *kabwelulu*. These consisted of female figures—misidentified as mendicant or begging figures—with raised arms, hands touching their breasts, a gesture linked with devotion, respect and containment of secrets. The figures sat atop calabashes (see LUBA DIVINATION), often augmented by a ring of giant land snail shells referring to the diviner's ability to fly at night. The Luba also make a unique type of object called a memory board, or *lukasa* that encodes mythology, history and genealogical information (see MNEMONIC DEVICES). The Luba are closely related to the SONGYE.

Luba Divination. Mbidi Kiluwe was the original Luba culture hero and diviner. The master of the forest hunt, Mbidi Kiluwe is associated with all black things, especially black cats, buffalo and the blue beads on LUKASA memory boards. All divination

paraphernalia is said to have come directly from him, including sacred calabashes (*mboko*) filled with magical objects such as bird claws, metal, hair, insects, seeds and miniature human figures. The diviner shakes the calabash and interprets the configuration of these objects. Carved figures of women identified as "mendicant" or "begging women" holding bowls are also part of the diviner's kit. The female figures are not actually begging, but rather represent the wife of the diviner's possessing spirit in a pose representing devotion, respect and containment of secrets. The female figures are said to underline the important role of the diviner's actual wife as a container of spiritual power.

Lucid Dreams. Dreams in which the dreamer is aware s/he is dreaming. The technique, which can be learned, appears to play a role in communication in some world cultures. The Mojave of California and the Great Basin, for instance, learn the mythology of their people in dreams.

Lukasa. LUBA memory board. The Luba Budye association was a cross-kinship age-grade society that acted as a regulatory group, primarily as a balance to and guardian of Luba royalty. The *lukasa* was the most important object associated with the society. The boards take the form of a tortoise, said to commemorate the Budye association's female founding patron, but they also have anthropomorphic associations, as one side is regarded as female and the other male. The front (female) side served as a "blueprint" for government, its form and markers paralleling the internal order of the court and courtiers. Some of the beads referred to specific individuals, such as the red beads signifying the red-skinned Nkongolo Mwanda, an anti-hero linked with the rainbow serpent, violence and blood. Blue beads (thought of as being black) symbolize the culture hero and master of the hunt, Mbidi Kiluwe with his

shining black skin and ambivalent power. Smaller beads signified the privileges and protocols of court dignitaries. Patterns and beads also relate to proverbs and praise songs. Other aspects of Luba life encoded in the *lukasa* include history, genealogy, medicinal lore and episodes in the creation myth. "Reading" *lukasa* boards requires considerable knowledge and narratives vary with the interpretive and oral skills of the reader. The multireferential quality of the *lukasa* allows expression of the Luba idea that life consists of "many memories" and "many histories." For a drawing of *lukasa* see MNEMONIC DEVICES.

Luluwa (also Bena Luluwa). The Luluwa live on the banks of the Luluwa River in Kasai having been driven south by the LUBA. Figures associated with the Luluwa are finely carved with extensive cicatrization, a practice no longer observed. Luluwa figures have large heads and feet, elongated and elaborate hairstyles. Autonomous chiefs who commissioned art to glorify their lineage governed the Luluwa people. Images of chiefs and of mothers and children embodied the power and vitality of the family lineage through such symbols as cicatrization patterns, umbilical hernias and the horn projecting from the top of the head. Additionally, these were associated with the ideal of beauty. Some figures had receptacles for magical materials and may have functioned as *minkisi*, taken into battle by high status warriors.

Lunda. A Central African empire that flourished in the 18th century, largely because of enrichment by the slave trade. The Lunda Empire influenced nearly all surrounding peoples, especially the CHOKWE and LUBA.

LULUWA

Above: Chibola figures represent a mother carrying a child. They were worn on women's belts to protect the unborn or newborn child. Chibola figures also stood guard over childbirth.

Maasai. The Maasai are East African (Tanzania and Kenya) cattle herders, who believe that their cattle are a gift from God. They deeply distrust agriculture, regarding the earth as dirty. Thus their dead are buried not in the earth, but in special houses made of cow dung. The preeminent Maasai art form is beadwork, a women's medium. Maasai males formerly practiced metalwork, but as women's beadwork became more valued, smiths ceased production. The Maasai oral tradition explains this shift as resulting from the female neglect of their cattle, which they therefore lost to the men, establishing male superiority. Maasai warriors wear

elaborate garb including jewelry made by their mothers and girlfriends. Before hunting lions and ostriches became illegal, men wore ostrich headdresses until they had killed their first lion; thereafter they donned the lion mane headdress. Although the younger warriors spend inordinate amounts of time on their garb and appearance, as they mature, ornamentation is progressively abandoned. The far more powerful and wealthy elders carry flysticks, clubs and snuff containers. Maasai

brides leave home laden with colorful beadwork and clothing and carrying milk calabashes, all symbols of their changed status. Mothers of warriors wear coiled brass armlets, but like male elders, in later years they too reduce their adornment.

Magical Flight. SHAMANS frequently return from trance states believing they have magically flown, either with the assistance of spirit helpers or under their own power. Since flight and weightlessness are commonly associated with spiritual states, this is not surprising. However, the sensation of flight experienced in dreams and ALTERED STATES OF CONSCIOUSNESS may also provide an explanation. Images of the airborne shaman are found in rock painting and in other media (see BIRDS and SAN).

Mahiole. Hawaiian feather helmets were worn only by the highest ranking chiefs. Sometimes worn with 'AHU 'ULA, feather cloaks, the helmets were of two types, both of which used a basketry foundation. One type had a wide shallow crest and was entirely covered with long, stiffened fibers to which feathers were attached. The other had a high, narrow crest covered with netting to which the feathers were attached. The crescent shape of both types was laden with complex symbolic associations including light, the moon, the rainbow and genealogy. By donning the *mahiole* and *'ahu 'ula*, the chief resembled a series of crescents, the protective power of which provided a vital linkage to his ancestral lineage all the way back to the divine progenitor.

Mahongwe. Inhabitants of southeastern Gabon, the Mahongwe are known for abstract metal-clad reliquaries based on those of the KOTA people. The northern Kota-Mahongwe make leaf-shaped figures with stem-like bodies called *bwete*.

Mai (or *mei, mwei*). IATMUL wooden masks representing the four original ancestors, two brothers and two sisters. Usually encrusted with cowry shells, such masks were attached to a bark and fiber superstructure that fit over the upper body of the dancer. The masks appear in pairs (the male masks are elongated and the female ones rounder and fuller) during INITIATIONS where they were used to act out flirtatious behavior and, in earlier times, to oversee the killing of prisoners. The male masks combine human and bird characteristics linked with clan totems.

Makemake. Name of the bird-like creator god on Easter Island, instead of Tane the creator elsewhere in Polynesia. For a boulder with a low relief image of a so-called Bird Man, see EASTER ISLAND.

Makonde. Living along both sides of the Ruvuma River that separates Tanzania from Mozambique are two distinct peoples called Makonde who share a common language, but little else. The Tanzanian Makonde refer to the Mozambican group as Maviha or Mawai. The people discussed here live in Mozambique. The Makonde have a long tradition of masks and figurative sculpture and are, today, one of the most prolific producers of contemporary art for tourists. The best-documented objects are the *mapiko* (sing. *lipiko*) helmet masks which, until the 1990s, came to the village from the bush to initiate boys and girls. The masks are typically realistic and were worn over a cloth tied over the bottom rim and falling down over the dancer's shoulders, part of an elaborate costume that completely concealed the wearer.

Older masks depict females wearing lip plugs, their faces decorated with raised tattoos applied with beeswax. The children were told that the performer was non-human and had been summoned from the land of the dead. Boys participated in a frightening ritual in which they had to overpower and unmask the performer, revealing his true identity. When not in use the masks were stored in a hut in the forest. Traditional Makonde carvings included five or six distinct types of drums. Recent Makonde carvings—encouraged by the establishment of the Makonde Carvings Cooperative in 1969—represent human beings, spirits and interlaced figures called "tree of life" carvings.

Malanggan (also *malangan*). A complex of festivals (funerary and commemorative ceremonies) and the associated art forms of NEW IRELAND and the surrounding islands. *Malanggan* (as well as NALIK figures associated with the ULI ritual) underwent a remarkable revival in the last two decades after having nearly died out following World War II. The style, which seems to have originated in the Tabar Islands, is associated with the coastal regions of New Ireland and other nearby islands and consists of open, highly complex interpenetrating sculptural forms. Although the right to make and present the forms of *malanggan* art is determined by birth, the rules governing it were flexible enough to allow its forms to spread throughout New Ireland (with the exception of the interior where the Uli cult held sway). *Malanggan* sculptures, generally made of the soft, light-weight wood of the Alstonia tree, are classified according to the following types: upright figures, compound figures, friezes and openwork display panels. *Malanggan* carvings are made and painted by specialists who are expert in creating the complex openwork and in reinforcing the resulting delicate structures. The sculptures incorporate elements

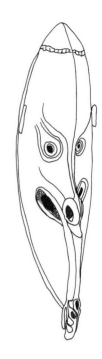

MAI

Above: Eastern Iatmul mask with the extended nose/beak characteristic of mai male ancestor masks. Collected 1914.

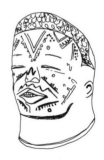

MAKONDE

Above: Attached human hair augments the realism of lipiko initiation masks. The eyes of the mask are mere slits and the face often tilts slightly back, enabling the performer to look out through the mouth.

MALEKULA

Above: Called nevinbumbaau, this large seated figure, carved from tree fern and painted, is now in the Musee Picasso in Paris, a gift from Matisse. South Malekula.

MALANGGAN

Right: Tatanua mask representing the most important of a man's three souls. During use the mouthpiece is inserted into the mouth from which the soul, lodged in the head, issues at death. The mouthpieces frequently represent birds, in this case a hornbill. 19th century.

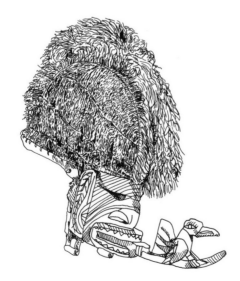

of the human body, fish (especially flying fish and sharks), birds, reptiles, crustaceans and hybrids. Westerners refer to *malanggan* sculptures using words like unreal, ethereal, even psychedelic, because of their brilliant color (made visually exciting by cross-hatching and outlining), the sense of restless, implied motion and layering of complex, overlapping forms. One of the most remarkable effects is their riveting gaze stemming from the use of opercula from the *Turbo petholatus* (a marine gastropod) which creates the illusion of living eyes. The sculptures are displayed in a ceremonial house, covered with green leaves, made for the occasion. The bones of the dead, wrapped in bundles of leaves, are placed in front of the carvings. Performances often accompany *malanggan* displays including the dramatic *tatanua* dances. *Tatanua* masks represent ideal manhood. According to D'Alleva, their red, black and white coloration signifies war, sorcery and the souls of those who died by violence. The great white spirals on the sides of the masks reproduce the hairstyles of bereaved youths—the sides of the head are shaved and covered with lime

dust. *Tatanua* masks, usually rented from sculptors, dance in lines, accompanied by a male chorus. At the end of the ceremonies,

the houses and *malanggan* sculptures are burned or allowed to rot, since their purpose—honoring, paying obligations to the dead and providing a proper send-off—has been fulfilled.

Malekula (or Malakula). An extraordinarily rich art-producing area of some antiquity in Vanuatu. The Ninde traced their ancestry back to the Kabat (or Ambat) brothers. Living on the coast in permanent villages in houses with dry-stone coral walls, the people grew yams and taro and hand-raised pigs. A well-organized system of crop rotation was possible with walled garden plots that kept the pigs out during growing season and in (providing fertilizer) when the gardens lay fallow. Wide paved paths graced villages that were connected by a network of footpaths. People living in another Malekulan village on Vao Island trace their origin to the Primordial One creator Ta-ghar who caused a fruit to fall on a tree root. From the split issued forth the first man and woman who sired four brothers whose ancestry is reflected in the organization of the village of Pete-hul into four quarters. Two-thirds of the population of Malekula disappeared during the first thirty years of the 20th century due to epidemics, which affected but did not obliterate the traditional way of life and art forms. Male initiation societies moved individuals upward to increasingly higher ranks, the aim of which was to achieve the status of a living ancestor. Energetic, carved, painted tree fern sculptures identifying individuals' ranks were placed at the edge of the dance ground following ceremonies, or less frequently in the initiates' homes, where they acted as an emblem. Funeral ceremonies, the culminating ritual of the rank/initiation groups, included the famous RAMBARAMP figures. Sand drawings (see CONTINUOUS LINE DRAWINGS), a fugitive art form connected with funerary rituals also existed in Malekula.

Malinowski, Bronislaw (1884–1942). Expatriate Pole trained in Cracow and at the London School of Economics. Self-proclaimed "godfather and standard bearer" of functionalist anthropology, Malinowski is generally regarded as the founder of the British fieldwork tradition. Among the most important of his field studies were those conducted among the Mailu of New Guinea and in the Trobriands Islands. Functionalist anthropology attempted to show organic relationships between social values and rituals, focusing especially on the ways in which human activities were or might be socially constructive. Although functionalist fieldwork was painstaking, the genuine tolerance for bizarre and even harmful practices (see HEAD HUNTING) has lately been criticized as static, ahistorical and overly concerned with seeing human endeavors as essentially positive.

Mamy Wata. Mamy Wata arrived on the coast of West Africa sometime around 1900 in the form of a chromolithograph of a snake charmer originally printed in Hamburg around 1885. The print was copied in England and India and widely distributed throughout West and Central Africa. In Africa, Mamy Wata is a water-spirit, with hidden mermaid attributes, believed to leave her watery home and roam the land in many guises: butterfly, child, man, snake or woman. Mamy Wata is unusual in that she combines BEAUTY and DANGER. Physically attractive, she is olive skinned, has a wealth of black hair and European or Indian features. Her association with non-African icons links her with wealth and power. Her positive activities include aiding human fertility, protecting *ogbanje* ("children born to die") and a host of practical matters such as passing examinations, buying a new car or getting a good job. But she can also cause gonorrhea, kidnap children, capsize boats and generally reverse all of the positive "gifts"

noted above. Her priests "marry" her and tend shrines that are found in many Igbo villages and without fail in towns and cities. Individuals may also erect shrines to mitigate her dangerousness. Common motifs in Mamy Wata shrines are images of pythons, crocodiles, signs, and poles festooned with red and white cloths. Altars usually have images of Mamy Wata, canoe paddles, fishnets, MIRRORS, and other objects from all over the world that create a stunning visual display pleasing both to humans and the deity herself. See INDEX: Animals.

Mana. A Polynesian term closely related to TAPU. The MAORI word is variously translated to mean "psychic force, authority, control, prestige, power and influence." *Mana* is a complex concept, having to do with being in a permanent, dynamic state of positive relationship with the ATUA (gods). *Mana* resides in places, certain objects (weapons, particularly, also see HEI TIKI) and in people. Although *mana* is generally inherited from noble ancestors descended from the *atua* themselves, it can also be attained by deeds, and accumulates in conjunction with certain activities (see MOKO) and with age.

Manaia. MAORI representations, variously identified as birds, bird-like heads, lizards or humans, in which the heads and sometimes the bodies are depicted in profile. *Manaia* are carved into canoe prows, WAKA TUPAPAKU (burial chests/bone boxes), prestige objects such as feather storage boxes, hand clubs, as well as throughout council houses and other buildings. *Manaia* heads/figures relate to the destructive forces of the universe, especially to death. The association may stem from the Maori belief that the spirits of the dead take the form of birds for the westward flight to the land of the dead. Furthermore, the Maori goddess Hine-nui-te-po has both human and bird character-

MAMY WATA

Above: Baule carving of Mamy Wata for a personal shrine. c. 1960.

MANAIA

Above: Profile manaia heads carved in relief and in the round adorn the ends of Maori feather storage boxes and are entwined into designs on numerous other Maori objects.

MANGBETU

Above: This standing female figure embodies the Mangbetu ideal of female beauty with its geometric body painting, elongated head and halo-like coiffure. Collected 1910.

Right: Double anthropomorphic pot of unknown use. The double-bowl form is derived from naando (hallucinogenic liquid) pots. Collected 1913.

istics (the latter consisting of claw-like three-fingered hands and feet and bird-like eyes). It was Hine-nui-te-po who brought death to mankind by crushing her firstborn son between her legs as he attempted to re-enter the womb (for a similar myth, see MAUI). Balancing the destructive symbolism, *manaia* are embedded in the energetic play of spirals and restless curvilinearity characteristic of Maori art and they are always found coupled with symbolism involving procreation, BIRTH and life.

Mandan. A Plains people, who along with the Hidatsa, lived on the Plains for more than a millennium prior to contact. They combined hunting and gathering with horticulture and lived in semi-permanent villages of thirty to two hundred earth lodges in what is now North Dakota. The lodges were circular, dome-shaped structures with sunken floors and a central area supported by four posts surrounding the hearth with a smoke hole overhead. The central posts were taller than the ring around the perimeter and a thick layer of earth was piled atop mats made of willow boughs and grass. A larger communal structure, used for public meetings and ceremonies, occupied the center of the villages. Swiss artist Karl BODMER, who accompanied Prince Maximilian of Wied on his exploration of the Missouri River in 1833 and 1834, painstakingly recorded Mandan material culture in realistic paintings and drawings. Although Maximilian was among the earliest to explore the area, the Mandan already had European trade goods—such as overcoats and hats—which Bodmer edited out. George CATLIN visited the Mandan not long after and became the only white man to witness the *okipa* ceremony. His sketches and reports of overt sexual content and warriors excruciatingly suspended from the rafters of the earthlodge by rawhide thongs inserted through their skin resulted in his being accused of fabricating the ritual. The *okipa*, last performed in

1881, reenacted shared mythology, thereby renewing health, welfare and fertility, especially the vital supernatural link with the buffalo. The ceremony is probably a forerunner of the Plains SUN DANCE ceremony.

Mangbetu. Closely related to the ZANDE, the Mangbetu live in the northeastern Democratic Republic of Congo and in the Central African Republic. By the 19th century the Mangbetu formed a loosely structured kingdom made up of diverse peoples. Women played a major role in Mangbetu culture and were both the subject and owners of highly sophisticated art objects. The best-known are wooden and bark containers, musical instruments, freestanding figures and figurative terracotta vessels. One of the most striking aspects of depictions of the female figures, beyond their naturalism, is the elongated head crowned with a halo-like hairstyle popular among upper class women in the late 19th and early 20th century. This characteristic female type appears on terracotta vessels, made by male potters. These anthropomorphic vessels, made for chiefs, colonial officials and missionaries, were popular between the end of the 19th century and the early 1930s. The prestige objects owned by Mangbetu kings and nobles included beautifully made functional and ceremonial knives, fly-whisks, horns, stools

and wooden paddles that apparently served as emblems of rank. Kings owned iron bells, believed to embody strong medicine derived from human blood.

Maori. The wave of Polynesians who settled New Zealand apparently arrived in the 11th century CE, having come from various locations in east Polynesia. The Maori trace their descent from the captains of the CANOES that brought the people to Aotearoa. Apparently isolated from further contact until 1769, the population grew and expanded throughout the North and South islands. The Maori share general Polynesian characteristics such as the outrigger canoe, expert navigation, social organization based on descent and seniority, and similar cosmological and mythological belief systems including, most importantly, the concepts of MANA and TAPU and the belief in the interrelatedness of people and nature. The Maori developed a variety of unique and increasingly complex art forms, with woodcarving being the most notable (treasure and burial boxes—see WAKA TUPAPAKU, flutes, GOD STICKS, architectural elements—see WHARE WHAKAIRO, POUTOKO-MANAWA—and canoe ornaments). They particularly valued greenstone (nephrite) which was carved into fishhooks, amulets called HEI TIKI and weapons. Finally, the body art of tattooing (see MOKO) was highly developed. Maori scholar Sidney Moko Mead identifies four chronological periods, the high point of which was the Flowering (1500–1800), otherwise referred to as Classic Maori art (*Te Maori*). Although devastated by European contact, Maori culture survives today in thirteen groups numbering some 400,000 individuals. Survival is due, in part, to Maori *taonga tuku iho* ("things highly prized," i.e. art), which provides a powerful, unifying link with their past and a sense of cultural identity. See Cliff WHITING, contemporary Maori artist.

Maori Aesthetics. Like many other groups, the Maori have no single word that corresponds to the Western word, art. Individual art objects have their own NAMES, and the phrase *taonga tuku iho*, meaning "property" and "anything highly prized," is used with further qualifiers such as *whakairo* (decorated, ornamented with a pattern). The artist in Maori society was generally a male of high rank. Art objects form part of what Sidney Moko Mead has called a cultural grid mediating between the people and their gods (*Te Maori*). The grid includes the land, the ancestors, ceremony and ritual, as well as other art forms such as song and storytelling. Art objects are imbued with MANA and as such evoke responses of fear and awe, as their source is supernatural. Works and performances are evaluated based on the spontaneous and physical response stemming from the degree to which the work embodies qualities of energy, authority, confidence and integrity. The response is communal, and when positive, credit is given to the gods (negative responses are regarded as being merely human, and not favored by the gods). The curvilinear, all-over patterns characteristic of Maori art create energetic, unified design fields which appear to be bilaterally symmetrical. However, within the overall symmetry, asymmetrical details and color use create an internal dynamism, which adds to the sense of barely contained energy. Art, like song and mythology (see RANGI and PAPA) expresses the Maori worldview of the dynamic tension existing between light and darkness, unity and separation, life and death.

Mapiko (sing. *lipiko*). MAKONDE intiation masks.

Maprik. See ABELAM.

Marae. Polynesian term for religious architectural complexes with common features

including a court or plaza demarcated by a terrace, a paved area or walled precinct, an altar with a sacred image or images often raised on a platform. See Hawaiian HEIAU. Maori *marae* are open spaces in front of WHARE WHAKAIRO, meeting houses.

Marianas Islands. The island group nearest Asia, the Marianas includes Guam and several other islands. The indigenous peoples called Chamorros were nearly driven into extinction in the 17th century by war and disease. Impressive archaeological sites include large double rows of megalithic columns that apparently once served as the foundations of buildings.

Marind-anim. Living to the east of the ASMAT, the Marind-anim produced little figurative carving. The people made elegant, ephemeral concoctions representing the *dema*, primordial beings connected with all aspects of nature. Some *dema* were

specific species (e.g., sago palm or banana *dema*), while others embody larger aspects of nature (the sea) or natural forces (clouds). The *dema* had an inner core and an outer visible form, which manifested itself in public on certain ritual occasions, each performance involving a "memory" of mythic events and spirits. Some of the events reenacted were creation myths, returning the community momentarily to primordial time. The embodiments of the *dema* consisted of beautifully crafted constructions made of seeds, feathers and other small objects attached to a framework of palm fronds all of which was discarded after the performance. The wing-like forked staffs may have been retained for displaying trophies. In any case, the forked shape is of the type SCHUSTER and Carpenter link with genealogy (*Patterns That Connect*).

Marka. See BAMANA.

Market Art (also curio art, trade art). Art made by indigenous artists specifically for sale. Although similar to AIRPORT ART, market art is generally considered to be of higher quality. In the area of OCEANIA, visiting museum curators, anthropologists and ethnographers constituted an important and informed clientele. In the ARCTIC AND SUBARCTIC regions, market art thrived from the earliest European contact. The introduction of metal tools contributed to an expansion which is referred to as being a golden age, or renaissance-like. Among NORTH AMERICAN NATIVES, artists must constantly combat the idea that the best art is in museums and that anything made recently is of inferior quality. Ralph Coe's 1986 exhibition *Lost and Found Traditions, Native American Art 1965–1985* addressed these issues and clearly demonstrated the vitality of Native American art. Beyond producing beautiful objects, contemporary traditional artists help preserve their cultural heritage. These

MARKET ART

Above: Figurines by Cochiti Pueblo artist, Seferina Ortiz. The Santa Fe dealer who handles these "bathing beauties" doubts that the artist has ever been to the beach. The "Storyteller" type figurine invented by Helen Cordero in 1964 is the immediate source for these, but Pueblo water imagery also plays a part, linking them to a far older inspiration. 1984.

MARIND-ANIM

Right: Man in costume of the Cloud-Dema. From a photograph by Paul Wirz, 1918.

artists also contribute to dynamic changes in tradition so that native art continues to evolve.

Maro. The word *maro* applies to bark cloth paintings and loincloths from LAKE SENTANI and HUMBOLDT BAY. Until the early part of the 20th century, only married women wore *maro*; all others wore no clothing. Decorated examples are ornamented with rows of connected and interlocking spirals, fish, reptile and bird images. Contemporary artists refer to the imagery as "dream work of spirits" which inhabit all of nature. The *maro* painter Hanuebi says of his designs: "At night I see the luminous dots of spirits (*uaropo*) moving on the beach close to and under my house, spirits coming from the sea and from the bush."

Marquesas Islands. In eastern Polynesia, these islands were settled starting about 2000 BCE (based on the presence of LAPITA pottery fragments) from the west, probably from SAMOA and TONGA. Stone architecture, including forts and religious precincts made up of dance grounds (*tohua*) and mortuary grounds (*me'ae*), exists all over the islands. The Marquesans raised the art of TATTOO (cf. Maori MOKO) to amazing heights. Boldly contrasting symmetrical patterns covered the entire male body. Those on the arms are found on food bowls. Above the wrist, separating the arm from the hand, was a named pattern referring to a garden enclosure; those on the ankles were based on a coiled shellfish; and those on shoulder joints and kneecaps mimicked sea and tortoise shell ornaments. Many of these patterns allude to warfare and killing. Early literature regarding the area reveals that tattooing reflected social and financial status, as well as ability to withstand pain. Not necessarily a sign of chiefly rank, it showed association with warrior groups, among others. Female tattoo was less

extensive and patterns related to fertility and sustenance. Marquesan carving is characterized by extremely precise, symmetrical, beautifully crafted detail which contrasts with an overall boldness of form. Objects carved in wood and bone include drums, food containers, canoe prow ornaments, war clubs, stilt steps, small cylinders for decoration of musical instruments and

MARO

Above: Painted bark cloth from Lake Sentani/ Humboldt Bay. Probably collected about 1930.

Below: Yotefa Bay maro painting by the 70-year-old Sibo Sriano depicting a spirit high up in a tree keeping watch over the village. 1972.

MARQUESAS ISLANDS

Left: Tattooed Marquesan. After von den Steinlen, 1925.

MARTINEZ, MARIA

Right: Black-on-black plate utilizing Julian's water serpent design by Maria and Popovi Da, 1956.

MARSHALL ISLANDS

Below: Navigation chart; there are two types of stick charts. One, similar to a map, has coral pieces representing islands tied to the sticks that represent navigation courses. The other type diagrammed the predominantly westward currents and wave patterns which navigators used to help them locate themselves. Both acted as MNEMONIC DEVICES.

food containers, and fan handles. Items for personal adornment included necklaces and gorgets of shell and woven coconut fiber as well as beautiful warrior headbands (UHIKANA) which attached to feathered headdresses of numerous cock tail feathers—as each cock has only two such feathers, these headdresses represented considerable wealth and prestige. TIKI heads also appear on U'U WAR CLUBS. Stone carvings (measuring from six inches to eight feet) representing deities and ancestors are equally bold, but simpler in form, thus emphasizing their rough basalt surfaces. Food pounders used to mash breadfruit and taro were carved from fine-grained gray stone. Some are elegantly simple, while others are ornamented with JANUS heads. The crisp, bold designs appealed to Paul GAUGUIN, who drew upon Marquesan motifs in his wood block prints. See map: OCEANIA.

Marshall Islands. An independent island nation east of the CAROLINE ISLANDS. Marshall Islanders excelled in tattooing and mats, some of which are the most finely made, intricately designed in Polynesia. Most remarkable, however, were canoes and navigation stick charts. The sparely elegant charts, with their crisscrossing sticks, layered patterns and shell punctuation points, are sophisticated functional objects making navigation possible over vast distances. See map: OCEANIA.

Martinez, Maria and Julian (Maria, c. 1881–1980). Maria, founder of a dynasty of Pueblo potters, was born at San Ildefonso Pueblo. She learned the art from her aunt, Nicolasa Pena. Maria married Julian Martinez (c. 1879–1943) in 1904 and together they inaugurated their unique black-on-black ware in 1918. Maria, sometimes with the assistance of other family members, formed the vessels, painted on clay slip and painstakingly burnished them. Julian overpainted the burnished vessel with designs inspired by Pueblo patterns augmented with his own specialties, bold feathers and water serpents with forked tongues. When the vessels were fired, the areas not covered by protective slip burned with a high gloss that looks almost metallic. At collectors' requests Maria began signing her pots after 1920, but as signatures and individual fame meant nothing to a Pueblo potter, she also signed pots made by other family members and apprentices, thus maintaining harmony and distributing the benefit throughout the entire community.

Masau'u (also Masawu, Maasawu, Masao). One of the oldest and most important Hopi spirits, Masau'u's status is indicated by the fact that he is the only god who appears in Hopi society during the non-*kachina* season when the spirits are not resident among the people. Masau'u is associated with the fertile, crop-bearing surface of the earth and the underworld of the dead. For a description, see KACHINA DOLLS.

Masks. Wearing masks is nearly universal among indigenous peoples. Masks take myriad forms from human faces and animal heads and forms, to imaginary, hybrid and abstract forms. The diversity of materials, sizes and uses is enormous. The greatest contrast exists between those masks that express cultural ideals of BEAUTY and those that are purposefully ugly and terrifying. The former are linked with the reaffirmation of society, while the latter are usually associated with DANGER and forces inimical to human society. Generally, speaking, masks in indigenous cultures are worn, not so much to disguise the wearer, as to please, evoke and embody supernatural spirits. Masks appear in cyclical increase/fertility rituals and in conjunction with major human RITES OF PASSAGE, such as initiations and funerals. Masks are one of the primary art forms in Africa, perhaps the most important one. Although masks are of great importance in the Pacific, shields are also of great significance. Masks were of major importance in conjunction with shamanism in the Arctic, Subarctic and on the Northwest Coast of North America. Although they played a slightly less important role in the continental United States, there are many distinctive mask types. See INDEX: Masks in Art, Artifacts and Techniques.

Massim. This area is also referred to as Trobriands, one of three archipelagos making up the Massim region. The Massim region lies at the far eastern point of New Guinea. The people were great sailors and established an extensive inter-island trading system called *kula*. Massim art objects, including canoes, bailers and paddles, dance paddles (see KAIDIBA), lime spatulas, drums, shields and weapons as well as

shell currency presentation scepters (GOBAELA), are characterized by elegance, subtle balance of plain and carved surfaces, finesse of detail and the often surprising way in which motifs which appear to be decorative become recognizable human, plant and animal forms. Architecture takes two forms, yam storage houses and chief's dwelling houses. Both were decorated with sea mammals painted on the curved barge boards either side of the saddle-shaped sloping roof. The slightly pear-shaped wooden MASSIM SHIELDS were painted with complex designs which have given rise to different interpretations. Most important of all Massim objects were the canoes said to be an embodiment of a witch who protects those aboard, or of the capricious sea or the feared sea eagle. The ornamented parts included prow boards (oriented parallel to the vessel's movement, these acted as wave breakers), finials and splashboards. Shirley F. Campbell has identified three types of designs: motifs (thirteen are basic), fillers (three) and dividers (three). The motifs (human figures, dolphins, fish, birds and bird beaks and abstract leaves) were carved

MASSIM

Left: The HERALDIC WOMAN at the top center of this canoe splashboard is more three-dimensional than most Massim carvings. As is the case with other Massim region art, the complex intertwined reptilian and avian forms appear at first to be symmetrical.

by master artists, whose skill increased their own and the patron's prestige. The curvilinear designs of Massim art, the presence of joint marks and certain cultural practices (canoe burial) are usually explained as resulting from DONGSON influences.

Massim Shields. More than sixty decorated war shields collected between 1885 and 1914 are found in museums and private collections. Gifford recently identified seven repeated design elements on Massim shields: head, belly-wheel, arms, MAZE, ANUS (anal anchor), magical knives and fillers. The anthropomorphic appearance of these body parts, most viewers agree, resembles a kind of anatomical specimen. Gifford suggests that the foreign elements were introduced by a Trobriand magician influenced by SOLOMON ISLANDS shields. Gifford supports earlier interpretations of the maze element as representing a vulva and points out its similarity to designs on gourd LIME containers. The earlier literature identified the vulva specifically as that of a mythical flying witch. Speaking further of the role of the magician, Gifford recalls MALINOWSKI's account of the war magician's "spelling" of the shields. The squatting magician held the shield across his knees, his head and open mouth positioned over the shield's center (where the belly-wheels and arms are located). The spell was said to sink down into the magician's abdomen and issue out through his throat, his breath transmitting the magic into the shield. The imagery on the shield, thus, was a kind of portrait of the magician and the powers (spells) located within his body. The entire ensemble often resembles an open-mouthed human face. Whatever their esoteric meaning, these symbols as well as the sheer beauty of the shields would seem to have offered substantial protection to Massim warriors. Anne D'Alleva suggests that the sexual imagery may have also

MASSIM SHIELDS

Above: These painted shields are no longer made and the people have forgotten the meaning of the designs. Schuster identified the design as a two-headed Sky Bird with a fish in each beak and the SKY GATE in its chest. Alternatively, the curvilinear patterns may symbolize the apotropaic powers of the magician.

served as challenging and insulting to enemies, functioning as visual incitements to attack.

Master of Ogol. See DOGON.

Master of the Cascade Hairdo. A Luba carver who created delicate images of female figures with layered hairstyles that resemble cascades. This master's work is more delicate, described sometimes as "miniaturistic," than that of the master of the BULI SCHOOL.

Master/Mistress of the Animals. In the ARCTIC and SUBARCTIC cultures, because of the absolute dependence on hunting and fishing for sustenance, people developed elaborate beliefs about their fellow creatures. When game was killed it was done causing the animal as little suffering as possible and its death was mourned. People wore special clothing (see INNU) and used decorated weapons to please the animals. Each species of animal had a spirit master/mistress which was its special protector and which humans had to propitiate in order to succeed. Hunting, thus, had spiritual implications as the hunter was constantly under the eye of supernatural beings.

Maternity Figures. See NURTURING FEMALE.

Maui. Polynesian culture hero and trickster associated with the sea and fishing—indeed, the MAORI credit him with having "fished up" the North Island of New Zealand. The Maori also say that Maui tamed the sun and brought fire to humans. They explain the continuing presence of death in a myth involving Maui. The god came upon the sleeping Hine-nui-te-po, the female *atua* who draws the souls of humans down to her in death. He planned to kill her by entering her vagina. Awakened by the laughter of birds, she

noticed the struggling Maui and crushed him to death by clenching her thighs. The myth is linked to the dynamic tension characteristic of Maori art and worldview. Like the story of the Primordial Couple Rangi and Papa, it involves the union and separation of opposing forces—life and death, above and below, light and darkness (see MAORI AESTHETICS). In TONGA, it was Maui who pushed up the skies which were ordered in ten layers (see LAYERED UNIVERSE). See also INDEX: Deity Archetypes.

Mazes. Mazes symbolize the path of life, and their often tortuous and confusing forms serve as visual metaphors for the difficulties of life. Most mazes in indigenous cultures are found in rock art, basketry and textile patterns (see SAN). These mazes may illustrate the ENTOPTIC PHENOMENA that occur in trance and hallucinatory states. Mazes are found pecked on boulders and cliff faces throughout the Southwest. The Hopi call the maze *tapu'at*, "Mother and Child." They say the path leads to rebirth and liken the design to an unborn child within the womb of its mother. Similar symbolism is found in the KIVA, the place of emergence in Hopi mythology and ritual, sometimes called "Earth Mother." On occasion, certain complex buildings are referred to as maze-like. The structure of such buildings, like the Cameroon royal palace at BAMUM, protects the inhabitants and serves as a model for the social relationships of those that live within its confines. See also CONTINUOUS LINE DRAWINGS.

Mbari. In *Igbo Art: Community and Cosmos* Herbert Cole suggests that for the southwestern IGBO around Owerri "*mbari* is life," and a "spiritual art gallery." These sundried mud houses, now erected less frequently than before, are total art works containing representations of all aspects of life from the heavens to everything on

earth. *Mbari* houses, located in the sacred grove, are begun following a sign from a local god, often the earth goddess Ala, or in response to community catastrophes or as thanks for bounty and deliverance. Twenty or thirty men and women may dedicate as much as two years to building

the house. The structure consists of a closed box with stage-like inset spaces supported by piers. Formerly, thatched roofs protected the houses, but since the 1930s, corrugated metal has been used. The walls are painted with geometric and figurative designs, including, under the eaves, depictions of the sun, moon, stars and rainbows. Prior to the 1960s, subtle gradations of earth tones were used, but since then, bright commercial poster paints began to replace them. Large *mbari* may have as many as one hundred or more sculptures encompassing all that is beautiful and dangerous. The first figure to be completed is the crudely constructed *nwaokwaojo*, the "child of a bad mortar," which served to neutralize any evil forces present. Dangerous creatures included lions, leopards, masks that women and children may not see and the ugly rapist, the part-monkey, part-human Okpangu. Good and beautiful scenes such as happy families, various benign authority figures and desirable material objects like bicycles or sewing machines balance these evil and ugly things. At the CENTER are the gods,

MBARI

Left: Ala, goddess of the earth, surrounded by her "children" in a mbari shrine, by Ezem and Nnaji, Owerri township, Nigeria. c. 1964.

MAZES

Above: Two rock art mazes from southern California, the larger and more elaborate is the so-called Reinhart Maze.

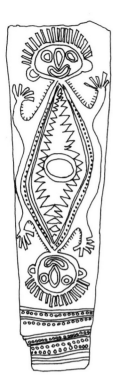

especially Ala, the source of life, to whom most *mbari* are dedicated. In fact, *mbari* is said to be her "crown." The sacrificial act of constructing the *mbari* is more important than the finished product, as the process is a metaphor for human energy and the totality of Igbo life. When the house is complete, it is dedicated with a sumptuous feast and dancing, after which it is allowed to decay, reverting to the earth from which it was made and to which it was dedicated.

Mbi (also *bi*). KWOMA paintings on flattened midribs of sago palm leaves depicting totemic plant and animal designs "owned" by the men associated with the house in which they are used. The entire interior surfaces of the houses are covered with *mbi*. Although there is no formal pattern to the arrangement of the paintings, taken as a whole they form a visual representation of the totems of the entire community. Totems include *manu*, the bird of paradise; *yirimagu*, the striped opossum; and *apunyoukugu*, the sago tree, all of which are the subjects of origin and adventure myths. Geometric forms tend to be multivalent. A circle, for instance, might represent a coconut or some other round fruit, an eye, a testicle, a water-lily seed, an animal's belly or navel, a hearthstone, a star, moon or a person's head. The most respected artists do not restrict themselves to simple reproduction of clan totems but rather modify and embellish designs. They also incorporate new objects and motifs.

Mbidi Kiluwe. The original LUBA culture hero and diviner.

Mbulu ngulu. Reliquary shrines, see KUBA.

Mead, Margaret (1901–1978). American anthropologist, student of George BOAS. Her book *Coming of Age in Samoa* (1928) which made her a well-known and popular

figure, was verbally refuted in the 1970s by Derek Freeman. Freeman's claim that Mead's fieldwork was flawed and incomplete created great controversy in the discipline of anthropology. Freeman did not publish until 1985, fifteen years after his verbal critique. Paul Shankman's recent analysis suggests that Freeman's work also is marred by "serious omissions and overstatements," and reinstates Mead's work to some degree. Recent documentary films draw attention to the impact of unquestioned aspects of ethnocentrism (Mead's upbringing—including gender constructs—and life as determinants of her work) and the difficulty of knowing the past and other cultures outside one's own experience.

Medicine. The Plains peoples preserved powerful substances called medicine, which were identified with the well-being of both the group and individuals. The substances were bound together in the form of bundles that were carefully preserved by priests and brought out on ceremonial occasions. Medicine can also be thought of as spiritual force or energy. The term medicine is also used to describe the magical substances sealed up in Kongo NKISI *nkondi*.

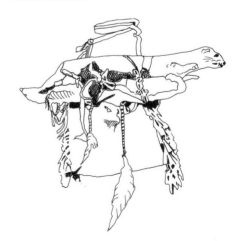

Medicine Bundle. The concept of the medicine bundle exists among all North American Natives and was particularly

important on the Great Plains. The bundle, consisting of various magical materials and objects, served as a portable shrine. Believed to contain relics of the first ancestors, the bundles were associated with the spiritual and physical well-being of the living society. Medicine bundles had NAMES, belonged to families, to the medicine man/woman or to native societies and ownership conferred rights that included songs, dances and ritual costumes.

Medicine Man/Woman. The English words are preferred by Plains peoples instead of SHAMAN which is used in the scholarly literature. Both healers and herbalists are referred to as medicine men/women. Individual peoples use specific words to name this important individual.

Medicine Rite. A secret WINNEBAGO rite centered on the origin myth recorded by Paul Radin in 1908. Radin happened to arrive among the Winnebago during a period of crisis attending the introduction of the Peyote Cult by John Rave. Radin's presence was regarded as semimiraculous as he was able to pronounce and transcribe Winnebago words, although he didn't fully understand the language and depended on translators to render the text into English. Jasper Blowsnake, who took it as his life's mission, subsequently dictated, over a two-month period, the entire rite to Radin. The Medicine Rite was democratic, the only requirement being membership in the group. The thrust of its ceremonies was to guarantee a long and happy life and to insure return to life after death. Admission to the rite involved being shot and symbolically killed and coming to life again, ritually repeated throughout the individual's life. Radin links this repeated shooting ritual with SHAMANISM. The rite changed with the passage of time and the absorption of ritual artifacts from other

groups, e.g., the MEDICINE BUNDLE otterskin pouch and the shooting ritual from the Ojibwa MIDEWIWIN ceremony.

Medicine Wheel. Scattered across the high Plains from Wyoming to Alberta, medicine wheels are circles of boulders. The largest, located in the Bighorn Mountains of Wyoming consists of a seventy-five foot diameter boulder cairn with twenty-eight spokes radiating outward. Although the purpose of these pre-contact structures is unknown, they are generally thought to have been erected to act like huge sundials as the main spoke often points toward the rising sun at the summer solstice. It is speculated that medicine wheels may relate to historical SUN DANCE LODGES, which are also aligned to the rising sun.

Meeting Houses. All over the world, communal structures are built for people (usually confined to high status male elders) to come together for the benefit of society. Often anthropomorphic in conception, the parts of the building correspond to human body parts. Some buildings, like the Maori WHARE WHAKAIRO, symbolized the body of an ancestor, who, joined by images of lesser ancestors carved on interior panels, literally formed the spiritual support of the living community of their descendants. The TAMBARAN houses of the SEPIK RIVER, the

MEDICINE WHEEL

Left: Bighorn Medicine Wheel, located high on Medicine Mountain in Wyoming. Twenty-eight lines radiate outward from the center, the number of days in a lunar month. In addition to marking sunrise and sunset on the summer solstice, sightings from the cairns mark the helical rising of Aldebaran on the morning of the solstice, Rigel a lunar month later and Sirius the next lunar month. c. 1250–1750.

KORAMBO spirit houses of the Abelam and the Asmat YEU embody similar ancestral associations, but are marked by more pronouncedly sexual imagery. The BAI houses of Belau in the Caroline Islands are among the most spectacular meeting houses in the Pacific. The houses are visual expressions of Belau society, its metaphorical and aesthetic principles and its focus on fertility, wealth and prosperity. In Africa, the TOGU NA men's house incorporates Dogon cosmology and cultural practices. The low profile of the building makes standing upright within it impossible—the Dogon say that true speech is only possible while seated. When debates become heated, those who jump to their feet get painful reminders of the need for self-control. See also FANG, IGBO, SECRECY and INDEX: Architecture in Art, Artifacts and Techniques.

Melanesia. The most complex art-producing area of Oceania. In some remote areas, life in Melanesia is little affected by the modern world, but generally, rapid social change is the rule. In a recent survey of the art of Oceania, Christian Kaufmann suggests that Melanesian art is disconcerting to the Western eye and more alien and "savage" than that of Polynesia. Kaufmann further suggests that any broad interpretations of the meaning of Melanesian images are impossible because solid material on the area has neither been consistently gathered nor organized. Kaufmann recommends couching discussion of Melanesian art in well-observed cultural contexts and while he cautions against generalizations, he lists five cultural characteristics, which appear in varying degrees and diverse forms throughout Melanesia. First, society is organized based on descent and genealogy. Second, overarching political or religious institutions are lacking, except for the authority of "BIG MEN," based on lineage and skills ranging from war to social intercourse, knowledge and artistic ability.

Third, a sedentary lifestyle with intimate links to the land and other sources of sustenance. Fourth, conservative attitudes toward tradition. Finally, and fifth, individual identity is defined in relation to genealogy, initiation societies and, very recently, a sense of national or ethnic identity. Within Oceania, practices unique to Melanesia are CANNIBALISM and head hunting which, when found in other Pacific cultures, seem to have been imported from Melanesia. Kaufmann also provides five groups of phenomena to describe Melanesian art/art objects: 1) use of a wide variety of materials, usually organic; 2) the essential role of the mobility of the entire object and/or its parts; 3) close connections between art works and specific spaces devoted to religious activities; 4) absence of representation of beings that can be identified with personalized deities; and 5) relative lack of interest in objective representation or approximation of natural forms. He points out that, since they depict supernatural beings/forces, it is not surprising that Melanesian art objects tend to be unnaturalistic. The art-producing regions of Melanesia include NEW CALEDONIA, VANUATU (New Hebrides and the Banks Islands), the SOLOMON ISLANDS, NEW BRITAIN and the DUKE OF YORK ISLANDS, NEW IRELAND, the ADMIRALTY ISLANDS and NEW GUINEA. Nearly all of these islands or island groups are further subdivided, especially New Guinea, which has some of the most complex native art in the world. Although European contact occurred very late in some areas of Melanesia (remote groups in the Sepik River area, for instance, were unknown until the 1930s), its impact was as strongly felt there as elsewhere in the world. Kaufmann remarks that artistic traditions have been revived in the last twenty years due to a widespread sentiment that "cultural memory" is important. He also lists names of several important contemporary Melanesian artists.

Mende. The Mende are one of several western Guinea Coast societies where the PORO and SANDE societies govern political, judicial and ritual activities. Nearly all Mende art is associated with these two powerful and complementary male and female societies which are conceived of as an aesthetically balanced set. Indeed, the Mende have a highly developed aesthetic sense, which, as is true elsewhere in Africa, combines ethical and artistic issues. They use several words to describe beauty. Physical beauty is *nyande*. But, beauty is not just physical, as the Mende say, "…no one can be beautiful if she doesn't have a fine character." *Nyande gbama* is wasted or empty beauty, referring to physical beauty marred by arrogance or lack of competence. Goodness, *kpeke*, is linked with goodheartedness, kindness and generosity. Real beauty contributes to the entire community because it is good to look at, fulfills its social purpose through industry and dedication and is generous and loving. The ideals of beauty are most evident in the *soweisia* masks worn by Mende women in Sande society masquerades. Sylvia Boone has detailed eight aesthetic criteria that apply to masks, which must be: 1) complete and correct in all parts (full, ringed neck, small face with closed eyes, lowered mouth and large forehead with an elaborate hairstyle); 2) comfortable for the dancer to wear; 3) shiny black; 4) smooth; 5) symmetrical, with well balanced horizontal and vertical planes; 6) clear and unblurred; 7) fresh, new and youthful looking; and 8) delicate and finely detailed in the handling of physical features. Poro masks (*gbini*) are regarded as the "husbands" of Sande *soweisia* and together they symbolize what Ruth Phillips calls "the corporate power of men and women." The combination parallels Mende social and family structure.

Mesa Verde. Now a National Park, Mesa Verde is one of the best-known ANASAZI cliff dwelling complexes. Occupied contin-

uously for 700 years, at its height, Mesa Verde may have been home to as many as 2500 people. The reasons for its abandonment after 1300 CE are unknown, but a quarter-century-long drought which ended in 1299, undoubtedly played a part. The largest structure is the spectacular Cliff Palace, named by ranchers Richard Wetherill and Charlie Mason who discovered it in 1888 while looking for cattle in a snowstorm. Built by the San Juan Anasazi, it is located in southwestern Colorado, some eighty miles north of Chaco Canyon. A second cliff dwelling, Spruce Tree House, is located one and a half miles to the north. Construction on Cliff Palace began around 1200 CE and by the 13th century it consisted of some 220 rooms, twenty-three *kivas* occupied by a population of approximately 250 people. The shapes of the rooms are adjusted to the uneven floor of the natural cave in which Cliff Palace is built. The cave, measuring 324' wide by 89' deep and 59' high, arches over the complex, sheltering it from the elements.

Messenger Feast. A local Alaskan ESKIMO development which the people themselves say originated in the Bering Strait area. The feast has mythological roots—commemorating Giant Eagle, humankind's benefactor. The sound of drums is said to be Giant Eagle's mother's heartbeat after he was killed. The sawtooth patterns on the drum are said to represent mountains. Masks were worn by both the shaman and lay persons as part of the dance that lasted five days. The dance and apparatus varied from place to place.

Metals. Metalworking in Africa was independently invented. Beyond their intrinsic value that stems in part from the craftsmanship necessary to transform raw materials into useful and beautiful objects, metals have symbolic associations. The shine and redness of brass, the material of the

MESA VERDE

Above: Anasazi petroglyphs from Pictograph Point, Mesa Verde National Park. The modern Hopi interpret the spirals as SIPAPU.

famous IFE and BENIN heads, suggests permanence and is said to distance evil. As the metal darkens with age, it becomes, according to one source, more dangerous and imbued with power. (The famous IGBO UKWU castings are leaded bronze, the composition of which closely resembles that of Benin metalwork; Ife metalwork is copper alloy with lead and zinc additions.) This power of metal can provide protection, as is the case with the metal-clad KOTA reliquary figures that guard ancestral bones. Iron is equally potent. Iron inlays in the pupils of the eyes of Benin heads contribute to their remarkable presence. One of the local names for the iris is "ray or menace of the eye." Additionally, iron insets on the foreheads of some figures were there to receive offerings, acting as conductors for sacrifices to renew the potency of the ruler. In the Pacific, metal working arrived with the DONGSON culture, but was never practiced very extensively. In North America, metalwork seems to have come into being only after European contact. On the Northwest Coast, COPPERS made from European sheetmetal were the ultimate symbol of wealth. Silver jewelry was raised to a high art form in the Southwest after the Navajo learned silverworking from the Spanish. See also GOLD, SILVER and INDEX: Metals in Natural Phenomena and Materials.

Metis. The word Metis comes from the Latin *miscere*, "to mix," and refers to Subarctic and Woodlands Canadian people of mixed heritage (European, mainly French, and Native North American, mostly Cree and Ojibwa). It is appropriate only in the Great Slave-Mackenzie River regions, and should not be used to refer to KUCHIN work. Metis clothing, their primary art form, reflects this mixture and is valued for beautiful floral designs and fine craftsmanship in embroidery, bead- and quillwork.

Micmac. See QUILLWORK.

Micronesia. Literally "small islands." Ironically, small is also an accurate description of the information available on the region. The area is made up of some 2500 small islands spread across 1000 square miles, apparently settled directly from Asia beginning as early as 2000 BCE. Religious beliefs reflect those of the Pacific region (see OCEANIA). Principal island groups are the MARIANAS, the CAROLINES (including Mortlock, Belau—see BAI houses—formerly Palau and Chuuk—formerly Truk), the MARSHALL ISLANDS and the Gilberts. Art forms include architecture: stone temples and impressive men's meeting houses. Much of the art has to do with the sea and, in fact, when Micronesians are asked about art, they begin by speaking about navigation. Due to excellent navigational skills (see MARSHALL ISLANDS, Caroline Islands) and elegant, clean-lined canoes, there was frequent contact amongst the islands. Woven suits of armor, weapons, containers of various sorts, stools and tattooing are other Micronesian art forms, with sculpture being found only rarely. Micronesian art is said to be spare and economical, in part due to scarcity of materials.

Middle Sepik. The best documented of the three areas into which the Sepik River is divided, Middle Sepik art forms are unique in their diversity. Included are the IATMUL, the SAWOS, the Ewa, the Alamblak, the Bahinemo, the KWOMA, the Nukuma, the Manambu, the Chambri and the WOSERA. In the same region, the Korewori River and Lake Yimas are renowned for crocodile sculptures carved from entire tree trunks (for an illustration, see CROCODILE). Also in the Middle Sepik, near the source of the Blackwater River, the YIMAR (or Yimam) make elegant hook figures called *yipwon*.

Midewiwin. A cult which emerged among the OJIBWA around the middle of the 18th century and which spread throughout the northeastern region. The cult's activities focused on curing rituals and social integration at a time when the fur trade was disrupting Ojibwa life. Ceremonies were conducted in lodges built for the purpose. Measuring up to 100 feet or more, the lodges were constructed of bent saplings, often partially covered with cloth or brush. Sometimes called the "blue house," the structure may have symbolized Lake Superior.

Milky Way. Stories abound regarding the origin of the Milky Way. In Arnhem Land (ABORIGINAL AUSTRALIA) Milnguya, the Milky Way, is spoken of as a great river in the sky or alternatively, the twinkling campfires of Walik the crow and Bari pari the cat who flew to the sky. Yingarpiya the great crocodile swims in the river and the biggest STARS mark the spines on his back and the curve of his tail.

The Milky Way, its myriad stars representing the campfires of the deceased, was the route of souls in Plains mythology. These people believed there was a fork in the road guarded by an old woman who sent some souls on to the final resting place and others were sent back to earth as ghosts. The Milky Way was the most important

celestial entity to the California Native peoples, who incorporated it into their cosmology, its meaning changing with the seasons. In late summer and early fall, it symbolized the northward journey of the people to gather pinon nuts, while during the winter it was regarded as the ghost road for spirits entering the land of the dead. It was also conceived of, and depicted as, a great supernatural downy cord, wrapped in a ring around the earth. See INDEX: Natural Phenomena and Materials.

Mimbres Pottery. The name of the ancient people (c. 600 – 1150 CE), a branch of the Mogollon, who lived in southwestern New Mexico is unknown. Named after the nearby Mimbres Mountains, the people painted fine-lined designs of bowls buried with the dead; their hemispherical shape is said to mimic the shape of the earth's dome. A hole was punched through the base of the bowl, ceremonially "killing" the pot, before it was inverted over the face of the corpse. The opening allowed the spirit to escape through the hole into the celestial regions. The hole is a spiritual analog to the hole in

MIMBRES
POTTERY

Above: Classic bowl showing a long necked bird, which apparently has eaten several fish. Although broken, this bowl was not "killed." c. 1000–1130.

MILKY WAY

Left: CHUMASH rock painting from Emigdiano Cave showing the sun at the center, the polar stars in the seven-pointed star and the Milky Way as the inner dotted band. The outer dotted pattern is said to depict the stars below the galactic equator.

the underworld (SIPAPU) from which the original people emerged into the physical world of daylight and existence. Among the most highly sought collector's items, Mimbres pots are painted with single isolated motifs or are divided into halves or quadrants, with bold, repeated black/white designs. Motifs include plants, animals, reptiles and insects, as well as human beings and celestial symbols. The designs show sophisticated use of negative space.

Mimi Spirits. Animated stick figures of TRICKSTER spirits that, according to tradition, live in caves, crevices and rocks. So thin are they, that the Mimi do not venture out on windy days for fear of being blown away or broken up by the gusts. The Mimi supposedly taught the people basic skills of hunting and gathering as well as proper ritual and social behavior. Found on the walls of caves and cliff faces in Arnhem Land, in Australia, the images are attributed to the Mimi themselves by the current aborigines who continue to use them as visual aids in teaching initiates as well as for magical purposes. Evidence of the age of the paintings is lacking, although some may be of considerable antiquity (a date as early as c. 10,000 BCE has been suggested based on environmental evidence). Their transparent quality is similar to the X-RAY style paintings found in the same area. Contemporary aboriginal artists include Mimi spirits in their BARK PAINTINGS.

Mimika. The Mimika area is on the southwest coast of Irian Jaya. The art of the area is overshadowed by that of the neighboring ASMAT. The art is characterized by a repetitious oval motif said to be a navel, especially a mother's navel. The form is multivalent, referring also to eyes, mouths and joint marks (wrist, elbow, shoulder and knee). After death, ghosts return to the kneecap to claim the spiritual essence needed to walk to the mountains where the land of the dead is located. Designs on objects like canoes, paddles, bowls, sago pounders and shield-shaped planks are begun with the navel and spread out to fill the entire space. Mimika art also includes spirit poles and, more importantly, life-sized pregnant figures used in the *kiwa* ceremony dedicated to female fertility.

Minkisi. Kongo power figures. See the singular form of the word, NKISI. Also see SONGYE.

Mintadi (sing. *ntadi*). Stone guardian figures were placed on royal burials. See KONGO.

Mirrors and Mirror Images. The symbolism of mirrors in indigenous art seems to have been primarily apotropaic. The SHAMAN wore round reflective disks on his/her costume which were said to be suns, but which may have also protected the shaman from evil spirits. In Africa, mirrors were set in sculpture and sewn on costumes to protect magical substances and human dancers. Mirrors were also associated with the Igbo MAMY WATA cult. In North America, the Plains peoples used European mirrors to signal across long distances and attached mirrors to the backs of dance costumes to protect the wearer. So-called "lady-killer" mirrors were used in the Grass Dance to attract young women and blind them to their suitor's faults. The horse-head ornamented mirrors probably reflect an older tradition of horse-stealing raids and war dances where the light from the mirror conveyed challenge and intimi-

dation. Ornamented mirrors were common among the CHEYENNE, CROW, Kansa, Omaha, Osage, Ponca, and SIOUX. Mirror images also play a role in indigenous societies. In some instances, the concept of the mirror image involves an invisible, spiritual presence that parallels (reflects or stands face-to-face with) reality. For instance, the pyramidal façade of the ABELAM *korambo* (men's house) faces its own mirror image. The path of the sun follows the actual ridgepole of the house upwards, until it stands overhead at noon, and then descends the invisible ridgepole to enter the underworld of the dead at sunset. See INDEX: Mirrors in Art, Artifacts and Techniques.

Missionaries. Although first contact with indigenous peoples was usually for military, political or commercial purposes, missionaries were never far behind. Nearly all religions sent representatives to far-flung locations, as they saw it, to convert and save native populations. In Polynesia the importation of new gods was fairly common due to contacts between the islands. What was different about European missionaries was their suppression of gods and forms of worship (see Colorplate 7). The first missions to TONGA, TAHITI, and the MARQUESAS all failed. In the Hawaiian Islands, missionaries prohibited the *hula* because they considered the hip movements far too carnal—the people of Hawaii, on the other hand, found European ballroom dancing where males and females touched in public lascivious. In Africa ISLAM spread largely in association with trade routes. Christian missions to West Africa occurred somewhat later than in the Pacific because of the disruption of African societies by the slave trade, but Christianity was probably the majority religion in the late 20th century. The first missionaries arrived in Sub-Saharan Africa in the late 15th century, following quickly after European contact, especially by the Portuguese. It was espe-

cially successful in the Kongo kingdom after the conversion of the king and his court in 1491. Kongo artists rapidly assimilated Christian iconography, producing finely crafted crucifixes and images of saints with haloes. Elsewhere the impact of Christianity on indigenous art was less positive, resulting in the destruction of "idols" and other objects linked with traditional religions. However, by the beginning of the 20th century greater tolerance existed, enabling men like the Roman Catholic priest Kevin Carroll to incorporate the work of YORUBA ARTISTS into churches and other buildings. Native American religions were affected by Catholicism in the Southwest and West. In California in particular, the Native population formed a work force important to the mission system, building sanctuaries and housing and working on the extensive mission lands. On the Northwest Coast, one notable instance of missionary activity was the establishment of the properous community of Metlakatla (now in Alaska) by the Anglican lay priest William Duncan. This Tsimshian community enjoyed economic prosperity and autonomy from its founding for quite some time. Generally, though, shamanism remained a powerful force throughout the area.

Mississippian. Following ADENA and HOPEWELL in the Woodlands area of North America, the Mississippian Period was distinctly different, although there is iconographic continuity, e.g., bird and ser-

MISSISSIPPIAN

Left: Pair of seated male and female figures, from the Etowah culture. These probably served as ancestor shrine figures; they were treated with scrupulous attention and commonly buried in their own boxes. Marble with traces of paint. 1200–1450.

MISSISSIPPIAN CULTS:

Right top: Shell gorget engraved with the chiefly litter motif and four woodpecker heads. The cross-in-circle within the litter framework symbolizes the chief as the embodiment of the solar deity.

Right center: Rogan Plate no. 1, showing a falcon-impersonator warrior holding a mace and severed head (a rattle-shaped head, or the real thing) from Etowah. Other items of costume are also associated with the ruling elite, such as the bellows-shaped apron and shell pendant. The figure wears a rectangular copper tablet on his forehead and a falcon mask. Copper repousse. c. 1200–1450.

Right bottom: Engraved paint palette stone from Moundville, Hale County, Alabama. Single-headed horned serpents associated with the fertility cult are knotted together, surrounding the hand-eye motif. 1200–1500.

pent imagery. Enduring some 600 years, between 1000 and 1600 CE, major Mississippian Period sites are found in Georgia, Oklahoma, Tennessee, Alabama and Florida—generally south and west of Adena and Hopewell. Mississippian settlements included large earth mounds—indeed, Mississippian culture is sometimes referred to as the Mound Builders. Earth works contained burials rich in grave goods, many of which are linked with a militaristic cult. Although the meaning of imagery associated with the Southern Cult is still being debated, it seems to be a unique combination of shamanistic and Mesoamerican elements which entered through intermittent contact, diffusion and occasional migration. Mississippian art should in no way be considered derivative, but rather seen as a highly unique, independent development. In addition to burials, architectural precincts contained large open courtyards for ceremonial purposes, artificial ponds and flat platforms for temples and chief's houses that dwarfed the burial mounds. One of the largest and most impressive Mississippian sites is CAHOKIA in East St. Louis, Illinois. Other notable sites are Moundville, Alabama; Spiro, Oklahoma, a site particularly rich in ancestor cult objects; and Etowah, Georgia. Mississippian art forms include functional and effigy pottery, embossed copper, engraved slate and shell plaques, ceremonial axes, pipes and masks. Mississippians played a ceremonial game called CHUNKEY, based on analogies with post-contact games. Finally, Mississippian culture involved elite lineages that controlled the economic and political life of the community, extensive trade networks and highly organized and intensive agriculture.

Mississippian Cults. Sometimes called the Southern Cult or a death cult, this phenomenon apparently consisted of a number of overlapping and widespread MIS-

SISSIPPIAN elite cults. Brown in Brose, Brown and Penney's *Ancient Art of the American Woodland Indians*, does not use the romantic and rather bombastic "Southern Cult" terminology, identifying instead a number of interlocking cults: an ancestor cult, a warrior cult dominated by falcon symbols and a fertility cult associated with serpent imagery. The extremely

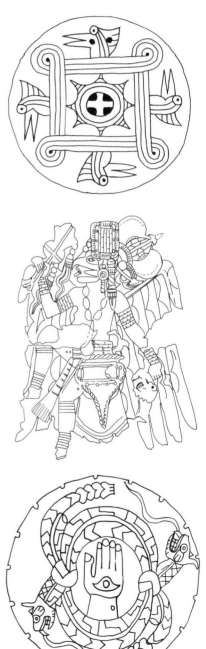

complex iconography of the cults is found on copper plaques, stone tablets, shell gorgets and some aspects are apparent in effigy sculpture pottery. Although Mexican inspiration plays a part (through diffusion, intermittent contact and occasional migration), the complex is unique to the southeastern United States from about 1300 to 1500 CE. What purpose cult objects may have fulfilled beyond grave goods is not known. The multiplicity, technical excellence and richness of design are all clear evidence of a powerful elite with supernatural powers, as much of the imagery suggests SHAMANISM.

Motifs by cult associations:

Chiefly themes and costume: the chiefly litter (framework of a litter enclosing a cross-in-circle design), *chunkey* players, falcon impersonators, columella pendants, serpent staffs and bellows- or heart-shaped aprons.

Military cult: falcons, the falconid forked-eye and severed heads.

Fertility cult: the hand-eye motif; various serpents and hybrid serpents, including rattlesnakes, horned serpents, winged snakes; the *piasa* (a hybrid combining human, serpent, avian and feline elements) panther or puma; frog and turtle effigy pottery.

Other repeated motifs include: birds and animals: eagles, woodpeckers, thunderbirds, spiders, deer; the barred oval (interpreted as a vagina or anus depending on context); the bi-lobed arrow; death motifs—skulls, bones; the swastika; and the whorl.

Skull motifs and severed-head effigy pottery, usually associated with the warrior cult and death may also be linked with the fertility complex. Skull motifs, in particular, are often found in conjunction with

serpent imagery, and what may be signified is human rebirth as paralleling agricultural cycles of annual renewal. Brown writes that the warrior cults were intermediary—a social bridge—between the exclusive, elite ancestor cults and the masses of rank-and-file farmers involved in the fertility cult. Skull and hand motifs are certainly linked with the mortuary complex as the heads and hands of the honored dead were sometimes buried separately. The hand-eye motif may symbolize the sun, as southeastern mythology describes the sun as a "blazing eye." Shamanistic elements may also play a part, such as the skeletonization of body parts and visual imagery associated with the sun, the center and the four directions. The recurrent hybrid figures can be seen as shape-shifters and the many birds and animals, while they have cultic associations, also may be helping spirits. The cosmological opposition between celestial birds and the underworld serpent or *piasa* is also an instance of the LAYERED UNIVERSE. The only element of shamanism that seems to be of less importance than elsewhere—oddly so given the forest environment—is the WORLD TREE. Certainly, the fertility complex was embodied in numerous symbols (see list above) and serpent and tree imagery may be conflated. It is also possible that the tree may have been ceremonially present in the form of actual trees, which have not survived. There is one tree-like image engraved in a whole shell and plants resembling corn do appear on other shell objects. See INDEX: Animals.

Mitaartoq (pl. *mitaartut*). *Mitaartoq* is a disguised male with a grotesque, hairy mask and a giant phallus that appears at ESKIMO solstice celebrations. The masqueraders behave in a sexually provocative manner, which is both aggressive and comic. People must give them gifts to be rid of them. They are to remain silent, despite all attempts to get them to laugh or

MITAARTOQ

Above: A masked performer from West Greenland, 1957.

MOAI

Above: Stone monoliths carved between 1000 and 1500 CE, are among the best-known objects from Rapanui. This one, called Hoa Haka Nana Ia, has been in the British Museum since 1868.

MOAI KAVAKAVA

Above: These remarkable figures have bird bone inlaid eyes and frigate bird motifs atop their heads. Late 18th–early 19th century.

speak. If they succumb, they must withdraw. Beyond their entertainment function, the *mitaartut* were apparently connected with guaranteeing good hunting and the cult of SEDNA.

Mnemonic Devices. In the absence of writing, indigenous peoples all over the world developed ingenious devices to aid memory. These vary from hieroglyphic signs which were "read" by specialists (e.g., *kohau rongorongo* from Easter Island) to very abstract devices such as the navigation charts from the MARSHALL ISLANDS. Plains peoples painted their tipis with narrative pictographs that served as reminders for oral historians. Additionally, the feathers in Plains WAR BONNETS recalled specific acts of bravery, wounds or episodes of COUNTING COUP. The intricate Navajo SAND PAINTINGS, accompanied by chanted songs, serve as memory aids as the singer recounts the long and complex myths connected with healing. One of the shortest, the Hailway Chant which guards against diseases caused by frost, has 447 songs. In Africa, patterns often evolved into SIGN

MNEMONIC DEVICES

Above: LUBA memory board (lukasa). This object (left-front and right-reverse) is said to be carved in the form of a tortoise. The arrangement of beads and hatched lines has an uncanny relationship to computer circuit boards.

SYSTEMS that conveyed meaning and may have been used to jog the memory. One of the most interesting devices is the so-called memory board (*lukasa*) of the LUBA, who live in the Democratic Republic of Congo. Members of the highest level of the royal association use the object and in it are encoded secret mythical, historical, genealogical and medicinal information. The board takes the form of a tortoise, commemorating the association's founding female patron. The front is studded with colored beads, the pattern and location of which assists in recalling history (especially kinglists), proverbs and praise songs. The back is engraved with geometric patterns edged with more beads that convey information about secret prohibitions relating to kingship.

Moai. Monumental stone megaliths from EASTER ISLAND, these sculptures are among the most memorable in the world. Excavated by Thor HEYERDAHL, these stone monoliths are synonymous with Easter Island as well as with the mystery and romance of Pacific cultures. Carved out of volcanic rock, the largest weighed eighty tons. Typical *moai* represent stylized human figures, shown from the hips up, with large, blocky heads, rectilinear facial features and attached arms. Set up on some 250 stone platforms, the figures represent known, named ancestors. Between 800 and 1000 were begun in a quarry at an extinct volcano, with all but about 150 reaching completion. Archaeologists now understand the processes by which they were carved and erected, but it is still unclear how they were transported. The size and number of *moai* erected is believed to have increased the status of those responsible.

Moai kavakava. Finely carved, highly detailed emaciated skeletal figures from EASTER ISLAND. According to legend, the hero Tuu-ko-ihu carved the first *moai kavakava* after seeing two sleeping skeletal

spirits in the crater of Punapau. Upon awakening, the spirits questioned him, but he denied having seen their ribs knowing they would kill him. He carved their images from discarded firebrands after returning home. Made of fine-grained toromiro wood, the hunched postures of the figures reflects the curvature and cylindricality of the branches of this now extinct bush-like plant. The purpose of these male figures (the female equivalents, *moai papa*, have flat bodies and elegant hands), is uncertain, although they have been interpreted as depictions of ancestors in ghost form or, alternatively, as images of the birdman deity of Easter Island mythology. As many as twenty figures were worn on important occasions, suspended from the pierced knob at the back of the figure's neck.

Moccasins. After about 1820, the predominant North American Plains peoples' foot gear consisted of the hard-soled moccasin with a tanned leather upper and a stiff rawhide sole. Before the introduction of European beads, Great Lakes' moccasins were decorated with quillwork. By the late 19th century, beadwork decoration became common. For additional examples see PLAINS PEOPLES.

Modern Art. Indigenous art, especially African sculpture and masks, is often said to have inspired the increasingly non-representational developments in early 20th-century European art. In 1906–1907, Picasso, Matisse, Derain and Vlaminck "discovered" the formal power of African art and began collecting pieces that hung in their studios. Later, the Surrealists were struck by the alien and fantastic quality of Oceanic art. The blockbuster 1984 Museum of Modern Art exhibition, *Primitivism in 20th Century Art*, set "primitive" sculptures and masks side by side with canonical works of modern art. The extensive catalog addressed issues such as the

difference between "influences" and "affinities" and the relative lack of interest on the part of the early modernists in anything other than the forms of indigenous art. More recently, artists' interest in native art generally does involve knowledge of and sensitivity to the cultures themselves, as well as a complex range of responses varying from emulation to appropriation.

Mogollon. With the Hohokam and the ANASAZI, one of the three major prehistoric cultural traditions of the SOUTHWEST. See MIMBRES POTTERY, made by a branch of the Mogollon.

MOCCASINS

Above: Assiniboin beaded leather moccasins with characteristic bold color combinations and dark, or medium value grounds. 1890.

MODERN ART

Above: Picasso's Les Demoiselles d'Avignon of 1907 is usually regarded as a seminal work of Modernism. The expressive plastic power of African masks is often cited as giving impetus to his radical distortion of the human face and his restructuring of space—or, at least, as a major element in a synthesis including other diverse sources such as contact with Gauguin, Cezanne's space, and early Iberian sculpture among others. Picasso himself said that the masks hanging in his studio were "more witnesses than models."

MOKO

*Above: The MAORI
preserved the heads of
important chiefs, which
were an important source
of MANA. The older the
chief at the time of death,
the more elaborate were
his tattoos.*

MOON

*Above: BAULE moon
masks are characterized by
continuous open-work
zigzags circling the face.
They appear at the begin-
ning of performances with
other masks representing
natural phenomena.*

Moki. The creator god of the Chico MAIDU was impersonated by a dancer wearing an ankle-length cape ornamented with condor, hawk, swan, eagle and turkey vulture feathers.

Moko. A form of tattooing practiced by the MAORI in which nearly the entire body of high-ranking males was ornamented with complex, symmetrical curvilinear designs. Female *moko* was less extensive, involving only parts of the face and the backs of the legs. Designs were individualized and, in fact, drawn tattoos were used as signatures on 19th-century documents. The designs, thus, were statements of both personal and group identity. Male *moko* was largely abandoned after 1865, due to pressure from missionaries and social change, but women continued to be tattooed until 1910. *Moko* was done using two techniques. Larger designs were done with a comb-like tool dipped in pigment, placed on the skin and struck with a wooden mallet, driving the pigment into the skin. Fine detail was done by chiseling grooves into the skin with sharpened tools made from nephrite, albatross or human bone in ancient times, and with metal chisels after European contact. Pigment, made from a mixture of oil and soot, produced color varying from dense blue-black to dark green. Because of the risk of illness, *moko* was controlled by TAPU and was accomplished gradually. High-ranking males' faces (facial *moko* was restricted to men of high chiefly rank) were transformed over time. Variations on the theme of the spiral, the patterns followed the contours of the face and were bilaterally symmetrical, but not absolutely so, creating a dynamic tension in keeping with MAORI AESTHETICS. Another aspect of the same attitude is found in the different aspects the face presents depending on emotion. In repose, *moko* lent the face great dignity, while contorted by anger or during battle, the patterns resembled those of a snarling animal.

The underlying conceptual and spiritual unity of Maori art is also apparent in the close visual relationship between *moko* and woodcarving.

Monkey. See INDEX: Animals.

Montagnais-Naskapi. See INNU.

Moon. The moon is generally associated with night and darkness, water and the left hand (see DIRECTIONAL SYMBOLISM). Although there are some exceptions, the moon is generally feminine in gender (for a notable exception, see the Eskimo Moon god ANINGAAQ). Because the moon moves through thirteen phases, it is also linked with fertility and the cycles of life. But because of its changeability, it is regarded as being dangerous. The California CHUMASH and the Yokuts explained the moon's phases as the shadows of birds' wings—condors or a giant eagle. Some Yokuts believed that the moon was actually eaten by the condor. See INDEX: Deity Archetypes; Moon in Natural Phenomena and Materials.

Morning Star Ceremony. This was the most famous PAWNEE ceremony as it involved human sacrifice. The Skidi Pawnee conducted it after a man had a vision of the Morning Star (Mars) commanding him to do so. After having the dream, the man knew the ceremony must be held if he awakened to find the Morning Star coming up over the eastern horizon. He was then to cry out in a loud voice and walk around the village crying out, finally going to the lodge of the Morning Star priest. After proper preparation, the dreamer and other mature warriors undertook a journey to take a captive, a thirteen-year old virginal girl, after which they returned to their village. After several days of song and dance, a scaffold was erected outside the village, with cottonwood verticals and cross bars of willow,

cottonwood, elder and elm. The captive, painted red on one side and black on the other to symbolize the Morning and Evening Stars, climbed the scaffold and was tied, facing east, to the uppermost crossbar. As the Morning Star rose, she was shot through the heart with an arrow after which a small hole was cut over the heart with a flint knife. For the ceremony to be successful, her blood had to drip on an offering of buffalo meat, but not on the down feathers lining the pit under the scaffold. The blood was believed to revive an ancient blessing and served as a guarantee of better fortune.

Morriseau, Norval (b. 1931). The founder of the Woodlands school of "legend" painting in the early 1960s. Morrisseau is a Canadian Ojibwa who originated a unique combination of style (FORMLINE structure similar to Northwest Coast art, but without its rigid symmetry) and content (Algonquian mythology). Morrisseau and others, including Daphne Odjig, Joshim Kakegamic, generally used bright colors and acrylic paint.

Mossbags. One of several types of Athapaskan beadwork bags, moss bags were folded rectangles with laces up the front used to carry newborns—the moss lining acted as a diaper and was easily changed as needed. Older children were carried on their mother's backs in a baby strap or baby belt, an Athapaskan art form still popular today.

Mossi. The Mossi are Voltaic speakers and at present are the largest group living in Burkina Faso (formerly Upper Volta). Historically, the Mossi Empire began with a 15th-century invasion from northern Ghana. The Mossi are the only centralized society in the area and still are governed by the ruling elite that originated outside the area. Regional masking styles show relationships with adjacent areas, as for

instance, two northern Mossi mask types, the *karanga* and the *karan-wemba* show definite DOGON influence. The people who live in this area are descended from the KURUMBA inhabitants who occupied the region before the Mossi invasion. Both masks appear in funeral rituals, but the *karan-wemba* is used only for the funerals of important female elders believed to be living ancestors. A third mask type, from the Ougadougu area, represents birds and animals. The Mossi also make sculptures said to represent deceased chiefs. The most famous Mossi sculptures are DOLLS called *biiga* ("child") given to girls who treat them as if they are alive. Girls feed, clothe and put their dolls to bed, even giving them the occasional enema. When their owners loose interest, the dolls are abandoned in corners, gathering dust, but creating no ill-reflection on their former mothers. Young women who have difficulty conceiving use dolls as surrogate infants. When a child is finally born, the doll is replaced by the infant, but continues to be cared for and is passed on from generation to generation.

Mountain. Mountains are often sacred ground in indigenous cultures. In North America, the INNU believe that the caribou and the lord who protects them live on a mountain. Innu caribou coats have triangular gussets symbolizing the mountain from which the caribou come to offer themselves to hunters. The NAVAJO live between the four sacred mountains, identified with actual geographical locations. Gobernador Knob Mountain, for instance, is called "heart of Earth, " while Huerfano Mountain, the home of Changing Woman, is known as "lungs of Earth" (see also HOGAN). The Hopi KACHINA live in the San Francisco Mountains. Finally, the APACHE spirits called *gaan* are also known as Mountain Spirits. Elsewhere in the world, mountains are often associated with the land of the dead.

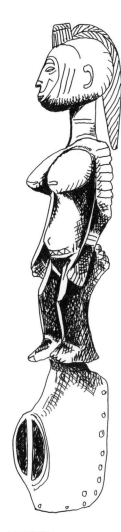

MOSSI

Above: Karan-wemba mask honoring a female elder. The lower part of karan-wemba masks is usually a large oval cylinder with vertical slits; some have antelope characteristics. The female figures atop the masks have bent knees and healthy young breasts. This one has an elaborate hairstyle and scarification patterns on the body and concave face.

Safan, the land of the dead among the ASMAT of New Guinea, is simultaneously in the mountains and the sky. Another New Guinea group, the Mimika, also locate the land of the dead in the mountains. In Africa, the Kongo cosmos consists of two mountains joined at their bases and separated by the sea. The sea is a barrier and a passage between the upper mountain, the land of the living and the lower, inverted mountain, the abode of the dead. The sun travels its circular path around both, a circuit also followed by human souls, which are thought of as miniature suns.

Mudfish. In Benin, the mudfish is a symbol of the Oba's liminality—human and divine, he is able to mediate between the watery realm of Olokun and the moral realm of men. The mudfish moves fluidly through the waters and can also move, "walk," on land. In periods of drought, their survival sometimes seems miraculous. Finally, they appear to be reborn following estivation.

Mudheads. The ten Koyemshi, or Mudheads, are the most sacred ZUNI supernaturals. They appear with the Shalako at the most important ritual that marks the beginning of a new ceremonial cycle, the coming of the gods among the Zuni and the approach of the winter solstice. They are CLOWNS who cavort around and make people laugh, but as the bringers of rainfall, they douse people with water and make women cry. Nothing must be denied to them, or ill luck will result. The nine Koyemshi children were born in a single night, the result of incest. The tenth, their father, overcome by his misdeed, wept until his eyes swelled, beat his head with his hands until welts appeared and rolled around until he was transformed into a lumpish, unfinished-looking creature. Koyemshi impersonators cover their bodies with mud from the Land of the Dead and wear cotton masks with knobs instead of facial features. The knobs are said to contain butterfly wings and bits of soil gathered from people's tracks around the village. They are the antithesis of the tall, stately Shalako as they cavort around, but they are more dangerous and powerful. They represent the enormous but capricious potential of nature to flourish or die. The knobs are like seed pods filled with the multicolored beauty of butterfly wings that may flutter forth or remain immeshed in a lifeless matrix.

Mukluk. The western Arctic word for sealskin boots.

Musical Instruments. Indigenous art objects are rarely static, instead, they must been seen as part of a complex whole involving sound and motion. A wide range of sound-producing instruments plays vital parts, including bullroarers, drums, slit gongs and flutes. The sounds produced by such instruments are literally the non-human voices of spirits and gods. The instruments themselves are full of power. In some cases, the instruments were images of the ancestors themselves, as is true of BIWAT flutes, which have superhuman qualities. Often, the original instruments came from divine sources and playing them was learned supernaturally. Among the ASMAT, the Culture Hero FUMERIP-ITS created the first hourglass-shaped drum. He played it to bring to life human figures he had carved from trees. See INDEX: Musical Instruments in Art, Artifacts and Techniques.

Mwaash aMbooy. See KUBA MASKS.

Najas. The Anglicized Navajo word means "crescents." The earliest use of *najas* was apparently to ornament horse bridles, where they may have served as a protective device, since the shape suggests a horseshoe. It is claimed that the shape originated with Spanish horse trappings, copied by the Mexicans. The pattern was quickly adopted for human ornament and, as Navajo expertise in silver increased, the crescent became more elaborate. The shape is compared to horse trappings and hunting charms from the Ancient Near East and Mediterranean, which are often associated with goddesses, especially the mistress of beasts (e.g., the Greek huntress Diana). The lunar crescent is also an important SHAMANIST symbol, linked with and opposed to the solar disk, making it possible that the shape can be traced back to the Navajo's Athapaskan origin. Or at least, they may have felt an immediate kinship with it when they saw it hanging on the foreheads of Spanish-Mexican horses. Whatever its source, it is still today one of the most popular motifs of Navajo silver. See also CRESCENT and SILVER.

Nalik. Sculpture from the interior of New Ireland characterized by massive solid forms and associated with the ULI cult. No longer observed, Uli rituals followed the death of a leader. A new figure was carved to commemorate the leader, whose spirit was invited to enter the sculpture during rituals led by the shaman. A series of feasts were staged and people from other villages brought their own *nalik* figures which were installed in shrines built for the occasion. After the feast, the activated *nalik* sculpture was placed on the bench inside the men's ceremonial house, where the continued spiritual presence provided guidance to the living. Ritual offerings of yams signified the maternal foundations of life, while the *nalik* figures themselves made visible the male contribution of ritual energy. The figures' ANDROGYNOUS form further underlines the vital complementary roles.

Names. Names in indigenous cultures are connected with power, individuality, genealogy and permanence. They are "owned" and cannot be used without permission or by those without the proper genealogical relationships. In the Sepik River region of New Guinea, names are social entitlements based on genealogy and myth. Totemic specialists learn 10,000 to 20,000 names in the form of mythic-historic patterns that trace "paths" relating people to their totemic origins and their family tree. According to Silverman, naming is a male activity (totemic birth) which serves to balance and displace female creative power (actual birth) onto the plane of cosmology. Totemism converts the material body into the male cosmic body. Indeed, in many world cultures, boys receive new names as part of initiation ceremonies, see HAMATSA, POWWOW and VISION QUEST. Asmat youths had to kill an enemy and take the victim's head and name, before they became adults. Equally prevalent is the way in which names link the living and the dead. Monuments, designs on shields and masks often represent specific named ancestors, such as Easter Island MOAI and

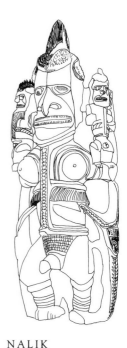

NALIK

Above: Figure for Uli ritual from Mandak, central New Ireland.

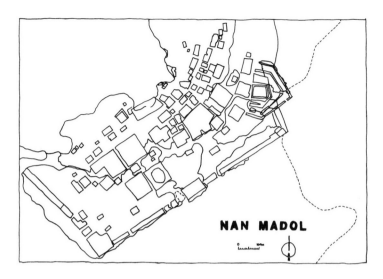

NAN MADOL

NAN MADOL

Above: Plan of the ruins of the city. After William S. Ayres.

Kominimung masks (YAM). The designs, thus, symbolize both the family line and its continuity. Design motifs and patterns are also named. Some such motifs relate to ancestors, while others resemble natural motifs or form parts of SIGN SYSTEMS. The sheer number of named designs is sometimes extensive (e.g., fifty to sixty designs on Asmat shields, fifty-five to eighty-five California basketry designs, 200 Kuba designs and 300 Asante Kente cloth patterns). There is also a more pronounced tendency to name important objects than in Western culture. For instance, Plains peoples named Medicine Bundles and the feathers in warrior's headdresses, while fishermen in the Solomon Islands named their fishing floats. The naming of such objects renders them equivalent to other named entities such as persons, ancestors and other spiritual forces. Finally, if naming makes such things tangible, lending them weight and importance, some things are too powerful to name. KONANKA-DA, the Northwest Coast deity associated with the undersea world of the dead is frequently represented, but rarely named. RAINBOW SNAKE plays a major role in AUSTRALIAN ABORIGINAL mythology, but he, too, is referred to indirectly and not by name. See INDEX: Names in Miscellaneous.

Nan Madol. Meaning "places in between," this city in the Caroline Islands has been called the most dramatic of all sites in Oceania. It reached its height between 1000 and 1500 when more than 1000 people lived here. Also called the "Venice of the Pacific," the city was built of basalt columns and boulders on ninety-two natural and man-made islets. The 200-acre architectural complex served the Sau Deleur dynasty as a religious and political center. The city was protected by an extensive sea wall and bisected by a waterway that separated the religious from the administrative precincts. Within the royal complex were a large tomb and the main religious center where lived the great salt-water eel, the intermediary between the people and their god. Turtles were sacrificed to the eel.

Nanook of the North. A famous film by Robert Flaherty showing the life of an ESKIMO named Nanook ("the bear") of Hopewell Sound, Northern Ungava.

Naskapi. The former name of a large group living on the Labrador Peninsula in eastern Canada. Also called Montagnais-Naskapi, the people now call themselves the INNU.

Nation. The collective term preferred by some Native Americans instead of tribe.

Native American Church. This pan-native religion rose to popularity after the beginning of the 20th century and is known in anthropological literature as the Peyote Cult. Originating in Mexico, the religion diffused northward among the Apache, Tonkawa, Kiowa, Comanche, Cheyenne, Arapaho and other surrounding Native Americans. The use of the hallucinogenic peyote is incorporated with traditional elements and Christianity. Rituals take place beginning at sundown Saturday, lasting until sunup Sunday in traditionally shaped tipis. Inside the tipi,

lined up from the eastern-facing entrance, are food, water, the fire pit in the center, a crescent-shaped mound of ashes and a crescent-shaped earth altar. The peyote, called Father or Chief Peyote, is placed on this altar. The leaders sit opposite the entrance, the "roadman" or "road chief" in the central place of honor, flanked by the drum chief on his right and the cedar chief on his left. The fire boy sits next to the entrance and the congregation occupies the remaining available space. Each participant has his own paraphernalia, kept in a "feather box" often decorated with traditional symbols including the crescent moon, tipi, a stylized water turkey, a star and utensils used in the ceremony. Inside the box are a feather fan, a large Chief Peyote, a staff, a gourd rattle and a blunt arrow. The staff, said to be an unstrung bow, and the arrow are both symbols of non-aggression and peace. Ceremonies are held in conjunction with life transitions such as birthdays, funerals and departures; for curing; or for prayer. The peyote is eaten, accompanied by rapid and rhythmic song and drumming which aid in creating the hallucinatory experience. Since peyote is a controlled substance, its use within the Native American Church has been controversial, yet the Church thrives.

Nausang. Distinctive red, black and white KILENGE (New Britain) masks have names and are the productions of master artists who "own" rights to the designs.

Navajo. The name Navajo is thought to derive from the Tewa word *navahu'u*, "arroyo with cultivated fields." Navajo call themselves *Dine* (or *Dineh*), "the People." Athapaskan speakers (technically speaking, a subdivision of the Apache), the ancestors of the Southwestern Navajo entered the area over a long period of time, possibly as early as 1200 CE up through the early 16th century. By the middle of the 19th century, Navajo lands were being taken by miners, settlers, New Mexicans and other Native Americans. When they resisted, the United States Army, in the 1860s, instituted military action and a scorched earth policy to drive the Navajo off their lands. Those that were not killed outright were driven southeast, taking what has been called "The Long Walk," to Fort Sumner (Bosque Redondo) where many more starved to death. Finally, the survivors returned home after the 1868 treaty established a reservation, which occupied only ten percent of their previous lands. Gradually, more land was added within the four sacred mountains. The Navajo have been intensively studied because of their accessibility, but more because of their aesthetic worldview and their powerful art, myth and ceremonials. By the 1980s over 200 fieldworkers had lived among and studied the Navajo and more recently, Tony Hillerman's detective novels have further popularized the Navajo. See also CHANTWAYS, HOGAN, NAVAJO CEREMONIALISM and SAND PAINTING.

Navajo Aesthetics. The somewhat untranslatable concept of HOZHO forms the basis of Navajo aesthetics. Usually translated to mean "harmony," *hozho* describes the ideal, dynamic quality of radiant, creative beauty possessed by First Man and First Woman. It is linked with the idea of living beautifully, in balance with oneself and others, and dying gracefully of old age. Threatened by ugliness and danger, *hozho* can be restored by ritual, especially by chants (see CHANTWAYS). Beyond this aesthetic attitude toward life, Navajo aesthetics involves a balanced duality. SAND PAINTING designs balance color, form and space, playing off curved/straight, mobile-energized/stable-quiescent, warm/cool, black/white, symmetry/asymmetry. Men are static, while women are considered to have dynamic natures. Men's art forms like sand painting

and chanting remain unchanged (although they have their own internal dynamism), while women's art forms, especially weaving, evolve. These qualities are linked to the cosmos itself, as men are associated with the south and women with the dangerous north. The Navajo way provides an alternative to the widespread fear of women's creativity found elsewhere in the world, by incorporating it into a dynamic way of seeing and living in the world.

Navajo Ceremonialism. According to Gladys Reichard, Navajo religion is non-hierarchical—no deity is more important than any other—and fluid, as there are no absolutes and no insistence on consistency (*Navaho Religion*). At the same time, Navajo cosmology could be said to be anthropocentric, everything is explained in relation to human beings and their activities. After emergence from a series of underworlds, First Man, First Woman and other Holy People created the "inner forms" of nature. They "thought" the world into existence, but its substantial, material form came into being through speech, the "outer form" of thought. These first beings embodied the Navajo concept of HOZHO, somewhat inadequately translated as harmony. The radiantly beautiful First Man and First Woman created CHANGING WOMAN, the Navajo Earth Mother who in turn gave birth to the HERO TWINS and created corn and the Earth-Surface People—the Navajo—from flakes of her skin. Thus, the primordial condition was one of beauty and harmony. The material and spiritual worlds are not separate, both being activated by and expressions of inner form and wind, or spirit/soul. The land itself, the four directions, makes manifest inner form and a particular wind. Each person has a "wind within one" that enters at birth and guides one through life. The aim of Navajo life is to achieve *hozho*, to move through life in harmony and beauty and finally, to die gracefully, of old age.

Imbalance and illness are caused by contact with ugly and dangerous things (natural forces like lightning, wind and thunder; certain animals including bears, coyotes and snakes; unprepared contact with ceremonial paraphernalia; and contact with ghosts or witches). The balance can be restored by ritual, by chants (SAND PAINTING is part of the ritual) and purification. Important deities in addition to Changing Woman are SPIDER WOMAN and the Holy People or YEI. See also CHANTWAYS and LAYERED UNIVERSE.

Navajo Weaving. The Navajo attribute the origin of weaving to SPIDER WOMAN, who, according to myth, wove the cosmos on an enormous loom, using clouds, sunbeams, lightning bolts and rainbows. She also taught the Navajo weaving and use of cotton. Some scholars suggest that the Navajo may have known weaving before they entered the Southwest. Most, however, hold that they learned techniques from the Pueblo peoples, particularly after the Pueblo Revolt when, driven off their own lands, many Pueblos lived adjacent to or in Navajo communities. Whatever its origins were, weaving was performed by Navajo women, while men were the weavers among the Pueblos. The earliest weavings were rectangular Pueblo-style shoulder blankets with alternating black and white stripes. By 1800 weavers added paired blue stripes at the ends and the center and widened the black areas resulting in what are called First Phase Chief blankets. After the United States took over New Mexico, c. 1850, small red rectangles were added to the ends of the blue stripes, creating the so called Second Phase Chief pattern. The Third Phase Chief blanket (c. 1870) consisted of terraced concentric diamonds and quarter diamonds. They also adopted the Spanish *serape*, usually decorated with stripes, which became a multipurpose weaving for

wearing, sleeping and carrying. During their exile at Bosque Redondo, the Navajo were supplied with commercial wool, *bayeta* (Spanish for baize, a rich red fabric that the Navajo unraveled) and more patterns were introduced as weaving became destined for commerce rather than personal use. During this period, they were also exposed to Spanish weaving from the Rio Grande Valley, which they took with them to the reservations. After their return to their homeland, regional styles developed, many of them in conjunction with trading posts. Some of the traders, like J.B. Moore at Crystal and J.L Hubbell at Ganado, introduced weavers to "Oriental" carpet designs, which they incorporated to suit midwestern and eastern Victorian tastes. Chinle, Wide Ruins and Klagetoh, Arizona are known for borderless vegetable-dyed rugs in soft colors. Two Gray Hills rugs are unequalled for the fine yarns and natural colors (white, black, gray and sometimes brown) woven with intricate geometric patterns. Tec Nos Pos rugs, also finely woven and geometric, are characterized by use of bright aniline dyes. Ganado, Arizona is the center for the famed Ganado red rugs which are tightly woven with geometric patterns. Other weaving centers are Crystal, New Mexico, Lukachukai and Coal Mine Mesa both in Arizona. The most recent development is the introduction of figurative elements inspired by SAND PAINTING motifs called pictorials. Initially controversial because of the use of sacred content, the first pictorials are said to have been woven in 1919 by the famed singer HOSTEEN KLAH who, in turn, taught the patterns to his nieces.

Navel. Great importance is attached to the navel in indigenous cultures. It is a symbol of the CENTER, the opening between the land of the living and the underworld. Most human figures are shown complete with navels, which are often dramatized by concentric geometric designs. In MIMIKA art of New Guinea, the navel is depicted as an oval design which, removed from its human context, appears on most decorated objects from canoes to shield-shaped planks. SENUFO doors are carved with masks (the *kpelie* mask is associated with female beauty and mother earth); equestrian figures, symbols of power; and mythological animals, especially the five primordial animals. A common feature is an **X** shape representing the

NAVAJO
WEAVING

Above left: Third Phase Chief's blanket with terraced concentric diamonds in white, black, indigo-dyed blue, red and green. c. 1870.

Above: A so-called Eye Dazzler because the bright color, bold value contrast and geometry of these rugs can cause optical illusions. 1880–1890.

navel, surrounded by scarification patterns, of a Senufo female. On one level, the navel symbolizes civilization and fertility, but it is also a symbol of the center and the FOUR/SIX DIRECTIONS. Thus, the combination of images linked with the earth, power and primordial creation makes these doors symbols of cosmos. See INDEX: Navel in Human Body.

NAVEL

Right: SENUFO doors like this adorned the storehouses of prominent chiefs and PORO society members. The ✘ shape symbolizes the navel of the Senufo female, associated with civilization and fertility.

Ndop (1). The name for the wooden portraits of Kuba kings, see KUBA ROYAL PORTRAITS.

Ndop (2). The name of display textiles from the Cameroons, see SIGN SYSTEMS, CAMEROON NDOP.

Net Bags. See STRING BAGS.

New Britain. One of the largest islands in Oceania, New Britain is now part of the state of Papua New Guinea. LAPITA pottery fragments (some 2500 years old) remain from what was apparently the earliest artistic activity on the island. Over the next 2000 years contacts existed between certain areas of New Britain and the Solomons as well as with New Guinea. Several art traditions are evident today, including Maenge, SULKA, KAIRAK BAINING, KILENGE, TOLAI, the Vitu Islands and the Nakanai. New Britain art forms are marked by diversity of materials (organic materials including leaves, parts of trees, feathers and human skulls) which are carved, woven, beaten and painted with natural pigments. The most notable art objects are masks, often completed by elaborate costumes. Additional art forms include statues and other portable cult objects, war shields, painted boards, canoes and objects for personal adornment. See map: NEW GUINEA, IRIAN JAYA, ADMIRALTY ISLANDS, NEW IRELAND, NEW BRITAIN.

New Caledonia. Currently a French overseas territory, the archipelago, named by Captain COOK, includes the Isle of Pines, Belep Islands and the Loyalty Islands. The oldest remains in the islands consist of LAPITA pottery fragments (the type-site of this culture is located in New Caledonia) dating between 3500 and 2500 years ago. Style variation exists among the islands, with those in the north emphasizing rounded forms, while the southern islands tend to treat surfaces in relief. KANAK carvers, from New Caledonia's central area, make roof finials, masks and figures, focusing on representations of the human head and bust as well as full-length human figures. Bamboo tubes, which may have been used for storage of feathered ornaments and/or ritual objects, are engraved with scenes depicting daily life and festive occasions. It is not clear whether the containers were made before European contact. Other important objects include ceremonial money objects, adzes, axes and clubs. See map: OCEANIA.

New Guinea. The first signs of creative activity appeared some 5000 years ago, overlapping with the LAPITA pottery tradition in the east and southeast (Indonesian influence occurs in the north and northeast only). The art of this island, one of the largest in the world, is extraordinarily diverse in materials and form, reflecting many different ethnic groups (over 700 languages are spoken). Three areas have been defined. First, Papua New Guinea (the eastern part of the entire island became an independent state with this name in 1975) includes the SEPIK RIVER area and the Huon Peninsula (TAMI stylistic region), among others. Second, the eastern point and south coast of the island includes the Torres Strait Islands, the MASSIM (Trobriand Islands); the Central Province (Mailu, Motu and Roro); the Gulf Province (ELEMA, Era, Wapo, Namau and KEREWA) and the Western Province (Gogodala and Kiwai). And finally, the western part, Irian Jaya (West Papua, since 1962 a province of the republic of Indonesia), includes the MARIND-ANIM, the ASMAT, the Vogelkop Peninsula from Arguni Bay to GEELVINK BAY and the northwest coast up to HUMBOLDT BAY and inland, LAKE SENTANI. Many of these groups have a highly developed aesthetic sense, but their art forms are characteristically ephemeral (body painting, masks and costumes of organic materials), lasting only as long as the rituals in which they appear. Indeed, the spectacles are themselves composite aesthetic productions in which gestures, songs and motion play parts equal to the role of the more material (art, in the Western sense) objects such as masks, costumes and headdresses. The extreme complexity of New Guinea art makes generalizations regarding style, motif and significance impossible.

New Ireland. The home of MALANGGAN and NALIK sculpture (and the asso-

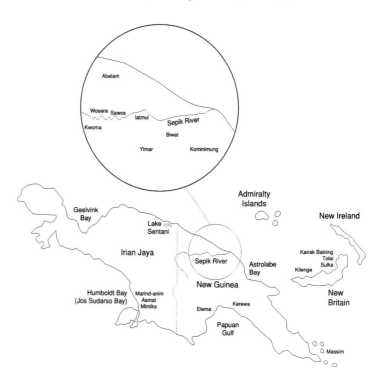

NEW GUINEA, IRIAN JAYA, ADMIRALTY ISLANDS, NEW IRELAND, NEW BRITAIN

ciated ULI cult), the art of New Ireland, Lihir, Tabar and Lavongai (New Hanover) is unusually homogeneous for Melanesia. Other art objects include small chalk *stelae* from the south, wooden masks closely related to the *malanggan* sculpture as well as masks made of bark and other perishable materials. See map: NEW GUINEA, IRIAN JAYA, ADMIRALTY ISLANDS, NEW IRELAND, NEW BRITAIN.

New Zealand (Aotearoa). See MAORI and map: OCEANIA.

Ngady mwaash aMbooy. See KUBA MASKS.

Nggwalndu (or *ngwalndu, nggwal*). Images of the Middle Sepik River ancestors (Barry Craig identifies the *nggwalndu* as non-ancestral supernatural beings). The exteriors of Abelam KORAMBO (spirit houses)

NGGWALNDU

Above: Painted panel representing an ancestor spirit from the interior of an Abelam korambo, spirit house.

NIMBA

Right: BAGA nimba masks are among the most memorable of all African masks because of their size and impressive presence. The great projecting jaw, mirroring the flaccid breasts below, suggests a majestic, still vital matron who has nurtured many children. The finesse of the chip-carved scarification patterns is a wonderful contrast to the mask's powerfully exaggerated masses. An Islamic cloth-covered amulet hangs from the nose. Collected in 1933.

are painted with large and small male faces and figures representing clan ancestors. The figures may measure as tall as ten to fifteen feet. The heads are often surrounded and connected by energetically executed zigzag patterns—reduced bodies—which symbolize genealogy. In many instances, however, the downward pointing penis is detailed, complete with a drop of white semen at its tip. The male aggressiveness of the façade images is balanced by the concept of the entire house as being feminine; the combination of energy and power are guarantees of fertility and prosperity. One of the most memorable aspects of the *nggwalndu* is the insistent concentric pattern around the eyes of the largest heads. These target-like forms have a hypnotic quality and, together with the somewhat disembodied character of the floating heads, they recall Campbell's discussion of IRMs. Forge discusses the verbal puns used to describe the eyes—including likening them to stars and fireflies—which creates a poetic ambiguity parallel to the pictorial double meanings.

Nggwalndu puti. The supreme manifestation of the Abelam great ancestor. The words mean "human ancestor who has given all." The ancestor is empty because he gave his life to the founding clan, to human beings and yams, but in a broader sense, *puti* refers to the void from which all life came. The KORAMBO spirit house is one embodiment of the ancestor. *Nggwalndu puti* is also embodied in images found within the *korambo*, which are deliberately polysemous in form, incorporating elements of male and female human figures, pigs and cassowaries. See INDEX: Animals.

Ngongo ya Chintu. The name of the master carver thought to be responsible for the highly distinctive sculpture associated with the BULI SCHOOL in southeastern Democratic Republic of Congo.

Nigeria. See map: WESTERN AFRICA AND THE GUINEA COAST.

Night. See DARKNESS.

Niman. Meaning "home," *niman* is a fifteen-day long Hopi ceremony marking the departure of the KACHINA spirits. Possibly the most spectacular of Hopi ceremonies, the public dances of the HEMIS KACHINAS provide a dramatic send off in mid-July while also celebrating the bountiful harvest resulting from the *kachinas'* generative influence. The *kachinas* live among the Hopi from the winter solstice, their arrival marked by the SOYALA ceremonies, until *niman*.

Nimba (*d'mba* among the Baga and *nimba* among Western collectors). One of three principal BAGA masks, the *nimba* is a large mask with a stylized female face and projecting jaw, atop a cylindrical neck. The lower part consists of four "legs" for the dancer to hold as he moves with the eighty-pound mask above his shoulders. The wearer looks out between the figure's flattened, projecting breasts. When not in use the mask sits on the legs. This mask has not been used since the 1950s. Nineteenth-

century photographs show the *nimba* in a context that suggests it may have had some connection with initiations. However, in the 20th century, it was controlled by village elders and danced after the harvest. This is appropriate, as the mask represents a woman who has borne many children, just as the earth has given up its bounty to nurture the people. In the literature, this and other Baga masks are associated with the Simo society, but as Lamp has shown, the term Simo is unknown to them—it is used by their neighbors the Susu to describe something that is sacred.

Niombo. Large and miniaturized KONGO reliquary figures called *niombo* contain the bones of powerful ancestors. The large ones have a formidable presence, indeed, consisting of the enlarged mummy wrapped in multiple layers of raffia pile cloth, topped with cloth cut from red blankets. (Another type, called *muzidi*, consistently large in scale, lacks the layers of cloth; the smoke-mummified body instead is sewn into a fabric shroud.) Characteristically, *niombo* have cylindrical legs supporting a thick cylindrical body, a strong neck surmounted by a head with an open mouth and diamond-shaped slightly tilted eyes with central dots. The arms extend laterally, in a graceful dance-like posture, right hand up, left hand down, called "the crossroads pose." Finally, symbolic designs called *bidimbu* (see SIGN SYSTEMS) adorn chest and abdomen. The entire ensemble conveys the continued spiritual power of the ancestor who mediates between the living and the dead, restoring or enhancing social integration and continuity. The open mouth is an indication that the ancestor addresses the dead—proverbially, "the funeral is over and now he is talking in the other world." The four corners of the eyes are linked to the *dikenga*, the Kongo cosmogram, the four moments of the sun, indicating that the ancestor has completed the four cor-

ners of his existence. The "crossroads pose" sets the figure at the CENTER, the boundary between life and death, with one foot, as it were, in both terrains. The right hand invokes God and the sky, as well as hailing the law and blocking witches. The left hand indicates the horizon, the threshold. As Thompson and Cornet have noted, the

reserves of power inherent in the crossroads cosmologize the *niombo* image, itself emphatically cross-shaped. See DOORS AND THRESHOLDS.

Nishga (also Nisg'a). See TSIMSHIAN.

Njoya. CAMEROON *fon* (king) prior to French colonialization. A great art patron, Njoya was a genius who developed a syncretistic religious doctrine. He also invented a writing system to record the kingdom's history, religion and medicinal knowledge. See BAMUM.

Nkisi (pl. *minkisi*). This word, meaning "medicine," is embedded in many Bantu languages and refers to power sculptures consisting of carved human or animal figures with added magical substances found throughout Central Africa. They are used by the living to evoke some external agency (nature spirits, ancestors) for protection and assistance in cases of disaster and illness. The KONGO people make the

NIOMBO

Left: Miniature niombo reliquary figure collected at Kingoyi in 1934. The front of the figure is covered with bidimbu signs. The bisected rectangle on the left shoulder indicates that the upper world of the living is empty because of the death of the chief. The spiral around the right nipple brings vital communication back from the other world. The squares either side of the belly have not been interpreted, but the central lozenges rising from the navel and ending at the heart are the sign of the python, mboma ndongo. The python is a symbol of longevity as well as of connection. No matter how far away the spirit goes, it is immortal and will return. Over the heart is a version of the Kongo cosmogram. The four divisions are linked with the four moments of the sun and the cycle of human life. A DREAM script, a message from the other world that presently cannot be interpreted, occupies the uppermost triangle.

Above: Detail.

best-known *minkisi*. These come from the lower Zaire River and involve the close link between chiefly power and healing. Formerly called fetishes, *minkisi* are of two types. Public minkisi were used at royal investitures to safeguard the new ruler and to ensure that ancestral traditions and laws

NKISI

Right: This carved wooden Kongo nkisi nkondi figure became more powerful with each piece of metal, peg or thorn driven into it. Each act engages the figure's power for healing, judgment or binding. The power resides in the magical substances, "medicines," sealed into a cavity in the figure's abdomen, forehead or back, often covered with a protective mirror. The rough, rudimentary carving of the bodies, although partially obscured by the thicket of nails, contrasts with the fixed, but rapt and subtle facial expressions. Before 1878.

were observed. The second private type is associated with rural areas and individuals outside the royal courts. In addition to the distinction between public and private *minkisi*, their powers are linked either with the sky (politics, male activities and disease of the upper body) or the earth (women's affairs, diseases of the lower body). One last duality—*minkisi* are also classified as benevolent or violent. The violent type, called *nkondi* (pl. *zinkondi*), from the word for hunt, typically depicts human figures with facial expressions that are both aggressive and defensive, with glaring eyes and bared lips. The upraised

arms of these figures have clenched fists or bear knives or lances. Hunting dogs (mediators between the human and animal realms) and other fierce animals, often double-headed, are also found. *Zinkondi* figures, once activated by driving nails or knife blades into them, hunt down and destroy the spirits causing disease. They also serve judicial functions such as sealing contracts, binding oaths or finalizing treaties. The participants drive blades partially into the figure and then wrap them with raffia, symbolizing the binding agreement. Should either party break his oath or agreement, the *zinkondi* become agents of punishment and destruction. Other legal applications include determination of innocence or guilt—the accused drives the knife into the figure and is absolved or suffers the consequences. The process was not irreversible, however. An offender could avoid punishment through ritual apology and payment of some form of "damages." After this, the knives or nails were ritually removed and the figure purified with water. The Kongo kingdom was one of the earliest to be converted to Christianity (1491). It is suggested that the driving of nails into *minkisi* derived from Christ's crown of thorns or images of martyrs pierced with spears and arrows. See also SONGYE.

Nkondi (pl. *zinkondi*). See NKISI.

Nok. The highly distinctive ceramics identified as Nok are named after the small village in central Nigeria where, in 1943, fragments were first discovered in the alluvial deposits of a tin mine. More than 1500 Nok pieces are now known, most from uncontrolled digging. The culture, which may date as early as 900 BCE, was certainly present between 500 BCE and 200 CE. It seems to have been a stratified, fairly sophisticated and wealthy iron-working culture. The characteristic style of Nok terracottas includes bulging semicircular or triangular eyes with arched eyebrows,

pierced eyes, nostrils and mouth, flared upper lip and unusually angled ears. Many figures show a preference for cylindrical forms. Finally, surface decoration—including carefully detailed hairstyles and jewelry—is painstakingly wrought. Animals as well as human figures make up the repertoire. Bernard Fagg, the "discoverer" of, and major expert on, Nok, compared Nok pieces to work from Katsina Ala in southeastern Nigeria, which constitutes a distinct substyle. The human figures likely served as ancestral images, or spirit images to benefit the living, while it is uncertain what function the animals satisfied. Formerly, Nok was cited as the first link in a Nigerian style sequence that included IFE, BENIN and the modern YORUBA. Although the sequence is questioned, largely because of the enormous gaps of time between the links, it can safely be said that echoes of the Nok style are evident in later works such as those found at Ife, Esie, Owo, TADA, JEBBA, BENIN and among the YORUBA.

Nommo. The DOGON creator god AMMA first created Nommo, a water spirit, who soon multiplied, becoming four pairs of TWINS. The sets of twins are the ancestors of all humanity and each pair contributed a particular gift to their descendants, sent to earth in an ark. Afterward, the Nommo continued to act as water spirits and overseers of the world. Paired figures and figures with their arms raised are commonly identified as Nommo—in the first case because it is assumed that one of the pairs of twins is depicted and in the second case, because of the Nommo's role as water spirits. It is more likely, however, that the figures represent worshippers, rather than the Nommo themselves. Nommo figures also appear supporting stools, on doors and the sides of containers. Often, they are ANDROGYNOUS. Herbert Cole has suggested that the figures' androgyny and

NOMMO

Above: Figure with raised arms, a gesture associated with prayers for rain. The simplification of this figure, as well as the heavy encrustation of sacrificial offerings, links it with Tellem figures.

NOK

Top: This figure once had a second head attached, probably Janus-style, to the back. The beaded collar is similar to those worn by Ife and Benin kings.

Bottom: The nearly life-sized Dinya Head was discovered in 1954 in a narrow channel in bedrock, covered with several yards of alluvial deposits. The attention paid to elaborate hairstyle is found also in the regalia of a somewhat smaller figure that seems originally to have been two-headed. 500 BCE– 200 CE.

Janus-faced figures refer to ideas of precultural, primordial beings, "children," who precede the present culture (*Icons: Ideals and Power in the Art of Africa*).

NOMOLI

Above: Reclining nomoli figure from Sierra Leone.

Nomoli. Small steatite figures made by the Sapi people of Sierra Leone. Characterized by squat bodies, oversized heads with protruding eyes and exaggerated sexual organs, none of these figures have come from controlled archeological conditions. Instead, they were dug up by Mende farmers who associated them with the fertility of the earth. As well as miniatures, the Sapi made nearly life-size human heads, called *mahen yafe* ("spirit of kings"), said to depict royalty and nobility. Similar figures called *pomta* (sing. *pomdo*) come from northern Sierra Leone. See WESTERN AFRICA and the GUINEA COAST.

Nootka. The Nootka live on the Pacific side of Vancouver Island. They are better known for their music and dance, and their art shows KWAKIUTL influence. Their most powerful deities were the moon and sun, who were husband and wife, to whom the Nootka prayed for food and luck. The Nootka valued cleanliness and ritual bathing was important as they believed that human odor was offensive to the spirits.

North Africa. See TASSILI N-AJJER and map: NORTH AFRICA AND SUDAN.

North American Natives. The bewilder-ing variety of indigenous peoples living between the Arctic Circle and the border between Mexico and the United States is traditionally organized by geographical area: ARCTIC and SUBARCTIC, (these two areas include the ALEUT, Alaskan ESKIMO/Canadian INUIT, ATHA-PASKANS and the NORTHWEST COAST), GREAT BASIN, PLATEAU, PLAINS, SOUTHWEST, WEST (CALI-FORNIA is sometimes listed separately, as it is here), WOODLANDS and GREAT LAKES.

North American Native Aesthetics. As is true of other indigenous peoples, those of North America made objects for both utilitarian and spiritual purposes. Most North American peoples see the world as a place of constant restless motion—the metaphor of a river is often used—but a place, nonetheless, of dynamic harmony and balance. These last two are the sources of beauty and it is a human obligation to remain in balance with the natural world, to "please the spirits" with their actions and appearance. The individuals who made art differed from area to area. Among the ESKIMO/INUIT the shaman made much of the art. On the NORTHWEST COAST there was a professional class of male carvers who were often chiefs as well; the shaman made objects necessary for various rituals. Women's art tended to involve "softer" materials such as clay and fibers for basketry and weaving. Embroidery, quillwork and beadwork were specialized women's crafts in the Arctic and Subarctic (e.g., Kuchin DOG BLANKETS) as well as throughout the GREAT LAKES, PLAINS and WOODLANDS areas. The tendency to undervalue women's art and apparel as being "merely" utilitarian led Westerners to overlook their importance—in fact, personal appearance is one of the most important ways of pleasing the spirits and thereby contributing to the sum of balance and beauty in the world.

North American Native Religion. The isolation of the North American continent resulted in the preservation of archaic cultures and religions until and even after European contact. Despite the numerous and diverse cultures, there are some common threads, such as ANIMISM and the belief that the world and all life is pervaded by spiritual force or power (called *wakan* on the Plains and *manitou* by the Algonquians); a hierarchy of spiritual beings headed by a single spiritual entity (Supreme Being, Great Mystery, Great Spirit) and a host of others, including personified forces of nature (sun, moon, stars, wind), animals (see INDEX: Animals), a CULTURE HERO who often is, or is at least closely associated with, a TRICK-STER (Coyote, Raven). Early hunting religions existed side by side with, or were replaced by, later agricultural religions (in the Southwest c. 3000-2000 BCE and in the southeast by 1000 BCE). Influences on the former came from Asia, Siberia and the Arctic region, while the latter were affected by Mesoamerican patterns. SHAMANISM was associated with the early hunting cultures and elements of shamanist beliefs and practices survived and carried over in later cultures such as the WORLD TREE, FOUR/SIX DIREC-TIONS and the LAYERED UNIVERSE. The world is conceived of as being in a state of delicate balance, a state which can be affected by human intervention, but its dynamic nature is often expressed in dualism, i.e., TWINS, culture heroes vs. CAN-NIBAL spirits or opposed celestial bird/chthonic serpent imagery. This dynamic conception also contributes to what can be described as ecological attitudes: respect for nature, using only what is necessary for survival and avoidance of wastefulness. Some societies, although highly stratified, developed systems for distributing resources, thus maintaining balance (e.g., Northwest Coast POTLATCH, Plains give-away ceremonies). Other

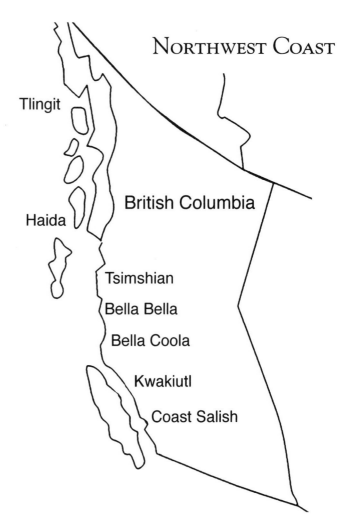

NORTHWEST COAST

Tlingit

British Columbia

Haida

Tsimshian

Bella Bella

Bella Coola

Kwakiutl

Coast Salish

shared cultural practices include the VISION QUEST, ritual smoking (PIPES) and the central importance of the MEDI-CINE BUNDLE. New forms of redemptive millenarian and prophetic religion developed in response to military and cultural conquest and debasement (e.g., the GHOST DANCE, the Native Shaker Movement and in the 20th century, the NATIVE AMERICAN CHURCH).

Northwest Coast. The term used in scholarly literature to describe the over 1500-mile area from the Oregon-California border northward to the Copper River delta of the Gulf of Alaska. SUBARCTIC and ARCTIC are used to describe the area above the Northwest Coast. The region is

divided into three areas: northern (TLIN-GIT, HAIDA and TSIMSHIAN), central (Bella Bella, BELLA COOLA, KWAKI-UTL and NOOTKA) and southern (COAST SALISH). Culturally, environmentally and linguistically (forty languages belonging to a dozen language families) this is an area of great diversity. Some common features do exist however: sustenance based largely on fishing and hunting, highly developed woodworking technology, permanent winter residences, vertically structured social organization based on a combination of genealogy and wealth and, finally, shamanism and the guardian spirit complex. The vertical social structure with the most powerful chiefs and their families at the top, lesser families beneath and at the bottom slaves (the latter made up fifteen to twenty-five percent of the population and were not regarded as being human) was atypical in North America. The structure was reinforced by art, especially by the POTLATCH ceremony. The ancestors of the most northwestern peoples had entered the area by 3000 BCE. The earliest recorded contact was Vitus Bering's second expedition for Russia in 1741. Earlier inhabitants include the Tlingit and Haida in the north, the Kwakiutl and Nootka on Vancouver Island and the Chinook on the lower Columbia River. Later immigrants lived further south and included the Bella Coola, Coast Salish and Tsimshian. Franz BOAS, the dominant scholar, first went to the region in 1886 and continued to work on Northwest Coast materials until his death in 1942. Although native populations were radically decreased due to disease resulting from European contact, cultural patterns were less negatively affected than elsewhere. This was due, in part, to the fact that the fur trade depended on Native North American participation in order to flourish. The fur trade, in fact, economically enriched the area. After 1834 with the arrival of missionaries in increasing num-

bers and the institution of European and American governments, destructive contact patterns were similar to those occurring elsewhere in the world. For example, some ninety-five percent of the Haida died from exposure to viruses in the 1860s and death may have swept away as much as eighty percent of the Northwest Coast population as a whole. See map: ARCTIC, SUBARCTIC AND NORTHWEST COAST.

Northwest Coast Architecture. The villages and houses with their associated sculpture were similar among most Northwest Coast peoples. Villages were built on a longitudinal axis, paralleling the waterfront, between the ocean and forest. The houses, which faced the water, radiated out from the most important chiefs' houses. The SHAMAN's house was generally located toward the forest, away from the chiefly residences—the different, but high status of the shaman was thus indicated without disrupting the chiefly hierarchies. Architectural and freestanding sculpture transformed the houses into sacred spaces and repositories of impressive and status-raising art (see TOTEM POLES). The interiors of the chief's houses consisted of a public section immediately inside the entrance backed by a carved, painted screen behind which lay the chief's private quarters. The houses were rectangular and had a large square sunken pit with a central fireplace around which the major public events took place. Broad posts that carried images of clan ancestors and acted as visual aids for the telling of clan myths supported the room divider screen. Although shorter than the exterior posts, these interior posts were placed higher in the hierarchy of sculptural objects (see ELITISM AND ART). Four large posts supported the longitudinal rafters. In the so-called Chilkat Whale House, built for the TLINGIT chief Katetsu by TSIMSHIAN craftsmen about

1835, these posts represented myths like the story associated with the woodworm. This post showed a child holding a woodworm with two more worms atop her head which, descending, became her ears. Beneath the girl was a crane with a frog in its beak. The post was said to symbolize the WORLD TREE where the worms live, where the crane alights and where the frog lives at its roots. The screen separating the public and private areas was called the rain spirit screen. The opening in the screen was the spirit's mouth, repeating the symbolism of entering on a deeper level—a spirit within the ancestor's body. During performances, the dancers emerged from the mouth of the rain spirit, and the chief in his private quarters was at the center of the most sacred space.

Northwest Coast Religion. Religious beliefs and practices are complex and varied throughout the region, but a number of beliefs are similar to those of other North American Natives. The world is pervaded by spirits (along with their physical manifestations) that are in a constant state of flux and transformation—a sort of web of interconnections. Human beings are inferior to these vast forces, especially to animals, the material and incarnate representations of spiritual beings. The relationship between human beings and the animals they depend upon for food is especially important—animals sacrifice themselves for human benefit and, in return, are ceremoniously treated with respect and gratitude. On the Northwest Coast, this reciprocity is extended on a spiritual level, since souls are believed to be interchangeable, manifesting themselves as human and animal by turns. Furthermore, humans stand in particular relationships with particular animals, which are visually depicted as clan CRESTS. These animals, the groups' special protectors, established identity and were constantly reenergized through ritual, especially the retelling of

the myths. The principal character in these myths is the trickster/culture hero Raven, a creature with a voracious and uncontrollable nature whose actions inadvertently create not only the shape of the terrain, but also moral order and restraint. Like Raven, human beings are driven by impulse and greed. Much of Northwest Coast ritual serves to counteract this basic nature. The POTLATCH, entailing as it does the redistribution of material wealth, reestablishes balance. The Kwakiutl winter HAMATSA dance encapsulates these beliefs. The Hamatsa, a human being abducted by the spirits, returns, wildly out of control, seemingly possessed by cannibalistic drives. As the dramatic ceremonies unfold, these urges are tamed and the Hamatsa is reintegrated within society as a dynamic and potent moral force.

Northwest Coast Style. Although the numerous groups who live in this area create art in various other materials such as stone, bone, horn, cedar bark and wool for blankets, plant materials for baskets and copper, the most common medium is wood. Some Northwest Coast people speak of descent from trees and all of them treat trees with great respect, begging permission before cutting a tree or stripping some of the bark. Bill Holm (*Northwest Coast Indian Art*), the first scholar after BOAS to thoroughly analyze the complex art styles, feels that all sculptural styles at least partially derive from a two-dimensional division of space, which was continually refined. So powerful was this two-dimensionality that when artists worked on three-dimensional surfaces, they conceived of them as flat patterns first and then wrapped them around the shape. Ralph Coe, by the way, believes that the overriding concept in Northwest Coast art is continuity (*Lost and Found Traditions*). Coe emphasizes the plasticity of form, what he calls the "organic ebb and flow of sculptured surfaces." He also finds a "fero-

NORTHWEST COAST RELEGION

Above: Haida tattoo design depicting Raven.

cious mystic power" in the art and implies that both these properties originate in and resonate with the rich flow of energies in the Northwest Coast environment. We owe to Holm the invention of the term FORMLINE to describe the raised positive outlines which surround incised negative shapes. All designs are derived from CRESTS or parts of crests, the ancestral symbols of family lineage. Repeated patterns include ovoids, "U" and "T" shapes, eyes and SKELETONIZED forms (ribs and JOINT MARKS). In two-dimensional work and large sculpture such as TOTEM POLES, house posts and screens, designs are organized with an obsessive bilateral symmetry sometimes augmented by horizontal balance. Nearly all the available space is filled with endless variations of basic design units, which creates an effect of teeming life and energy. Color is used in solid blocks with red and black being preferred. Blue, blue-green and gray are also used. Human and animal figures are generally treated frontally except on smaller carvings such as pipes. Although some large scale, two-dimensional decorations occur on house fronts, the majority of objects are small in scale. The range of scale is much greater in three-dimensional work that shows the ability to adjust forms to objects as small as ceremonial spoons or as large as sixty-five-foot-tall totem poles. Since the 1870s the names of many of the artists have been rediscovered through careful style analysis of scholars like Holm and others. Generally speaking, forms and designs appear to be polysemic, their meanings and arrangements in a state of flux paralleling the common idea that the universe is composed of restless, fluctuating energies and that the spirits of humans and animals are interchangeable.

Ntadi (pl. *mintadi*). Stone guardian figures placed on royal burials. See KONGO.

N'tomo (or Ndomo). The first of six

BAMANA secret societies, N'tomo is concerned with the initiation and circumcision of boys. N'tomo society members make blood offerings on stones placed beneath tree altars. Combined, tree and stone embody organic and inorganic immortality, continuity and strength.

Bamana Diviner Marks

The Cantor Set

Number Symbolism. Numbers play an important part in indigenous art in a variety of contexts. As far as cosmology is concerned, indigenous peoples conceive of the universe as a LAYERED UNIVERSE with different numbers of layers, with three being the most common (sky, earth, underworld). There may be a slight preference for odd numbers. A sampling of numbers of layers follows: Bella Coola four, Haida three, Maori ten or eleven, Navajo two to fourteen layers. The earth is generally divided into FOUR/SIX DIRECTIONS and frequently sacred colors, birds, animals, minerals and other properties are associated with each direction. Architecture often follows COSMIC MODELS or replicates the divisions of the earth. The six-sided Navajo HOGAN, for instance, is supported on four posts that are linked with the four directions and the four sacred minerals. Mythology is often a numbers game as well, a sort of sacred Fibonacci series of creators and human descendants. A single Creator god creates a Primordial Couple or four sets of twins, who in turn create humankind (see DOGON COSMOLOGY, IATMUL, MALEKULA). The intervals between rituals and the

length of time they span involve symbolic numbers. The numbers are reported in ethnographic literature, but unfortunately, their significance is not discussed. Some rituals occur annually—especially renewal rituals—frequently in conjunction with the solstices. The Hopi SOYALA ceremony occurs at the Winter Solstice and lasts nine days. Among the Papuan Gulf ELEMA, the *heheve* cycle occurs at ten or twenty year intervals. Finally, the great DOGON SIGI festival occurs every sixty years, a number associated with the passing of a generation. Other periods of duration are built into the ranks or grades of secret societies all over the world. These time periods are bracketed by initiation rituals that help individuals move smoothly from one phase of life to another (see RITES OF PASSAGE). Finally, numbers are important in DIVINATION. Ron Eglash suggests that the marks made by Bamana sand diviners resemble the Cantor set. And Yoruba IFA divination, while it has mathematical implications, is based on 256 verses in an oral literature, which must be memorized by the diviner and recalled in conjunction with casting palm nuts or chains. Ritual repetition plays a part in Ifa divining and in other cases as well. For instance, Kuba enstoolment rituals involve a transfer of power to the new ruler who must touch the GOLDEN STOOL three times to complete the transfer.

Nunavut Movement. Meaning "our land," this INUIT movement began in 1974 and ended with the signing of an agreement with the Canadian government in 1992. The Inuit attained legal rights to over 350,000 square kilometers, certain hunting and fishing rights, mineral, oil and gas rights as well as a cash settlement. In exchange, the Inuit gave up all other rights and claims to land elsewhere in Canada. The Inuit, who make up approximately eighty-five percent of the area population, became self-governing in the year 2000.

Nupe. The Nupe live on both sides of the middle Niger River in Nigeria. According to legend, the Nupe kingdom was founded in the 16th century by Tsoede, a guard at the court of the king of Idah, who fled up the Niger River, taking with him nine copper alloy sculptures which he left at JEBBA and TADA.

Nurturing Female. The numerous images of mothers holding children found in African art are sometimes called "madonnas" or are casually referred to as fertility figures. The universal desire to depict the fecund, nurturing aspect of the feminine generates such figures which often convey ideals of female beauty as well as embodying good character. Some images of the nurturing female type are made to correct problems of infertility and sexual dysfunction. Childless Bamana women affiliate with the Gwan society, for instance, to receive assistance. Another reason such figures are so prevalent is that, as Henry Drewal has pointed out with regard to the Yoruba, nursing mothers represent a time of sexual abstinence and suppressed menstruation, a state of purity and ritual cleanliness. The earth itself is usually conceived of as female and the deities most intimately connected with it are also female. See INDEX: Earth Mother listings in Deity Archetypes.

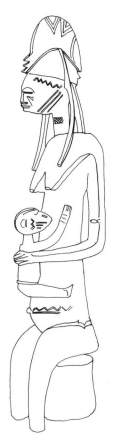

NURTURING FEMALE

Above: The flowing, rounded forms of BAMANA Gwan society figures powerfully express the beauty associated with the nurturing mother. Gwan society members assist childless women and attend births. Grateful mothers sacrifice to images like this one and name their children after them. The lives of the children are dedicated to the beauty and moral goodness embodied in the sculptures.

Oba of Benin. The present-day Oba traces his ancestry and power back to the 13th century and to Aranmiyan, an Ife prince (son of ODUDUWA) who was asked to rule in Benin following a period of political disruption. The Oba's power is balanced by seven hereditary title-holders called the Uzama, by nineteen town chiefs and twenty-nine palace chiefs. Each of these groups is further subdivided into various grades. The divine Oba inherits by primogeniture, but must validate his claim by erecting a shrine to his father within the palace courtyard set aside for that purpose. The Oba's palace is the CENTER of the cosmos and his centrality is reiterated by daily and cyclical rituals as well as by his complex regalia. He appears in public only on certain ritual and state occasions; this sequestered life adds to his power by surrounding him with SECRECY. See BENIN ANCESTOR SHRINES.

Oceania (also Pacific Islands). Composite name for the enormously complex and diverse art forms and cultures found on the islands in the Pacific Ocean. The traditional geographic divisions of the region, established in 1831 by the French explorer and geographer, J.C.S. Dumont d'Urville, are MELANESIA, MICRONESIA, POLYNESIA and Malaysia. Today, the

OCEANIA

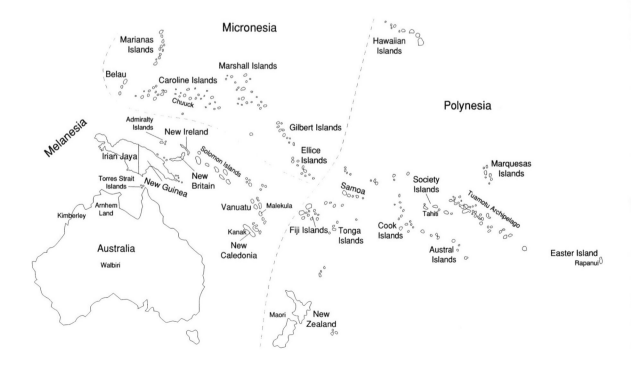

indigenous cultures on the continent of Australia (see ABORIGINAL AUSTRALIA) are also included. The peoples who settled Oceania came originally from Asia, beginning as early as 50,000 years ago. Melanesia was the earliest to be settled, the outlying islands of Polynesia the latest. Certain religious commonalities can be identified, such as creation myths involving primordial progenitors (Earth Mother/Sky Father). Throughout the area one finds a belief in invisible forces which unite and affect all living things. Although humans cannot control these forces, they can maintain a positive relationship (MANA) with them through ritual. A number of behavior patterns developed aimed at decreasing human vulnerability in the face of the powerful forces (TABOO/TAPU). Social structures based on ancestor worship and an extraordinary concern with lineage preoccupy Oceanic peoples. Finally, certain aspects of material culture are similar throughout the area, such as the artistic focus on the human form and the relative disinterest in large-scale permanent architectural structures. European contact was often disastrous, native populations decimated by disease and hostility, and indigenous social, artistic and religious systems willfully ignored and supplanted by missionary and secular intrusion.

Odu. The complex oral tradition consisting of over 600 sayings or poems used by Yoruba diviners. See IFA.

Oduduwa (also Ododua). One of sixteen lesser gods sent by the supreme god Olodumare to shape the world and set human affairs in action. Oduduwa and the others descended an iron chain. Oduduwa had the foresight to bring a calabash of sand (in some versions, a snail shell) and a five-toed chicken and when he reached the primordial ocean he sprinkled the sand about and set the chicken down. The chicken scattered the sand over the face of the waters, forming dry land. Then Oduduwa founded IFE at that place, the center of creation, and became its first Oni or king. He sent his sons out to rule elsewhere; Aranmiyan thus became the OBA of Benin.

Odwira. A transitional festival marking the New Year (and the new yams) among the Asante. See KUDUO.

Ogboni Society (or Osugbo Society). The YORUBA word Ogboni, meaning "thirty" or "wisdom" refers to the society of male and female elders responsible for the selection, installation and removal of rulers. They also oversee burials and are responsible for all judgment and punishment of

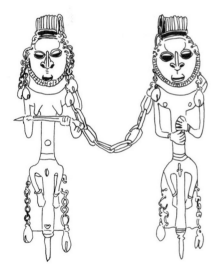

OGBONI SOCIETY

Above: Paired brass Ogboni edan figures retain the core of clay or earth after casting, connecting them to the powers of the earth. The figures have spikes at the base so they can be driven into the earth on the spot of blood sacrifices and during judgments where contact with the earth activated their power and legitimized the decision. The female figure holds a pair of edans, as she would hold twin children. The male figure's gesture is a greeting to Onile. The protruding, oddly sightless eyes suggest both the trance state and the objective, yet implacable quality of justice. Ijebu area.

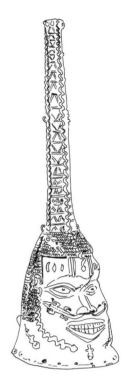

ODUDUWA

Above: The Oba Eresonyen introduced a new royal masquerade into the New Yam festival. Crowned with fearsome brass masks with great points extending upwards, masqueraders performed rites honoring the royal dead. The crosses on the mask's cheeks are said to symbolize the transitional period of the festival. Said to personify a mythic healer or spirit of health, the masks' faces, with their clenched teeth, stretched lips and squirming serpents, suggest terror and the paralysis associated with snakebite. Striking images of ill health, the masks are linked with Ogiwu, god of mortality and death, and mark the physical and cosmological transition to the new year.

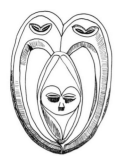

OGOWE RIVER
BASIN

*Top: Kwele ekuk masks
supposedly represent
antelopes.*

*Bottom: Masks represent-
ing the spirits of beautiful
deceased women, like this
Lumbo example, are worn
by stilt dancers throughout
the area, performing at
funerals, initiations and to
help unmask witches.*

serious crimes. All issues are decided by debate among the members. Society members wear woven sashes over their shoulders or wrapped around their heads and voluminous garments called "cloth of many designs," said to symbolize their long lives filled with many experiences. Two sorts of art are associated with the society: large free-standing figures called "owners of the house" refer to the original human ancestors and to society members; paired male and female brass figures (*edan*) symbolize the importance of the cooperative bond between women and men at all levels of society. These figures, which may depict the entire human figure or heads atop cylinders, are linked by a chain and can be worn around the neck of their owner. On a deeper level, the figures represent the dangerous and ambiguous powers of Oduduwa, Onile "owner of the earth," as well as of the left hand and the wrong side of the cloth. The left hand is regarded as unclean, because of its traditional connection with defecation. The wrong side (inside) of the cloth is in contact with the sweat of the wearer—contact with both represents an inversion of propriety. Ogboni society members, when they wear the *edan*, become a third entity, which is said to be the mystery itself, the primordial unity that transcends the opposites that characterize human existence. Ogboni members must set aside personal considerations in favor of objectivity, and are thereby able to balance the dangerous powers represented by their insignia and use their wisdom for the benefit of society. Other Ogboni society objects are drums, various regalia signifying the different grades within the society, spoons, staffs and bullroarers.

Oglala. See LAKOTA.

Ogowe River Basin. This area is dense equatorial rainforest, south of the CAMEROON grasslands, that stretches from the coast of Gabon as far as Lake Tanganyika in eastern Africa. The people are Bantu speakers who migrated into the area at least 3,000 years ago. Society in the area is village-based, except for the MANGBETU State located in the northeast. Gabon masks are some of the most beautiful, to the Western eye at any rate, of all African masks. The white ground coloration, black delineation of features and heartshaped faces are similar to IGBO and IBIBIO masks. The Kwele (formerly Bakwele), who arrived in their current location sometime in the 19th century, make masks called *ekuk* ("forest spirit," or "children of *beete*") for *beete* cult masquerades involved with social control and creating political unity. *Ekuk* masks are characterized by arc shapes that represent the horns of an antelope. The calm harmony of *ekuk* masks contrasts with the dangerous power of *gon* (or *gou*), a gorilla mask hung with ropes and worn by a nude performer. The white ground of Kwele, Punu and Lumbo masks refers to clarity and light, as well as beauty, and counteracts the dark powers of witches who are abroad at night. The remaining two societies of the Ogowe River area are the FANG and the KOTA.

Ojibwa. The Ojibwa, also known as the Chippewa, are Algonquian speakers who live in the Subarctic, Great Lakes and Woodlands areas. There are many shamanistic elements evident within their religious practices, see for instance SHAKING TENT, WINDIGO and MIDEWIWIN. See also WIGWAM.

Okipa. An exhausting four-day and four-night ceremony with overt sexual content and self-mutilation performed by the Plains MANDAN until 1881. The ritual is believed to be a forerunner of the SUN DANCE.

Okpangu. The rapacious Igbo CANNIBAL rapist, the part-monkey, part-human. See MBARI.

Old Oyo. An ancient Nigerian kingdom, located in the central and southwestern regions of YORUBA territory. Old Oyo, which had a population of 95,000 at its height, gained power after the decline of Ife. The city of Old Oyo was briefly invaded by the Nupe in the early 16th century at which time the Nupe may have taken the famous TADA figure. SANGO, fourth ruler of the city, was the son of a Yoruba father and a Nupe mother who committed suicide after being exiled for his abuse of power. The religious cult that grew up around the deified ruler expanded throughout the region, accompanied by Old Oyo's rising political power. After its collapse in the early 19th century, following wars with the Fulani, Yoruba survivors founded cities including Ibadan, Abeokuta and New Oyo.

Olokun. The god of the sea and wealth among the people of BENIN. Things associated with Olokun, like coral, snakes and mudfish are symbols of the OBA, the ruler of Benin, especially of his liminality. The Oba is simultaneously human and divine, capable of mediating between the shifting restless sea, the realm of spirits and the solid, material realm of human affairs.

Olowe of Ise. See YORUBA ARCHITECTURE.

Oni. Title of rulers of IFE. The first Oni was the divine ODUDUWA, son of the high god Olodumare, creator of the dry land and founder of Ife. Today the city of Ife is divided into quarters (More, Ilare, Ilode and Otutu), each quarter having its own royal line. King-makers decide which of the candidates put up by the quarters will accede.

Opon. Literally, "to flatter," the word identifies carved boards used by the Yoruba diviners. See IFA.

Opossum. See INDEX: Animals.

Oriki. This word means "appellations, attributions, epithets," but is often used to refer to praise songs. *Oriki* focus on the achievements and character of individuals and are sung by the wives and daughters of the lineage or by professional women performers. The professionals have a wider repertoire. In recent years, art historians have learned much about artists from these oral histories/praise songs. For instances of *oriki* see YORUBA ARTISTS, ESU, GELEDE, IBEJI, SANGO.

Orisa (also *orisha*). Yoruba term meaning "god(s)"; the term also can refer to deified ancestors. See YORUBA PANTHEON.

Osugbo Society (preferred form, Ogboni). The name of the cult devoted to Onile, "owner of the earth," in southern Yorubaland, which spread elsewhere, becoming one of the most powerful political and judicial factors in Yoruba life. See OGBONI.

OLOKUN

Above: The mudfish is a liminal creature symbolizing the peace, prosperity and fertility of Olokun and the sea as well as the land-based prosperity of the OBA of BENIN. Detail from design on a carved elephant tusk.

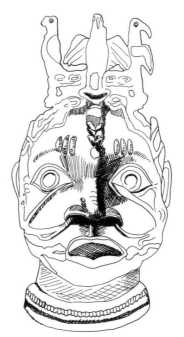

OSUN

Left: The famous 10 1/2" high brass royal osun, "spirit head," is one of the most memorable BENIN objects. The enthralled gaze suggests the shaman's trance state as he travels in search of the lost soul of a sick person. The ambiguous symbolism of birds, serpents, knots and plants suggests the vulnerability of human beings and the fragility of health. Early 18th century.

Osun. At BENIN, Osun was one of several gods associated with health and healing.

The most striking manifestations of the god are the brass so-called *osun*, "spirit head" altars. Leaf-shaped eyebrows, knots or plaits and reptiles emerging from nostrils, ears and eyes combine to dramatize the Oba's (and Osun priests') healing powers. The leaves and the coiling snakes that suggest vines are linked with the dangerous powers of the forest, which, nonetheless, is the source of healing plants. Knots may refer to the permanence and force of the spirit world. Snakes and birds embody the powerful forces invoked to aid in healing—powers associated with the sky and the secrets of the earth. The paired birds and serpents also adorned the Oba's palace (see BENIN PALACE COMPLEX), where they served as complex symbols of the Oba's liminal powers.

Otobo. A hippopotamus mask made for festivals honoring water spirits. See KALABARI.

Owhyhee. Indigenous name for the HAWAIIAN ISLANDS.

Owl. As creatures of the night, owls are linked with death, magic and dreams. As such, for many Native North Americans, the owl was especially closely tied to the shaman. One of the PAWNEE four sacred birds, the owl's powers were linked with darkness and night (see HAKO). The Kiowa believed that the shaman became an owl after death. The Ojibwa called the bridge over which the dead passed, the "Owl Bridge" and buried owl feathers with the dead to facilitate their journey. Owls frequently appear on smoking pipes in the Woodlands and Plains regions. In Aboriginal Australia, the owl is the sacred bird of the WANDJINA.

Owo. A 15th-16th century Yoruba kingdom said to have been founded by the youngest son of the creator god Oduduwa. Owo may have served as a transitional link between IFE and BENIN. Naturalistic terracotta heads and other sculpture, dated between the 13th and 16th centuries, all came from a single excavation.

Oyo. See OLD OYO.

Ozette. A Northwest Coast archaeological site of the Makah (NOOTKAN speakers) on the Olympic Peninsula. At this site, around 1500 CE a mudslide buried several houses, preserving them and over 65,000 artifacts from what has been called a North American Pompeii.

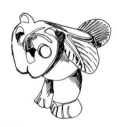

OWL

Above: This lively owl is characteristic of the realism and energetic poses of North American Plateau sculpture after 1400. Carved out of stone, the object is identified as a mortar used for grinding pigment. Found at Five Miles Locks, Columbia River, Oregon.

Pahu. Large Hawaiian drums, see HULA.

Pakeha. Non-MAORI whites, now the majority population of New Zealand.

Palau. Now Belau, see CAROLINE ISLANDS.

Pale Fox. See YURUGU.

Papa (Papatuanuku). Polynesian Earth Mother (see RANGI).

Papago. A Southwestern people who still live in southern Arizona. The Papago and the Pima are O'odham speakers, a dialect of Uto-Aztecan. They are famed as basketmakers. See BASKETRY.

Papuan Gulf. The most prolific art producers of this highly cohesive area of New Guinea are the KEREWA who made *agiba* SKULL RACKS, woven cane masks and *gobe* ancestor boards. Other Papuan Gulf peoples include the ELEMA, the people living on the Bamu River, the Turamarubi people on the Turama River and the coastal Namau or Purari, known for *gope* ancestor boards.

Parfleche Bags. From the French *parer une fleche* ("to turn away an arrow"), referring to the impenetrability of these rawhide bags made by women. Plains peoples carried pemmican in these bags which were made in a variety of ways. Pemmican was dried and pulverized buffalo meat mixed with dried and mashed berries covered with fat and marrow. This preparation made it possible for the people to live through the winter when no buffalo were hunted and small game was scarce. *Parfleche* bags were often decorated with geometrical designs.

Pataka. MAORI food storage house (see WHARE WAIKAIRO).

Parturition. The act of giving birth is depicted most often in conjunction with highly potent architectural and ritual contexts. The HERALDIC WOMAN pictured over the doors of men's houses in Oceania sometimes is shown actually giving birth—since the pose itself suggests birth, the inclusion of the infant's head seems almost unnecessary. Furthermore, the symbolism involved in passing beneath the widely spread legs of the figure reverses the process, to enter into the house is to reenter the womb.

Path of Life. The idea that life is a journey is nearly universal. It is made manifest in ceremonies, in oral traditions and in various symbolic and visual motifs. The shape of the journey varies from people to people probably in complex ways that relate to their cosmology and worldview. Sometimes the path is tortuous and maze-like, confronting individuals with switchbacks and blind alleys comparable to the

PARFLECHE BAGS

Left: Cheyenne parfleche bag painted with delicate abstract designs. Before 1875.

various setbacks of life. In MALEKULA, people create sand drawings called *nahal*, "the path," connected with the journey of ghosts to the realm of the dead. A female ghost guards the way, with the *nahal* sand drawing before her. As the ghost approaches, she erases the drawing and challenges

PATTERN

Above: The basic genealogical patterns are conventionalized human figures. Descent is suggested by linked figures resulting in visually active and perplexing designs that powerfully suggest the unending energy of creation itself. Redrawn after SCHUSTER and Carpenter.

the spirit to reproduce it correctly. Those who are able to do so pass on safely to the land of the dead (see CONTINUOUS LINE DRAWINGS). The YORUBA say *aye l'ajo*, "life is a journey," and their art as a whole is affected by the idea. Henry Drewal suggests that what he calls seriate compositions—those in which all elements are discrete, interchangeable and of equal value—are assembled "section by section," or "step by step." This approach posits a world that is fluid, flexible, indeterminate and infinite and, like a journey, always progressing and evolving. Despite this dynamic view of life, Yoruba still seek relief from the anxiety associated with change through IFA, divination. Given their idea that life is a journey, it is not surprising to find that the right side of the divination board is called "the straight path," and the left side "the direct path." Path imagery is also prevalent in the SOUTHWEST. The Navajo speak of walking in beauty. Baskets, blankets and pottery often have a line called variously the SPIRIT BREAK or spirit path, said to be the place where the spirits can enter or escape the object. The interrupted lines on ZUNI

pottery are also said to represent the as yet incomplete artist's lifespan or path. In many cultures, the path is tied to cosmology and the landscape, as for instance on the NORTHWEST COAST where birth is associated with the ocean, and death with the forest. Ways of approaching sacred places embody path metaphors as do dance patterns all over the world. The path of the sun across the sky is marked as the seasons' progress by many cultures (e.g., see ARCHEOASTRONOMY, SOLSTICES). Finally, the WORLD TREE is often conceived of as a path, a conduit that the shaman travels in search of lost souls, or a means by which the dead can reach the land of the dead. See also KIFWEBE and TEKET.

Pattern. The modernist Western tradition has tended to interpret pattern as decorative, meaningless fill. As a result, studies of indigenous art have largely overlooked the importance of pattern in art, making it difficult to find reliable information. Another reason for the shortcoming is that earlier studies that did address the issue of significant patterns often linked them to diffusionism, an approach now seen as subjective and lacking solid supporting evidence. This attitude led to the undervaluing of important work by scholars like Franz BOAS. Fortunately, recent scholars increasingly address the shortcoming. In *Patterns That Connect*, Edmund Carpenter, working with the collected papers of Carl SCHUSTER, provides a complex text and numerous illustrations of the WORLD TREE (Tree of Life). The tree's "symbolic reduction" in the form of the forked post/Y-post, they interpret as "simultaneously a cosmic man and a tribe whose limbs or branches represent successive generations..." (*Patterns That Connect*). Carpenter deals with many other related patterns as well. Further reductions are analyzed, including numerous variations of chevrons and stacked triangles in sculp-

ture, fabrics, tattoos and body painting. Carpenter avoids speculating on the origins of the patterns, but does compare them to Paleolithic patterns. Nor does he give explanations for the repetition of patterns, but provides substantial ethnographic and mythological data, which shows not only that pattern resemblance is not meaningless or accidental, but also that its significance is similar from culture to culture. The importance of pattern in Oceania is evident in the restrictions placed on pattern use. Individuals in ABORIGINAL AUSTRALIA, Polynesia (HAWAII, MAORI) and in Melanesia (KILENGE, KOMINIMUNG, KWOMA) are entitled to use ("own") certain designs by birth. Although this use of pattern is similar to European heraldry, there is a much greater sense of identification between persons and emblematic patterns in the Pacific. In both cases the designs appear on shields as a form of identification and protection, but the beliefs concerning them seem to be more literal in the Pacific. The literature frequently includes reference to the terror such images evoked in enemies. An explanation for the difference may lie in the greater strength of oral traditions for preserving the past in non-literate cultures and in the unified worldview which included cosmology, mythology and culture. In Africa, patterns evolved into SIGN SYSTEMS capable of conveying complex information about the status and even the emotional state of individuals. For additional references see INDEX: Pattern in Art, Artifacts and Techniques.

Pawnee. The Pawnee lived in what is now the state of Nebraska before they were forcibly removed to Oklahoma. They lived in semisubterranean earth lodges measuring between thirty and fifty feet in diameter. Their religion is one of the most complex in North America. The creator, sky god Tirawa was married to Vault of Heaven. These spiritual beings communi-cated with humans through lesser gods and messengers many of whom were linked with stars. In fact, the Pawnee believe that a particular star founded each of their villages. The most important were Tcuperika (Evening Star, a maiden gardener and source of all food) and her mate Oprikata

West
Altar
Skararu
Path
Beds
Firepit
Firewood
East

(Morning Star, a powerful warrior who drove all the other stars before him), who gave birth to the first human being. Other Pawnee deities include the gods of the four directions, identified as northwest, southeast, southwest and northeast. Below them in importance were the gods of the North—North Star, chief among the stars; North Wind, donor of the buffalo; and Hikus, breath, who gave life to the people. The sun and moon married and gave birth to the second human who mated with the child of the Morning and Evening Stars and produced the second generation of human beings. The Milky Way was the path of souls. Their rich ceremonial life included the MORNING STAR CEREMONY, the HAKO (Peace Pipe or Calumet) ceremony, the SUN DANCE and the GHOST DANCE. See INDEX: Stars in Natural Phenomena and Materials.

Peace Pipe. See HAKO.

Pele. The destructive aspect of the

PAWNEE

Left: The earthlodge was simultaneously a COSMIC MODEL and the womb of a woman. The interior was arranged according to sacred tradition. The altar at the west side of the lodge represented the Evening Star's garden (where the buffalo and corn were constantly renewed). The westernmost supporting post represented the Goddess herself. The eastern post was Morning Star, the North Star, God of light, fire and war. Every morning the beam of starlight passed through the doorway and lit the fire, reenacting Morning Star's union with Evening Star from which human beings were born. Tirawa, the supreme deity was not symbolically represented, except for his open mouth, signified by the firepit and his throne, a foot-deep square hole in front of the altar called the skararu. The inhabitants of the house lived at the CENTER and the strength of the star gods poured down on the roof in a constantly energizing stream.

Polynesian creator goddess Hina, Pele was the Hawaiian goddess of volcanic fires called Hina-who-eats-the-moon. Said to be the daughter of Haumea (possibly an aspect of Hina), Pele, the consumer of vegetation, is the natural rival of Lono, god of agriculture and an instance of the destructive female archetype. Pele is also connected with the origins of the Hawaiian national dance, the HULA. Her favorite little sister Hi'iaka-in-the-bosom-of-Pele, was charged with escorting Pele's lover to her. As her journey progressed, she chanted continuously, and her words of power made her a conduit between Pele and her lover. When the lover died, Hi'iaka chanted him back to life, linking the *hula* to rebirth and healing. See INDEX: Deity Archetypes.

Pende. The Pende of the Democratic Republic of Congo are said to have immigrated to their current location from Angola in the 18th century. There are many autonomous groups generally divided into the Eastern and Western Pende. A distinctive form of architecture is the chief's *kibulu*—the name translates "treasure house" or "insignia house." Among the Eastern Pende, these structures are erected following a strict protocol connected with Pende ideas about witchcraft and the powers of the chief. Lack of visibility is equated with SECRECY and witchcraft— only the most powerful and respected chiefs can afford complete privacy without being accused of sorcery. Thus, only the greatest chiefs have enclosed courts composed of a fence of living trees that effectively blocks the view from outside. The CENTER pole of the rectangular building is cut in secret and hidden until it is erected. The chief, his ministers and a few helpers plant the pole in a hole called the house's "stomach" along with seeds, grains and plants representing the Pende's major food sources. The pole itself represents both a "family tree" of ancestors and a gra-

nary—the source of nurture under the ancestors' otherworldly protection. The entrances to the complex may be flanked by statuary representing ghostly guardians that serve as the chief's personal bodyguard. These images show that the chief has secret weapons and, like the enclosing fence, can be taken as evidence of sorcery. Z.S. Strother has described the entire complex as a "foyer to the other world populated by the ancestors." The prosperity and health of the community are associated with the chief's delicate balancing of public and private power as well as with the good repair and purity of the house. Adjacent to the *kibulu* is the public dance floor, the openness of which dramatizes the chief's closed confines. Pende masquerades involve three masks kept in the most secret room of the *kibulu* as well as others owned by various associations. Other Pende masks known generically as *mbuya* are carved in lightweight wood with various attachments and painted. The older, so-called antique, masks have names referring to mythological characters or types. Some masks are referred to as powerless (*ya gitugu*), while others are thought of as fearsome and sacred (*ya mafuza*). The latter were worn on top of the head, facing the sky, more precisely the sun. These danced in the late afternoon, with the oldest, most powerful ones appearing just before sunset. The last to appear was a stilt dancer who, presumably thanks to his elevated vantagepoint, was said to be able to see "the sun's tail." Beautiful female masks with delicately carved faces and demure, downcast eyes are perhaps the most common. These are associated with boys' initiation rituals and embody a variety of female types from the seductive temptress to the chief's wife. Another class of Pende objects is the small ivory amulets called *ikhoko* (sing. *gikhoko*) that are miniature versions of face masks. Family heirlooms, these prestige objects are passed from generation to generation, and cleaned daily with sand, giving them a

PENDE

Above: Mbuya mask with characteristic protruding forehead, continuous eyebrow and downcast eyes.

golden patina, but gradually blurring the features. See INDEX: Trees in Natural Phenomena and Materials.

Penis. See INDEX: The Human Body.

Petroglyphs. Petroglyphs are designs made on rock by carving, pecking, scratching, abrading and/or bruising. The designs are visible because weathered, aged rock is darker in color than areas revealed by the above techniques. See also ROCK ART and MAZES.

Peyote Cult. See NATIVE AMERICAN CHURCH.

Pictographs. Pictographs are designs made visible by use of color applied as paint in six basic colors—red, black, white, yellow, green and blue—all obtained from natural mineral sources. See also ROCK ART.

Pigs. Pigs play important roles in many Non-Western groups, especially in the Pacific. Beyond their importance as a food source, they are often seen as having supernatural properties as among the ABELAM of New Guinea. The Abelam believe the pig originated in the underworld and forms a link with other spheres such as the primary forest, the walled gardens and the human community. Hand-raised by Abelam women, pigs are exchanged, sacrificed and ultimately (see BABA masks) assist the dead in finding their way to the land of the dead. Richard Salisbury's fieldwork among the Siane of highland New Guinea has shown that the diamond pattern (*gerua*) stands for pigs, and by association since pigs are associated with wealth and regeneration, the diamond implies potency. The diamond is closely linked to the X shape (*sirirumu*) used to symbolize the opossum, a creature that has much the same significance as pigs. The relationship between the two is pictured by placing two X shapes together, which results in a diamond. For

additional references to pigs, see INDEX: Pigs in Animals.

Pima. A Southwestern people who still live in southern Arizona. The Pima and the Papago are O'odham speakers, a dialect of Uto-Aztecan. They are famed as basketmakers. See BASKETRY.

Pipes. Smoking pipes were important ceremonial and secular objects throughout North America. SMOKE carried prayers and messages to the spirit realm, thus the pipes from which it issued were often elaborately carved with symbolic and facilitating images. The earliest pipes come from the ADENA and HOPEWELL cultures. The so-called "peace pipe" is uniquely associated with the North American Plains. The most prized pipes were made from CATLINITE, a red stone found in Minnesota and traded throughout the Plains. Shale, limestone and wood were also used. The SIOUX drilled out the bowl

PIGS

Above: Pigs are killed only on important ceremonial occasions because of their spiritual and monetary value. On Ambryn Island, VANUATU, janiform clubs carved with the heads of ancestors subdue and assuage the pig and protect the killer.

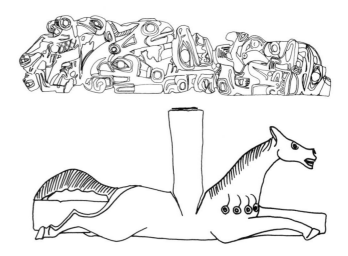

PIPES

Top: This complex HAIDA panel pipe is carved out of argillite. The larger figure on the left is a bird or an insect with a curled proboscis and cross-hatched wings. This creature sits atop a supine human figure with a forward facing, but inverted head. Facing the opposite direction is killer whale with his dorsal fin turned into raven's head. Myriad other creatures appear including frogs, a tadpole, bears, possibly an eagle, and insects including moths or butterflies and a grasshopper.

Bottom: Sioux running horse effigy pipe. Before 1899.

PLAINS AND PLATEAU

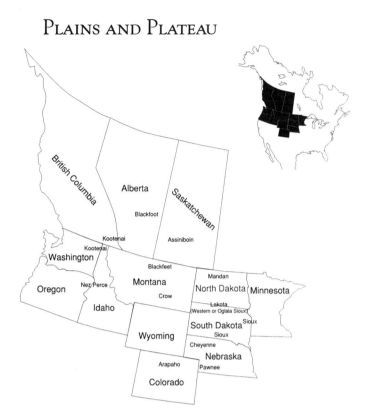

and stem first and then carved the effigies. Plains effigy pipes are carved with human figures (including portraits), bears, beavers, bighorn sheep, buffalo, dogs, horses, rac-

PLAINS PEOPLES

Figurative and geometric designs in quill- or bead-work adorned Plains moccasins.

Left top: This LAKOTA quilled moccasin is ornamented with SELF-DIRECTED buffalo head and bear claw designs, possibly the wearer's spirit animals. In any case, looking down at his own feet, the owner must have felt the animals' strength and fleetness guiding his footsteps. c. 1895.

Left bottom: Geometrical designs also seem to have carried symbolic meanings such as those on the toe of an Arapaho moccasin where the longitudinal stripe represents the path to the destination and the small dark rectangles called hiiteni, represent life, abundance, food, prosperity, prayers or things wished for. The white border is a snowy field sprinkled with triangles and verticals signifying hills and trees.

coons, several species of birds (cormorant, eagle, crow, owl), snakes, fish, sometimes as isolated figures and sometimes in combination. Pipes were smoked to carry prayers to the spirits, in deliberations before hunting and warfare, in curing rituals and to seal covenants. See also the Pawnee HAKO ceremony.

Plains Peoples. The vast area of the North American Plains covers from the Rocky Mountains to the Mississippi River valley and from the Saskatchewan River south to Texas. There are several sub-regions within the area, but the coalescence referred to as the Plains culture only occurred in the 17th century with the introduction of the horse. With their WAR BONNETS, beaded garments and aquiline profiles, the Plains Natives became the stereotypical "Indian," first through "Wild West" shows and later, in Hollywood movies. Although the stereotype is composed of both noble savage and savage warrior, it does not capture the rich cultural and artistic life of these people. Plains inhabitants spoke many different languages but shared cultural patterns based on limited agriculture combined with semi-nomadic, hunting-based practices. Classic Plains culture flowered beginning in the late 1700s—with the theft, purchase or recapture of escaped horses from the Spanish in the Southwest—and declined by the late 1800s due to increasing white settlement. During the florescence, extensive trade occurred throughout the region facilitated by the invention of a form of sign language that made communications possible. After European and American contact, several of the Plains peoples became increasingly aggressive as their territory dwindled. Despite systematic attempts to obliterate their way of life (killing the buffalo and horses as well as relocation and confinement to reservations), Plains culture has shown a remarkable vitality. Some Plains peoples lived in permanent huts through-

out much of the year, briefly joining other groups for the summer buffalo hunt. Others were primarily nomadic, moving their TIPIS from place to place. Among the latter, art consisted of portable objects appropriate for their nomadic way of life—women made most of the apparel and objects for personal adornment (beadwork and quilling), horse trappings and tipis, while men painted narrative scenes on buffalo-hides and tipis and made dance and war paraphernalia. The most important Plains ceremony was the SUN DANCE. Two other cultural practices, the VISION QUEST and SWEAT LODGE ceremony were less widespread. As pressure from westward settlers became more threatening in the late 19th century, the millenarian GHOST DANCE flourished briefly. Peoples are generally subdivided by their language groups as follows in a partial list: Algonquian (Arapaho, Blackfeet Confederacy, Cheyenne, Plains Cree and Plains OJIBWA—the latter also known as Chippewa); Athapaskan (Apache); Caddoan (Caddo, PAWNEE, Wichita); Kiowa-Tanoan (Kiowa); Siouan (Assiniboin, CROW, Omaha, Osage, Ponca, MANDAN, Dakota, LAKOTA); Tonkawan (Tonkawa); and Uto-Aztecan (Comanche).

Plateau. A North American subdivision, the Plateau is surrounded by the Subarctic on the north, the Great Basin to the east, California and the southern Northwest Coast on the west and the Southwest to the south. The area is sometimes called the Intermontaine. The closest relationships up to the arrival of the horse were with the Northwest Coast, afterward, the Plateau was strongly affected by Plains cultural patterns. The primary native groups are the Shuswap, Kootenai, Lillooet, Coeur d'Alene, Kalispel, Spokane, Yakima, Palouse, Flathead, Cayuse, Walla Walla, Nez Perce, Molala, Klamath and Modoc. Art forms include rock art, basketry, bead-

work (Kootenai cradle boards are particularly elaborate) and ceremonial costume. Chief Joseph, the great Nez Perce leader, fought a skillful defensive war against the U.S. Army in 1877 known as the Nez Perce War or Chief Joseph's War. Faced with "voluntary" removal to a reservation, for nearly three months Chief Joseph led his people some 1300 miles seeking refuge. Former alliances with other groups were not honored and eventually to save those that remained, Chief Joseph surrendered. Initially most were sent to Oklahoma, but in 1885 they went to live on the Colville Reservation in Washington. Chief Joseph spent the remainder of his life attempting to get permission for his people to return to their homeland. He died in 1904.

Pleiades. The ESKIMO call the Pleiades Nanook, the bear and his hunting dogs.

Po. In Polynesian myth, the primordial darkness pre-existing human society (see RANGI).

Polynesia. Meaning "many islands," Polynesia was settled from southeast Asia (eastern Indonesia and the Philippines) over a long span of time, from before 1500 BCE to 1100 CE. This area of Oceania is further divided into western Polynesia (TONGA, SAMOA, 'Uvea, Futuna, Tokelau, Tuvalu, Niue and Rotuma); FIJI (included because, although it borders on Melanesia, its culture is closer to that of Polynesia); the Polynesian Outliers (Nukuoro, Kapingaonarangi, Tikopia, Anuta, Rennell, Bellona, Nukumanu, Skiiana, Ontong Java and West Futuna); eastern Polynesia (the MARQUESAS, SOCIETY ISLANDS, AUSTRAL ISLANDS, the Tuamotu Archipelago, Mangareva and the COOK ISLANDS). Outside the core of eastern Polynesia but also included are the apexes of the Polynesia triangle: the HAWAIIAN ISLANDS, EASTER ISLAND and New

PLATEAU

"...And when the last Red Man shall have perished from the earth and his memory among the white men shall have become a myth, these shores will swarm with the invisible dead of my tribe; and when your children's children shall think themselves alone in the fields, the store, the shop, upon the highways, or in the silence of the pathless woods, they will not be alone. In all the earth there is no place dedicated to solitude....The white man shall never be alone. Let him be just and deal kindly with my people, for the dead are not powerless....Dead did I say? There is no death, only a change of worlds."

—*From Chief Joseph's Unanswered Challenge.*

Zealand, see MAORI). Despite the far-flung locations of these islands, there is substantial cultural unity including similar cosmology (variations on themes involving the Primordial Couple Rangi and Papa and their four most important sons Tane, Tangaroa, Tu and Rongo); see INDEX: Deity Archetypes. Art forms show considerable diversity of style while reflecting underlying principles of aesthetics such as what Kaeppler (*Oceanic Art*) calls an "aesthetic of inequality," which served to dramatize the social hierarchies characteristic of Polynesia (see OCEANIA for general characteristics). Although Polynesian art objects were not thought of as static and unchanging products, they were meant to last. Many were labor intensive and used rare materials requiring great technical skill. Objects were believed to accumulate power (MANA) with age and use.

Pomdo. *Pomdo* (pl. *pomta*) is a modern KISSI word meaning "the deceased." These small steatite figures were made in the 16th century by the Sapi people of northern Sierra Leone. Characterized by squat bodies, oversized heads with protruding eyes and exaggerated sexual organs, none of these figures have come from controlled archeological conditions. The Kissi, who believe the sculptures act as intermediaries with their ancestors, wrap them in cloth and place them on small altars or in deep bowls with other amulets. Similar figures called NOMOLI were dug up by Mende farmers who associated them with the fertility of the earth. See WESTERN AFRICA and the GUINEA COAST.

Pomo. The Pomo lived in six dozen autonomous villages in the mountains north of San Francisco. The finely crafted baskets made by Pomo women were admiringly described by a member of Sir Francis Drake's 1579 expedition. Unornamented coiled and twined baskets had black and white geometric designs—depictions of

the human figure were forbidden, according to contemporary basketmaker Elsie Allen. Another prohibition was copying a medicine woman's designs. Ornamented baskets were festooned with abalone and clam shell as well as brightly colored bird feathers. Most valued were red woodpecker crests, augmented by green mallard feathers, black quail, yellow meadowlark and blue jay feathers. Feather baskets were made almost exclusively as GIFT BASKETS for very important people. Pomo women deliberately interrupt perfect patterns, introducing breaks, called DAU. Although the reason for these intentional imperfections is unknown, it has been interpreted as a spirit break—an outlet where the spirit can enter to inspect the basket or escape should the basket be destroyed. Before contact, Pomo women made baskets on the occasion of births. A new mother received red feathered baskets from her female kin and she, in turn, gifted the baskets to her mother-in-law. The infant's first bath was in a watertight basket and its mother carried it in a willow baby basket (called *sicka*) complete with a loop for hanging in a tree. Baskets also played parts in first menstruation confinements, weddings and funerals. Bodies were cremated along with piles of the finest feathered baskets. After contact, Pomo baskets quickly became collectors' items, from very large globular storage baskets to astonishingly miniaturized ones. Mary Benson (early 1870s – 1930) was one of the most accomplished Central Pomo basketmakers. The Museum of the American Indian has a collection of sixty-four baskets donated by Benson and her husband (for line drawings of two of Benson's baskets see CALIFORNIA BASKETRY). Today traditional natural materials are becoming difficult to obtain because of destruction of environment and restrictions on harvesting.

Pony Beads. The name comes from the fact that the beads arrived packed on the

POMO

Above: Burden basket made of sedge root, redbud and willow shoots. c. 1890.

Burden baskets were usually conical—the wide mouth made it easy to fill them and the conical shape fit well in the large mesh net and tump strap (worn across the forehead) for carrying.

backs of ponies. These European beads are earlier and larger than the seed beads that were generally preferred by North American Natives. The use of pony beads became more extensive in the early 19th century after the western groups on the Great Lakes adopted the use of the hole-and-slot heddle. This apparatus consisted of a rectangular grid of alternate slots and slats with holes in them, which separated warp threads and speeded up the tedious process.

Poro. A powerful male society found in several ethnic groups in western Africa. Among the SENUFO, Poro along with the female SANDOGO society, maintains balance within society, especially in relation to tensions that might occur as a result of gender differences. Nearly all art forms are connected with or used by the Poro society, which is responsible for the education and initiation of male youths and funerals of high-status society members. The fact that the head of the society is a high-ranking female elder is an indication of the importance of women in Senufo culture. Additionally, wooden cultivator staffs depict female figures as symbols of procreative power and society altars are graced with seated female figures representing the Ancient Village Mother. Offerings are made to these figures in the form of butter and white kaolin, the sacred color of the Sandogo society. The figures are made based on the advice of the women diviners of the Sandogo society. A dramatic Poro mask called *landai* (or *dandai*) represents a Poro society founder in the border area where Sierra Leone, Guinea and Liberia meet. Monumental in scale, the mask has a long wooden snout surrounded by feathers, fur and raffia. It appears during the boys' initiation cycle, abducting and devouring them at the beginning and returning at the conclusion to symbolically regurgitate the initiates. A similar duality exists among the MENDE, where the

complement of Poro is the SANDE society. *Gbini* and *goboi* are two nearly identical-looking Poro masks. *Gbini* is conceived of as the male complement of Sande society *soweisia* masks. Researchers disagree about the precise relationship between *gbini* and *goboi*. Ruth Phillips suggests that

goboi is the "speaker" for the more powerful *gbini* mask which rarely appears in public. Like the Senufo *landai* mask, *gbini* is a spirit that swallows Poro initiates and regurgitates them as adults. The masks are associated with the WILDERNESS and their white coloration connects them with the spirit world. Other Poro masks act as messengers (*nafali*) and clowns (*gongoli*).

Postures. Despite the enormous range of postures in which the human body could be depicted, a few seem to be universal. Felicitas Goodman has linked them with ecstatic states and transformations—especially with divination, healing and trance states. Relating them to SHAMANISM as well as to a large body of archaeological and ethnographic imagery and literature dating as early as the Paleolithic era, Goodman also studied their spontaneous appearance among a group of student volunteers. Although the postures are interchangeable and overlapping, one fairly

PORO

Left: Formerly, carved wooden headdresses like this were worn by SENUFO men in the region of Sinematiali during a public festival to mark the end of the intermediate phase of Poro training. At the end of the festival, initiates entered the sacred grove to undergo ritual death and rebirth, after which they began the final seven years of their training. The shape of the figure is reminiscent of the kanaga masks worn in DOGON MASQUERADES. 20th century.

POSTURES

Above: KWAKIUTL alter ego representation of "Bear Spirit" helper. Late 19th century.

consistent feature is the figures' wide-open eyes—their gazes seem unfocused and awe-struck as if they are witnessing scenes of incomparable beauty. Another shared quality is the sense that the figures that take these repeated postures are pervaded by a sense of energy and spiritual force. Three of these postures are found often in the illustrations in this volume. The first pose consists of figures with upraised, out-spread arms, hands with fingers spread, such as the COAST SALISH spindle whorl. In Western traditions the position of the hands and arms is known as the Orans pose and it is linked with prayer and/or worship. In indigenous cultures it seems to be closely connected with the HERALDIC WOMAN and parturition images. Second, there are figures with their hands placed either side of the waist, fin-gers meeting at, framing, or just below the navel, as in the ALTER EGO "Bear Spirit" representation. Finally, there are figures kneeling with one leg or both legs bent, hands resting on the lap or at the sides of the body. The MISSISSIPPIAN male and female figures from Etowah are striking instances of this final posture. Other pos-tures are associated with power and aggres-sion, such as the KONGO arms akimbo gesture. Called *pakalala*, the gesture of hands resting on hips, elbows outward, is a challenge pose in traditional wrestling. The posture is incorporated into *minkisi* power figures where it signifies the power of the figure to grasp the adversary, like a wrestler, and triumph. See also SAN.

Potlatch. From the Chinook jargon term meaning "to give." Originally practiced only in the northernmost areas of the NORTHWEST COAST, after European contact, the potlatch soon spread through-out the entire area. Hosts formally invited guests to ceremonies during which quanti-ties of gifts were given away and/or destroyed. Missionaries and government officials found the practice wasteful and as

Right: Carved wooden hats topped the hierarchy of chiefly regalia. This Tlingit Frog Clan hat is crowned with four woven rings, indicating that the chief who owned it spon-sored four potlatch feasts.

a result, the potlatch was forbidden between 1884 and 1951 under Canadian law—this did not prevent its occurrence, however. Scholars continue to debate the function, details and meaning of the cere-mony. BOAS based his work on the Kwakiutl potlatch, proposing that it was a

means of acquiring rank. Drucker and Heizer see it as a process of social integra-tion, leading to identification of the group and determining status within the group. Walens, by contrast, sees the potlatch as a religious ceremony aimed at increasing the circulation of souls among humans, ani-mals and spirits. Walens stresses three con-cepts he feels central to understanding Northwest Coast beliefs, the idea of a uni-verse in a constant state of flux and trans-formation, the importance of self-sacrifice and the web of mutual reciprocity between spirits, humans and animals. He suggests that the potlatch goes beyond profit and loss motives to a way of obtaining spiritual purity through philanthropy. Walens points out that although the environment was rich in resources, access to them was confined and difficult. The control of access was linked to the social system in which powerful chiefs and their clans owned fishing and hunting rights and were responsible for distributing the surpluses they obtained. Walens cites Raven's theft of the sun and his gift of it to humankind as setting the scene for human acts of gen-

erosity, reciprocity and sacrifice. The pot-latch, thus, was a vital means of maintaining order and balance in human affairs in a way that is in keeping with Northwest Coast cosmology.

Pottery. One of the oldest art forms of humankind, pottery is unevenly distributed throughout indigenous cultures. Pottery use is widespread in Africa, but is little known because it appears humble in comparison to carved wood figures and masks and metalwork. Nonetheless, Mangbetu anthropomorphic pottery is finely crafted. Early LAPITA culture pottery remains are evidence of sophisticated pottery techniques in the Pacific. KWOMA pottery, made by men, occupies an important role in this New Guinea society. More commonly, in keeping with the division of labor entailed in gender roles, pottery is made by women. Clay is a soft, maleable material that comes from the earth, used fittingly to create vessels for food and water. The material, process and form of pottery involve the parallel between the nurturing mother earth and women as mothers, artists and food providers. Enormous quantities of Native American pottery were made exclusively by women until recently. PUEBLO POTTERY, in particular, is well documented. See INDEX: Pottery in Art, Artifacts and Techniques.

Poutokomanawa. The central pole of MAORI meeting houses (WHARE WHAKAIRO). With their realistic, calm and dignified faces, the full-round ancestor carvings found at the foot of the pole differ from other Maori carvings, which are marked by aggressive expressions. Maori art, in general, can be seen as involving a balance between overall bilateral symmetry and dynamically asymmetrical details and colors (see MAORI AESTHETICS). The unusually composed faces of the central figures may thus reflect the importance

and significance of the pole as a symbol of the CENTER, the stable *axis mundi* around which all else is in motion.

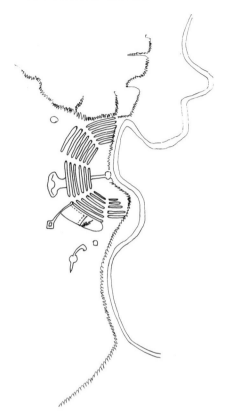

Poverty Point. The largest and most complex early Woodlands site in North America, located in West Carroll Parish, Louisiana, begun around 1200 BCE. Domestic structures were built on six concentric embankments forming a huge semicircle facing the bluffs overlooking the Macon Bayou. The ten-foot-high rectangular embankments covered an area measuring eighty by one hundred fifty feet. Archaeologists estimate that people carried thirty million loads of soil to build the 3,950 foot diameter crescent. Mound A, seventy feet high and six hundred forty feet across, sat behind the central set of embankments and took the form of an enormous bird, wings extended. Three other mounds, their purpose also unknown, are found nearby. Poverty Point burials contained effigy pendants and beads, trade valuables from far-flung loca-

POVERTY POINT

Left: The great crescent-shaped earthworks and the east-west axis of the bird-shaped Mound A are aligned to mark sunrise on the equinoxes.

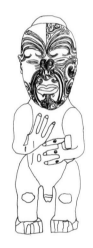

POUTOKO-MANAWA

Above: Center post figure (poutokomanawa), Rongowhakaata people. The realism and calm dignity of this youthful, recently dead ancestor (his moko are incomplete) contrasts with the protective aggression of the side posts (see WHARE WHAKAIRO). After 1800.

tions (the Great Lakes, Appalachians and the Florida Peninsula) and the first known human figures (in fired clay), many of which appear to be pregnant females, indicating a fertility cult of some sort.

Powwow. Word describing a gathering of WOODLANDS and PLAINS PEOPLES for ceremonial purposes, especially for dancing. There are several possible origins of the word such as derivation from an Algonquian word for a gathering of medicine men and spiritual leaders for the purpose of healing. The LAKOTA used the word to refer to a ceremony of undetermined, but substantial antiquity. The Ponca powwow, discussed below, was originally called He-thus-ka, or the Man Dance. In addition to healing, great warriors were honored during powwow, dead ancestors memorialized and name-giving rituals were performed. These ceremonies occurred during the summer months when several bands came together for communal hunts, trading, feasting and celebration. Elaborate costumes consisted of quillwork, beadwork, ribbon and leatherwork and signified warriors' status by particular feathers. Women's jingle dance costumes had metal disks, traditionally made from tobacco can lids, and predated "fancy dancing" which began in the late 19th to early 20th century. Most powwows today involve dance competitions where costume, dance form and ability and participation are judged. Among the Ponca, the powwow was said to have originated with a young Ponca who saw a fight between two buffaloes—when the old buffalo won, he began to sing and dance and taught the ritual to the youth and told him to take it back to his people. The word powwow apparently didn't come into widespread use until the Wild West shows began—the Ponca He-thus-ka Man Dance was called a war dance by white promoters to make it more exciting and to perpetuate the stereotype.

Praying Mantis. The ASMAT depict stylized praying mantis figures called *wenet*, which are said to be interchangeable with the human figures representing lineage. The praying mantis, one of several creatures associated with HEAD HUNTING, appears on ASMAT WAR SHIELDS, BIS POLES and spirit CANOES. The link with head hunting likely stems from the resemblance between the articulated limbs of the mantis and human extremities and from the mantis' cannibalistic dietary habits, as well as the fact that the female mantis bites off the head of the male following mating. Gerbrands also notes the human quality of the insects' movements and their large eyes. He suggests that they are like sticks come alive (*Wow-Ipits*). This analogy is of interest, given the symbolic importance of wood and trees among the Asmat who believe that humans and trees are interchangeable. The Sulka also represent the praying mantis on their masks. See INDEX: Insects in Animals; Asmat War Shields in Sign Systems.

Primordial Conditions. Attitudes and imagery connected with beginnings vary from culture to culture. There are, however, common themes evident in myth and ritual. Some cultures conceive of the primordial condition as inchoate and/or chaotic. The Aboriginal people of Australia, for instance, recall a time before the land and the things in it took shape, dreamed into existence by primordial beings. Liminal images such as androgynous figures and Janus faces/figures stem from the idea that the physical nature of humans evolved from genderless, childlike and sometimes aberrant forms. The simple contours and rather fetal appearance of some Eskimo *inua* masks may reflect the fluidity of primordial forms. In contrast, in other cultures, primordiality was believed to be a condition of harmony, beauty and unity. Ritual in indigenous cultures reflects the diverse concepts. Dogon masquerades,

in which eighty different masks may appear, recreate the multiplicity and creative energy of primordiality. On the other hand, Navajo sand painting ceremonies seek to restore the primordial state of harmony and beauty that is corrupted by evil and ugliness. The two should not be seen as a dichotomy, however, because in both cases, the primordial state is regarded as desirable, a time linked with life force, energy and creativity. Highly stratified cultures, such as those of the Northwest Coast, recreate primordial chaos to dramatize social order. In the Hamatsa ritual initiates' behavior involves transformation of the wild, antisocial, uncontrolled forces of nature into controlled, socially responsible human beings. See INDEX: Primordial Conditions in Miscellaneous.

Primordial Couple. Many indigenous cultures trace their descent to a primordial pair. See INDEX: Primordial Beings in Deity Archetypes.

Primordial One. Some creation myths trace human origin to a single cosmic being that is simultaneously male and female (although one sex may predominate). Similarly, human beings are made up of both male and female parts, inherited from the Primordial One and from both parents. Among those groups which share this sort of creation story, architecture often takes the form of a cosmic diagram, picturing the body of the creator being. See INDEX: Primordial Beings in Deity Archetypes.

Proverbs. African art often incorporates visual references to proverbial sayings. Proverbs serve as a rich repository of encapsulated wisdom. Also, in highly stratified societies, proverbs are "illustrated" on status items, such as the AKAN GOLD-WEIGHTS. These objects, supplemented by the message of the proverb, augment and draw attention to the importance of

their owners. Many other Akan objects involve proverbs such as Asante ADINKRA and KENTE textiles and KUDUO. Other instances of word and image working together to convey personal power and status can be found among the FON and in KUBA ROYAL PORTRAITS. Beyond serving as markers of status, there is another purpose for the unique combination of visual and oral traditions. As M.D. MacLeod suggests, with regard to ASANTE proverbs, they provide an indirect way of discussing difficult subjects. Woyo carved wooden pot lids (sing. *mataampha*) achieve the same purpose. Woyo women enjoy a certain amount of freedom in this matrilineal society, but proper marital relations do not allow wives

PRIMORDIAL COUPLE

Below: DOGON paired figures are identified as the primordial couple–actually, the people traced their ancestry to four pairs of twins. In this famous piece, the couple is seated on a stool that is said to be an imago mundi. Two pairs of small figures act as caryatids, while the couple's legs complete the symbolic number eight. The female bears an infant on her back, while the male has a quiver identifying him as a hunter or warrior.

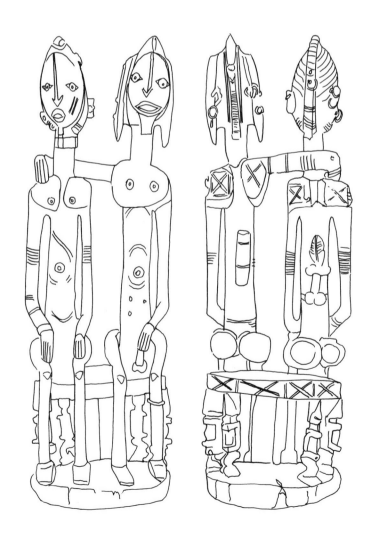

to voice criticisms overtly to their husbands. Instead, they achieve their ends by serving food in a vessel topped with a lid that conveys the message through a combi-

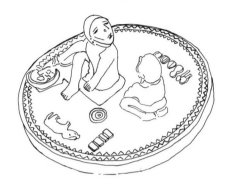

nation of figurative representations and proverbial references. Meals are communal occasions and the message is not lost on the husband or on other family members or guests. The proverb provides a verbal buffer, which is further softened by its nonverbal representation on the pot lid—one wonders what possible recourse Woyo husbands have against such gentle diplomacy. Pot lids can also be used to convey respect and encouragement. See also HAUSA, LEGA and Luba memory boards discussed as MNEMONIC DEVICES.

Pueblo Architecture. See SOUTH-WESTERN ARCHITECTURE.

Pueblo Bonito. The largest and most dramatic cities of the ANASAZI Chaco Phenomenon, Pueblo Bonito was built between 935 and 1150 CE. The arc of the multistory semicircular structure backed up against the towering 100-foot high cliffs. Covering three acres, the south baseline measures approximately 500 feet and the radius is 310 feet. Four stories high, containing as many as 800 rooms, it is said to have been built by a work force of 250 to 300 with women playing a major role as they do in modern Pueblo cultures. Windows apparently pierced the curved perimeter wall, but there were no doorways. Reconstructions show curved tiers,

rising toward the high back wall, with ladders that provided access to the levels and to the rooms. The rooms at the bottom of the structure were likely used for storage. The small circular rooms (twenty- to twenty-five-foot diameters) probably served as KIVAS for individual clans, while the larger ones (up to sixty feet in diameter) were for unified ceremonial activity. The extraordinarily refined dry stone masonry of the earlier parts often shows great sensitivity in the selection and placement of stones. The unusual T-shaped doorway is characteristic. It is suggested, based on the breadth of later Pueblo ceremonial headdresses, that the enlargement of the door's upper part may have permitted performers to move through without restraint. At its height, Pueblo Bonito was a thriving city linked to other Chaco cities by a network of roads. It may have been the center of a trade network that monopolized turquoise produc-

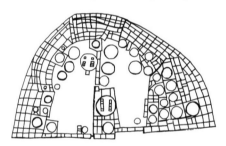

PROVERBS

Right: Woyo pot lid with proverb. The lid shows a wife facing her husband who points to a food dish. It "illustrates" the proverb, "If you have nothing available to prepare for your husband, put a few pieces of manioc in the plate." The wife faces her husband's displeasure because it is her duty to prepare and serve food. The proverb, visually acted out on the lid, helps her communicate that her lapse is the result of her husband's failing his obligation, namely to provide the food itself.

PUEBLO BONITO

Right top: Plan of Pueblo Bonito.

Right bottom: View of a room with a T-shaped doorway. The trapezoidal opening provides two "benches" either side of the door.

tion. Turquoise was not only a prestige item for personal adornment, its spiritual connotations resulted in the growth of Pueblo Bonito as an elite political and religious center. There are a number of puzzling unresolved questions about Pueblo Bonito, the most surprising of which is that although the city was inhabited for over 150 years, with a population numbering between 2,000 and 10,000, only about fifty to sixty burials have been found. There is also an unusual amount of broken pottery, 125 vessels for each family, in comparison to other archeological sites.

Pueblo Ceremonialism. Pueblo communities followed and continue to follow a complex calendar of rituals aimed at increasing fertility and prosperity within the community as a whole. Organized priesthoods and religious societies carry out the rituals. NAVAJO CEREMONIALISM, by contrast, is more individualistic and concerned with personal health. See also Hopi ceremonials, NIMAN, SOYALA and ZUNI.

Pueblo Peoples. All Pueblos are agriculturalists, although the western Pueblo villages—Acoma, the Hopi and the Zuni—located in spectacular arid landscape must depend on irrigation. The eastern Pueblos, with access to the Rio Grande River, live in a more fertile environment. The architecture, ceremonies and social organization of these two areas differ. The KACHINA cult is strongest in the west and hunting cults that performed various animal dances were more important in the east. All Pueblo peoples share a cosmology with a layered cosmos, a creation myth in which human beings, after several earlier destructions, emerged on the earthly plane of the fourth world (third among the Hopi). Pueblo communities are tightly-knit, cohesive bodies that inhabit a world full of sacred forces. Most Pueblo communities consider themselves to be living at the CENTER, although their gods live elsewhere at least part of the year. Pueblos are generally categorized by language. Keresan speakers include the western Pueblos of Acoma and Laguna and the eastern Santo Domingo, Cochiti, San Felipe, Santa Ana and Zia. Kiowa-Tanoan speakers are subdivided into the Tiwa branch (Taos, Picuris, Sandia and Isleta) and the Tewa branch (there are six Tewa Pueblos: San Juan, Santa Clara, San Ildefonso, Tesuque, Nambe and Pojoaque). The Hopi speak a Uto-Aztecan language. The Zuni language is distantly related to Uto-Aztecan and Tanoan. To the south of the Pueblos, Yuman speakers live in Arizona, Southern California and Baja California. Politically, the area was controlled by the Spanish from 1598 (interrupted by the PUEBLO REVOLT of 1680–1692); briefly by Mexico between 1821 and 1846 and thereafter by the United States government. Years of legal discussion followed, finally resulting in much-reduced but firmly established reservations. Beyond contending with the military, other Native North Americans and missionaries, the Pueblo people had to deal with "yearners," or *aficionados*. After World War I, intellectuals, scholars and artists flocked to the area in search of spiritual wholeness. Yearners varied from those with genuine respect and affection such as Mabel Dodge Luhan, D. H. Lawrence and Georgia O'Keeffe to the superficiality of some sixties hippies. The most sought-after art of Pueblo people in recent times is pottery. MARIA MARTINEZ and her family at San Ildefonso Pueblo raised pottery to a high art form from the 1920s onward. Their economic success led to a renaissance in Pueblo pottery. Cochiti artist Helen Cordero's storyteller figures, seated women with open mouths and many children attached to arms, legs and lap, became popular tourist items in the 1970s. Cordero invented the type, although the Cochiti did make figurative animal pottery in the late 19th century.

Pueblo Pottery. Although prehistoric pottery traditions including Mogollon, Hohokam and Chacoan had an impact on Pueblo pottery, it is on the whole a recent development. Pottery is traditionally a woman's art; only women, daughters of Mother Earth, could take clay, asking "Clay Woman" for permission. Pueblo potters developed great technical expertise, beginning with locating clay sources, grinding and preparing the clay and finally shaping it into graceful bowls, jars and canteens, all made by the coil technique. Some earlier pottery was cord marked, but more recently polychrome painting is common. There are no true glazes in North American wares, the high shine of such recent black-on-black or red ware comes from painstaking burnishing (rubbing). The tendency to regard utilitarian vessels and women's art as being less significant than ceremonial paraphernalia like masks and figurines, has resulted in there being comparatively little information about the meanings of patterns. Other factors also undoubtedly play a part as well, such as the natural tendency to guard secrets from non-Natives and the uninitiated. As an adopted Zuni, Frank CUSHING was in a unique position, and women apparently spoke freely to him. He learned, for instance, that the porous indigenous canteen (the form existed prior to European contact) not only kept water cool through evaporation; its breast-like shape was metaphorical. Water, the source of life, was the mother's milk of adults, a sacred gift from the breast of Mother Earth. As it was impractical to place the spout anywhere but the top of the vessel, the nipple was referred to in the painted designs. Additionally, the coils with which the canteen was made followed the contours of the object, and the last ones in the curved center where the nipple would be, were completed by feel only. The women believed that were they to look at the closure, they might close off their own breasts. The con-

cept of keeping exits open—keeping life alive—is evident in the so-called X-RAY or heart line found in Zuni animal images and on the broken encircling lines inside food bowls. In later years, Cushing was told that the broken line also represented the potter's lifeline, signifying her awareness of her own mortality. Ruth Bunzel was told that women sometimes dream the designs they paint.

Pueblo Revolt. In 1680, Pope, a San Juan Tewa religious leader succeeded in expelling the Spanish from all the Pueblo villages in the Southwest. Twenty years later, the Spanish resumed control.

Pukamani. The word designates mortuary rituals, taboo conditions associated with the dead and the carved, painted wooden poles made by the Tiwi of Bathurst and Melville Islands. Measuring between eight and twenty feet high, the posts are erected on and around the graves some two months after a death. Before the 1930s, designs were simple and geometric, while by the mid-1950s varied, intricate, often representational designs were favored. The posts serve as memorials to the dead, as well as temporarily housing their spirits. At the conclusion of the ritual, the living are purified to rid them of contamination and to finally dispatch the dead. The *pukamani* are left to rot on the grave. It is also very likely that *pukamani* are symbols of the CENTER. The symbolic designs identify and attract the spirit of the deceased for its final send-off via the pole's vertical axis. A parallel interpretation is provided by SCHUSTER and Carpenter's arguments (see PATTERN) concerning the Y-shaped pole which is interpreted as a universal symbol of the anthropomorphic WORLD TREE and the genealogical family tree which connects individuals to their ancestors and mediates their transition into the realm of spirits and ancestors (*Patterns That Connect*). See ABORIGINAL AUSTRALIA.

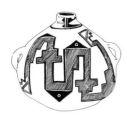

PUEBLO POTTERY

Top: Zuni water canteen with abstract bird and snake patterns. The Zuni called the hunter's double-lobed canteen "mammaries joined together" signifying the connection between water and life. Before 1880.

Botom: Acoma polychrome pot with traditional Zia-Acoma type bird designs by Lucy M. Lewis. 1969.

Queen Mother. The mother of the oldest son held a position of special power in BENIN. Although she was not permitted to see her son after puberty, constant contact was maintained through messengers. The Queen was said to have magical powers that she handed on to her son. These powers, the energy with which she supported her son's right of accession and her equality with the town chiefs may explain why the Queen Mother's palace was located outside the city walls—she and her son constituted the greatest threat to the Oba's power. The Queens had their own altars and their own special peaked coral-beaded CROWNS, known as a "chicken's beak." Queen Mother shrines have wonderful paired brass roosters, permanent, incorruptible offerings recalling the actual sacrifice of cocks and other creatures. Beyond the sacrificial association, the cock is a symbol for the Eson, the Oba's senior wife who trains the junior wives in court etiquette and ritual and oversees the women's quarters of the king's palace. Her praise name—evidence of her dominant character—is *Eson, Ogoro Madagba*, "the cock that crows at the head of the harem." The title Queen Mother was introduced in the 16th century by Oba Esigie to honor his mother for her help in averting disaster.

Quillwork. A sophisticated precontact art form found in the Arctic, Subarctic (Athapaskan), and somewhat later in the Great Lakes and Plains areas. Quillwork was probably among the earliest artifacts collected by Europeans. The simplest technique consisted of laying quills side by side and fastening them with twined sinew across the middle and near the ends. The quills were also twined or folded to produce bands and zigzag patterns. Both bird (probably goose) and porcupine quills were used, colored originally with vegetable dyes and later with aniline dyes introduced in the 19th century. Quills could also be woven directly on hide or on looms. Athapaskan patterns utilize basic "V" or diamond shapes to produce intricate repeating patterns. Algonquian quillwork, by contrast, uses alternating patterns (ABAB instead of AAAA) and individual elements are more complex, consisting of cross-shaped geometric patterns. Iroquois, Huron, Cree and OJIBWA quillwork was famous, with the final two producing the most elaborate designs. Geometric patterns predominated early on, but were replaced by pictorial designs in the late 19th century.

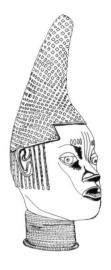

QUEEN MOTHER

Above: The brass heads representing the Queen Mothers of BENIN are finely crafted and sensitive works.

QUILLWORK

Left: Micmac birch-bark box decorated with colored porcupine quills with characteristic geometric patterns. Early 19th century.

R

Rain. Indigenous people understandably attach great importance to rain, particularly those who live in arid climates. The over 300 Hopi KACHINA spirits are spiritual intermediaries between the people and the gods associated with rain and fertility. Their essence is described as moist and cloudlike and their images overflow with rainbows, clouds, zigzag lightning and raindrops. Myths tell why the rains fall or cease, and ceremonies reenact such myths to bring the nurturing rain down. Rain is often associated with aquatic creatures such as toads, frogs, turtles and snakes. And it is often categorized by gender. The NAVAJO speak of "he" rain, the violent thunderstorms that drive the seed into the earth and "she" rain, the gentle rain that brings forth the first green shoots. In Africa, rain animals were pictured as huge creatures with exaggerated bellies sometimes resembling hippopotami or elephants. The SAN also distinguished between two types of rain: thunderstorms, "he" or male rain left deep footprints in the sand in contrast to the softer, soaking "she" female rains that "walked" across the land. Female raindrops formed "legs" referred to

as milk or blood. The shaman's task was to catch the rain animal and control it for human benefit. See INDEX: Rain in Natural Phenomena and Materials.

Rainbow. In many world myths, the rainbow is a path connecting the sky and the earth. It is so among the Navajo, who say it is the path of the yei, the Holy People. The rainbow is depicted arching around the sacred designs of SAND PAINTINGS. Furthermore, one Navajo creation myth tells of SPIDER WOMAN weaving the cosmos using raw materials that included rainbows. In Hawaii, the rainbow is connected with the highest chiefs and it adorns their robes and helmets, making their divinity evident. Although the arch shape of the rainbow is the most common, some peoples depict it as an entire circle. The FON rainbow python encircles the world and HUTASH, the Chumash Earth Mother is depicted in cave paintings as a multicolored circle. The multicolored aspect of the rainbow is important to other groups as well, as for instance, the ZUNI whose concept of beauty leads them to appreciate and emulate the most colorful things in nature such as butterflies. The Zuni see the rainbow as the exquisitely beautiful combination of all colors. Beyond its shape and its colorful beauty, the rainbow is a universal symbol of bountiful rain, growth and hope. See INDEX: Rainbow in Natural Phenomena and Materials.

Rainbow Snake. One of the most important ABORIGINAL AUSTRALIAN ancestor spirits, Rainbow Snake goes by many names throughout the vast conti-

RAINBOW
SNAKE

Below: Bark painting of the great serpent coiled around its eggs at the bottom of the sacred water hole. By Dowdi, of Millingibmi, Arnhem Land.

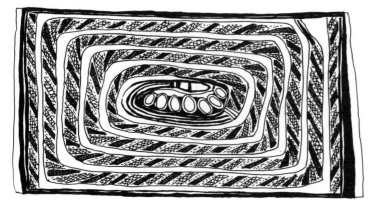

nent. Of cosmic proportions, the spirit is connected with fertility, rain and the increase/continuity of natural species and humankind. The spirit is fundamentally multivalent and indefinable—its gender is sometimes male, sometimes female, and at other times, ambisexual. It is not confined to any one time or locale, nor is it associated, like other spirits, with any specific landscape features. In the myths of some groups, it is the creator of humankind, which it vomits out. Surrounded by an aura of danger, which extends to those places associated with it, the spirit is often destructive and capricious. Curiously, the spirit is often not named, but spoken of indirectly. Very few ritual cycles are devoted to Rainbow Snake alone. The themes of Rainbow Snake myths serve to remind aborigines of the enormity of natural forces and the potential danger of power, resulting in life-giving beneficial rains or death-dealing destructive monsoons. The well-known myth of the WAWALAG (Wagilag) SISTERS involves a serpent sometimes called Rainbow Snake, although a more correct identification probably is YULUNGGUL, the Great Python. The rainbow snake of Central Africa is responsible for rainfall and the great Rainbow Python of the FON surrounds the world as well as bringing rain. See INDEX: Animals.

Ram. Rams are found frequently in African sculpture where they symbolize power, particularly the power of rulers. Rams are reputed not to fight often, but when they do, they engage the enemy fiercely and indefatigably. Therefore, they symbolize the restraint necessary in a good ruler, as well as aggression and perseverance. Ram imagery seems to center in Nigeria where it has been associated with influence from Ancient Egypt or the Yoruba kingdom of Owo. As a domestic animal, Ben-Amos associates the BENIN ram with civilization and "the home" as

opposed to creatures linked with the wilderness ("Humans and Animals in Benin Art"). Carved ram's heads are placed on ancestor altars, along with goats, chickens and cows, as surrogate sacrifices, conveying the wealth and respect such sacrifices indicate. Ben-Amos writes that

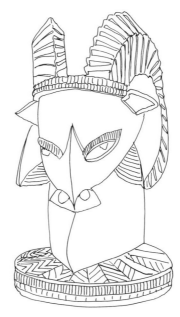

RAM

Left: Benin Ram's head, from Owo, Nigeria. In BENIN, ram's heads were placed on ancestor altars where sacrifices were made during the yam harvest. 19th century.

human relationships with these creatures involves aggression, hostility and consumption and that their images express domination. As symbols of nobility, then, rams indicate the right to dominate and kill the less powerful. This power symbolism undoubtedly explains why pectorals of rulers and high-ranking individuals were adorned with ram's heads. One such Benin pectoral, now in the British Museum, was found in 1907 by a man digging a well. The JEBBA figure wears a ram's head pectoral on his chest. It is also likely that in Benin, the ram's horns were linked with fertility, as ram's heads were placed on ancestor altars during the yam harvest. Among the YORUBA, the ram is SANGO's animal. The horns of Igbo IKENGA sculptures are those of rams and rams' horns are also prominent in *mgbedike* masks (see IGBO MASQUERADES). Outside Nigeria, Baule GOLI *kpan pre* (junior female)

masks have backward curving rams' horns. For additional references to the ram, see INDEX: Animals.

Rambaramp. High-ranking elders in MALEKULA celebrated their own funerals while they were still alive which enabled them to acquire another grade within the rank-based society and raised them to the equivalent of a (still) living ancestor. This practice ensured that the ritual was carried out properly, conducted as it was, under the watchful eye of the candidate himself. After death, a sculpture was made, using the SKULL of the deceased, a practice continued even today, overmodeled with a secret mixture of chopped plants (compost) and soil from riverbanks, to reconstruct the living face. Rather rudimentary emaciated-looking bodies, some of which have wooden arms and legs, support the skulls. Body painting included arm and leg bands, and the figures hold the jaws of pigs or nautilus shells. The sculptures were traditionally set up in the men's house, then later removed and allowed to disintegrate. When disintegration was complete, the skull was placed in an ossuary. As long as the *rambaramp* figure was intact, the substance of the deceased was regarded as still physically present, but through ritual, memory of individuals' accomplishments (rank) outlived the physical body.

Rangi (Ranginui). Sky Father of Polynesia. Rangi and Papa (Papatuanuku), Earth Mother, had seventy children who governed the lesser forces of nature and the affairs of humans. Some of the children were Tane (god of the forests), Tangaroa (god of the sea), Maui (a culture hero associated with fishing—he fished up the North Island of New Zealand). The Maori say that originally, there was only cold, dark nothingness (Te Kore). Then Rangi clothed the cold earth, Papa, with vegetation and as she became warmer, she gave birth to the gods. Still there was no light between Rangi and Papa and the gods suffered in the constricted space and darkness. Finally, Tane used all of his strength to push his parents apart, hands plunged like roots into mother earth, he pushed his legs upward, bent like branches (see INVERSION). Tane set props between them, and light flooded the world. Rangi and Papa show the sadness of separation in the falling rain and rising mists. Allan Hanson sees the myth as characteristic of what he calls ambivalent tension, noting the dilemma—union is fertile but confining (united, Rangi and Papa gave birth to the gods, but there was no light or space) while separation is liberating but sterile. Hanson sees parallels in Maori art and suggests that the attitude pervades the Maori worldview. Various accounts are given of the creation of man. One Maori myth gives the honor to Tane who created the first woman, Hine-hau-one and made her pregnant. See INDEX: Deity Archetypes.

Rapa. Easter Island DANCE PADDLES are among the most finely crafted objects from the island. Nearly identical, the paddles have smooth, elegant, curvilinear hourglass-shaped forms. The top represents a highly stylized human face with arched eyebrows that mirror the curvature of the top. No eyes are delineated, but a slender nose ridge and elongated ear lobes terminate in polished hemispheres. The face has been compared to that of the skull-faced creator god Makemake. The lower section has been interpreted as a protruding tongue or an abdomen. The penis projecting out of the base makes the second interpretation more viable. Held by the middle, the paddles were swung in circular motions during dances. In ancient times *rapa* were said to have been used to ward off evil spirits from sweet potato crops or in bird cult ceremonies.

Rapanui. Indigenous name for the people, language and land of EASTER ISLAND.

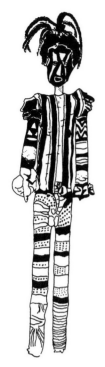

RAMBARAMP

Above: Life-sized figures, regarded as substitutes for the decayed body of the deceased, continue to play a part in funeral rituals in MALEKULA. Ideally, the figure should capture the image of the deceased at the moment he passes over to the world of the ancestors.

RAPA

Above: Wooden dance paddle from EASTER ISLAND. 18th –19th century.

Raven. The TRICKSTER/CULTURE HERO Raven is one of the most important deities of the Northwest Coast. The HAIDA tell how Raven disguised himself to enter the house of Sky Chief to steal the sun, moon and stars, which he gave to humankind to illuminate the dark world. Thus, Raven is also a Culture Hero, as he supplied human beings with light and fire. Furthermore, in his encounters with other supernatural beings, he often acquired useful things such as the salmon, most material goods and, especially, the idea of the house stolen from Beaver. According to another myth, Raven found a giant shell on the beach. It opened a bit and he could see tiny figures inside. He overcame their fear and coaxed the first humans out of their shell. Unfortunately, Raven was also responsible for human death. When the creator entrusted Eagle with the job of awakening human beings after they died, Raven was displeased as he depended on carrion. He convinced the creator and Eagle not to restore humans to life and has had no shortage of food since.

Raven Rattles. One of two types of carved wooden rattles characteristic of chiefly and shamanistic regalia on the NORTHWEST COAST. Although it may seem unusual for an object to be associated with what in Western terms are identified as the secular and spiritual authorities, this separation is not as precise in indigenous cultures. As Berlo and Phillips point out, we would be better advised to see this as a continuum from the very sacred, with a substantial overlap in the middle, to the mundane. Raven rattles commemorate the TRICKSTER/CULTURE HERO's gift of the life-giving sun to humanity. The lower part of the rattle shows Raven, his belly carved with the face of the shared soul of Raven and humankind. Lying atop Raven's back is an image of a dead man, his vital force depicted as a red bridge like a tongue arching into the mouth of another creature,

often a frog, a symbol of life. In Raven's beak is a small red object representing both the sun and the man's soul. Chiefly regalia were not complete without a Raven rattle which the chief shook to emphasize his speech. Bill Holm mentions that these rattles were always carried pointing down-

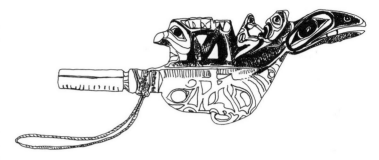

ward because of a myth telling how an upward directed rattle came alive and the bird flew away. Walens counts the Raven rattle among the most significant of Northwest Coast objects, suggesting that it is a powerful image and activator of the vast forces of life, death and the cycle of rebirth. The second type is called the Oystercatcher rattle.

RAVEN RATTLES

Above: KWAKIUTL Raven rattle from Sullivan Bay.

Ravenstail Robes. The earliest form of weaving on the Northwest Coast, these intricately patterned robes were elite apparel based on basketry designs. Woven by women, these 18th-century robes were pictured by Russian artists as early as 1816. Made until the early 19th century, Ravenstail mountain goat wool robes had white borders and interior geometric designs in black, white and yellow. The figurative CHILKAT-style robe gradually eclipsed this type of robe.

Rebirth (also second birth). See BIRTH.

Reid, Bill (1920–1998). Born to a HAIDA mother and German-American father, Reid played a major role in the revival of traditional Haida art. Serving as an apprentice on a late 1950s grant to recreate a Haida village on the campus of the University of

British Columbia in Vancouver, Reid learned woodcarving techniques. He honed those techniques by replicating the work of his great-great-uncle, Charles EDEN-SHAW and studied Haida art in books and museum collections. Working within tradition, Reid began to enlarge the scale of his pieces, creating sculptures that were

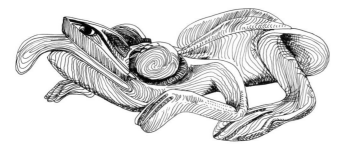

REID, BILL

Above: Phyllidula, the Shape of Frogs to Come. Yellow cedar. 1985.

increasingly innovative. His work had achieved international recognition and was avidly collected by the 1970s and 1980s. The nearly twenty-foot-long bronze *Black Canoe* stands outside the Canadian Chancery in Washington D.C. and a second casting with a green patina called *The Jade Canoe* is located at the Vancouver airport. The Chancery piece was delayed as Reid refused to work on it in protest against clearcutting of timber on Haida Gwaii. He resumed work with the establishment of the South Moresby National Park Reserve in the late 1980s. He continued to work despite being afflicted with Parkinson's disease.

Religious Structures/Precincts. See INDEX: Architecture in Art, Artifacts and Techniques.

Right. See DIRECTIONAL SYMBOLISM.

Rites of Passage. Arnold van Gennep first used the French phrase *rites de passage* in his 1909 book by that name. Transition and change are periods of anxiety in all societies, especially pre-technological societies where change was especially threatening because of its rarity. Ceremonies and rituals serve to alleviate the anxiety, to

integrate society and provide continuity. The main transitions for all people are BIRTH, INITIATION, MARRIAGE and DEATH. In stratified societies, the principal leaders undergo INSTALLATION rituals and, in some cases, may be ritually or actually killed. All of these rituals incorporate symbols and images to achieve the goal of transforming the individual and incorporating him/her into society. Myerhoff, Camino and Turner write that these rites of passage play out a number of paradoxes. First, human lives are lived out in suspension between the borders of nature and culture—they both preserve and celebrate change and continuity. Second, they reveal the conflict between individuality and society. Individuals undergo the ceremonies that by their nature are communal events, which integrate the individual into society and preserve shared ideals and the sense that life is meaningful. At the same time, all human beings, even in the most integrated societies, are born, pursue their individual destinies and, finally, die alone. Ritual, Myerhoff and his collaborators feel, exposes these paradoxes and exaggerates them thereby heightening tension. Because of the irresolvable nature of the paradoxes, no actual resolution is possible, but ritual, by revealing the paradoxical nature of existence, serves to make the world more comprehensible. Van Gennep in 1907 identified three phases within the structure of rites of passage: separation, transition and incorporation (elsewhere these phases are discussed as isolation/withdrawal/seclusion followed by education and finally return, see INITIATION and BIRTH). The period of transition has been identified as a LIMINAL state first by van Gennep and expanded by Victor Turner, a period during which the individual's worldview is inculcated in ways that establish the beliefs and practices current in the society. For example, many initiation rituals involve role reversal in the form of transvestitism as a

way of severing boys from their close association with their mothers and emphasizing their proper male roles.

Ritual. Term for the collection of events and behaviors that human beings engage in to understand themselves, their communities and the broader world around them. Evan Zeusse's work provides a helpful framework for understanding ritual. Zeusse defines ritual as the conscious, voluntary, repeated and stylized symbolic bodily actions that center on cosmic structures and/or sacred presences. Ritual is located in the body, since without bodies humans could have no experience or awareness of the world. The simplest sensory experiences often form the basis for ritual symbolism, especially eating, sexuality and pain. In ritual, these bodily sensations are transformed into symbolic experiences of the divine, even on a cosmic scale, which often results in humility and "recentering." The recentering enables individuals to go beyond merely personal and societal concerns and gives meaning to life. Zeusse presents several systems for understanding ritual. Structuralist approaches are found in the work of Freud (1913) and Durkheim (1915) which distinguished two types of rituals. Durkheim categorized rituals into positive and negative. Negative rituals, such as TABOOS separated the sacred from the profane, preserving the transcendent character of the former. Positive rituals (primarily sacrifice) unified sacred and profane. Freud's totemistic sacrifices, by reenacting primordial parricide, were of the latter type. Anthony Wallace's (1966) functionalist system classified rituals as follows:

Technological rituals aimed at controlling nature—divination, increase, protection;

Therapy and antitherapy rituals—curing vs. witchcraft and sorcery;

Ideology rituals aimed at controlling social groups and values—RITES OF PAS-

SAGE, TABOOS, judicial;

Salvation rituals enabling individuals to cope with personal difficulties—possession, SHAMANISM, mystical rites and expiation; and

Revitalization rituals aimed at societal issues—millenarian movements.

As Zeusse points out, there is considerable overlapping between these categories. Zeusse provides his own (structuralist) approach, differentiating between confirmatory rituals (those which confirm, unchanged, the divine order such as taboos, blessings, prayers and meditation) and transformatory rituals (rituals that bridge divisions and regenerate the divine structure such as rites of passage, calendrical rites, consecration rites, conversion rites, restorative rites and millenarian or revitalization rites).

Rivers. Myths often tell of the paths of rivers being created by the movements of water creatures like snakes or crocodiles—the IATMUL believe that a crocodile swishing its tail created the Sepik River. Spirits inhabit rivers all over the world and people make offerings in rivers to guarantee fertility of fish and women (see KALABARI, MENDE, TADA, TWINS). Rivers are also linked with rebirth. ASMAT initiations involve an actual river journey and immersion of the boys, who are reborn. In Malekula RAMBARAMP funereal figures made for high-ranking chiefs as part of ceremonies that raise them to the status of living ancestors incorporate soil from the riverbank as well as other magical substances. In Arnhem Land, the people conceive of the MILKY WAY as a great river in the sky where a great star-studded crocodile swims. Finally, in North America, the river is a metaphor for the constant flux and motion of the world and of human existence.

Roach. Woodlands, Plains and Plateau warriors shaved their heads, leaving only a narrow short crest from the forehead to the nape of the neck. One long lock often tightly braided and decorated, the scalplock, was left hanging from the crown or at the back. The scalplock was some-

ROACH

Right top: Artificial Sauk roach made of porcupine and deer guard hairs, 1910.

Right bottom: The carved elkhorn roach spreader was used to attach the roach to the wearer's own hair as well as to keep the roach upright.

times wrapped except for the splayed end and made to stand upright over the head, like a small parasol. The scalplock was the most valuable spoil of war. Extra drama was achieved with artificial roaches made from animal hair (deer and porcupine guard hair, horse or skunk hair and turkey beard), and attached to the warrior's own hair with a roach spreader. Although largely concealed by the headdress and plume, these were nonetheless important prestige items. The oldest spreaders, carved from thin plates of highly polished elkhorn, were made by the Osage, Mandan and Hidatsa. After the Osage were removed to Oklahoma in 1872, elkhorn was abandoned, replaced by other materials such as leather and even plastic.

Rock Art. Rock art is the broadest term used to describe the various ways indigenous people create images on rock. Rock art may be one of the oldest art forms and it is found all over the world. Definitions of more specific descriptive terms follow. Petroglyphs are designs made on rock by

carving, pecking, scratching, abrading and/or bruising. The designs are visible because weathered, aged rock is darker in color than areas revealed by the above techniques. Pictographs are designs made visible by use of color applied as paint in six basic colors—red, black, white, yellow, green and blue—all obtained from natural mineral sources. Intaglios are made by removing surface gravel, thereby revealing lighter colored sand beneath (see EARTH WORKS). Ground paintings are the most fragile form of rock art, made by painting the ground with various earth pigments. Used in various ceremonies, none of these currently exist in North America. Native North American rock art images vary greatly in antiquity, style (from naturalistic to geometric) and degree of accomplishment. Speculations regarding purpose include marking (mapping) important locations, such as springs and camp sites, initiation rituals, depictions of spirits and legends, records of VISION QUEST images, and images associated with hunting rituals and magic. Rock art is vulnerable to destruction by vandals, environmental pollutants and land and industrial development. Some rock art sites are protected as historical landmarks. South African rock art associated with the SAN may date back as far as 8000 BCE. The ZUNI regard rock art as signs from the ancestors and believe it is imbued with power and of the on-going interaction between the spiritual and material worlds. See also CHUMASH ROCK ART.

Rongo. Lono in Hawaii. One of the four principal Polynesian deities, the god of cultivated (cooked) food.

Rotse. The term Barotse was applied by the Paris Evangelical Mission to the entire group of neighboring peoples in western Zambia that includes the Ndundulu, Kwangwa, Mbunda, Ila, Tonga, Lunda, CHOKWE and the dominant Lozi.

Saharan Rock Art. See TASSILI N-AJJER.

Samoa. Sharing cultural characteristics with nearby TONGA, Samoa consists of two nations: independent Western Samoa and American Samoa, a territory of the U.S. The Samoan social system consisted of four titled ranks, which were achieved by election or appointment and thus did not depend strictly on genealogy. Tattooing, oratory (elaborated in dance, music and comic performances) and the ritual mixing and serving of 'ava (see DRINKS) in highly crafted bowls were of great importance. Mats and bark cloth, fly-whisks, staffs and openwork wooden combs were prestige items. Margaret MEAD lived among the Samoans and *Coming of Age in Samoa* stemmed from her experiences. See map: OCEANIA.

San. The San, a term preferred to Bushmen which is regarded by some as derogatory, live in South Africa's Kahalari Desert. The San continue the tradition of ROCK ART that may date back as far as 8000 BCE—some 15,000 sites have been identified. Finely engraved petroglyphs are found on isolated rocks and paintings are located on the walls of rock shelters. Anthropologists have studied the ritual, religion and cosmology of San still living in the area to interpret the imagery, emphasizing SHAMANISM and the trance (or curing) dance. Among the most important were images associated with rain which was depicted metaphorically in the form of so-called "rain animals." These were pictured as huge creatures with exaggerated bellies sometimes resembling hippopotami or elephants. The San distinguished between two types of rain: thunderstorms, "he" or male rain left deep footprints in the sand in contrast to the softer, soaking "she" female rains that "walked" across the land. Female raindrops formed "legs" referred to as milk or blood. The shaman's task was to catch the rain animal and control it for human benefit. Other common imagery consists of geometric shapes including zigzags, chevrons, dots, flecks, grids, vortexes and U-shapes. Rock art scholars link these with ENTOPTIC PHENOMENA (visual illusions/hallucinations that occur in altered states of consciousness, ASC) experienced by shamans in their trances. The San have been using

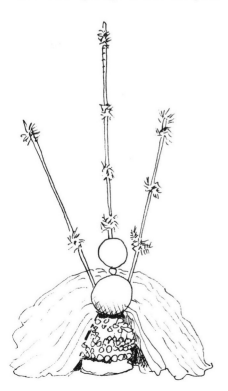

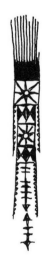

SAMOA

Above: The design motifs on finely crafted Samoan wood combs are the same as those on bark cloth.

Left: Headdress called tuiga worn for 'ava mixing and dancing made of a bark cloth cap topped with human hair, shells and feathers.

SAN

Top right: Two fragmentary rock engravings, one with pecked maze-like patterns and the other with concentric circles with radiating lines. c. 1800–800 BCE.

Bottom right: San engraved ostrich eggshell flasks from South Africa. The one with the linked circles is from Namibia and dates to the early 20th century.

Below: Three important San rites of passage are associated with the eland: girls' puberty and boys' first kill rituals, as well as marriage rites. J. David Lewis-Williams suggests that the eland is a linking or unifying symbol that promotes cohesion within San society as well as preserving balance between the human community and the rest of the world. Even more closely related to the eland, however, is the medicine man who "becomes" the eland in trance states in order to draw upon the creature's potency to effect cures and cause rain to fall. In the excerpt from the Barkly East painting, elands and human figures appear, all with lines streaming back from their heads representing their spirits departing during the out-of-body state. The so-called "flying buck" is said to be the eland-possessed medicine man.

ostrich eggshells as containers for some 15,000 years. Both men and women engraved designs into the eggs and rubbed colored earths into the designs that may have identified the owner. Since colonialization systematic enslavement and genocide have tragically reduced the San, a few of whom continue to cling to their heritage in the Kalahari desert. The work of scholars like J. David Lewis-Williams has done much to preserve San traditions.

Sand Painting. Also called dry painting. There are over 1,200 sand painting designs, which the NAVAJO call "the

place where the gods come and go." Together with the chanted songs, the images serve as MNEMONIC DEVICES, assisting the healer as s/he recounts myths as part of healing ceremonies. The materials and the techniques have divine origin. Done within the HOGAN of the afflicted person, the paintings are made of sand, pigments of ground minerals, pulverized charcoal, corn pollen, corn meal and other materials. The materials themselves are regarded as being alive, having come from the body of Walking Rock, the last of the monsters slain by the HERO TWINS. The elder twin, Monster Slayer, transformed the raw materials into forces for good. According to myth, the art of sand painting was learned from a deity who drew the designs in the clouds. Thus, once they have served their healing purpose, the intricate designs of traditional sand paintings were equally ephemeral. In size, paintings vary from small ones about three feet across to large, twenty-five-foot diameter designs that take the chanter and as many as forty assistants a full day to complete. When the design is finished, the patient sits in the center of the design and pigments from various parts of the design are

rubbed on his/her body. The patterns are extraordinarily diverse, but their arrangement is symmetrical (usually organized bilaterally or in quarters) and resembles the archetypal patterns associated with SHAMANISM such as the CENTER, WORLD TREE, FOUR/SIX DIRECTIONS, helping spirits/animals and the LAYERED UNIVERSE. Some of the patterns also resemble those found in rock art worldwide. ENTOPTIC patterns—crosses, zigzags, concentric figures and mazes—are also related to shamanism, and more specifically to the visual displays associated with altered states of consciousness. The sand painting pictures the ideal harmony and beauty of the primordial universe and by sitting within its confines, sufferers have access to that perfection as individuals. Today, shops specializing in Native North American art sell sand paintings stuck on masonite, but these are generally not made by healers. See INDEX: Pattern in Art, Artifacts and Techniques.

Sande. The MENDE Sande society is responsible for educating girls with regard to practical, sexual and ritual knowledge. The girls are taken from their families to a newly erected initiation shelter where they undergo excision. At present, initiations are shorter in duration and occur during school vacations. The wearing of masks by the women's secret Sande society is the only documented instance in Africa of female mask use. Mende use of masks dates back only to the 19th century and the Sande society may have originated with the Gola people. Senior Sande members, called *soweisia* (sing. *sowei*; pl. *bundu* among the Sherbro), oversee "medicine" and the masks which are kept in a special enclosure called the *kunde*. The Mende have no separate word for mask; *soweisia* refers to both the women and the mask, which is also called *ngafa*, spirit. The masks embody different sorts of spirits, all of which live in the rivers or the forest and

are dangerous and mischievous. Masks appear in public on three occasions connected with initiations, reminding others

of the powerful forces at work and keeping them informed. Their final appearance heralds the return of the girls to the community. The girls receive new clothing, the finest their families can supply. They dress, wash carefully and are feasted. Masks formerly appeared in judgment, and when a new mask was initiated. The shining black color of the mask, a sign of ideal beauty, is echoed in an all-black costume that includes herbal charms, animal horns and Islamic amulets. They have elaborate hairstyles, semi-closed eyes and layers of rings around their necks. The rings are said to represent the beauty and health of plump flesh and/or the concentric rings on the water's surface from which the Sande spirit emerges. The masks' attributes and the abundant cowry shells on the costumes convey wealth and health. The dance of the principal mask is rapid and intricate and the performance brings prosperity, liveliness and a feeling of well-being to the

SAND PAINTING

Above: Navajo sand painting called Endless Snake and Wind People, part of the Big Starway chant held to combat problems caused by ghosts and witches. When the painting is complete, the patient sits in it to absorb its medicine, in this case to cure tension, nightmares, sleeplessness, mental upset or fainting spells. The four spirals are said to encircle the four sacred mountains. Four of these paintings are made, with a black snake on the first day, followed by blue, yellow and white snakes on succeeding days. After a 1936 watercolor by Mrs. Franc J. Newcomb.

SANDE

Right: Sande masks represent the ideal of feminine beauty among the Mende–small facial features, high domed foreheads and elaborate hairstyles. The fleshy rings around the neck are regarded as beautiful, as they indicate health and fecundity. The rings evoke the concentric rings caused by the spirits as they emerge from the water. The gleaming black finish of the mask, from ritual applications of palm oil, is also part of the ideal. 20th century.

SANGO

Above: Painted YORUBA wooden dance wand for Sango, topped with a double axe (thunderbolt symbol), attributed to Arobanjan of Pobe, Nigeria. 1950–1960s.

The face of a Sango priest is like a mask. The back of his head is like a rainbow.

–Yoruba praise song, Ade Anike P.C. 1977.

community. On the other hand, the masks may comment satirically on social conduct, especially the shortcomings of men. Although *soweisia* spirits are female, Sande masks are named after important male warrior ancestors. The masculine personal name invests the mask with sexual ambi-

guity and potential aggressiveness. *Soweisia* masks form a balanced set—male/female, husband/wife—with PORO society *gbini* masks, together symbolizing the powers of both genders in the life of society and the family. Today, Sande continues to be a social and political force in Sierra Leone, despite having been weakened by Islam. For the complex aesthetic criteria applied to *sowei*, see MENDE.

Sandogo. A female society among the SENUFO, which along with the male PORO society maintains balance within society, especially in relation to tensions that might occur as a result of gender differences. The Sandogo society specializes in divination, invoking nature spirits representing the five primordial animals, the

python—the diviner's insignia—chameleon, hornbill, crocodile and tortoise. Diviners may recommend that the client commission brass amulets or special painted *fila* cloth, both of which protect and neutralize the source of disease and misfortune, the dangerous powers of forest creatures. Sandogo society members also are the keepers of kinship and genealogical knowledge. Thus, the society exercises social control and maintains purity, through memory.

Sandwich Isles. Name given the Hawaiian Islands by Captain COOK in honor of his patron, Lord Sandwich, First Lord of the Admiralty.

Sango. According to Yoruba legend, Sango was the fourth ruler of Old Oyo who was deified, becoming one of the most powerful ORISA. There are as many variations told of Sango's life as there are dualities and ambiguities to his divine nature. Said to be a terrible tyrant ousted by his chiefs, or an obsessed magician who brought destruction on his people, Sango personifies the burden of power, the crucial equilibrium between benign control on the one hand, and dangerous, destructive violence on the other. Like many other Yoruba *orisa*, Sango embodies *tutu* (see YORUBA AESTHETICS), a dynamic balance between desired and feared alternatives. An aesthetic ideal, *tutu*, or coolness, pervades Yoruba life, affecting all aspects of human behavior as well as beauty in art. A sky god, Sango is associated with FIRE, thunder, and lightning. The creative potential of fire is linked to sexual heat, as Sango is said to be the giver of children and the protector of TWINS. To balance the god's fiery sexuality, Sango's priests wear women's clothing and dress their hair in female styles. Initiates perform literal balancing acts, dancing with pierced vessels filled with living fire on their heads. The god's colors are the red of fire and blood and the white of

bone, as well as the dark ominous colors purple, maroon, and indigo. His animals are the ram and the dog, and sacrifices of bitter kola, palm oil, and chickens are made to him. Objects associated with Sango worship are dance wands, staffs, double axes, calabash containers for celts, called "thunder stones," and carved pedestals upon which the celts are sometimes placed. Beaded or decorated bags are hung in his shrines. Sango is said to have invented the *bata* drum, an instrument with two heads that produce very different sounds, corresponding to the contrasting voices of the god. Devotees of Sango inherit worship of the god from their parents or are possessed by the god in dreams, in the dance and trance states. Through possession, individuals literally become one with the god. Balancing violence, aggression and capriciousness with beauty and creative power, Sango's cult mirrors the forces at large in the world and at war within individuals. Parallels exist in other cultures. The German scholar Frobenius, who did fieldwork among the Yoruba at the beginning of the century, noted the similarity between Sango and the Norse gods Thor and Wotan. Like Sango's thundering double axe, Thor wields a hammer. Sango hanged himself from a tree as did Wotan and both are types of the self-sacrificing, dying-rising god.

Santeria. Thousands of YORUBA slaves arrived in the Americas in the 18th and 19th centuries, resulting in the transplantation of African belief systems to Cuba and Brazil. Santeria is the name of the religion that developed in Cuba. Because the people were forced to convert to Catholicism, the *orisa* underwent a transformation. Called *santos*, the disguised deities maintained their identity, but were "overlaid" with Catholic saints sharing compatible powers and attributes. For instance, SANGO "becomes" St. Barbara because her murderers were killed by light-

ning. Barbara holds a cup and sword said to be parallel to Sango's mortar and axe. Santeria ceremonies honor the gods and ancestors, and a variety of divination related to IFA is practiced. Santeria is increasingly important in the United States, especially in Florida and New York City. The transformation of Yoruba beliefs in Brazil takes a different form and is called Candomble.

Sapi. Living in Sierra Leone, the ancient Sapi people made steatite figures called NOMOLI.

Satimbe. A mask made by the Dogon of Mali topped by female figures depicting *yasingine*, the "elder sisters" of the mask. See DOGON MASQUERADES.

Sawos. The Sawos are linguistically related to their Middle Sepik neighbors the IATMUL, but they depend more on agriculture for sustenance. Like the Iatmul, the Sawos built impressive TAMBARAN houses, overmodeled human skulls and carved SKULL RACKS (*malu*), suspension hooks, flute stoppers and food bowls. Among the finest Sawos carvings are the larger than life-sized figures of founding ancestors kept in the men's houses where they were tied to the central post supporting the ridgepole. A half-dozen of these seven- to nine-foot-tall figures were collected in the 1960s and are now in museums around the world. The faces are painted with concentric patterns around the eyes and on the cheeks, while curvilinear lines follow the contours of facial features. These are said to be the mark of a successful head hunter. The crescent designs on the chest and the snake above the navel represent scarification marks obtained during INITIATION ceremonies. Other repeated motifs include joint marks, an unexplained diamond pattern surrounding the navel and kneecaps and raised, circular nipples and what may be more scarifica-

SAWOS

Above: Large figure representing the founding ancestor Mian Gandu who transformed the swamps into firm agricultural land. Yamok Village, Middle Sepik.

SCEPTER

Above: The KANAK gi okono was the most powerful symbol of the chief. The serpentine or jade blade was attached to a wrapped wooden shaft mounted on a half-coconut shell (often with rattles inside) wrapped with plaited coconut fiber or flying fox hair.

SCHUSTER, CARL

"Nobody has the vaguest notion of what this world is really like: the only thing that can be safely predicted is that it is very different from what anybody supposes....I avoid discussions of principles and devote my energy to building up a picture of the world as it is, by looking at it, instead of arguing about it, and drawing inferences from what I see."

–From a letter to Douglas Fraser, 1966.

tion patterns on thighs and upper arms. Further designs appear on the feet which on one figure resemble animal or reptile heads.

Scalplock. See ROACH.

Scarification. In Africa, scarification fulfills a variety of functions. For some, like the BAULE and Tabwa, scarification is a form of beautification that separates human beings from animals. It has been suggested that scarification was connected with the slave trade, providing a means of marking individuals to identify and facilitate the redeeming of those sold as slaves; or alternatively, to disfigure and thereby make people undesirable to the slave traders. Neither argument is accurate, according to Cornelius Adepegba and Joanne Bubolz Eicher. They point out that although slavers infrequently bought Igbo with facial scarification, it was not because of disfiguration, but because those so marked were more likely to rebel or commit suicide rather than submit to slavery. The parallel vertical lines on some NOK terracottas and on images from OLD OYO are believed to be scarification patterns made for cosmetic reasons. Scarification is often done during initiations to dramatize the transition from childhood to adult status—the blood flow symbolizing a second birth. Cicatrization, raised welts achieved by rubbing foreign substances into wounds, is common from southeast Nigeria to the Democratic Republic of Congo. Maori MOKO, although technically a form of tattooing, involves carving grooves into the face and body. See also TATTOO and INDEX: Scarification in Human Body.

Scepter. Chiefs and kings often carry hereditary SYMBOLS OF OFFICE in the form of a scepter. Such objects bear symbols of power and sometimes symbolize the chief's power metaphorically as a microcosm as is the case in Oceania, with the

KANAK ceremonial scepter (*gi okono*) from New Caledonia. This object, which has also been identified as a ceremonial axe, symbolized the power of the chief and the culture. According to one interpretation, the *gi okono* embodies the people's vision of the cosmos—the circular green serpentine blade representing the leafy tree top is mounted on a wooden shaft/trunk which is mounted, in turn on a knotted and woven hemisphere, the earth. Thus, like the WORLD TREE, the scepter represents the chief as the connecting link between the physical and spiritual worlds, between his people and the ancestors. According to another interpretation, the oval or circular green stone blade was analogous to the chief's head/headdress. When held up to the sun, the blade's thin edges are translucent. According to this line of interpretation, the blade could be an image of something "found," i.e., the essence of the chief before he became a child. The scepter, thus, contains the substance of the chief, his metamorphoses and all his links to the physical and spiritual worlds. Tree or vital essence, the scepter is clearly an object of profound significance within Kanak culture.

Schuster, Carl (1904–1969). A pioneer in the study of folk symbols, Schuster published widely (sadly, his manuscript on the Sunbird remained unpublished) and compiled an enormous archive of notes and photographs which is now in the Museum fur Volkerkunde, Basel. He traveled widely throughout Asia, served briefly as a museum curator, but devoted the last twenty years of his life to research. Twelve sumptuous volumes entitled *Materials for the Study of Social Symbolism in Ancient and Tribal Art*, edited by Edmund Carpenter, contain a part of Schuster's life's work on genealogical patterns. The material is synopsized in Schuster and Carpenter, *Patterns That Connect*.

Seal. See INDEX: Animals.

Seaweed, Willie (1873–1967). Famed Kwakiutl carver. See COPPERS and KWAKIUTL Crooked Beak mask, for illustrations of his work.

Secrecy. Secrecy serves to unify cultures and groups within cultures by exclusion. Men's secret societies exclude women and uninitiated boys as well as foreigners, thereby reinforcing their authority and power. In Oceania elaborate architectural structures (see MEETING HOUSES) dramatize the secrecy. Women are prevented from entering the buildings except in very special circumstances and, in some cases, must even avert their eyes in the vicinity. Initiation ceremonies remove the boys from the realm of their mothers and, by learning the secrets appropriate at their stage of life, they become members of the male community. In many cultures, both men and women pass through stages or grades. Individuals' understanding of the rituals may exist on many different levels and only the eldest members of society attain full knowledge of the secrets. Some secret societies preserve their secrets by using fear and intimidation. The most important rituals take place in private, closely guarded sacred spaces that can be entered only by initiates. Knowledge is often associated with visibility. This distinction between public and private also applies in the differentiation between rulers and commoners. The OBA OF BENIN, for instance, appeared in public only rarely and lived most of his life within the confines of the royal palace, totally out of sight of those he ruled. Some groups fear such invisible power. The PENDE, for example, equate lack of visibility with secrecy and witchcraft—only the most powerful and respected chiefs can afford complete privacy without being accused of sorcery. Thus, only the greatest chiefs have enclosed courts composed of a fence of living trees that effectively blocks the view from outside. Some secrets are encoded in SIGN SYSTEMS, graphic symbols understood by the initiated or in the form of various MNEMONIC DEVICES. See also SENUFO MASKS.

Sedna (or Niliajuk, "young girl). The INUA of the sea and undersea mistress of ARCTIC sea mammals, from the name given to her by the people of Baffin Island. A Central Inuit myth tells of the CANNIBAL child of giants who grew abnormally fast and had an enormous appetite. When Sedna's parents awakened one night to find her gnawing on them, they took her out to sea and cast her overboard. She clung to the sides of the boat, but her father cut off her fingers, which sank to the bottom of the sea becoming the seal, walrus and the whale. When she made a final effort to save herself, her father gouged out one of her eyes with his paddle. She sank to the bottom of the sea, fingerless and one-eyed. From her undersea home, she determines human life and death as she sends the creatures to the hunters. On Baffin Island Sedna was ritually killed during an autumn increase ceremony which included spouse exchange. The outcome of a tug-of-war predicted the weather for the coming winter. Sedna's husband was a huge hairless dog who guarded her territory and periodically brought death and disaster to human beings. Many versions exist telling of Sedna and her dog husband (sometimes a bird husband), who disguised himself as a human in order to convince her to elope with him. Sedna's home was also the abode of death, her monstrous dog husband standing sentinel at the door. The shaman's songs paralyzed the dog and he interceded for the souls of the dead. Sometimes Sedna, moved by his song of life, released the soul, which was free to return to the land of the living.

Self-Directed Designs. Designs on cloth-

ing applied in such a way that they are best viewed from the wearer's point of view. This orientation can be used to differentiate between indigenous North American designs and those influenced by European/American sources. The latter are oriented to impress the spectator. This self-direction should not be understood as mere self-gratification, however, as supernatural beings and personal guardian spirits are the intended viewers, seeing the beautiful designs through the wearer's eyes. See INNU, PLAINS PEOPLES.

Senufo. The Voltaic-speaking Senufo live in an area that includes the northern Ivory Coast and extends into Mali and Burkina Faso. Senufo art is extraordinarily rich, including masks and figurative sculpture of great refinement and power. Senufo religion posits a bipartite deity conceived of as male (divine creativity) and female (protection and nurture). This duality is embodied in the male PORO association and the female SANDOGO society that together help maintain balance within the community, especially conflicts arising from gender differences. The ancient mother deity, the most important ancestral deity and head of the founding matrilineage, regulates all cult activity. The male Poro society, headed by an honored female elder, is responsible for educating and initiating males, which takes place in sacred groves. A Poro society composite raffia and fabric masquerader called *yarajo* appears in funeral ceremonies for important Poro members. Although the mask appears to be acting humorously and nonsensically, fully initiated Poro members understand the secret, deeper significance. Two other major SENUFO MASKS are the *kpelie* face mask and the *kponyugu* composite mask. Poro society figurative sculpture includes *poro piibele,* "children of Poro," large (about two-thirds life-sized) paired male and female figures that appear during funeral ceremonies where they ease the

SENUFO

Right: Male and female figures whose secret names are "ones who give birth," or "ones who bear off-spring." The pair represents the ideal social unit, wise members of the Poro and Sandogo societies. Such "reborn" men and women embody those ancestors who have "suffered" for the group during their lives. The male figure wears an openwork headdress and holds a fly-whisk, both emblems of one of the stages within the Poro society. The female figure's scarification patterns and headdress identify her as an initiated member of the Sandogo society.

transition from living to deceased ancestor. Their over-arching purpose is to make the power of the Poro society continuously and publicly visible. These elongated figures, which range from fairly naturalistic to quite abstract, are often called rhythm pounders because those carrying them

swing them laterally and pound the ground with them. In the literature, they often are inaccurately identified as *deble,* a corruption of the Tyebara name for a bush spirit. The sculptures represent the Senufo ideal of mature physical beauty and behavior, with the female sometimes depicted larger, indicating the high status of women in Senufo culture. Details of scarification and adornment indicate rank within the Poro and Sandogo societies. The emphasis placed on paired figures is comparable to

the primordial ancestor figures made by the DOGON. Other important Senufo art includes carved doors, stools, heddle pulleys, weapons and KAFIGELEJO, composite figures made of wood, cloth, feathers and sacrificial materials, associated with judicial and punitive functions. The Senufo also make spectacular doors, see NAVEL.

Senufo Masks. The Senufo carve two major mask types, called *kpelie* (or *kpeli-yehe* and *kodoli-yehe*) and *kponyugu* (or *kponyungo*). The two dance at Poro society funerals, acting in tandem to commemorate the deceased and reintegrate mourners into society. *Kpelie* masks, danced competitively by junior grade Poro members, represent female spirits. These masks are made in both metal and wood, the metal ones used by smiths and brass-casters and the wooden ones by wood carvers. They are sometimes called "girlfriend," or "wife," and embody the beauty and sexual desirableness of young women. On a deeper level, the masks are associated with mother earth. The convex teardrop mass of the mask often flows into a concave heart-shaped form linking the arched eyebrows with the oval or circular protruding mouth. The small protrusion carved on the swelling forehead is a secret symbol of the vulva, known only to high-ranking immigrant artisans. The narrow rectangular slit eyes have an inward, somewhat sleepy gaze. Most *kpelie* masks are dark in color and highly polished. Elements added to the periphery of the mask include a top-knot crest composed of a bombax-thorn motif or hornbill bird as well as earrings, flattened sheep and buffalo horns, the symbolic meaning of which varies with the context and combination. *Kpelie* masks are sometimes carved with two faces. In keeping with Senufo dualism, the *kponyugu* mask is horizontal and bristling with energy. *Kponyugu* means "funeral head mask," or "head of Poro." The masks represent composite forest spirits with great toothy

crocodile jaws, hyena ears, bush cow tusks and antelope or buffalo horns. Other creatures including hornbills, chameleons or monitor lizards sit atop the mask. The chameleon, one of the Senufo primordial animals, is a symbol of transformation because of its ability to change colors. During the funeral ritual, the mask appears from the sacred grove, approaches the body already sewn into its shroud, places its drum on the ground and beats it with several short blows. The drum is then placed on the body, an act believed to separate and free the *nyui*, the deceased's shadow or life force, from the corpse. Janus-faced *kponyugo* masks are called *waniugo*. Perhaps the most important mask of all is the *yarajo* (or *yalimidyo*) mask, a name meaning "speaks blah-blah." *Yarajo* masqueraders are among the most skilled dancers. At funerals, the mask speaks to the audience in a secret language and determines who may attend the rituals. The mask is rarely found in Western collections because it has no wooden face mask and is made up of cloth and fragile natural materials.

Sepik River. Winding through one of the most complex art-producing regions in the world, the Sepik River rises in central New Guinea, flows north and then east, emptying into the Pacific over 700 miles from its source. The area includes the northern coastal mountains enveloped in classic tropical forest and the swampy delta. The art of the region is traditionally divided into three zones, the Upper Sepik at the western headwaters of the river, the Middle Sepik, and Lower Sepik including the delta. The ABELAM live north of the

SENUFO MASKS

Above left: The person who commissions a kponyugu mask requests the combination of symbolic elements. This one has wild boar tusks sprouting up from its crocodile jaws. A chameleon with a bird on its back stands between the water buffalo horns. 19th–20th century.

Above right: The kpelie mask symbolizes female beauty and sexuality as well as mother earth. In this mask the six rows of breast-like nodules above the face symbolize the pods of the kapok tree associated with civilization and human settlement. Senufo villages are established near sacred kapok groves where Poro society youths undergo initiation.

river in the fertile part of the region where intensive agriculture is possible. Upper Sepik groups include the Nggala, Wogumas and those living on the Green River tributary. The best-documented of the three areas, Middle Sepik art forms are unique in their diversity. Included are the IATMUL, the SAWOS, the Ewa, the Alamblak, the Bahinemo, the KWOMA, the Nukuma, the Manambu, the Chambri and the WOSERA. In the same region, the Korewori River and Lake Yimas are renowned for crocodile sculptures carved from entire tree trunks. Also in the Middle Sepik, near the source of the Blackwater River, the YIMAR (or Yimam) make elegant hook figures called *yipwon*. The Sepik Delta and Lower Sepik region is less coherent and includes the art of the Schouten Islands, just off the coast, the Keram and Porapora River areas, as well as the Mundugumor and BIWAT of the Yuat River. The birds of paradise living in the area were sought after for their beautiful feathers resulting in early trade contacts as far away as the Malay Peninsula. The YAFAR, who live in the interior of the West Sepik Province, make headdress masks for the *yangis* ceremony. To the south of the Lower Sepik, the KOMINIMUNG of the Ramu River make standing figures, striking masks and shields. See map: NEW GUINEA, IRIAN JAYA, ADMIRALTY ISLANDS, NEW IRELAND, NEW BRITAIN.

Sexual Characteristics. See INDEX: The Human Body.

Sexual Control. Attitudes toward sexuality vary extensively throughout the world. In some societies, myths incorporate cautionary tales that warn against uncontrolled sexuality. One striking example is the *yagegir* figures carved by the YIMAR of the Sepik River area. These legless male figures are shown to boys during initiation ceremonies when presumably they are told the myth about legendary spirits who lost their penises (bitten off by the white cockatoo) because they copulated with the women so extensively that they almost killed all of them. Many TRICKSTER myths involve the results of unchecked sexuality (e.g., the Southwestern Coyote and the god Esu among the Yoruba). However, the Trickster also represents the power of creativity, and ritual often provides ways of ameliorating the sexual heat and transforming it into beneficial creativity. One such case is the fiery and sexually potent Yoruba god Sango whose priests seek to moderate the god's masculinity by wearing female clothing and dressing their hair in women's styles. Sango represents the burden of power, the crucial equilibrium between benign control on the one hand, and dangerous, destructive violence on the other. See also DANGER, INITIATIONS, TAPU and TEMPERATURE.

Shadow. The idea that the human soul is shadowlike is widespread in indigenous cultures. Among the KWOMA of the Sepik River area of New Guinea, the word for soul is *may*, which means "shadow," "reflection in a mirror or water," or "image in a photograph." The *may*, which resides in the head, is responsible for consciousness and rational thought. It leaves the body during sleep and sits beside the body or wanders the neighborhood, re-entering when the individual awakens. Furthermore, the Kwoma believe that dream content arises from the soul's journeys. Also, fairly commonly, people believe that the shadow is only released from the earthly plane by the performance of rituals. For instance, *nin*, the souls or shadows of the dead in Geelvink Bay, in Irian Jaya, cannot depart from the earth until a KORWAR figure is carved. In Africa, the SENUFO call the shadow/life-force *nyui*. It is separated from the body and freed by placing a drum on the corpse during the funeral ritual.

Shaking Tent. During this ceremony, INNU shamans entered a small cone-shaped tent within another tent in order to communicate with the animal masters, whose presence was expressed when the tent began to energetically shake and sounds such as knocking, thunder, running

water and owl hoots were heard. Despite missionaries' attempts to ban the ritual, shaking tent ceremonies continued as late as 1973. The Innu say that the ritual fell into disuse because there was no need to interact with the animal masters as hunting became less important. The OJIBWA shaman constructed his shaking tent of three birch and three spruce uprights, lashed together with two horizontal hoops of both woods. Other peoples used four or seven uprights. The uprights were sunk deeply in the ground and pulled together so tightly at the top that the slightly globular result was under considerable tension. Rattles of caribou or deer hooves or cups of lead shot were tied to the frame. The floor was covered with freshly cut spruce boughs and the entire structure covered with bark or cloth before the shaman entered. The structure, which may be a stand-in for the WORLD TREE, is symbolically located at the CENTER enabling the shaman to enter other realms.

Shalako. One of the most important Zuni rituals that marks the beginning of a new ceremonial cycle, the approach of the winter solstice and the return of the gods. Also the name of one of the principle Zuni spirits, impersonated by stately masqueraders wearing ten-foot-high, multicolored, composite costumes. See ZUNI.

Shalako Mana. Hopi and Zuni Corn Maiden represented in fairly recent times in *kachina* dolls with elaborate TABLETA headdresses rife with fertility and water symbolism. See KACHINA DOLLS.

Shamanism. Shamanism is a religious phenomenon that centered in Siberia and Inner Asia, but diffused throughout the Artic and Subarctic regions and, in a less predictable way, into parts of North America. Aspects of shamanism are also found in Oceania, preserved in the DONGSON and LAPITA cultures. Although the mechanism and even the concept of diffusion is controversial, the fact that shamanistic elements occur in decreasing amounts the further south (i.e., away from the Arctic source) one travels and rarely in Africa is of interest. The word comes from the Tunguz *saman*. The term shaman has been used loosely to describe any priest-magician although, in fact, it

should be reserved for those men and women who share certain qualities and abilities as well as a pattern of heredity, calling and initiation. Shamans may inher-

it their status or through a "call" or "election" as Mircea ELIADE, the preeminent scholar of shamanism, has said. In his exhaustive study, Eliade notes the universal pattern of unusual behavior that follows the call: an increasing antisocialism (seeking isolation and solitude) marked sometimes by serious symptoms including fits, hysteria, loss of consciousness and crises bordering on madness. Occasionally, physical illnesses such as smallpox are involved. Often the shaman will appear to die. The crisis is followed by a period of weakness and recovery and finally, by a return which may have the impact of a rebirth. Initiated shamans tell similar stories of their journeys through symbolic terrains for protracted time spans. They tell of being tortured, dismembered and killed by divine or demonic beings. Their bodies are reassembled, sometimes with added body parts that grant them additional powers. While in this altered state, the shaman learns important lessons such as the NAMES and treatments of all diseases, the secrets of nature and the languages of birds and animals. S/he receives her/his spirit helpers, costume and drum. Finally, the shaman is revived, reborn and returns to her/his normal earthly life with vastly increased health, knowledge and special powers made possible by having survived the ordeals. Eliade remarks that the initiatory pattern of shamanism is repeated in epic themes in the world's oral traditions that tell of the hero's quest, trials, triumphs and eventual return. Joseph CAMPBELL has made major contributions in this area, especially in his book, *The Hero with a Thousand Faces*. In addition to the similarity of initiatory experiences there are a number of shared practices and images wherever shamanism is found. All of these work together to make it possible for the shaman to fully realize her/his role in society—namely to defend the physical and psychic integrity of the community—to maintain the delicate and dynamic balance between the living and the vast realms of supernatural. Although there are "black" shamans, the focus here is on the "white" shaman who works for the benefit of society. These shared elements, practices and images might be called the shamanistic complex:

MAGICAL FLIGHT;

Shape-shifting;

Spirit (animal) helpers;

COSMOLOGY, including an *axis mundi* usually in the form of the WORLD TREE, various other symbols of the CENTER, such as the CROSS, the FOUR/SIX DIRECTIONS and finally, the LAYERED UNIVERSE;

The link between the shaman and the BLACKSMITH;

Attributes such as costume (disks representing sun and moon, MIRRORS, animal bones, embroidery or applique representing skeletonization, ancestors and the World Tree), drum and charms and amulets (for an illustration see World Tree);

Altered states of consciousness including seance, possession, trance, loss of consciousness, dreams; and

Special powers including speaking in spirit voices, "medicine" in various forms (MEDICINE BUNDLES, bags, sculptural receptacles), charms and songs.

The shaman fulfills many roles in traditional societies including artist (s/he always makes her/his own costume and drum, and often makes the charms, masks and other paraphernalia used by others), priest, healer, mystic, spiritual and political leader and repository of the oral tradition. The shaman's activities include healing (diagnoses, seeking lost souls—soul theft or rape was a common cause of illness), control over weather, animals (game charms and

divination), war, finding lost objects, seeing into the future and generally restoring imbalances. See also ALTERED STATES OF CONSCIOUSNESS.

Shell. One of the most prized natural materials, shell is incorporated into costume, hairstyles, masks, and many other indigenous art objects. Shell currency is exchanged in many cultures throughout the world. Because of the intrinsic value of shell, it is a symbol of wealth and status. Important individuals took their shell currency and adornments with them into the grave, sometimes in numbers exceeding thousands of worked and unworked shells. For example, a single HOPEWELL burial in Ohio contained 20,000 shell beads along with a wealth of other objects. The symbolic association of shells with the sea is evident in creation myths where they often serve as important props. In the Raven cycle, a giant shell acts as a surrogate egg holding the first humans. And in one version of the Yoruba creation myth ODUDUWA forms solid earth on the primordial waters with the help of a shell filled with sand and a chicken who spreads the sand. Shells are important enough to be represented on sacred objects, for instance cowry shells circle the AKAN GOLD soul washers where they evoke the power of the ruler, the sun as well as wealth and joy. The cowry is also particularly important in the great Nigerian kingdoms of Ife and Benin (also see JEBBA). Among the Yoruba shells are equally valued, especially in association with the trickster god ESU and with IFA divination. Shells add color and iridescent richness to much of the art of Oceania. Among the most impressive are the large shells that form part of SOCIETY ISLANDS' mourners' costumes used in high chiefs' funerals. See INDEX: Shell in Natural Phenomena and Materials.

Shield. Shields, like weapons, are imbued with magical properties that serve to pro-

tect the warrior. The designs depict powerful totem creatures, ancestors or symbolic geometry. The making of shields is surrounded by rules, including locating and cutting the wood. Shields may be made by the warriors themselves, or by specialist carvers. In POLYNESIA, distinctive nautilus-shell-inlaid wicker, bark or rattan shields were made in the SOLOMONS until c. 1860. Oval or elliptical in shape, the shields have straight sides and rounded tops and bottoms. They are constructed over concentric lengths of cane bent into U-shapes and bound with rattan or vine. Ordinary fighting shields were simply painted black, while the inlaid shields were covered with parinarium nut glue and then decorated with hundreds of pieces of shell—non-inlaid sections were painted red and black. The central design of the shields is an anthropomorphic figure with upraised arms and a long rectangular body that fills nearly the entire shield. In some cases, the position of arms and legs resembles the KOKORRO motif. Other designs consist of small human faces, fish and geometric patterns. The head motif, which appears elsewhere in Solomon Islands' art, may reflect the HEAD HUNTING aspect of warfare. In North America, PLAINS PEOPLES' shields were among the most prized items of warriors' regalia. The circular form of the shield linked the warrior to the sacred circle of life and the earth. Moreover, the warrior received its particular form in a dream or during the VISION QUEST and its imagery personalized and augmented the power of the circle. Creating the shield, usually under the direction of the medicine man, was a sacred act evoking and activating the powers associated with its imagery. See INDEX: Shields in Art, Artifacts and Techniques.

Shyaam the Great (Shyaam aMbul a Ngoong). See KUBA and KUBA ROYAL PORTRAITURE.

SHIELD

Above: Inlaid wicker shield from Santa Isabel, SOLOMON ISLANDS. Basketry, parinarium nut paste, shell inlay and pigment.

Sigi Festival (also Sigui). An eight-year-long DOGON festival of community renewal that occurs in a sixty-year cycle, in conjunction with Sirius. The Sigi festival is passed from village to village following a rotational cycle, marking the passing of a generation. It is said to commemorate the arrival of death in human society. The high point of the festival is the carving and appearance of the Great Mask (*imina na*, "Mother of Masks"). Each village carves a new mask, which after use is hidden in a cave where it gradually decomposes much like the ancestors' bodies. A new mask is carved from a single tree trunk, measuring up to twenty feet or more, and is said to represent the living snake that was found when people dug up the bones of Lebe, the first ancestor to die. The mask is regarded as containing *nyama,* or life force, and it symbolizes the continually regenerating powers of nature. It is not actually worn, but instead is carried. Other DOGON MASQUERADES are held on a regular basis to mark initiations and to restore the disruption of society resulting from death.

Sign Systems. In some cultures, symbolic geometric patterns are systematized into a graphic schema that can be "read" by knowledgeable individuals. The "literacy" involved in reading the signs and interpreting their relationships is a reflection of the individual's status, wisdom and rank within society. As a result, the systems are often cloaked in secrecy and serve to maintain social, political and religious structures, including gender separation. Furthermore, the degree to which the systems are understood often varies within a culture, with the non-elite and uninitiated having no, or very little, grasp of their meaning. Many of the systems are intimately associated with rulers and the symbols enhance their power and continuity. In cultures where such systems are associated with age-grade associations, as individuals move upward in rank, the symbols take on increasing

depth of meaning, so that elders are the most knowledgeable. In other cases, the symbols are a form of communication and are understood much more widely. Although these systems may have common elements, each system must be studied separately to determine who has access and how it functions within the society. In Africa, many of the sign systems are found on textiles, while in Oceania and North America, they tend to be carved in wood. This distinction is of some significance, since textiles are generally regarded (in the West) as a lesser medium. This is partly because they are less durable. Use of textiles in Africa is frequently gender specific, such as ADINKRA which is woven and decorated by men, but worn by women. The use of Igbo *ukara* cloth is confined to male EKPE society members. The designs on *ukara* cloth are reportedly drawn and designed by high-ranking Ekpe society members, but they may be stitched and dyed in secret by postmenopausal women. Some fabrics, however, are worn by both sexes, as is true of Bamana BOKOLANFI-NI (woven by men, but dyed and patterned by women) and the male-woven Asante KENTE cloth. In the history of Western culture, women were excluded from power by denying them access to literacy (or at least to all but the rudiments of literacy). In Africa, women had access to and even invented their own sign systems. While the systems may not constitute true literacy, women's use of them is an indication that further study of gender relationships in Africa is needed. The visual images discussed here are referred to as "sign systems" (in preference to icon, ideogram, pictograph or symbol) as being the most general description. In addition to the sign systems discussed below, see WALBIRI.

Sign Systems, Asante Adinkra. *Adinkra* cloth formerly functioned primarily as funeral cloth, but is now in general use. The term *nkra* means "message," and the

individual symbols form a system conveying meaning that often relates to the soul and to proverbs, both of which provided spiritual insight of supernatural origin. Some of the designs may have been introduced through the North African trade route. The designs are named; for instance,

 Hand seen from the back. *Valor, courage, bravery.*

 "If the hen steps on her chicks, they will not die." *Fitness, protection, patience.*

 "God, everything which is above, permit my hand to touch it."

 Eagle claws. Hairstyle of the Queen Mother's servants. *Ability to serve.*

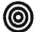 Moon, female symbol. *Fidelity, patience, determination.*

 Talisman against negative influences. *Good luck.*

 "King of adinkra." *Authority, grandeur, firmness, magnanimity.*

 Five tufts of hair, traditional hairstyle of priestesses.

 Chain. "We are bound in life as in death."

Variant of the preceding.

Windmill. *Ability to face difficulty.*

Ram's horns. *Humility, excellence, wisdom, knowledge.*

Four-story house, castle. *Government, authority, seat of power.*

the design composed of three concentric circles is called *adinkrahene*, "king of adinkra." This design, considered to be the most important of all, is associated with the founding king and indicates authority, grandeur, firmness, magnanimity and prudence. Early *adinkra* were red, russet or black, the dyes applied with carved calabash stamps. Those dark hues of mourning are now supplemented with many oth-

ers, including green, blue, purple and yellow, worn as fine dress on Sundays or for festivals.

Sign Systems, Asmat War Shields. In his book on Asmat wood carving, *Wow-Ipits*, Gerbrands has identified fifty to sixty motifs on ASMAT WAR SHIELDS all of which are connected with specific named ancestors and close relatives. The designs represent a system of signs, arranged in registers suggesting a ladder-like form, symbolizing the family tree or the lineage as a whole. The shields, thus, represent the collective protection of the ancestors. In addition to protecting warriors during raids, they were sometimes placed standing, fence-like, at the entrances to the YEU houses to repel intruders and keep evil spirits at bay.

 Large human figure motif from the Central Asmat style region. Gerbrands suggests it is composed of two profile praying mantis motifs.

 Flying fox motif, called *tar*, from Northwest Asmat style region. Carved after World War II.

 Flying fox motif from Northwest Asmat style region; combines human and *tar* motifs.

 Paired *bi pane* motifs from Central Asmat style region.

 Right: Praying mantis motif (*wenet*) from the Central Asmat style region. Left: "Foam on the river" motif from an old Northwest Asmat style region shield. The zigzag may represent waves, or white water ripples on the river.

Sign Systems, Cameroon Ndop (also called *doma* and *duop*). *Ndop* is an indigo stitch-dyed cloth originally made by Hausa dyers in the Jukun region of northern

SIGN SYSTEMS

Above: Asante Adinkra. Four squares from a large piece of adinkra cloth.

Far left: A selection of Adinkra signs.

SIGN SYSTEMS

Left: Motifs from Asmat Shields

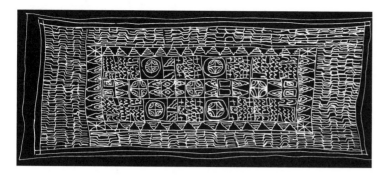

Around 1912, BAMUM king Njoya set up looms and dye vats to produce *ndop* locally. The designs are sketched by men and sewn by women. The designs are said to have roots in divination signs, Western cartography and Islamic patterns and, furthermore, they may have some relationship to the script invented by Njoya.

Sign Systems, Ejagham/Igbo nsibidi. *Nsibidi* is an esoteric system used to decorate Igbo and Efik *ukara* cloth and objects of importance to the EKPE society. The designs may serve as passwords. However, the full depth of symbolism is unknown because of the secrecy that surrounds it.

SIGN SYSTEMS

Above: Cameroon Ndop. This blue and white ndop is an ideal symbolic map of the BAMUM palace grounds. The individual design elements symbolize the myriad people and spaces of the palace.

Right: Cameroon Ndop signs.

Symbol	Meaning
	Cornerstones and guardhouses.
	Paramount wives.
	Clubhouses of officials.
	Garden plots.
	Residence quarters of officials.
	Food storage.
	Ruler and Queen Mother.
	Audience chambers.
	Wives and female servants.
	Treasury huts.
	Shrines.
	A protective device.
	Farms.

Symbol	Meaning
	A man and woman in love.
	Ekpe house.
	Lots of money (metal rods).
	Palaver or money.
	Ekpe house.
	Man who has traveled to the four directions
	Hand: first in friendship, war and work.
	Turtle in house: wisdom, trickery.
	Nsibidi tree, egbo feather or stick?, arrows.

Nigeria and traded to Cameroon grassland kingdoms. The cloths are displayed in palace reception rooms, worn by the king and court members and royal masqueraders, draped over fences for royal ceremonies and exhibited during the annual harvest dance celebration. In some locations, *ndop* is also associated with funerals.

SIGN SYSTEMS

Far right: Igbo/Ejagham Nsibidi.

Sign Systems, Fon Fabrics. Fon applique is said to have originated as espionage maps introduced by King Agaja. During the reign

of King Agonglo, the Yemadje family of male royal tailors took over the formerly female art form. They expanded it from appliqued banners made to surround the king on state occasions, adding umbrellas, hammocks and cushions. The symbols refer to specific rulers and their attributes. Some of the symbols are known to all, but the intricacies of meaning may be known only to the most prominent. The best known symbols are listed by Blier: Ganye Hesu (c. 1620), a drum and a large bird; Dako Donu (c. 1625–1645), a lighter; Huebgadja (c. 1645–1685), a fish and a net; Akaba (1685–1705), a pig; Agaja (1708–1732), a ship; Tegbesu (1732–1774), a buffalo with a cloth wrapper; Kpengla (1774–1789), a bird; Agonglo (1789–1797), a pineapple; Guezo (1818–1858), a buffalo; GLELE (1858–1889), a lion and a sword; GBE-HANZIN (1889–1894), a shark and an egg; Agoli Agbo (1896–1900), a foot (or shoe), a snake biting its own tail and a broom.

Sign Systems, Kickapoo Prayer Sticks. There are other instances of graphic systems among Woodlands cultures, e.g., Iroquois roll call canes, Shawnee prayer sticks, Potawatomi prescription sticks and Ojibwa song boards. The most beautiful, Kickapoo prayer sticks, were a recent introduction by Kanakuk, a prophet who reacted against removal of the Kickapoo from their homelands around 1812. He carved the prayer sticks himself and gave them to his followers. A late-19th-century source reports that every Kickapoo man, woman and child recited prayers morning and evening. Held vertically, the sticks apparently served as MNEMONIC DEVICES, the supplicant moving the right index finger from sign to sign while chanting the prayer each suggested.

Sign Systems, Kongo bidimbu. The Kongo encode and preserve ritual information in signs called *bidimbu* (sing. *dimbu*). These

SIGN SYSTEMS

Above: Kickapoo Prayer Stick. If the prophet Kanakuk actually carved this prayer stick, he was clearly an artist as well as a holy man. The subtle anthropomorphism of the form, swelling slightly at the "waist" and the neat placement of the elegant signs result in an appealing and functional object. c. 1825–30.

 The Kongo cosmogram, the "Four Moments of the Sun." The cosmogram is depicted in numerous ways, including a circle, a cross and a spiral. The cross represents the cosmos as circled by the sun, its zenith at the top or north, and its nadir in the underworld at the south or bottom. The rising and setting sun are the other two "moments." The cosmogram is a dynamic symbol, moving counterclockwise, that embodies the power of the center and the immortal life of the sun and the most honored ancestors. Human beings, thought of as miniature suns, are symbolized by small circles at the ends of the arms of the cross.

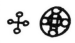 Sunrise and its sign, *nseluka ntangu ye sinsu siandi.*

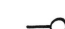 Sunset and its sign, *ndumunu a ntangu ye sinsu kiandi.*

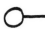 Concentric circles symbolize growth and change.

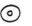 The spiral (snail shell) spatializes time.

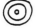 Sign of the chameleon and his cane, *tendwa kia lungwenya ye mvwala*, from a cave painting. This sign symbolizes old age (an elder with a cane) and by association, the brittle, slow movement of old age. It also symbolizes the chameleon, equally slow in its movement. On a deeper level, the care and deliberation is linked with the rate of attaining wisdom, expressed in the proverb, "slowly, slowly, the way the chameleon goes."

 Sign of the python, *mboma ndongo.*

 Sign with dots said to represent the missing members of the clan united in death.

SIGN SYSTEMS

Left: Kongo bidimdu.

SIGN SYSTEMS

Above: Kuba Patterns: The pattern called Woot is named after the first man whose incestuous union with his sister (Mweel) brought forth the first children, but also death, illness and discord. Woot was said to have fled taking with him a "basket of knowledge." The basket was found by a pygmy and given to a Bushoong man who, using its power, became the first Kuba ruler. Woot's symbol— linked with the sun, kingship, and social well-being—appears on many Kuba objects.

SILA

A song-poem by Uvavnuk:

The great sea
Has sent me adrift,
It moves me
As the weed in a
 great river;
Earth and the great
 weather
Move me,
Have carried me away
And move my inward
parts with joy.

appear on the walls of caves in Bas-Zaire, some of which date at least as early as the 1600s. The signs can be written in chalk on the ground, carved as messages on staffs and pot-lids or take the form of strategic placement of symbolic objects. Among their more important appearances, however, is their delineation on the chest and abdomen of Kongo NIOMBO reliquary figures. The Kongo also use colored stones and crystals as mnemonic devices. This practice is recorded as early as 1491 when a queen received Portuguese missionaries at court. She questioned them about Christianity, placing stones to assist her memory of their answers. The name for the act is *koma mambu*, literally "nailing the affair." Thus, the act of placing stones parallels that of nailing *minkisi* power figures to enforce judicial acts or for protection.

Sign Systems, Kuba Patterns. Jan Vansina writes that the history of Kuba design is a history of invention of new designs by named individuals—originality and invention were the rule rather than the exception. Some 200 named patterns have been identified, appearing on textiles in the form of embroidery or on raffia pile cloth, in the patterns on the mat-like architectural walls, on body decoration, on masks and in woodcarving. The raffia pile cloth was worn for ritual occasions, such as funerals for which it also served as burial cloth. Some designs are named after the kings or other skilled originators who invented them. Other names refer to physical objects of which they are said to be stylized representations, such as knots and knives. The name of the most prestigious design of all, the *imbol*, a guilloche knot, refers only to itself. Some names refer to the tracks of animals, for example, the Nile monitor lizard, or to the animals themselves. The interest in tracks extends to man-made traces as well. One resembles and is named for the pattern left by a bicycle tire on a dirt path. Some recall natural

objects such as one or two plant names, celestial bodies, smoke and eyebrows. Others refer to human beings, although few depict human figures. These include figures, faces, hands, feet, or more abstractly, the traces left by moving actors. Mythological references also play a part, including the ubiquitous Woot pattern named for the first man or another called "house of the first ancestor." Some things are never represented, such as rain, clouds and landscapes. The raffia tree, maize, elephants and leopards do not appear. And there are no kings, witches, dancers or spirits. Generally, Kuba iconography reflects cultural values including the importance of objects, the prestige gained through innovation and the significance attached to moving things.

Sila. The ESKIMO word Sila refers to both thought and outside, intellect and universe. An ambiguous concept, it refers to the world outside man, especially the weather, the elements and natural order. But at the same time, thought does not exist without man, so Sila refers to the state of the inner mind. Humans experience the inchoate energy of Sila, and in turn through intellect and emotion give shape and meaning to it. The gender of Sila differs from group to group and some do not personify it, instead conceiving of it as the INUA of the natural order; as such, Sila rewards those in tune with it and when offended, causes suffering and death.

Silver. The craft and designs of Southwestern silver jewelry were introduced in the early 19th century through Hispanic contact. Characteristic Navajo motifs such as the SQUASH BLOSSOM, *conchas, najas, ketohs* and crosses show Mexican influence. The Navajo worked iron, copper and brass first, but regarded silver as the most beautiful metal. The Navajo Atsidi Sani ("old smith," also known as Herrero, Spanish for smith) is credited with learning blacksmithing from

the Mexicans, which he expanded to include silver, later teaching it to family members. The source of silver initially was the U.S. silver dollar, but after 1890 when the government began enforcing the law against defacing currency, smiths turned to the Mexican *peso*. Jewelry made from Mexican silver has a bluish cast in contrast to the yellowish color of that made from American coin. The Zuni learned silversmithing from the Navajos and in turn taught it to the Hopi. Other Pueblo people also make silver jewelry. The so-called Zuni "needlework" jewelry, that uses many intricately set, small stones, is particularly famous. Before the 1890s most jewelry was made for personal use or for trade with others. Afterward, jewelry making became increasingly commercialized, especially through the aggressive marketing of the Fred Harvey Company. Contemporary jewelry is a major art form and economic mainstay in the Southwest with designs that range from traditional to innovative elaboration. In Africa, the FON used the technique of silver repousse to make objects associated with their rulers, such as the silver lion of King GLELE. In the same way that the moon is often regarded as the antithesis of the sun, silver is seen as the antithesis of gold. Thus, silver is associated with night, darkness and the feminine, and

the gold with day, light and masculinity—this symbolism is most evident among the AKAN peoples for whom gold was the ultimate symbol of life force, energy and of their rulers.

Simo Society. See BAGA.

Simultaneous Image. Simultaneous images consist of two mirror design elements, often profile animal or human faces or parts of faces, which symmetrically confront one another and thereby make up a frontal image. Such images seem to appear most frequently in those cultures that have strong SHAMANISTIC elements. Simultaneous images occur in conjunction with other design motifs, such as the HERALDIC WOMAN. In North America, they are prevalent in the Arctic and Subarctic and especially on the Northwest Coast. In Oceania, simultaneous imagery is most numerous in those peoples affected by the DONGSON and LAPITA cultures. Design elements tend to be complex, curvilinear and energetic. The impact of simultanous images is often rather formidable and frightening and may serve an apotropaic function.

Sinew. The sinew used in Arctic and Subarctic beadwork was generally made from caribou tendons.

Sioux. From a derogatory Ojibwa word *nadouwesou* (snake) shortened by the French. Many people referred to as Sioux prefer to call themselves by the names of the languages they speak, such as the Teton or (Western) Sioux or LAKOTA which includes the Oglala, Brule, Two Kettles, Minniconuou, Sans Arcs Blackfeet (not the same as the Algonquian-speaking Blackfeet) and Hunkpapa. The Dakota, Eastern or Santee Sioux lived in what is now the state of Minnesota. The Nakota, or Middle Sioux consisted of the Yankton to the south and the Yanktonai to the north in eastern North and South Dakota. The word Sioux will be used here if more specific linguistic or group affiliation is unknown.

Sipapu. Place of emergence, or navel.

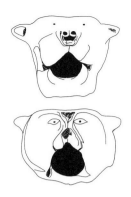

SIMULTANEOUS IMAGE

Above: The Eskimo carver reveals the powerful polar bear as if seen from both outside and inside, thereby magically suggesting both the physical and the spiritual animal. Also, by sleight of hand, the artist pays homage to the whale, as the interior view is a simultaneous image made up of two leaping killer whales.

SILVER

Left: Prominent NAVAJO archers protected their wrists with bowguards called ketohs. Usually measuring three and a half inches wide, the earliest ketohs were solid silver plaques decorated with simple stamped or chiseled patterns. The most beautiful are sand cast and are set with polished stones. The symmetrical designs suggest feathers, plants and quivers of arrows.

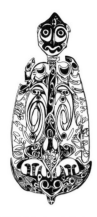

SKULL RACKS

Above: SAWOS open-work malu board. The representations are related to the myth explaining how death entered the world, especially the opening of the path of the dead by which spirits return to their ancestors. The lacy patterns and the open mouth might be seen as crevices for spirits. The purposeful and shifting ambiguity of forms, open and closed spaces becomes a metaphor for the transformation from material to spiritual.

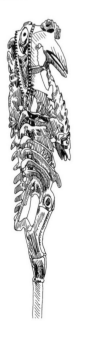

Probably originating with the Anasazi, the concept of the earth as a vast dome within which the first people lived is widespread throughout the Southwest. Myths tell of the emergence of people from the underworld through the navel. Mimbres bowls buried with the dead are said to mimic the shape of the earth's dome. A hole is punched through the base of the bowl, ceremonially "killing" the pot, before it is inverted over the face of the corpse. The opening allows the spirit to escape through the hole into the celestial regions. Anasazi KIVAS had holes in their floors believed to be the entrance to the underworld, and the place of emergence. As such, the hole is a symbol of the CENTER, of the place where spiritual/immaterial and temporal/material worlds touch. Hopi *kivas* have a *sipapu* in the floor through which the *kachina* spirits depart after their sojourn among the living at the culmination of the *niman* ceremonies. And Navajo mythology, possibly influenced by their Pueblo neighbors, tells of the HERO TWINS' battle to emerge from the underworld.

Sirige. A fifteen- to twenty-foot openwork mask from Mali in Africa. *Sirige* masks are smaller versions of the Great Mask, the most important of all Dogon masks that appears at sixty-year intervals. See DOGON MASQUERADES.

Sisiutl. Fabulous Kwakiutl double-headed serpent associated especially with warriors.

SKELETONIZATION

Left: Hair ornament from a flute stopper, BIWAT, Lower Sepik River region. Intertwined skeletonized cassowary and hornbill birds with a crocodile spinal column. These and the downward hanging lizard may be clan totems. FLUTE STOPPERS had great mops of hair made from feathers sprouting aggressively from the very tops of their heads—the effect was even more dramatic when hair ornaments were added.

It had the power to assume fish shape and to touch it was death. According to BOAS, its eyes, used as sling stones, could kill whales. See also SOUL CATCHERS.

Skeletonization. Carvers sometimes strip parts of, or the entire, human figure and other creatures of their flesh, leaving the skeletal structure revealed. The purpose of this varies, but the effect is usually strikingly elegant. In Oceania, skeletonized forms are found on Easter Island (MOAI KAVAKAVA) and in New Guinea among the BIWAT. The range of associations includes ancestors and the branching WORLD TREE. Skeletonization also plays a part in SHAMANISM, as the shaman's initiation frequently includes a vision of the flesh being removed from the body, revealing the skeleton beneath. The shaman must come to terms with her/his own death in order to face death in curing others. See INDEX: The Human Body.

Skull Racks. The skulls of ancestors or of enemies are preserved on skull racks. Among the most intricate are those carved by the SAWOS people of the Middle Sepik region, who, like other Melanesian peoples, were actively involved in HEAD HUNTING. The openwork *malu* boards are carved with low relief and painted. Many boards are anthropomorphic in form, topped by a human head and abstract limbs. Other creatures, such as birds, serpents and crocodiles also appear. One of their most remarkable properties, however, is the mask-like handling of the lower, openwork portions—the arms of the human figure are the mask's eyes and the prongs for hanging the skulls become fangs in gaping mouths. The human figure has characteristics (the crescents on the shoulders) similar to Sawos ancestor carvings. The fierce mask is apotropaic. For ancestor skulls see MAORI, WAKA TUPAPAKU and for additional skull racks see KEREWA *agiba*.

Skulls. Great importance is attached to the human skull, particularly to that of an important person. This veneration is especially pronounced among those indigenous peoples for whom ancestor worship is paramount. The head is often regarded as the seat of the human soul and the skull retains something of its identity after the physical death of the individual. Thus, the preserved heads of powerful chiefs, their tattoos still evident, were kept by the MAORI, and the IATMUL overmodeled skulls with clay to mimic the semblance of life. In Africa skulls were kept with other bones in containers guarded by vigilant wood sculptures such as the FANG *bieri* figures. For additional references, see INDEX: Human Body.

Sky Door. Circular openings carved in funeral monuments serve as passageways between the realms of the living and the dead. The massive rings made on the SOLOMON ISLANDS are decorated with ancestor figures that follow the same patterns as those found on KAPKAPS. See DOORS AND THRESHOLDS, MASSIM SHIELDS and TOTEM POLES.

Slit Gong. Percussion musical instruments hollowed out of the limbs and trunks of trees. Slit gongs in the Pacific vary from several inches in diameter to huge ones taller than a man. Among the most impressive are those carved in VANUATU by the Ambryn and MALEKULA where they are placed (in what has been called a phallically upright position) in the dancing grounds—the center of ritual life. The other object occupying the dancing ground is a stone megalith commemorating the ancestors. The slit gongs are regarded as the living equivalents (the voices) of the megaliths. The drums also transform the men through inciting them to dance, integrating them momentarily with the spirit world. On Atchin the largest drum was called *miren*, which means "mother" and the slit may be interpreted as the vulva. The drum, thus, is ANDROGYNOUS, providing another mode of integration. In the matrilineal cultures of Vanuatu (e.g., Banks Islands), the slit gongs are laid horizontally on the ground. Finally, the same type of tree used for the slit gongs is used for canoes and the two are regarded, in a sense, as analogs—both provide a means of transport to and in the spirit world. See INDEX: Musical Instruments in Art, Artifacts and Techniques.

Smoke. The HAIDA believe that smoke from the hearth (and from pipes) carries prayers and the souls of the dead to the sky. The smoke hole in the Haida house was a symbol of the CENTER, the point where this world and the upper world met. The rising smoke followed the path of the MILKY WAY. RAVEN got his black color from the smoke as he flew through the

SKY DOOR

Above: SOLOMON ISLANDS funerary offering decorated with paired ancestor figures topped by the guardian Sun Bird.

SMOKE

Above: This HAIDA carving may have been placed in the smoke hole to keep the inhabitant's souls from wandering during illness or in sleep. The carving shows two killer whales facing away from a small crouching human figure. The arrangement is reminiscent of shaman's double-ended SOUL CATCHERS. Before 1900.

SLIT GONG

Left: MALEKULAN slit gongs are placed in the center of meeting and dance grounds. From a 1912 photograph.

World Box's smoke hole, bringing the sun, moon and stars to humankind.

Snakes. Snakes appear in the art of many indigenous peoples, and generally have more positive associations than in Western art. Linked with water and fertility, snakes are, because they shed their skins, universal symbols of immortality. The emphasis on phallicism in Western symbolic contexts is not nearly so important. Snakes are often, as in Australian aboriginal myth, of both genders or are ambisexual. YULUNGGUL of the WAWALAG SISTERS cycle is male, but by swallowing the sisters, he takes on feminine gender and is able to fertilize the land. Snakes appear frequently in the American Southwest. Images of Kolowisi, the PUEBLO plumed or horned water serpent, are often found in ROCK ART near springs. The Zuni believe that all bodies of water are connected by an underground system that reaches all the way to the oceans. Kolowisi moves through these underground passages and comes out wherever there are bodies of water. Navajo sand paintings frequently contain snakes. In Africa, an enormous brass python slithered headfirst down the turret over the entrance to the royal palace of BENIN. The python was regarded as the king of snakes and was associated with two Benin gods; Ogiwu, god of death and lightning and OLOKUN, god of wealth and the sea. Furthermore, as in Australia the python is associated with rain and the rainbow. In Benin, the rainbow in the form of *ikpin ama*, the "rain python" is reputed to swallow and kill unwary humans. See also SWALLOWING and INDEX: Snakes in Animals.

Society Islands. Located in central Polynesia two island groups make up the Society Islands: the windward group includes TAHITI, Moorea and three others and the leeward group of Bora Bora, Raiatea, Tahaa, Huahine, Maupiti and two

atolls. Probably settled between the 9th and 12th centuries, the islands shared cultural characteristics, such as a social structure with four social classes and a religious system with three types of gods. An additional feature of the social system was a specialist group called the *arioi* whose members came from all four classes. The *arioi* were travelling performers who worshipped Oro, the war god. Performances of the group apparently played a part in social control. Similar to medieval court jesters, the *arioi* were permitted to comment on and even ridicule the chiefs and others of lesser status. Wood sculpture was the most prominent art form, including carvings for canoes, staffs and images placed in temples. The style, rather consistent throughout the Society Islands, is marked by smooth shiny surfaces, a combination of rounded and angular forms, figures with large heads and energetic postures with bent knees, protruding bellies and chins. The body (divided into thirds—head, torso, hips and legs) is treated as a series of rhythmically repeating volumes. Impressive MARAE are found, particularly on Tahiti. Other art objects include TAPA, war regalia, flywhisks, fan handles and GOD STICKS. TATTOO art was practiced and, in fact, the generic word for this type of body decoration was derived from the Tahitian word *tatau* ("to strike"). Mourner's costume, the most elaborate and valued apparel, has survived. Bark cloth, feathers, sea and tortoise shells combine to create a spectacular costume used in funeral rituals following the death of a high chief. See map: OCEANIA.

Solomon Islands. Lying east of New Guinea, the Solomons consist of seven large and over thirty small islands. The Solomons (Bougainville to the north, Santa Isabel and the New Georgia Group in the center, south-central Guadalcanal and Malaita to the east) and Santa Cruz Islands are at the geographic heart of

SOCIETY ISLANDS

Above: Mourner's costume with a tapa cloth skirt, coconut shell apron and breastplate covered with hundreds of pearl-shell slivers. The wooden crescent topped with shell discs surmounting the breastplate may symbolize the moon or possibly a spirit canoe. Late 18th century.

Melanesia. The most populated islands are Malaita and Guadalcanal. The Solomons, inhabited as early as 4000 years ago, seem to have been a crossroads of influences, with an interweaving of traditions from Polynesia, Micronesia and New Guinea. Continuously exploited since the 1830s,

the Solomons were the center of World War II battles between the Allies and the Japanese. A distinctive characteristic of Solomon Islands' art is the inlaid pearl shell-work that glitters against resin-based black backgrounds. Sculpture often takes the form of the human figure (ancestor figures, guardian deities, WATER SPIRITS), zoomorphic creatures (birds and fish, particularly —e.g., the BONITO CULT in the southeastern islands) and human/animal hybrids. Funereal art includes grave markers, stone sarcophagi and shrines for overmodeled ancestor skulls. Masks, boats, carved and ornamented dishes, bowls and cups, ceremonial paddles, staffs, weapons and cargo cult objects are also found, in various combinations in various areas. The Northern Bougainville style area is said to be the most productive area. The varied,

but always recognizable, KOKORRA motif (a frontal, squatting anthropomorphic figure surrounded by a huge head which sometimes replaces the figure) decorates most objects including house boards, boat planks, paddles, bullroarers and coconut graters. Artists achieve status by gradually expanding their reputation through competition, moving from the village to the region. Becoming a *mwane manira* ("artistic man") entails not only artistic skill and esoteric knowledge, but also the attainment of widespread public recognition and acclaim in the form of commissions and the purchase of art outside the region. One final art form is the funeral offerings which take the form of massive stone and giant clamshell rings which act as SKY DOORS, or gateways through which the souls of the dead pass into the afterworld. See map: OCEANIA.

Solstices. The Chumash ritually marked the winter solstice. Their observations of the sun's movement is especially dramatic at Condor Cave where a beam of light passes through a window cut in the cave wall and moves slowly across the floor of the cave following its long axis, disappearing after about an hour. Chumash rock art is replete with sun imagery. Other places or peoples who marked the solstices include CAHOKIA, HOPI and ZUNI. See INDEX: Solstices in Natural Phenomena and Materials and Archaeoastronomy.

Songhai Empire. See SUDAN.

Songye (or Songe, formerly Basonge). The Songye of the Democratic Republic of Congo are the neighbors of the LUBA with whom they share a common history and similar social organization and artistic tradition. Powerful chiefs held sway from c. 1700 to the 1870s, after which internal conflicts led to their destruction. Despite disruption, cultural traditions survived into the 1980s in the more isolated

SOLOMON ISLANDS

Left: Canoe prow figurehead (nguzunguzu) inlaid with shell from Morovo Lagoon, New Georgia. Such figureheads depict protective spirits, their supernatural status indicated by the tapering head and projecting jaw. The prognathic shape of the jaw may relate to the mythological dog that taught the people all they know, including how to make canoes. Collected 1928.

regions. The Songye made potent *minkisi* figures (sing. *nkisi*). Magical substances such as parts of lions, leopards, snakes,

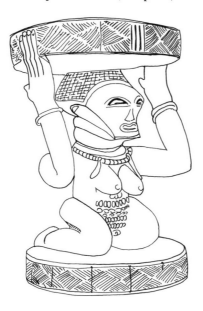

SONGYE

Right: This Songye stool symbolizes the ruler's authority—the caryatid female figure likely represents the continuity and support of the ancestral lineage. The kneeling figure is also said to be a reminder that rulers often used the bodies of slaves or retainers as seats.

Top: Nkisi figure. The enlarged cranium and protruding abdomen may be hollowed out to receive magical substances. The nails driven into the face of the nkisi are said to be reminders of smallpox epidemics. Collected before 1900.

birds of prey and crocodiles' sexual organs, earth from elephant's tracks and human elements from especially powerful people were sealed up in the abdominal cavities of these figures. The Songye believed that these substances created a link to primordial time, making them more powerful than other matter. They transformed the *nkisi* figure into a vehicle of mystical force. The *nkisi* often has added metal which augments its power, as metal is not only a con-

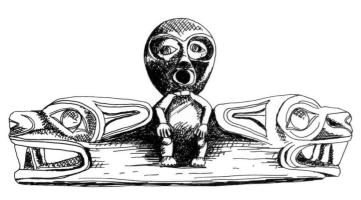

SOUL CATCHER

Above: Small carved soul catchers were part of the SHAMAN'S kit. This wooden KWAKIUTL soul catcher depicts the Sisiutl, a fabulous double-headed serpent, and a central human figure with a removable head. From Kitlope.

ductor, it comes from the earth and is associated with the dark powers of the underworld and witches. Communal *minkisi* benefitted society as a whole. Warned by dreams or visions of lightning strikes or other omens, the *nkisi* was brought out and carried through the village on poles kept in the burial grounds. The powers resident in the *nkisi* "cleared" the area, driving out evil forces. The Songye make some of the most distinctive masks in Africa, see KIFWEBE.

Soul Boat. The belief that the land of the dead lies over the sea is common in world mythology, especially in the Pacific. Boat burial, whether by setting the bodies of the dead adrift in canoes or boats, or by interring them in boat-shaped containers is the natural result of the desire to provide appropriate transportation for the last journey. Soul boats seem to be associated with both the LAPITA and DONGSON cultures which may explain the concept of an aquatic final journey as well as the flowing curvilinear patterns used to adorn the boats. Soul boats are also used in conjunction with initiation rituals, as for instance among the ASMAT (BIS POLE). Spirit boats hang from the rafters inside men's houses on Chuuk. See also CANOES (on the Asmat *uramon*), SOLOMON ISLANDS, TURTLE and the Maori WAKA TUPAPAKU.

Soul Catchers. Northwest Coast SHAMANs used these small, carved objects to retrieve lost or strayed souls of ill persons. The shaman pursued the soul visible only to him, usually at twilight, and distracted it with incantations. He could then catch the errant soul in his container, pop the stopper in and return it to his patient. Once the soul was reunited with the body, the patient could recover. Soul catchers are generally carved with symmetrical magical symbols that aid the shaman in capturing souls. Soul catchers were carved from tubular bone and wood.

"Soul Washers" (*akrafokonmu*). See AKAN GOLD.

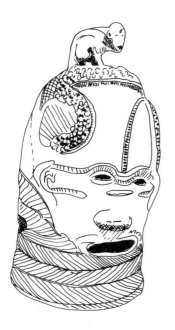

Southern Africa. The early art of southern Africa includes the prehistoric rock art associated with the SAN peoples, the isolated archaeological find known as the Lyndenburg heads, the Mapungubwe State (c. 1000 CE) and the Shona State of GREAT ZIMBABWE (c. 1250–1450 CE). The range and significance of this art has been unappreciated until recently because of adherence to European traditions and attitudes about "art" during the colonial period. More recent art, including woodcarving, dolls, beadwork, basketry and pottery, is produced by the ZULU, Tsonga and Ndebele. See map: EASTERN AND SOUTHERN AFRICA.

Southern Cult. See MISSISSIPPIAN CULTS.

Southwest. This arid but physically beautiful geographical area (nearly 500,000 square miles) centers on the so-called Four Corners where the states of New Mexico, Arizona, Utah and Colorado meet. In prehistoric times, the cultural forerunners—the Hohokam, Mogollon and Patayan—

lived as far south as Texas, Baja California and the adjacent areas of Mexico, and into southern Nevada and California. The Hohokam, Mogollon (see the MIMBRES branch) and ANASAZI are considered to be the major Southwestern cultural traditions beginning as early as 750 BCE and lasting until approximately 1250 CE. The Anasazi, in particular, are regarded as the ancestors of the modern PUEBLO PEOPLES. There is evidence of Mexican contact, through trade at the large site of CASAS GRANDES, in Chihuahua, Mexico. Generally speaking, however, developments in the Southwest occurred independently and represented a high point of art and culture in North America. The major groups of the historical period were the Pueblos—today there are nineteen Pueblos in New Mexico and several HOPI towns on the three mesas of northern Arizona—as well as the NAVAJO and the APACHE. Two religious patterns exist in the area. First, there are those people who focus on illness and curing rituals,

SOUTHERN AFRICA

Left: Seven striking terra-cotta heads, known as the Lyndenburg Heads, are said to be the earliest sculptures from southern Africa. Two of the heads, large enough to have been worn as helmet masks, have clay studs that follow the hairline and are surmounted by animal figurines. Not part of a burial, the heads were found in a pit, indicating that they were possibly hidden when not in use. Their purpose is speculative, but it has been suggested that they were used in initiation rituals. From Lyndenburg, Eastern Transvaal. c. 500–700 CE.

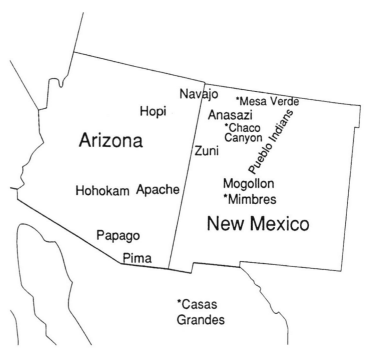

THE SOUTHWEST

Navajo *Mesa Verde
Hopi
Anasazi
*Chaco
Canyon
Zuni
Arizona
Hohokam Apache
Mogollon
*Mimbres
Pueblo Indians
Papago
New Mexico
Pima

*Casas Grandes

such as the Navajo and Apache. And second, peoples who, like the Pueblos, the Hopi and the Zuni, celebrate the cycles of nature. Acculturation in the Southwest resulted in the addition of some Christian elements within existing traditions. Major Southwestern art reflects these two religious patterns and includes masonry, wood and adobe architecture—including wall painting—sand painting, sculpture, masks, basketry, pottery, various items of personal apparel and textiles. As with Plains art, much of the art of the Southwest is regarded as being stereotypically "Indian." The peoples of the Southwest were able to maintain their cultural identity somewhat more extensively than other indigenous peoples because of their strong political, social and religious organization. Another factor in this is that their somewhat inaccessible arid environment was not particularly desirable as "real estate" or for raw materials until well into the 20th century. Thus Southwestern peoples were able to continue living at the center of their own beloved, sacred world.

Southwestern Architecture. The buildings of the present-day Pueblo people are an amalgam of earlier Anasazi forms and Spanish influence dating from the mid 16th century. The Spanish taught the Pueblos how to make adobe bricks of mud and straw, molded in forms. The Navajo brought with them the dome-shaped HOGAN, which did not evolve into its present form until after they settled in the Southwest. Amos Rapoport compares pueblo and *hogan* with regard to what they reveal about the worldviews and social structures—kinship and gender relations— of their builders. The pueblo, with its closely built, additive and clustered plan, expresses the highly organized social life of Pueblo communities. Pueblo architecture is also closely linked with the land, both in terms of its overall shape which is in tune with the mesas and cliffs and its materials,

adobe and local stone. Furthermore, the pueblo's orientation is linked to the cycles of the seasons, the mountains and the cardinal directions, setting the entire structure in harmony with the cosmos. The Navajo *hogan* is also an expression of harmony and of the people's worldview. But in contrast to the multi-family Pueblo dwellings, single families inhabit *hogans*. *Hogans* may be built in clusters of four to six, uniting three generations. The relative isolation of such clustered *hogans* reflects the Navajo sense of duty to family and distrust of outsiders. Like pueblos, *hogans* are closely linked with nature, but their location is governed by a number of prohibitions. The *hogan* must not intrude upon nature, cannot be located closer to water than two or three miles and must respect the grazing and water rights of others. *Hogans* cannot be located near prehistoric ruins for fear of pollution from the ghosts of the old ones who once lived there. These "rules" reflect the more individualistic way and looser social organization of the Navajo, which entail controls not needed in the communal pueblos. Pueblo life and art seek to restore harmony in the entire universe, while the Navajo pursue personal harmony as well as seeking harmony with other humans and supernatural forces.

Soweisia (sing. *sowei*). Masks worn by Mende women in Sande society masquerades representing ideals of beauty and morality. See MENDE.

Soyala. One of the most important of the round of Hopi ceremonies marking the cycles of nature, *soyala* lasts nine days and occurs in December at the winter solstice. It celebrates the return of the *kachina* spirits to Hopi society and marks the beginning of the *kachina* season that lasts until mid-July. The word is derived from *soyalangwul*, meaning "establishing life anew for all the world." Unlike NIMAN, with its exciting

public dances, *soyala* is a time of silence, fasting and waiting. First to appear is the Soyala Kachina which, wearing a turquoise helmet mask and white robe, staggers into the village from the east, like a child learning to walk. On succeeding days, Mastop, a monster *kachina* who chases married women and engages in mock copulation, Masau'u the earth spirit and Muyingwa, associated with plant germination, appear (see KACHINA, KACHINA DOLLS). In the *kiva*, the *soyala* altar is erected and offerings of bird feathers, corn, melons, squash, cotton and pumpkins are made. The painted altar screen carries symbols of the masculine sky (the sun and its rays and the moon) and the feminine earth, as well as raindrops. The war priest and the star priest officiate at ceremonies that reenact a myth about how the war god Pookon changed the direction of the sun.

Spider. On Belau in the CAROLINE ISLANDS, Mangidab, the spider, is painted on the interiors of community houses called BAI. Mangidab, who brought natural childbirth to the island, is part of complex symbolism connected with wealth, which apparently includes human fertility as well as material possessions. Spiders figure prominently in North American art and myth. Prehistoric MISSISSIPPIAN CULT imagery included spiders with crosses on their backs said to be solar symbols. Among the historical Natchez, inheritors of the Mississippian traditions, the water

spider retrieved fire after many other creatures had failed. Among the Pueblo peoples, spider was female in gender. According to the Navajo, SPIDER WOMAN wove the cosmos on an enormous loom, using clouds, sunbeams, lightning bolts and rainbows. She also taught Navajo women the sacred activity of weaving and use of cotton. The HOPI Spider Woman saved human beings from floods that destroyed the earth by hiding them in reeds. There are many LAKOTA stories about Inktomi, the spider who plays tricks on spiritual beings, animals and humans. His body is like a fat little bug, but his spider legs terminate in human hands and feet. See INDEX: Spider in Animals.

Spider Woman. According to Navajo mythology, on an enormous loom, Spider Woman wove the universe out of cosmic materials. Using clouds, rainbows, sunbeams and lightning bolts, Spider Woman transformed the ephemeral into the material substance of the cosmos. For the Navajo, weaving is a sacred activity, done by women who transform the raw materials supplied by Earth Mother/CHANGING WOMAN who had, herself, learned weaving from Spider Woman.

Spinal Column. Representations of the spinal column are common in POLYNESIA where it is associated with genealogy. SCHUSTER and Carpenter argue that the split stick/Y-forked stick derives from the spinal column, and provide numerous examples with convincing evidence (*Patterns That Connect*). See also SKELETONIZATION and INDEX: The Human Body.

Spiral. The historic PUEBLO people (Zuni) describe spiral images in prehistoric rock art as representing water, creatures associated with water (SNAKES and snails) and the journey of people searching for the CENTER. The coils of the spiral

SPIDER

Left: Engraved shell gorget with spider motif. The water spider is surrounded with concentric rings suggesting the radiating rays of the sun. Dallas culture, Mississippian. 1300–1500.

SPIRIT SPOUSES

Right: Sculptures representing beautiful people serve as spirit spouses among the BAULE. The figures function as spiritual marriage counselors, assisting people with sexual and reproductive difficulties. This spirit wife is the first Baule figure ever published and was probably the first to enter a museum collection. 19th century.

"She is in the house....It is my wife. She is something to hide. The one that is here outside [in the visible world], she is the one I show to my father: 'Here is my wife.' The other one I hide. She brings me happiness. And it is that happiness that I give to the other [earthly wife] who is here."

—*Teki Kouakou, 1994.*

SQUASH BLOSSOM

Above: The Squash Blossom is one of the most popular patterns found in NAVAJO silver jewelry. The crescent-shaped pendant on this necklace is called a NAJA.

could be said to encode years of hardship and travel during the search. The relationship between the spiral and the passage of time is also apparent in the KUCHIN concept of "spiral time." Fundamental to their cosmology, the Subarctic Kuchin describe spiral time as the time "before we knew how to tell the time." Time evolves spirally, events repeating themselves, but with differences. Spiral time continues to exist in their culture, side by side with Western linear time. The spiral, in contrast to the stable circle, is restless and incomplete. Thus it is a powerful metaphor for flux, energy and evolving phenomena. For additional references to the spiral, see INDEX: Pattern in Art, Artifacts and Techniques.

Spirit Break. Deliberate interruption of otherwise perfect patterns in basketry, pottery and weaving. The purpose of the Spirit Break is said to provide a place where spirits are invited to enter the object or an escape route if the object is destroyed. There may also be some notion of deliberately introducing imperfection so as not to show lack of humility or rival the perfection of the spirits. POMO women basketmakers call the interruption the DAU, which takes the form of introducing a new pattern instead of simply repeating the main pattern.

Spirit Spouses. The BAULE believe that each man and woman has a spirit spouse that resides in the other world or with whom they were romantically involved in a former spiritual existence. Communication with the spirit beings occurs in dreams. One night a week, people sleep alone to receive dream visits from the spirit spouse. Just like living husbands and wives, spirit spouses become jealous and angry and can do harm. Diviners advise individuals to commission sculptures representing their spirit spouses called *blolo bian* ("otherworld man") and *blolo bla* ("other-world woman"). The owner oils, clothes and

adorns the sculpture to appease the uneasy spirit. The sculptures are kept covered with a cloth to protect them from dust, revealing only the head. The beauty of the sculptures adds to their efficacy.

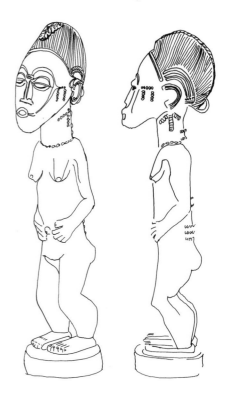

Spruce Tree House. Ranchers Richard Wetherill and Charlie Mason found the complex of Anasazi cliff dwellings at MESA VERDE when they were searching for cattle lost in a snow storm in 1888. They mistook the Douglas Fir growing nearby when they named it. See MESA VERDE.

Square. See INDEX: Pattern in Art, Artifacts and Techniques.

Squash Blossom. A favored motif in Southwestern art, found in jewelry and ceramics. The Navajo word for the design translates "bead that spreads out." The gobular beads have a stem-like shank for hanging and a multi-petaled trumpet shape. They are clearly flowerlike, but there is substantial disagreement about

what flower is represented. Some sources state that it is, as its name suggests, the blossom of some sort of squash, an important element in the Southwestern diet. It is also likened to the pomegranate and to the small flowers in the central part of sunflowers. Finally, the large white trumpet-shaped blossoms of *Datura inoxia* are also said to have been the inspiration for the design. The Hopi call the horn-shaped hairstyle of unmarried girls squash blossom.

Stars. The Aboriginal Australians of northeastern Arnhem Land believe that when people die, their spirits are transported over the sea in a spirit canoe which travels along the beam of light (called *jari*) which falls from Barnambirr, the Morning Star. The stars played a central role in California Native cosmology and, together with the sun, regulated the ritual calendar and influenced all of life (see CHUMASH). Stars are represented using a variety of forms in indigenous art, such as CROSS and other shapes among the Hopi and circular forms in Kwoma MBI paintings. Conversely, star shapes do not always represent stars. In CAMEROON art, the six- or eight-pointed stars actually are spider symbols. See INDEX: Stars in Natural Phenomena and Materials.

Stilthda, Simeon (d. 1889, c. age 90). Recent research by Robin K. Wright suggests that finely carved and dramatic HAIDA sculpture attributed to both Charles EDENSHAW and John GWAYTIHL was actually the work of Simeon Stilthda. Wright points to differences in the carving of eyesockets and ears, among other factors, that are characteristic of Stilthda's hand. Wright's work reveals that both Stilthda and Gwaytihl lived in Yan before moving to Massett. She feels that they must have worked closely and perhaps even collaborated.

String Bags (also called net bags). In New Guinea, women make "utilitarian" two-ply looped string bags. In Papua New Guinea the bags, called *bilum*, have multiple uses, including carrying various items (from produce to babies), storage of household utensils and catching fish. Children carry their schoolbooks and invent games to play with them. Maureen MacKenzie, who has researched them, remarks that although they are described in the literature as "humble," the bags are nonetheless significant, as they are the carriers of the fruits of women's labor—garden produce and children. When they work in the gardens, the women hang the bags cradling the infants from sticks and it is believed that as they rock, the babies absorb the energy of the ancestral spirits associated with the garden plot. This not only promotes growth, but involves an obligation as well, tying the child to the nurturing ground. The womb-like bags, thus, are laden with social significance involving the mother, growth, fertility, ancestors and the earth itself. Bags are made in several sizes (from large expandable carrying bags to small amulet bags) and are used by all members of society. Well-made bags are synonymous with good women and epitomize a woman's capacity to transform natural materials into useful and beautiful products. *Bilum* used by women may be patterned with various col-

STARS

Left: AUSTRALIAN ABORIGINAL bark painting of the Morning Star by Binyinuway from Dipirrigurr.

STRING BAGS

Above: In Papua New Guinea string bags are both utilitarian and deeply significant. Made mostly by women, the womblike bags symbolize the good mother, growth, fertility, ancestors and the earth itself.

ors, but men's are decorated with feathers, transforming their feminine character into male display items. The people regard this as paralleling the difference between the impressive plumage of male birds and the comparatively drab females. The comparison is particularly apt, as some male birds (see cassowary and hornbill) take on what are normally considered to be female roles with regard to hatchling birds (see INDEX: Birds in Animals). Similarly, human males become surrogate mothers during the initiatory period when the boys are removed from their biological mothers. This underlying significance is reiterated in secret, sacred *bilum* called "the mother of us all" which contains the bones of the ancestors. The ABELAM of Maprik paint bags on the facades of the men's houses. See KORAMBO. See also WOSERA and INDEX: Textiles in Art, Artifacts and Techniques.

NORTH AFRICA AND THE SUDAN

String Figures. The CHUGACH Eskimo made string figures to "tangle" the sun's legs and thereby delay the coming of winter. See CONTINUOUS LINE DRAWINGS.

Structuralism. Methodology for studying culture originated by Claude Levi-Strauss, based on analyzing the various structures (e.g., religious, social, political and economic) within societies.

Subarctic. This vast area was settled by at least 7000 BCE, and possibly even earlier in the western portions. The area stretches the full width of the North American continent from Labrador and Newfoundland to the western coastal ranges beyond which lies the NORTHWEST COAST. Many nomadic groups—almost all of them Athapaskan- and Algonquian-speakers—moved throughout the area seeking game and living in transportable architecture. See INNU and map: ARCTIC, SUBARCTIC AND NORTHWEST COAST.

Sudan. Little is known about the western and central Sudan before the end of the first millennium CE. By that time kingdoms arose in both areas, their wealth accumulated by virtue of control of the gold trade with North Africa. Gold, kola nuts, ivory, slaves, leather and ostrich feathers were traded northward in exchange for salt, copper and manufactured goods. Islam played a major role and became associated with the ruling class in some areas, resulting in sophisticated courts featuring literate Muslim scholars. One of the most remarkable was that of the 14th-century Mali ruler, Mansa Musa at Timbuktu. Arab travelers reported the splendor of the Islamic-style palace and the king's golden regalia. Elsewhere in the area, rulers tolerated Islam but did not convert. The Songhai Empire held sway in the area from the early 15th to the late 16th centuries, when it was overpowered by invasions from Morocco. Songhai rulers

like Sunni Ali and Askia Muhammad built mosques and tombs, the remodeled descendants of which still stand today. The mosque at DJENNE, completed in 1907, is a reconstruction of the original 13th-century adobe structure. The building is larger than others, having ten aisles divided by ninety monumental pillars. Buttresses with pointed profiles support the exterior walls, punctuated with the ends of the beams that give the building a spiky appearance. Three hollow minarets project outward from the east, Mecca-facing, wall, each topped with an ostrich egg symbolizing purity and fertility. The strikingly vertical façade, silhouetted against the brilliant blue sky, towers over smaller buildings. Furthermore, the contrast of smooth mud walls and spiky beam ends and gutter spouts, as well as the dramatic bands of light and shade created by the minarets and buttresses, make this an unforgettable building. The great court traditions of earlier times partially survive in the present-day art of the HAUSA. Characteristic of western Sudan village-based societies are artist families that make up about ten percent of the total population. These families play a part in their host societies that exceeds their numbers. The crafts of working iron, clay and leather as well as weaving and woodcarving are handed down within families and artisan families often intermarry resulting in their social segregation. This situation exists among the Mande-speaking peoples such as the BAMANA and Malinke; the DOGON, Minanka as well as in BOBO and Kulango communities. In some cases, the artists also fulfill religious roles. Tuareg, FULANI and other Islamic artisans have similar status. Voltaic speakers in the area include the MOSSI, BWA, Frafra and the SENUFO of the Ivory Coast. See also NOK.

Suku. The Suku and closely related YAKA live in the Democratic Republic of Congo.

Sulka. The Sulka are one of five groups, each with its own artistic tradition, living on the island of New Britain. The most distinctive traditional Sulka art forms were large, fantastic, brilliantly colored basketry masks made of pith fibers. Face-shaped, umbrella-shaped and conical headdress masks formed composites consisting of separate pieces. Some were topped with sculptural forms, which were also incorporated

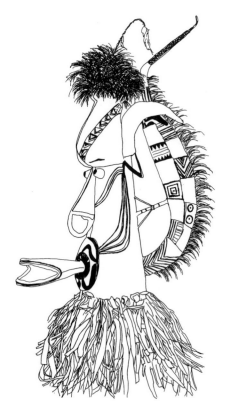

into houses and boats. Six months or more were spent preparing for elaborate rituals, during which supernatural phenomena such as lightning—an expression of the

SUDAN

Above left: The Great or Friday Mosque at DJENNE (modern Zaria), Mali stands on a raised platform between the two halves of the city.

Above right: Another view of the reconstructed 13th-century structure, completed in 1907.

SULKA

Left: This hemlaut mask is a rich salmon color. The word hemlaut means "old man," an expression of respect for elders. This mask, probably inspired by a dream, incorporates sea snake and shellfish imagery. The sea snake's body arches up behind the conical mask, but its head protrudes out of the mask's mouth, doubling as a tongue.

praying mantis, python, sea snake or flying fox—occurred, acted out by the masks inhabited by the spirits. The masks appeared during funeral ceremonies for important males and females and possibly at BIRTHS, INITIATIONS and marriage ceremonies. See INDEX: Animals.

SUN

Top right: Circular sun disk post decoration from Lake Sentani men's house. Ayafo, Lake Sentani. Collected 1926.

Bottom right: BELLA COOLA sun mask painted blue, red and black.

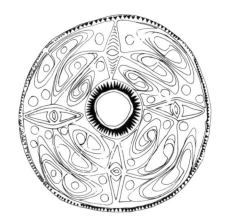

Sun. Generally, the sun is associated with life, blood, the right (see DIRECTIONAL SYMBOLISM) and the COLOR red. Although the gender of the sun in world myths varies, more often than not it is male. In fact, the sun is often a divine, generative force, father of other deities and heroes. Human rulers are sometimes the offspring of the sun, or at the very least, they derive their power from the sun (see Kanak SCEPTER). One instance of this is the rich sun symbolism associated with the ASANTE rulers. The sun, life force, the human soul, GOLD and the ruler are all intricately connected. Perhaps the most dramatic manifestation of this conflation is the GOLDEN STOOL said to have come from heaven. Like the undying sun, the stool symbolizes the very identity of the Asante State and serves as the repository of power and continuity. Some of the best-known sun myths involve how the sun came to be in the sky and the CULTURE HERO's theft of fire for the benefit of humankind (e.g., see RAVEN and INDEX: Fire in Natural Phenomena and Materials). Throughout the world, buildings are oriented in relation to the sun's path and are adorned with sun symbols. For instance, the entire structure of Abelam KORAMBO spirit house corresponds to the course of the sun—after rising in the east, the sun follows the ridgepole until it stands directly overhead at noon and, following the invisible ridgepole of a mirror image, it descends into the west. Among other sacred objects found in LAKE SENTANI men's houses, fastened to the top beam, circular carved and painted disks were said to be images of the sun. Sun symbols take many forms throughout the world, such as the hand-eye motif in MISSISSIPPIAN CULTS, an illustration of the concept of the sun as the blazing eye of the heavens. For the CHUMASH, the sanddollar was a sun symbol and the Sun's resting-place during his daily journey. The Sun, an anthropomorphic CANNIBAL, lived in the sky world in a quartz crystal house. The Sun was the source of all life, but also had moral implications as a watchman over humankind. Solar and lunar eclipses were explained as the shadows of the condor's wings. See INDEX: Archaeoastronomy, Solstices and Sun in Natural Phenomena and Materials.

Sun Dance. Sun Dance is the generic name for the most characteristic religious ceremony of the North American Plains peoples. Although the precise origin cannot be determined, it may have originated among the MANDAN. This ceremony took place when groups came together for the communal buffalo hunt. It goes by different names, depending on the emphasis of each people—the Paiutes, Shoshone and CROW refer to it as the Thirst Lodge; for the Cheyenne it is the Medicine Lodge. Among Sioux-speakers it is known as the Dance Gazing at the Sun, stemming from the fact that the male dancers gazed at (in the direction) of the sun as they performed. Although the title emphasizes the role of the sun, it is possible that it was originally performed at night. Linguistic evidence shows a lack of distinction between moon and sun among the LAKOTA. One of the repeated elements found in all variants of the ritual is the importance of the shamanistic WORLD TREE that is set up at the center of the dance lodge. Acting as the *axis mundi*, the tree is the connector that runs through the three layers of the universe—the underworld, the world of the living and the sky world. Offerings of ribbons and animal sacrifices were made to the tree. The various Plains peoples performed different versions of the ritual, but all shared the idea that the only thing worth offering to the Great Spirit was the human body, as it was the only thing which human beings truly owned. Some rituals included self-mortification—thongs were inserted through the skin of the chest and fastened to the structure of the lodge. This aspect of the Sun Dance was regarded as primitive and "heathen" and was banned by the United States government in the 1880s. As a result, the ceremony went underground and reemerged publicly in 1934. Among other groups, it was the ritual itself—participants abstain from food and water and dance for three to four days without stopping except to sleep

for short periods—that constituted the bodily offering. Today the Sun Dance is one of the most widely celebrated and attended Native American rituals.

Sun Dance Lodge. The first ritual of the Sun Dance consists of cutting a special cottonwood tree with forked branches at the top. The tree must fall in a certain direction and must not touch the ground. It is carried on poles and set upright in a hole and becomes at that moment the WORLD TREE, a symbol of the CENTER and the link between the spheres of existence. It is spoken of as a "person" and transmits the offerings and sacrifices to the spirit realm. Colored ribbons symbolizing heaven and earth are tied high in its branches. Among the Crow, the symbols of earth and heaven are the head of a buffalo placed facing east and an eagle in the branches. A lodge is erected, beginning with a ring of twenty-eight vertical, forked poles (the days of a lunar month) and horizontal beams laid between the perimeter and the central tree. This arrangement recalls the twenty-eight stone spokes of

SUN DANCE

Above: Rawhide cutouts depicting humans and animals were tied to the central post inside the Sun Dance lodge. Dancers focused their attention on them, hoping to increase their own and the group's fertility.

SUN DANCE LODGE

Below: Plan of modern Sun Dance lodge.

DANCE AREA

DANCERS STALLS

SACRED PIT

FIRE TENDER

DRUM

GATE KEEPER LODGE POLICE

MEDICINE WHEEL structures. This structure becomes the cosmos for the duration of the ceremony, the primordial sacred place within which creation is reenacted.

Supernatural Animals. Hybrid creatures that combine characteristics from several animals often play central roles in indigenous myth and imagery. In North America, the Algonquians' Underwater Panther, which usually looks like a feline except for the horns added on males, is said to live in streams and lakes and can kill with a mere flash of an eye. The *piasa*, a hybrid combining human, serpent, avian and feline elements, is represented on MISSISSIPPIAN CULT objects associated with fertility. Horned and winged serpents also appear on Mississippian cult objects. Perhaps the most prevalent North American supernatural creature is the Thunderbird, associated with power, the sky and spirituality. Other Northwest Coast hybrids are KONANKADA, chief of the undersea world (a combination of bear, avian and human elements) and the numerous hybrids associated with Kwakiutl HAMATSA rituals. Finally, masks and costumes can be considered hybrids, as they combine significant representations, materials and behavior that serve to unite a variety of creatures and concepts. A dramatic instance of this is the dignified and impressive ZUNI Shalako costume that combines avian, buffalo and ogre features along with valued and colorful inorganic materials such as turquoise and coral. Barbara Tedlock refers to the Shalako as "unfinished." Perhaps "coming into being" is a better description, as the Shalako seem to be composed of all the raw materials needed to create great beauty and spiritual power ("The Beautiful and the Dangerous: Zuni Ritual and Cosmology as an Aesthetic System"). See INDEX: Animals.

Suspension Hooks. Nearly all the peoples of the SEPIK RIVER region made carved hooks to protect food and other possessions. These were suspended from the rafters beneath a large disk to prevent animals from climbing down. The food was put into net bags and hung from the upward curving hooks. Since most were carved with human, fish, reptile and avian imagery, it is difficult to differentiate between utilitarian hooks and the more important ones associated with the well-being of the community. The latter were named and offerings were made to them before undertaking important activities such as HEAD HUNTING. It is possible that the hook is related to the beak of the great hornbill bird associated with ancestors and head hunting. Although the literature reports that skulls were sometimes hung on suspension hooks, their function was different from SKULL RACKS (cf. KEREWA). See also IATMUL, LOWER SEPIK and INDEX: Birds in Animals.

Swahili Coast. The Arabic word Swahili, referring both to a language and a culture, means "belonging to the coast." This distinctive culture had developed on the east coast of Africa by the 9th century CE resulting from complex interweaving of the local Bantu with influences from Persian and Arabian traders. In the 16th century the Portuguese controlled trade. Swahili art, including mosques, pillar tombs and woodcarving, reflects the aniconic, calligraphic style of Islamic art. Swahili-speaking women wear commercial *kanga* cloth with designs determined earlier by Indian and Portuguese traders, and more recently by East Indians and East Africans. The brightly colored designs include a central motif, borders and often a proverbial text. Women value *kanga*, and regard the cloth as a form of wealth and communication through their proverbial texts.

Swallowing. The gods often swallow human beings in order to transform them.

SUSPENSION HOOKS

Above: Iatmul suspension hook with HERALDIC WOMAN, from Yentshanmagua. Collected 1914.

In initiations the swallowing amounts to a symbolic death, prior to the initiate being vomited out and reborn. Swallowing may also be a substitution for sexual intercourse as, for instance, in the north Australian myth of the WAWALAG SISTERS, where Yulunggul, the Great Python swallows the sisters. The conjunction of snake and sisters brings on the monsoon rains, thus fertilizing the land. In the border area between Sierra Leone, Guinea and Liberia, fearful looking PORO society masks called *landai* (or *dandai*) abduct and mime devouring boys during initiations. The initiation concludes when the masks reappear and regurgitate the boys who are reborn to adult status, having become part of (been digested by) the founding spirit of the society. See also ALTER EGO, BENIN PALACE COMPLEX, BIRTH, CRESTS and THUNDERBIRD.

Swastika. The swastika is an ancient symbolic form of the CROSS and is linked with the CENTER and the intersection of the FOUR/SIX DIRECTIONS. Because of its dynamic quality, it is also associated with water, the sun and motion. It appears frequently in North America, on textiles and pottery; for illustrations see BASKETRY and MISSISSIPIAN CULTS. Frank Waters suggests that Hopi swastikas depict the migration routes of the various clans. It does appear in Africa, although less often.

Sweat Lodge. Among North American Plains and some Southwestern peoples, small domed lodges are made of saplings covered with hides and blankets to make them airtight. Inside, a hole is dug and heated stones are placed in it. Water is sprinkled on the hot stones, causing hot steamy air to fill the lodge. Participants slap their bodies with pine boughs or buffalo tails to increase blood circulation while singing, asking favors from the spirits and praying for the general welfare of

their people. The lodge is opened periodically to allow fresh air to enter and the ceremonial PIPE is smoked at that time. Sweat Lodge ceremonies are conducted prior to war, before undertaking a VISION QUEST or some other important event. The Sweat Lodge ceremony is regarded as spiritually and physically purifying.

Symbols of Office. The king or chieftain often has elaborate hereditary regalia that complexly symbolize his power. Craftsmanship and materials—these are often, but not always, intrinsically valuable—reflect their importance. Such objects accumulate power with age. See CROWN, fly-whisks (JANUS FIGURES), LINGUIST STAFFS, SCEPTER and TALKING STICKS.

SWAHILI COAST

Above: Carved doors made for the most part between 1600 and 1900 are concentrated in Zanzibar, Lamu and Mombasa. The quality and size of double doors with intricately detailed lintels and jambs were signs of wealth and social status. Some of the motifs are significant: the chain, for instance, is said to symbolize security; fish and wavy lines indicate the sea and its produce; and the frankincense and date palm trees stand for wealth and plenty. Rosettes and lotus designs show Indian influence, while that of Islam is evident in the Koranic texts that, along with the owner's and artist's names, may be incorporated into the designs. c. 1900.

Right: Sio Hemis KACHINA DOLL with the characteristic elaborate tableta. The cylindrical face mask is painted half-red, half-green and the bands separating the parts of the mask and arching up over the face are red, yellow, green and black with white dashes. The stick figures at the sides of the tableta represent water skates (Gerridae).

TADA

Above: This superb seated figure was, until recently, kept in a shrine in the village of Tada where the villagers took it down to the river every Friday and scrubbed it with gravel, causing its smoothed appearance. Although converted to Islam, the villagers continued to observe older beliefs: the statue was thought to guarantee the fertility of their wives and the fish in the river. The almost pure copper figure wears a bead net wrapper and a hip ornament similar to others from Ife. The figure is more rounded and fleshy than those of Ife, but is similar in its monumentality and regal presence. 13th–14th century.

Tableta. Hopi and Zuni masks and *kachina* dolls often have flat, plank-like extensions called *tabletas* radiating outward from the face. Their stepped pyramid or semicircular profiles show that they are closely associated with clouds—the nature of *kachinas* is said to be "cloud-like." Other symbols of water and fertility adorn them including corn and flowers, rainbows and the parallel hatched marks of falling rain. The HEMIS mask, the main performer in the Hopi *niman* ceremonies which bid the *kachinas* farewell as they return home to the San Francisco Mountains, was borrowed from the Zuni. Its *tableta* often includes simplified linear depictions of the water skate, an insect that flits across the surfaces of almost all bodies of water in the Southwest. Its watery environment links it with water as source of all life, but it is also apparently a symbol of the FOUR/SIX DIRECTIONS and the CENTER. According to the Zuni, who depict the water skate as an X shape, the creature was given magical powers by the Sun Father, enabling him to locate the center. By stretching his four legs out to the solstices, his body separated above and below and rested at the center, the heart and navel of Earth Mother. It was there that the Zuni built their pueblo. The Hopi represent the water skate on *kachina* table-

tas as a stick figure with downward turned legs and its antennae form an upright V shape. The figure is reminiscent of WORLD TREE and genealogical patterns. Doubtless, some of the significance of this symbolism has been lost, but the water skate's ability to "walk on water" and the way its body is reflected in still water make it a magical creature suggesting the spirit realm and the ephemerality of life.

Tabwa. The Tabwa consist of six groups of Bantu speakers living in the Democratic Republic of Congo and Zambia. They are closely related to the LUBA and HEMBA. Due to colonialization and conversion to Catholicism, Tabwa art and religion disappeared from public view in the 1920s. Allan Roberts writes that the dualistic

Tabwa worldview involves the struggle between good and evil, light and darkness and fertility and sterility. The duality was expressed visually on the chests of figures, see DIRECTIONAL SYMBOLISM.

Tada. Tada is today an obscure NUPE village located north of IFE on the Middle Niger River. It is famed for a cache of nine copper alloy figures in the Ife style which are now in the Lagos museum. How the objects came to be there and what role they played is speculative, but it has been suggested that Tada and possibly the upstream village of JEBBA may have been the place where the agents of Ife interacted with the Wangara of Mali. The sculptures may have in some way legitimized Ife's presence in the north. Alternatively, the figures may have been sent from Ife to Old Oyo and appropriated by the Nupe when they conquered Old Oyo in the early 16th century. At any rate, the stylistic differences between the Tada figures and those found at Jebba and Tsoede indicate that there are, in the Niger region, additional centers of copper alloy casting as yet to be located.

Tahiti. Located in the Windward group of the SOCIETY ISLANDS, Tahiti was associated with Eden in the minds of Europeans. Tahitian society was anything but pacific and, in fact, included a powerful warrior class and formidable navy. Captain Cook described the war fleet of king Tu which consisted of some 330 canoes and, decked out in full regalia, the chiefs and the nearly 8000-man army were an impressive sight. European wishful thinking, however, led artists like Paul GAUGUIN to seek an earthly paradise on the island. Larger Tahitian sculpture is described as being crude, but smaller woodcarvings such as canoe prows, fan handles, staffs and royal seats are finely crafted. None of the canoes has survived, but carved ornaments from them are found

in museum and private collections. Earlier literature attributed intricately carved flywhisks to Tahiti, but they are now said to have originated in the AUSTRAL ISLANDS. See also JANUS FIGURES.

Talking God. One of the more important NAVAJO *yei*, "holy people," Talking God is said to have created the first HOGAN. One of several masqueraders appearing during the Nightway or Yeibichai Chant, Talking God keeps careful watch to make sure that no error occurs.

Talking Stick. In indigenous cultures, staffs symbolize the authority of powerful individuals and their right to speak in public. For instance, Northwest Coast chiefs carried carved staffs with ornamented tops called talking sticks. AKAN linguist staffs, topped with figurative goldleaf ornaments, function similarly. These finials, believed to be a 19th-century development, proverbially depict the ruler's power. For instance, the image of a bird is linked to the proverb "Woodpeckers hope the silk cotton tree will die," i.e. ordinary people, like woodpeckers, can only hope that the mighty will fall.

Tambaran. The term has a variety of applications including the INITIATION cult, the spirits venerated by the cult, the grades within the cult and its ritual paraphernalia, and finally, the cult building itself (see Colorplate 8). Although it usually refers to SEPIK RIVER cultures, the term is also used in conjunction with Abelam

TAHITI

Above: Wooden carving from a canoe with back to back figures. The silhouette of the profile shows protruding tongues, a sign of aggression. 18th century.

TALKING STICK

Right: This TLINGIT talking stick has a wolf's head with haliotis shell-inlaid eyes and teeth. The wolf head sprouts out of the top of a masked human figure seated in the HOCKER position.

TAMBARAN

Above: Iatmul ridgepole finial, East Sepik Province.

KORAMBO spirit houses. Unlike the Abelam structures, those built by the IATMUL served all the needs of the male community—meetings, debates (see TEKET, orator's stool), initiations and residential quarters for initiated bachelors. These massive ceremonial houses were raised up off the ground on four thick corner posts representing protective bush spirits. Ladders with steps carved in the form of ancestors provided access to the upper floor. In earlier times, the houses were surrounded by carved fence posts with human faces that lent further warning and protection. Another distinctive feature of the Iatmul *tambaran* houses was the finials that topped the gables. Made in both ceramics and wood, the finials depict male or female figures and birds. They are described as representing enemies in the grip of eagles, symbols of the aggressive force of the village. They may also refer to the mythic bird-human spirits that taught people the secrets of musical instruments. Finally, at the center top of both gables were huge monster faces with enormous eyes, open mouths with fiercely pointed teeth and protruding tongues. This was the "face" of the house, the entirety of which was conceived of as a female monster; entering the house was to enter the belly of the monster. Over the doors were three-dimensional sculptures of the HERALDIC WOMAN, further emphasizing the transformation (second BIRTH) those entering the house underwent. An additional displayed male figure was often carved at the bottom of the central post supporting the ridgepole. Further instances of Iatmul focus on sexuality and procreation can be seen in the male figures with erect penises and the sculptures showing female figures copulating with various mythic ancestral beings. See INDEX: Birds and Crocodiles in Animals.

Tami Islands. These islands are located in the Huon Gulf. Known as master carvers,

TAMI ISLANDS

Above: Mask representing an ancestral spirit or mythological hero. Huon Gulf. 19th century.

the craftsmen of this area also make masks of organic materials representing *tago* spirits, which were used during INITIATIONS, but may have had a judicial function as well. Wooden masks of the *nausang* type were influential (see KILENGE). Freestanding sculptures of the human figure were made for the interiors of men's and cult houses. Typically the figures have flexed knees and are accompanied by reptiles including snakes, crocodiles and lizards. The latter are believed to be manifestations of *balum*, both a powerful male spirit and a cult (the cult was concerned with initiations and the pursuit of the energy of souls after death). Tami carvers also make wood bowls, headrests, suspension hooks and betel mortars as well as painted war shields. See INDEX: Animals.

Tane. God of forests, Tane was one of the four principal Polynesian deities. It was he who separated the primordial parents (see RANGI for a fuller account) making it possible for human beings to be created. The Hawaiian equivalent, Kane, was god of sexual fertility as well as forgiveness and revenge.

Tangaroa. After the progenitors Rangi and Papa, one of the four principal Polynesian deities. Tangaroa was the god of the sea, fish and reptiles. See A'A, CITY OF REFUGE, COSMIC MODELS and INDEX: Deity Archetypes.

Taniko (or *taaniko*). Geometric patterned borders of MAORI chief's cloaks and the patterned mats on the walls of WHARE WHAKAIRO, meeting houses. The intricate rectilinear patterns of contrasting colors were worked by twining flax fibers. The colors are vegetable dyes and swamp mud. Women made *taniko*.

Tapa (*kapa* in Hawaii). Cloth made throughout Oceania, usually reserved for those of high social status. *Tapa* was made

from the bark of the paper mulberry plant, which was soaked, beaten and then painted, with earth-toned dyes obtained from boiling tree bark. Long narrow strips were sewn together to create larger garments. The finest *tapa*, beaten paper-thin and felted, was created in Tahiti and the Hawaiian Islands. Hawaiian *kapa* is characterized by complex geometric patterns such as stair-steps, zigzags, parallel lines and opposing triangles. A combination of stamping and painting resulted in rich, textural effects.

Tapu. Translated into English as taboo; *kapu* in Hawaii. Closely related and sometimes antithetical to MANA, this Polynesian concept is superficially understood as referring to forbidden behavior or to a restrictive and puzzling set of rules. More broadly, *tapu* is concerned with controlling the powerful forces resulting from contact between human beings and the gods. Of shorter duration than *mana*, *tapu* can be understood as stemming from the capriciousness of life force itself—a transitional state of simultaneous potentiality and vulnerability. The volatility of *tapu* and its attraction to places/objects in growth or transitional states means that it is easily transmitted and open to corruption. The potential can be maximized through ritual incantation and offerings in the form of food (human hearts). Women are particularly powerful sources of *tapu* because their genitalia represented a passageway between life and death (see MAUI). Menstruation (the state of infertility) and pregnancy were equally *tapu*. Also, women evoke the ambivalence of sexual desire in men—copulation creates new life, but is also believed to result in a loss of virility/vitality. Women, thus, act as lightning rods, attracting and defusing *tapu*. *Tapu* and *mana* are best seen, as Allan Hanson suggests, as embodying the ambivalent tension found in Maori art and life (see RANGI AND PAPA).

Tassili n-Ajjer. Tassili n-Ajjer, located in Algeria, is the best-known of all Saharan rock art sites. The earliest art of the region dates between 6000 and 4000 BCE. The things represented change with the passage of time reflecting differences in the pattern of life—from hunting to herding and agrarian—and climate. As the desert advanced, people moved southward into the Sudan and east to the Nile Valley. Most of the paintings date between 4000 and 1000 BCE. The female figure called the "White Lady" of Aouanrhet has been identified as a goddess or priestess. The marks on her body are said to be tattoos and the cloud of dots hovering around her head is called both rain (as are the streamers coming

TAPA

Above: HAWAIIAN kapa cloth painted with seemingly random patterns, was actually created using highly complex, sophisticated principles of design.

Left: The distinctive tapa (hiapo) from Niue was made into ponchos and dresses from c. 1830 to 1930 when European cloth was introduced due to the missionaries' insistence that people cover up. The cloth is divided into squares and occasionally concentric circles and appears to have been painted freehand. The patterns were named and meaningful, for instance, in TONGA, the triangles joined at their points (manulua) were a metaphorical reference to chiefs. Detail, early 20th century.

TATTOO

"You should be tattooed so that you become beautiful and so your skin does not shrink with age. The fishes in the water are striped and have lines; therefore, also human beings should have stripes and lines. Everything disappears after death, only the tattoo continues to exist; it will surpass you. The human being leaves everything behind on earth, all his possessions, only the tattooing he takes with him into the grave."

— *Marshall Islands, message from the gods of tattooing.*

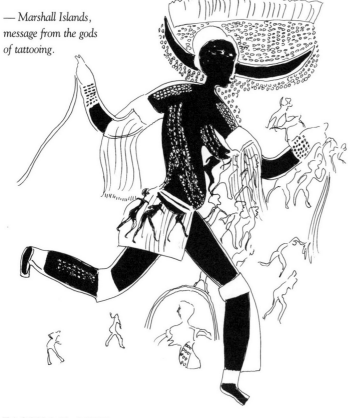

TASSILI N-AJJER

Above: The "White Lady" of Aouanrhet from Tassili is one of the most appreciated African rock paintings, perhaps because her grace and elegance correspond to Western tastes. The "lady" is linked with the so-called Round Head period of Tassili art. c. 3000 BCE.

from her hands) and corn. Given their likeness to similar forms in the rock art of southern Africa, it is likely that the dots and streamers relate to the spiritual energy and visualization of the out-of-body experience of the medicine woman (see SAN art which is also concerned with increase, rain and prosperity). One other notable feature is the figure's horned headdress, also generally linked with fertility. Finally, the painting indicates that cattle played an important part in the lives of these people as they continue to do in eastern Africa.

Tatanua Masks. These distinctive masks from New Ireland represent ideal manhood and frequently play a part in MALANG-GAN rituals.

Tattoo. From the Tahitian word *tatu* or *tatau* ("to strike"), tattooing is a form of BODY ART performed in many cultures. The techniques used vary from injection of dyes to color the skin, pounding colored material into the skin and coloring grooves carved into the skin (see MOKO). Patterns and significance also vary from culture to culture, including clan, lineage or group identification marks, indicators of rank, as well as enhancement of the natural contours of the face and body. Generally, the ability to withstand the pain involved is understood as a mark of bravery.

Tawhiri. Polynesian god of winds, Tawhiri rose up when Rangi and Papa were separated. Jealous of Tane's success, Tawhiri loosed his offspring, the four great winds of the FOUR DIRECTIONS, hurricanes and other small, but violent winds. All creation, except Tu, god of destruction, fled in terror. Tu eventually defeated his brother.

Taumata atua. Maori receptacles for the gods (see GOD STICKS).

Teke. The Teke established an 8th-century kingdom on the right bank of the Zaire River. Outside the royal hierarchy, the basic social unit was the lineage headed by the senior elder. Blacksmiths often served as chiefs and diviners also held positions of power. The most distinctive Teke masks come from the northwest and are associated with the secret Kidumu Society, which played a major role in all social rites of passage. Around 1900 some 300 of these masks existed, but most disappeared following colonialization in 1913. The Teke began making masks again in the 1960s after independence. The Teke shared with the KONGO the concept of a divided circular cosmos, the upper half inhabited by the living and the region below the "hori-

TEKE

Above: Teke masks, described as moon shaped, are among the most abstract in Africa. Sometimes said to depict faces, the circular forms of the masks represent the cyclical path of the soul.

zon" being the land of the dead. Kidumu dancers turn cartwheels, literally and energetically enacting the cycles of life. Marie-Claude Dupre offers a political interpretation, suggesting that the circular form and distribution of shapes either side of the horizonal line developed in response to political changes. Formerly, two chiefs coexisted in one territory, a political duality that changed with the beginning of trade in the 19th century. The cartwheeling mask is said to represent the desire to maintain the old dualistic but balanced political structure. See also CURRENCY.

Teket. IATMUL orator's stool. One of the most important of all Iatmul sculptures, these stools stood permanently next to the central post supporting the roof of the men's house and were used during debates. The *teket* is a receptacle for the most important spirit of the community, *wagen*, the primeval crocodile creator, as well as the spirit associated with the ground on which the men's house stands. When these spirits are present, the stool is regarded as being hot. Often noisy, even violent, affairs, the debates played a major part in Iatmul life.

Debaters punctuated their points by striking the top of the *teket* with a bunch of ritual leaves. Totemic specialists (*tsagi numba*) who commit between 10,000 and 20,000 NAMES to memory, are often called upon to resolve disputes (they also cure illnesses, consecrate houses and canoes as well as initiate rituals). Debate is conceived of as complex and shifting "paths" of ancestral lineage by which the world is defined. The specialists, by chanting paths, can redefine the social and cosmological structure.

Tellem. According to mythology, the present DOGON homeland was occupied by a group of people they called Tellem. The Dogon, who forced these people to leave their settlements on the cliffs, claim that they fled to Burkina Faso. Human remains found in the caves have revealed an ethnically distinct people. Additionally, sculptures, encrusted with sacrificial offerings, have been found in the caves that are age weathered, simpler and more geometric than most Dogon carving. The Dogon themselves tend to identify objects of unknown origin as being Tellem, and some scholars followed the same practice. However, Dogon carvings for ancestor altars do accumulate similar offertory patina with time and it is known that the Dogon reused sculptures they found in the caves or commissioned carvers to make replicas of them. Thus it not clear what role the so-called Tellem figures play in the chronology and development of Dogon art. However, as more is learned about the Inland Niger Delta region, these problems may be resolved.

TELLEM

Right: Tellem figures are characterized by simplicity and geometry and are often encrusted with layers of sacrificial offerings. Many have their arms raised in a gesture interpreted as a prayer for rain. This female figure has scarification patterns on her torso and wears jewelry.

TEKET

Above: Orator's stool carved with a powerful-looking male figure said to represent a primordial creator. The back of this teket is carved with the mythical crocodile on whose back the Iatmul live.

Teluk Cenderawasih. See GEELVINK BAY.

Temperature. Among the KWOMA and elsewhere in New Guinea, heat is associated with creativity, energy and power, regarded as typically male characteristics. Women are cold, but not passively so, instead they have an active coolness capable of draining male heat physically, spiritually and ritually. As a result, sexual contact was prohibited before and during creative activity (e.g., carving masks), ritual and war. The YORUBA of Nigeria value composed, aloof and cool behavior and the aesthetic criterion *tutu*, or "coolness," is used to judge works of art, as well as pervading Yoruba life. See INDEX: Temperature in Natural Phenomena and Materials.

Tepee. See TIPI.

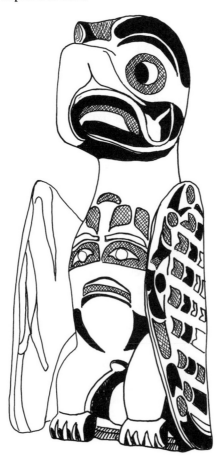

THUNDERBIRD

Right: Haida carving of the mythical Thunderbird, believed to have an extra head on its abdomen.

Textiles. See INDEX: Textiles in Art, Artifacts and Techniques.

Thunder. See INDEX: Thunder in Natural Phenomena and Materials.

Thunderbird. The Thunderbird is a powerful mythic creature that appears all over North America. The ultimate sky creature, lightning flashed from his eyes and thunder was heard when he flapped his wings. Mostly eagle, Thunderbird is usually represented with his wings spread out, tail fanned, sharp beak and flashing eye in profile. The ESKIMO depicted him and further south, on the Northwest Coast, Thunderbird was an enormous eagle-like bird that could swallow whales whole. He appears on HAIDA totem and house poles often with an extra head on his belly. On the fronts of Kwakiutl houses (see COSMIC MODELS), Thunderbird and Killer Whale symbolize the two realms that bracket human existence—the sky and the sea, life and death. Thunderbird also appears on numerous Plains objects, from tipis, to GHOST DANCE costumes. Thunderbird was the totem of two WINNEBAGO clans—Thunderbird and Bear, the former associated with peace and spirituality and the latter with war, policing and judicial functions. It is difficult to say whether Thunderbird imagery came from the north in the form of shamanist influences or from the south and Mesoamerican sources, or from some combination. The association of Thunderbirds (falcons) and serpents in MISSISSIPPIAN CULT imagery is certainly among the earliest appearance in North America of the typical Mesoamerican duality.

Tiki. The word means literally "man" or "human image," but is used in the West as a generic title for Polynesian figurative sculpture. The art of the MARQUESAS ISLANDS is replete with Tiki representations in the numerous three-dimensional

figures in stone and wood made for the temples and on other Marquesan objects (see U'U war clubs, UHIKANA headbands). In the Marquesas, Tiki was a creator god who lived in Havai'i, land of the gods where he formed a wife out of sand with whom he fathered a son and daughter

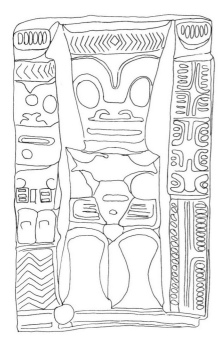

who in turn gave birth to many others. When Havai'i was fully populated, Tiki moved on to the two island groups of the Marquesas—Nuku Hiva and Ua Pou which he also populated. The three-dimensional figures may have served more than one purpose: as votive offerings, to cure the sick and to petition the gods for good fortune in various undertakings. Finally, Maori myth attributes the creation of humankind to the *atua* Tiki, but Tane is also credited with creating humans, using his *tiki* (penis) to do so. See also HEI TIKI.

Time. Indigenous peoples conceive of time in various ways. Most, however, distinguish between primordial time, the time of beginnings, myth and ritual and the ordinary time of daily existence. Some imagine primordial time as a chaotic or at least

formless period during which the world took shape as the result of divine intervention. The Australian Aborigines believe that the shape of the earth resulted from the dreams and/or the journeys of primordial beings during the DREAMING (or Dreamtime). Similarly, human beings only come into being after having been dreamed of by their fathers or by specialist dreamers. The spiritual residue of the primordial spirits is present in the earth and in all living things, resulting in an interpenetration of spiritual/material and of primordial time/ordinary time. Mircea ELIADE identified the time of primordiality "sacred time" and opposed it to "profane time." The term "fluid time" has been used to describe the way the Maori thought of time until European contact. The Maori developed new artistic approaches (see KOWHAIWHAI) in order to incorporate the Western concept of linear time into the images in the meeting houses. Another instance of the interpenetration of sacred and profane time is discussed in the INDIAN TIME entry. Among other concepts, North American natives are described as perceiving time as moments in the circle of life. The idea of cyclical time is widespread. It can take the form of "spiral time," as among the Subarctic KUCHIN. In primordial time, people and nature were united. The connection was severed following a fratricidal act by the Culture Hero that began the spiral of time. In spiral time, events and relationships repeat, but with differences. The Navajo believe that before human time began a primordial state of beauty and harmony existed; the aim of NAVAJO CEREMONIALISM is to restore that ideal primordial state. See INDEX: Time in Natural Phenomena and Materials.

Tipi (or tepee). The characteristic conical, portable housing of PLAINS' nomads, tipis were made of animal hides hung on poles. The structures were made entirely by

TIKI

Left: Tiki figure on a carved plaque from a Marquesas crown (paekaha). Tortoise shell. 18th–19th century.

TIME

"For religious man time too, like space, is neither homogeneous nor continuous. On the one hand there are the intervals of a sacred time, the time of festivals… on the other there is profane time, ordinary temporal duration, in which acts without religious meaning have their setting…

"One essential difference between these two qualities of time strikes us immediately: by its very nature sacred time is reversible in the sense that, properly speaking, it is a primordial mythical time made present. Every religious festival, every liturgical time, represents the reactualization of a sacred event that took place in a mythical past, 'in the beginning.'"

—*Mircea Eliade, The Sacred and the Profane.*

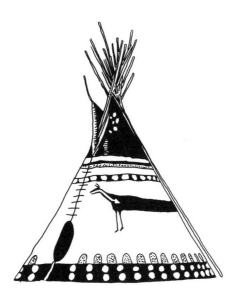

TIPI

Right: Blackfeet tipis were the largest on the Plains, using up to thirty-eight buffalo hides and forty poles. Blackfeet women made the tipis, but the symbolic paintings were done by specialists according to a prescribed order. The dark band at the base represents the earth and the light disks are stars. The dark background at the top represents the sky and again disks represent certain constellations of stars. The stripes below represent the rainbow and the trail of a spirit animal. The light space between is the place for the image associated with the owner's VISION QUEST, usually an animal figure. The tipi poles link sky and earth and serve as paths for prayers to rise to the spirits.

TJURUNGA

Right: Sacred plaque from the Pidgentara people, Central Australia. Incised stone, 12" high.

women—in fact, most regarded the tipis as women's property—but men generally painted the narrative scenes on the outsides. Sometimes especially talented women artists rendered the designs. Narrative subjects included men's exploits in war and hunting in Plains art, while Great Lakes tipis depicted visionary and dream imagery. One unique aspect of narrative paintings was the so-called "Winter Counts" which recorded in pictographic form the most important events of the year. The images served as visual reminders used by oral historians to order and assist their memories. Events recorded in this way sometimes covered decades, even centuries. The largest tipis were made by the Blackfeet and could consist of as many as forty lodge poles and thirty-eight skins. Tipi making was often a communal activity that took place in the late spring. The buffalo skins were sewn together with sinew, the peeled poles were raised and the hides stretched over them and held down with a ring of stones. The stones were left behind when the people moved and thousands of stone circles have been found throughout the Plains. A fire was built inside to smoke the skins to make them resilient and watertight. Tipis lasted one to three years due to wear and tear from

weather and moving. After the eradication of the buffalo, canvas was used instead. Among the Cheyenne the specialized skills of tipi making were governed by a guild—to belong to this guild was a woman's highest aspiration. Additional arrangements for the tipi interior such as liners, robes and storage bags were made and decorated by women. Use of the interior space was controlled by rank and etiquette. Women occupied the south of the eastward facing entrance and men the north side. The place of honor was opposite the entrance, reserved for high-ranking men.

Tjurunga (also *churinga*). Originally an Aranda word referring to oval stone and wooden slabs incised with geometric designs associated with particular ancestral spirits and places (see also WALBIRI). The word is now used generically, covering a wide variety of secret/sacred objects including bullroarers, ground painting designs, ritual poles and songs. Found throughout central and northern Australia, *tjurunga* are incised with geometric patterns including meandering parallel lines, concentric circles, cross-hatching, zigzags, and more rarely bird and animal footprints as well as stylized human forms. The first *tjurunga* were of supernatural origin, created by ancestral spirits during the DREAMING to represent tangible

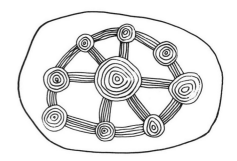

aspects of their bodies and spiritual essence. The reproduction of the designs is the responsibility of those entitled to them by birth. The designs, which signify identi-

ty, the relationship and rights to specific localities as well as the continued spiritual essence of their originator, are so powerful that they are kept in secret lodges. Exposure to them involves proper preparation, although in some aboriginal societies women are permitted to see them in cere-

monial situations. SCHUSTER and Carpenter cite the accumulation of *tjurungas* in places of power as symbolizing an assembly of ancestors, gathered to protect their descendants—the greater the number, the greater the power (*Patterns That Connect*).

Tlingit. The Tlingit live on the south coast of Alaska from Yakutat Bay on the north to the Portland Inlet—a distance of over 480 air miles. Their social organization consists of two groups, Raven and Wolf/Eagle (in the north), further subdivided into clans or lineages. The Tlingit pattern of activities involved hunting and trapping in the spring. June through September they caught and cured salmon and in the late summer took trading trips

and engaged in war and slave raids. The sea otter hunt occurred in the fall. In October the people moved to their winter villages and finally, November and December were devoted to the POT-LATCH and trading trips to the interior. Tlingit houses followed the pattern of most NORTHWEST COAST ARCHITEC-TURE. Houses held six families, between forty and fifty individuals. Their big war canoes were purchased from the HAIDA. Like other North American indigenous peoples, the Tlingit practiced hunting rituals of purification before the hunt, asking their prey for forgiveness. While the men were away, even the behavior of families at home was important, since too much boisterousness among the children would affect the game. Tlingit art consists of the same range of objects found commonly among Northwest Coast peoples—TOTEM POLES, interior sculpture, masks, boxes, utensils and the shaman's tools (when not in use these were kept hidden in the woods). Unique among Tlingit art forms are the famed CHILKAT blankets made by the northern Tlingit. See also TALKING STICK.

Tobacco. The HAIDA say that native tobacco was brought to the Queen Charlottes by Raven and his cousin Cloudwoman. The plant was ground after it was dried and pressed into cakes for chewing. After contact, the Haida used the stronger commercial tobacco and native plants almost ceased to be cultivated. The TLINGIT (possibly the Haida as well) smoked tobacco at funeral feasts due to the belief that the SMOKE, rising upward, conveyed the dead soul and prayers to the upper world. It is possible that chewing tobacco was regarded as secular, while smoking fulfilled ceremonial purposes. Tlingit pipes were carved out of wood, while the Haida made theirs of both wood and ARGILLITE. Argillite pipes began as bold, but simple designs around

TLINGIT

Left: This famous house partition screen was originally part of Chief Shakes' Grizzly Bear House at Wrangell, Alaska. Such screens were erected parallel to the back wall of the house and separated the chief's private apartments from the rest of the house. They served as a backdrop for ceremonies during which the richly attired chief, emerging from the bear's belly must have seemed a living incarnation of the powerful ancestral creatures. Small faces are used as JOINT MARKS, smaller bears fill the ears and symmetrical raven images face inward on the adjoining wings. This screen belonged to the Surrealist artist Wolfgang Paalen before the Denver Art Museum acquired it. c. 1840.

TOLAI

Above: Tubuan mask of the Duk-Duk society.

TOGU NA

Above: Number symbolism plays an important role in the togu na. In DOGON thought the male number is three and the female number is four, thus objects occur in groups and multiples of seven, a number associated with procreation. This post represents a copulating male and female with exaggerated genitalia, standing foot-to-foot. The inverted female figure's arms are raised, in NOMMO fashion, while the male's rectilinear body is reminiscent of kanaga masks. Above the male's head is a curved staff, a prestige item carried over the shoulder by elders. The eight posts supporting the togu na are linked with the primordial Nommo ancestors. Spaced with three on the east and west sides and two in the interior, the posts are conceived as sequential, inwardly coiling in plan like the body of a snake.

1833 and evolved into the complex intertwined figures on the so-called panel pipes (c. 1884). One variation is the Ship Pipe (c. 1841) which shows greater European/American influence. See also PIPES.

Togu Na. Dogon men build and meet in the *togu na*, the physical and symbolic CENTER of every community. Usually the largest structure, the *togu na* is the first to be erected in a new village, or in larger towns, in each quarter. Low in profile, the buildings are rectangular in plan and characteristically have massive roofs of millet thatch. On the cliffs, brick or stone pillars support the roofs, while on the plains below they are supported by exceptionally hard, carved wooden posts made from the forked trunks of the kile tree. Called "house of words," the *togu na* is the place where the young men are instructed, judicial matters decided and village affairs debated. The ceilings of the *togu na* are low, because the Dogon believe that the only true speech is uttered while seated. Words uttered while seated in the *togu na* thus take on added value and importance—jumping up in anger results only in banged heads. The centrality of the place is also evident in the low mud relief on the pillars or carved wooden posts that support the roof. The same multiplicity evident in DOGON MASQUERADES is present here as well. Masks, mythological characters, human figures, body parts, footprints and a host of other symbols appear on the eight (or a multiple thereof) supporting posts. The most prevalent images are large breasted females (or just breasts) which may alternate with male posts (or just phallus and testicles). While women are not permitted to enter the *togu na*, both sexes are crucial for continuity and prosperity. The Dogon believe that the spirits of the deceased visit the *togu na* as the sun sets, re-energizing it for the living.

Tohunga Whakairo. The woodcarver held high status in MAORI culture. As was true elsewhere in Oceania, carving hard substances and using the tools needed to do so were the exclusive prerogatives of males (see GENDER ROLES). Carvers held the patterns in their memory and observed rigid restrictions (*tapu*) to maintain *mana*, or spiritual power and purity.

Tolache. The Aztec name (adopted by the Spanish) for the psychotropic plant *Datura inoxia*. See CHUMASH and HALLUCINOGENS.

Tolai. These people live in the northeast part of the Gazelle Peninsula, the Duke of York Islands and nearby islands off southern New Ireland. Art forms included objects associated with three masking traditions, elaborate mortuary canoe carvings and chalk images of humans and animals. Best known is the masking tradition associated with the Duk-Duk society, which served as an extension of the chief's regulatory and judicial powers. Two types of Duk-Duk masks exist. The simpler of the two is called *tubuan*, an immortal female spirit who every year gives birth to Duk-Duk spirits. The masks are boldly painted cone-shaped sackcloth forms worn over a cascade of leaves and sprouting a tuft of white feathers. The male Duk-Duk masks have elaborate superstructures encircling the cone. The Tolai also make carved wood masks and overmodeled skulls. The people practiced BOAT BURIAL, setting

the corpse adrift and lighting fire to the non-functional canoes with elaborate geometric and representational (scorpions in one instance) designs made in delicate openwork. The chalk figures mentioned above were used by a secret Iniet medicine society which also used large figures and intricate openwork dance wands.

Tonga (formerly called the Friendly Isles). Tonga and SAMOA are adjacent island groups in western Polynesia with a similar material culture. The only one of the four Polynesian gods venerated was Tangaroa, god of the sea. Tongan social structure, traced back to the union of Tangaroa with a woman from an earlier population descended from a worm, is one of the most hierarchical in Polynesia. Impressive wood sculptures of female figures are generally identified as the goddesses of death and the afterworld, Hikule 'O and Sakaunu. Alternatively, the figures may represent senior female lineage figures as they reflect ideal female characteristics (generous breasts, shoulders and calves). Very few of these images survived destruction by missionaries. The most numerous carved wooden objects to survive are clubs in a wide variety of shapes. Decoration consisted of finely incised lines, human and animal shapes inset (sometimes in ivory) into geometric grounds. The same geometric patterns, metaphors for chiefly attributes, recur on baskets and bark cloth. Music was highly developed on Tonga and was apparently understood and appreciated on different levels depending on the spectator's degree of sophistication. See map: OCEANIA.

Tongues. Protruding tongues were common in IATMUL art (on war shields and on the great monster masks on the men's house gables), where they were linked with both aggression and protection. In Northwest Coast art, the tongue often acts as a path transferring life from one being to

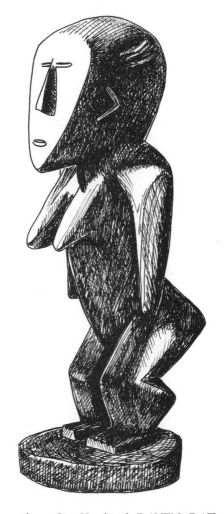

TONGA

Left: Female figure from Lifuka, Ha'apai group. Probably collected c. 1830.

another. On Kwakiutl RAVEN RATTLES, owned by important chiefs and used by the shaman, the tongue of the reclining human figures enters the mouth of another creature, such as a frog, associated with life and rebirth. The tongue serves as a vital connection between humans and animals—a connection that protects and sustains life. See INDEX: Tongues in The Human Body.

Tools. Great care and attention were often lavished on tools in indigenous cultures. The common attitude in Western 20th-

TOOLS

Below: Mesquakie crooked knife from Tama, Iowa. The crooked knife was the primary carving tool on the Northwest Coast and in parts of North America. It was held palm up and used as a drawknife to trim lodge poles, shape canoes and for carving sculpture and numerous other purposes. 19th century.

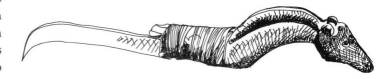

TORRES STRAIT ISLANDS

Right: Turtle-shell mask decorated with sennit, wood, human hair and cassowary feathers.

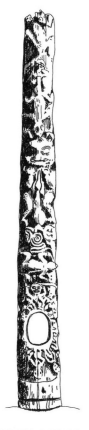

TOTEM POLES

Above: Called Hole in the Sky (or Ice), this old pole was carved by the celebrated Haesemhliyawn. Raised over a century ago, it was the Wolf clan totem of the Gitksan TSIMSHIAN in Kitwancool. It apparently served as the entrance to the house. The pole shows, among other things, three wolves and a bear with visible entrails. The figures around the hole are said to be an ancestor who saved the people from starvation.

century culture, that the efficiency of use is most important, seems in many Non-Western societies to have been far less important than the beauty of the object. Tools and their use were often the gift of the CULTURE HERO and this mythological, spiritual origin added to their importance. Furthermore, tools and tool use are closely related to GENDER ROLES in both Western and Non-Western cultures. Although modern Western women use many tools and machines without question, in indigenous cultures, forbidding women access to tools was part of the fabric of society. Women traditionally were prevented from using tools connected with "hard" materials. Clearly, this resulted in women weavers, potters and basketmakers, while men forged, carved and built. The division of labor was partly practical, but also had to do with the concept of women as being unclean (resulting also in their physical removal) during their menstrual cycles. Control of tools also served to support and maintain male superiority. The handles of tools are often carved with imagery associated with the tool's purpose and served to protect the user and facilitate the work. Some were intended to be whimsical, such as those that depict hands, puns for the hand that grasps the tool. In many places the introduction of European/American metal tools resulted in what has been called a golden age of carving (e.g., Eskimo and Northwest Coast). See INDEX: Tools in Art, Artifacts and Techniques.

Torres Strait Islands. Little figurative sculpture is made in this area which lies between Australia and New Zealand. *Paruag* or *opop*, "man arrows," highly detailed arrows used in warfare, and canoe prow ornaments represent the human figure. Perhaps the most memorable objects are sacred turtle-shell masks representing a CULTURE HERO or founding ancestor from the time of creation. These were kept

in special buildings within sacred sites called *kwod*. The turtle shells were shaped after soaking in hot water, drilled along the edges and sewn together. Masks were also made from wood and even more modern materials such as the sheet metal example formerly in Picasso's collection. Small ele-

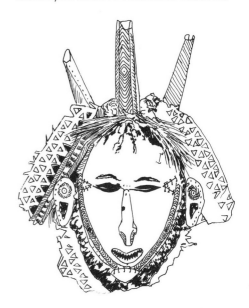

gant carvings in stone, coral and wood served as hunting charms and enhanced the productivity of Torres Strait gardens. Some of the figures, especially the squatting ones, may have represented mythical ancestors.

Totem. According to Joseph Campbell, the word totem is from the Algonquian (Cree, *ototama*; Ojibway, *ototeman*) and originally referred to a brother-sister blood relationship. As used by anthropologists the word totem generally refers to a common ancestor (as well as the physical symbol, often an animal, which depicts and embodies it) which unites a group of people. The totem generally stands in a particular protective relationship to the group. In Northwest Coast art, see CRESTS.

Totem Poles. This generic term is used to identify a variety of vertical cylindrical poles. The most common use of the term is

in reference to the impressive carved poles found on the Northwest Coast of North America. There are, in fact, several objects loosely called totem poles—exterior house posts, memorial poles and mortuary poles. Occasionally, the smaller interior house posts are also called totem poles. Early 18th-century reports on the Northwest Coast mention carved interior house posts, but freestanding totem poles were unusual (mentioned as occurring only at Dadans on Queen Charlotte Island and in the TLINGIT territory). Soon after contact, poles became more common, partly as a result of the introduction of metal tools, which made carving easier and also due to inter-group cultural exchange and competition resulting from closer relations due to the fur trade. These factors, in addition to increased wealth from the fur trade, resulted in what is generally regarded as a golden age in Northwest Coast art. Carved with CRESTS, the placement of designs, especially subsidiary figures attached to the ears, chest or mouth of primary figures, refers to specific myths involving the lineage that owns the crest. Generally, the heads of animals and human beings are as large as the rest of the body and arms and legs are simplified and attached closely to the sides of the figures. Totem poles use FORMLINES, but to a lesser degree than do other objects because of their greater three-dimensionality. The freestanding poles may be an elaboration of house posts attached to the house fronts like those visible in John Weber's watercolors done on the Cook expedition. House posts are identifiable because in addition to the stacked crests, they are pierced by an oval hole through which the house was entered. This hole usually occupied the belly of the lineage's foundation ancestor or some other ancestor of great importance. Thus, climbing through the hole was to enter into the body of the ancestor, to move from the outside, secular world into the interior, sacred realm, tantamount to dying

and being reborn, according to one source. Memorial poles were commissioned when high-ranking chiefs died to mark the death but also to solidify the successor's claims of inheritance and power. Finally, mortuary posts supported the coffins of high-ranking chiefs or their wives.

Trail of Tears. In the 1830s the Jackson administration forcibly evicted hundreds of Native North American families, freeing their fertile agricultural lands for white settlers in Georgia, Tennessee and Alabama. The Cherokee called the route to eastern Oklahoma, where most were resettled, the Trail of Tears. Despite their displacement, the Cherokee, the Creek, Choctaw and Chickasaw tried to maintain tradition, carrying embers from the sacred fire west where they built the square sacred enclosures modeled on those they left behind.

Transformation Masks. The KWAKIUTL made the most famous and intricate masks of this type. Some scholars suggest that

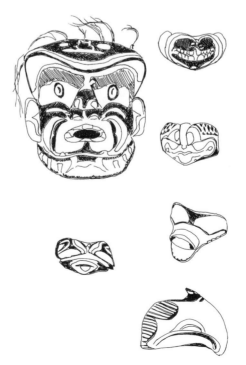

TRANSFORMA-
TION MASKS

Left: Kwakiutl echo mask with nine (five shown) detachable mouths representing sounds echoing off cliffs and waterways. The dancer could mimic the appearance and sound of a wild man in the woods, a bear, frog, eagle, cannibal woman (TSONOQUA) and killer whale.

there may be a connection between these masks and the Eskimo INUA masks which also have two very different aspects. Transformation masks have moveable parts, which can be manipulated by the dancer to reveal different creatures as the performance progresses. The sleight of hand and excitement made possible by these masks may also be an attempt to give visual form to the shaman's shape-shifting. In addition to moveable parts, some masks had detachable parts, which could completely change the appearance of the ensemble.

Tree Dwellers. The Eastern Sioux believe that evil spirits live in hollow tree stumps in the forest. Certain shamans who had these as helping spirits made small images of them, which were kept with other ritual paraphernalia. They were contained in wooden boxes representing the tree stump. The Santee Sioux may have used Tree Dweller images in hunting magic—Canhotdan was a somewhat capricious spirit that had the power to help or harm hunters. Tree Dweller images usually have horns and faces of rather frightening aspect. Bells are attached around their necks and they hold their hands clasped in front of the waist. Indeed, the auditory aspect of tree dwellers is of some significance—they are said to attract victims by imitating the sound of leaves moving in the wind, which sounds like *cice, cice,* which translates "come to the feast."

Tree of Life. See INDEX: World Tree in Natural Phenomena and Materials.

Trees. See INDEX: Trees in Natural Phenomena and Materials.

Triangle. Carl SCHUSTER's work suggests that triangles are one of a number of patterns linked with ancestors and the family tree (*Patterns That Connect*). This can be seen in the GIRYAMA mortuary

TREE DWELLERS

Above: Eastern Sioux images belonging to the shaman. This figure has visible ribs, which contrast with its powerful physique.

posts where the triangles are said to simultaneously represent ribs, genealogy and the family tree. The ancestral implications of the design are most important in connection with the most powerful ancestors, such as on KUBA masks and raffia cloth where triangles symbolize the dynastic succession of rulers. Similarly, on TONGA the motif of three or four triangles meeting at their tips is called *manuahua*, a word no longer in use that meant two birds, a metaphor for a chief whose genealogy was strong on both sides. Sometimes, the genealogical/power symbolism is expressed indirectly, as for instance on FON FABRICS, where nested trangles bring to mind the claws of lions, and lions in turn are royal symbols. In the less stratified societies of North America, paired triangles are butterfly symbols among the PUEBLO and HOPI. Stacked triangles conflate butterfly and cloud symbolism among the Hopi, who say the design is a cloud ladder associated with the Butterfly Clan. The triangular designs on BWA masks are said to represent the hooves of the koba antelope. Although triangles appear and even dominate designs in other objects (e.g., BAGA snake masks, Hawaiian TAPA cloth and INNU coats) their symbolic implications are not known. For additional triangles, see INDEX: Pattern in Art, Artifacts and Techniques.

Trickster. Tricksters can be animal or anthropomorphic in form. Generally characterized by energy, sexuality and creativity, tricksters are LIMINAL BEINGS that can be beneficial or destructive by turns. Their often childish, anti-social behavior recalls primordial times prior to the institution of human laws and regulations. As such, tricksters serve as dramatic reminders of the value of order over chaos. But at the same time, their boundless creative energy, like that of artists, invigorates society, gives the world color and makes life worth living. Tricksters often double as CULTURE

HEROES in some cultures. See INDEX: Deity Archetypes.

Trobriand Islands. See MASSIM.

Tsimshian. These people live on the Northwest Coast between the Skeena and Nass Rivers. There are four subdivisions among the Tsimshian—Coast Tsimshian, Southern Tsimshian, Gitksan and Nishga. Tsimshian tradition holds that they moved into the area from the southern interior, driving the indigenous TLINGIT farther south. Today, they live between the Tlingit and the KWAKIUTL and their coastline looks across the Hecate Strait toward HAIDA Gwaii. Although most Tsimshian territory is in British Columbia, the prosperous community of Metlakatla is now located in Alaska. Originally, Metlakatla was founded by an Anglican lay priest named William Duncan who moved "his" 825 Tsimshian there after obtaining the land from the Canadian government. The community prospered from its founding in 1887 and is still in existence although its economy cannot adequately serve the 1400 inhabitants. The Tsimshian are credited with inventing the RAVEN RATTLE, which spread to several other Northwest Coast Native groups. They painted their house fronts with CREST designs which were regarded as the "real crests," TOTEM POLES being merely commemorative. See also LABRET.

Tsonoqua (also Dzonokwa, Tsonaqua). The feared KWAKIUTL CANNIBAL woman, Tsonoqua lives in the depths of the forest and catches and eats children. Her presence was always announced by a whistling in the woods. At the same time, this supernatural being is a symbol of riches and wealth. She is sometimes depicted as a series of vessels aligned to represent her head, breasts, navel and knees. Participants symbolically eat those parts of her body.

Tu (Ku in Hawaii). After the progenitors, one of the four principal Polynesian deities. Tu was the god of destruction.

Tubuan Mask. See TOLAI.

Tunghak (also *tungat*). *Tunghak* are the spirit helpers of the SHAMAN which manifest themselves in numerous forms such as animals, elemental beings, and the spirits of places or diseases. Because of their power to harm, they are regarded as being extremely dangerous. ESKIMO *Tunghak* masks often involve distortion, dynamic asymmetry and are less realistic than their counterparts, which depict beneficent INUA (human counterpart) spirits. The characteristic appended protruding elements must add considerably to the mask's impact, as they would move and even make sounds as the wearer performed. Like *inua* masks, *tunghak* masks were worn in increase (especially hunting), curing and funeral rituals. Corbin referred to Eskimo masks as wearable mobiles.

Tupilak. Sculptural images used for sorcery among the ESKIMO, primarily to kill others. Among the Greenland Inuit, the *tupilak* is fashioned by a sorcerer out of parts of

TUNGHAK

Left: The teardrop shape of this Alaskan Eskimo mask has added on feathers, flippers with dangles on the left and human legs on the right. The misplaced human features add to the dynamic quality of the mask. Redrawn after Nelson, 1899.

TSONOQUA

Above: Cannibal woman masks are characterized by powerful facial planes, deep-set eyes and a puckered mouth. Children hide behind their mothers when the dancer appears.

TUPILAK

Above: Carved wooden Inuit image of a dog-like tupilak with pronounced ribs and backbone from East Greenland. Collected 1930–31.

TURTLE

Above: Cameroon art objects are often decorated with checkerboard patterns said to represent the turtle's back, linked by its watery associations to the realm of the ancestors.

a dead child and animals, especially the bones of animals killed by the person against whom the sorcery is directed. The mixture is wrapped in an old skin, padded with peat "flesh" and brought to life by a magical formula. Having gained strength by sucking on its creator's genitals, the *tupilak* was sent out to kill. To the unsuspecting victim, it might look like an animal, recognition of its true nature coming too late if the *tupilak's* creator was stronger than the victim. The strong victim, protected by powerful amulets, could turn the *tupilak* back on its maker. The maker could neutralize its effect only by public confession of sorcery. Among the Iglulik Inuit the *tupilak* was a wandering ghost visible only to the shaman who could frighten it away by attacking it with a knife.

Turtle. The turtle plays a major role in many world creation myths. Often, the turtle is the solid mass on which the earth is created and the *axis mundi* that separates earth and sky reaches upward from turtle's back. The back of the IROQUOIS Great Turtle served as the foundation for the earth, which was brought up from the primordial waters by the EARTH DIVER, Toad. Turtle shell is a favorite material for various prestige items throughout the Pacific (see KAPKAP, TIKI, UHIKANA).

Often, such objects are associated with ancestral descent since the wise turtle possesses the secret of rebirth, knowledge of the future and other wisdom. The patterns on turtle's back are regarded as significant, as for instance, among the Cherokee the patterns reflected the movement of human dancers and singers performing rituals. The Cherokee believed that catastrophes were foretold when the images of ritual dance and song were replaced by unfathomable, enigmatic patterns. The patterns on turtle's back are also associated with the path to the land of the dead in CONTINUOUS LINE DRAWINGS (Malekula). Among the Asmat, the turtle is a symbol of fertility because of the large number of eggs it lays. The turtle is the central image in SOUL BOATS called *uramon* (see CANOES) which are used in initiation ceremonies. The boys straddle the canoes and the blood from their circumcision and scarification flows over the turtle. See also UMBILICAL CORD and INDEX: Tortoise/Turtle in Animals.

Twins. All over the world, twin births are received with ambivalent, but powerful emotions. Twins are often believed to have a special connection to the spiritual realm. Because of low birth weight and high infant mortality among indigenous peoples, twins were especially vulnerable which may have led to the belief that they shared one soul between two bodies. The CHUGACH Eskimo believed that twins were especially lucky. The souls of twins were said to live on an island where they sat on water-lily leaves in a lake. On the Northwest Coast, twins were associated with the primary food source, the salmon. The BELLA COOLA attribute the occurrence of twins to a salmon entering the body. The parents of twins had to observe rituals to avoid offending the salmon and both parents and children would facilitate the salmon runs by throwing miniature cedar carvings of salmon into the river as

gifts. When they died, the bodies of twins were placed in burial boxes in trees. The NOOTKA of Vancouver Island also associated twins with the salmon but feared them, often imposing isolation on the family for between one and four years. The Algonquian creation myth tells of twin

brothers, one good and one evil. Gluskap, the good brother, was the creator who formed the body of his mother, the earth, into land forms, plants, animals and human beings. The evil brother, Malsum the wolf, plotted to kill his brother, but Gluskap prevailed, driving his evil counterpart below the earth. A pair of dichotomous twins also exists among the IROQUOIS. The ZUNI Twins (sometimes identified as the Twin War Gods) were the result of a union between the sun and a waterfall. Thus, they represent the two

most precious things in the Zuni world— the fertilizing warmth of the sun and the nurturing waters. The Navajo HERO TWINS play an equally central role. Twins play major roles in Africa, especially among the Yoruba. The Yoruba regard children as a blessing, so twins are doubly valued. The Yoruba believe that twins share a soul. If one or both twins die, the family commissions commemorative sculptures called IBEJI which are cared for as if they are living children. The four sets of DOGON ancestral twins are often represented in art. Acting as Culture Heroes, each contributed something of crucial importance to Dogon society.

TWINS

Left: Dogon sculpture of a woman with twins. Dogon twins are endowed with the vital force (nyama) of Nommo water spirits.

U

UMBILICAL
CORD

*Right: Lakota umbilical
cord amulet. The Plains
Indians packed the child's
cord in soft material like
buffalo wool and preserved
it in beaded amulets.
Although some sources
report that Lakota amulets
were made by grandmoth-
ers during the mother's
pregnancy, others state
that the type of creature
depicted was gender specif-
ic. If this is so, this one
was apparently for a girl
child, as the turtle was
believed to have control
over women's reproductive
functions. Other amulets
took the form of lizards
(also for girls) and snakes
(for boys). 1860s.*

UHIKANA

*Below: Among the most
refined Marquesas crafts,
these headband ornaments
contrasted the dark carved
silhouettes in tortoise shell
against the shimmer of
mother of pearl. 19th
century.*

Uhikana. MARQUESAS ISLANDS headband ornament. Making powerful use of negative space, these ornaments consist of dark circular plaques with finely detailed symmetrical designs meticulously cut with rat-tooth tools silhouetted against a light background. Designs are anthropo- or zoomorphic. Some are decorated with the small human faces with flattened, flared noses and the goggle eyes representing Tiki, the god of creation. According to Carl SCHUSTER, the faces are human-reptiles or *etua* regarded by the Marquesans as gods or ancestral ghosts (*Patterns That Connect*). They have been compared to Solomon Islands KAPKAP ornaments. Marquesan craftsmen in the southern islands also made headdresses (*paekaha*) of alternating tortoise- and conch-shell plaques, mounted on a fiber base. The natural curvature of the shells provides a graceful outward curvature. See TIKI.

Ukara Cloth. Igbo *ukara* cloth is decorated with *nsibidi* signs, an esoteric system connected with the EKPE society. For an illustration of *ukara* cloth, see IGBO; regarding the symbols see SIGN SYSTEMS – EJAGHAM/IGBO NSIBIDI.

Uli. See NALIK. The Uli cult was practiced by the Mandak population of central NEW IRELAND until the 1930s. The Uli was a supernatural force/ritual energy that manifested itself through human beings. The extensive preparations for the ceremonies involved the presentation of the female element (children, tubers and taro) and the male element (social control) responsible for controlling the Uli for the benefit of society. Uli festivals were organized following the deaths of important individuals. During the ceremonies, the skulls of the deceased were carefully washed in seawater and then overmodeled and decorated before being displayed in the CENTER of a structure said to represent the sun.

Umbilical Cord. Many indigenous people preserve the infant's umbilical cord, believing it to be connected with the child's con-

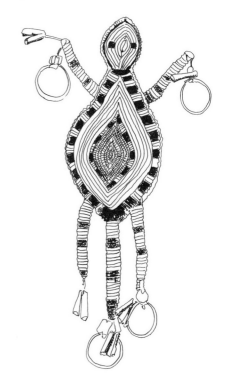

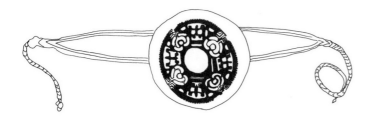

tinued well-being. LAKOTA amulets were hung from the child's CRADLE BOARD as playthings and later were made into necklaces so people could wear the cords as amulets. Many Lakota amulets are now in museum collections, sans the umbilical cord as most were removed before their owners would part with the beadwork pouch. In other cases, special containers are made to keep it safe.

Umbilicus. See NAVEL.

Unangan. The name by which people called the ALEUT identify themselves.

Underwater Panther. Underwater Panthers and Thunderbirds often appear in pairs in Great Lakes art and myth, representations of sky/water, above/below. The Panther stirred up tempests by whipping its tail. The two are in constant battle. When they appear on opposite sides of the twined bags made to contain MEDICINE BUNDLES, they allude to the powerful objects kept within, without revealing the contents. The bundle becomes a metaphor for the cosmos, an expression of balance and complementary forces. See INDEX: Supernatural Animals in Animals.

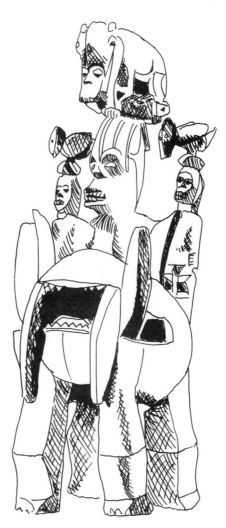

Urhobo. The Urbobo are Edo speakers living in the western Niger delta who believe they are of Bini, IGBO and IJO origin. Social organization at the village level consists of lineage chiefs, war chiefs, a priest-king (guardian of the common lineage ancestor shrine) and members of the Ekpeko society. Urhobo religion is animistic, and each community has its own spirit that resides in a tree, the river or some other natural form. Snakes are intermediaries between the human and spiritual realms and often appear in dreams. Ancestors are worshiped at all levels, from the family to the common lineage ancestor. Like several other African peoples, the Urhobo attribute special power to

URHOBO

Left: The ivri sculpture combines human and animal elements to embody power and protect against its negative effects. The central figure is said to be crowned with an elephant trampling heads under its feet; the subsidiary figures sport birds on their heads. The figure's aggressive jutting jaws and bared teeth contrast with heavy eyelids over eyes that seem intensely inner-directed. The composite nature extends to the zoomorph below, as its body is covered with painted spots and its head sprouts triangular ears, both of which link it with the leopard. Its great over-lapping fangs or tusks, however, are those of some other creature. Ivri shrines are said to become more powerful with time and more dangerous and difficult to control. 19th century.

UNDERWATER PANTHER

Far left: Potawatomie bag showing the Underwater Panther and Winnebago bag with four Thunderbirds. Both 1840–60.

the hand. Sculptures called *ivri* (also *ivwri*, *iphri*) are referred to as altars or shrines to the hand. The underlying concept parallels Igbo IKENGA sculptures. The hand is a symbol of power and humanity because it is able to transform thought into action, the immaterial into the material. Urhobo *ivri* seem to deal, to a greater degree than *ikenga*, with the negative potential of power. Small Urhobo boys may be given *ivri* if their fate seems problematic, or as the diviner puts it, his "*ivri* is tormenting him." In this case, the *ivri* is a simple four-sided pyramid atop two or four bases that is worn around the boy's neck. *Ivri* sculpture for adults has a marked aggressive character, consisting of four "legs" that support a spherical or ovoid volume with a tooth-lined cavity. Atop this element, described alternatively as a zoomorph or as a stomach, sits a central figure, flanked by two smaller figures. The figures wear various sorts of symbolic headgear including animals and birds. The human figures are said to be involved in self-defense and the redirection of hostility to outside enemies. Both the boys' pendant *ivri* and the free-standing *ivri* serve to protect from excesses of power. If a man is too aggressive, he is given the title of war chief and made superintendent of the communal *ivri* that protects the entire community. The successful man moderates his power as well as exhibiting tenacity and stoicism. Personal success results from spiritual as well as physical strength.

U'U. War clubs. Goggle-eyed *tiki* heads, characteristic of the art of the MARQUESAS ISLANDS, are found on the five- to six-foot-high Marquesan war clubs, where they replace the nose and eyes of the stylized JANUS faces at the top of the club. The warrior was thus awarded protection by the god of creation. The striations radiating out from the eyes are derived from a TATTOO motif known as "bright eyes," guaranteeing further protection and vigi-

lance. These clubs were functional as well as prestige objects. In battle, the transverse element was used to wound enemies, but the clubs may have been thrown as well. Regarded as heirlooms, the clubs were important spoils of war. For public display, they were held at the warrior's side or inserted crutch-like under the armpit. Three categories of clubs are identifiable: 1) the ancient type pictured, 2) modern 20th-century clubs and 3) a plain (cruder) type probably contemporary with ancient clubs. The rich patina comes from burying the clubs in swamp mud and giving them a final polishing with coconut oil.

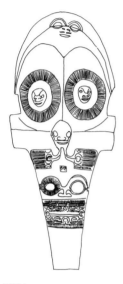

U'U

Above: Variations on a theme, these Marquesas war clubs, found by the hundreds in collections around the world, appear at first to be identical. The variations in pattern, based on TATTOOS, probably personalized the club, identifying it with its owner. 18th–19th century.

Vanuatu. The Republic of Vanuatu (the New Hebrides and Banks Islands), independent since 1980, embraces an extraordinary wealth of artistic traditions over some eighty islands. Little or no evidence of art has survived in some areas (the southern islands, Futuna and Erromango) whereas others, Epi, Paama (tree fern sculpture), MALEKULA and Ambrym, for instance, have rich visual traditions. Other art-producing areas are Malo, Santo, Maewo and Pentecost Islands; Banks Islands; and the Torres Islands. Art objects include non-figurative forms, zoomorphic and anthropomorphic figurative sculptures. Architectural elements (sculptural posts and painted panels), masks, slit gongs, *kava* bowls, implements (knives, axes, adzes) and items of personal apparel including *tapa* appear as well. Social organization is based on two systems, one "civil," rank-based and the other, with stronger religious functions, governed initiation societies. Both male groups, operating largely independent of kinship relations, serve to locate the individual within the larger society. Recent work in the area has highlighted the contributions of the artistic roles of women in Vanuatu. See map: OCEANIA.

Veils. Veils are worn for two primary reasons: to protect and conceal the wearer and to protect those nearby from the forces radiating out from powerful people. Veils are made of various materials, but those made of beads are among the most impressive. YORUBA chiefs wear tall, conical beaded crowns with a wrap-around veiling bead curtain. The chief's BREATH is so powerful that it may be injurious to those in the vicinity. Adolescent girls of the SUBARCTIC wore beaded veils because they were thought to have such great supernatural power that their mere glance could do great harm.

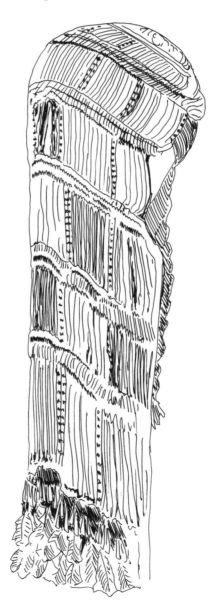

VEILS

Left: Puberty veil, probably Tanaina, interior Alaska. Beads, leather, yarn. c. 1900.

Vili. One of six main Kongo subgroups. For a Vili power figure, see MIRRORS.

Vision Quest. In the North American Plains, people, usually males, isolated themselves from the rest of society to undergo a spiritual experience called the Vision Quest. Under the direction of the medicine man (the term SHAMAN is generally used in scholarly literature, but Plains peoples prefer the English words medicine man), the person remained in seclusion for an agreed upon number of days, fasting until a vision was received. The vision usually involved some form of communication between the searcher and a ghost, an animal, bird or an inanimate object, which became the individual's guardian spirit. The medicine man assisted the individual in interpreting the vision. The individual might also acquire a new name, a song and a prayer or incantation as well as protective and empowering fetishes, amulets or medicine bundles.

Vodun (voodoo in the Caribbean). Vodun arrived in the Americas during the 17th and 18th centuries with the nearly one million FON slaves. Vodun is particularly strong in Haiti because of the island's isolation and because slaves assimilated Catholic saints but were free from control when the priests were expelled after the 1804 slave revolt. The vodun pantheon, derived from YORUBA and Fon beliefs, is organized into a duality with aggressive, hot gods at one pole and peaceful, cool ones at the other. The two are seen as complementary despite their differences; unity in diversity is a vodun ideal. Vodun spirits are called *loas* and number 401. The NAMES of Yoruba and Fon deities are often different in vodun, and their attributes show adaptation to the new environment. Legba, for instance, takes on attributes of several Catholic saints. In Haiti, Legba is depicted as an old man wearing work clothes, a large hat and a straw bag over his shoulder. He sometimes carries a cane like St. Anthony or keys like St. Peter; clothed in rags, he limps along on painful swollen legs like Lazarus. His TRICKSTER, shape-shifter origins are only intensified by these additional associations. Vodun priests called *houngans* and priestesses called *mambos* undergo possession. Brilliantly colored vodun flags made of velvet, silk or rayon are embroidered with sequins and beads with depictions of *loas*. It is suggested that vodun, like its African antecedents, is primarily a life-affirming religion. Unfortunately, Hollywood and the pulp fiction market have badly distorted its practices.

Vulva. Oval and lozenge-shaped Paleolithic designs have been interpreted as vulvae by Carl SCHUSTER and Mariya Gimbutas (*Patterns That Connect*). Similar patterns appear with great frequency in Non-Western art as well, usually in conjunction with complexes involving fertility and procreation. Occasionally, the shape is used apotropaically. See HERALDIC WOMAN and INDEX: Pattern in Art, Artifacts and Techniques; Genitalia in Human Body.

Vungvung (also *vunbun* or *vunvun*). A large KAIRAK BAINING composite helmet mask representing a leaf and used in the night dance.

Waka Tupapaku. MAORI burial chests (also called bone boxes, bone chests) made to contain the scraped bones of high-ranking chiefs. Primary burial took place in which bodies were exposed on sand hills or on platforms in trees. After the body had decayed, the bones were collected and prepared for secondary burial in caves. *Waka tupapaku* protected the bones from intruders, but also served as a warning, since bones are highly TAPU as they still contain MANA. *Waka tupapaku* can take the form of miniature canoes, see SOUL BOAT.

Wakan. An untranslatable word describing PLAINS PEOPLES' cosmology, *wakan* refers to the spiritual realm outside human comprehension and perception. *Wakan* can be seen as a sort of spiritual life force, known to human beings through intermediary spiritual forces of animals and the natural world. It is the source of visionary experience and dreams which, in turn, inspired human activities, including ritual and art.

Walbiri (or Warlpiri). The Walbiri people use a number of symbolic graphic elements identified by Nancy Munn, including circles, arcs, dots, ovals and meandering or straight lines. Each element is multivalent, its specific meaning determined by the context in which it appears. Generally speaking, however, concentric circles refer to women's sexuality, while parallel lines are linked with male sexuality. Women and men draw different designs. Women's designs are revealed to them in dreams, and while dreams also are sources for men's

designs, the latter are said to be reproductions of marks originally created by the ancestral beings. The designs link the living to the land, which retains the residue of ancestral presence and power. Originally, the designs were drawn in sand as visual aids for song stories and painted on the human body and sacred objects as part of important ceremonies. After mid-century, thousands of aborigines were rounded up ("controlled for their advancement") and confined to reservations in the central desert area at places like Papunya, Yuendumu and Lajamanu. Although aborigines, encouraged by missionaries, painted from the 1940s onward, in 1971 Geoffrey Bardon, assigned to teach arts

WALBIRI

Above: Witchetty Grub Dreaming by Sonda Turner Nampitjinpa. The three concentric circles in the center may be mountains, water or journey lines, while those at the top indicate hunters' camps. From left to right across the bottom of the painting are found a lizard with its eggs, witchetty grubs (large white grubs, an important food source) in their underground chambers and Rainbow Snake, eggs within his coils. Nampitjinpa was one of the first women artists to win recognition. Acrylic/canvas, 48" square. 1988.

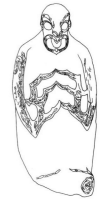

WAKA TUPAPAKU

Above: Maori burial chest. The word tupapaku means corpse, while waka means canoe. These burial chests are sometimes are boat shaped, but the canoe reference may be related to the Maori belief that they came from the land of their ancestors aboard several canoes. Thus a canoe is required to return to the ancestors. 1500–1800.

and crafts at the Papunya Special School, acted as a catalyst resulting in the energizing of aboriginal painting. Papunya women began to paint in earnest after the arrival of art advisor Daphne Williams in 1981. Aboriginal paintings in acrylic on canvas now enjoy considerable critical and economic success, which has served to partially restore dignity and cultural identity.

Walk-About. An ABORIGINAL AUSTRALIAN practice which serves to restore balance within the cosmos and more narrowly, within the human community. On extended journeys, often covering hundreds of miles, individuals or groups visit the locales associated with their ancestors, thereby directly experiencing the spiritual aura still present from the DREAMING. A contemporary account of an American woman's experience of Walk-About can be found in Marlo Morgan's *Mutant Message Down Under*. Nicolas Roeg's *Walkabout* is a disturbingly beautiful film about two lost Anglo children and their adolescent aborigine rescuer.

Wampum. White and purple tubular beads made from marine shells were used for decorative purposes and served as currency among indigenous North Americans. The earliest *wampum* may be precontact in date, but its production increased markedly after the introduction of European/American metal tools. In fact, its production was mechanized by Europeans who thereby gained economic control. The Dutch settlers introduced *wampum* in the Hudson River Valley and the first *wampum*

belts date as early as the 1620s among the Susquehannock of Pennsylvania. They were found among the IROQUOIS by 1640. The Iroquois spread the use of *wampum* belts throughout the eastern Woodlands. Designs on belts were originally significant, but the meaning of the colors and patterns was often lost with the disappearance of oral traditions. Predominantly white belts appear to have signified peace, health and prosperity, whereas belts with purple grounds symbolized hostility, sorrow and death. *Wampum* belts accompanied and lent weight to words in all political and ceremonial transactions. Glass wampum was also supplied by Europeans but never had the popularity of shell.

Wandjina. Primordial, legendary totemic clan CULTURE HEROES of the Kimberley region of ABORIGINAL AUSTRALIA. The Wandjina are commonly depicted as frontal human faces, with only the most basic features (those JOSEPH CAMPBELL has identified as IRMs), i.e., enormous staring eyes and a rudimentary nose. The large-scale bodiless heads are typically circled by horseshoe shaped bands described as haloes, which the aborigines say is hair surrounded by radiating lines

identified as feathers. They are said to have come from the clouds, originally living in the sea, but on moving ashore they transformed themselves into the paintings found on the walls of caves and rock shelters. It is dangerous to enter the caves without proper ceremony to warn the Wandjina of human presence. This is particularly important, since the Wandjina are TRICKSTERS, capable of disruptive and vengeful behavior. On the other hand, the Wandjina are the protectors of human infant spirits which live in pools of water until they are implanted into their mothers' wombs by the Wandjina after they are dreamt of by their fathers. Since the Wandjina are connected with water and fertility, it is especially important to maintain positive relationships as a means of controlling the natural world. Responsible for defining social order for the aborigines of the area, the Wandjina are often accompanied by other important mythological beings such as snakes, trees, the owl—their sacred bird—and pregnant females. The paintings may be as much as 3000 years old, although most have been ritually repainted. See INDEX: Snakes and Owls in Animals.

War Bonnets. Plains war bonnets—some claim they were invented by the CROW—are rich symbols of both the individual warrior's and the group's prowess in war. War (and closely associated gambling) was an outgrowth hunting tradition and was not directed at total annihilation of the enemy, but rather gaining personal and communal power (see COUNTING COUP). After the arrival of the horse, aggression became more common and the horse itself was a symbol of power. Most Plains war bonnets are made of eagle feathers and the way in which the feathers were attached, their direction and attachments such as horsehair symbolized various exploits. Warriors achieved the honor of wearing the upper part through

their own deeds, but the long train, made up of feathers donated by other warriors, symbolized collective accomplishments. The war bonnet was not an idle symbol, as the feathers served as MNEMONIC DEVICES each associated with a particular event. The cap part of the headdress is

WAR BONNETS

Left: Lakota shaved horn war bonnet with eagle feathers.

sometimes surmounted with buffalo horns, an animal whose stamina and endurance the warrior emulated. Feathers from other

birds, especially raptors, were used to indicate swiftness, courage and sharp vision. See INDEX: Birds in Animals.

War Gods. See INDEX: Deity Archetypes.

Washoe. The Washoe, renowned for their basketry, lived in California's Great Basin and in western Nevada. Between 1895 and c. 1935 several Washoe women created remarkable baskets, particularly Louisa Keyser. Keyser (promoted as Dat So La Lee, "wide hips") made exquisitely crafted willow baskets that were tightly coiled and distinctively decorated with patterns worked in dyed bracken fern roots. Despite their beauty, the shapes and patterns had no precedents in traditional Washoe basketry. Keyser is usually credited with having invented the distinctive globular form known as *degikip* for which Washoe basketry became famous. The entire phenomenon resulted from the unique combination of Keyser's artistic genius and the marketing skills—including the invention of a romantic, but entirely fictionalized past— of Lake Tahoe and Nevada City shop owners Abe and Amy Cohn. The Cohns succeeded in publicizing and profiting from Washoe artistry when the culture itself was on the brink of disappearing.

WATER SKATE

Above: Stylized rendering of the insect from Hopi tableta.

WASHOE

Right: Dat So La Lee completed this lidded degikip-type basket in one week. The weaver described the designs: Rainy weather in month succeeded by clear sky after the storm. 1905.

Water. See INDEX: Rain in Natural Phenomena and Materials; Natural Forces and Locales in Deity Archetypes.

Water Skate. The water skate or water strider (*Gerridae*) is an insect that flits across the surfaces of almost all bodies of water in the Southwest and appears in petroglyphs where it is sometimes mistaken for a lizard. Its watery environment links it with water as source of all life, but it is also apparently a symbol of the FOUR/SIX DIRECTIONS and the CENTER. According to the Zuni, who depict the water skate as an X shape, the creature was given magical powers by the Sun Father, enabling it to locate the center. By stretching its four legs out to the solstices, its body separated above and below and rested at the center, the heart and navel of Earth Mother. It was there that the Zuni built their home. The Hopi represent water skates on *kachina* TABLETAS as stick figures with downward turned legs and antennae in the form of an upright V shape. The figure is reminiscent of WORLD TREE and genealogical PATTERNS. Doubtless, some of the significance of this symbolism has been lost, but the water skate's ability to "walk on water" and the way its body is reflected in still water make it a magical creature suggesting the spirit realm and the ephemerality of life.

Water Spirits. The people of several Pacific cultures, particularly sea-going peoples who depend on fishing for sustenance, believe in capricious sea spirits inhabiting the ocean. Called by various NAMES (*ataro ni matawa* in the SOLOMON ISLANDS, *tindalo* or *adalo* in San Cristobal), they are conceived of as hybrid creatures combining human, fish and sometimes bird attributes. Easily propitiated by food gifts, their images hung on house gables and appeared on dance paraphernalia, paddles, bowls and fish floats. Twelve or so named floats were attached to a line at intervals. Lines and hooks were attached to the floats that were weighted with stones. Early observers describe figurative, decorated fish floats in use, while

recent observers note that that type of float is not utilitarian but instead is kept for use in the sacred canoe. The ten- to twenty-year ELEMA *hevehe* cycle culminated with the building of a ceremonial house from which masks representing the daughter of the sea spirits issued forth in a pre-dawn ceremony. In Australia the

watery WANDJINA, said to have lived originally in the sea, are the protectors of the souls of infants that live in pools of water until they are reborn. Furthermore, in Australia snakes are the ubiquitous embodiments of water spirits, such as Rainbow Snake, YULUNGGUL. See also MARO. A variety of underwater creatures play important roles in North America, seemingly more fraught with danger and mystery than beneficence. KONANKA-DA, another composite creature, is the Haida Chief of the Undersea World and is the Master of Souls. The Underwater Panther of the Great Lakes, often paired with the Thunderbird, is a source of thunder and lightning and his glance can be fatal to humans. The Navajo site their HOGANS carefully so as not to incite the jealousy of spirits living in bodies of water. See also SEDNA. Finally, in Africa, the Dogon NOMMO were primordial water spirits and the ancestors of humankind. One of the most powerful embodiments of

water spirits are the masks used by the KALABARI/Ijo in ritual cycles honoring the beneficent water spirits associated with particular bodies of water. The masks combine attributes of various water creatures, principally the hippopotamus, and are worn horizontally atop the head, mimicking the way water creatures' heads seem to float on the surface of the water. Water is universally associated with fertility, but it is also mysterious and its dark depths symbolize the unknown and sometimes the realm of the dead. See INDEX: Animals; Natural Forces and Locales in Deity Archetypes.

Wawalag Sisters. One of the most popular and well-known of Australian aboriginal myths, the cycle is found in conjunction with the KUNAPIPI CULT throughout northcentral and northwestern Australia.

WATER SPIRITS

Far left: Kalabari-Ijo hippopotamus mask, Degema Region, Nigeria. 19th century.

Left: The half-shark, half human fish float from San Cristobal in the Solomon Islands is an image of Kareimanua, a legendary figure frozen while in the process of transformation from man into shark.

WAWALAG SISTERS

Left: A bark painting by Dawudi shows the sisters twice. In the lower right-hand corner, they approach the sacred pool (the half circle in the lower center). They reappear at the center within the coils of YULUNGGUL, who prepares to swallow them. The sisters' footprints are shown above and below the snake's body. The triangular shape on the left is the depression made by the snake when he fell back to earth. The black circle within the triangle represents the snake's anus. Other shapes include celestial bodies, weapons, a log cabin flanked on the left by a bandicoot and on the right by caterpillars, the sisters' clan totem. The diagonally hatched band at the bottom represents placental/menstrual blood.

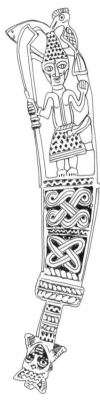

Although different versions exist, the basic outline of the story involves two sisters who camped beside the sacred water hole home of YULUNGGUL, the Great Python, who caused a great storm to break over them. The sisters attempted to protect themselves from the great snake that was attracted by the placental/menstrual blood of one of the sisters. The fact that the python was their clan totem should have been ample protection, but the attraction of the blood was so powerful that he swallowed both sisters and their babies. Yulunggul lied to his brother serpents and, embarrassed by this as well as by having eaten those he should have protected, he reared up into the clouds and then plunged to the earth where a great hole appeared. Admitting his error, he regurgitated the sisters and then revealed his most secret songs and dances to his brother snakes, who in turn taught them to their people. The Wawalag sisters, thus, activated the power of the snake. Ritually reenacting the myth, as they were taught to do by the snakes, people bring on the monsoon rains, which, although often disastrous, fertilize the land. The mythic conjunction of water, blood and snake is necessary to guarantee natural continuity and fecundity. An alternate interpretation of the story is that the motifs of SWALLOWING and repeated regurgitation represent the chaos leading to cosmic renewal.

Weapons. Enormous skill, attention and use of precious materials are lavished on weapons all over the world. Originally, decoration may have been thought to enhance the weapon's use, as in hunting magic where images of the animals were etched on Stone Age implements. It is unclear whether the animals were the hunters' prey or protective totem animals. Weapons associated with killing fellow human beings seem to involve symbolism associated with the power and prowess of the warriors as well as serving to protect them while they wielded the weapons. Often weapons take on supernatural qualities that extend and justify male aggression. Elaborate ceremonial and functional weapons are common SYMBOLS OF OFFICE for chiefs and kings. Royal weapons in Africa are among the most potent embodiments of power. For instance, Yoruba ivory ceremonial swords from Owo are carved with images of kings holding swords and sacrificial birds, wearing coral crowns and wrappers. These swords are tours de force of ivory carving that advertise the power and wealth of the ruler. Owning ivory is a royal prerogative and, furthermore, the material's unsuitability for any actual use makes its advertising function abundantly clear. See INDEX: Tools in Art, Artifacts and Techniques.

Weather. See INDEX: Natural Phenomena and Materials.

Weaving. See INDEX: Textiles in Art, Artifacts and Techniques.

Western Africa and the Guinea Coast. This area is comprised of the modern states of Guinea, Sierra Leone, Liberia, Ivory Coast, Ghana, and CAMEROON. With the exception of the Cameroon, the people of the area today sustain themselves with subsistence farming. The BAGA, Temne and Bullom peoples—referred to in 16th–century accounts as the Sapi—of Guinea and Sierra Leone were indigenous to that

WEAPONS

Top: The Maori made beautifully crafted weapons, including several types of clubs. The whalebone example pictured is called a kotiate paroa, literally "cut liver" describing the club's shape. Used in single combat between two chiefs, the winner was determined by who could get in the first three blows. A blow to the temple was followed by use of the notches which, by a twist, lifted off the top of the head. c. 1830.

Bottom: Ivory Yoruba ceremonial sword (udamalore) from Owo. The guilloche-knot patterns not only fill the space beautifully, they symbolize royal continuity and the ruler's power to mediate between the various factions of his realm, as well as between the spiritual and material realms. 19th century.

area. In the 16th century these people carved small stone sculptures called *nomoli* and *pomta*, none of which come from controlled archeological contexts. The two are stylistically similar, having squat bodies, oversized heads with bulging eyes and exaggerated genitalia, but they are carved from different stone and come from different regions. The *nomoli*, found in southern Sierra Leone, are carved from steatite, while *pomta* are made of inland stone and come from northern Sierra Leone. The Mende farmers who dug the *nomoli* up in their fields associated them with the earth's fertility. In the 17th century, area carvers produced AFRO-PORTUGUESE ivories for foreign patrons.

Whale. See INDEX: Animals.

Whare Whakairo. MAORI meeting houses were complex structures used for council meetings of elders. Called *whare whakairo*, "carved house," the buildings were adorned with woodcarvings (ridgepole, lintels, panels, posts, gable mask and other sculptures), latticework and painted rafters. Both men and women participated in the building of the houses, although the division of labor common in Oceanic art prevailed, with the men doing the construction and carving while the women painted the designs on the rafters and wove the latticework. The parts reflect the anthropomorphic nature of the house which represents the body (literally embodies) of some prominent ancestor— the ridgepole (*tahuhu*) is the ancestor's spine, the gable mask (*koruru*) is the face, the bargeboards with carved ends (*raparapa*) are arms with hands stretched out in welcome, the rafters are the ribs and the interior is the belly. Low-relief sideposts, depicting additional ancestors, line the interior walls. Thus, when people enter the building, they physically enter the presence of the ancestors and are literally inside the ancestor—art unites the past

WESTERN AFRICA AND THE GUINEA COAST

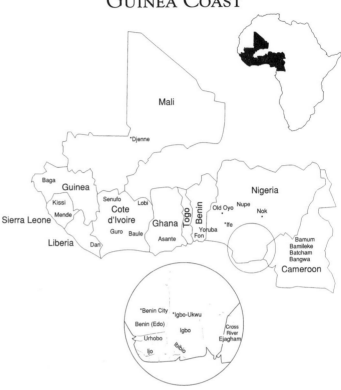

and present human community and collapses space and time. One source lists seventeen named elements including the POUTOKOMANAWA, or center pole, a symbol of the CENTER. The HERALDIC WOMAN motif carved on the entrance lintel may represent Papa, the Maori Earth Mother. Passing beneath the legs of this powerful deity likely relates to the myth in which Maui attempted to banish death from human society, but may also be linked to the ability inherent in women to nullify the effects of TAPU. Thus, negative forces were neutralized, making interactions occurring within the structure harmless. It can be said that the *whare whakairo* concentrates energy. Smaller *pataka* (food storage houses) have a similar architectural form. Although modern meeting houses incorporate commercial materials and safety features, the essential form has

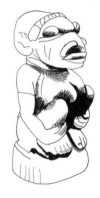

WESTERN AFRICA AND THE GUINEA COAST

Above: Carved stone figure of the type called nomoli by the modern Mende and pomdo by the Kissi. This one has the typical bulbous eyes and large breasts.

WHARE
WHAKAIRO

Above: Side panel or post (poupou) from the interior representing an ancestor from Te Hau-ki-Turanga carved by Raharuhi Rukupo. The glaring eyes, gaping mouth and aggressive stance of this club-wielding figure contrast with the POUTOKO-MANAWA. 1842–43.

remained unchanged. In fact, the Maori successfully incorporated new temporal, historical elements into the houses (see KOWHAIWHAI) without losing any of the old significance.

White Buffalo Woman. The incarnation of a LAKOTA deity, the spiritual side of which is Woope, the Law.

Whiting, Cliff (b. 1936). Whiting is a highly respected contemporary MAORI artist who depicts Maori myths and themes in important commissioned work like the murals now in the National Library and the Meteorological Service buildings, both in Wellington. Educated at the Dunedin Teacher's College, his work as an artist and teacher has had a substantial impact. In the 1990s he guided a group of carvers as they produced an archway entrance for the Otago Museum in Dunedin.

Wigwam. A widespread North American Native hemispherical house type, constructed of flexible poles anchored in the ground and lashed together making an arched profile. Floor plans were round or oval, and horizontal stringers were tied to the uprights for additional strength. Roofing consisted of reed or grass mats or sheets of birch, elm or chestnut bark. Men erected the main structure, but women wove the mats and installed the furnishings. Wigwams were the first indigenous structures noted by Europeans. They are

found throughout the Woodlands among the Algonquian and in the Great Lakes area. Further north, Algonquian peoples lived in conical wigwams. A similar framework was used in Plains grasshouses.

Wilderness. The dual regions of wilderness and habitation exist in most indigenous societies. The wilderness is everything that is dangerous, chaotic and unknown in contrast to the safety, order and known realm of the settled community. Further dualistic attributes describe both: the wilderness is dark, either with a permanent dusk or night and is the place of death. The village, on the other hand, is the place of daylight, or fires to keep the dark at bay, and the realm of the living. Sometimes a third element is added, among people who live on coastlines, as for instance the Haida, for whom the ocean is a realm similar to the wilderness (see COSMIC MODELS). The art associated with the two realms is markedly different. The spirits linked with habitation embody the ideals of society and are generally humanistic in appearance. These figures and masks exhibit calm, dignified, restrained expressions and are more often than not physically symmetrical (or if symmetry is lacking, the asymmetries are subtle and dynamic). These objects are "visible," even when highly secret, having a clarity of outline and overall simplicity that is orderly and balanced. Inhabitants of the forest or bush, in contrast, are unclear, exaggerated, distorted, raw and generally anti-ideal. They are often made of composite materials and their forms are often obscured by the buildup of sacrificial offerings. They often depict animals or combinations of animals. Sacred places exist within the wilderness, used for initiations, and the dead are often buried there, but surrounded by rituals that mitigate the dangers involved. Between the wilderness and the civilized realm of the village there is often a sort of no-man's-land, as among the Baule of the Ivory

WIGWAM

Right: Bent sapling framework of an Ojibwa wigwam. After Lewis Henry Morgan, 1881.

Coast. There, garbage is tossed, children defecate, unfortunates are buried and tobacco is cultivated. People who frequent the wilderness, such as hunters and the shaman in search of medicines, become liminal beings who mediate between society and the unknown.

Wind. The Aivilik ESKIMO use twelve unrelated terms for various winds that are named according to their impact—survival often depends on the ability to read the wind. The critical importance of this element is apparent also in the concept of SILA, which is linked both to the natural world (weather, the elements) outside man and to human thought. In Aboriginal Australia, monsoon winds are the great fertilizing forces that are needed but destructive (see WAWALAG SISTERS). The Navajo site their HOGANS carefully so as to avoid bad dreams sent by the Wind People. But for them, wind also has spiritual connotations. The material and spiritual worlds are not separate, both being activated by and expressions of inner form and wind, or spirit/soul. The land itself, the four directions, makes manifest inner form and a particular wind. Each person has a "wind within one" that enters at birth and guides one through life. See INDEX: Deity Archetypes; Natural Phenomena and Materials.

Wind Charms. In the CAROLINE ISLANDS, captains carry small figures wrapped in coconut leaves which they brandish against storm clouds. To activate the charm, the captain had to chant the power of his patron spirit (or according to one source, *yalulawei*, benevolent water spirits) into it while standing near the coconut tree where he learned navigation. Some of the charms apparently were Janiform, offering double the protection.

Windigo. A cannibalistic monster the OJIBWA believed haunted the winter forests. Described as a giant, human male, the Windigo appears suddenly and devours those unlucky people he comes upon. Also a psychological disorder involving a craving for human flesh; human beings, thus, can be or become Windigo as a result of black shamanistic sorcery. The cure is great doses of hot animal or fish fat. See CANNIBALISM.

Winnebago. Siouan-speaking agriculturalists who live in the WOODLANDS (Great Lakes) AREA, in the midwestern United States and in Canada from Saskatchewan to Alberta. The culture seems to have centered originally in the lower Mississippi area and spread, following the rivers, throughout the midwest and southern Canada. Paul Radin believed that the complex Winnebago religion, ritual and mythology showed strong influences from Mexico, dating as late as the 12th century. Two competing clans were conceived of as embodying the fundamental duality of life and human nature—sacred/profane, spiritual/material and good/evil. This duality is reflected also in the opposition of *waika* ("that which is sacred") and *worak* ("what is recounted"). Winnebago mythology involves a creator called Earthmaker, TWIN CULTURE HEROES and four mythic cycles recounting the adventures of the twins, TRICKSTER, hare, the battle of good (e.g., the hero Morning Star) and evil forces (e.g., Waterspirits). The Twins are the offspring of the sun and the sister of Morning Star. Human beings were created last and were regarded as weak and defenseless orphans. The two clans were the dominant Thunderbird clan associated with peace and spirituality and the Bear clan, linked with war, judicial and policing functions. Two sacred objects were associated with both clans, the peace pipe and a club-like baton. The principal ritual of the Winnebago was the MEDICINE RITE. See INDEX: Animals.

WIND CHARMS

Above: Hos, wind/weather amulet used for protection against the elements by canoe captains. Chuuk, Caroline Islands. Wood and sting-ray spines.

WOODLANDS

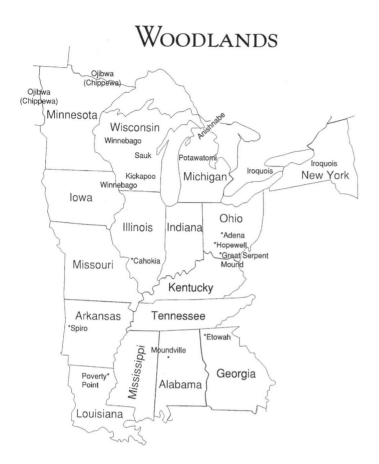

Winter Count. Pictographic records of historical events painted on the outsides of Plains TIPIS or on buffalo skin robes to aid in the telling of oral history. Usually painted by men, these records could cover decades, even centuries. Their style reflects pre-contact rock art.

Witches/Witchcraft. Witches are men and women who use their powers to harm others. Although sometimes a distinction is made between white witches and black ones, generally the behavior of witches is antisocial and witches are feared and shunned. All over the world, indigenous people develop ways of protecting themselves from witchcraft, both on individual and social levels. These range from punishment to placation. Like the SHAMAN, witches have familiar spirits, medicine and various objects which help them achieve

their ends. On the Northwest Coast suspected witches are tied up and confined beneath the platforms inside the chief's house until they confess or die. In Africa, the dances of the Yoruba GELEDE society are one of the most spectacular ways people have developed to cope with the negative power of witches.

Wolf. See INDEX: Animals.

Womb. See INDEX: The Human Body.

Woodlands. The Woodlands cultures centered in Ohio and Illinois and are characterized by earth works and elaborate burial practices. The earliest date prior to European contact, beginning as early as 700 BCE with the ADENA Culture, which was succeeded and surpassed by the HOPEWELL "Interaction Sphere," and in turn by the MISSISSIPPIAN Period. The term Eastern Woodlands is used to describe those areas near the Great Lakes peripheral to the Mississippian florescence. Many of these peoples continued to practice mixed hunting/fishing and gathering patterns for longer periods than in the south, although agricultural subsistence patterns became more common after 800 CE. The IROQUOIS were among the most important of these peoples.

Woodlands "Legend" Painting. A contemporary school of Woodlands artists who use bright acrylic paint to render Algonquian mythology in a style inspired by the art of the Northwest Coast. Canadian Ojibwa artist Norval MORRISSEAU is credited with originating the school.

Woot. The legendary founder of the KUBA Bushoong dynasty was regarded as the culture hero, and in some cases, as the first man. Woot is referred to in art with his own distinctive pattern, see SIGN SYSTEMS – KUBA PATTERNS.

World Renewal Cult. A cult found in northwestern California among the Yurok, Karok and Hupa and to a lesser degree in other groups. These people believed that the world had become unbalanced due to the weight of human error and misconduct. The ten-day JUMP DANCE, held in the fall, "fixed" the world and the Deerskin Dance reaffirmed the interdependence and vitality of life.

World Tree. Also called the Tree of Life or Cosmic Tree, the World Tree is an archetypal symbol of the vitality of life. With its roots in the earth, the underworld, its trunk in the human realm and its leafy crown reaching up into the sky realm, the tree is a powerful symbol of the *axis mundi* and the CENTER. And too, trees are easily conflated with human beings. The reasons for the conflation are many—among them is the mythical idea of tree as progenitor; a sort of variation on the notion of the family tree, according to which human beings are descended from trees. The branching shape and verticality of trees is compared to human anatomical structure with its bilateral symmetry, ribs and

appendages branching off the spinal column. From there it is quite natural to leap to the idea of the family tree to create a powerful visual image of the serried ranks of generations. Powerful people, including SHAMANS and chiefs, also evoke the energy of the tree, incorporating it into their costumes, regalia and rituals. The shaman's robe often has a tree image running up the center, picturing the means by which s/he gains access to other realms. A striking instance of the link between the chief and the tree is found among the Kanak of New Caledonia. In the royal SCEPTER, the *gi okono*, the circular green serpentine blade representing the leafy tree top is mounted on a wooden shaft/trunk, which is mounted, in turn, on a knotted and woven hemisphere, the earth. Thus, like the World Tree, the scepter represents the chief as the connecting link between the physical and spiritual worlds, between his people and the ancestors. Finally, the tree is the nesting/resting place of a host of creatures that are often pictured symmetrically either side of its trunk. The location of the various creatures has obvious symbolic associations with the realms through which the tree passes: birds in its uppermost reaches, mammals (especially deer and bears) lower down, and lowest of all, serpents. See INDEX: Animals; Trees in Natural Phenomena and Materials.

Wosera. Sometimes called the southern ABELAM, the Wosera live northeast of the Washkuk hills. Like that of the Abelam, Wosera art is brightly colored and expressive, although it has been described as more defined, three-dimensional and naturalistic. The inverted V-shaped nostrils are characteristic. The cultivation of long yams is as important among the Wosera as it is in Abelam territory. The most impressive yams—referred to as *nggwal*, ancestors—are "dressed" with miniature masks, headdresses and necklaces and ornamented with body paint. The Wosera

WORLD TREE

Left: Siberian shaman's costume showing a ten-branched World Tree on the skirt, flanked by heraldically arranged felines, birds and snakes. Late 19th century.

WOSERA

Above: Large male ancestor figure. The hornbill atop the head is an important HEAD HUNTING symbol. The bird's beak is repeated over the sternum and beneath the feet (the latter are not intended to function as suspension hooks). The powerful rounded forms characteristic of Wosera art are reminiscent of the shapes of long yams.

WUNKIRLE

Above: The handles of Dan spoons, status emblems of the wunkirle, took the form of energetic paired legs, a sacrificial ram's head, a closed fist or a bowl of rice. Most common, however, were female faces (sometimes Janiform) that embody the Dan ideal. The cavity of the spoon's ovoid bowl suggests the fecund womb, linking human and plant (rice) fertility.

also make basketry masks and cult ceremonial bowls out of clay. Additionally, STRING BAGS called *wut* are the female component of bride wealth transactions and important trade items. The word *wut* has several connotations including bag, womb, cocoon, initiation chamber and painted panels. Women carry babies in the bags, like an external womb, and the men's house is a surrogate social womb from which the boys emerge following their initiation, as butterflies emerge from cocoons.

Wounded Knee. South Dakota massacre site. See GHOST DANCE.

Wovoka. Late 19th-century Northern Paiute prophet, see GHOST DANCE.

Wowipits (or Wow Ipits). The ASMAT word for sculptor; *wow* means "carver," *ipits* means "man."

Woyo. A Kongo sub-group known especially for the unique pot lids (*mataampha*) carved with proverbial scenes. See PROVERBS.

Wunkirle. An honorific title conferred on a DAN woman when she and her husband were successful farmers and she was identified as the most generous woman in the community. According to other sources, the *wunkirle* was chosen by her predecessor who passed on the spoon (*wa ke mia*, "feast acting spoon") embodying the spirit of generosity and bounty. The *wunkirle* danced at feasts dressed as a man and distributed rice to all members of the community with her right hand. Acolytes accompanied her, hanging on to her skirts and giving peanuts to the crowd. When not in use, the spoon hung in the woman's hut, hidden over the door. Touching it was forbidden; the penalty incurred was organizing and bearing the expense of a feast to exhibit the spoon.

X-Ray Images. Images of animals, usually seen in profile, with their internal organs depicted, are found in several places throughout the world. Lommel points out that X-Ray views are found in prehistoric rock art in Scandinavia and Siberia and that in the Americas they are found only north of the equator, in Australia no further south than Arnhem Land and not at all in Africa (*Prehistoric and Primitive Man*). He suggests that the X-Ray Style, together with a tendency toward abstraction and use of curvilinear patterns can be traced to the nomads of Central Asia. X-Ray images are found in Arnhem Land, among the Marind-anim in New Guinea, in Eskimo art, in Ojibwa drawings made during magic rites, in rock art in Kansas, Minnesota and Virginia and, finally, on ZUNI pottery in the American Southwest. Given the vast distances in time and space, it is hard to see how these connect. It is undeniable, though, that X-Ray imagery was of great significance, as in all cases the animals treated in this unusual manner were of paramount mythological importance. Some were major food sources, others were linked with creation myths and fertility complexes. Perhaps the Subarctic Kuchin belief that each human being has a bit of caribou heart and the caribou has a bit of human heart is a key to the revealing of internal anatomy. X-Ray images are found more frequently than anywhere else in the art of northern ABORIGINAL AUSTRALIA, particularly that of the Western Arnhem Land. The images, which show the internal organs and bones of animals and human beings, are called the X-Ray Style, referring specifically to the most recent of several styles of rock painting (c. 7000/5000 BCE–1000 CE). The X-Ray Style was adopted by contemporary aboriginal artists in their BARK PAINTINGS. Rock paintings, some of which are nearly life-sized, show frontal and profile images of humans and animals with compartmentalized bodies filled with geometric patterns and accurately detailed internal anatomical features. Genitalia are also depicted. Unlike the tricky, but beneficent MIMI SPIRITS, at least some of the X-Ray Style images may depict powerful, potentially harmful spirits such as Nangintain (thief of spiritual essence which causes illness and death) and Namandi (CANNIBAL/rapist spirit). The depiction of such frightening images may have served as social control by evoking fear, or possibly by capturing/containing or propitiating the spirits themselves. Less dreadful X-Ray Style images also appear, such as those of pregnant women where propitiation is the likely motive, guaranteeing fertility and safe births. The geometric patterns filling nonanatomical areas of the X-Ray figures are the same as those painted on bodies during ceremonies concerned with fertility, initiation and the dead. Called *rarrk*, the patterns are linked with the DREAMING ancestors whose movements and acts created the land—the geometric patterns, then, are simultaneously landscape features and remnants (body parts or imprints) of the ancestors. Recreating the patterns on human bodies connects people with the fertile, creative powers of the ancestors and the land.

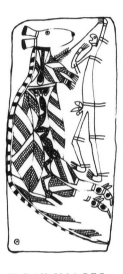

X-RAY IMAGES

Above: Bark painting by Yirrawala of a Mimi spirit killing a kangaroo. One theory explaining such transparent views of internal organs and bone structure is that paintings were used as visual aids for the hunting and butchering of food animals. Arnhem Land (Gunwinggu).

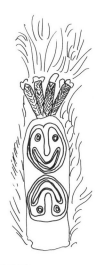

YAFAR

Above: Headdress mask for yangis ceremony, Border Mountains, Sepik Region. The colors and shapes of the mask encode complex meanings.

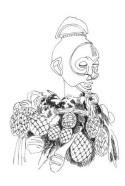

YAKA

Above: Nkisi bundle. The hooked shape of the nose is a Yaka characteristic.

Yafar. Agriculturalists who live in northern New Guinea, the Yafar make complex, polysemic masks associated with the *yangis* ceremony. Bernard Juillerat's fifteen years of fieldwork revealed intricate relationships between language (myth) and symbolic art forms. The masks' forms and colors encode meaning that, combined with ritual, non-verbally communicate cultural knowledge and socially constructed roles. The two-night *yangis* ceremony reenacts the stages of reproduction from conception by the original mothers of the two Yafar moieties, to the birth of two totemic sons—original men. Further dualities are built into the myth, including Sky/Earth, Father/Mother and sago palm/coconut palm. Juillerat's work suggests that although the ritual is concerned with Yafar cosmogony (the secret origin myth is never publically verbalized, not even in disguise), it focuses on initiation and human gender roles. The complex series of substitutions of, for instance, the sun for the original mother's womb, eases the human transition from the mother to, as Juillerat puts it, "separation, emancipation and socialization." Additionally, the enactment of the ritual recalls primordial female fertility (the first mothers were the originators of villages, game and all ritual apparatus) and its subsequent loss to the males after the first coupling of man and women. Thus, the men, by controlling ritual with all of its non-verbal coded elements—i.e. substituting socially constructed roles for biological functions—control fertility, continuity and prosperity for the entire community.

Yaka. The Yaka and closely related Suku live in southwestern Democratic Republic of Congo. Social organization is based on the centrality of the founding lineage, to which all others pay homage and tribute. The so-called "master of the earth" is important in hunting rituals. Yaka NKISI power figures can take a variety of forms from entire figures to heads that sit atop bundles of magical materials. The Yaka also make amulets for hunters and warriors and large naturalistic images of chiefs. Yaka masks are energetic and diverse. They are associated with sexuality and procreation, curing impotence and sterility, protecting the village food supplies and protecting the boys undergoing initiation. Those associated with initiation appear in public to greet the boys after their seclusion. The masks alternately terrorize and generously receive the boys. They were said to frighten the boys into submission while at the same time protecting them from anyone who might harm them.

Yam. Major food source for many Non-Western cultures. Because of its importance for survival, the yam is a potent symbol and its planting, tending and harvesting is surrounded with elaborate rituals. The KANAK of New Caledonia believe man to be the image and product of the yam, which serves as a temporary receptacle for the spirit. The tuber, with its three parts (head, middle and growing tip), is considered to be an analog of the human body. It is said that the chief is born from a yam in the forest; the yam thereby becomes a representation of his ancestral clan. Among the ABELAM of Papua New Guinea the most important men are also

yam growers. The yams are regarded as incarnations of ancestors and, like art, are produced by expert knowledge. Displayed in public, the yams are decked out with masks or small, carved heads, painted and adorned with energy-bearing attributes. Once on display, the yams are judged for their aesthetic merits including straightness, smoothness and size. The KOMINIMUNG make male and female dance masks called "mothers of the yams." The named masks are representations of the *bwongogo* ancestral spirits; the female masks are associated with gardening and the male ones with hunting, especially pigs. Performances of the masks promote fertility and good hunting. The yam is equally important in Africa. The Oba Esigie was credited with introducing the New Yam festival at BENIN. The festival took place annually in October-November following the yam harvest. It began with a weeklong fast during which people stayed in their homes. Then people offered the new yams to promote fertility of farms and families. The last ritual of the ceremonial year, it marked the transition and link between one year and the next. The IGBO of Kwale in Nigeria formerly made terracotta yam-spirit shrines that were conse-

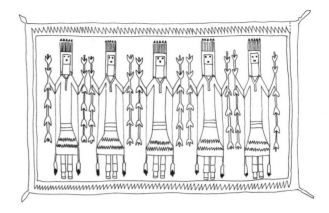

crated during the October yam harvest and festival. The terracotta sculptures, usually representing families, likely were set on altars and surrounded by new yam tubers. As in other cultures, the yam cult linked plant and human fertility. See INDEX: Pigs in Animals; Yam in Natural Phenomena and Materials.

Yei. This NAVAJO word is generally translated "holy people," and refers to the many supernatural beings equivalent to the Pueblo KACHINAS and APACHE *gaan*. The *yei* are represented in human form in sand paintings (and since 1919 in weaving) and impersonated by masked dancers in various ceremonies. Associated with the cardinal directions, some of the

YEI

Above: The yei were not represented in weaving until HOSTEEN KLAH began to weave them and other sand painting designs into rugs in 1919. Note the SPIRIT BREAK in the upper right hand corner. This rug, woven by Mary Nez Jim (possibly only her fourth or fifth weaving) in 1984, relates to a sand painting called The Four Arrow People, although the design is simplified and does not include the surrounding Rainbow Goddess motif.

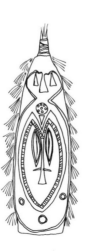

YAM

Left to right: Igbo terracotta yam shrine from Kwale. The shrine depicts a titleholder, identified by his top hat, flanked by two pregnant wives. All three hold fans and the male holds a drinking horn. In front of him is an ikenga, a shrine within the shrine, representing the male's personal power.

Kominimung "mother of the yams" dance mask with three catfish spines on its forehead. The circular motif represents the abode of certain insects (possibly bees).

Middle Sepik Wosera ceremonial digging stick used for planting the first yams of the season. The figure represents a nggwal. 19th–20th century.

most important are Talking God, Calling God and the HERO TWINS, Monster Slayer and Born-for-Water.

Yena. The name of an annual KWOMA ceremony associated with the yam harvest, as well as the name of art objects (heads) made in conjunction with the ceremony. The *yena* is the first of three ceremonies (the second is *mija*, the third *nowkwi*) which last approximately three or four weeks, but may be performed separately. Each ceremony is accompanied by distinctive sculptures called by the name of the ritual. The Kwoma formerly celebrated two other complex age-grade ceremonies every three to five years. Surprisingly, unlike the ABELAM and Arapesh who also celebrate the yam harvest, yams constitute only a small portion of the Kwoma diet (less than 5%). It is, however, the most important *cultivated* food source, as sago (which accounts for 79% of the diet) grows wild. Celibate master sculptors do the carving of *yena* figures in the forest following a set procedure. Although the *yena* carved at Bangwis in 1973 were the first made in twenty years, the men had a clear idea of how to proceed and what the heads should look like. The master carvers welcomed and responded positively to all comments from bystanders. Women were not permitted to see the carvings or to interact with the carvers, as their coldness (see TEMPERATURE) was seen as potentially sapping. Once the carvings were complete and before the ceremony began, the men's houses were swept, accompanied by the sound of flutes and drumming said to be the calls of totemic birds who were invited to attend. The *yena* heads were brought to the house and kept covered along with the yams while a stage scaffolding of poles and vines was constructed for their display. The carvings were ritually repainted and decorated with feathers, shells, wigs and other adornments and then lashed to poles on the stage. Female *yena* heads were positioned facing the sides of the building, while male images faced front and back. Yams were placed inside the framework and covered with leaves and a solid floor on which were laid women's string bags, shell currency and musical instruments. Music and dancing followed for some eighteen hours. Friendship gifts were given and powdered LIME was sprinkled on spectators to prevent hostility or magical acts.

Yeu (or *jeu*). ASMAT villages are divided into four quarters called *yeu*. Each quarter contains a ceremonial house also called a *yeu*, which is the residence for boys and unmarried men. The building always faces the river and its interior is divided down the middle into upstream and downstream halves. Because of the damp environment, the wood of which the houses are built rots quickly and they must be rebuilt every four or five years. After the construction is complete, the men leave and the women dance within the new structure, moving around a central bark container called "the tree of life" moving from the upstream to the downstream half. The sago tree, the Asmat's primary food source, is likened to women, since nourishment comes from within the tree. The women's dance prepares the shell of the *yeu*, infusing it with their potential. The men return, having collected as many capricorn beetle larvae (sago worms) as they can which they place in the tree of life. The worms are apparently multivalent symbols of sustenance, sperm and the human brain. The men thus fertilize the tree, making it possible for the *yeu*, a symbol of the community, to be born. Similar symbolism is involved when newcomers are "adopted" into the community. The women of the village stand with their legs outspread, and those being adopted must crawl beneath the tunnel of legs as the women moan as if in childbirth. As with other peoples of New Guinea, women are linked with birth and rebirth, with sustenance—but since the power of

YENA

Above: Yena heads are not masks, but are regarded as disembodied heads linked with totem spirits and the may, *the Kwoma word for human soul. The long noses are sometimes referred to as phallic as are the extended tongues. Recent research shows that the combination of nose and tongue is linked to representations of homicides. The decoration of the yena heads as killers idealizes individual and collective male power. Made by Mebudi Yipilas. c. 1930.*

women is regarded as dangerous, they are forbidden entrance into the *yeu* except when it is being inaugurated and on certain other occasions, such as peace ceremonies. The Asmat culture hero FUMERIPITS built the first *yeu* and filled it with carved lifeless human figures of wood. He made a drum and as he played, the figures came alive and danced.

Yimar (or Yimam). A SEPIK RIVER group that lives near the source of the Blackwater River. The striking stylized hook figures were called *kamanggabi* by Anthony Forge who first drew them to Western attention (named after the main village of the area Amangabbi, the term means "figures from Amangabbi"). Called *yipwon* by the Yimar, the elegant profile figures have large heads, a body composed of upward and downward curved hooks and a single leg. Myths tell of spirit sculptures that either were carved by the CULTURE HERO or brought themselves to life from the chips carved off the first slit gong. Initially dangerous to human beings, they later became beneficent and were particularly helpful in preparing for HEAD HUNTING campaigns and hunting expeditions. Another type of Yimar sculpture called *yagegir* takes the form of a legless male body. Aggressive mythic spirits, the *yagegir* created the mountains and then inhabited the men's houses, from which they incessantly pushed their penises. Their relentless copulation eventually killed all the women but two, who begged the white cockatoo to save them. The cockatoo nipped off the *yagegirs'* penises with his beak. The *yagegir* left human society, but charged men with the task of carving their images to be shown to boys, presumably as a cautionary tale, at the time of their initiation.

Yipwon. See YIMAR.

Yoruba. Today more than twenty-five million Yoruba live in Nigeria and in the neighboring Benin Republic. The ancient city of IFE is the center of the universe, the place where the world came into being and the spiritual and historical source of Yoruba tradition. Yoruba territory is divided into a series of interrelated and autonomous city states, each with its own distinct artistic and ceremonial approach. Certain unifying elements do exist, however, such as a pantheon of deities, a shared mythology and a value system that emphasizes the nurturing of children, health, wealth and prosperity. The qualities associated with YORUBA AESTHETICS are moral as well as formal and artistic, and constitute ideals that govern all aspects of life. Other unifying features include the spectacular court dress of Yoruba kings (also see CROWN) and the importance of powerful associations and individuals concerned with religious, political and judicial ritual. Art plays a major role in the ceremonial activities in all cases. The societies and individuals act in complex interlocking ways to celebrate rites of passage, harness power, restore or maintain balance within society, lessen anxiety as well as mark the cycles of nature. The elders that make up the OGBONI society balance the ruler's authority and are concerned primarily with judicial issues. The GELEDE society, prevalent in southwestern Nigeria, is concerned primarily with channeling the potentially dangerous power of older women. IFA divination and the IBEJI cult both aim to diffuse anxiety; in the first case about the future and in the second, with regard to the power of TWINS. Religious cults devoted to ESU and SANGO likewise are concerned with balance and order, particularly linked with sexuality, aggression and self-control. The EGUNGUN cult, perhaps the most diverse in its costume and ceremony, is concerned with the ancestors. Finally, the EPA cult commemorates the creative powers of childbearing women, and also celebrates individuals

YIMAR

Above: Yipwon figure associated with hunting and war. The size of yipwon varied from small ones used as personal charms to very large ones such as the one pictured. The large ones were kept in the men's houses where, after successful raids, they were smeared with blood and possibly head hunting victim's heads were impaled on them.

YORUBA

Right: Beaded crown with sixteen birds. Highly intricate Yoruba beadwork is made by itinerant artists. Kings' crowns have beaded veils that protect both the king and his subjects. The king, especially his head and breath, the container and carrier of his life force, is so powerful that other people may be damaged. The faces on crowns are said to be those of various gods as well as evoking destiny (ori) as the province of the king. The birds have multiple associations, including healing and the transformative and complementary powers of the king and witches.

YORUBA
AESTHETICS

Right: The anti-ideal is evident in this egungun mask called "the Barbarian" by Sarakatu Ayo of Abeokuta. The sightless, overly visible eyes, the distorted off-center nose and the deep incised lines on the cheeks, signs of age, all run counter to their aesthetic ideals.

and their cultural and community achievements. The Old Oyo-Yoruba Empire collapsed at the end of the 18th century, followed by a long period of disruption, warfare and the great diaspora. The Yoruba were displaced all across western Africa and throughout the Americas, particularly in Brazil, Cuba, Haiti and Trinidad. Their strong, late presence resulted in considerable impact on the art and religion of the Americas (see SANTERIA).

Yoruba Aesthetics. At the heart of Yoruba aesthetics is a deeply energetic, positive approach to life in which art, life and the complex ideal of beauty are inextricably linked. The purpose of art is expressed in the saying *iwa l'ewa*, "character (or essence) is beauty." The aim of art is to capture the vital essence of things. The Yoruba believe that everything is imbued with life force or *ase*, which pervades both realms of existence: *aye*, the tangible, visible plane of human and material existence;

and *orun*, the spiritual realm of gods, deified ancestors (*orisa*) and other ancestors and spirits. Beauty in art involves the capturing of the essential character or spirit of the thing represented. Although it manifests itself in physical appearance, beauty also has moral and spiritual implications. The criteria, gathered by Robert Farris Thompson (*Black Gods and Kings*) from over two hundred informants, used to judge the physical beauty of objects are numerous:

Jijora—relative mimesis: this, the most important criterion, is not concerned with photographic realism, but instead with the ways in which the image resembles virtuous human beings, embodying integrity (character) and the ability to live harmoniously with others.

Ifarahon—relative visibility: works are judged based on the sculptor's selective representation of the most important aspects, which should be visible when the object is used, say, in dancing.

Didon—relative luminosity: the polished surface should glow, but should not produce glare (like mirrors and brass) which can be dangerous. *Didon* must be balanced by *fifin*, incised detail; both contribute to

clarity of mass and line, and must be present but should not compete.

Gigun—relative straightness: a slight curvature is enlivening, offsetting too much straightness, which would be rigid and inhuman; symmetry is present, but not absolute.

Odo—ephebism: the literal translation of *odo* is "making the subject look young." Age can be implied by costume, hairstyle and regalia, but physical signs of age are regarded as ugly. The Yoruba do not value old, weathered objects because these signs of age are degrading—such objects are discarded. Roundness and fullness of forms is linked with youthfulness.

Tutu—coolness or composure: absence of facial expressions or gestures resulting in a quality of aloofness.

Relative delicacy: again, the mean is sought, neither too detailed or oversimplified, too large or too small.

Balance—*iwontunwonsi*: Thompson initially referred to this criterion as midpoint mimesis, but Nobel Prize winner Wole Soyinka calls it "a rhythm of proportion, an inner rhythm created by proportion." In the actual carving of sculpture this entails balancing the movements of the right hand which strikes with the adze and the left hand which turns the piece.

Other criteria include skill and good composition.

These criteria, on occasion, are violated consciously to produce works that represent the antithesis of the ideal, such as foreigners, criminals and fools. Practicing the criteria involves seeking moderation, the beautiful mean between the extremes. Beyond sensuous beauty, art must also embody the highest moral and spiritual

ideals. Goodness and beauty are linguistically linked in other African cultures, such as the CHOKWE of Central Africa, the MENDE of Sierra Leone and the Turu of Tanzania. The connection is evident in Yoruba art, for instance, in the great emphasis given to the disproportionately large head, regarded as the seat of consciousness and the moral sense. And the face, the "mirror of the soul," is characterized by the calm, beatific expression of an individual in harmony with her/himself, other human beings and the spiritual forces of the cosmos. For the Yoruba, goodness and beauty are infused with a kind of dynamic harmony. The Yoruba apply the criteria to life as well, seeking to live as individuals empowered with unbounded energy and creativity while abiding within a social context of acquiescence to authority, tradition and familial ties. Beyond this balancing act of individual autonomy and social obligation, the Yoruba aesthetic ultimately involves, through ritual and ceremonial actions, maintaining balance and harmony between human beings and the vast spiritual energies of the cosmos.

Yoruba Architecture. Since 800 CE the Yoruba have lived in clusters of small single-story square or rectangular dwellings around courtyards. The buildings were fashioned of sun-dried clay with thatched roofs, now replaced by concrete walls and corrugated iron or zinc roofs. These lineage compounds are called *agbo ile*, "a flock of houses." Palaces are an elaboration of this model, with multiple courtyards. The palace was generally located at the center of the town and the compounds of the most important chiefs were located close to it. Some cities, like Ilesha, were surrounded by a dry moat and massive walls with heavy doors on the gates located at the cardinal points. Impressive architectural sculpture served to increase the status of the chief/king and, as well as providing visual symbols of his power, surrounded the

YORUBA
ARCHITECTURE

Above: Veranda post carved by Olowe of Ise, for the palace of the Ogoga of Ikere, Ise. Olowe emphasized his figures by reducing the size of the trapezoidal capitals that support the crossbeams. The sculptures were originally boldly painted which would have added to their liveliness. 20th century.

ruler with beauty. With the 19th-century arrival of the British, the tropical architectural form of buildings on pilings with porches and shuttered windows appeared and is now widespread.

Yoruba Artists. In the last twenty-five years art historians have made strides toward identifying individual artists and assembling historical facts about their lives and work. John Picton has established a

YORUBA ARTISTS

Above: One panel from a pair of palace doors from Osi-Ilorin by Areogun. Esu, the trickster, sits atop the king's throne grasping his crown, suggesting the precariousness of power. Areogun's style is marked by taut, compact figures, carved in fairly low relief, which fill the space. His work has a finesse of detail and it is infused with dignity, energy and humor. The lack of emphasis on individual elements may be an instance of a type of composition that Henry Drewal calls a "discontinuous aggregate." The interchangeable, discrete motifs appear in no particular order and appear to be of equal value. The impression created is of a world teeming with relationships, events and energies that are fixed for a moment only. At the same time, repetitions and similarities give the impression that that moment is part of an ordered, universal whole.

The expert, whose sculptures dazzle the beholder.
He made his reputation in Ijero.
He confronts the wicked bravely.
He carved and was given a horse.
Dada [Areogun], who knows how to dance.
He carves hard wood as though he were carving a soft calabash.
He fed his younger children as though he were feeding an older person.
….
One whose mother lived to see his greatness [as a carver].
One who knows how to carve appropriately for kings.

—*Yoruba praise song for Dada Areogun.*

relative chronology and "artistic genealogy" for the 19th and 20th centuries for the areas of Ikerin, Isare and Osi. Work by some of the artists, e.g., Rotimi Baba Oloja, the founder of the artistic dynasty at Isare, is not known, although the people's memories of his work survive. Two of the most famous Yoruba artists are Bamgboye (d. 1978) founder (along with Ajijola) of the Osi area (see EPA) and Areogun (or Arowogun, 1880–1954) of Osi-Ilorin. Areogun's style and work are known in the literature largely through the work of Fr. Kevin Carroll and all identifications of the artist's work derive directly or indirectly from Carroll's friendship with the master. Another acclaimed artist was Olowe (d. 1938) of Ise-Ekiti, court artist of the King of Ise, whose architectural sculpture is known for its dynamic form and illusion of movement (see YORUBA ARCHITECTURE).

Yoruba Pantheon. The complexity of Yoruba aesthetics, thought and cosmology is mirrored in the innumerable deities that have multiple and often conflicting characters. Only a few are represented in Yoruba art, but their visual representations are equally tangled. The supreme creator god is Olorun or Olodumare who is not depicted and remains aloof from human affairs. He sent sixteen lesser gods to shape the earth and set human life on course; one of the sixteen, Oduduwa, created the center of the earth at IFE. SANGO is the protector of twins, the fourth king of Old Oyo and the thundergod. The god of crossroads is ESU (or Esu Elegba), the mischievous TRICKSTER. Ogun is the god of war and iron. There are two female deities associated with water: Osun is goddess of the Osun River and patron of the town of Osogbo; Yemoja is the goddess of the Ogun River and other streams in western Yorubaland. She is regarded as the mother of life and is associated also with the negative power of the feminine embodied in witches. Orisa

Oko is the god of the farm and fecundity. There are several gods associated with hunting. Osanyin is associated with herbal medicines. Finally Obatala, one of original sixteen deities Olodumare entrusted with creating the earth, fell asleep having overindulged in palm wine before depart-

ing. Enraged that Oduduwa had already created the earth, eventually Obatala regained some of his lost dignity by becoming the fashioner of human bodies. While not all of the deities are physically represented in art, all have ritual objects associated with them.

Yukon River. With the Kuskokwim River, one of the most important areas of Eskimo mask making. See INUA.

Yulunggul. The Great Python of the Australian aboriginal WAWALAG SISTERS myth. Unlike other Australian mythic snakes, Yulunggul is tied to a specific place, the sacred water hole Miraraminar or Mura-wul. In the versions of the myth in which Yulunggul speaks with his brother snakes, he faces east, so he is also a cultural area, a directional indicator. Some consider Yulunggul to be an aspect of

Rainbow Snake, but his greater specificity would seem to indicate a separate identity. Like other snakes in aboriginal myth, he is associated with water and fertility, and is so powerful as to be dangerous to those who come upon him unprepared or who defile his sacred place. See INDEX: Snakes, Supernatural Animals in Animals

Yup'ik (also Yupiaq, or Cupik, pl. Yup'iit). The word means "a real person" and is the name preferred by the ESKIMO. Although the terminology is gradually shifting in scholarly literature, at present, Eskimo is still used.

Yurugu. One of the original male twins created by the DOGON Supreme Deity Amma. While still in an embryonic stage, Yurugu became impatient and tore away part of the placenta, which became the earth with which he mated, thus committing incest and defiling the earth. Amma transformed Yurugu into the tongueless pale fox—the embodiment of disorder—enemy of light, water, fertility and civilization. Yurugu is condemned to wander eternally, searching for his twin. Yurugu symbolizes individual liberty in contrast to group cohesion on which society depends for survival. Yurugu does make one important contribution, however: Dogon diviners "read" his tracks on their sand grids to predict the future.

YORUBA PANTHEON

Left: The iron staffs for Osanyin, the orisa of health and herbal medicines, are like miniature trees with birds in their limbs. The leaf-like shapes of the bird's bodies as well as the birds themselves, as forest residents, allude to the forest as the source of healing power. At the same time, the birds are linked with the negative forces of witchcraft. Such staffs are also associated with Erinle, orisa of the forest and Oginyan, orisa of new yams.

Z

ZANDE

Above: Yanda figure with characteristically shaped head and closely grouped features. Yanda figures offered protection against witchcraft and acted as buffers between commoners and chiefs. 19th – 20th century.

ZULU

Right: Headrests, part of bride wealth even today among Zulu traditionalists, are prestige objects to protect elaborate hairstyles. Late 19th – early 20th century.

Zamble. GURO mask representing an antelope with a crocodile snout and leopard eyes. The mask is the antithesis of *gu,* the beautiful female type, and the brother of *zauli.*

Zande. Closely related to the MANGBE-TU, the Zande live in northeast Democratic Republic of Congo and in the Central African Republic. Typical Zande art objects include ancestor and maternity figures, neckrests, fly-whisks, musical instruments and *yanda* figures, all rather stylized and refined.

Zauli. GURO mask, an animal with exaggerated features, said to be the brother of *zamble.*

Zigzag. The zigzag is one of the most repeated patterns in indigenous cultures. Clearly, it is an elegant and direct way of filling space. But its visual resemblance to certain natural phenomena and its inherent energy result in a number of cohesive associations, all of which relate to motion. Perhaps the most common is the zigzag shape of lightning found throughout the American Southwest, pecked into rocks, in wall paintings, on pots, tipis and clothing. Furthermore, the sinuous movements of snakes result in zigzag depictions, such as the great metal pythons that once cascaded down the façade of the BENIN PALACE COMPLEX. These, too, were associated with lightning, as were the great metal birds that stood atop the roof, acting as rods to attract lightning strikes. The motion of water inspired the POMO basketry pattern called *ci.yoci.yo,* "waves on

the lake." Finally, zigzags are often associated with genealogy on objects linked with various stages of human life. GIKUYU boys' initiation shields are ornamented with zigzags and eye shapes, presumably for protection. The zigzags on GIRYAMA memorial markers mimic the human ribcage and double as family trees. In the Pacific, KEREWA *agiba* (skull racks) connect life force, zigzags and the ancestors. NGGWALNDU heads in ABELAM *korambo* are surrounded by radiating zigzags said to be the reduced bodies of ancestors. Finally, zigzags are common ENTOPTIC PHENOMENA visualized in trances and under the influence of hallucinogens. It is not entirely clear what significance zigzags have in rock art around the world, but their visual intensity (like the energy and movement that unites the snakes, lightning and water) makes them symbols of vitality and life force. For additional examples, see INDEX: Pattern in Art, Artifacts and Techniques.

Zimbabwe. See GREAT ZIMBABWE.

Zinkondi (sing. *nkondi*). See NKISI.

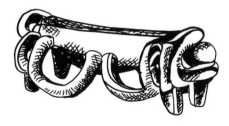

Zulu. The Zulu of southern Africa are members of a large group of related people. Known for warfare, the Zulu are also famed for the finesse and elegance of their carved

figures, staffs, spoons, headrests and weapons. Zulu headrests are boldly carved with the raised geometric patterns similar to those once reserved for the royal family. The raised studs may be a survival of patterns on heavy brass gauntlets awarded by the king to the most distinguished of his subjects. Now called the *amasumpa* motif (a colloquialism meaning "warts") the motif is said to represent a large herd of animals. This is not surprising, since Zulu cattle are the primary source of wealth and well-being and formed, along with headrests, part of brides' dowries. Elders of both sexes carried staffs as prestige objects and signs of rank. They were carved with human and animal figures and abstract designs which apparently varied regionally but, for the most part, focused on imagery associated with fertility and symbols of wealth. The *amasumpa* motif is also found on the highly polished black pottery made by women who in earlier generations had similar scarification patterns on their bodies. Although Zulu pots are used for cooking and storing various substances, their most important use is for sorghum-based beer. The beer is enjoyed by the living, and it is common to spill a small amount as an act of homage to the ancestors to whom larger amounts are offered on ritual occasions. The decorations, thus, are part of an interlocking web connecting the ancestors, royalty, the herds that constitute wealth, wives and the joys of the living.

Zulu Beadwork. The Zulu are famed for their impressive beadwork beginning with the 18th-century arrival of European beads. Dingiswayo, the uncle and protector of the under-age king, established a royal monopoly controlling the distribution and use of beads, a practice continued by later rulers. At that time, wearing beads was an honor permitted by the king. Now bead use is widespread, but the color and type of bead continues to be an indication of social status. It is said that some Zulu court

dresses were so heavily beaded that they weighed fifty pounds. With time, the patterns, colors, type and context of beads came to carry significance. Some beadwork conveys only general information, such as the places people come from. Other work, however, especially the type called "love letters," carried more specific messages. The "love letters" are necklaces with small square or rectangular pendants made by teenaged girls as gifts to boys. Color symbolism differs locally, and the location within the design can alter the meaning, but generally white symbolizes purity and truth. Black may represent the black marriage skirt or disappointment and mourning. Red indicates the fires of passion, or anger and pain. Pink, formerly a symbol of royalty, now indicates poverty and a vow. Yellow has both a positive meaning (pumpkins, home and wealth) and a negative implication (calf dung, a term of abuse). Green stands for grass, fields, the

ZULU

Above: This beer vessel, like other Zulu pottery, is coil built and polished with a small pebble and animal fat after firing to produce the lustrous shine. 19th century.

Below: Zulu beadwork is a popular tourist item, especially the so-called "love letters." These three bags are from the Nongoma and Mahlabatini areas. c. 1960s.

homestead and domesticity or it may mean that the maker is pining away. The different shades of blue convey various meanings from sky, sea and fidelity to gossip. Striped blue and white beads refer to the locusts that cling together while mating and "stay together for life." When a couple becomes engaged, the girl makes a *ucu*, a six- to nine-foot string of white beads worn by her intended in different configurations indicating the progress of the relationship. She may also wear one herself. If the young man is disloyal, the girl's friends may throw a black beaded *ucu* at his feet. He must wear it at least once or be branded a coward. Some sources suggest that "love letters" and the so-called fertility dolls are recent innovations, created largely in response to the tourist market. The Zulu also stage annual competitions for which beadworkers create huge costumes entirely encrusted with beads.

Zuni. The Zuni, who speak a language not directly related to any other, live in a pueblo on the banks of the Zuni River, just west of the continental divide in western New Mexico. Their ancestors have lived in the area since about 1300 CE and there were strong connections with the Chacoan Anasazi in pottery and house construction. The Zuni abandoned all settlements except the one called Zuni by 1692. The Zuni call it Halona, or "Red Ant Place." Frank CUSHING, who lived among them in the 1880s, described the pueblo as "a gigantic pyramidal mud honey-comb." Although a great deal of the original struc-

ture has been replaced with concrete block, and much else is crumbling, the rock CENTER shrine, which the Zuni say contains the beating heart of the world, still exists. Zuni art and culture involve a balanced antithesis between what Barbara Tedlock has called the "beautiful and the dangerous" (see "The Beautiful and the Dangerous: Zuni Ritual and Cosmology as an Aesthetic System"). Both aspects of this duality are celebrated in the annual Shalako ceremony where the Zuni, other Native Americans and non-Native guests witness an extended performance, visit beautifully decorated homes and feast. The heart of the duality is embodied in the words *tso'ya* and *attanni*. *Tso'ya* encompasses everything that is beautiful, dynamic and filled with life, while *attanni* includes things that are dangerous and tinged with death. *Tso'ya* appears to be linked with agricultural rituals which foster human life and promote germination of seeds. *Attanni* is probably a survival of the older shamanistic hunting rituals of earlier times. Beyond the antithesis of life and death, the two are expressed in color symbolism—the colors of the rainbow on the one hand and dark colors on the other; in beautiful creatures like butterflies, prong-horned antelope and macaws as opposed to dangerous bears, snakes and ravens. Both sides of the duality are incorporated into the Zuni Shalako ritual, which marks the beginning of a new ceremonial cycle, the coming of the gods among the Zuni and the approach of the winter solstice. Dancers wearing ten-foot-high costumes consisting of turquoise helmet masks that sprout eagle feathers and buffalo-shaped horns impersonate the Shalako. The masks have foot-long articulated snouts and great black spherical protruding eyes surrounded by white crescent moons. The costume also includes Hopi dance kilts, macaw feathers, abalone shells, a raven feather collar, sleigh bells and thousands of dollars worth of turquoise and coral jewelry. Other multi-

ZUNI

Right: Zuni pottery is ornamented with bold black and red designs on a white background. One of the most characteristic designs is the red, arrow-tipped X-Ray or heart line that the Zuni call o-ne-yathl-kwa'to-na, "entrance trail." Connected with the Zuni water serpent, the line is associated with life, BREATH and the path of the spirit. The curved triangular designs with hooks are sometimes said to represent butterflies. The broken line on the shoulder of this vase may symbolize the potter's own incomplete life. After 1850.

colored, life-filled masqueraders partici-
pate, such as the five member Council of
the Gods (spirits of the directions, the sun
and moon, the rainbow, various stars, corn
and fire) and the twelve Salimopiya (also
associated with the directions and specific
colors). These vital contributors to life,
procreation and germination are balanced
by the Koyemshi, or Mudheads, the infer-
tile offspring of the original incestuous
human sexual act. The Mudheads are
CLOWNS who wear lumpy-looking cot-
ton masks with inside-out eyes and no hair
or noses. They are smeared orange-brown
with sacred clay from the Land of the
Dead. They cavort around, play childish
games, but as they entertain, they also con-
vey moral lessons and psychic knowledge.
Although they are apparently the antithe-
sis of the stately and dignified Shalako,
they are regarded as far more powerful and
dangerous. The interaction between the
Mudheads and the Shalako does not, how-
ever, take the form of a battle between
good and evil, beauty and ugliness, life and
death, but rather involves the recognition
that both elements are part of a greater
whole. In addition to the impressive cere-
monial regalia, Zuni pottery is regarded as
among the most expressive and boldly
painted of all Pueblos. See also FOUR/SIX
DIRECTIONS, KACHINAS, PUEBLO
POTTERY and SILVER.

Zuni Fetishes. Although the word fetish is
disappearing from the literature concern-
ing indigenous peoples, it is still is popular-
ly used to describe the small carved images
of the six Beast Gods: mountain lion, bad-
ger, bear, wolf, eagle (or Knife Wing) and
mole as well as of many other creatures.
Those of the Beast Gods are associated
with the FOUR/SIX DIRECTIONS and
their purpose is to bring success in the hunt
based on the concept of COMPULSIVE
MAGIC. The Zuni believe that the Twins
transformed the Beast Gods into stone in
the time of myth. The most powerful

fetishes are the fragments of the large boul-
ders thought to be petrified animals.
Fetishes carved by men (women don't
make fetishes) show human artifice and
are less efficacious than those made "by
nature." Hunting Magic and fetish are
falling into disuse as outmoded terms

linked with older views. Hunting Magic
implies a simple-minded, mighty hunter
mentality that does not take into account
the awe and reciprocity that tied human
beings to their animal prey. Barbara
Tedlock writes of the respect with which
Zuni hunters address the slain deer—"May
you visit us often. Be happy"—and how
the lungs and bladder are buried with a
mixture of white shell and turquoise.
Other internal organs are left as offerings
to other beasts of prey (*The Beautiful and
the Dangerous*). The deer's body is carried
into the house following a cornmeal path,
head laid to the east to help her travel the
path to the land of the dead. There is a
lively tourist market for fetishes today—
many have inset eyes of a contrasting
stone. Traditionally, fetishes had medicine
bound around their midsections.

ZUNI FETISHES

*Left: Fetishes from Frank
Cushing's "Zuni Fetiches,"
1883.*

"It is supposed that the
hearts of the great ani-
mals of prey are infused
with a spirit or medicine
of magic influence over
the hearts of the animals
they prey upon, or the
game animals…; that
their breaths…derived
from their hearts, and
breathed upon their prey,
whether near or far,
never fail to overcome
them, piercing their
hearts and causing their
limbs to stiffen, and the
animals themselves to
lose their strength….
Since the mountain lion,
for example, lives by the
blood ('life fluid') and
flesh of the game animals,
and by these alone, he is
endowed not only with
the above powers, but
with peculiar powers in
the senses of sight and
smell. Moreover, these
powers, as derived from
his heart, are preserved
in his fetich, since his
heart still lives, even
though his person be
changed to stone."

—*Frank Cushing, 1883.*

Bibliography

Abiodun, Rowland, Henry J. Drewal and John Pemberton III. *The Yoruba Artist*. Washington. DC: Smithsonian Institution Press, 1994.

Acatos, Sylvio. *Pueblos, Prehistoric Indian Cultures of the Southwest*, trans. Barbara Fritzemeier. New York: Facts on File, 1990.

Adepegba, Cornelius and Joanne Bubolz Eicher, "Body Arts," in Turner, ed., *The Dictionary of Art*, Vol. I, 342–347.

Allen, Elsie. *Pomo Basketmaking*. Healdsburg, CA: Naturegraph Publishers, 1972.

Allen, Louis A. *Time Before Morning*. New York: Thomas Y. Crowell, 1975.

Anderson, Richard L. *Art in Small-Scale Societies*. Englewood Cliffs: Prentice Hall, 1979 (1989).

_____. *Calliope's Sisters*. Englewood Cliffs: Prentice Hall, 1990.

Anderson, Richard L. and Karen L. Field, eds. *Art in Small-Scale Societies: Contemporary Readings*. Englewood Cliffs: Prentice Hall, 1993.

Auer Falk, Nancy E., "Feminine Sacrality," in Eliade, ed., *The Encyclopedia of Religion*, Vol. 5, 302–312.

Bacquart, Jean-Baptiste. *The Tribal Arts of Africa*. London: Thames and Hudson, 1998.

Baglin, Douglass and David R. Moore. *People of the Dreamtime*. New York: Walker/Weatherhill, 1970.

Bancroft-Hunt, Norman. *The Indians of the Great Plains*. Norman: University of Oklahoma Press, 1981 (1992).

Barbier, Jean Paul and Douglas Newton. *Islands and Ancestors*. Munich: Prestel, 1988.

Barringer, Tim and Tom Flynn, eds. *Colonialism and the Object*. London: Routledge, 1998.

Barrow, Terence. *Art and Life in Polynesia*. Rutland, VT: Charles E. Tuttle Company, 1973.

Bassani, Ezio and William B. Fagg. *Africa and the Renaissance: Art in Ivory*. New York: Center for African Art, 1988.

Bateson, Gregory. *Naven*. Stanford: Stanford University Press, 1936 (1958).

Beane, Wendell C. and William G. Doty, eds. *Myths, Rites, Symbols: A Mircea Eliade Reader*, Vol. I. New York: Harper & Row, Publishers, 1976.

Bedinger, Margery. *Indian Silver*. Albuquerque: University of New Mexico Press, 1973.

Ben-Amos, Paula. *The Art of Benin*. London: Thames and Hudson, 1980.

_____. "Humans and Animals in Benin Art," in Berlo and Wilson, *Arts of Africa, Oceania, and the Americas*.

Ben-Amos, Paula and Arnold Rubin, eds. *The Art of Power/The Power of Art: Studies in Benin Iconography*. Los Angeles: Museum of Cultural History, University of California, Los Angeles, 1983.

Berjonneau, Gerald and Jean-Louis Sonnery. *Rediscovered Masterpieces*. Boulogne, France: Art 135, 1987.

Berlo, Janet C. and Ruth B. Phillips. *Native North American Art*. Oxford and New York: Oxford University Press, 1998.

Berlo, Janet Catherine and Lee Anne Wilson. *Arts of Africa, Oceania, and the Americas*. Englewood Cliffs: Prentice Hall, 1993.

Bibby, Brian. *The Fine Art of California Indian Basketry*. Sacramento: Crocker Art Museum, 1996.

Biebuyck, Daniel, Susan Kelliher and Linda McRae. *African Ethnonyms: Index to Art-Producing Peoples of Africa*. New York: G.K. Hall, 1996.

Birket-Smith, Kaj. *The Chugach Eskimo*. Copenhagen: Nationalmuseets Publikationsfond, 1953.

Black Elk. See Neihardt, *Black Elk Speaks*.

Black Elk, Charlotte. Quoted regarding Lakota law in Don Doll, S.J. *Vision Quest: Men, Women and Sacred Sites of the Sioux Nation*, pp. 156ff.

Blier, Suzanne Preston. *The Royal Arts of Africa: The Majesty of Form*. Upper Saddle River: Prentice Hall, 1998.

Boas, Franz. *Primitive Art*. New York: Dover Publications, Inc., 1927 (1955).

Bol, Marsha C. *North, South, East, West: American Indians and the Natural World*. Pittsburgh and Boulder: Carnegie Museum of Natural History and Roberts Rinehart Publishers, 1998.

Boone, Sylvia A., "Radiance from the Waters: Mende Feminine Beauty," in Anderson and Field, *Art in Small-Scale Societies: Contemporary Readings*.

Bowden, Ross. *Yena Art and Ceremony in a Sepik Society*. Oxford: Pitt Rivers Museum, University of Oxford, 1983.

Brake, Brian, et al. *Art of the Pacific*. New York: Harry N. Abrams, 1980.

Brettell, Richard, et al. *The Art of Paul Gauguin*. Washington, DC: National Gallery of Art, 1988.

Bringhurst, Robert. *The Black Canoe: Bill Reid and the Spirit of Haida Gwaii*. Seattle: University of Washington Press, 1991.

Brody, Hugh. *Maps and Dreams: Indians and the British Columbia Frontier*. Vancouver: Douglas & McIntyre, 1981.

Brose, David S., James A. Brown and David W. Penney. *Ancient Art of the American Woodland Indians*. Detroit and New York: Detroit Institute of Arts and Harry N. Abrams, 1985.

Buehler, Alfred, Terry Barrow and Charles P. Mountford. *The Art of the South Sea Islands*. New York: Crown Publishers, 1962.

Burch, Ernest S., Jr. *The Inupiaq Eskimo Nations of Northwest Alaska*. Fairbanks: University of Alaska Press, 1998.

Burland, Cottie. *North American Indian Mythology*. New York: Peter Bedrick Books, 1965 (1985).

Burnham, Dorothy. *To Please the Caribou*. Toronto: University of Toronto Press, 1992.

Campbell, Joseph. *Historical Atlas of World Mythology*, Vol. I, pts. 1–2, *Mythologies of the Great Hunt* and Vol. II, pts. 1–3, *The Way of the Seeded Earth*. New York: Harper & Row, 1988.

Carey, Margret. *Beads and Beadwork of East and South Africa*. Princes Risborough, Aylesbury, Bucks: Shire Publications, 1986.

Carlson, Roy L., ed. *Indian Art Traditions of the Northwest Coast*. Burnaby, BC: Archaeology Press, Simon Fraser University, 1982.

Carpenter, Edmund, Frederick Varley and Robert Flaherty. *Eskimo*. Toronto: University of Toronto Press, 1959.

Carpenter, Edmund. *Eskimo Realities*. New York: Holt, Rinehart and Winston, 1973.

Clark, LaVerne Harrell. *They Sang for Horses*. Tucson: University of Arizona Press, 1966.

Coe, Michael, Dean Snow and Elizabeth Benson. *Atlas of Ancient America*. New York: Facts on File, 1986.

Coe, Ralph T. *Lost and Found Traditions, Native American Art 1965–1985*. Seattle: University of Washington Press in association with the American Federation of the Arts, 1986.

_____. *Sacred Circles*. London and Kansas City: Arts Council of Great Britain and Nelson Gallery of Art – Atkins Museum of Fine Arts, 1976.

Cole, Herbert M., "Africa – Animal Imagery," in Turner, ed., *The Dictionary of Art*, Vol. I, 276–281.

_____. *Icons: Ideals and Power in the Art of Africa*. Washington, DC: Smithsonian Institution Press, The National Museum of African Art, 1990.

_____. *Mbari, Art and Life among the Owerri Igbo*. Bloomington: Indiana University Press, 1982.

Cole, Herbert M. and Chike C. Aniakor. *Igbo Arts: Community and Cosmos*. Los Angeles: Museum of Cultural History, University of California, Los Angeles, 1984.

Cole, Herbert M. and Doran H. Ross. *The Arts of Ghana*. Los Angeles: Museum of Cultural History, University of California, Los Angeles, 1977.

Colombo, John Robert, ed. *Poems of the Inuit*. Ottawa: Oberon Press, 1981.

Conklin, Abe, "Native American Expressive Culture," *Akwe: Kon Journal*. Ithaca and Washington, DC: Akwe: Kon Press, Cornell University and National Museum of the American Indian, 1994.

Conn, Richard. *Circles of the World: Traditional Art of the Plains Indians*. Denver: Denver Art Museum, 1982.

_____. *Native American Art in the Denver Art Museum*. Denver: Denver Art Museum, 1979.

Corbin, George A. *Native Arts of North America, Africa, and the South Pacific*. New York: Harper & Row, Publishers, 1988.

Craig, Barry. *Art and Decoration of Central New Guinea*. Aylesbury, Bucks: Shire Publications, 1988.

Cummins, Tom, "Kinshape: The Design of the Hawaiian Feather Cloak," in Berlo and Wilson, *Arts of Africa, Oceania and the Americas*.

D'Alleva, Anne. *Arts of the Pacific Islands*. New York: Harry N. Abrams, 1998.

Danzker, Jo-Anne Birnie. *Dreamings, Tjukurrpa*. New York: Prestel, 1994.

Dark, Philip J.C. and Roger G. Rose, eds. *Artistic Heritage in a Changing Pacific*. Honolulu: University of Hawaii Press, 1993.

D'Azevedo, Warren L. *Handbook of North American Indians, Great Basin*, Vol. 11. Washington, DC: Smithsonian Institution, 1986.

Doll, Don, S.J. *Vision Quest: Men, Women, and Sacred Sites of the Sioux Nation*. New York: Crown Publishers, Inc., 1994.

Dowson, Thomas A. *Rock Engravings of Southern Africa*. Johannesburg, South Africa: Witwatersrand University Press, 1992.

Drewal, Henry J. in Abiodun et al. *The Yoruba Artists*.

Drewal, Henry J. and Margaret Thompson Drewal. *Gelede: Art and Female Power Among the Yoruba*. Bloomington: Indiana University Press, 1983.

Drewal, Margaret Thompson. *Yoruba Ritual*. Bloomington: Indiana University Press, 1992.

Duchateau, Armand. *Benin, Royal Art of Africa from the Museum für Volkerkunde, Vienna*. Munich: Prestel, 1994.

Duncan, Kate C. *Northern Athapaskan Art: A Beadwork Tradition*. Seattle: University of Washington Press, 1989.

Dupre, Marie-Claude, "Teke," in Turner, ed., *The Dictionary of Art*, Vol. 30, 418–421.

Dwyer, Jane Powell and Edward Bridgman Dwyer. *Traditional Art of Africa, Oceania and the Americas*. San Francisco: Fine Arts Museums of San Francisco, 1973.

Eglash, Ron, "Bamana Sand Divination, Recursion in Ethnomathematics," *American Anthropologist* 99 (March 1997) 112–122.

Eliade, Mircea. ed. *The Encyclopedia of Religion*, 16 volumes. New York: Macmillan Publishing Company, 1987.

_____. See Beane.

Erickson, Jon T. *Kachinas: An Evolving Hopi Art Form*. Phoenix: The Heard Museum, 1977.

Ewers, John C. *Plains Indian Sculpture*. Washington, DC: Smithsonian Institution Press, 1986.

Ewing, Douglas C. *Pleasing the Spirits*. New York: Ghylen Press, 1982.

Ezra, Kate. *Art of the Dogon: Selections from the Lester Wunderman Collection*. New York: The Metropolitan Museum of Art, Harry N. Abrams, Inc., 1988.

_____. *Royal Art of Benin: The Perls Collection in the Metropolitan Museum of Art*. New York: The Metropolitan Museum of Art and Harry N. Abrams, 1992.

Fagg, William and John Pemberton III. *Yoruba, Sculpture of West Africa*. New York: Alfred A. Knopf, 1982.

Faik-Nzuji Madiya, Clementine. *Tracing Memory*. Quebec: Canadian Museum of Civilization, 1996.

Feest, Christian F. *Native Arts of North America*. London: Thames and Hudson, 1980 (1992).

Ferg, Alan, ed. *Western Apache Material Culture, The Goodwin and Guenther Collections*. Tucson: Arizona State Museum and University of Arizona, 1987.

Firth, Raymond. *Art and Life in New Guinea*. London: AMS Press, 1979.

Fletcher, Alice C. *The Hako*. Lincoln: University of Nebraska Press, 1996.

Forge, Anthony, ed. *Primitive Art and Society*. London and New York: Oxford University Press, 1973.

Fraser, Douglas and Herbert M. Cole, eds. *African Art & Leadership*. Madison: University of Wisonsin Press, 1972.

Furst, Peter T. and Jill L. Furst. *North American Indian Art*. New York: Rizzoli, 1982.

Garlake, P.S. *Great Zimbabwe*. New York: Stein and Day, Publishers, 1973.

Gathercole, Peter W., Adrienne L. Kaeppler and Douglas Newton. *The Art of the Pacific Islands*. Washington, DC: National Gallery of Art, 1979.

Gennep, Arnold van, discussed in Evan M. Zuesse, "Ritual," in Eliade, ed., *The Encyclopedia of Religion*, Vol. 12, 405–422.

Gerber, Peter R. *Indians of the Northwest Coast*, trans. Barbara Fritzemeier. New York: Facts on File, 1989.

Gerbrands, A. A. "Talania and Nake, Master Carver and Apprentice," in Berlo and Wilson, *Arts of Africa, Oceania and the Americas*.

____. *Wow-Ipits: Eight Asmat Woodcarvers of New Guinea*, trans. Inez Wolf Seegar. The Hague and Paris: Mouton, 1967.

Gidley, M. *Kopet, A Documentary Narrative of Chief Joseph's Last Years*. Seattle: Unversity of Washington Press, 1981.

Gifford, Philip C. "Trait Origins in Trobriand War-Shields: The Uncommon Selection of an Image Cluster," *Anthropological Papers of the American Museum of Natural History*, 79 (March 1996) 2–13.

Gilpin, Laura. *The Enduring Navaho*. Austin: University of Texas Press, 1968.

Goodman, Felicitas D. *Where the Spirits Ride the Wind*. Bloomington: Indiana University Press, 1990.

Grant, Campbell. *The Rock Paintings of the Chumash*. Berkeley and Los Angeles: University of California Press, 1965.

Green, Jesse, ed. *Zuni, Selected Writings of Frank Hamilton Cushing*. Lincoln: University of Nebraska Press, 1979.

Greub, Suzanne, ed. *Expressions of Belief: Masterpieces of African, Oceanic and Indonesian Art from the Museum voor volkenkunde, Rotterdam*. New York: Rizzoli, 1988.

Gross, Rita M. "Birth," in Eliade, ed., *The Encyclopedia of Religion*, Vol. 2, 227–231.

Haberland, Wolfgang. *The Art of North America*, trans. Wayne Dynes. New York: Crown Publishers, Inc., 1964.

Haile, Berard. *Head and Face Masks in Navaho Ceremonialism*. St. Michaels, AZ: St. Michaels Press, 1947.

Halifax, Joan. *Shaman, The Wounded Healer*. New York: Crossroad, 1982.

Handelman, Don. "Clowns," in Eliade, ed., *The Encyclopedia of Religion*, Vol. 3, 547–551.

Hanson, Allan and Louise Hanson, eds. *Art and Identity in Oceania*. Honolulu: University of Hawaii Press, 1990.

Heathcote, David. *The Arts of the Hausa*. London: World of Islam Festival Publishing Company Ltd., 1976.

Helm, June, ed. *Handbook of North American Indians, Subarctic*, Vol. 6. Washington, DC: Smithsonian Institution, 1981.

Hertz, Robert in Richard C. Martin, "Left and Right," in Eliade, ed., *The Encyclopedia of Religion*, Vol. 8, 495f.

Holm, Bill. *Northwest Coast Indian Art; An Analysis of Form*. Seattle: University of Washington Press, 1978.

____, "Will the Real Charles Edenshaw Please Stand Up?: The Problem with Attribution in Northwest Coast Indian Art," in Berlo and Wilson, *Arts of Africa, Oceania and the Americas*.

Hudson, Travis and Ernest Underhay. *Crystals in the Sky: An Intellectual Odyssey Involving Chumash Astronomy, Cosmology and Rock Art*. Santa Barbara: Ballena Press, Santa Barbara Museum of Natural History, 1978.

Idiens, Dale. *Cook Islands Art*. Princes Risborough, Bucks: Shire Publications, 1990.

Isaacs, Jennifer, ed. *Australian Dreaming*. Sydney: Lansdowne Press, 1980.

Johnson, Harmer. *Guide to the Arts of the Americas*. New York: Rizzoli, 1992.

Jonaitis, Aldona, "Heirarchy in the Art of the Northern Tlingit," in Anderson and Field, *Art in Small-Scale Societies, Contemporary Readings*.

Jones, G.I. *The Art of Eastern Nigeria*. Cambridge: Cambridge University Press, 1984.

Kaeppler, Adrienne L. *Artificial Curiosities.* Honolulu: Bishop Museum Press, 1978.

Kaeppler, Adrienne L., Christian Kaufmann and Douglas Newton. *Oceanic Art,* trans. Nora Scott et al. New York: Harry N. Abrams, 1997.

Kaliman, M.H., "Masculine Sacrality," in Eliade, ed., *The Encyclopedia of Religion,* Vol. 9, 252–258.

Kan, Michael and Roy Sieber. *African Masterworks in the Detroit Institute of Arts.* Washington, DC: Smithsonian Institution Press, 1995.

Kaufmann, Christian, see Adrienne Kaeppler, *Oceanic Art.*

Kerchache, Jacques, Jean-Louis Paudrat and Lucien Stephan. *Art of Africa,* trans. Marjolijn de Jager. New York: Harry N. Abrams, Inc., 1993.

Keyworth, C.L. *California Indians.* New York and Oxford: Facts on File, 1991.

King, Noel Q. *African Cosmos.* Belmont, CA: Wadsworth Publishing Company, 1986.

Kirch, Patrick Vinton. *Feathered Gods and Fishhooks.* Honolulu: University of Hawaii Press, 1985.

Kleivan, I. and B. Sonne. *Eskimos, Greenland and Canada.* Iconography of Religions, VIII. Leiden: E.J. Brill. 1985.

Kopper, Philip. *The Smithsonian Book of North American Indians.* Washington, DC and New York: Smithsonian Books and Harry N. Abrams, 1986.

Lamp, Frederick, "Baga," in Turner, ed., *The Dictionary of Art,* Vol. 3, 45–48.

Laude, Jean. *African Art of the Dogon,* trans. Joachim Neugroschell. New York: Brooklyn Museum and Viking Press, 1973.

Layard, John. *Stone Men of Malekula.* London: Chatto and Windus, 1942.

Lebot, Vincent, Mark Merlin and Lamont Lindstrom. *Kava, The Pacific Drug.* New Haven: Yale University Press, 1992.

Lewis-Williams, J. David. *Believing and Seeing: Symbolic Meanings in Southern San Rock Paintings.* London: Academic Press, 1981.

Lommel, Andreas. *Masks, Their Meaning and Function,* trans. Nadia Fowler. New York: McGraw-Hill, 1972.

———. *Prehistoric and Primitive Man.* New York: McGraw-Hill, 1966.

Lutkehaus, Nancy, et al., eds. *Sepik Heritage, Tradition and Change in Papua New Guinea.* Durham: Carolina Academic Press, 1990.

Malinowski, Sharon and Anna Sheets, eds. *The Gale Encyclopedia of Native American Tribes,* 4 vols. Detroit: Gale Research, Inc., 1998.

MacDonald, George F. *Haida Art.* Seattle: University of Washington Press, 1996.

MacKenzie, Maureen Anne. *Androgynous Objects: String Bags and Gender in Central New Guinea.* Chur, Switzerland and Philadelphia: Harwood Academic Publishers, 1991.

Macnair, Peter L. and Alan L. Hoover. *The Magic Leaves: A History of Haida Argillite Carving.* Victoria, BC: British Columbia Provincial Museum, 1984.

Mails, Thomas E. *The Mystic Warriors of the Plains.* Tulsa: Council Oak Books, 1972 (1991).

Mansell, Maureen E. *By the Power of Their Dreams, Songs, Prayers, and Sacred Shields of the Plains Indians.* San Francisco: Chronicle Books, 1994.

Mead, Sidney Moko. *The Art of Maori Carving.* Wellington, NZ: A.H. & A.W. Reed, 1961 (1973).

———, ed. *Exploring the Visual Art of Oceania.* Honolulu: University of Hawaii Press, 1979.

——— et al. *Te Maori: Maori Art from New Zealand Collections.* New York: Abrams/American Federation of the Arts, 1984.

Mead, Sidney Moko and Bernie Kernot. *Art and Artists of Oceania.* Palmerston, North New Zealand and Mill Valley: The Dunmore Press, 1983.

Merrick, George Charlton. *Hausa Proverbs.* London: Kegan Paul, Trench, Trubner, 1905.

Meyer, Anthony J. P. *Oceanic Art.* Edison, NJ: Knickerbocker Press, 1996.

Meyer, Laure. *Art and Craft in Africa.* Paris: Terrail, 1995.

———. *Black Africa: Masks, Sculpture, Jewelry,* trans. Helen McPhail. Paris: Terrail, 1992.

Meyerhoff, Barbara G., Linda A. Camino and Edith Turner, "Rites of Passage," in Eliade, ed., *Encyclopedia of Religion,* Vol. 12, 380–387.

Moon, Beverly, "Archetypes," in Eliade, ed., *The Encyclopedia of Religion*, Vol. 1, 379–382.

Moore, Albert C. *Arts of the Religions of the Pacific*. London and Washington: Cassell, 1997.

Morgan, Marlo. *Mutant Message/Down Under*. New York: HarperCollins, 1991 (1994).

Morgan, William N. *Ancient Architecture of the Southwest*. Austin: University of Texas Press, 1994,

Morphy, Howard, ed. *Animals into Art*. London and Boston: Unwin Hyman, 1989.

Morris, Jean and Eleanor Preston-Whyte. *Speaking with Beads: Zulu Arts from Southern Africa*. New York: Thames and Hudson, 1994.

Munn, Nancy D. *Walbiri Iconography*. Ithaca: Cornell University Press, 1973.

Murie, James R. *Ceremonies of the Pawnee, Part I: The Skiri*. Smithsonian Contributions to Anthropology, No. 27. Washington, DC: Smithsonian Institution Press, 1981.

Nabokov, Peter and Robert Easton. *Native American Architecture*. New York: Oxford University Press, 1989.

Neihardt, John G. *Black Elk Speaks*. Lincoln: University of Nebraska Press, 1961.

Newcomb, Franc Johnson, Stanley Fishler and Mary C. Wheelwright. *A Study of Navajo Symbolism*. Papers of the Peabody Museum of Archaeology and Ethnology, Harvard, Vol. 23, no. 3. Cambridge: Peabody Museum, 1956.

Newton, Douglas. *New Guinea Art in the Collection of the Museum of Primitive Art*. New York: Museum of Primitive Art Handbooks, 1967.

_____. Also see Barbier, Jean Paul and Douglas Newton.

Newton, Douglas and Lee Boltin. *Masterpieces of Primitive Art*. New York: Alfred A. Knopf, 1978.

Nooter, Mary H. *Secrecy, African Art that Conceals and Reveals*. New York: Museum for African Art, 1993.

Oakes, Jill and Rick Riewe. *Our Boots: An Inuit Women's Art*. London: Thames and Hudson, 1996.

O'Flaherty, Wendy Doniger and Mircea Eliade, "Androgynes," in Eliade, ed., *Encyclopedia of Religion*, Vol. 1, 276–281.

Ortiz, Alfonso. *Handbook of the North American Indians, Southwest*, Vol. 9–10. Washington, DC: Smithsonian Institution, Vol. 9–1979, Vol. 10–1983.

Ottenberg, Simon. *New Traditions from Nigeria*. Washington, DC: Smithsonian Institution Press, 1997.

Page, Susanne and Jake Page. *Hopi*. New York: Harry N. Abrams, 1982.

Parmentier, R.J. "Diagrammatic Icons and Historical Processes in Belau," *American Anthropologist*, 87 (1985) 840–52.

Paterek, Josephine. *Encyclopedia of American Indian Costume*. Denver: ABC-CLIO, 1994.

Patterson, Alex. *A Field Guide to Rock Art Symbols of the Greater Southwest*. Boulder: Johnson Books, 1992.

Pelrine, Diane M. and Patrick R. McNaughton. *African Art from the Rita and John Grunwald Collection*. Bloomington: Indiana University Art Museum and Indiana University Press, 1988.

Penney, David W. *Art of the American Indian Frontier: The Chandler-Pohrt Collection*. Seattle: The Detroit Institute of Arts and University of Washington Press, 1992.

Perani, Judith and Fred T. Smith. *The Visual Arts of Africa*. Upper Saddle River: Prentice Hall, 1998.

Phelps, Steven. *Art and Artefacts of the Pacific, Africa and the Americas: The James Hooper Collection*. London: Hutchinson, 1976.

Phillips, Philip and James A. Brown. *Pre-Columbian Shell Engravings: From the Craig Mound at Spiro Oklahoma*. Cambridge: Peabody Museum Press, 1984.

Phillips, Ruth B., "Masking in Mende Sande Society Initiation Rituals," in Berlo and Wilson, *Arts of Africa, Oceania, and the Americas*.

Phillips, Tom, ed. *Africa: The Art of a Continent*. Munich: Prestel, 1995.

Picton, John, "Art, Identity, and Identification: A Commentary on Yoruba Art Historical Studies," in Abiodun et al., *The Yoruba Artist*, 1–34.

_____. "Artists," in Turner, ed., *The Dictionary of Art*, Vol. 2, 243–245.

Plog, Stephen. *Ancient Peoples of the American Southwest*. London: Thames and Hudson, 1997.

Poignant, Roslyn. *Oceanic Mythology*. London: Paul Hamlyn, 1967.

Poynor, Robin. *African Art at the Harn Museum, Spirit Eyes, Human Hands*. Gainesville, FL: University of Florida, 1995.

Preston, George Nelson. *African Art Masterpieces*. New York: MacMillan and Hugh Lauter Levin Associates, Inc., 1991.

_____. *Sets, Series & Ensembles in African Art*. New York: Center for African Art and Harry N. Abrams, Inc., 1985.

Radin, Paul. *The Road of Life and Death*, Bollingen Series V. New York: Pantheon Books, Inc., 1945 (1953).

Rapoport, Amos, "The Pueblo and the Hogan: A Cross-Cultural Comparison of Two Responses to an Environment," in Berlo and Wilson, *Arts of Africa, Oceania and the Americas*.

Ravenhill, Philip L., "Baule," in Turner, ed., *The Dictionary of Art*, Vol. 3, 404–409.

Ray, Benjamin C. *African Religions*. Englewood Cliffs: Prentice Hall, 1976.

Ray, Dorothy Jean. *Aleut and Eskimo Art*. Seattle: University of Washington Press, 1981.

_____. *Eskimo Masks*. Seattle: University of Washington Press, 1967.

Reichard, Gladys A. *Navajo Medicine Man Sandpaintings*. New York: Dover Publications, Inc., 1977.

_____. *Navaho Religion*, Bollingen Series XVIII. New York: Pantheon Books, Inc., 1950 (1963).

Ricks, J. Brent and Alexander E. Anthony, Jr. *Kachinas: Spirit Beings of the Hopi*. Albuquerque: Avanyu Publishing Inc., 1993.

Ritchie, Carson I.A. *Art of the Eskimo*. South Brunswick, NJ: A.S. Barnes and Company, 1979.

Robbins, Warren M. and Nancy Ingram Nooter. *African Art in American Collections, Survey 1989*. Washington, DC: Smithsonian Institution Press, 1989.

Roberts, Allen F., "Tabwa" in Turner, ed., *The Dictionary of Art*, Vol. 30, 224–226.

Roberts, Mary Nooter and Allen F. Roberts. *The Shape of Belief: African Art from the Dr. Michael R. Heide Collection*. San Francisco: Fine Arts Museums of San Francisco, 1996.

Robinson, David, "The Decorative Motifs of Palauan Clubhouses," in Mead and Kernot, *Art and Artists of Oceania*.

Roosevelt, Anna Curtenius and James G.E. Smith, eds. *The Ancestors, Native Artisans of the Americas*. New York: Museum of the American Indian, 1979.

Ross, Doran H., "Asante," in Turner, ed., *The Dictionary of Art*, Vol. 2, 584–591.

Roy, Christopher D. *Art and Life in Africa: Selections from the Stanley Collection*. Iowa City: The University of Iowa Museum, 1985.

Rubin, Arnold. *Art as Technology*. Beverly Hills: Hillcrest Press, 1989.

Ruby, Robert H. and John A. Brown. *The Chinook Indians*. Norman: University of Oklahoma Press, 1976.

Saitoti, Tepilit Ole. *Maasai*. New York: Harry N. Abrams, 1980.

Salisbury, Richard P., "A Trobriand Medusa?" *Man*, 59 (1959) 50f.

Schildkrout, Enid and Curtis A. Keim. *African Reflections: Art from Northeastern Zaire*. Seattle and New York: University of Washington Press and the American Museum of Natural History, 1990.

Schuster, Carl and Edmund Carpenter. *Materials for the Study of Social Symbolism in Ancient & Tribal Art*. New York: Rock Foundation, 1986–88.

_____. *Patterns That Connect*. New York: Harry N. Abrams, Inc., 1996.

Seiber, Roy. *African Textiles and Decorative Arts*. New York: Museum of Modern Art, 1972.

Shankman, Paul. "The History of Samoan Sexual Conduct and the Mead-Freeman Controversy," *American Anthropologist*, 98 (Sept. 1996) 555–67.

Silverman, Eric Kline, "The Gender of the Cosmos: Totemism, Society and Embodiment in the Sepik River," *Oceania* (September 1996) 30–49.

Slifer, Dennis and James Duffield. *Kokopelli: Fluteplayer Images in Rock Art*. Santa Fe: Ancient City Press, 1994.

Smidt, Dirk A.M., et al., eds. *Asmat Art*. New York: George Braziller, 1993.

Smith, Gerald A. and Wilson G. Turner. *Indian Rock Art of Southern California*. Redlands: San Bernardino County Museum Association, 1975.

Smith, Robert. *Kingdoms of the Yoruba*. Madison: University of Wisconsin Press, 1969 (1988).

Sonnichsen, C.L. *The Mescalero Apaches*. Norman: University of Oklahoma Press, 1958.

Suttles, Wayne, ed. *Handbook of North American Indians, Northwest Coast*, Vol. 7. Washington, DC: Smithsonian Institution, 1990.

Strother, Z.S., "Eastern Pende Constructions of Secrecy," in Nooter, *Secrecy: African Art That Conceals and Reveals*.

Tedlock, Barbara. *The Beautiful and the Dangerous*. New York: Viking Press, 1992.

____. "The Beautiful and the Dangerous: Zuni Ritual and Cosmology as an Aesthetic System," in Berlo and Wilson, *Arts of Africa, Oceania and the Americas*.

Teilhet, Jehanne, "The Role of Women Artists in Polynesia and Melanesia," in Mead and Kernot, *Art and Artists of Oceania*.

Thompson, Jerry L. and Susan Vogel. *Closeup*. New York and Munich: Center for African Art, Prestel, 1990.

Thompson, Robert Farris. *Black Gods and Kings*. Bloomington: Indiana University Press, 1971 (1976).

____. *Face of the Gods*. New York: Museum for African Art and Prestel, 1993.

Thompson, Robert Farris and Joseph Cornet. *The Four Moments of the Sun: Kongo Art in Two Worlds*. Washington, DC: National Gallery of Art, 1981.

Thompson, Stith. *Motif-Index of Folk-Literature*, 6 vols. Bloomington: Indiana University Press, 1955–58.

Turner, Jane M. *The Dictionary of Art*, 34 volumes. New York: Grove's Dictionaries, 1996.

Turner, Victor, in Brose et al., *Ancient Art of the American Woodland Indians*, 104.

Turpin, Solveig A., ed. *Shamanism and Rock Art in North America*. San Antonio: Rock Art Foundation, Inc., 1994.

Ucko, Peter J., ed. *Form in Indigenous Art*. Atlantic Highlands, NJ: Humanities Press, 1977.

van Baaren, Th. P. "Death," in Eliade, ed., *The Encyclopedia of Religion*, Vol. 4, 251–259.

Vansina, Jan. *Art History in Africa*. London and New York: Longman, 1984 (1988).

Villasenor, David V. *Tapestries in Sand: The Spirit of Indian Sandpainting*. Healdsburg, CA: Naturegraph Company, 1963 (1966).

Vincent, Gilbert T. *Masterpieces of American Indian Art*. New York: Harry N. Abrams, Inc., 1995.

Vogel, Susan Mullin. *Baule, African Art, Western Eyes*. New Haven: Yale University Press, 1997.

____. "The Buli Master, and Other Hands," in Berlo and Wilson, *Arts of Africa, Oceania, and the Americas*.

Vogel, Susan and Francine N'Diaye. *African Masterpieces from the Musee de l'Homme*. New York: Center for African Art and Harry N. Abrams, Inc., 1985.

Waite, Deborah B. *Artefacts from the Solomon Islands and the Julius L. Benchley Collection*. London: British Museum Publications, 1987.

Walens, Stanley, "The Weight of My Name Is a Mountain of Blankets: Potlatch Ceremonies," in Berlo and Wilson, *Arts of Africa, Oceania and the Americas*.

Walker, Deward E, ed. *Handbook of North American Indians, Plateau*, Vol. 12. Washington, DC: Smithsonian Institution, 1998.

Wardwell, Allen. *Island Ancestors*. Seattle: University of Washington Press, 1994.

Warner, John Anson. *The Life & Art of the North American Indian*. New York: Crescent Books, 1975.

Washburn, Dorothy K., ed. *Hopi Kachina, Spirit of Life*. San Francisco and Seattle: California Academy of Sciences, University of Washington Press, 1980.

Waters, Frank. *Book of the Hopi*. New York: Ballantine Books, 1963 (1971).

Weber, Michael John, et al. *Perspectives: Angles on African Art*. New York: Center for African Art, Harry N. Abrams, Inc., 1987.

Willett, Frank. *African Art, An Introduction*. New York: Praeger Publishers, 1971 (1973).

Willey, Gordon R. *An Introduction to American Archaeology, North and Middle America*, Vol. I. Englewood Cliffs: Prentice-Hall, 1966.

Williams, Denis. *Icon and Image*. New York: New York University Press, 1974.

Willis, Roy, ed. *Signifying Animals*. London and Boston: Unwin Hyman, 1990.

Wright, Barton. *Hopi Kachinas: The Complete Guide to Collecting Kachina Dolls*. Flagstaff: Northland Press, 1977 (1986).

_____. *Kachinas: The Barry Goldwater Collection at the Heard Museum*. Phoenix: Heard Museum, 1975.

Wright, Robin K. "Two Haida Artists from Yan: Will John Gwaytihl and Simeon Stilthda Please Step Apart?" *American Indian Art*, Vol. 23 (Summer 1998) 42–57.

Young, M. Jane. *Signs from the Ancestors*. Albuquerque: University of New Mexico Press, 1988.

Young, Michael W., ed. *Malinowski among the Magi: The Natives of Mailu*. London: Routledge, 1988.

Zuesse, Evan M., "Ritual," in Eliade, ed., *The Encyclopedia of Religion*, Vol. 12, 405–422.

Index

This index contains entries organized by very broad categories. It is recommended that the reader study the index in order to become familiar with the categories. The purpose of the index is to enable the reader to find information that may not be evident simply by relying on the cross references in the text. For instance, below, under the general category Animals and under the subcategory Amphibians and Reptiles, the reader will find an entry for Fish. There is no separate encyclopedia entry for fish, so the reader would otherwise have no access to the thirty-something entries referring to fish. Generally speaking, there are no individual entries for those words in the index set in italics; words set in roman type do refer to encyclopedia entries.

ANIMALS

General References to Animals – Aleut, Alter Ego, Crests, Culture Hero, Master/Mistress of the Animals, North American Native Religion, Shamanism, X-Ray Images

Amphibians and Reptiles

Chameleon – Esu, Sandogo, Senufo Masks

Crocodile – Admiralty Islands, Akan, Asante, Asmat, Banda, Canoes, Dogon Masquerades, Flute Stopper, Glele, Iatmul, Ivory, Kominimung Shields, Ladder, Mamy Wata, Middle Sepik, Milky Way, Rivers, Sandogo, Senufo Masks, Sepik River, Skull Racks, Songye, Tambaran, Tami Islands, Teket

Fish – Alter Ego, Asante, Asmat, Bonito/Bonito Cult, Crests, Djanggawul Cycle, Eskimo, Fon Fabrics, Gift Baskets, Humboldt Bay, Kairak Baining, Kiva, Liminal States/Beings, Malanggan, Maro, Massim Shields, Mimbres Pottery, Mudfish, Pipes, Shields, Sisiutl, Solomon Islands, Suspension Hooks, Swahili Coast, Tada, Tangaroa, Tattoo, Totem, Water Spirits

Frog – Akan, Bamum, Cameroon, Crests, Hemis, Ifa, Kairak Baining, Liminal States/Beings, Mississippian Cults,

Northwest Coast Architecture, Pipes, Rain, Raven Rattles, Reid, Transformation Masks

Lizard – Akan, Cameroon, Kokopelli, Manaia, Moon, Tami Islands, Skeletonization, Umbilical Cord, Walbiri

Octopus – Alter Ego, Amulets

Snake –

Snakes in General – Baining, Benin, Cameroon, Djenne, Dogon, Dogon Cosmology, Dogon Masquerades, Earth Diver, Gbehanzin, Great Serpent Mound, Ifa, Jebba, Kairak Baining, Kilenge, Korwar, Lime, Liminal States/Beings, Mamy Wata, Mississippian Cults, Navajo Ceremonialism, North American Native Religion, Oduduwa, Osun, Pipes, Pueblo Pottery, Rainbow Snake, Sand Painting, Sawos, Sioux, Skull Racks, Songye, Spiral, Sulka, Supernatural Animals, Swallowing, Tami Islands, Togu Na, Umbilical Cord, Urbobo, Walbiri, Wandjina, Water Spirits, Wawalag Sisters, World Tree, Yulunggul, Zuni

Snakes by Species –

Cobra – Baga

Rattlesnake – Mississippian Cults

Python – Akan, Baga, Benin, Benin Palace Complex, Birth, Fon, Ijele, Mamy Wata, Sandogo, Sulka, Wawalag Sisters

Snakes and Birds – Benin, Mississippian Cults, North American Native Religion

Snakes and Lightning – Benin

Snakes and Royalty – Cameroon

Snakes and Water – Great Serpent Mound, Kokopelli, Olokun, Supernatural Animals, Wandjina

Tortoise/Turtle – Akan Gold, Basketry, California Basketry, Canoes, Continuous Line Drawings, Earth Diver, Key Marco, Mississippian Cults, Mnemonic Devices, Nan Madol, Rain, Sandogo, Shaking Tent, Soul Boat, Torres Strait Islands, Umbilical Cord

ART, ARTIFACTS AND TECHNIQUES

Islands, Danger, Esu, False Face Society, Golden Stool, Kota

Blue – Corn, Kuba Masks, Midewiwin

Green – Scepter

Multicolored – Adinkra, Baga, Beauty, Butterfly, Cameroon Masquerades, Chumash Rock Art, Four/Six Directions, Hako, Hemis, Hogan, Hutash, Kifwebe, Kilenge, Metals, Mudheads, Pomo, Rainbow, Sango, Wampum, Zulu Beadwork, Zuni

Red – 'Ahu ' Ula, Bonito Cult, Button Blankets, Coppers, Coral, False Face Society, Fon Fabrics, Goli, Kanak Masks, Mamy Wata, Morning Star Ceremony, Pomo, Sun

White – Corn, Crests, Esu, Fang, Golden Stool, Ivory, Kota, Mamy Wata, Moon, Ogowe River Basin, Poro, Raven Rattles

Yellow – 'Ahu ' Ula

Containers (including Bags, Boxes) – Algonquian, Athapaskan, Austral Islands, Babiche, Baby Carriers, Bone Receptacles, Bonito Cult, Cross, Djanggawul Cycle, Fang, Firebags, Geelvink Bay, Jump Dance, Konankada, Kuduo, Lime, Mossbags, Native American Church, Parfleche Bags, Quillwork, San, Shamanism, String Bags, Underwater Panther, Waka Tupapaku, Wosera, Yena, Yeu, Zulu Beadwork

Costume and Clothing – Apache, Baba, Bark Cloth, Beauty, Chokwe, Clowns, Cook Islands, Cult, Dan, Egungun, Featherwork, Fiji, Gelede, Ghost Dance, Haida, Hair, Igbo Masquerades, Innu, Jebba, Jump Dance, Kachina, Kuba, Kuchin, Maro, Metis, Moccasins, Ogboni Society, Powwow, Samoa, Sande, Sango, Self-Directed Designs, Shamanism, Society Islands, Sulka, Supernatural Animals, Tonga, Veils, Zulu, Zuni

Currency – Abelam, 'Ahu 'Ula, Bai, Beadwork, Benin, California, Coppers, Gobaela, Jump Dance, Mahiole, Malekula, Pigs, Shell, Wampum

Featherwork – 'Ahu 'Ula, Benin, Birds, Hako, Hopi, Native American Church, Mahiole, Niman, War Bonnet

Ladders – Admiralty Islands, Akan, Asmat War Shields, Bis Pole, Butterfly, Cook Islands, Dogon, Entoptic Phenomena, Pueblo Bonito, Tambaran, Triangle,

Masks – Apache, Baba, Baga, Baining, Bamana, Bembe, Bo Nun Amuin, Bobo, Butterfly, Bwa, Cameroon, Cameroon Masquerades,

Chugach, Chuuk, Cross River, Dan, Dogon Masquerades, Elema, Elephant, Epa, Eskimo Masks, False Face Society, Fang, Finger Masks, Gelede, Goli, Guro, Hamatsa, Hemis, Hero Twins, Iatmul, Ibibio, Igbo Masquerades, Ijele, Inua, Ipiutak, Iroquois Religion, Ivory, Kachina Dolls, Kairak Baining, Kalabari, Kanak Masks, Key Marco, Kifwebe, Kilenge, Kuba Masks, Kurumba, Kwakiutl, Labret, Layered Universe, Lega, Mai, Makonde, Malaggan, Mississippian Cults, Mitaartoq, Moon, Mossi, Nimba, Oduduwa, Ogowe River Basin, Pende, Poro, Sande, Senufo Masks, Sulka, Sun, Tableta, Tami Islands, Teke, Tolai, Torres Strait Islands, Transformation Masks, Tsonoqua, Tunghak, Water Spirits, Yafar, Yam, Yoruba Aesthetics

Metals – *See Natural Phenomena and Materials below*

Mirrors and Mirror Images – Abelam, Ala, Dikenga, Glele, Horses, Igbo, Ijele, Kwoma, Mamy Wata, Kongo Nkisi, Shadow, Shamanism, Sun, Vili, Yoruba Aesthetics.

Musical Instruments – Akan Goldweights, Benin, Benin Ancestor Shrines, Biwat, Butterfly, Bwa, Bullroarers, Didjeridu, Drums, Effigy Figures, Ekpe, Flute Stoppers, Flutes, Iatmul, Ivory, Hula, Humboldt Bay, Kokopelli, Mangbetu, Melanesia, Messenger Feast, Ogboni Society, Sango, Sawos, Skeletonization, Slit Gong, Solomon Islands, Tambaran, Tjurunga, Yena

Pattern –

Specific Patterns – Concentric Patterns, Continuous Line Drawings, Crescent, Cross, Maze, Sign Systems, Spiral, Swastika, Triangle, Vulva, Zigzag

Incidences of Patterns – Akan Gold, Amasumpa Pattern, Asante, Baby Carriers, Basketry, Body Art, Bokolanfini, Butterfly, Bwa, Chumash Rock Art, Divination, Entoptic Phenomena, Islam, Kairak Baining, Kente, Kerewa, Kokorra Motif, Kuba, Kuba Royal Portraiture, Kwoma, Maori Aesthetics, Massim Shields, Mnemonic Devices, Moko, Northwest Coast Style, Pigs, Pueblo Pottery, Sand Painting, Sawos, Shields, Spinal Column, Tableta, Taniko, Tapa, Tattoo, Tjurunga, Tonga, Turtle, World Tree, X-Ray Images, X-Ray Style In Aboriginal Australia, Zulu Beadwork.

Checkerboard – Bwa, Dogon Masquerades, Entoptic Phenomena, Turtle

Chevron – Altered States of Consciousness,

Entoptic Phenomena, Great Zimbabwe, Inua, Kanak, Kerewa, Kominimung Shields, Pattern, San

Circle – Adena Complex, Adinkra, Akan, Akan Gold, Asante, Asmat War Shields, Bai, Bakor, Bamum, Bwa, Clouds, Concentric Patterns, Cross, Entoptic Phenomena, Felines, Fon, Ghost Dance, Hutash, Kaidiba, Kerewa, Kongo Cosmology, Lega, Mbi, Medicine Wheel, Mississippian Cults, Poverty Point, Rainbow, San, Shaking Tent, Shield, Tapa, Tipi, Tjurunga, Walbiri, Wawalag Sisters

Crescent – Apache, Bwa, Canoes, Eastern Africa, Hawaiian Islands, Head, Heiau, Hula, Mahiole, Najas, Native American Church, Poverty Point, Sawos, Society Islands, Skull Racks, Squash Blossom, Zuni

Cross – Apache, Crossroads, Currency, Dogon Masquerades, Entoptic Phenomena, Felines, Fon, Four/Six Directions, Gauguin, Hair, Mississippian Cults, Navel, Oduduwa, Shamanism, Spider, Stars

Spiral – Archaeoastronomy, Canoes, Center, Cross River, Entoptic Phenomena, Great Serpent Mound, Igbo Masquerades, Innu, Kaidiba, Kokopelli, Kongo Niombo, Kuchin, Manaia, Maro, Moko, Sand Painting

Square – Adena Complex, Coyote, Fon, Northwest Coast Architecture, Sign Systems (Asante Adinkra), Tapa, Trail of Tears, Yoruba Architecture, Zulu Beadwork

Triangle – Bwa, Butterfly, Clouds, Fon Fabrics, Horses, Innu, Kongo Niombo, Kuba Masks, Ladder, Pattern, Plains Peoples, Tapa, Wawalag Sisters

Zigzag – Altered States of Consciousness, Benin Palace Complex, Bwa, California Basketry, Chi Wara, Clouds, Coyote, Djenne, Entoptic Phenomena, Gikuyu, Giryama, Hero Twins, Kerewa, Kiva, Korambo, Moon, Nggwalndu, Quillwork, Rain, San, Sand Painting, Tapa, Tjurunga

Pottery – Akan, Amasumpa Motif, Anasazi, Casas Grandes, Gender Roles, Kiva, Kwoma, Lapita Pottery, Mangbetu, Martinez, Mimbres Pottery, Mississippian, Mississippian Cults, Proverbs, Pueblo Pottery, Zulu, Zuni

Shields – Asmat War Shields, Astrolabe Bay, Circle, Elema Ancestor Boards, Eye, Featherwork, Gikuyu, Head, Kominimung Shields, Massim Shields, Sign Systems (Asmat Shields), Tongues,

Textiles – Adinkra, Bark Cloth, Beauty, Bokolanfini, Button Blankets, Cameroon, Chilkat, Dog Blankets, Egungun, Fiji, Fon, Goli, Igbo, Innu, Kente, Knots, Kuba, Mamy Wata, Maro, Navajo Weaving, Niombo, Ogboni Society, Ravenstail Robes, Sande, Self-Directed Designs, Senufo, Sign Systems (*specifically* Asante Adinkra, Cameroon Ndop, Ejagham/Igbo Nsibidi), Society Islands, String Bags, Swahili Coast, Tapa, Yei

Tools – Adze, Africa, Blacksmith, Culture Hero, Eskimo, Gender Roles, Gu, Ifa, Ipiutak, Moko, Tlingit, Tohunga Whakairo, Uhikana, Wampum

Weapons – Benin, Blacksmith, Compulsive Magic, Cook Islands, Counting Coup, Culture Hero, Divination, Fiji, Gu, Hawaiian Islands, Horses, Humboldt Bay, Hunting Magic, Ibibio, Mana, Massim, Master/Mistress of the Animals, Pende, Pigs, Senufo, Solomon Islands, Wawalag Sisters, Zulu

ARTISTS

Aboriginal Australia – *The Aboriginal Memorial by several artists*

Arobanjan of Pobe – Sango

Areogun – Yoruba Artists

Ayo, Sarakatu – Yoruba Aesthetics

Bamgboye – Yoruba Artists

Beli bi Ta *(known as Descar)* – Guro

Benson, Mary – Pomo

Boti – Guro

Buli Master – Buli School

Cordero, Helen – Pueblo Peoples

Dat So La Lee (Louisa Keyser) – Washoe

Dawudi – Wawalag Sisters

Edenshaw, Albert Edward

Edenshaw, Charles

Fogarty, Joyce Growing Thunder – "Indian Time"

Gwaytihl, Charles

Haesemhliyawn – Totem Poles

Hanuebi – Maro

James, Charlie – HAMATSA

Jim, Mary Nez – Yei

Klah, Hosteen

Lawore – Ibeji

Madaman – Djanggawul Cycle

Martinez, Maria *and* Julian

Master of Buatle – Guro

Master of Ogol – Dogon

Master of Yasua – Guro

Mben – Asmat War Shields

McKay, Mabel – Gift Baskets

Mebudi Yipilas – Yena

Nampitjinpa – Walbiri

Ngongo ya Chintu – Buli School

Olowe of Ise – Yoruba Artists, Yoruba Architecture

Ortiz, Serefina – Market Art

Reid, Bill

Rotimi Baba Oloja – Yoruba Artists

Rukupo, Raharuhi – Whare Whakairo

Seaweed, Willie – Coppers, Kwakiutl

Sriano, Sibo – Maro

Stilthda, Simeon

Talamia – Kilenge

Tame – Dan

Tra bi Tra – Guro

Tsagay – Bears

Viti – Asmat War Shields

Whiting, Cliff

DEITY ARCHETYPES

Culture Hero – *See* Arctic, Kalabari, North American Native Religion, Tools, Torres Strait Islands, Winnebago

Ataachookai – Kuchin

Chibinda Ilunga – Chokwe

Fumeripits – *Asmat*

Kuksu – *Pomo*

Maui – *Polynesia*

Mbidi Kiliwe and Kalala Ilunga – Luba

Nommo – [see Dogon Cosmology]

Raven – *Northwest Coast*

Tsenta – [see Iroquois Religion]

Wandjina – *Aboriginal Australia*

Woot – Kuba

Creator Gods – *See* Culture Hero, Dreaming, Earth Diver

A'a – *Austral Islands*

Above Person, Great Traveler, Immortal One – California

Amma – *Dogon* [see Dogon Cosmology]

Bemba *or* **Ngala** – Bamana

Changing Woman – *Navajo*

Chukwu – Igbo

Crocodile – Iatmul

Earthmaker – Winnebago

Fumeripits – *Asmat*

Gluskap – *Algonquian* [see Twins]

Judge – *Mojave* [see Earth Works]

Kuksu – *Pomo*

Lizard

Makemake – *Easter Island*

Mbwoom – Kuba

Moki – *Maidu*

Nzambi Kalunga or Nzambi Mpungu Tulendo – Kongo

Odudwa – *Yoruba* [see Yoruba Pantheon]

Old Man Coyote – *Crow* [see Horses]

Oldumare – *Yoruba* [see Oni]

Olorun – *Yoruba* [see Yoruba Pantheon]

Pele – *Hawaii*

Rainbow Snake – *Aboriginal Australia*

Raven – [see Northwest Coast Religion]

Ta-ghar – Malekula

Tane – *Maori* [see Rangi]

Tiki – *Marquesas Islands*

Tirawa – Pawnee

Tsenta – [see Iroquois Religion]

Spider Woman – *Navajo* [see Rainbow]

Supreme Being – [see Bella Coola Cosmology]

Wuro – Bobo

Gods of Death and Destruction – Color, Culture Hero

Animals associated with death – Akan, Birds, Korwar, Lizard, Manaia, Mississippian Cults, Owl, Raven

Deities – Hikule 'O (Tonga), Hine-Nui-Te-Po, Kaggin Inua, *Nangintain* (see X-Ray Images), Ogiwu (Yoruba Pantheon), *Sakaunu* (Tonga), Sedna, Sila, Slo'w (Chumash), *Taweskare* (Iroquois Religion), Tu

Earth Mother – Birth, Cult, Kongo, Maasai, *Masau'u* [see Hopi, *a male earth deity*], Nurturing Female, Oceania, Zuni

Ala – *Igbo, Ibibio*

Changing Woman – *Navajo*

Hutash – *Chumash*

Papa – *Polynesia* [see also Rangi]

Gods of Natural Forces and Locales –

Fire – Hutash, Maui, Pele, Raven, Sango, Spider

Moon – Aningaaq – *Eskimo*, Hina/Hine – *Polynesia, see also* Nootka and Pawnee

Rain – Kachina, Kokopelli, Ku, Mudheads, Northwest Coast Architecture, Rainbow Snake, Tassili-N-Ajjer, Waterspirits

Sun – Baule, Changing Woman, Chumash, Cosmology, Kanak, Ku, Mississippian Cults, Nootka, North American Native Religion, Pawnee, String Figures, Togu Na, Winnebago, Zuni

Thunder and Lightning – Amadioha, *Ogiwu*, Sango, Spider Woman, Thunderbird, Underwater Panther

Volcano – Pele

Water – *Ayidohwedo* (Fon), *A-Nabtsgi-na-Tsol* (Baga), *Ekine* (Kalabari), *Kolowisi* (Snakes), Konankada, *Koyemshi* (Mudheads), Mamy Wata, Nommo, Olokun, *Osun* (Yoruba Pantheon), Sedna, Tangaroa, Underwater Panther, Wandjina, Water Spirits, *Yalulawei* (Wind Charms), *Yemoja* (Yoruba Pantheon), Yulunggul

Wind – *East Wind and his three brothers* (Geelvink Bay), *Gagohsa* (Iroquois False Face Society), Hutash, *North Wind* (Pawnee), *Wind People* (Navajo Ceremonialism), Tawhiri

Primordial Beings – Cross, Dreaming, Inua, Marind-Anim, Nommo, Sandogo, Wandjina

Primordial One – A'a, Kuksu, *Ta-ghar* (Malekula), Tangaroa

Primordial Couple – Dogon, Hutash *and the Sun* (Chumash), *Navajo Primordial Couple* (Hogan), Ku *and* Hina, Malekula, Nootka, Rangi *and* Papa, Senufo, *Tirawa and Vault of Heaven* (Pawnee)

Trickster – *Ananse* (Asante), Coyote, Esu (*see also* Vodun), *Inktomi* (Spider), Maui, Mimi Spirits, Raven, Wandjina

Gods of War – Gu, Kukailimoku, *Morning Star* (Pawnee), *Ogun* (Yoruba Pantheon), *Oro* (Society Islands), *Pookon* (Hopi, *see* Soyala), *Twin War Gods* (Zuni, *see* Twins)

GEOGRAPHICAL SUBDIVISIONS AND NATIVE CULTURES

Africa

Central Africa (*Gabon, Congo, Central African Republic, Democratic Republic of Congo, Angola*) Bembe, Chokwe, Fang, Kongo, Kota, Kuba, Lega, Luba, Luluwa, Mangbetu, Ogowe River Basin (Kwele), Pende, Songye, Teke, Woyo, Yaka, Zande

Eastern and Southern Africa (*Tanzania, Kenya, Zimbabwe, Kalahari Desert*) – Dinka, Gikuyu, Giryama, Great Zimbabwe, Maasai, Makonde, San, Swahili Coast, Zulu

North Africa – Tassili n-Ajjer

The Sudan (*Mali, Niger, Burkina Faso*) – Bamana, Bobo, Bwa, Dogon, Fulani, Hausa, Kurumba, Lobi, Mossi, Senufo

Western Africa and the Guinea Coast (*Guinea, Sierra Leone, Liberia, Ivory Coast, Ghana, Republic of Benin, Nigeria, Cameroon*) – Akan, Asante, Baga, Bakor, Bamileke, Bamum, Bangwa, Batcham Baule, *Benin (Edo)*, Cross River (Ejagham), Dan, *Djenne*, Fon, Guro, Ibibio, *Ife*, Igbo, *Igbo-Ukwu*, Ijo, Kalabari, Mende, Nok, Nupe, Urhobo, Yoruba

North America

Arctic and Subarctic – Alaskan Eskimo (Yupik)/Canadian Inuit, Aleut, Chugach, Inupiat, *Ipiutak*, Athapaskans, Kuchin, Innu (Naskapi)

California – Chumash, Pomo, Washoe, Yokuts, Yurok

Great Basin

Great Lakes – Anishnabe, Ojibwa (Chippewa)

Northwest Coast – Bella Bella. Bella Coola, Chilkat, Coast Salish, Haida, Kwakiutl, Tlingit, Tsimshian

Plains – Arapaho, Assiniboin, Blackfeet, Crow, Lakota (Western or Oglala Sioux), Mandan, Pawnee, Sioux

Plateau – Kootenai, Nez Perce

Southwest – Anasazi (*Pueblo Bonito, *Mesa Verde*), Apache, Casas Grandes, Hohokam, Hopi, Mogollon (*Mimbres*), Mohave, Navajo, Papago, Pawnee, Pima, Pueblo Peoples, Zuni

Woodlands – *Adena, Algonquian, *Cahokia, *Great Serpent Mound, Hopewell, Iroquois, Key Marco, Kickapoo, Mississippian, Pawnee, Potowatomie, *Poverty Point, Sauk, Winnebago

Oceania (*see* Dongson *and* Lapita Cultures)

Australia – Arnhem Land, Kimberley, Walbiri

Melanesia – *New Guinea and Irian Jaya* (Admiralty Islands, Asmat, Astrolabe Bay, Geelvink Bay, Humboldt Bay [Jos Sudarso Bay], Lake Sentani, Marind-anim, Massim [Trobriands], Mimika, Sepik River [Abelam, Biwat, Iatmul, Kominimung, Kwoma, Lake

*Yimas, Sawos, Wosera, Yimar] Tami Islands),
New Britain and the Duke of York Islands
(Baining [Kairak Baining], Kilenge, Sulka,
Tolai), New Caledonia (Kanak), Papuan Gulf
(Elema, Kerewa), Solomon Islands, Torres
Strait Islands, Vanuatu (New Hebrides and
Banks Islands), Malekula*

Micronesia *– Caroline Islands (Chuuk), Cook
Islands, Marianas Islands, Marshall Islands*

Polynesia *– Austral Islands, Easter Island
(Rapanui), Fiji, Hawaiian Islands, Marquesas
Islands, New Zealand (Maori), Samoa, Society
Islands (Tahiti), Tonga*

*Indicates archaeological sites or cities.

THE HUMAN BODY

Bodily Functions – Birth, Coitus, Death,
Parturition, Swallowing

Body Art – Butterfly, Bwa, Cicatrization, Easter
Island, Hair, Hand, Igbo, Initiations,
Kinaalda, Labret, Maori, Marquesas Islands,
Moko, New Guinea, Pattern, Rambaramp,
Scarification (*see below*), Tassili N-Ajjer,
Tattoo, Wosera

Eye – Akan Gold, Baba, Cameroon
Masquerades, Concentric Patterns, False
Face Society, Gikiyu, God's Eyes, Hei Tiki,
IRMS, Kerewa, Kokorra Motif, Kota,
Kwoma, Malanggan, Mende, Metals, Mbi,
Mimika, Mississippian Cults, Nggwalndu,
Niombo, Nkisi, Postures, Praying Mantis,
Rapa, Sawos, Secrecy, Sedna, Self-Directed
Designs, Sisiutl, Tambaran, Thunderbird,
Uhikana, U'u, Wandjina, Zuni

Hair

Hand – Directional Symbolism, Ikenga,
Hosteen Klah, Ku, Niombo, Mississippian
Cults, Ogboni Society, Tools, Urhobo

Head – Akan, Akan Gold, Asmat, Bai, Benin
Ancestor Shrines, Bis Pole, Cleft Head,
Dreams, Fang, Hei Tiki, Humboldt Bay, Ifa,
Ife, Ikenga, Janus Faces/Figures, Kalabari
Ancestor Shrines, Konankada, Korwar, Kuba
Royal Portraits, Luluwa, Manaia,
Mississippian Cults, Mudheads, Nggwalndu,
Nomoli, Osun, Pomdo, Shield, Society
Islands, Solomon Islands, Southern Africa,
Wandjina, Yaka, Yena, Yimar, Yoruba

Heraldic Woman

Navel – Bakor, Cannibalism, Center, Cross,
Eye, Mbi, Mimika, Postures, Sawos, Sipapu,
Water Skate

Postures

Scarification – Akan, Bembe, Bobo, Body Art,
Bwa, Checkerboard, Cicatrization,
Initations, Luba, Luluwa, Navel, Sawos,
Senufo, Turtle, Zulu

Sexual Characteristics

Breast – Androgyny, Cameroon,
Cannibalism, Chokwe, Gelede, Igbo
Masquerades, Mossi, Nimba, Pueblo Pottery,
Senufo Masks, Togu Na, Tonga

Genitalia – Androgyny, Ikenga, Tapu,
Western Africa and the Guinea Coast, X-
Ray Images

Penis – Bis Pole, Esu, Hei Tiki, Korambo,
Kwoma, Nggwalndu, Rapa, Sexual Control,
Tambaran, Yimar

Vulva – Bullroarers, Coitus, Heraldic
Woman, Massim Shields, Senufo Masks, Slit
Gong, Togu Na

Womb – Baby Carriers, Bamum, Doors and
Thresholds, Gender Roles, Initiations,
Korambo, Mazes, Pawnee, String Bags,
Wosera, Wunkirle

Skeletonization – Biwat, Mississippian Cults,
Moai Kavakava, Shamanism, Spinal Column

Skulls – Asmat War Shields, Baule, Bocio,
Bone Receptacles, Bonito Cult, Canoes,
Color, Cross River, Ekpe, Fang, Head, Head
Hunting, Iatmul, Igbo Masquerades, Kachina
Dolls, Kerewa, Korwar, Kota, Lega,
Mississippian Cults, New Britain,
Rambaramp, Rapa, Sawos, Skull Racks,
Solomon Islands, Suspension Hooks, Tolai,
Uli

Spinal Column – Head, Hine-nui-te-po,
World Tree

Tongue – Kilenge, Martinez, Rapa, Raven
Rattles, Sulka, Tahiti, Tambaran, Yena,
Yurugu

Umbilical Cord

NATURAL PHENOMENA
AND MATERIALS

Archaeoastronomy – Center, Chumash, Great
Serpent Mound, Haida Cosmology, Kongo
Cosmology, Kuba, Medicine Wheel, Path
of Life, Korambo, Solstices, Sun, Sun
Dance Lodge

Darkness – Ala, Aningaaq, Bembe, Cameroon
Masquerades, Danger, Eye, Gold, Haida
Cosmology, Hako, Igbo Masquerades, Kairak

Shields, Bis Poles, Malekula, Northwest Coast Style, Yeu

World Tree – Bamana, Center, Cosmic Models, Crow, Drum, Haida Cosmology, Inversion, Kifwebe, Makonde, North American Native Religion, Northwest Coast Architecture, Path of Life, Pattern, Pukamani, Sand Painting, Sango, Scepter, Shaking Tent, Shamanism, Skeletonization, Sun Dance, Sun Dance Lodge, Water Skate, Yeu

Thunder and Lightning – Apache, Benin Ancestor Altars, Benin Palace Complex, California, Clouds, Crescent, Golden Stool, Hemis, Hogan, Ibeji, Navajo Ceremonialism, Navajo Weaving, Rain, Santeria, Shaking Tent, Snakes, Songye, Sulka, Zigzag

Wind – Breath, Chugach, Hamatsa, Hogan, Layered Universe, North American Native Religion, Wind Charms

MISCELLANEOUS

Cosmology– Bella Coola Cosmology, Dogon Cosmology, Haida Cosmology, Kongo Cosmology, Navajo Ceremonialism, Zuni

Danger – Bamana, Bear, Beauty, Benin Palace Complex, Bocio, Bokolanfini, Breath, Butterflies, Dogon, Felines, Gelede, Ibeji, Igbo Masquerades, Korwar, Leopard, Liminal States/Beings, Mamy Wata, Mbari, Metal, Mudheads, Navajo Aesthetics, Oduduwa, Ogboni, Ogowe River Basin, Osun, Rainbow Snake, Sande, Sandogo, Sango, Tunghak, Water Spirits, Wilderness, Yimar, Yulunggul, Zuni

Cameroon Masquerades, Chunkey, Dogon, Epa, Esu, Fon, Fon Fabrics, Ife, Glele, Lizard, Luba Divination, Number Symbolism, Path of Life, Postures, Ritual, Sandogo, Santeria, Sign Systems–Cameroon Ndop

Divination – Bamana, Baule, Bembe, Bwa, Cameroon

Dreams – Bembe, Chumash, Dan, Danger, False Face Society, Geelvink Bay, Ghost Dance, Gift Baskets, Giryama, Hogan, Iroquois, Kairak Baining, Kwoma, Lucid Dreams, Magical Flight, Maro, Morning Star Ceremony, Owl, Pueblo Pottery, Sango, Self-Directed Designs, Shadow, Songye, Spirit Spouses, Tipi, Urhobo, Wakan, Walbiri, Wandjina

Layered Universe – Bella Coola Cosmology, Center, Four/Six Directions, Maui, Mississippian Cults, Navajo Ceremonialism, North American Native Religion, Number Symbolism, Sand Painting, Shamanism, Sun Dance

Names – Asmat War Shields, Basketry, Baule, Coppers, California Basketry, Featherwork, Fon, Golden Stool, Haida, Hamatsa, Hausa, Head Hunting, Igbo, Kente, Kilenge, Kominimung Shields, Konankada, Kuba, Maori Aesthetics, Marquesas Islands, Medicine Bundles, Powwow, Sande, Sign Systems, Sign Systems – Asante Adinkra, Solomon Islands, Suspension Hooks, Teket, Vision Quest, Water Spirits, Whare Whakairo, Yam, Yoruba

Primordial Conditions – Androgyny, Beauty, Color, Cosmic Models, Cross, Dogon Masquerades, Dreaming, Earth Diver, Hamatsa, Hozho, Inua, Kuksu Cult, Marind-Anim, Navel, Janus, Ogboni Society, Primordial Couple, Primordial One, Sandogo, Songye, Sun Dance Lodge, Time, Trickster, Yafar